Sir Herbert Read was born in 1893 and was at the

University of Leeds when the First World War broke out. He served as an Infantry Officer in France and Belgium, and gained the DSO and MC. In 1931 he became Professor of Fine Arts at the University of Edinburgh. He was Clark Lecturer, Trinity College, Cambridge, 1929–30; Sydney Jones Lecturer in Art, University of Liverpool, 1935–36; and Norton Professor of Fine Art, Harvard University, 1953–54. His publications include: A Concise History of Modern Painting, Art and Alienation, The Origins of Form in Art, Arp and Henry Moore.

He died in 1968.

WORLD OF ART

This famous series provides the widest available range of illustrated books on art in all its aspects. If you would like to receive a complete list of titles in print please write to: THAMES AND HUDSON 181A High Holborn, London WCIV 7QX In the United States please write to: THAMES AND HUDSON INC. 500 Fifth Avenue, New York, New York 10110

Printed in Singapore

FREE PUBLIC LIBRARY UXBRIDGE, MAN

MODERN SCULPTURE A Concise History

Herbert Read

339 illustrations, 49 in color

Thames and Hudson

735.3 READ

Any copy of this book issued by the publisher as a paperback is sold subject to the condition that it shall not by way of trade or otherwise be lent, resold, hired out or otherwise circulated without the publisher's prior consent in any form of binding or cover other than that in which it is published and without a similar condition including these words being imposed on a subsequent purchaser.

© 1964 The Herbert Read Discretionary Trust

Published in the United States of America in 1985 by Thames and Hudson Inc., 500 Fifth Avenue, New York, New York 10110 Reprinted 1999

Library of Congress Catalog Card Number 86-51574 ISBN 0-500-20014-9

All Rights Reserved. No part of this publication may be reproduced or transmitted in any form or by any means, electronic or mechanical, including photocopy, recording or any other information storage and retrieval system, without prior permission in writing from the publisher.

Printed and bound in Singapore

1000 lipit,

Contents

- Page 7 Author's Note
 - 9 CHAPTER ONE The Prelude
 - 43 CHAPTER TWO Eclecticism
 - 59 CHAPTER THREE From Cubism to Constructivism
 - 115 CHAPTER FOUR From Futurism to Surrealism
 - 163 CHAPTER FIVE The Vital Image
 - 229 CHAPTER SIX A Diffusion of Styles
 - 279 Text References
 - 283 Select Bibliography
 - 287 List of Works Reproduced
 - 306 Index

The upshot is that we are not justified in identifying history as a process in homogeneous chronological time. Actually history consists of events whose chronology tells us but little about their relationships and meanings. Since simultaneous events are more often than not intrinsically asynchronous, it makes no sense indeed to conceive of the historical process as a homogeneous flow. The image of the flow only veils the divergent times in which substantial sequences of historical events materialize.

SIEGFRIED KRACAUER Time and History

Author's Note

An author should not begin his book with an apology, but the planning of this concise history of modern sculpture has inevitably meant the omission of the names of many artists of distinction and a brevity of treatment of many others that would not have been justified if my space had been unlimited. For the same reasons of economy I have tended to apply rather a rigid definition to the art itself, and have excluded from the illustrations those reliefs and constructions which hover ambiguously between the crafts of painting and carving. It is not possible to ignore the general tendency to abandon carving and even modelling in favour of various easy methods of *assemblage*, but I cannot pretend to accept this development with complacency.

The illustration of sculpture, for effectiveness, demands a certain scale, and within the limits set by the publisher I did not have room for some of the works I would have liked to include. In making a choice between alternatives I have tried to represent every type of work that is historically significant, but the exclusions were often unfair to artists of considerable achievement.

This volume has been conceived as a companion to the author's *Concise History of Modern Painting*, and it has been assumed that the reader is already familiar with those phases of the modern movement in the arts which all the arts have in common. Otherwise the narrative is quite independent.

As on previous occasions, I would again like to express my great indebtedness to the publications of the Museum of Modern Art, New York, which provide in accessible form much of the essential documentation for the period. I would also like to pay a tribute to the pioneer in this subject, Dr Carola Giedion-Welcker, whose *Contemporary Sculpture: an Evolution in Volume and Space*, first published in 1956 (new and revised edition, 1961), is not only an indispensable work of reference, but also contains a Selective Bibliography by Bernard Karpel of the Museum of Modern Art of great value to the student and the general reader.

Finally I would like to thank all those artists, collectors and art galleries who have helped me to assemble the many photographs required for the illustration of this book. I am particularly indebted in this respect to Mr Joseph H. Hirshhorn, who has allowed me to draw liberally from his own magnificent collection, and to Mr Abram Lerner, the curator of this collection. I have also received considerable assistance from Mr Thomas M. Messer, the Director of the Solomon R. Guggenheim Museum in New York.

It is not usual to thank members of the firm responsible for the publication of a book, but an exception must be made in the present instance. The work could not have been completed without the patient and tireless assistance of Miss Pat Lowman.

February, 1964

H.R.

The Prelude

The history of art like the history of any other subject depends for its coherence on the arbitrary choice of a principle, though 'principle' is perhaps a solemn word for what is no more than a convenience. Against a background of chronological time we have various 'movements' to which we give names like Impressionism, Cubism or Surrealism. These movements do not necessarily follow one another in chronological sequence, and even if they did we should find them criss-crossed by the paths made by individual artists. In other words, the personal development of the artist often traverses two or three movements, and an eclectic artist like Picasso will move in and out of half-a-dozen stylistic categories for no better reason than the one that makes us from time to time seek a change of climate.

We might also say that the history of art is dominated by the works of a few geniuses, and that the minor manifestations of a period arc particles on the lines of force that emanate from these fixed points. A chart representing these fixed points and radiating lines (which often meet and merge) would perhaps give us the most accurate image of the historical situation, but it cannot be translated into a verbal narrative. A chronological sequence must be attempted, with the full realization that it is an arbitrary simplification and involves repetitions, contradictions and ambiguous problems of *value*.

In the companion volume on the history of modern painting it was possible to give good reasons for beginning with Cézanne (1839–1906). In sculpture it is tempting to begin with the artist who was his almost exact

contemporary, Auguste Rodin (1840-1917). But there is a difference. Cézanne was 'the primitive of a new art'; by concentration on the 'motif', by his patient 'realization' of the inherent structure of the object, he discovered modes of representation that gave solid substance to his perceptual images. He reacted against Impressionism, which had no purpose beyond the rendering of subjective sensations, and could, he thought, only end in meaningless confusion. By his insistence on clarity of form and an architectonic principle of composition, Cézanne laid the foundations of a new classicism, an art of measure and serenity. But Rodin, who began with the ambition to restore the art of the medieval cathedrals, an aim that might have brought him by another path to the same kind of 'masonry', was seduced by the prevailing mood of subjectivism, and could therefore never supply sculpture with the same solid ground for 'a new art'. Rodin was a great artist, and I shall presently describe the kind of rectitude he restored to the art of sculpture; but he was not an originator in the same sense as Cézanne was, and paradoxically the achievements of the painter were to have more significance for the future of sculpture than the achievements of the sculptor. Rodin was followed by Maillol and Bourdelle, who were also great sculptors. But Cézanne was followed by Picasso, González, Brancusi, Archipenko, Lipchitz and Laurens, and it is they who were to be the primitives of a new art of sculpture. This 'new art' will be our concern in this volume, the sculpture we call 'modern' because it is the peculiar creation of our age, and owes little to the art that preceded it in history.

Though the habit is often questioned, there is sufficient excuse for using the word 'modern' to describe a development in sculpture which does not comprise every kind of sculpture that is contemporary. The day on which I write these words I note that a reviewer, Professor Quentin Bell, is questioning this habit; he tells us that the reader of the book he is reviewing (*A Dictionary of Modern Sculpture*):

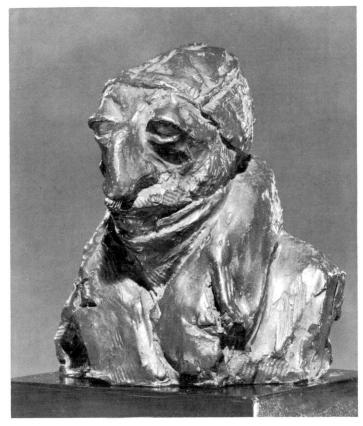

I HONORÉ DAUMIER L'Homme à tête plate c. 1830-2

will seek in vain for modern sculptors who are not 'modern'; he will find Renoir and Daumier, who for some reason *are* 'modern', but neither Dalou nor Carpeaux, who for some equally obscure reason are not. In short, it is a dictionary of those sculptors who happen to interest the authors and, so long as we realize that, it will cause us no disappointment.¹

One should perhaps not pay too much attention to a witty remark intended to enliven a review, but I use the word 'modern' with this same restricted meaning and feel perfectly justified in doing so. 'Modern' has been used for centuries to indicate a style that breaks with accepted traditions and seeks to create forms more appropriate to the sense and sensibility of a new age. From this point of view Dalou and Carpeaux were born 'ancient', and though the traditionalist has a perfect right to be a partisan of the ancient, he cannot deny the use of 'modern' to describe what Harold Rosenberg has called 'the tradition of the new'.²

The whole purpose of Rodin had been to restore to the art of sculpture the stylistic integrity that it had lost since the death of Michelangelo in 1564. Three centuries of mannerism, academicism and decadence stretch between the last great work of Michelangelo, the Rondanini Pietà, and the first confident work of Rodin, The Age of Bronze of 1876-7. It is true that in the interval there is the odd intrusion of Honoré Daumier, who as early as 1830 was producing busts as superficially 'modern' as any works of Rodin. But Daumier was a caricaturist, and the kind of deformations made by the caricaturist to secure his satirical emphasis have nothing in common with the formal conceptions of a Rodin (as the satires of Goya, for example, have only a superficial resemblance to Picasso's drawings for his Guernica). Caricature itself is a relatively modern form of art (it was not known to the world before the end of the sixteenth century), but already in 1681 it had been defined as:

a method of making portraits, in which they (painters and sculptors) aim at the greatest resemblance of the whole of the person portrayed, while yet, for the purpose of fun, and sometimes of mockery, they disproportionately increase and emphasize the defects of the features they copy, so that the portrait as a whole appears to be the sitter himself while its component parts are changed.³

Any resemblance with the stylistic forms of modern art is therefore 'purely coincidental'.

The principles of sculpture to which Rodin returned were clearly stated by the artist himself on many occasions. They may be conveniently consulted in the *entretiens* (conversations) collected by Paul Gsell.⁴ Rodin resumed these

2

Ι

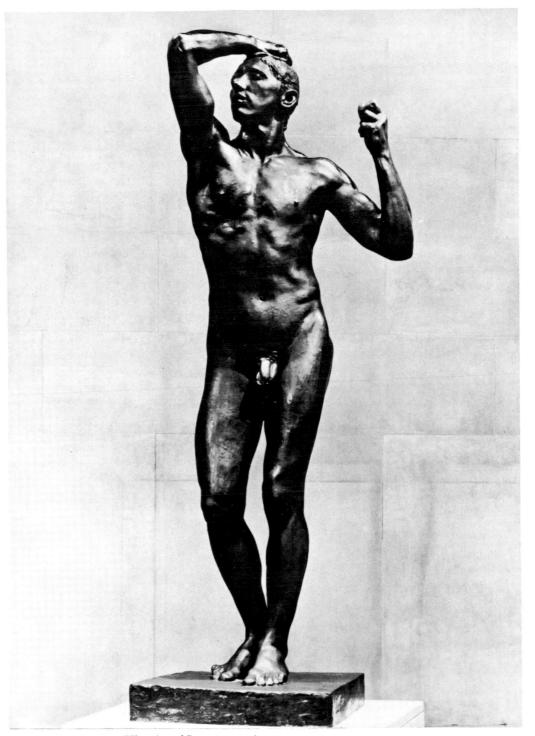

2 AUGUSTE RODIN The Age of Bronze 1876-7

principles in a 'testament' of less than two thousand words, which, apart from exhortations to love the great masters of the past (particularly Phidias and Michelangelo), to have an absolute faith in Nature, and to work relentlessly, gives the following advice:

> Conceive form in depth. Clearly indicate the dominant planes. Imagine forms as directed towards you; all life surges from a centre, expands from within outwards. In drawing, observe relief, not outline. The relief determines the contour. The main thing is to be moved, to love, to hope, to tremble, to live. Be a man before being an artist!

These are the words of a humanist, of an artist who was always concerned to serve humanity and to give his work a public setting. His ideals, social and artistic, were the same as those of Phidias and Michelangelo, the same as those of the 'image-makers' of the Middle Ages, of whom, he said, Michelangelo was the heir.

It is important to keep these ideals in mind if we are to measure the extent to which modern sculpture has abandoned them in order to substitute other ideals. In general we may say that two developments have taken place, one of which continues to 'conceive form in depth' and generally to follow the tradition of the image-makers, the other rejecting the humanist tradition as such together with its organic criteria, in order to create values of a different kind, the absolute values of 'pure form'. For all his modernity a sculptor like Henry Moore remains within the same formal tradition as Michelangelo; a Constructivist like Naum Gabo has quite other ideals. We continue to call all free-standing threedimensional works of plastic art 'sculpture', but the modern period has seen the invention of three-dimensional works of art which are in no sense 'sculpted' or even moulded. They are built up, like architecture, or constructed like a machine. It will be necessary to elucidate these distinctions and seek to justify them aesthetically.

Two modifications of the organic tradition that preceded the modern period should next be noted, those stylistic phases known as Impressionism and Eclecticism. Whether Rodin is to be called an Impressionist depends on one's definition of Impressionism. We do not immediately associate him with the Impressionist movement as such, though he once exhibited with Monet (at Petit's, in 1889)⁵ and he owned Van Gogh's Le Père Tanguy, now in the Musée Rodin. Like most labels in the history of art, 'Impressionism' covers a multitude of individual styles, and it is not easy to isolate a quality common to artists so diverse as Cézanne, Degas, Manet, Pissarro and Renoir. As Mr Rewald suggests in his definitive history of the movement, 'no one word could be expected to define with precision the tendencics of a group of men who placed their own sensations above any artistic program'.6 If one accepts the then current definition of one of Renoir's friends (G. Rivière), 'treating a subject in terms of the tone and not of the subject itself', then it is difficult to apply it to the work of Rodin, or to sculpture in general. Even if one accepts Mr Rewald's amended definition -'rejecting the objectivity of realism, they had selected one element from reality (light) to interpret all of nature' - one still has painting rather than sculpture in mind (and even then it is difficult to fit a painter like Cézanne into the definition, for he regarded light as a deceptive or ambiguous element in the representation of form). As for Rodin, though he thought of light as the element in which form was revealed, it was not 'la vérité intérieure'. The inner truth of growth and form is revealed to touch rather than to sight; touch at least has the sensational priority, and if it is objected that the spectator does not normally apprehend

3 MEDARDO ROSSO Conversazione in Giardino 1893

sculpture by this means, it is the spectator's loss. The sensations involved in the act of creation are essentially those of thrust and pressure, tactile sensations.

This distinction would not exclude an impressionistic sculpture, for the definition changes with the material. Nevertheless, one is much nearer the truth of the matter if one concentrates on movement rather than light, and movement was equally the concern of the painters and sculptors involved. Rodin realized that the *illusion* of life could not be given except by the representation of movement. Movement he defined as the transition from one attitude to another, and this could not be rendered 'realistically' in a piece of sculpture, which is a static object. The alternative is to

4 AUGUSTE RODIN Monument to Balzac 1897

suggest successive positions simultaneously. An instantaneous photograph, he maintained, was deceptive because it illustrated an arrested movement; but the artist was interested in movement itself, and this could be represented only by certain conventions. He therefore defended Géricault who painted racehorses with their four legs simultaneously extended, which never occurs in reality but is indicative of the sensation experienced in watching a race. The artist depicts his visual feelings, which may be illusory, but the result is nearer to the truth than any photograph.

One might say, therefore, that Rodin sympathized with those aspects of Impressionism that were based on '*la vérité intérieure*', on subjective feeling, but would have

nothing to do with those aspects based on a science of visual perception. In this respect he differed radically from such Impressionists as Seurat and Pissarro, who for a time attempted to base their methods of painting on the optical theories of Chevreul, Maxwell and other physicists. If Rodin's statues were so realistic that he could actually be accused of casting his Age of Bronze from a live model, this was not because he had any ideal of photographic accuracy, but because the representation he made corresponded exactly to the sensations he experienced. In this sense he was a realist, but an ambiguity remains, due to the fact that the truth is often stranger than fiction, fiction being, in this case, the prevailing academic conventions. There are at least three possibilities: 1. the counterfeiting of reality (mimetic representation), 2. the representation of the visual experience, and 3. the creation of various substitutes (signs, symbols) for such experience. If the Impressionist is one who attempts to be faithful to the visual experience, then Rodin was an Impressionist in such works as The Age of Bronze (1876-7) and a Symbolist in such a work as the final version of the 4 Monument to Balzac (1897).

The modernity of Rodin lies in his visual realism. There were, of course, realists in sculpture before Rodin. In this sense Michelangelo was a realist, and above all Donatello. But the significance of Rodin for the sculptors who came after him lies not so much in his fidelity to his visual experience, still less in the humanistic prejudice he always displayed, but solely in the integrity of the technical means he employed, his almost blind reliance on his tools. A gulf separates the work of Rodin from that of Arp or Henry Moore; but all three sculptors share the same concern for the virtues proper to the art of sculpture - sensibility to volume and mass, the interplay of hollows and protuberances, the rhythmical articulation of planes and contours, unity of conception. The ends differ but the means are the same, and most modern sculptors recognize that it

5 ARISTIDE MAILLOL Torso of the Monument to Blanqui (Chained Action) c. 1905–6

was Rodin who brought back to the art of sculpture a proper sense of sculptural values. The nature of this achievement has been beautifully described by the poet who was for a short time the sculptor's secretary, Rainer Maria Rilke:

There is above all the indescribably beautiful bronze portrait bust of the painter Jean-Paul Laurens, which is perhaps the most beautiful thing in the Luxembourg Museum. This bust is penetrated by such deep feeling, there is such tender modelling of the surface, it is so fine in carriage, so intense in expression, so moved and so awake that it seems as if Nature had taken this work out

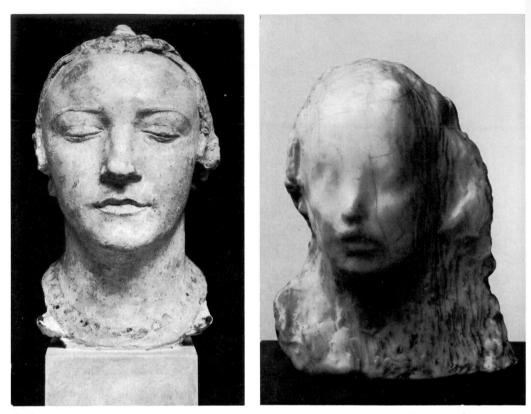

6 CHARLES DESPIAU Head of Madame Derain 1922

7 MEDARDO ROSSO *Ecce Puer* 1906–7

of the sculptor's hands to claim it as one of her most precious possessions. The gleam and sparkle of the metal that breaks like fire through the smoke-black patina coating adds much to make perfect the unique beauty of this work.⁷

Rodin's immediate successors in France, Aristide Maillol (1861–1944), Antoine Bourdelle (1861–1929) and Charles Despiau (1874–1946) do not concern us, except in so far as they maintained these sculptural values for another generation. Bourdelle worked for a long time as Rodin's chief assistant and Maillol, before he became a sculptor at the age of forty, was attracted to Impressionism as a painter or

8

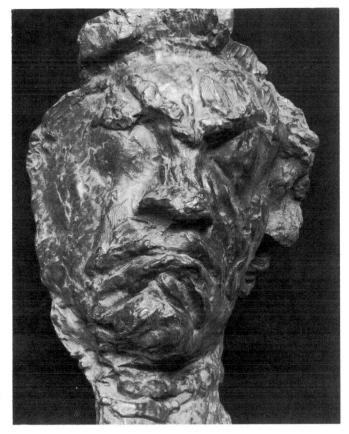

8 ANTOINE BOURDELLE Beethoven, grand masque tragique 1901

designer. But both sculptors returned to classical idealism (Maillol lived in Greece for a year) and both reacted against Impressionism. 'Nature is deceptive,' said Maillol. 'If I looked at her less, I would produce not the real, but the true. Art is complex, I said to Rodin, who smiled because he felt that I was struggling with nature. I was trying to simplify, whereas he noted all the profiles, all the details; it was a matter of conscience.'⁸ This ingenuous confession reveals the difference between the two artists. Despiau also worked for Rodin, but he confined himself almost exclusively to portraits and, sensitive as these are, they did not contribute anything to the future development of sculpture.

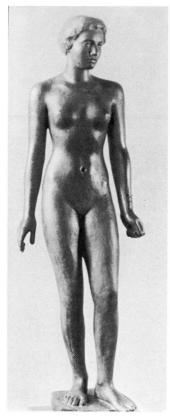

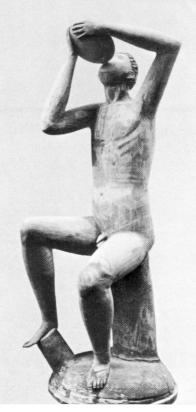

9 GEORG KOLBE ARTURO MARTINI Young Girl Standing 1915 Boy Drinking 1926

More unreservedly impressionistic in his style than Rodin is the Italian sculptor Medardo Rosso (1858-1928). He was born in Turin and like Maillol began as a painter. He was in Paris from 1884-5 and worked in the studio of Dalou. He met Rodin from time to time and may even have influenced him - it has been suggested that his Conversazione in Giardino (1893), a large sculptural group dominated by a figure turning its back, inspired Rodin in his Monument to 4 Balzac (1893-7).9 But Rosso was a social realist as well as an Impressionist - perhaps an Impressionist because he wanted to catch the actuality of daily life rather than because he had any scientific theories about illusion and reality. In

this respect he is closer to Degas, whom he knew personally, than to Rodin or Maillol, and it is significant that Zola was one of his early patrons. His realism had led him to revolt against a static conception of sculpture. In group compositions like the *Conversazione* his style is distinctly manneristic and violent. It is this quality in Rosso's work, rather than the serenity of his portraits, that was to attract the Futurists who from 1909 onwards hailed him as a pioneer of 'dynamism' in art. Boccioni in particular was strongly influenced by Rosso.

There are several other sculptors of this generation, caught between Impressionism and classicism, refusing the challenge of modernism as first revealed in Cubism, who nevertheless, by their very eclecticism, contributed to the

II GERHARD MARCKS Freya 1949 12 ERNESTO DE FIORI *The Soldier* 1918

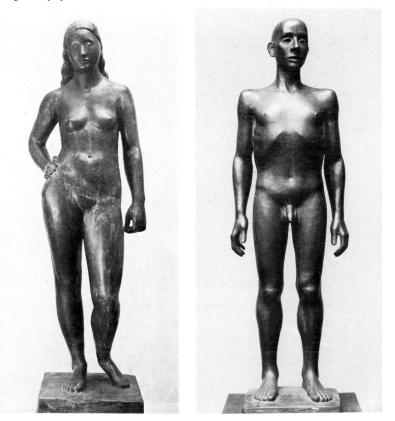

revival of sculpture. Rosso's compatriot and contemporary, Arturo Martini (1889–1947) is one – a sculptor little known IO outside Italy (except possibly in the United States). Martini was trained as a potter and his most characteristic works are in terracotta. They recall certain Renaissance works in that medium (for example, the terracottas of Antonio Rossellino). But they are more mannered, and a certain 'mannerism' is characteristic of all this group of 'hesitants' -Wilhelm Lehmbruck (1881–1919), Ernesto de Fiori (1884– 13, 12 1945), Georg Kolbe (1877-1947), Gerhard Marcks (b. 9, 11 1889), Renée Sintenis (b. 1888) - it is significant that so 14 many of them are of German origin, and I can think of no better explanation than the continuing influence of that great German classicist, Adolf Hildebrand (1847-1921). Hildebrand did not think of himself as a classicist, but

13 WILHELM LEHMBRUCK Young Man Seated 1918

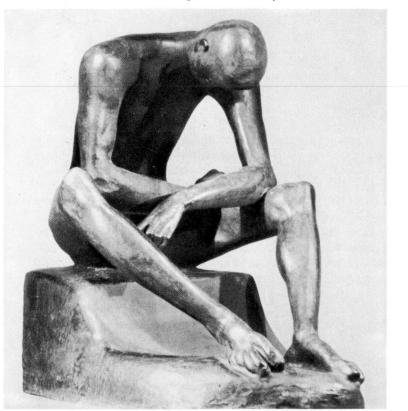

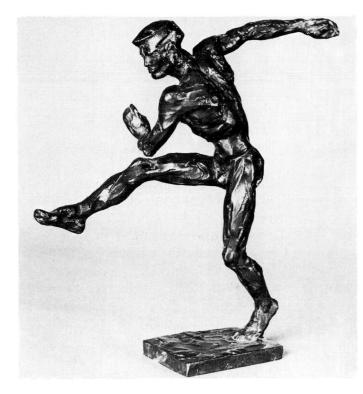

14 RENÉE SINTENIS Football Player 1927

rather as a humanist reviving the best traditions of Renaissance sculpture. I have discussed his theories elsewhere;¹⁰ in my opinion they had a disastrous influence on European sculpture because they elevated visual and pictorial values above the essential sculptural values which are tactile and haptic. Mannerism in modern sculpture has no other origin. On the credit side it must be granted that Hildebrand's emphasis on direct cutting as distinct from modelling had a good effect on the purely technical development of the art. But a good technique cannot save a false aesthetic.

In a rather different category is the German sculptor Ernst Barlach (1870–1938), who also insisted on the virtues of carving as distinct from modelling. But Barlach deliberately rejected the classical tradition in favour of the Gothic or Nordic tradition. In some degree this brings him nearer to Rodin with his admiration for the image-makers of

the Middle Ages, but Rodin was sensitive enough to feel the classical element in mature Gothic, and he might have claimed that Gothic only reached its maturity when, as at Reims or Augsburg, the Abstract Expressionism of the Northern 'will to form' combined with the idealistic naturalism of the Greek tradition to achieve a new and higher synthesis of styles. In other words, Barlach and Rodin had very different 'image-makers' in mind. Barlach really belongs to Expressionism - at least, his Gothic forms were modified by expressionistic tendencies just as Rodin's classic forms were modified by impressionistic tendencies. In his early work, the ceramic figures of 1903-4 and the terracotta and bronze figures of 1906-7, there is a distinct element of the prevailing Jugendstil (art nouveau), but that is true of the early stages of German Expressionism in general. These generalizations apply equally to the work of two other German sculptors who may be associated with Barlach -Gerhard Marcks and Käthe Kollwitz (1867–1945). Kollwitz, better known as a graphic artist, was nevertheless a sculptor with great understanding of plastic form, and

15 KÄTHE KOLLWITZ The Complaint 1938

16 LEONARD BASKIN Head of Barlach 1959

one of great compassion. Marcks began as an animal sculptor 'until, at the sight of finches in the zoo, despair seized me'.¹¹ His native Nordic feelings have been to some extent modified by classical influences, but it should not be forgotten that Gropius called him to the Weimar Bauhaus in 1920, where he remained until the Bauhaus was closed five years later (to reopen in Dessau). He was persecuted by the Nazis and included in the infamous exhibition of Degenerate Art.

17 ERNST BARLACH Veiled Beggar Woman 1919

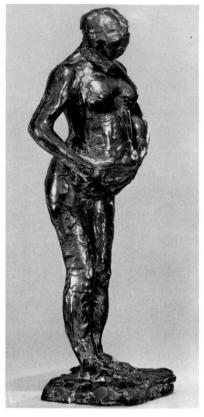

18 PIERRE BONNARD Girl Bathing c. 1923

19 EDGAR DEGAS Pregnant Woman c. 1896–1911

Rodin apart, it could be said that the most significant contributions to the evolution of modern sculpture before the advent of Cubism were made by two painters – Degas and Matisse. The sculpture of painters is a fascinating subject, inclining to paradox. That sculpture can be combined with painting without detriment to the exercise of either craft is sufficiently proved by the case of Michelangelo. In the case of the artists now to be considered, Degas, Gauguin, Renoir, Bonnard and Matisse, we are concerned with painters whose main preoccupation was the art of painting, for whom sculpture was either an amusement or a test in another medium of their passionate involvement in plastic values – the rendering of volume in space, the conflict of light and mass. It is difficult to regard the sculpture of Gauguin (1848–1903), for example, as more than a diversion from his main purpose. For the most part in the form of reliefs, it does not claim to be more than decorative, except perhaps in two or three small statuettes, such as the figure $(27\frac{1}{2}$ inches high) in painted wood, *Caribbean Woman (La Luxure*), carved at Le Pouldu in 1890–1. The same figure appears in a painting, *Caribbean Woman with Sunflowers*, of 1889–90 (Collection of Dr and Mrs Harry Bakwin, New York).¹² The sculpture adds nothing of aesthetic significance to the painting; it was apparently inspired, according to Mr Rewald, by a fragment of a frieze in Gauguin's possession that had fallen from a building in the Javanese village that was part of the Universal Exhibition of 1889.

Auguste Renoir (1841–1919) and Pierre Bonnard (1867– 1947) had more feeling for the tactile values of sculpture,

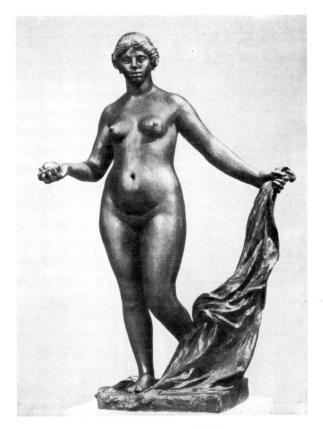

43

20 AUGUSTE RENOIR Standing Venus (Venus Victorious) 1914

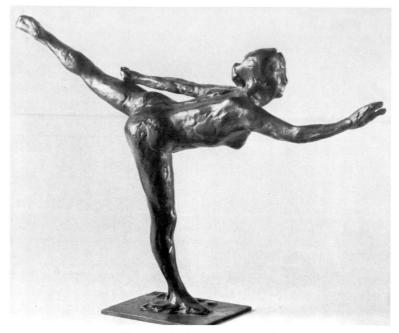

21 EDGAR DEGAS Dancer, Arabesque over right leg, right arm in front 1882-95

and their few pieces are well modelled in the tradition of Rodin or Maillol. Bonnard's Girl Bathing, a bronze of about 18 1923, is sensitive enough to be mistaken for a Rodin. Renoir did not attempt sculpture until late in life (1907), and most of his work was done with an assistant, Guino, in the last five or six years of his long life, when he had begun to experience difficulty in handling a paint-brush. Nevertheless the bronze Standing Venus (Venus Victorious) of 1914 does succeed in translating into solid three-dimensional form the grace and tenderness of his paintings.

The cases of Degas and Matisse are quite different. Both took an essential part in the formation of a new type of sculpture, and had a profound influence on their successors. A considerable distance in time separates these two artists. Degas was born in 1834 and died in 1917; Matisse lived from 1869 to 1954. They made their first attempts at sculpture at about the same age, in their early thirties. Degas did

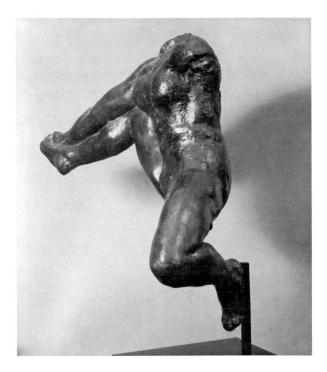

22 AUGUSTE RODIN Iris, Messenger of the Gods 1890–1

not exhibit any sculpture before 1866; Matisse's first sculpture dates from 1899.

It would be possible to distinguish the two artists sculpturally by describing them as Impressionist and Post-Impressionist, but there was a more fundamental difference of aim. For Degas sculpture was never more than ancillary to his painting, but ancillary in the sense that through its means Degas was able to explore problems of form and movement which he found difficult to solve in the twodimensional medium of painting. His bronze dancers and horses are always part of and contemporary with his preoccupation with these motifs in his painting. This brought him near to Rodin, and there is in fact little distinction to be made between Rodin at his most impressionistic, say the *Iris, Messenger of the Gods* (1890–1), and a Degas representation of a similar motif, such as the *Dancer, Arabesque over right leg* (1882–95). Nevertheless, when Degas exhibited his

23 Little Dancer at the sixth Impressionist exhibition in 1881 (it was the wax original now in the possession of Mr and Mrs Paul Mellon) it was to strike a contemporary like Huysmans as 'the only really modern attempt of which I know in sculpture'.¹³

Matisse's reaction to Impressionism is quite another story – the story, indeed, of Post-Impressionism in general. Matisse as a young man had admired Rodin from a distance. In 1906 (according to André Gide's *Journal*, repeating an anecdote told him by Maurice Denis) Matisse had been to Rodin's studio for the first time and had shown him some of his drawings. Rodin had told him to persevere (*pignocher*) for a fortnight with the same drawings and then show them to him again.¹⁴ Matisse himself told rather a different story to Raymond Escholier:

I wanted to know what Matisse himself had to say about his relations with Rodin, and he also defined the gap which separated their different conceptions of sculpture, and art itself. 'I was taken to Rodin's studio in the rue de l'Université, by one of his pupils who wanted to show my drawings to his master. Rodin, who received me kindly, was only moderately interested. He told me I had "facility of hand", which wasn't true. He advised me to do detailed drawings and show them to him. I never went back. Understanding my direction, I thought I had need of someone's help to arrive at the right kind of detailed drawings. Because, if I could get the simple things (which are so difficult) right, first, then I could go on to the complex details; I should have achieved what I was after; the realization of my own reactions.

'My work-discipline was already the reverse of Rodin's. But I did not realize it then, for I was quite modest, and each day brought its revelation.... Already I could only envisage the general architecture of a work of mine, replacing explanatory details by a living and suggestive synthesis.'¹⁵

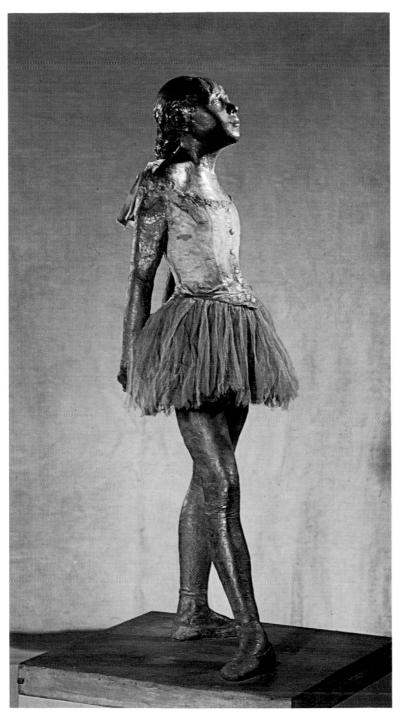

23 EDGAR DEGAS The little Dancer of fourteen years 1880-1

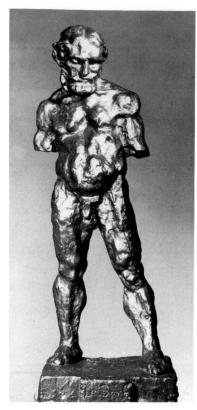

²⁴ HENRI MATISSE The Slave 1900–3

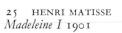

Matisse's criticism of Rodin is that he neglected the whole (monumentality) for the sake of the carefully realized detail – that he conceived the whole as an assemblage of such details. Matisse knew instinctively that wholeness has a quality of its own which differs from the sum of the parts, and that it was more important to capture this unique quality of wholeness than to get lost in the study of detail. Detail, that is to say, should be strictly subordinated to the creation of a dominant rhythm. As in his painting, so in his sculpture; Matisse is in search of 'ease', harmony, of what he called the arabesque. His reaction to Maillol's work is significant in this respect. He was much more closely related to Maillol – indeed, they were intimate friends, but

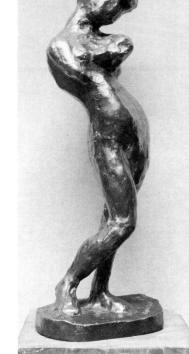

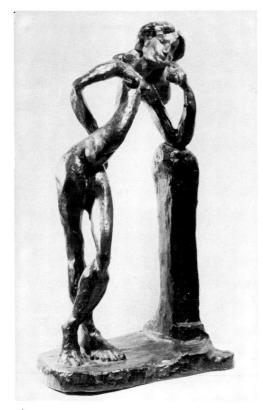

26 HENRI MATISSE La Serpentine 1909

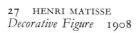

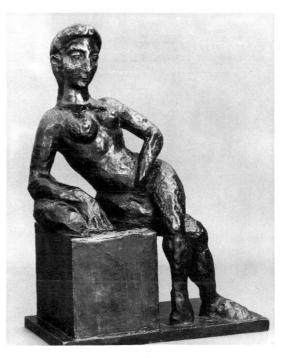

28 HENRI MATISSE Jeanette V 1910–11

29 HENRI MATISSE Large Seated Nude 1907

Matisse was never influenced by Maillol. On the contrary – as he told Escholier, he had practised sculpture, 'or rather modelling', before he knew Maillol:

I did it as a complementary study to put my ideas in order. Maillol's sculpture and my work in that line have nothing in common. We never speak on the subject. For we wouldn't understand one another. Maillol, like the Antique masters, proceeds by volume, I am concerned with arabesque like the Renaissance artists; Maillol did not like risks and I was drawn to them. He did not like adventure.¹⁶

This is a very revealing confession. Arabesque, a word often on Matisse's lips, is a linear conception; it is also, in its

Oriental origins, a decorative conception. It is an escape from mass and volume, towards movement or action, and that, of course, with many qualifications (for Matisse was a master of suggestion, that is to say, of the first principle of Impressionism), is also true of his painting.

Nevertheless, Matisse took his sculpture seriously. It has often been related how he made his first piece, a free copy of Barye's Jaguar devouring a Hare – how he worked for months in a studio at the École de la Ville de Paris, dissecting a cat to get a realistic knowledge of the anatomy of such an animal. His first human figure, The Slave of 1900–3, might be mistaken for a free copy of Rodin's Walking Man, but again it was based on detailed observation of the model. In the contemporaneous Madeleine I he has already broken 25 away from his predecessors, and the result is indeed an

30 HENRI MATISSE Seated Nude 1925

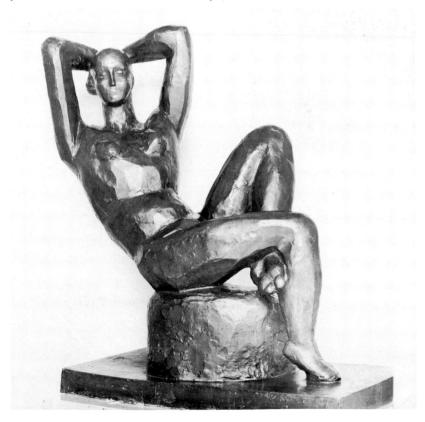

arabesque – a human body deprived of arms and features to emphasize its sinuous curves.

Âll Matisse's most characteristic sculptures - the Large Seated Nude of 1907, the Decorative Figure of 1908, La 29, 27 Serpentine of 1909, the series of Jeanette busts (1910-11), the 26, 28 Reclining Nude II of 1929, the Venus in a Shell of 1931, are 34, 32 arabesque in the sense claimed by Matisse. But they are also increasingly 'haptic', emphasizing by distortion the inner muscular tensions of the human figure. One has only to compare a graphic and a sculptural representation of the same model - for example the lithograph of a Nude in an Armchair (1925) with the Seated Nude of the same year in the 30 Baltimore Museum - to see how certain features, such as the lower extremities of the legs and the arms held behind the head, are used to produce tensions that give the pose the visual effect of balance. The same features in an even more exaggerated form are found in *La Serpentine* as early as 1909. This expressionistic tendency in Matisse's sculpture - a

32 HENRI MATISSE Venus in a Shell 1931 (right)

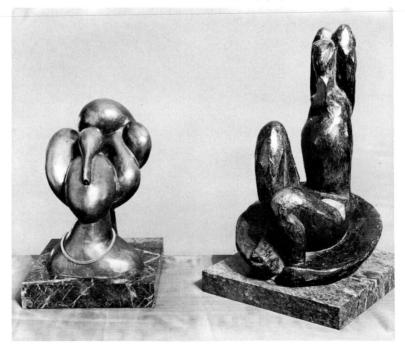

³¹ HENRI MATISSE Tiari with Necklace 1930 (left)

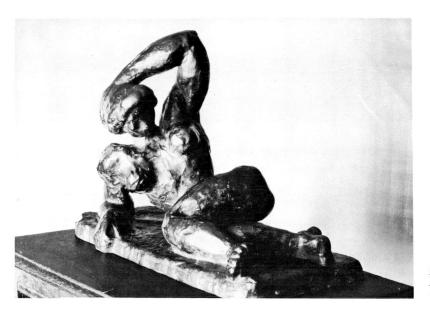

33 HENRI MATISSE Reclining Nude I 1907

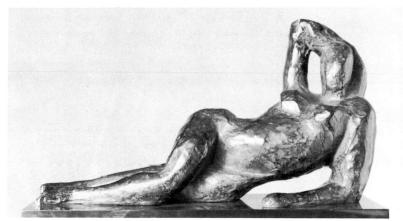

34 HENRI MATISSE Reclining Nude II 1929

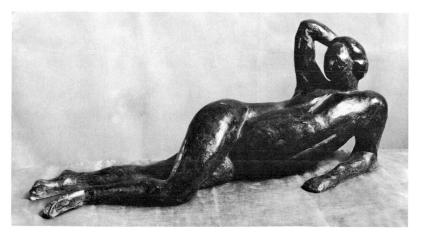

35 HENRI MATISSE Reclining Nude III 1929

tendency not generally found in his painting, which shows how carefully he observed the distinct sensational values involved in each art^{17} – comes to a climax in the series of

36–9 'Backs' he experimented with from 1909 to 1929. Though we are concerned with reliefs and not with sculpture in the round, the series does nevertheless summarize the complete evolution of Matisse's stylistic development in this art. The

- 36, 24 first *Back* is almost as naturalistic as *The Slave* and repeats the 25, 37 arabesque of *Madeleine I*; the second is rather more summary
 - or 'brutal', but there is no essential departure from the human model. But the third *Back*, which was apparently made immediately after the second, shows drastic simplifications of form. The limbs have become rigid trunks and a long 'tail' of hair descends from the head to balance the
 - 39 upward thrust of the legs. In the final version, which followed after an interval of fifteen years, the forms have become simplified to a degree rarely found in the paintings – the *Bathers by a River* of 1916–17 in the Henry Pearlman Collection and the figure of the painter in *The Painter and His Model* of 1916 (Paris, Musée National d'Art Moderne) are

36 HENRI MATISSE The Back I c. 1909

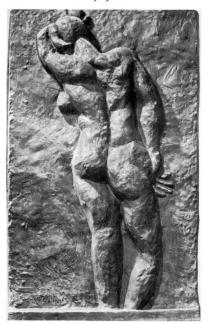

37 HENRI MATISSE The Back II c. 1913–14 (?)

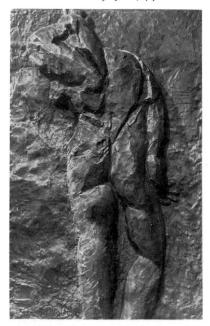

the nearest equivalents. Two smaller pieces of free sculpture, the *Reclining Nude III* of 1929 and the strange *Tiari* of 1930 (a tiari is a tropical plant; its form is combined with a human head) show that Matisse was in this year experimenting in a direction that brought him curiously near to the altogether different conception of the sculptor's art represented by Arp and Henry Moore.

How intimately and sensuously Matisse grasped the basic principles of the art of sculpture is shown by some notes which Sarah Stein took down when she attended Matisse's lectures or demonstrations at the 'Académie Matisse', a school run by Matisse in Paris from 1908–11. They have been reproduced in Alfred Barr's monograph on the artist.¹⁸ The following four instructions reveal the fundamentally expressionistic bias of Matisse's conception of art:

See from the first your proportions, and do not lose them. But proportions according to correct measurement are after all but very little unless confirmed by sentiment, and expressive of the particular physical character of the model...

38 HENRI MATISSE The Back III c. 1914

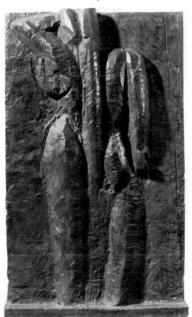

39 HENRI MATISSE The Back IV c. 1929

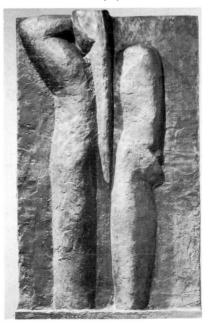

All things have their decided physical character – for instance a square, and a rectangle. But an undecided, indefinite form can express neither one. Therefore exaggerate according to the definite character for expression...

The model must not be made to agree with a preconceived theory or effect. It must impress you, awaken in you an emotion, which in turn you seek to express. You must forget all your theories, all your ideas before the subject. What part of these is really your own will be expressed in your expression of the emotion awakened in you by the subject. . . .

In addition to the sensations one derives from a drawing, a sculpture must invite us to handle it as an object; just so the sculptor must feel, in making it, the particular demands for volume and mass. The smaller the bit of sculpture, the more the essentials of form must exist.

There are many more detailed observations taken down by Sarah Stein which show Matisse's profound understanding of sculpture – for example: 'Arms are like rolls of clay, but the forearms are also like cords, for they can be twisted.' And: 'The pelvis fits into the thighs and suggests an amphora.'

On another occasion¹⁹ Matisse summed up all his experience and his philosophy of art in a sentence that has often been quoted but cannot be repeated too often: *L'exactitude n'est pas la vérité*.

Very few sculptors can be associated directly with Matisse, and in general it can be said that the influence that changed the course of Impressionist (and Expressionist) painting changed the course of sculpture. These influences were partly *eclectic* or *exotic*, the impact of types of sculpture from outside the European tradition, and partly *revolutionary* – the revolution in question being the Cubist one, which, however, gave impetus to a further revolution (which in its turn may have received contributory influences from other sources), the Constructivist revolution.

Eclecticism

Eclecticism is an attitude in art that permits a free choice and combination of styles other than one's own; *exoticism* implies that these styles are borrowed from a culture other than one's own. The distinction need not be pressed, for even when an artist borrows from a primitive source in his own civilization (early Greek, Romanesque, Etruscan in European art), these periods are usually remote enough to seem exotic, and the same artist (Picasso, for example) makes no distinction between primitive and exotic sources. There is perhaps an ethical distinction between the two procedures – to borrow from a remote source does not seem to have the same implication of plagiarism as borrowing from a contemporary source. If the borrowed style is thoroughly assimilated, its source has little aesthetic significance.

The past hundred years have witnessed the injection of at least seven exotic styles into the main stream of modern art. They may be listed as follows:

- 1. Far Eastern art.
- 2. African tribal art.
- 3. Primitive art (folk art, child art, naïve art).
- 4. Prehistoric art (especially neolithic carvings).
- 5. Pre-Columbian art of America.
- 6. Early Greek and Etruscan art.
- 7. Early Christian (especially Romanesque) art.

There may be still other minor influences, such as Celtic art or Polynesian art, but these fall into the general pattern.

Before tracing the impact of these influences on modern sculpture it might be interesting to attempt to find a reason for such eclecticism. It is not, of course, altogether a new

phenomenon: art has always been subject to influences and otherwise would scarcely have a history. Archaeology is the science that attempts to trace all the elements of 'independence, convergence and borrowing' involved in the history of culture, and to this process gives the name of cultural diffusion. When such diffusion occurs in the field of art, e.g. the spread of Greek art to India, or of Buddhist art from India to China, it is in an historical process, taking place in time, often lasting centuries. Eclecticism is a more restricted process, and though it may have political or economic origins, it is manifested as individual choice rather than as historical necessity. For example, the chinoiserie of the seventeenth and eighteenth centuries was a consequence of the growth of the trading with the Far East that took place at that time. Porcelain and embroidered silks were imported along with tea and spices, and the ornamentation on these objects was available to individual European artists as a source of motifs. But there was no unconscious assimilation of an Oriental style powerful enough to modify the general development of European art. In the same way, the importation of Japanese prints in the second half of the nineteenth century, which had such a decisive effect on Gauguin, Van Gogh and Whistler, did not change the course of the main stream of artistic development in Europe. The style of a few artists was modified, often only for a short time or even only in a few works. An artist like Gauguin received confirmation from Japanese art of certain principles he had evolved from inner necessity, just as he also received confirmation of other stylistic features from such sources as medieval stained glass, folk art, primitive coloured woodcuts and other sources. Such sources 'converge' in the sensibility of one artist, but a receptive sensibility is the necessary prerequisite. That sensibility is the end-product of a complex process, partly deriving from the individual artist's psychological constitution, partly from what might be called the available colours on the palette, the palette

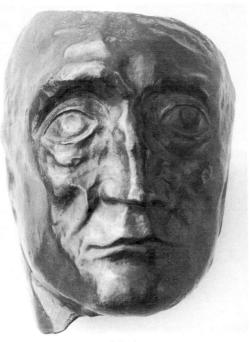

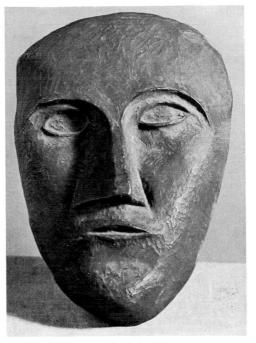

40 PABLO PICASSO Mask 1901

41 PABLO PICASSO Head of a Woman 1907

being the artist's consciousness of the social forces prevailing in his environment.

When a sufficient number of artists submit to the same influences, what is usually called a 'revival' may take place, as in the Renaissance (a 'rebirth' of classical art). The Gothic Revival of the early nineteenth century was in its turn a revolt against this classical tradition, and the fact that two such 'revivals' could contend with each other shows that an arbitrary element of choice is involved. This is still more evident in the eclecticism of the last hundred years. But a romanticist might suggest that the real conflict is between, not romanticism and classicism, but between romanticism and esotericism. The romantic artist always claims to be 'original'.

The esotericism present in the modern movement since the beginnings of Post-Impressionism and Expressionism

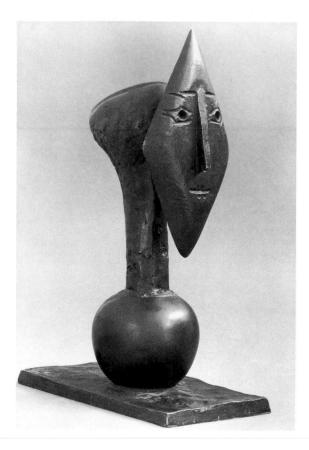

42 PABLO PICASSO Head of a Woman 1951

has never dominated modern art. One reason is that it has been too various – an artist has been offered too many alternatives and has often, as notably in the case of Picasso, decided to try them all. The only question is whether, in any particular case, such diverse influences have been assimilated, or whether they have merely produced a fragmentation of the artist's sensibility.

We are concerned at present with the art of sculpture, but it is precisely this art, because of its perdurability and transportability, that has been most effective as an agent of stylistic diffusion. In the case of some of the civilizations concerned, painting was not practised, or has not survived in significant quantities (except, perhaps, as mural decora-

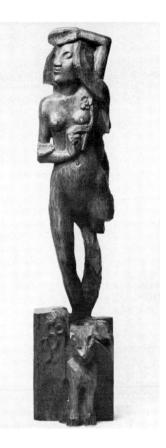

43 PAUL GAUGUIN Caribbean Woman (La Luxure) 1890–1

tion), whereas the sculpture is plentiful and is now to be found in all the important museums of the world. After pottery, the most indestructible of all arts, sculpture has been the main agent of stylistic diffusion in modern times.

I have already mentioned how Gauguin made a carving of a *Caribbean Woman* based on a fragment from a Javanese building in the Universal Exhibition of 1889. This exhibition was a decisive event in the history of modern art, and Van Gogh was impressed no less than Gauguin. He wrote to Émile Bernard about it:

You know, there is something I am very sorry not to have seen at the Exhibition; it is a series of dwellings of all the peoples.... Now look here, could you, since you 43

have seen it, give me an idea, and especially a coloured sketch of the primitive Egyptian house. . . . I saw in one of the illustrated papers a sketch of ancient Mexican dwellings; they too seem to be primitive and very beautiful. Ah, if only one knew the dwellings of those times, and if only one could paint the people who lived in the midst of them, it would be as beautiful as the work of Millet; I don't say in the matter of colour, but with regard to character, as something significant, something one has a firm faith in.¹

There are one or two points to note in this extract. First, what is primitive is found to be beautiful – 'as beautiful as the work of Millet'. Further, such art is not merely beautiful: it has 'character' and gives one 'firm faith' – faith in the significance of art, faith in humanity.

In a letter to his brother Theo of 9 June of this same year, which also refers to the exhibition, Van Gogh defines more precisely what he means by 'faith':

Now what makes Egyptian art, for instance, extraordinary – isn't it that these serene, calm kings, wise and gentle, patient and kind, look as though they could never be other than what they are, eternal tillers of the soil, worshippers of the sun?

. . . the Egyptian artists, having a *faith*, working by feeling and instinct, express all these intangible things – kindness, infinite patience, wisdom, serenity – by a few knowing curves and by the marvellous proportions. That is to say once more, when the thing represented and the manner of representing agree, the thing has style and quality.²

There were two reasons why primitive art should have made such a strong appeal to Gauguin³ and Van Gogh – first this feeling of 'faith' which it gave to these anguished artists, faith not in the doctrinal sense, but simply faith in nature, in life. During this century artists and poets and philosophers

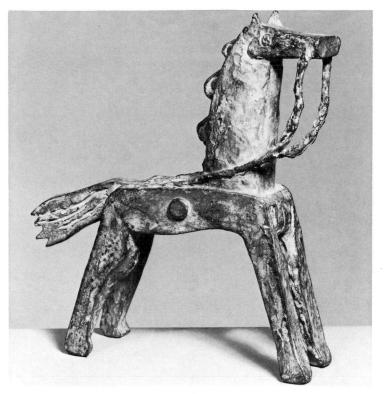

44 GEORGES BRAQUE Horse (Gelinotte) 1957

(Nietzsche, Ibsen, Marx) everywhere in Europe were becoming aware of the tragic alienation that had been caused by the growth of industrialism. Van Gogh was acutely aware of the contrast revealed in the simple, serene, and monumental works of primitive people. But he then perceived that this effect on him was made by purely formal means. He had no intellectual key to the doctrines of these primitive people and did not need one: the faith was implicit in the forms. It was the sculpture itself (the architecture and all these primitive artefacts) that emanated confidence in nature, kindness, existential calm.

Therefore it became a question of once more trying to work by feeling and instinct, a question of discovering forms that expressed 'the intangible'. From that moment

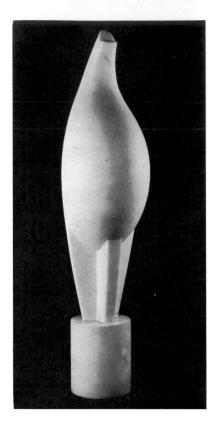

the historical destiny of the modern movement was fixed – fixed by the greatest pioneer of this movement. We must always return to Van Gogh if we would understand the origins of modern art – to Van Gogh and Gauguin, who at the same time had experienced in Tahiti 'a delight distilled from some indescribable sacred horror which I glimpse of far-off things... the odour of an antique joy... animal shapes of a statuesque rigidity: indescribably antique, august and religious in the rhythm of their gesture, in their singular immobility'.

The interest in primitive art that began with Van Gogh and Gauguin grew from year to year. Van Gogh died in 1889. In 1891 Gauguin went to Tahiti, and apart from a return to Europe in 1893 stayed there and in the Marquesas

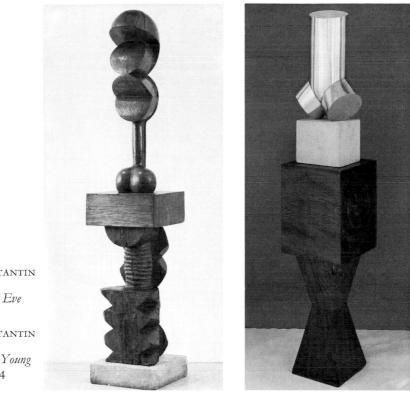

46 CONSTANTIN BRANCUSI Adam and Eve 1921

47 CONSTANTIN BRANCUSI Torso of a Young Man 1924 (far right)

Islands until he died in 1903. But the idea of the primitive had penetrated deeply into the consciousness of French artists. By 1904 the painter Vlaminck was taking an interest in primitive art, and from Vlaminck the interest passed to Derain and from Derain to Matisse. Both Derain and Matisse began to collect Negro sculpture before 1907, and according to Gertrude Stein⁴ it was to Matisse that Picasso owed his first knowledge of African sculpture. An uninterrupted chain of influences from Van Gogh to Picasso is thus established.⁵

I have already suggested why all these artists were drawn to primitive art in the first place. The interest has continued to grow for the same reason. The explanation, as I wrote on a previous occasion,⁶ lies in mankind's return to a 'primitive' state of mind ... modern man, and the modern artist in particular, is no mere eclectic monkey, trying to imitate for his occasional amusement the artefacts of primitive races; on the contrary, he is, spiritually speaking, in a tough spot himself, and the more honest he is with himself, the more resolutely he rejects the traditional shams and worn counters of expression, and the more nearly, and the more unconsciously, he finds himself expressing himself in a manner which bears a real and no longer superficial resemblance to so-called 'primitive' art.

Most of the exotic influences I have described are 'primitive' in the sense defined by Van Gogh-they proceed from works that are the expression of feeling and instinct - simple, serene, devoid of all intellectual sophistry. Other exotic influences on the development of modern art have been more complex, simply because they come from a phase of a past civilization that is itself more complex. There is, after all, a difference of both style and quality between African Negro sculpture and Egyptian sculpture, a still greater difference between Negro sculpture and Greek sculpture of the geometric period. Etruscan sculpture also belongs to a relatively sophisticated civilization and Mexican sculpture of the kind that affects our sensibility may belong to the decadence of that highly complex civilization. Very few modern artists have sought in exotic art a simplicity 'as beautiful as the work of Millet'. Rather they have been attracted by its remoteness and its mystery, even its complexity. This is certainly true of Far Eastern art, the extremely refined expression of a metaphysical outlook that has nothing in common with the art of Africa or Tahiti. We know very little of the religion and philosophy of the Incas and Mayas, but again it was complex rather than simple, fearful rather than serene. Even when we come to the primitive art of our own Christian civilization, to Romanesque or

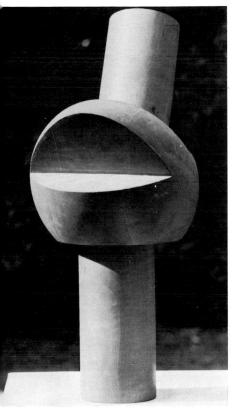

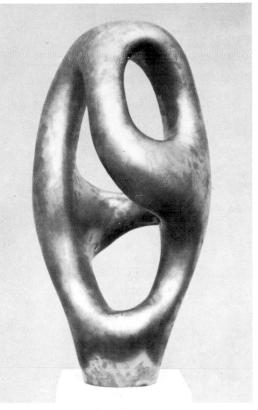

18 JEAN ARP Landmark 1938

49 JEAN ARP Ptolemy I 1953

Gothic art (both fundamental influences on Picasso and Henry Moore), we are in the presence of spiritual qualities that have quite a different metaphysical significance. But two qualities perhaps all these exotic arts have in common – their remoteness in time and the symbolic nature of their representations. Modern man has been in search of a new language of form to satisfy new longings and aspirations – longings for mental appeasement, aspirations to unity, harmony, serenity – an end to his alienation from nature. All these arts of remote times or strange cultures either give or suggest to the modern artist forms which he can adapt to his needs – the elements of a new iconography.

Imitation is not his purpose, but always assimilation and regeneration. The whole 'drive' in any purposive will to form (the only rational explanation of artistic development) is towards an equilibrium of inner feeling and the outer world of experience, and the work of art functions as the realization of such an equilibrium. It is thus a symbol of reconciliation, of appeasement, and it serves such a purpose more effectively when it is 'abstracted' both from the immediacy of our feelings and from the immediacy of an objective or impersonal world. The work of art therefore functions best (and this is its normal function throughout history) when it acts as a bridge between the two worlds of feeling and perception, giving definition to feeling and form to perception. This was the whole significance of Cézanne's heroic struggle with his sensations, and it was he, more than any other artist of the nineteenth century, who laid the foundations of the modern movement.

Cubism was not one more phase in the evolution of art – an evolution corresponding to social and economic trends: it was a decisive break with tradition. For five centuries European art in all its phases had been committed to *representation*; from the advent of Cubism onwards it was committed to quite another aim, that of *substitution*.⁷ That is to say, the representation of the phenomenal image given in visual perception was abandoned as the immediate *motif* of the artist's activity, and in its place the artist elaborated a symbol, which might still retain reminiscences of, or references to, the phenomenal object, but no longer sought to give a faithful report of the optical image.

This is not the place to enter into the reasons for this revolutionary change in the development of art: I have given my own explanation in other books.⁸ But it is not possible to appreciate the fundamental nature of the changes that came about in the early twentieth century, particularly in the art of sculpture, without realizing that the individual artist was carried away in currents that were

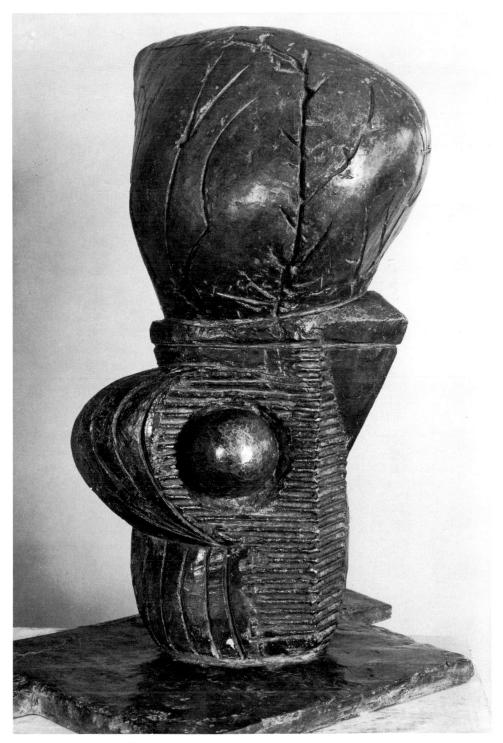

51 JEAN ARP Shell and Head 1933

beyond his control. He might pull back from time to time, to consolidate what he had already gained, as Picasso and Braque pulled back from the logical extreme of Cubism, i.e. an abstract art. But the action of these artists is not to be interpreted as a withdrawal from the revolutionary enterprise, but merely as a refusal to take one particular path for fear it led to a dead end. The revolution as it proceeded dis-

52 HENRY MOORE Reclining Figure 1938

53 HENRY MOORE Two-piece Reclining Figure, no. 1 1959

persed its energies in various directions, but all the artists involved continued to be guided by the same purpose: to find symbols to symbolize their inner feelings, which feelings they shared with mankind everywhere.

That their scarch often became esoteric is easy to understand. A symbolic art, an art of substitution, had prevailed for long epochs in the past, and it was natural, therefore, to seek in the past either symbols that might still be serviceable, if adapted to contemporary sensibility (such as those Cycladic statues of the Mother Goddess that symbolize an everlasting archetypal feeling), or, more generally, a confirmation of the fact that inner feelings could be objectified in symbols that had no other function. This does not imply that illusory images of the 'real' world can never have a symbolic function – at some epochs, notably in Europe from the fifteenth to the nineteenth century, they served this

purpose adequately. But the effectiveness of symbolization is determined by the metaphysical ground of our existence, and that ground in the modern age is similar to what it has often been in other civilizations - obscure, fragmented, without confidence in nature or man. In such a human condition we seek a style in art that gives us a sense of security, of permanence, of vitality, of immediate sensuous enjoyment. Since we do not find these qualities in the objective world, the world of industry, of poverty, alienation and war, we seek it in works of art that renounce the objective world. We seek deliverance, as Worringer says, 'from the fortuitousness of humanity as a whole, from the seeming arbitrariness of organic existence in general, in the contemplation of something necessary and irrefragible. Life as such is felt to be a disturbance of aesthetic enjoyment.'9 But such aesthetic enjoyment is not an escape from life. On the contrary, it is an affirmation of the deepest instincts of life against their frustration by the inhuman forces of an industrial civilization.

These principles (not cold conceptual dogmas, but profound metaphysical intuitions) will become clearer as we review the work of the great sculptors who have contributed so much to their realization in the forms of art – Picasso, Brancusi, Arp, Gabo and Henry Moore, to mention only the most originative of them. I shall confine myself to the historical developments as they unroll in chronological sequence, but movements are rough generalizations, often the improvisations of journalists and critics rather than of the artists themselves, and the work of the greatest of these sculptors defeats all categories, whether of time or place or nationality. The modern artist, by nature and destiny, is always an individualist.

From Cubism to Constructivism

'Cube', which was used spontaneously by critics and journalists to describe the immediate effect of the paintings exhibited by Braque and Picasso from 1910 onwards,¹ is a word which suggests a three-dimensional object rather than a painted canvas. From the beginning of the movement it was obvious that sculpture no less than painting was involved in the new adventure. There is no need to describe the general history of the movement in the present context, but it sprang from the confluence of two of the sources mentioned in the preceding chapters, the paintings of Cézanne and the tribal sculpture of Africa. Whether Picasso or Braque had priority in effecting this fusion is an idle question that has been much discussed. The two artists came together (introduced to each other by Apollinaire) towards the end of 1907. At that time Picasso had already painted Les Demoiselles d' Avignon, without doubt the most revolutionary work of art in the history of the modern movement, and at first Braque shared the general bewilderment produced by this painting.2 But the two artists soon became intimate friends and from 1908 onwards were virtually living and working together. In general we might say that of the two influences that combined to form the new style, one, primitive art, and in particular Negro sculpture, was represented by Picasso; the other, the art of Cézanne, by Braque. It has been pointed out (by Jean Revol, for example) that Braque, though fascinated by Negro sculpture, never assimilated its style directly into his painting.3 And equally Picasso was never profoundly affected by what is essential in Cézanne's style, his search for solidity, for 'plenitude' as

54 PABLO PICASSO Head of a Woman 1909–10

Cézanne called it. There was therefore an essential conflict between the styles of Picasso and Braque when they began to work together in 1908, and although Picasso had already made superficial use of motifs from Cézanne (even in *Les Demoiselles*), it was not until he met Braque that he began to see the significance of Cézanne, and made the necessary connection between Cézanne's form in depth and the

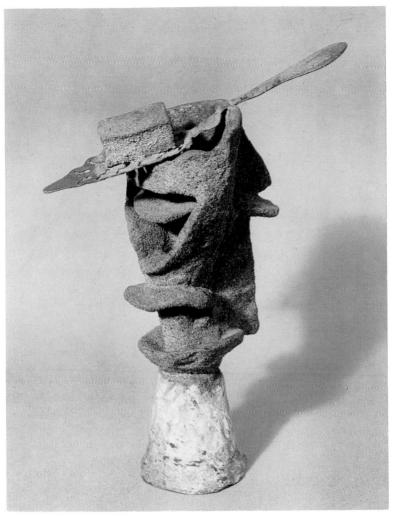

55 PABLO PICASSO Glass of Absinthe 1914

simplification of surfaces in Negro and Romanesque sculpture. The one 'point of view', he suddenly realized, could be combined with the other to produce the necessary synthesis of two-dimensional movement (dynamic pattern) and three-dimensional volume. The probability is that Braque arrived at this synthesis slightly ahead of Picasso – his landscapes painted at L'Estaque in the summer of 1908

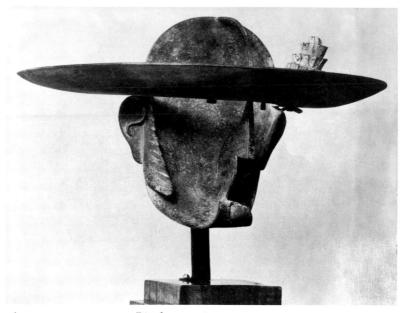

56 PABLO GARGALLO Picador 1928

seem to anticipate Picasso's Cubist landscapes painted at Horta de San Juan a year later, though the first intimations of Cubism were already present in Les Demoiselles d'Avignon a year earlier.⁴

Picasso's first quasi- or proto-Cubist sculptures were three carvings in wood made in 1907, but the first fully 54 Cubist piece is the bronze Head of a Woman of 1909-10. This is a direct realization of the methods already evolved in painting a three-dimensional object (see, for example, the Seated Nude of the same year in the Tate Gallery). This head is an impressive work of art, in which the aims of Cubism (to create 'a scaffolding of planes', to use Henry Kahnweiler's expressive phrase, that would cause light to reinforce the impression of solid structure rather than destroy it – always Cézanne's problem) are successfully attained.

Why then does this piece remain the solitary masterpiece of sculpture in Picasso's Cubist period? When he resumed sculpture three years later he was already off on

57 JULIO GONZÁLEZ Cabeza Llamada el Encapuchado 1934

another line of exploration, one that was to continue throughout his career, assemblage - that is to say, the construction of sculpture from miscellaneous ready-made materials. The explanation is one that concerns his general development at this period (1910–13). It was a retreat from abstraction, to which a conceptual approach to painting was inevitably leading him. The abandonment of Cubism by Picasso and Braque is usually attributed to the outbreak of war in August 1914, but the nearest point to abstraction in the work of Picasso had been reached earlier, in 1912-13. From this year onwards he became more and more interested in the surface texture of the painting: the Cubist ideal of 'pure form' was gradually 'adulterated' by a whole battery of miscellaneous objects - pasted paper, linoleum, pieces of wood and string - all kinds of devices that tended to produce an effect which Alfred Barr has called 'rococo'. Out of this development came the first piece of sculpture produced by assemblage - the Glass of Absinthe, which is a

55

bronze $(8\frac{3}{4})$ inches high) cast from a model of wax on which a real spoon has been balanced. If we ignore the models designed for the ballet *Parade* it is the only piece of threedimensional sculpture produced by Picasso between 1910 and 1925. When Picasso resumed 'sculpture' it was with constructions in iron and wire which belonged to an altogether new and unprecedented type of art.

As far as Picasso is concerned, this new direction was suggested by his fellow-Catalan, Julio González (1876–1942). González had gone to Paris in the same year as Picasso, 1900, and had soon formed a friendship with him which was to last all the rest of his life. For fifteen years he lived a solitary life as an unsuccessful painter, but in 1927 he began

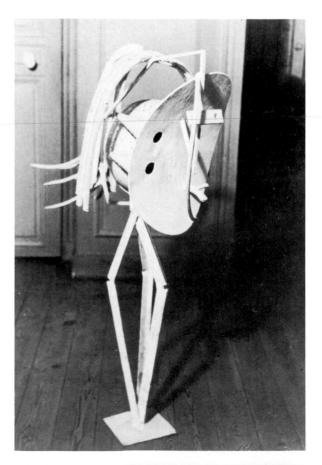

58 PABLO PICASSO Construction (Head) 1930–1

59 JULIO GONZÁLEZ Mascara de Montserrat Gritando 1936

60 JULIO GONZÁLEZ Hombre-Cactus, no. 2 1939–40 to experiment with wrought iron. This was not Picasso's first introduction to metal sculpture, for he was an intimate

- friend of another Spaniard, Pablo Gargallo, who had shared a studio with him in Barcelona in 1901, and again in 1906 when he followed Picasso to Paris. Gargallo's first sculptures in iron date from 1911⁵ and Picasso was perfectly familiar with these early works (mostly masks which in their turn owe something to African prototypes). Gargallo's masks, incidentally, may have given Picasso the idea of open-work sculpture (Kahnweiler makes a distinction between open-work sculpture, generally made open for decorative purposes, and transparent sculpture, made to display the exterior and interior of an object simultaneously,
- 55 as in the *Glass of Absinthe* of 1914). But in so far as metal sculpture is concerned Picasso's relation to González was
- 54 much more direct. The Head of a Woman of 1909–10 had been

61–5 PABLO PICASSO Stick-statuettes 1931

modelled in González's studio and in 1931, having moved to a château in the country where there was plenty of space for such an activity, Picasso asked his old friend to teach him the necessary technique. Between 1930 and 1932 Picasso made at least fifty pieces of metal sculpture. They vary greatly in style, but two completely original inventions emerge, to constitute prototypes for the future development of the art of sculpture. A third type, though not without precedents in antiquity, was in effect an innovation.

At Boisgeloup, the country house already mentioned, Picasso began to extend the idea of 'assembling' actual objects and raw materials which he had already used for reliefs to three-dimensional constructions:

Pieces of scrap-iron, springs, saucepan lids, sieves, bolts and screws picked out with discernment from the rubbish heap, could mysteriously take their place in these

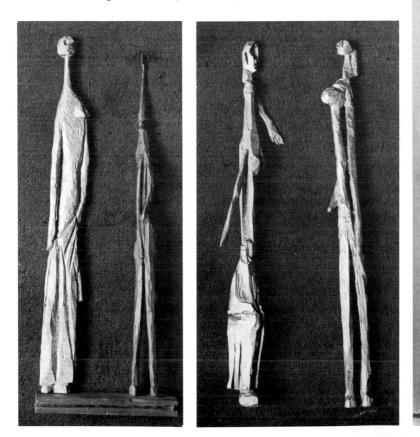

58

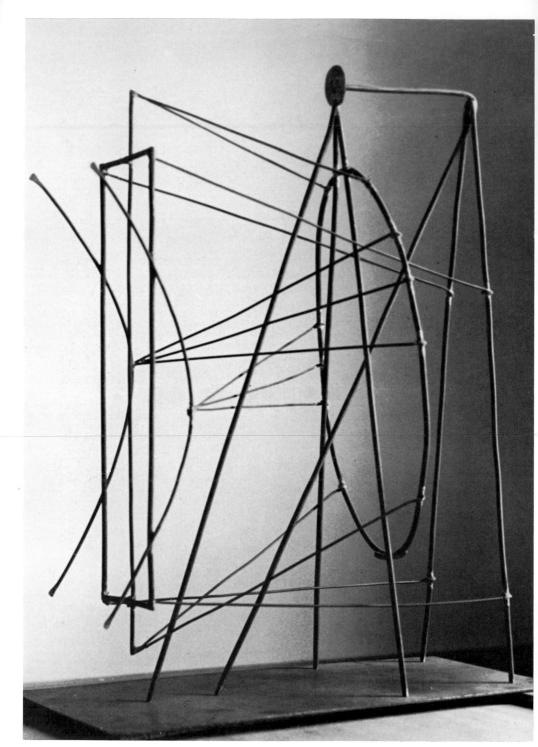

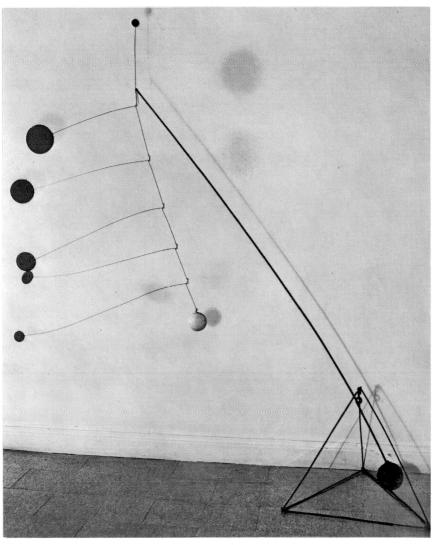

67 ALEXANDER CALDER Calderberry Bush 1932

constructions, wittily and convincingly coming to life with a new personality. The vestiges of their origins remained visible as witnesses to the transformation that the magician had brought about, a challenge to the identity of anything and everything.⁶

This is Roland Penrose's description of the procedure involved in this new type of sculptural construction, and it will at once be seen that it has nothing in common with the aims of the Russian Constructivists, whose constructions were far from having 'magic' as their aim. A Constructivist 'construction', as evolved by Tatlin, Gabo and Rodchenko, was deliberately impersonal, and the spatial relations it created were as abstract as a mathematical formula - it has often been noted that they approximate, unintentionally, to the visual models constructed by scientists to illustrate an algebraic formula. Picasso's iron figures, however, have definite emotional attributes - they are sinister, mysterious. or even humorous. There may have been no conscious intention to create anything analogous to a tribal idol or totem, but that is the effect achieved. They possess the kind of magic we associate with the animistic cults of primitive races.

As such, far from being irrelevant to our sophisticated civilization, they seem to meet a long-felt need. Elsewhere I have called them the icons of a scientific age, and to understand this kind of sculpture we must first dismiss the rationalistic prejudice which sees magic as a force belonging to a past stage of civilization, as a kind of pseudo-science preceding the true science whose benefits we now rather doubtfully enjoy. Magic is not, and never has been, a substitute for science, but is rather a constructive activity with a specific social function,⁷ and one that is still operative. The interpretation of magic as primitive science, typical of Tyler, Frazer and other anthropologists of the last century, has since been replaced by a theory which sees it as a permanent feature of collective groups, closely allied to art. According to anthropologists like Malinowski and Levi-Strauss and to a philosopher like Collingwood, the aim of magical objects and magical rites is to arouse emotion in the group and to make such roused emotions effective agents in the practical life of the community. 'The primary function

of all magical arts,' says Collingwood, 'is to generate in the agent or agents certain emotions that are considered necessary or useful for the work of living.... Magical activity is a kind of dynamo supplying the mechanism of practical life with the emotional current that drives it. Hence magic is a necessity of every sort and condition of man, and is actually found in every healthy society.' He points to many of our daily activities, not only religious ceremonies and military parades, but also fox-hunting and football, as essentially ritualistic activities undertaken as social duties and surrounded by all the well-known marks and trappings of magic – 'The ritual costume, the ritual vocabulary, the ritual instrument, and above all the sense of electedness, or superiority over the common herd, which always distinguishes the initiate and the hierophant.'⁸

Even in 1938, when Collingwood published his Principles of Art, he could note that 'a recrudescence of magical art is going on before our eyes'. He does not give examples, but he probably had in mind jazz music and dancing as well as the works of painters like Picasso. Thirty years later we can find thousands of examples to illustrate and prove Collingwood's theories. I confine myself to magical sculpture, for there can be no doubt that the makers of such sculpture aim to create objects which focus and crystallize emotions that are not so much personal as public, and stand in relation to society, not as representations of the external world, much less as expressions of the artist's personal consciousness or feeling, but rather as catalysts of a collective consciousness. Mass emotions are not so much symbolized discretely, but rather given a disciplined outlet in organized ritual. We must remember that the beginnings of this new development in sculpture coincide with the heyday of Surrealism, and the Surrealists were also insisting on the creation of magical objects, many of which were classified as sculpture. As early as 1917 Kurt Schwitters and Arp had constructed magical objects, often out of rubbish, and they

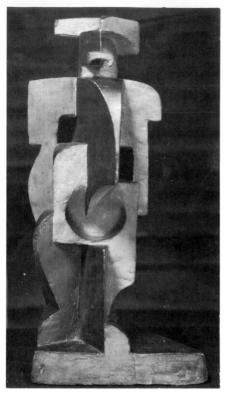

69 ROGER DE LA FRESNAYE Italian Girl 1912

carried this activity over into the Surrealist movement, where it was adopted by other sculptors (see Chapter Four). The typical Surrealist sculpture, as made by Max Ernst or Giacometti in the late twenties or early thirties, is not to be distinguished from Picasso's sculpture of the same period, except from the point of view of technique. The same can be said of some of Brancusi's work of this period (*Le chef*, 1925, for example) and of Henry Moore's early work. Indeed, it was largely through sculpture that this animistic trend entered the modern movement, to constitute one of its main characteristics.

Before I follow up this trend, I would like to refer briefly to two of the other inventions introduced by Picasso at this time. One is curious and short-lived - the elongated 'stick-61-5 statuettes' which Picasso in the year 1931 whittled from long thin pieces of wood and then had cast in bronze. They would scarcely be worth mentioning, but they bear a superficial resemblance to those elongated figures of men and 146-7 limbs which Alberto Giacometti began to make fifteen years later. The carving technique differs from Giacometti's modelling technique, which has more affinity with the elongated figures found in Etruscan and Iberian tombs. Giacometti is also concerned with movement and space, whereas Picasso's figures are more magical in intention. But the comparison with Giacometti gains in plausibility when we consider the third and more important of Picasso's innovations - the wire 'space cages' which he constructed in 66

70 ALEXANDER ARCHIPENKO Woman with a Fan 1914 71 HENRI LAURENS Head 1917

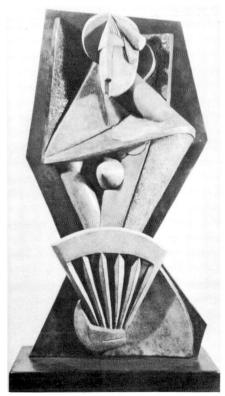

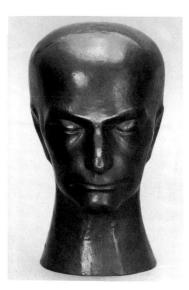

72 RAYMOND DUCHAMP-VILLON Head of Baudelaire 1911

73 ALEXANDER ARCHIPENKO Seated Mother 1911

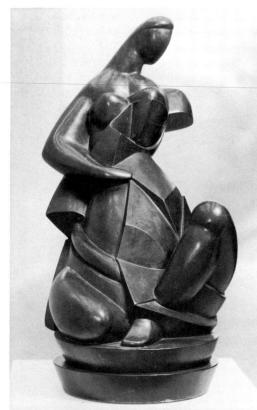

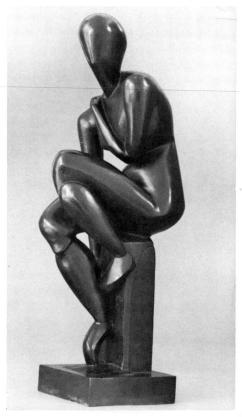

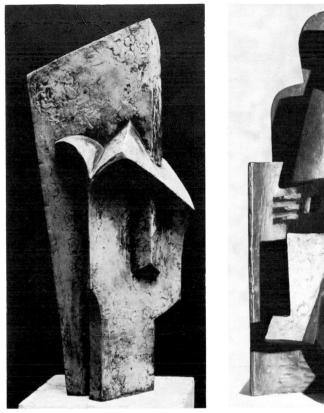

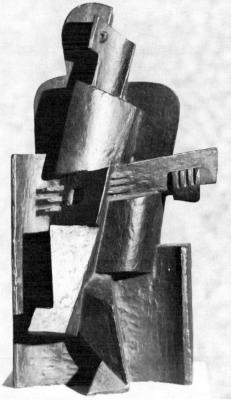

75 JACQUES LIPCHITZ Head 1915 76 JACQUES LIPCHITZ Guitar Player 1918

1930.⁹ The idea is to define space by wire outlines – a 'drawing in space' – which is a complete denial of sculpture's traditional values of solidity and ponderability. According to Kahnweiler, Picasso intended these constructions, which are only about $12\frac{3}{4}$ inches high, to be models for large monuments, into which human beings could enter and so be aware of the space outlined. Rodchenko and other Russian Constructivists had had the same ideas as early as 1920, but there is no reason to suppose that Picasso was aware of their experiments. But through Picasso the idea spread, to Giacometti (e.g. *The Palace at 4 a.m.*, 1932–3) and 142 then to Alexander Calder (b. 1898; in Paris 1929–32), whose 67

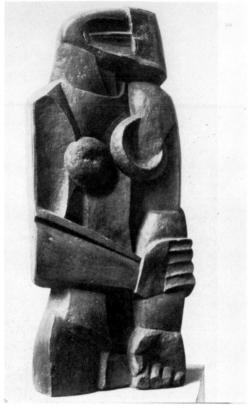

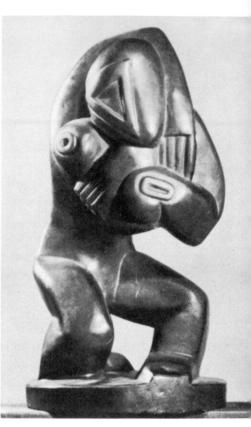

77 OSSIP ZADKINE Standing Woman 1920

286

78 HENRI GAUDIER-BRZESKA Red Stone Dancer 1914

mobiles are 'space cages' of wire that move in order to create ever-changing spatial relations. Since that time many other variations of wire sculpture have been evolved, notably the gossamer constructions of Richard Lippold (b. 1915). But such constructions tend to move towards pure abstraction, whereas Picasso and Giacometti always include some reference to human forms or activities.

I have by no means exhausted the sculptural inventions of Picasso, but from 1930 onwards he was to be more and more exclusively preoccupied with *magic*: he is concerned to represent in his figures certain vital forces of social significance – the *anima* that we project into all subjects, animate or in-

79 JACQUES LIPCHITZ Figure 1926-30

animate, the quality the Chinese call *ch'i*, the universal force that flows through all things, and which the artist must transmit to his creations if they are to affect other people. This *vitalism*, as I prefer to call it, has been the desire and pursuit of one main type of modern sculptor. It has little or nothing in common with the quality that has been the desire and pursuit of the other main type of modern sculptor, the Constructivists, the quality we may call *harmony*, or if we are not afraid of an ambiguous word, *beanty*. Henry Moore and Naum Gabo may be taken as typical representatives of these two distinct aesthetic ideals, and I propose to anticipate a fuller consideration of their work and give a brief

80 CONSTANTIN BRANCUSI *Sleeping Muse* (1st version) 1906

81 CONSTANTIN BRANCUSI Sleeping Muse 1909–10

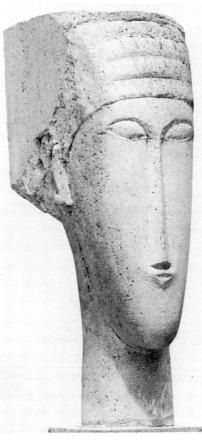

82 AMEDEO MODIGLIANI Head 1912 (?)

characterization of their respective aims and achievements in the present general context. But before I do so I must pay tribute to that other great artist already mentioned, whose work embodies more precisely and perhaps more deliberately than any of the pioneers of modern sculpture the universal element of spirituality I have just referred to: Constantin Brancusi (1876–1957). Brancusi came to Paris from Rumania in 1904, the year in which Picasso finally decided to settle in Paris. His work eventually attracted the attention of Rodin, who asked him to become his assistant, but Brancusi refused. He preferred solitude and simplicity, ideals which he had derived from the mystical treatise of the eleventhcentury Tibetan monk, Milarepa.

It is difficult to trace the influence that Brancusi undoubtedly exercised on the development of modern sculpture, because his works are relatively few and were rarely exhibited. But in 1909 he became an intimate friend of Amedeo Modigliani (1884–1920), the Italian painter and sculptor who came to Paris in 1906. Modigliani was primarily a painter, but he practised sculpture under the direct tutelage of Brancusi, and his style, even in his paintings, is closely related to Brancusi's. Modigliani's paintings were destined to attract more attention than his sculpture, and after his tragic death his fame spread throughout the world. But Brancusi, too, attracted much attention, some of it hostile; from 1926 to 1928 he was involved in a lawsuit with the United States Customs Service, which had refused to admit his Bird in Space duty-free as a work of art, maintaining that it was taxable as a piece of metal.

Brancusi's early work is mannered and not free from traces of the art nouveau sophistication of the period (the early versions of the Sleeping Muse, 1906-10, and of Mademoiselle Pogany, 1913). But his form evolves under two compelling ideals - universal harmony and truth to materials. Universal harmony implies that form is determined by physical laws in the process of growth. Just as the crystal takes on a determinate form, or a leaf or a shell, by the operation of physical forces on matter animated by an internal energy, so the work of art should take form as the artist's creative energy wrestles with the material of his craft. The egg, for example, takes on its ovoid shape by virtue of the mechanical forces which operate during its growth, gestation and delivery. When Brancusi conceived a symbol in marble for The Beginning of the World (1924), it assumed an egg shape. This was perhaps a reduction of the process of art to an imitation of natural processes, and it might be possible criticism of Brancusi that the forms he reaches by this reductive process are too jejune, too simple and summary. But simplicity and purity were his ideals, and he never passed beyond the

130

82

80-I

83

80

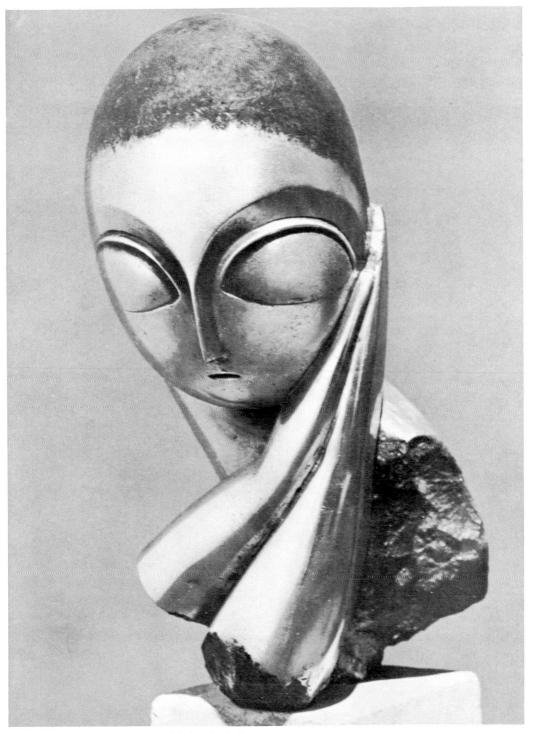

limits of organic vitality: his simple forms, of fish or bird, are alive. But simplicity is only one of several possible virtues in vital objects: the human form, for example, without sacrificing any of its complexity, can express the same ideals of vitality and harmony.

This is, indeed, the lesson we learn when we pass from the work of Brancusi to that of Henry Moore (b. 1898). Moore may have been momentarily influenced by Brancusi, though I doubt it – Picasso would again provide more immediate data from the Boisgeloup period. Nor can we ignore, as I have done so far, the influence of another great innovator, Jean Arp (b. 1887), whose work has always been inspired by these same ideals of organic form. Arp's Dada and Surrealist period is an influence apart, but from 1931–2 (contemporanecusly with Picasso's Boisgeloup period) he began to concentrate on sculpture in the round, modelling and carving in stone and wood, and from this time onwards his sculpture, equally with Brancusi's, became an attempt to represent 'the secret ways of nature'. Arp began to call his sculptures

84 JACQUES LIPCHITZ Benediction I 1942

85 JEAN ARP Human Concretion 1933

concretions, which he defined as 'the natural process of condensation, hardening, coagulating, thickening, growing together. . . Concretion is something that has grown. I wanted my work to find its humble, anonymous place in the woods, the mountains, in nature' (unfortunately it was usually destined to find its place in that most unnatural environment, a public art gallery).

Moore, too, has expressed a desire to have his sculpture placed in the open, and some of his works have found a natural setting on moors and in parks. But Moore's work is much more complex than Brancusi's or Arp's, and its complexity proceeds from its humanity – its involvement in human destiny. Moore has been obsessed from the beginning with two or three archetypal themes – the reclining figure, 167

165 167, 173

the mother and child, the family – not deliberately, but from 161 some inner compulsion, some drive from the unconscious. If Moore had merely illustrated such themes, in the manner of academic artists, his work would not have become so significant. But he combined his mythological motivation with the same respect for the secret ways of nature as Brancusi and Arp. In fact, there are two forces operative in the sculpture of Moore, which I would call the vital and the mythical. From the vital source comes everything represented by Arp's word 'concretion' - formal coherence, dynamic rhythm, the realization of an integral mass in actual space. From the mythical source comes the mysterious life of his figures and compositions, in one word, their magic. And it is this quality that allies him, not only with Picasso, but also with all the magical and ritual art of the past - the art of Babylon and Sumer, of Egypt and the Aegean, of Mexico and Peru, of Africa and Oceania.

86 OTTO FREUNDLICH Composition 1933

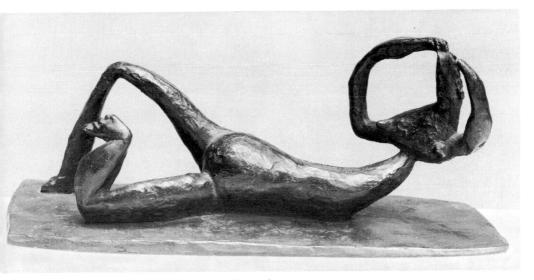

87 HENRI LAURENS Reclining Woman with raised arms 1949

I shall return to Moore, and to the sculptors that may be said to have followed him into this world of magic, in a later chapter. But first I must resume the main theme of the present chapter, which is to trace the origins and development of Cubist sculpture. Apart from some superficial elements that may have been derived indirectly from Picasso and Brancusi, this stylistic development owed nothing to African sculpture and pursued an aim which from the first was quite distinct from that of the Cubist painters. It began in Moscow and was at first independent of wider European influences.

It is unwise to claim originality for any images or ideas in this age of swift extensive communications: a discovery made in Paris, Milan or New York is immediately common property, and this is true especially of discoveries in significant expression. The whole world is waiting for novelties, whether in scientific experiment, medicine or modes of living (housing, clothing, entertainment). The modern artist is affected, however unconsciously, by this restless research, and it is inevitable that his work should reflect such a universal mood. Art has always been a symbolizing activity,

89 VLADIMIR TATLIN Corner Relief 1915

and though in the past such activity was restricted to the sphere of myth and religion, it continues unabated in our materialistic age. Mankind has an insatiable need for icons – for signs, symbols, emblems, slogans – images and metaphors of every kind. It is not surprising, therefore, that the most significant feature of our civilization – the machine – should itself become a symbol: a symbol of power, dynamism, speed, all the ideal concepts of our mechanized way of life.

Cubism itself, from this point of view, is a mechanic reaction to the fluidity and organicism of Impressionism. Picasso's *Head of a Woman* of 1909–10, which corresponds, 54 of course, to the 'analytical' paintings of the same period, was inspired by his desire to avoid the disintegration of structure and volume that takes place in Impressionist painting and sculpture. In spite of his concern for the traditional values of sculpture, even Rodin, in his later work, had tended to sacrifice integral volume or solidity for the sake of the visually impressive effect of highlights. Such use of light in sculpture tends to destroy the palpable, the ponderable and tactile values of the mass - its solidity is dissolved in a purely visual delight. This, to Picasso, was the weakness inherent in Impressionism, and like Cézanne, though by more drastic means, he wished to recover the sense of structure, of permanency, of precision. He said to Henry Kahnweiler at this time: 'I'd like to paint objects so that an engineer could construct them, after my pictures,' and Kahnweiler comments: 'To replace "engineer" by "sculptor" is to realize that sculpture transposed onto a plane surface was what Picasso was driving at, taking into account, of course, all the "distortions" imposed by such a transposition. . . . '10

This desire expressed by Picasso, to paint objects 'so that an engineer could construct them', shows that he too, as an artist, was subject to the tendency to idealize the machine, to make the machine itself a symbolic icon. He was not himself to pursue this aim, for he realized that the age demanded spiritual compensations for the alienation of man caused by the machine – in other words, an art of the unconscious, a magical art. But whenever he made this remark to Kahnweiler – and it seems to have been about 1909–10 – he was predicting a development that was to take place more or less immediately, with Moscow as its centre.

'Creative engineering', as we might call it, is an ideal born with the industrial revolution, and Paxton's Crystal Palace and Brunel's bridges are the primitives of a constructive art. The Futurists were perhaps the first artists to accept the machine age as an aesthetic ideal, but as we shall see,

90 ALEXANDER RODCHENKO Construction 1917

91 VLADIMIR TATLIN Relief 1914

they worshipped the *concepts* of power and speed represented by the machine rather than its products. But from 1914 onwards a group of artists in Moscow attempted to apply engineering techniques to the construction of sculpture, and the objects thus made were called 'constructions'. The chief promoter of this new development was Vladimir Tatlin (1885–1953), originally a painter. Perhaps mainly thanks to an enthusiastic collector of contemporary French paintings in Moscow, Sergei Shchukin, the Moscow artists at this time had an up-to-date knowledge of the *avant-garde* movements in Paris, and Tatlin and his rival, Kasimir Malevich, quickly went through a development that included Impressionism, Post-Impressionism and analytical Cubism. Late in 1913 Tatlin succeeded in realizing his ambition, which was to go to Paris and visit Picasso. He saw Picasso several times – indeed, suggested to Picasso that he might stay with him as an assistant, a proposal that did not appeal to Picasso. Tatlin returned to Moscow, but he had seen and been inspired by the reliefs in sheet iron, wood and cardboard that Picasso was making at the time.¹¹ These represent, in a very arbitrary manner, guitars, wine-glasses and other such objects, but the similar reliefs made by Tatlin on his return to Moscow have no such representational motive – they are the first completely abstract constructions.¹²

Tatlin had taken a hint from Picasso but deliberately went further in his explorations, now following the Italian Futurists. This influence was proclaimed in the title of an exhibition held in Petrograd in February 1915: 'The Futurist Exhibition: Tramway V', in which Tatlin showed six 'Painting Reliefs'.¹³ Picasso's reliefs remained 'painterly'; that is to say, extensions in depth of the two-dimensional picture plane. The object of the experiment was to develop the range of painting, not to create a new type of sculpture. But Tatlin did conceive precisely that possibility - a new type of sculpture – a sculpture that would take raw materials and ready-made objects and arrange them in 'real' space without any representational intention. The materials, each with their own plastic qualities, the specific qualities of wood, iron, glass, etc., would compose into a work of art, 'real materials in real space'. Within a year or two the construction had been emancipated from the picture frame, and for a background Tatlin would take the corner of a room, and sling the construction on a wire between the walls, the intersecting planes of the walls playing an essential part in the spatial construction.14

Tatlin was not alone in these experiments, though he may have been the leading spirit after his return from Paris. As an innovator he had been preceded by Kasimir Malevich (b. 1878, therefore seven years older than Tatlin). But

91

88

89

92 KASIMIR MEDUNETZKY Abstract Sculpture. 93 LEV BRUNI Construction c. 1918 Construction no. 557 1919

Malevich, who as a painter went through even more distinct phases of development than Tatlin, contributed little to the art of sculpture except his influence. He passed from Expressionism to Cubism, and then about the same time that Tatlin went to Paris and came under the influence of Picasso, Malevich began to work out his theory of geometrical abstraction, to which he gave the name Suprema-157 tism. He may have been influenced by Kandinsky,¹⁵ or by Worringer's theory of abstraction and empathy (first published in Munich in 1908), but the abstract style he invented was original, and of great importance for the future development of the modern movement.

94 ALEXANDER RODCHENKO Construction of Distance 1920

Tatlin and Malevich were not alone in their advance towards abstraction. Luckily they had established contacts – personal as well as literary – with the Futurist and Cubist movements in other countries before the war which broke out in August 1914 isolated them. It is more than likely that they had read Boccioni's 'Technical Manifesto of Futurist Sculpture' (see page 126 below). But isolation also meant consolidation. Filonov, Popova, Larionov, Goncharova, Udaltsova, Yakulov, Rodchenko, Puni, Exter, Menkov – all these artists carried out an intense creative activity during these war years in Moscow, and they were to be joined by other artists driven back to their native country

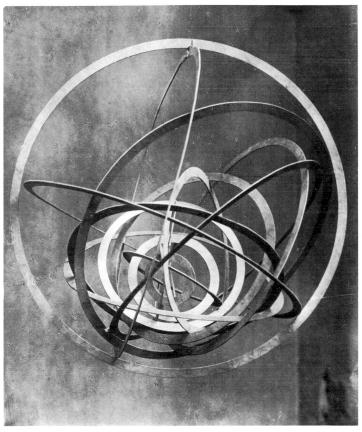

95 ALEXANDER RODCHENKO Hanging Construction 1920

by the war – notably Kandinsky, Pevsner and Gabo. Then in October 1917 came the Revolution, to intensify for a time all this revolutionary fervour in the arts. The artists themselves claimed that they had anticipated the revolution, had provided the basis of a revolutionary art. For a few years the politicians were too busy to interfere in such matters, but five years later they felt compelled to call a halt. The movement was suppressed, its promoters silenced or exiled, but they had already created, not merely a new movement in art, an advance in the evolution of style, but an altogether new kind of art, Constructivist art, and its practice was to spread from Moscow throughout the world. We should note two or three decisive prototypes in this development, as expressed in the art of sculpture. One is Tatlin's *Monument to the Third International*, commissioned early in 1919 by the Department of Fine Arts and exhibited in model form at the Exhibition of the VIII Congress of the Soviets in December 1920. It was designed to be twice the height of the Empire State Building in New York and to be executed in glass and iron.

An iron spiral framework was to support a body consisting of a glass cylinder, a glass cone and a glass cube. This body was to be suspended on a dynamic asymmetrical axis, like a leaning Eiffel Tower, which would thus continue its spiral rhythm into space beyond. Such 'movement' was not to be confined to the static design. The body of the Monument itself was literally going to move. The cylinder was to revolve on its axis once a year, the activities allocated to this portion of the building were lectures, conferences and congress meetings. The cone was to complete a revolution once a month and to house executive activities. The topmost cube was to complete a full turn on its axis once a day and to be an information centre. . . . A special feature was to be an open-air screen, lit up by night, which would constantly relay the news. . . .¹⁶

Of course, such a project was never realized, and perhaps could never have been realized with the limited technical means available in Moscow at the time. But not only had a symbolic gesture been made – a gesture signifying that the modern artist was capable of creating new monuments to symbolize in appropriate materials the achievements of a new age; but further, a new type of art, relying on new materials like steel and glass, embodying dynamic instead of static principles, had been created, and given a social significance.

Naum Gabo conceived, but did not carry to the model stage, a similar project for a Radio Station, but his main

96

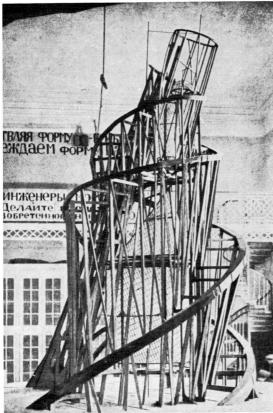

97 KASIMIR MALEVICH Architectonics 1924–8

researches were of a more intensive kind, and are represented by the *Constructed Head*, *no. 2* which he made in 1916. Gabo had been in Munich and Paris and was familiar with the early stages of analytical Cubism and of the later development towards synthetic Cubism. His *Head* of 1916 may be contrasted with Picasso's *Head* of 1909–10. Picasso's head, as I have already observed, has been conceived with a strictly naturalistic aim – to reinforce the 'realism' of the object by consolidating its form, by eliminating the uncertainties of chiaroscuro. Gabo's aim, like Tatlin's, is to create a spatial reality – the motif is an excuse for this creative intention, a point of departure. The head still gives us an illusion of the

95

98

54

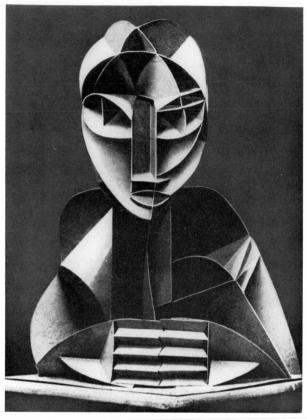

98 NAUM GABO Constructed Head, no. 2 1916

original form of the motif, and is even expressive of a certain feeling – melancholy or meditation. But what holds our attention and overwhelms all other sensations is the disposition and interlocking of precisely defined planes, the rhythmic organization of space. As a promoter of feeling the humanity of the motif is irrelevant; we are asked to assimilate an image of dynamic forces, and nothing more.

90, 92-5

A similar intention is present in the constructions of Alexander Rodchenko, and those of Kasimir Medunetsky and Lev Bruni, all made between 1917 and 1920.¹⁷ Some of these seem to have been crudely put together, and have none of the exquisite refinement that was to characterize the later

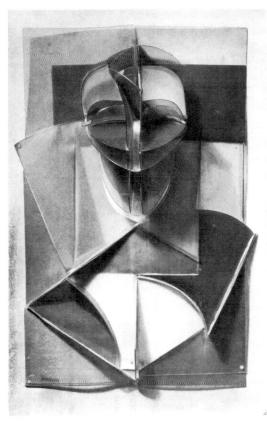

99 ANTOINE PEVSNER Portrait of Marcel Duchamp 1926

works of Gabo and Pevsner. In general one might say that all the basic features of Constructivism were discovered and elaborated in these formative years, and all that remained for subsequent sculptors outside Russia in future years was to apply these principles and refine their applications.

The diffusion of the Constructivist 'idea' throughout Europe and America received its main impetus from the dispersal of the Russian artists from 1922 onwards. But we must remember that some of these artists had already established links with sympathetic groups in other countries. Although, as already suggested, one must not underestimate

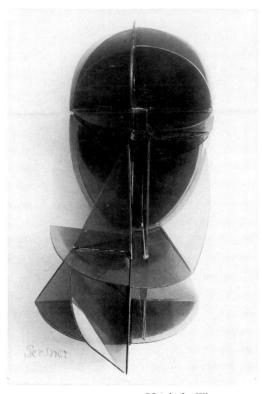

100 ANTOINE PEVSNER Head of a Woman (Construction) 1925

the infiltration of visual 'ideas' or images through the circulation of printed magazines and photographs, it is nevertheless certain that a 'will to abstraction' became manifest more or less simultaneously in several countries, and one can find reasons for this in the rising level of anxiety and disillusion that preceded, accompanied and followed the First World War. In retrospect the years before that war seem calm and unperturbed; but this was not the intellectual atmosphere of the period, which was full of poets and philosophers prophesying doom (Nietzsche, Ibsen, Dostoevsky, Strindberg, Spengler). By the early years of the new century a lack of confidence in inevitable progress, a feeling of spiritual uneasiness, had affected sensitive artists everywhere, and a complacent reflection

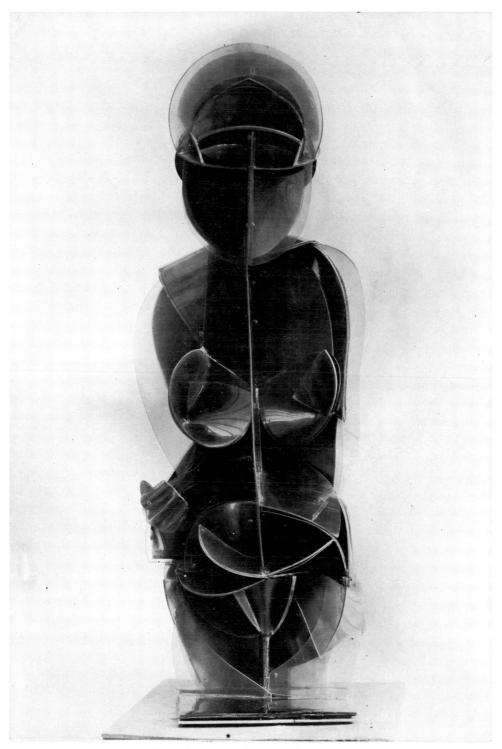

IOI ANTOINE PEVSNER *Torso* (*Construction*) 1924-6

of the world of nature no longer suited the mood of the intelligent public.

This reaction took the various forms we call Expressionism, Cubism, Futurism, Suprematism, etc., but of all these reactive tendencies the one that was most positive, and in a sense most optimistic, was that which sought to ally itself with engineering and other productive crafts – architecture, furniture manufacture, pottery, typography. But it soon became apparent – and this was most decisively demonstrated in Russia – that a new society in the making had no use for the engineer-artist, precisely because, in the stress of revolution or of economic crisis, he was useless, functionless. In Moscow Tatlin tried desperately to maintain the link, but his 'laboratory art', in so far as it was utilitarian, was industrial rather than artistic (he had, in any case,

102 NAUM GABO Monument for a Physics Observatory 1922

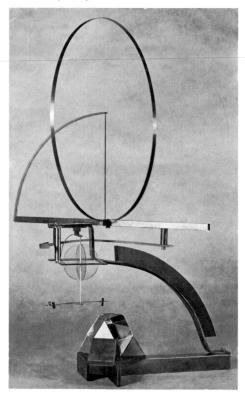

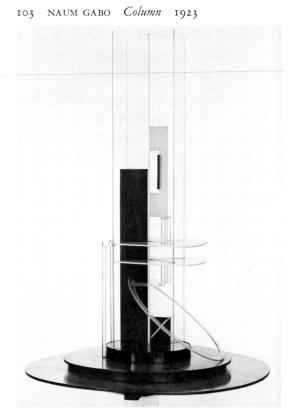

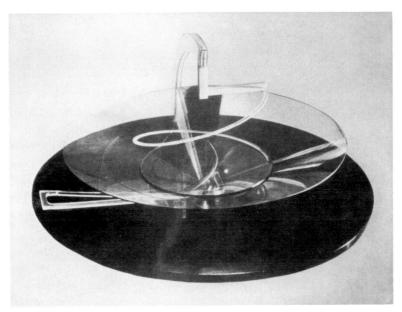

¹⁰⁴ NAUM GABO Circular Relief 1925

renounced 'aesthetics'). He designed workers' clothes, stoves, pottery and furniture, and affected to despise the painted canvas and functionless sculpture.

A practical activity of this kind was acceptable to the doctrinaire communists (who, however, more and more demanded that the artist should be a pictorial propagandist, a visual educator of the proletariat). But other artists in the group, notably Kandinsky, Gabo, Pevsner, Rodchenko and El Lissitzky, believed that the function of art was more indirect – that it was a research into basic elements of space, volume and colour, in order to discover, as they said, 'the aesthetic, physical and functional capacities of these materials'. Sculpture and constructions in relief seemed to offer the best means of demonstrating such physical and functional capacities, for the *eventual* benefit of production.

Their enterprise, in retrospect, seems courageous but, in the revolutionary situation, unrealistic; and so it proved. By 1921 or 1922 the position of these artists had become untenable. In 1922 a comprehensive exhibition of Russian art was organized by the Van Diemen Gallery in Berlin, and several of the Constructivists from Moscow accompanied it, to mount the exhibits and to give demonstrations and lectures. Tatlin, Rodchenko and El Lissitzky took part in these activities, but afterwards returned to Moscow; Gabo, who also took part, decided to stay in Western Europe and eventually found his way to Paris.

During his stay in Berlin in 1922 El Lissitzky edited, with Ilya Ehrenburg, a Constructivist magazine of the arts with a title in three languages – *Vestich*, *Objet*, *Gegenstand*. The contributions were also in Russian, French and German and included work by Constructivist artists from all over Europe – Léger and Le Corbusier from France, Hans Richter from Germany, Moholy-Nagy from Hungary. A

105 LE CORBUSIER Ozon, Op. 1 1947

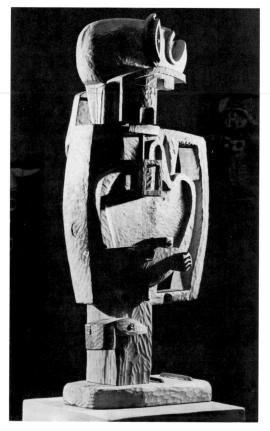

106 GEORGES VANTONGERLOO Sculpture in Space: $y=ax^3-bx^3$ 1935

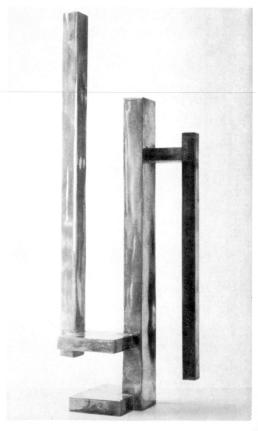

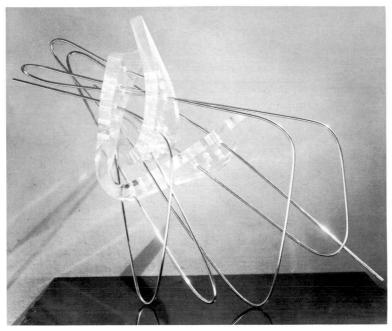

107 LÁSZLÓ MOHOLY-NAGY Plexiglass and chromium-rod Sculpture 1946

Congress of Constructivists was held in this same year in Düsseldorf and henceforth Constructivism was a European movement. Its Constructivist character, in a practical sense, was confirmed by the gravitation of several of the Constructivist artists to the Bauhaus established by Walter Gropius at Weimar in 1919, with ideals almost identical with those of the Russian group. 'The complete building,' declared the first 'proclamation' of the new school, 'is the final aim of the arts. . . Architects, painters and sculptors must recognize anew the composite character of a building as an entity. Only then will their work be imbued with the architectonic spirit which it has lost as ''salon art''. Architects, sculptors, painters, we must all turn to the crafts.'¹⁸

Theoretically and practically sculpture did not exist as a separate 'art' in the Bauhaus – the curriculum was divided into *Werklehre* and *Formlehre*, that is to say, instruction in materials and tools and instruction in observation, representation and composition. What emerged from this teaching

was a 'construction' and if such a construction was threedimensional, it might bear some resemblance to a piece of sculpture in the conventional sense. But it would be called an 'exercise in static-dynamic relations', or simply a 'composition'.

This Constructivist approach to sculpture received further emphasis when, in 1922, Theo van Doesburg came from Holland to Weimar and organized a section of the 'Stijl' movement. This movement had been founded at Levden in 1917 and included among its members Piet Mondrian, the painter, and J. J. Oud, the architect. Its ideals were by no means identical with the realistic or practical aims of the Bauhaus – indeed, van Doesburg boasted: 'I have radically turned everything upside down in Weimar. . . . Every evening I spoke to the pupils there and everywhere I scattered the poison of the new spirit.'19 The new spirit was defined by van Doesburg as 'the development of modern art towards the abstract and universal idea, i.e. away from outwardness and individuality', towards 'a collective style which - beyond person and nation - expresses plastically the highest and deepest and most general desires of beauty of all nations'. As this ideal was to be realized by the de Stijl group, above all by Mondrian, it had less and less application to the 'craft' approach of the Bauhaus. The only sculptor produced by the de Stijl group, Georges Vantongerloo (b. 1886), was never very prolific and his work was to remain experimental, and well within Tatlin's ideal of 'laboratory art':

It is space that has always haunted me, even when my studies of the three dimensions still limited my vision. I didn't possess any other means of experience . . . space never ceased to occupy my thoughts. . . . Thus, in 1914 I made a Head of a Child. Without my wanting it, the child became my pretext for my study of space. I wasn't satisfied with that work. Why not? Well, it took me years to realize that the subject 'child' is nothing but a parasite

106

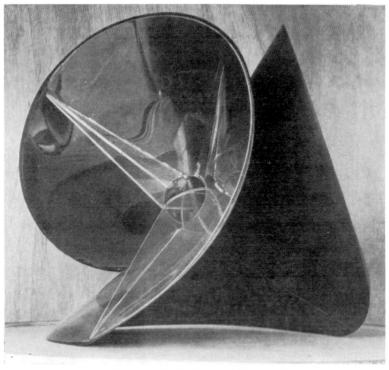

108 NAUM GABO Construction in Space with crystalline centre 1938

which by dominating space destroys the very nature of it. No, the child failed as a means of expression, it failed as a language in which to express Space. Seeing that the subject 'Nature' never provided me with anything more than a limited experience, I abandoned both painting and sculpture.²⁰

Equally within the concept of laboratory art was the work of a much more prolific artist, László Moholy-Nagy (1895– 1946), who joined the Bauhaus in 1923 and for five years conducted the preliminary course (in association with Josef Albers). There was no limit to the ingenuity and inventiveness of Moholy-Nagy, and he did much to develop what he called 'a direct experience of space itself', the interweaving of shapes 'ordered into certain well defined, if invisible, space relationships; shapes which represent the fluctuating play of *tensions* and forces'.²¹ This led him eventually to mobile sculpture, and since he wanted 'to supersede pigment with light' he had to 'dissolve solid volume into defined space'. He seized upon the new material 'plexiglass', but it was not until 1943 that he completed his first plexiglass and chromium-rod sculpture. 'Two heavy planes of perforated plexiglass were held together by chromium rods; as the suspended form turned, it created a virtual volume of reflected light or it merely vibrated as the air around it moved.'²²

Though a concern to represent space is a legitimate pursuit for an artist, it may be doubted whether this element can be realized by concrete media that remain within any logical definition of sculpture. If the art and the word that signifies the art have any precise meaning, they indicate a solid material that is carved (or, by a permissible extension of meaning, moulded) to represent an integral mass *in* space, i.e. occupying space. It is perfectly legitimate to create volumes whose spatial confines have an expressive function,

109 NAUM GABO Spheric Theme 1937

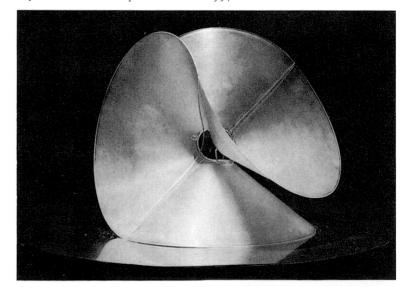

107

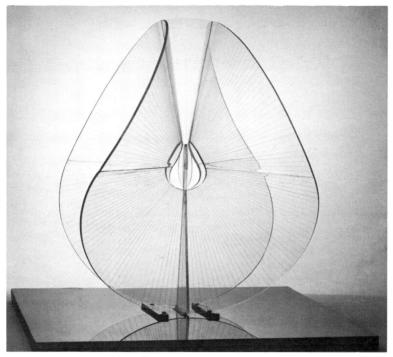

110 NAUM GABO Translucent Variation on Spheric Theme 1951

and that is precisely the function of architecture, which is an art of hollows. The specifically plastic sensibility, as I have written elsewhere,23 involves three factors: a sensational awareness of the tactile quality of surfaces: a sensational awareness of the volume or (to avoid this ambiguous word) the mass encompassed by an integrated series of plane surfaces; and an acceptable sensation of the ponderability or gravity of the mass, i.e. an agreement between the appearance and the weight of the mass. The 'language of space' invented by Vantongerloo and Moholy-Nagy satisfies none of these conditions. In his introduction to the catalogue of the Vantongerloo exhibition held in London in 1962, Max Bill states that Vantongerloo's 'point of departure was not to produce works of art but to present his ideas through colour and space' - a conceptual activity, therefore, not an aesthetic one. 'More and more,' we are told, 'Vantongerloo

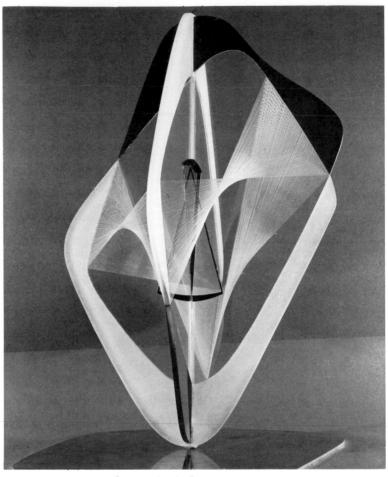

111 NAUM GABO Construction in Space 1953

dissociates himself from the "making of works of art" and to an ever-growing degree his works become idea patterns, sketches of captured processes of nature."

As 'a characteristic expression of our age . . . in tune with the experimental thinking of our time', Vantongerloo's 'ideas' are of great interest, but they have no sculptural significance. This is also true of most of Moholy-Nagy's experiments, and that is why these artists must finally be dissociated not only from Piet Mondrian and the de Stijl

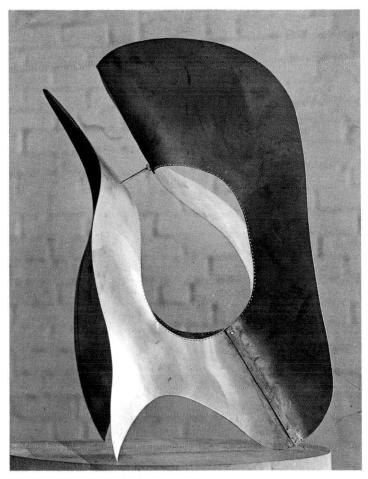

112 NAUM GABO Arch no. 2 1960

group, but also from Constructivists like Gabo and Pevsner.

At the conclusion of the Russian Exhibition of 1922, Gabo stayed in Berlin for a period of ten years, with occasional visits to other parts of Germany, to Holland and Paris. Pevsner, who had not gone to Berlin, left Moscow early in 1923 and first stayed with his brother in Berlin for nine months. It was during this period that he made his first construction. It is to be noted that Marcel Duchamp was also in Berlin at this time and may have had some contact with

100

Pevsner. In October Pevsner went to Paris, where he had lived before the war (in 1911 and again from 1913 to the outbreak of the war in 1914) and where he had already come into contact with the Cubist painters, and where, in 1913, he had seen Boccioni's exhibition of 'architectonic constructions'.

The relation between the work of the two brothers has been the subject of much controversy and misunderstanding. Pevsner and Gabo had spent the first years of the war in Norway, and it was there that together they worked out the basic principles of constructive form that were to survive the impact of Suprematism and 'laboratory art' through the five years of revolution in Moscow (1917–22). But from 1914 to 1923 Pevsner confined himself to painting, while Gabo during this decade concentrated on three-dimensional constructions. The first constructions of Pevsner repeat the early experiments of Gabo, and it was only gradually, and away from the influence of his brother, that Pevsner developed his individual style in sculpture.

In 1924 the two brothers held a joint exhibition at the Galerie Percier in Paris. Pevsner's work then, and even later, (the Torso of 1924-6 and the Portrait of Marcel Duchamp, 1926), shows little advance on Gabo's Constructed Head, no. 2 of 1916, whereas in Gabo's Monument for a Physics Observatory of 1922, the Column of 1923, and Circular Relief of 1925 new materials like glass and plastic were for the first time used to express a new sense of space and dynamic rhythm, and also a sense of social relevance. 'The constructive principle leads into the domain of architecture,' Gabo had declared. 'Art formerly reproductive has become creative. It is now the spiritual source from which future architects will draw.' In addition to the project for a Monument for a Physics Observatory he designed a Monument for an Airport (1924-5) and a project for the Palace of the Soviets (1931) and was commissioned by the Berlin city architect, Hugo Häring, to design a Fête lumière for the Brandenburg Gate (1929). Two

101,99

- 98
- 102
- 103-4

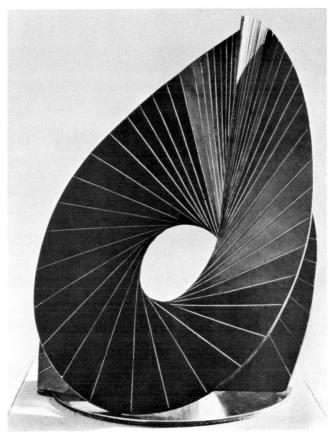

113 ANTOINE PEVSNER Developable Surface 1938

years earlier the two brothers had collaborated in the décor for Diaghilev's ballet *La Chatte*, which was successfully produced in Monte Carlo, Paris, London and Berlin.

From 1932 Gabo was in Paris and took a leading part in the direction of the group 'Abstraction-Création, art nonfiguratif'. This group was for a time extremely active, even aggressive, and did much to establish the concept of a completely non-figurative kind of art. In a manifesto which the two brothers issued on joining the group in Paris, partly a translation of their 'Realistic' manifesto issued in Moscow in 1920, they reaffirmed the 'fundamental bases of art' (space and time) and denied volume as an expression of space. They also rejected physical mass as an element of plasticity and 'announced' that the elements of art have their basis in a *dynamic rhythm* (kinetic rhythms, the 1920 Manifesto explained, are the basic forms of our perception of *realtime*). This has remained the aim of an uncompromising Constructivist like Gabo – to create structures that are 'a vital image of space and time'.

Gabo remained in Paris until 1936, Pevsner until his death in 1962. From 1936 to 1946 Gabo lived in England, at first in London and after the outbreak of the war in Carbis Bay, Cornwall, where Ben Nicholson, Barbara Hepworth and several other artists had found a refuge. Since 1946 Gabo has lived in the United States, becoming a citizen in 1952.

The Constructivist idea in art has not changed since it was first formulated by Gabo - it is one of those irreducible concepts that do not change, and that even tend to a theoretical exclusion of the personal elements in style. But the artist cannot altogether escape from his personality, and in spite of the many manifestations of the Constructivist idea that have taken place in the past thirty years, the work of a Gabo or a Pevsner, a Mondrian or a Vantongerloo, remains personal and distinctive. One may note, especially, the divergencies of style that evolved as between Gabo and Pevsner once they had become separated. While never departing from the basic principles of Constructivism, Pevsner's carefully wrought constructions, usually made from solid metals rather than transparent plastics, gradually took on a 'painterly' (malerisch) surface quality that is quite distinct from the crystalline precision of Gabo's images. Both styles are therefore personal. Before the concepts of space and time can be embodied in a material construction they must pass through the mobile lens of a human sensibility, and in the process they take on distortions (i.e. stylistic modifications) that are inseparable from the human element that conceived them. Even scientists have had to admit the

presence of this human element in their carefully controlled empirical observations. For this reason the Constructivist has never been content to describe his work as 'abstract'.

'Abstract' is not the core of the Constructive Idea I profess [Gabo has said]. The idea means more to me. It involves the whole complex of human relation to life. It is a mode of thinking, acting, perceiving and living. . . . Any thing or action that enhances life, propels it and adds to it something in the direction of growth, expansion and development is Constructive.²⁴

In his writings as well as in his works, Gabo has established certain standards for a constructive art which have had and continue to have a profound effect throughout the world. They combine with and support similar standards established by Mondrian for the art of painting and they have structural correspondences with the ideals and standards of modern architecture as established by Gropius, Mies van der Rohe, Aalto, Le Corbusier and others.

Must we conclude that Constructivist sculpture is a proto-typical or ideal form of architecture, with no aesthetic justification as a separate art? That is not the belief of Gabo, who assigns to constructive sculpture an entirely independent function, an ontological function. The mind or consciousness of man progresses, however slowly, by the conquest of reality, by which we mean the invention of new images to represent the nature of that reality, as present in the consciousness of the artist. In that sense, science and art are parallel activities, the one advancing from empirical observations to new and ever more comprehensive concepts or hypotheses about the nature of the physical world, the other advancing from intuitive apprehensions of the nature of the same physical world to new and ever more exact images to represent such intuitive apprehensions. The images of the artist are concrete - that is to say, material constructions that project the mental image as icons of universal significance.

From Futurism to Surrealism

'I am obsessed these days by sculpture! I think I can perceive a complete renewal of this mummified art' – so wrote Umberto Boccioni (1882–1916) in a letter from London to his friend Vico Baer dated 15 March 1912.¹ Boccioni's interest in sculpture had begun early in that year; he died as the result of an accident on 17 August 1916. In these four years he made a profound contribution to the renewal of the art, and fifty years later his influence still persists.

The general character of 'Futurism' is well known and has been described in A Concise History of Modern Painting. I shall confine myself to the application of its 'principles' made by Boccioni to the art of sculpture. It is important to stress the originality of the movement. Cubism, as we have seen, was a logical development from the position in painting reached by Cézanne. One can even interpret it as a form of classicism, and in their development the Cubist protagonists, Braque and Picasso, never made a decisive break with the figurative tradition - Cubism to them was another style for achieving the same ends as Ingres, Degas or Cézanne. The Futurists, by contrast, were not only the first artists specifically of a technological civilization: their principles were derived from technology - from power and movement, from mechanical rhythms and manufactured materials. In another letter to Vico Baer, this time from Paris (undated, but probably written in June 1913) Boccioni makes very clear his awareness of this distinction:

All cubism does not seem to be going ahead by a single step, painting moves little and is surely not on a path of a true revolution of sensitivity. Archipenko's sculpture

115 HENRI LAURENS Composition in black and red sheet iron 1914

has lapsed into the archaic and the barbaric. This is a mistaken solution. Our own primitivism should have nothing in common with that of antiquity. Our primitivism is the extreme climax of *complexity*, whereas the primitivism of antiquity is the babbling of *simplicity*.²

This statement serves to distinguish the Futurists from the Cubists and those sculptors influenced by Cubism such as Archipenko and Brancusi; it indicates that a 'true revolution of sensitivity' implies more than a change of style: more than a change of method or means. The whole ideological foundations of art as a human activity were to be changed, and corresponding to the new ideology there would be new images, new materials, new social functions. More than the plastic arts were involved – poetry, architecture,

116

116 UMBERTO BOCCIONI Horse+Rider+House 1914

drama and even, as a method of engaging all society in a transformation of sensibility, political action.

The machine came first, as the icon that inspired their ideas. The Futurists decided that the distinguishing characteristic of the machine was its self-sustained movement, its dynamism. Filippo Tommaso Marinetti, the leader of the group, declared in his first manifesto that 'the world's splendour has been enriched by a new beauty: the beauty of speed.... A racing motor-car, its frame adorned with great pipes, like snakes with explosive breath... a roaring motor-car, which looks as though running on shrapnel, is more beautiful than the *Victory of Samothrace*.'

This 'initial' manifesto, signed by Marinetti only, which was first published in *Le Figaro*, Paris, on 20 February 1909,

117 UMBERTO BOCCIONI Unique Forms of Continuity in Space 1913

is full of sound and fury but contains little that deals specifically with the arts – Marinetti himself was a poet:

We shall sing of the great crowds in the excitement of labour, pleasure and rebellion; of the multi-coloured and polyphonic surf of revolutions in modern capital cities; of the nocturnal vibration of arsenals and workshops beneath their violent electric moons; of the greedy stations swallowing smoking snakes; of factories suspended from the clouds by their strings of smoke; of bridges leaping like gymnasts over the diabolical cutlery of sunbathed rivers; of adventurous liners scanting the

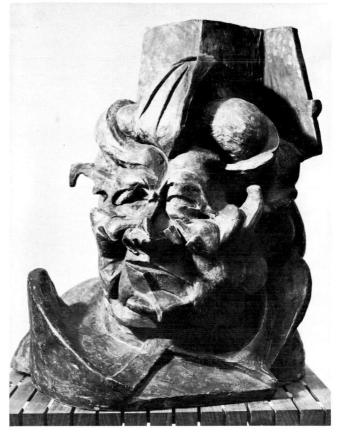

¹¹⁸ UMBERTO BOCCIONI Anti-Graceful (The Artist's Mother) 1912

horizon; of broad-chested locomotives prancing on the rails, like huge steel horses bridled with long tubes; and of the gliding flight of aeroplanes, the sound of whose screw is like the flapping of flags and the applause of an enthusiastic crowd.

And much more of this kind, breathless and incoherent. As for art – 'art can be nought but violence, cruelty and injustice.... We wish to destroy the museums, the libraries, to fight against moralism, feminism and all opportunistic and utilitarian meanness.' There is a more sinister note, prophesying fascism: 'We wish to glorify War – the only

health giver of the world – militarism, patriotism, the destructive arm of the Anarchist, the beautiful Ideas that kill, the contempt for women.'

But when, about a year later (11 April 1910), the group that had gathered round Mussolini issued a second so-called 'technical' manifesto, there was less sound and fury, far more about aesthetics. The signatories (Boccioni, Carrà, Russolo, Balla and Severini) set about 'to expound *with precision*' their programme for 'the renovation of painting'.

We are only concerned for the present with this programme in so far as the general principles announced in it

120 UMBERTO BOCCIONI Development of a Bottle in Space 1912

121 OSKAR SCHLEMMER Abstrakte Rindplastik 1921

apply to sculpture as well as to painting. There is really only one such principle:

... the gesture which we would reproduce in canvas shall no longer be a fixed *moment* in universal dynamism. It shall simply be the dynamic sensation itself made eternal.... Space no longer exists.... Who can still believe in the opacity of bodies, since our sharpened and multiplied sensitiveness has already penetrated the obscure manifestations of the medium? ... Our bodies penetrate the sofas upon which we sit, and the sofas penetrate our bodies.... The harmony of the lines and folds of modern dress works upon our sensitiveness with the same emotional and symbolical power as did the nude upon the sensitiveness of the old masters.... We fight against the nude in painting, as nauseous and as tedious as adultery in literature.

The essential point in this manifesto (which also declared that 'the art critics are useless or harmful') is the insistence on dynamism as the typical sensation of our time and on the consequent duty of the artist to render this sensation in painting. Of the technical means to be employed there is no indication in the manifesto, but in the years that immediately followed (1910 to 1914) one method is common to all these painters – a divisionism that allows them to give an overall dynamic rhythm to the representation of the subject or 'motif'. Superficially their canvases may look like those of the Cubists – still more like those of the 'Orphist', Roger Delaunay. But there is a fundamental difference. In the analytical Cubism of Picasso and Braque, the definite purpose of the geometricization of the planes is to emphasize the formal structure of the motif represented. In the synthetic

122 DAVID HARE Man with Drum 1948

123 GIACOMO BALLA Boccioni's Fist—Lines of Force 1915

Cubism of Juan Gris the definite purpose is to create an effective formal pattern, geometricization being a means to this end. In Delaunay's case it is a question of conveying the radiant energy of light or perhaps the 'space that no longer exists'. But the fragmentation that takes place in a Futurist painting has quite another aim – to create linear

¹²⁴ ALEXANDER ARCHIPENKO Boxing Match 1913

elements ('force-lines', as they were called) that can be 'serialized' to give the effect of movement (Boccioni's drawings of 'states of mind' are always the mental sensations conveyed by swirling lines). If these swirling elements nevertheless add up to a 'composition' with an overall formal structure, this is merely an arbitrary design imposed on the painter by the two-dimensional area of the canvas. Formal coherence is of secondary importance.

When Boccioni turned to sculpture he sought to apply these same principles to the free-standing object. The 'Technical Manifesto' he issued on 11 April 1912, whatever its polemical aim, is in any case a profound analysis of the aesthetic principles of sculpture. Boccioni begins with a denunciation of the 'pitiable barbarism, clumsiness and monotonous imitation' of the sculpture of every country 'dominated by the blind and foolish imitation of formulas inherited from the past'. 'In all these manifestations of sculpture . . . the same error is perpetuated: the artist copies the nude and studies classical statuary with the simple-minded conviction that he can find a style corresponding to modern sensibility without relinquishing the traditional concept of sculptural form.' Boccioni has little difficulty in demonstrating the absurdity of such an aim, and then declares that 'there can be no renewal in art whatever if the essence itself is not renewed, that is, the vision and concept of line and masses that form the arabesque'. To renew the art of sculpture:

we have to start from the central nucleus of the object that we want to create, in order to discover the new laws, that is, the new forms, that link it invisibly but mathematically to the APPARENT PLASTIC INFINITE and to the INTERNAL PLASTIC INFINITE. The new plastic art will, then, be a translation into plaster, bronze, glass, wood, and any other material, of those atmospheric planes that link and intersect things.

Boccioni called this 'vision' PHYSICAL TRANSCENDENTA-LISM, a vague enough phrase, but he went on to define his meaning. Sculpture must give life to objects by a system of interpenetration. Objects do not exist in isolation – they cut through and divide the surrounding space in 'an arabesque of directional curves'. Only Medardo Rosso,

125 KURT SCHWITTERS Merzbau Begun 1920, destroyed 1943

among the sculptors of the past, had had any inkling of 'rendering plastically the influences of an ambience and the atmospheric ties that bind it to the subject'. Boccioni had a high regard for Rosso's revolutionary approach to sculpture, but felt that in the end 'the impressionistic necessities' had unduly limited his research 'to a kind of high or low relief, demonstrating that the human figure is still conceived of as a world in itself with traditional bases and an episodic goal'. Rosso, therefore, remained an Impressionist, his work fragmentary and accidental, lacking a synthesis.

Boccioni's 'synthesis' would be a 'systematization of the interpenetration of planes'. The foundation would be architectural, 'not only in the construction of the masses, but in such a way that the block of the sculpture will contain within itself the architectural elements of the SCULPTURAL ENVIRONMENT in which the subject lives'.

This might seem to be nothing more than a reversion to

126 KURT SCHWITTERS Autumn Crocus 1926–8

127 KURT SCHWITTERS Ugly Girl c. 1943-5

the 'open form' and dynamism of Baroque sculpture, but this Boccioni fiercely denied, and it is perhaps easy to see the distinction. Apart from Boccioni's desire to 'abolish in sculpture as in every other art THE TRADITIONAL SUBLIMITY OF THE SUBJECT', there is a technical difference. The lines of force in a piece of Baroque sculpture (and especially so when part of an architectural complex) are self-sufficient, or, to use Boccioni's own word, 'episodic'. They turn in upon themselves, at best relating to an architectural complex. But the general aim of the Futurists was to achieve an interpenetration of the work of art and the environment, of form and atmosphere. 'WE BREAK OPEN THE FIGURE AND ENCLOSE IT IN ENVIRONMENT,' declared Boccioni with maximum emphasis. 'The sidewalk can jump up on your table and your 129 head be transported across the street, while your lamp spins a web of plaster rays between one house and another.'

To translate all these precepts into practice was not easy. The most literal attempt was a structure in various materials that has not survived (though a photograph exists) which shows the *Fusion of a Head and a Window*. The head in question is split open to admit a section of wood and glass from a window frame, and very solid rays of light stream down and over the head. The general effect, judging by the photograph, is very confused. This cannot be said of the three bronzes which are the permanent representatives of Boccioni's solution of 'the problem of dynamism in sculpture' – the *Anti-Graceful (The Artist's Mother)* of 1912, the *Development of a Bottle in Space* of the same year, and *Unique*

118 120, 117

128 Mathematical Object. Kummer's plane surface with sixteen points, of which eight are true. Photograph by MAN RAY

¹²⁹ SOPHIE TAUEBER-ARP Last Construction, no. 8 1942

Forms of Continuity in Space (1913). Some drawings in the Winston Collection provide a clue to the sculptor's procedure. The head of a woman, for example, is reduced to a series of intersecting curves which may be intended to represent characteristic lines of facial expression – a smile, a grimace, a pout, etc. These are then translated into a model (of plaster or wax) and the result (in *Anti-Graceful*) is hardly to be distinguished, except in its ruggedness, from the frankly expressionistic (or impressionistic) work of Rosso. Dr Taylor, in his monograph on the artist,³ describes the piece as:

combining the heavy sculptural mass with freely moving surface planes . . . a lively image that seems to burst with inner life. It startlingly merges geometrical forms with

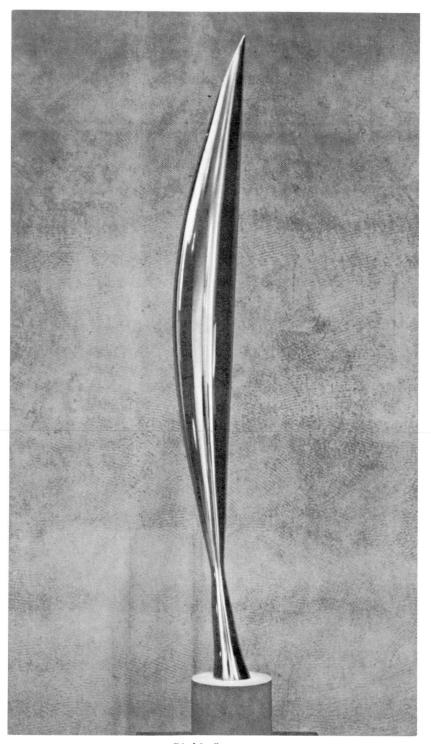

130 CONSTANTIN BRANCUSI Bird in Space 1919

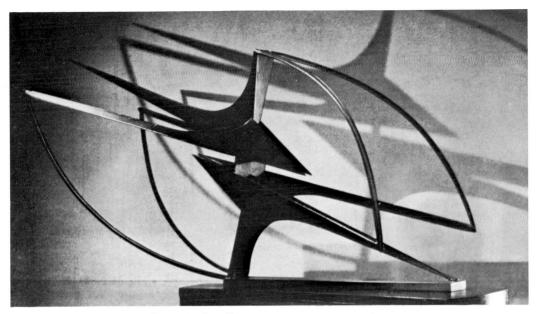

Projection into Space ANTOINE PEVSNER 1924 131

soft fleshy shapes, yet is unified by the unflagging vitality of the surface. Many of Boccioni's cherished ideas find voice: the forms of far-away houses merge with the form of the head; the face has an extraordinary range of expression, it smiles, frowns, or is pensive according to the view and the viewer; and bold rhythms seem to envelop the physical form.

Though, as Dr Taylor suggests, this work may be 'just one long step removed from the freely modelled heads of Rosso', it still does not constitute such a revolutionary advance as the Development of a Bottle in Space. In certain respects 120 this highly original piece is an anticipation of Picasso's Glass of Absinthe of 1914 in that the inner space of the 55 bottle is exposed and it becomes possible to suggest the immateriality of the substance (glass) by means of the dynamic rhythm of the open spiral form. Ingenious as this solution is, it is exceeded by the skill with which Boccioni, in his monumental Unique Forms of Continuity in Space, succeeds in conveying the striding advance of a human

117

figure – one is tempted to add 'through space', but since we have been told that 'space no longer exists' the intention is presumably to suggest 'a bridge between the exterior plastic infinite and the interior plastic infinite'. That may be a rather meaningless phrase, but Boccioni had in mind the idea that 'objects never end', and 'intersect with infinite combinations of sympathetic harmonies and clashing aversions'. The infinity is one of movement and not of space.

None of the other Futurists had the plastic sensibility and creative ambition of Boccioni, but Giacomo Balla (1871–1958) experimented with assemblies of various impermanent materials, presumably in the manner of the *Horse*+Rider+*House* of 1914 in the Peggy Guggenheim Collection, which is a delicate construction of wood, cardboard and metal. Balla's works of this kind seem to have perished, with the exception of the structure in cardboard and wood (painted

- 123 red) in the Winston Collection, *Boccioni's Fist* \overline{Lines} of *Force* (1915). This piece bears a certain resemblance to
- 124 Archipenko's *Boxing Match* (1913) and there are other parallels to be drawn between the sculpture of Boccioni and Balla and the contemporary sculpture of Archipenko, Duchamp-Villon and Henri Laurens. I think there can be no question of the priority of the Futurists: their concept of a dynamic sculpture had been formed as early as 1910, at a time when the Paris sculptors were still working out the implications of the quite different principles of Cubism.
- Laurens's Composition in black and red sheet iron of 1914 (Collection Maurice Raynal) is a tribute to Boccioni's Horse+ Rider+House (dated 1912-13 by one authority, 1914 by another);⁴ and Duchamp-Villon's series of Horses (1914), if
- not directly related to Boccioni's *Development of a Bottle in Space*, is inspired by the same principle of dynamics.

The connecting link between Futurism and Cubism, between Paris and Milan, was the painter Gino Severini (b. 1883). He had settled in Paris in 1906 but nevertheless he kept in close touch with his friends Balla and Boccioni, with

116

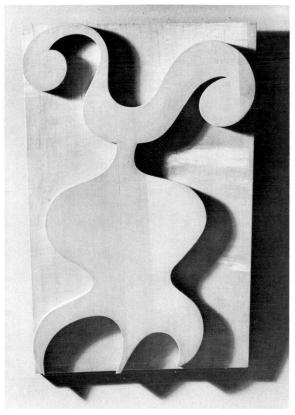

132 JEAN ARP Madame Torso with wavy Hat 1916

whom he had worked in Rome from 1900 onwards (Balla had spent seven months in Paris that year, and returned to Rome as an apostle of Seurat). In spite of his Parisian domicile, Severini signed the Futurist manifestoes of 1910 and 1912, but apparently with some mental reservations. Severini had summoned his friends (Boccioni and Carrà) to Paris in the autumn of 1911, to confront them with the Cubists' achievements. Boccioni was impressed, but the final effect was to clarify his own methods rather than change any principles. There could be no compromise between an art that sought to realize movement and 'states of mind', and one (like Cubism) that sought to establish the position

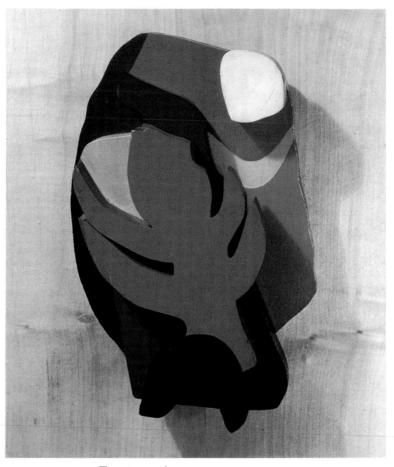

133 JEAN ARP Forest 1916

of objects in space. There is a clear realization of this fact in Daniel-Henry Kahnweiler's book, *The Rise of Cubism*, written in 1915 but not published until 1920. Kahnweiler, the intimate friend of Picasso and Braque, was in a good position to observe the conflict between Cubism and Futurism. He suggests that many artists were using the Cubist language of forms for aims other than those of the

134 MAX ERNST Fruit of a long Experience 1919

founders of the movement, and in particular refers to the Futurists (with whom, it is interesting to note, he associated Marcel Duchamp):

Even before the Futurists went over to Cubism, while they were still using Divisionist technique, the subject of all their manifestoes was dynamism, the endeavour to represent movement in painting and sculpture. The idea

135 MARCEL DUCHAMP In advance of a broken arm 1915

has not been abandoned since that time, for a book by Boccioni, one of the school, which was published in 1913, contrasted 'static' Cubism with 'dynamic' Futurism.

The Futurists tried to represent movement by depicting the moved part of the body several times in various positions, by reproducing two or more phases of movement of the entire figure, or by lengthening or widening the represented object in the direction of the movement. Can the impression of a moving form be awakened in the spectator in this way?

It cannot. All these solutions suffer from the same mistake which renders that impression possible. In order to produce 'movement', at least two visual images must

136 PAUL NASH Found object interpreted (Vegetable Kingdom) c. 1935

exist as succeeding points in time. In Futurism, however, the various phases exist simultaneously in the painting. They will always be felt as different, static, single figures, but never as a moving image. This is borne out by fact, as observation of paintings by Carrà, Severini or Boccioni will show.⁵

A Futurist might have answered (and probably did) that it is not necessary to present *objects* (paintings or sculpture) separately in order that two visual images may exist as succeeding points in time; the eye is capable of detaching such separate images from the area of the canvas or the mass of the sculpture: there are successive moments in the one visual event. But Kahnweiler's criticism does serve to show

137 MAX ERNST Tête double: Oedipus 1935

the decisive nature of the difference between the aims of the Cubists and the Futurists. It is a difference that has persisted beyond the period of Cubism and Futurism – it is fundamentally a difference between a perceptual and a conceptual approach to art. Apollinaire tried to evade the distinction by establishing a category which he called 'instinctive cubism', in which he included the Futurists. The meaninglessness of the term is shown by his inclusion within the category of artists as diverse as Matisse, Rouault, Dufy, Severini and Boccioni.

The principle of dynamism in sculpture first established by the Futurists was to persist down to the present day. We

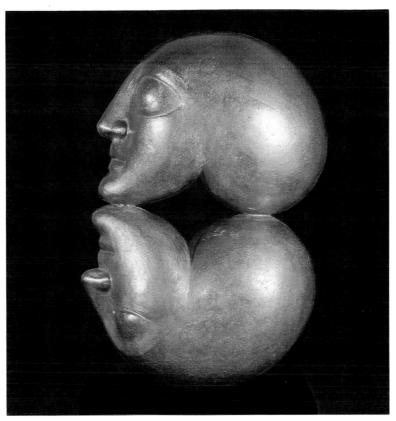

138 VICTOR BRAUNER Signe 1963

have already seen how it passed to Moscow at least as early as 1913; Marcel Duchamp developed it in paintings like his *Nude Descending a Staircase*, one of the most influential works in the history of the modern movement. Even works like Brancusi's *Bird in Space* ('a design which should expand to fill the vault of heaven') or Pevsner's *Projection into Space* (1924), have aims which correspond to those of the Futurist sculptors. In short, the Futurists in their manifestoes gave to art, and to sculpture in particular, an ideal of dynamism, of environment and atmosphere, of interpenetration and 'physical transcendentalism' which has persisted for half a century and still inspires many artists.

130 131 I have already attempted, in A Concise History of Modern Painting, to trace the confused paths that led from Futurism to Dada and Surrealism. The confusion was deliberate - a systematic 'dérèglement' of the senses which had as its objective the release of the mechanisms that normally subdue the imagination in the interests of rational order and social conformity. The work of art, it was argued, aspired to or proceeded from a realm of indeterminacy, of chance, of dream which might have significance for life, but was superior to it - a realm of super-reality. In this general sense super-realism is the characteristic of this whole phase of modernism, and may be regarded as an extreme development of romanticism. The Surrealists were not formal or even technical innovators, as were the Cubists and Constructivists. They were very conscious of the past and found precursors in Blake and Baudelaire, Novalis and Nietzsche, Rimbaud and Lewis Carroll. The Dadaists, however, disdained the past as well as the present: they were in the strictest sense nihilists, and among the conventions they wished to destroy were the categories established for the arts

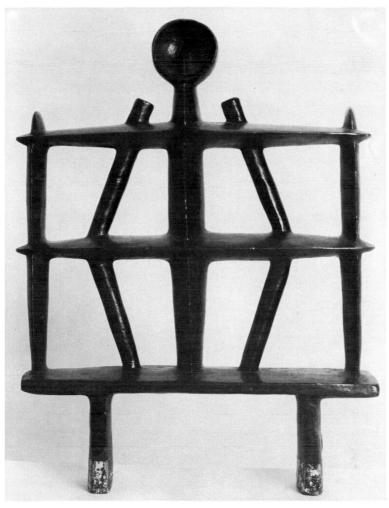

140 Alberto Giacometti Man 1929

by the academies of the past – categories like painting and sculpture, restrictions to materials like canvas, oil-paint, marble. To quote a passage from *A Concise History of Modern Painting*:

... from the beginning Dada, inheriting the rhetorical propaganda of Marinetti, had claimed to be 'activist', and this in effect meant an attempt to shake off the

141 ALBERTO GIACOMETTI Reclining Woman 1929

142 ALBERTO GIACOMETTI The Palace at 4 a.m. 1932-3

143 MAX ERNST The Table is Set 1944

dead-weight of all ancient traditions, social and artistic, rather than a positive attempt to create a new style in art. In the background was wide social unrest, war fever, war itself, and then the Russian Revolution. Anarchists rather than socialists, proto-fascists in some cases, the Dadaists adopted Bakunin's slogan: destruction is also creation! They were out to shock the bourgeoisie (whom they held responsible for the war) and they were ready to use any means within the scope of a macabre imagination - to make pictures out of rubbish (Schwitters' Merzbilder) or to exalt scandalous objects like bottle-racks or urinals to the dignity of art-objects. Duchamp provided Mona Lisa with a moustache and Picabia painted absurd machines that had no function except to mock science and efficiency. Some of these gestures may now seem trivial, but that is to forget the task that had to be done - the breaking-up of all conventional notions of art in order to emancipate completely the visual imagination. Cubism had achieved much, but once it had rejected the laws of perspectival vision, it threatened to rest there and revert to a formal

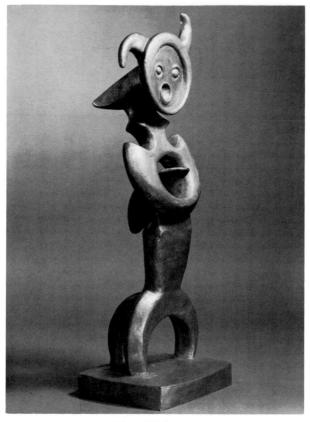

144 MAX ERNST Moon Mad 1944

classicism more severe and rigid than the realism it had escaped. Dada was the final act of liberation, and apart from the response it elicited from Picasso and Braque, and even Léger, it provided 'a lasting slingshot' for a new and not less important generation of artists.⁶

Very significant for the future development of sculpture was the obliteration of any formal distinction between the painting, the relief, the sculpture-in-the-round and the ready-made object. Indeed, certain works of the Dadaists may be classified indifferently as paintings or sculpture, and to separate them for the sake of a tidy history of either category is to destroy their historical significance. Just as a

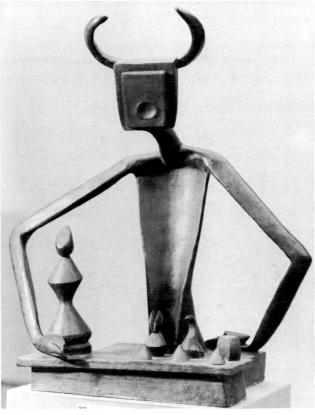

145 MAX ERNST The King playing with the Queen 1944

"merzbild" of Schwitters is no longer a painting, so a paintedwood relief by Arp is no longer either sculpture or painting. It is an *objet d'art*, but in a sense not always implied by that phrase; it is an object without qualifications. It could be, as Marcel Duchamp was to perceive, *ready-made* – that is to say, an ordinary object invested with significance by being removed from its normal environment or position, simply, for example, by being *turned upside down*.

The history of this phase of modern sculpture can best be related by annotating a paragraph written by Arp himself:

In 1914 Marcel Duchamp, Francis Picabia, and Man Ray, then in New York, had created a dada (hobby-horse) that

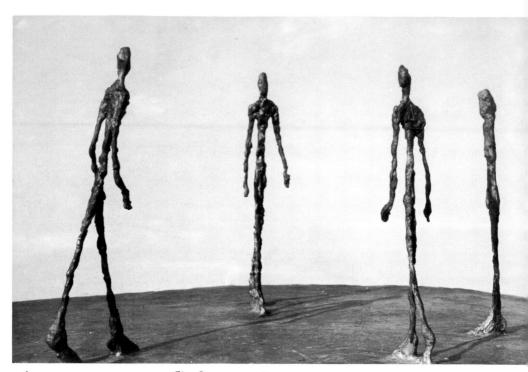

146 ALBERTO GIACOMETTI City Square 1948-9

left nothing to be desired. But great was their distress, for they found no name for it. And because it was nameless, we in Zurich knew nothing of its existence. But when in 1916 we engendered our Dada and it was born, we – Hugo Ball, Tristan Tzara, Richard Huelsenbeck, Emmy Hennings, Marcel Janco, and I – fell rejoicing into each other's arms and cried out in unison: 'Da, da ist ja unser Dada' ('There, there's our Dada'). Dada was against the mechanization of the world. Our African evenings were simply a protest against the rationalization of man. My gouaches, reliefs, plastics were an attempt to teach man what he had forgotten – to dream with his eyes open. Even then I had a foreboding that men would devote themselves more and more furiously to the destruction of the earth. The choicest fruits on the tree of Dada, gems

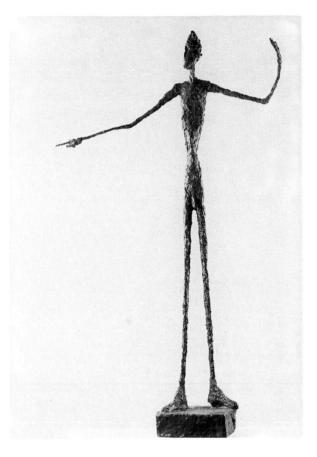

147 ALBERTO GIACOMETTI Man pointing 1947

from top to toe, were those raised by my friend Max Ernst and myself in Cologne. A little later we moved to the Tyrol and Tristan Tzara joined us in the good work. In Cologne Max Ernst and I founded the great enterprise of 'Fatagaga' under the patronage of the charming Baroness Armanda von Duldgedalzen and the well-to-do Herr Baargeld (Mr Cashmoney). Overcome by an irresistible longing for snakes, I created a project for reformed rattlesnakes, beside which the insufferable rattlesnake of the firm of Laocoön and Sons is a mere worm. At the very same moment Max Ernst created 'Fata'. My reformed rattlesnake firm and Max Ernst's Fata firm were merged under the name of Fatagaga, and can be brought back to life at any time on request. The important thing about Dada, it seems to me, is that the Dadaists despised what is commonly regarded as art, but put the whole universe on the lofty throne of art. We declared that everything that comes into being or is made by man is art. Art can be evil, boring, wild, sweet, dangerous, euphonious, ugly, or a feast to the eyes. The whole earth is art. To draw well is art. Rastelli was a wonderful artist. The nightingale is a great artist. Michelangelo's Moses: Bravo! But at the sight of an inspired snow man, the Dadaists also cried bravo.⁷

The points to emphasize in this statement are:

1. 'Dada was against the mechanization of the world. . . . My gouaches, reliefs, plastics were an attempt to teach man what he had forgotten – to dream with his eyes open' – this antirationalism is the emotional force behind the movement, and it was to be intensified by the prevailing wartime atmosphere – for modern war is essentially a war of machines, and victory goes to the side that invents the swiftest or most powerful machines. In protesting against the mechanization of the world, the Dadaists were protesting against war.

2. 'The choicest fruits on the tree of Dada . . . were those raised by my friend Max Ernst and myself in Cologne' – the Dada movement was essentially Germanic in its origins. 'My old love for the German Romantics,' Arp says in this same article, 'is still with me.' He mentions Novalis, Brentano and Arnim – and 'the most beautiful thing of all . . . the interior of the Strasbourg cathedral with its great jewels, the miracle of its stained-glass windows. I will write a thousand and one poems about those windows.' But this romanticism, in 1914, had turned to self-mockery, to masochism and destructiveness. This is not the place to give a psychological explanation of the process, but Arp in his statement says

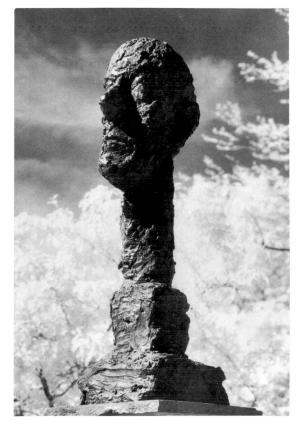

148 ALBERTO GIACOMETTI *Monumental Head* 1960

that 'even then I had a foreboding that men would devote themselves more and more furiously to the destruction of the earth' and his 'reformed rattlesnake firm' was a contribution to that end. To identify the Dada movement with the *furor teutonicus* is perhaps misleading, in that its political alignment was pacifist and anti-nationalistic. But it is always possible to ride the local storm on a broomstick or a wild ass.

Germany [as Jung has said] is a land of spiritual catastrophes where certain facts of nature never make more than a pretence of peace with the world-ruler reason. The disturber is a wind that blows into Europe from limitless and primeval Asia, sweeping in on a wide front, from

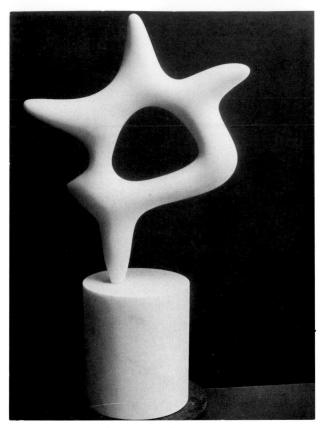

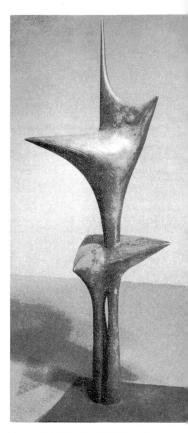

149 JEAN ARP Star 1939-60

150 BERNHARD HEILIGER Vegetative Sculpture, no. 1 1956

Thrace to the Baltic. Sometimes it blows from without and scatters the nations before it like dry leaves, and sometimes it works from within and inspires ideas that shake the foundations of the world. It is an elemental Dionysus that breaks into the Apollonian world.⁸

The rattlesnake of Dionysus can turn against the 'insufferable rattlesnake of the firm of Laocoön and Sons'.

3. 'The important thing about Dada, it seems to me, is that the Dadaists despised what is commonly regarded as art . . . we declared that everything that comes into being or is made by man is art. Art can be evil, boring, wild, sweet, dangerous, euphonious, ugly, or a feast to the eyes.' In other words,

Dada represented a complete liberation of the creative impulse, and it was therefore able to embrace the most astonishing contradictions - above all the contradiction that, in spite of their destructive intentions, the Dada artists returned to certain essentials of art, and their art - the sculptures of Arp, the collages of Schwitters, the paintings of Max Ernst - has proved as enduring as any art of the twentieth century. 'I tried to be natural,' writes Arp. In that attempt lies the revolutionary significance of Dada, for to be natural is by no means the same as to be 'faithful to nature'.

Dada, in any coherence, did not survive the end of the First World War, but in that short period Arp had produced some works of great significance for the future of sculpture, notably certain painted-wood reliefs (such as Madame Torso I 3 2 with wavy Hat, 1916 and Forest, 1916). After the war groups were formed in Berlin, Cologne, Hanover (which again emphasize the Germanic character of the movement), with smaller offshoots in Basle and Barcelona. Arp went to join the new group in Cologne, and there rejoined Max Ernst, whom he had first met in 1914. Arp has in his possession a

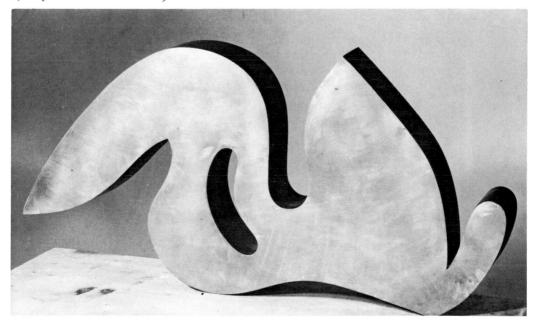

wooden figure of *Lovers* carved by Max Ernst in 1913, and the painted relief of 1919 (*Fruit of a long Experience*, Collection Roland Penrose) may still be regarded as Dada sculpture. This latter piece is near to the painted reliefs made by Kurt Schwitters about the same time, such as the *Merz Construction* of 1919 which has not survived.⁹ The 'method' of all these sculptures is to assemble 'found-objects' into meaningful relationship, to create a kind of plastic metaphor which has the same evocative power as a metaphor in poetry. But this method is also the method of Surrealist sculpture, so in this sense there is a complete continuity between Dada and Surrealism.

What might be called the apotheosis of the ready-made object is, however, a joke peculiar to Dada, and perhaps to be attributed to Marcel Duchamp alone. The idea seems to have arisen in the course of utilizing the shadows cast by ready-made objects as elements in a design. Robert Lebel, in his study of Duchamp,¹⁰ quotes a note from Duchamp's *Green Box*, a portfolio of photographs, drawing and manuscript notes published in Paris in 1934:

Shadows cast by ready-mades. Shadows cast by 2, 3, 4, ready-mades *brought together*. Perhaps use an enlargement of that so as to derive from it a figure formed by an equal /length/ (for example) taken in each ready-made and becoming by the projection a part of the cast shadow.... Take these 'becomings' and from them make a tracing without naturally changing their position in relation to each other in the original projection.

The ready-mades of Duchamp begin with the *Bicycle Wheel* of 1913 and it is important to understand the artist's intention in choosing and exhibiting a ready-made object. That intention is in no sense aesthetic, as is the later intention of the Surrealists in presenting (and even mounting

154

135

¹³⁶ or framing) an *objet trouvé*; much less any intention of using ready-made materials, as we have seen the Cubists did, for

their inherent decorative or plastic qualities. As Robert Lebel so acutely observes, Duchamp's intention was

to cut short any counter-attack of taste. He did not select a bicycle wheel as a beautiful modern object, as a Futurist might; he chose it just because it was *commonplace*. It was nothing but a wheel, like a hundred thousand others, and in fact if it were lost it could soon be replaced by identical 'replicas'. For the moment, resting upside down on a kitchen stool as a pedestal, it enjoyed an unexpected and derisive prestige which depended entirely upon the act of choosing by which it was selected. It was a kind of sacralization.

But is any act of choosing entirely arbitrary? Can any personal action be described as 'entirely arbitrary'? The objects chosen by Duchamp - a wheel, a bottle-rack, a urinal (upside down), a snow-shovel, a comb, a hat-rack suspended from the ceiling, etc., may conceivably have some unconscious association for the artist; and if not the object itself, its configuration or Gestalt may have some hidden significance. 'His is the whimsical mood of a spoiled child taking his revenge on the arbitrary decisions of adult logic,' declares Mr Lebel.¹¹ But one has a suspicion that the objects may be taking their revenge on the artist. 'He has never come so close to magic as in these veritable fetishes, which he has invested with a power which is evidently real, for since their consecration they have never ceased to inspire a devoted cult' - Mr Lebel again. But to replace the aesthetic cult by a magical cult does not seem to be the kind of liberation the Dadaists were seeking, and I doubt if Duchamp, who compared his ready-made to a 'sort of rendezvous', had any such pretensions. To import the notion of magic contradicts the only distinction that I believe can be made between Dadaism and Surrealism.

In June 1915, Duchamp decided to leave Paris and went to the United States, where his fame had preceded him. The decision was no doubt forced on him by the wartime atmosphere in Paris (Duchamp had been exempt from military service, but that was not a comfortable situation for a young man). It may also have been prompted by a feeling that he had nothing in common with the aesthetes of Paris, and wanted an unspoilt and naïve public for his audience. Duchamp was to be claimed by the Surrealists but, as Robert Lebel has perhaps been the only critic to appreciate, he has remained one of the few authentic Dada artists, and as such he has had his unique influence, especially in America. There is little in the prolific development of modern sculpture in the United States that cannot be attributed directly to the example of Duchamp. This is not to deny that he played an important role in the development of the Surrealist movement in Paris, but it was in the spirit with which he worked as a librarian when very young - 'I was always glad to supply any information I could to anyone who asked me politely.'12

If there is some doubt about the intention of Duchamp to invest his 'ready-mades' with magic, there is no doubt that the somewhat similar 'found-object' (objet trouvé) of the Surrealists was selected for its supposed magical quality. 'Magic' is an ambiguous word; what it usually means here is strangeness or fantasy, or what André Breton has called 'objective humour' - 'a synthesis in the Hegelian sense of the imitation of nature in its accidental forms on the one hand and of humour on the other'.13 Breton himself illustrated such a synthesis in his Poème-objet of 1935, which is an assemblage, mounted on a board, of a dummy egg, a broken piece of mirror-glass, and the wings of a bird or angel presumably detached from some toy. It is a long way from the sculptural integrity of a Rodin or a Matisse, and to be just to the Surrealists we should remember that, like the Dadaists, they had no respect for formal categories therefore they spoke of 'objects' and not of 'sculpture'. Rather different, however, were the intentions of Alberto

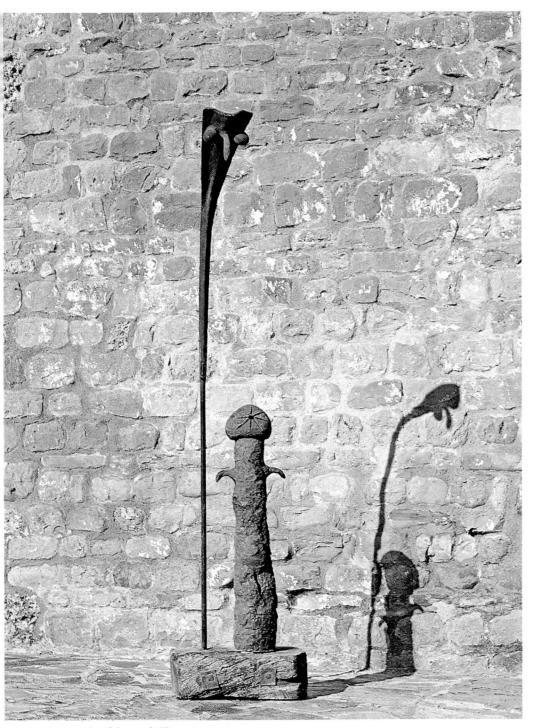

152 JOAN MIRÓ Man and Woman 1956–61

Giacometti (b. 1901), who from the beginning was obsessed by the specifically sculptural theme of spatial relationships. At the time of the construction of his most Surrealist work, *The Palace at 4 a.m.* (1932–3, now in the Museum of Modern Art, New York), he wrote:

I whirl in the void. In broad daylight I contemplate space and the stars which traverse the liquid silver around me.... Again and again I am captivated by constructions which delight me, and which live in their surreality – a beautiful palace, the tiled floor, black, white, red under my feet, the clustered columns, the smiling ceiling of air, and the precise mechanisms which are of no use.¹⁴ [And further] Once the object is constructed, I tend to see in it, transformed and displaced, facts which have profoundly moved me, often without my realizing it; forms which I feel quite close to me, yet often without being able to identify them, which makes them all the more disturbing.¹⁵

In these two statements the whole purpose and effect of a Surrealist sculpture is expressed – the construction in space of precise mechanisms that are of no use but are nevertheless

153 JOAN MIRÓ Bird 1944-6

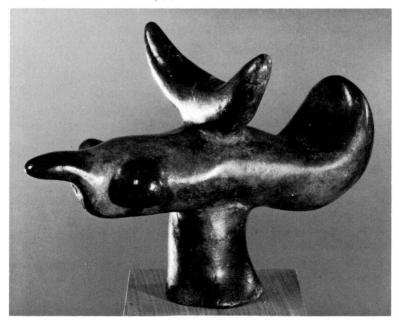

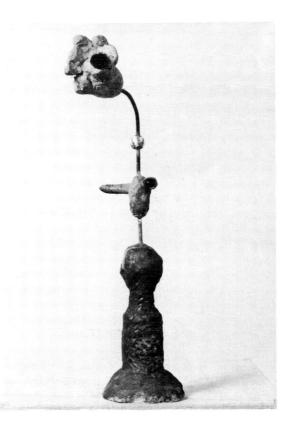

154 JOAN MIRÓ *Figurine* 1956

profoundly disturbing. The constructions were to become at a later date (from 1940 onwards) human figures, sometimes disposed as a group like figures in a street or a square, each intent on his own purpose and direction but constituting, in the totality of their movements, a spatial texture. Giacometti still called these human groups 'constructions' – 'I have never regarded my figures as a compact mass, but as transparent constructions' – and the persistent effect of surreality in his work is due to this fact. Attempts have been made to claim Giacometti for realism in art, or even for humanism, but the human body has for him only the significance of being the outward symbol of an intangible subjectivity. A mournful sense of inner emptiness, which cannot in any physical sense be 'filled', may perhaps be

159

redeemed by some solid symbol. But the symbol must not be too solid or precise, for the emptiness has no precise contours – hence plaster is his preferred medium. 'Pétrissant le plâtre, il crée le vide *à partir de plein*,' as Sartre has said.¹⁶ 'Kneading the plaster, out of fullness he creates emptiness.'

Giacometti takes us beyond the immediate subject of Surrealist sculpture, but that was always the ambiguity, and one might say the deeper significance of a movement that claimed the greatest possible spiritual liberty. No limits can be set to human imagination - that was the specific claim of Breton's Manifesto (1924); but if there are no limits, there are no confining rules, which fact always made it difficult to establish in any coherent sense a Surrealist movement. Strictly speaking, there was never more than one Surrealist, the one who wrote the manifestoes. Admiration and affection (or a natural desire to participate in such brilliantly organized publicity) brought many adherents to the various manifestations that took place between 1924 and 1936, but they were all paying tribute, perhaps first to the poet and animator of the movement, but more significantly to 'le seul mot de liberté'. Certainly one must interpret Giacometti's Surrealism in this sense.

The case of Max Ernst is a little different. As a sculptor, as we have seen, he began with Dada and his motives were as destructive as those of the rest of the group. But like Arp and Schwitters, he too was to be seduced by beauty. 'The nightingale is a great artist.' In a letter to Carola Giedion-Welcker of 1935 Ernst relates:

Alberto Giacometti and I are afflicted with sculpturefever. We work on granite blocks, large and small, from the moraine of the Forno Glacier. Wonderfully polished by time, frost and weather, they are in themselves fantastically beautiful. . . . Why not, therefore, leave the spadework to the elements and confine ourselves to scratching on them the runes of our own mystery.¹⁷

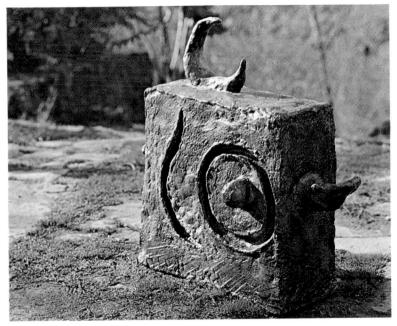

155 JOAN MIRÓ Head 1961

Some of the blocks thus scratched *in situ* at Maloja are now in private collections in New York and London. Similar stones were worked on when Ernst lived in Arizona (1946–9). In 1938 he occupied a house at Saint-Martin d'Ardèche, about fifty kilometres north of Avignon, and while there covered the walls with gigantic sculptural reliefs. But the more characteristic sculpture of Max Ernst, original in form and fantastic in conception, belongs for the most part to the summer of 1944, when he had a house at Great River, Long Island.

This series of modelled compositions (subsequently cast in bronze) shows Ernst's mastery of a technique he has only sporadically practised, and without any loss carries over into sculpture the wit and fantasy of his paintings. There are exceptional pieces like *The Table is Set* (1944) which seem to have some spatial significance reminiscent of Giacometti's wooden *Model for a Square* (1930–1), but most of them are figurative in intention, it being understood that the figures are not of this world. Their features (An Anxious Friend and

144 Moon Mad, 1944) are a throwback to the bronze Lady Bird of 1934-5, but the most successful piece is The King playing 145 with the Queen (1944), which has a purely adventitious

172

resemblance to Henry Moore's *King and Queen* of 1952-3. Max Ernst's sculptures remain in the realm of the 'elemental Dionysus': their spirit is uncanny rather than in any sense spiritual. The 'other' world into which they plunge us is not super-real, but infra-real, Plutonic rather than Olympian.

Other artists associated with the Surrealist movement made a decisive contribution to the development of modern sculpture, but it was mostly outside the period of the group's coherent activity. Joan Miró, for example, made a series of 'constructions' in 1929, but these are reliefs and more allied to painting than to sculpture. More recently he has experimented in ceramics, and some of his clay figurines

- have been cast in bronze (e.g. the *Bird* of 1944–6, the *Woman* of 1950 and the *Figurines* of 1956). Alexander Calder is often
- of 1950 and the *Figurines* of 1956). Alexander Calder is often
 claimed as a Surrealist sculptor, but his characteristic mobiles,
 - although they belong to the realm of fantasy, do not conform to Breton's definition of Surrealism as 'pure psychic automatism'. Rather they belong to the realm of play; they are products of that 'play instinct' which Schiller identified with the essential freedom, and essential humanity, of the work of art.

Impossible to separate from the typical manifestations of Surrealism are the works of the two dominating artists of our period – Picasso and Henry Moore. But it has never been possible to confine Picasso and Moore within the limits of a particular group or movement: their geniuses are universal and the manifestations of that genius in each case multifarious. Indeed, to approach an understanding of their great contribution to the art of sculpture we must consider them under a new rubric, that of *vitalism*.

The Vital Image

I have already (Chapter Three, page 77) referred to that development of modern sculpture which is best designated by the word *vitalism*. Like most new developments in modern art it was first inspired by Picasso, but this particular phase of sculpture has been dominated by the genius of Henry Moore, and an often-quoted statement of his justifies the use of the word vitalism in this connection:

Vitality and power of expression. For me a work must first have a vitality of its own. I do not mean a reflection of the vitality of life, of movement, physical action, frisking, dancing figures and so on, but that a work can have in it a pent-up energy, an intense life of its own, independent of the object it may represent. When a work has this powerful vitality we do not connect the word Beauty with it.

Beauty, in the later Greek or Renaissance sense, is not the aim of my sculpture.

Between beauty of expression and power of expression there is a difference of function. The first aims at pleasing the senses, the second has a spiritual vitality which for me is more moving and goes deeper than the senses.

Because a work does not aim at reproducing natural appearances it is not, therefore, an escape from life – but may be a penetration into reality . . . an expression of the significance of life, a stimulation to greater effort in living.¹

This statement was contributed to a volume of manifestoes by British painters, sculptors and architects which I edited in 1934. Moore was already thirty-six years old, but his

156 HENRY MOORE Internal and External Forms 1953-4

157 HENRY MOORE Standing Figure (Knife-Edge) 1961

158 JACOB EPSTEIN Rock Drill 1913

159 JACOB EPSTEIN Jacob and the Angel 1940

development had been forcibly delayed by the First World War and he had devoted only about ten continuous years to his craft, and these much interrupted by the necessity of teaching. The force and coherence of his ideal is already quite astonishing.

In the first stages of his development there are traces of the influence of Jacob Epstein, at that time a dominating and controversial figure in English art. Moore has also acknowledged his early debt to Anglo-Saxon sculpture, and as in the lives of most artists there is a preliminary phase of assimilation and rejection of prevailing styles. But influences are not always direct or precise, and a painter may be influenced by sculpture or a sculptor by painting. It is perhaps not necessary to observe further that art is a highly

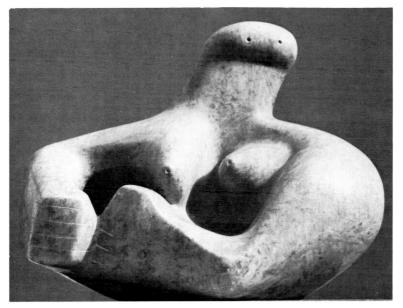

160 HENRY MOORE Composition 1931

contagious 'disease' – that the eye of the artist feeds unconsciously on whatever formal motes come its way. To strive to be uninfluenced by the work of one's predecessors or contemporaries is neither possible nor desirable, all questions of traditionalism apart. Artists confront their destiny – the general history of the civilization of which they

161 HENRY MOORE Reclining Mother and Child 1960 1

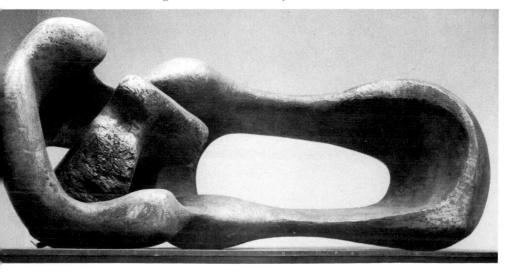

162 PABLO PICASSO Bathing Woman. Design for a Monument (Drawing) 1927

are a part – with a certain unity. They react to this common destiny with a certain uniformity – we do not need a theory of dialectical materialism to explain such an obvious fact. But within this general historical process there are complex variations that arise fundamentally from differences in individual psychology, from difficulties of communication, from physical variations of all kinds. To distinguish between general influences and personal indebtedness in any particular case is almost impossible. Some attempt must, however, be made to assess Moore's debt to Picasso.

Before 1927 the few pieces of sculpture made by Picasso 54 (such as the *Head of a Woman* of 1909–10) might be described as 'translations' – a motif from a painting is detached

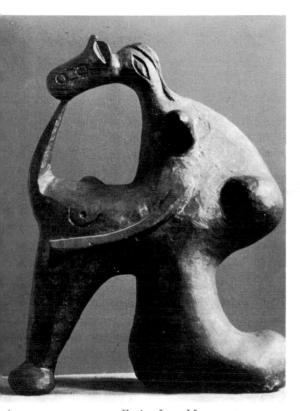

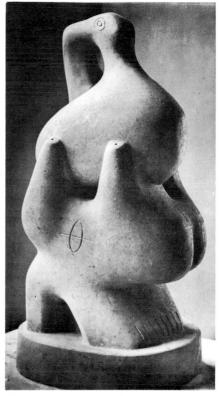

63 PABLO PICASSO Design for a Monument 1929 164 HENRY MOORE Composition 1931

165 HENRY MOORE Reclining Figure 1945-6

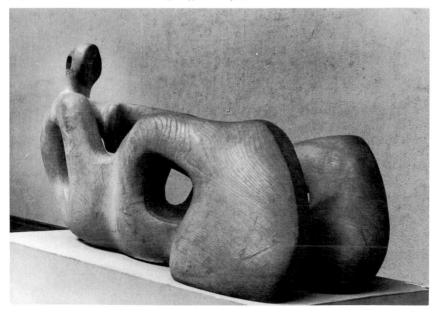

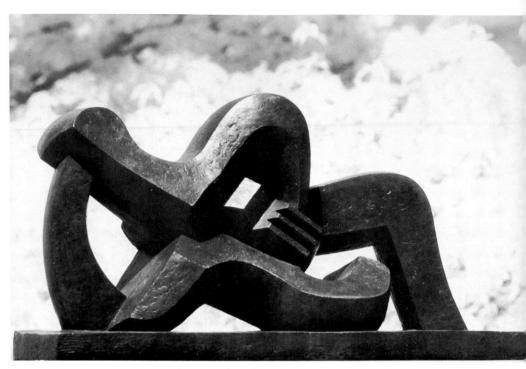

166 JACQUES LIPCHITZ Reclining Nude with Guitar 1928

and given independent, solid existence. It may have sculptural qualities, but the original image was pictorial. In 1927 Picasso began to conceive independent sculptural images, at first on canvas or as drawings, and then as threedimensional forms. The distinction is perhaps subtle, but it is significant. Even in the preliminary drawings Picasso was.

162 163

so to speak, feeling round the object depicted. The *Design* for a Monument which he modelled at Dinard on 28 July 1928 is a decisive innovation in the history of modern sculpture, though it is possible, as Alfred Barr notes, that it was influenced by the early paintings of Tanguy and the metamorphic figure paintings of his friend Miró.²

As I have already noted, Picasso began to concentrate on sculpture in 1931, in the newly acquired Château de Boisgeloup. A photograph by A. E. Gallatin, taken in

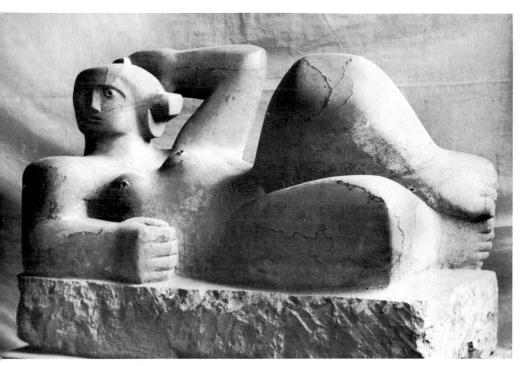

67 HENRY MOORE Reclining Figure 1929

1933, shows a studio full of plaster models, most of which were subsequently cast in bronze. They vary from the head of a woman of almost classical sweetness and serenity to serpentine contortions of the same head, and figures of animals (a *Cock* and a *Heifer*) which are distorted only to the degree necessary to give expressive emphasis.

There are a few figures by Henry Moore which may, perhaps, be directly related to Picasso's *Design for a Monument* – for example, the *Composition* in blue Hornton stone of 1931. But in general Moore's development, though related by a common purpose, was independent of Picasso's. Precisely the year of the *Design for a Monument* (1928) was the year in which Moore was overwhelmed by the Mexican sculpture in the British Museum, and this source of inspiration, with minor contributions from African sculpture,

168 HENRY MOORE Time-Life Screen 1952

169 HENRY MOORE Helmet Head, no. 2 1950 Romanesque sculpture, Brancusi and Archipenko, was decisive. Picasso may have continued to influence Moore, by his paintings rather than his sculpture, but from 1929 (the date of the first *Reclining Figure* now in the Leeds City Art Gallery) Moore was strong enough to pursue his own course, the course described in his Statement of 1934.

We should perhaps look at Moore's development from two aspects – the technical and the stylistic. Moore began with a strong preference for direct carving – practically all his work, with the exception of a few terracottas, up to the outbreak of the Second World War in 1939, is sculpture in stone or wood; there are a few pieces in carved cast concrete. Even between 1939 and 1945 there is a predominance of carved objects, but the 'sketch-models', usually in terracotta, increase, as if the sculptor wished to record his ideas in this

170 HENRY MOORE Bird Basket 1939

167

171 HENRY MOORE Glenkiln Cross 1955-6

172 HENRY MOORE King and Queen 1952-3

emergency medium for later use when solid materials became available for large-scale versions of the same subjects.

From 1945 onwards the bronzes predominate, though from time to time it seems as if the sculptor must test his sense of form in direct carving. For example, the important *Internal and External Forms* first appears as a bronze maquette, 7 inches high (1951); then in the same year as *Working Model* for *Internal and External Forms*, $24\frac{1}{2}$ inches high; next as a plaster model of the full-scale conception, 79 inches high. The final stage is the immense version carved in elm wood, 103 inches high (now in the Albright-Knox Art Gallery, Buffalo, USA). The screen for the Time-Life Building in

London (1952) went through a similar process of transmutation – first four experimental maquettes in plaster, then a working model cast in bronze, and finally the screen itself, carved in Portland stone. But increasingly bronze was envisaged as the final material, and the maquettes were modified accordingly.

These technical developments, in such a scrupulous artist, imply certain stylistic modifications, but between the first characteristic reclining figures of 1929-30 and the latest reclining figures of 1961-3 it is surprising how little the forms have changed. Even discounting the persistence of the same motif, such as the reclining figure, the only decisive difference is one of surface rather than of mass, of accent rather than of rhythm. What this means is that the specific sculptural values - those of volume and surfacetension - persist right through the artist's development, and what changes (if anything changes) are merely the wrinkles on the skin that covers the firm bone and flesh. Compare, for example, the Composition in Cumberland alabaster of 1931 with the bronze Reclining Mother and Child of 1960-1; or even the 1929-30 reclining figures with the monumental three-piece figures of 1961-3. The more they differ, in material, scale and method of execution, the

differ, in material, scale and method of execution, the more they are the same thing, the same conformation or *Gestalt*.

Nevertheless, there is a development over the thirty years of this artist's mature creative period, and it might be called a development in archetypal consciousness. Ignoring certain brief deviations, such as the stringed figures of 1937–40 (which nevertheless can be assimilated to the more naturalistic motifs), there persists right through this artist's career a deepening sense of the numinous – of the *mana*, or animistic vitality, informing all natural forms – not only those of organic beings, more particularly human beings, but all inorganic things in so far as a structure has been given to these by growth (e.g. crystals) or by natural forces (e.g.

168

160

161

167

173

170

173 HENRY MOORE Three-piece Reclining Figure 1961-2

the erosion of rocks by wind or waves). This sense of the numinous may be an illusion, as the more materialistic type of psychologist would maintain, or it may depend on inherited reactions to our physical environment – there are many hypotheses to account for it. In any case, the artist is nearly always a man who is acutely aware of what Baudelaire called 'correspondences' – that is to say, real but irrational associations between disparate objects. To the poet these correspondences may be of colour, sound or rhythm, but to the sculptor they are always of *shape*. Moore himself has said: 'There are universal shapes to which everyone is subconsciously conditioned and to which they can respond *if their conscious control does not shut them off*' (that conditional clause is important). Further:

174 HENRY MOORE Sculpture (Locking Piece) 1962

Although it is the human figure which interests me most deeply, I have always paid great attention to natural forms, such as bones, shells, and pebbles, etc. Sometimes for several years running I have been to the same part of the sea-shore – but each year a new shape of pebble has caught my eye, which the year before, though it was there in hundreds, I never saw. Out of the millions of pebbles passed in walking along the shore, I choose out to see with excitement only those which fit in with *my existing form-interest* at the time. A different thing happens if I sit down and examine a handful one by one. I may then extend *my form-experience* more, by giving my mind *time to become conditioned to a new shape*.³

175 PETER VOULKOS Terracotta Sculpture

176 GEOFFREY CLARKE Battersea Group 1962

177 OSCAR JESPERS Torso C. 1921

178 EUGÈNE DODEIGNE Torso in Soignies stone 1961

The phrases which I have italicized indicate that in Henry Moore's experience there exists a buried treasury of universal shapes which are humanly significant, and that the artist may recognize such shapes in natural objects and base his work as a sculptor on the forms they suggest. He may become obsessed with one such significant form, but by accident rather than design he will become conscious of others, and select these for development in their turn.

Such, at any rate, has been the practice of this artist, and by his example he has initiated a world-wide development in

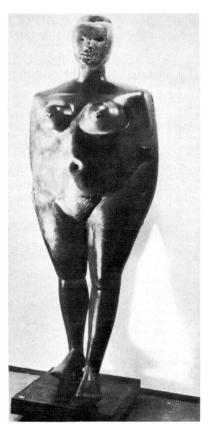

179 JOACHIM BERTHOLD Stooping Man 1960

180 JEAN-ROBERT IPOUSTEGUY La Terre 1962

the art of sculpture – an alternative principle of creation. That it is not entirely a new discovery we have already seen – it was the principle that animated Early Greek, Etruscan, Ancient Mexican, Mesopotamian, Fourth and Twelfth Dynasty Egyptian, Romanesque and Early Gothic sculpture and not least the sculpture of the primitive tribes of Africa and Polynesia. Obviously it has inspired many diverse kinds of sculpture, but in all these periods we find that the classical ideal of beauty is not the aim of the artist, but this alternative ideal of vitality, of integrated form and feeling. But there is just one qualification to make to this general theory of vital form and we find Moore himself making it, with particular reference to the example of Brancusi. A form can be vital without thereby becoming a work of art – every animal or human being, every tree and flower, is vital, but the work of art is in some sense a concentration of this vital force. It is precisely this distinction which has made the work of Brancusi so important for the development of modern sculpture.

A sensitive observer of sculpture, [Moore said in the broadcast just quoted] must also learn to feel shape simply as shape, not as description or reminiscence. . . . Since the Gothic, European sculpture had become overgrown with moss, weeds – all sorts of surface excrescences which completely concealed shape. It has been Brancusi's special mission to get rid of this overgrowth, and to make us once more shape-conscious. To do this he had to concentrate on very simple direct shapes, to keep his sculpture, as it were, one-cylindered, to refine and polish a single shape to a degree almost too precious. Brancusi's

181 SALVATORE Corrida

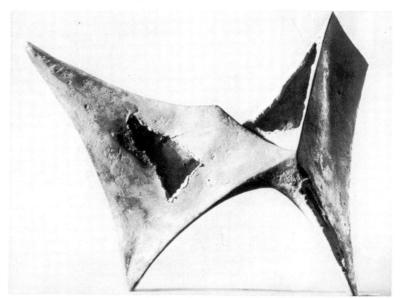

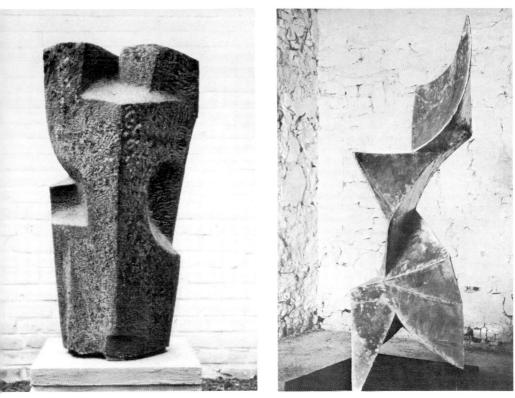

82 MORICE LIPSI Volvic Stone 1958

183 COSTAS COULENTIANOS Le Mollard 1961

184 F. E. MCWILLIAM Puy de Dôme Figure 1962

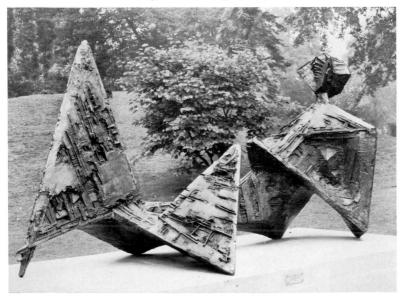

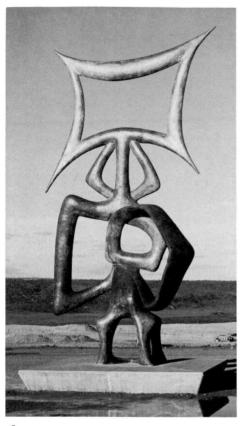

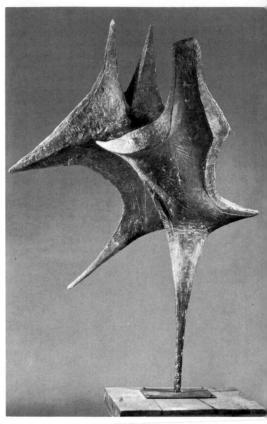

185 MARIA MARTINS R*ituel du Rythme* 1958

186 LUCIANO MINGUZZI The Shadows 1956-7

work, apart from its individual value, has been of historical importance in the development of contemporary sculpture. But [Moore concludes] it may now be no longer necessary to close down and restrict sculpture to the single (static) form unit. We can now begin to open out, to relate and combine together several forms of varied sizes, sections, and directions into one organic whole.⁴

This statement points clearly to the difference between Brancusi's and Moore's work – the one clings to what Wölfflin called 'closed form', the other proceeds to 'open form'. It would be too confusing to equate this difference with the difference that Wölfflin found between classical and

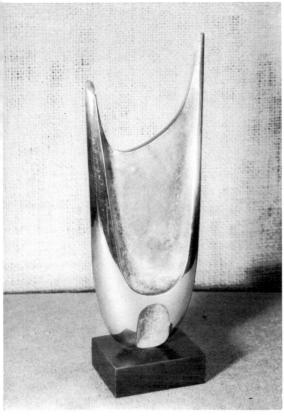

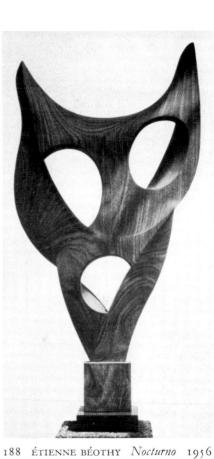

187 DENIS MITCHELL Gew Form 1960

189 ANDREA CASCELLA The White Bride 1962

190 WILLY ANTHOONS Infinite Form 1949–60

191 ALICIA PENALBA Forêt Noir, no. 2 1960

192 PIETRO CASCELLA Pygmalion 1963

193 LORENZO GUERRINI Mono macchina orizzontale 1963

Baroque in Renaissance art – Brancusi is not a classical artist. He merely represents, in the formal development of modern sculpture, the outwardly simple as opposed to the outwardly more complex organic form – the fish or bird as opposed to the woman or the tree. But this is not a sentimental preference – not even a formal preference. 'Simplicity is not a goal,' Brancusi said with his perfect understanding of his art, 'but one arrives at simplicity in spite of oneself, as one approaches the real meaning of things' – one might say, as one approaches the numinous quality of things. Brancusi claimed that the art of wood-carving had been preserved only by Rumanian peasants (of whom he was one) and those African tribes which had escaped the influence of

194 HANS SCHLEEH Abstract Form in Serpentine

195 ALBERTO VIANI Torso 1956-62

196 HELEN PHILLIPS Moon 1960

Mediterranean civilization, 'thereby retaining the art of reanimating matter'.⁵

This animistic character of his work does not mean that Brancusi was any less conscious of the formal necessities of his art – on the contrary, he would have said that the form must be perfect to be worthy of the spirit. Ionel Jianou in his recent book on the sculptor suggests that Brancusi built his works the way a peasant builds his wooden house:

He was concerned with the firmness and balance of volumes, with proportions, strength and structure. Most of his sculptures were projects, meant to be enlarged and erected like buildings in the open.

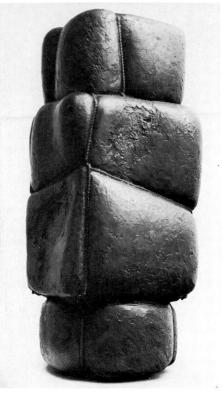

- 197 JAMES ROSATI *Delphi IV* 1961
- 199 ÉMILE GILIOLI *La Chimère* 1956

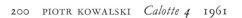

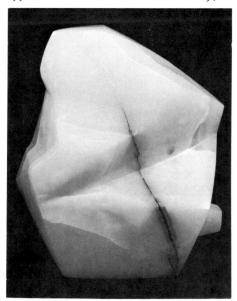

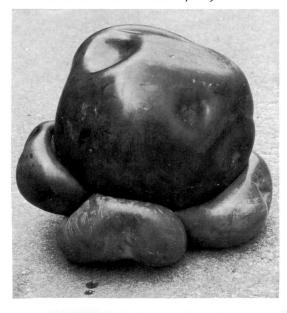

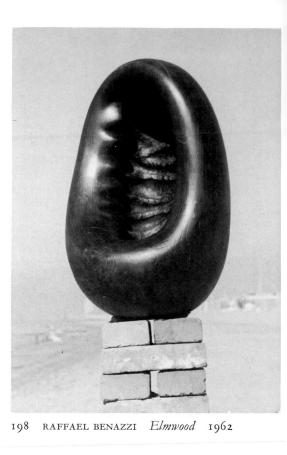

01 OLGA JANĆIĆ Doubled Form 1962

The problem was no longer that of integrating sculpture into architecture, as in the great synthesis of antiquity and the middle ages. On the contrary, Brancusi felt that a work of architecture should become a kind of inhabited sculpture.⁶

It was through Brancusi that a further characteristic of modern sculpture was established – respect for the nature of materials. It has more than once been observed that there is a decisive formal difference between Brancusi's sculptures in stone or metal and those in wood. Jianou suggests that

the choice of a medium was determined by the content. Marble lends itself to the contemplation of the origins of life, while wood lends itself more easily to the tumultuous expression of life's contradictions. Brancusi's intimate knowledge of the laws and structures of his materials enabled him to achieve perfect harmony between form and content.⁷

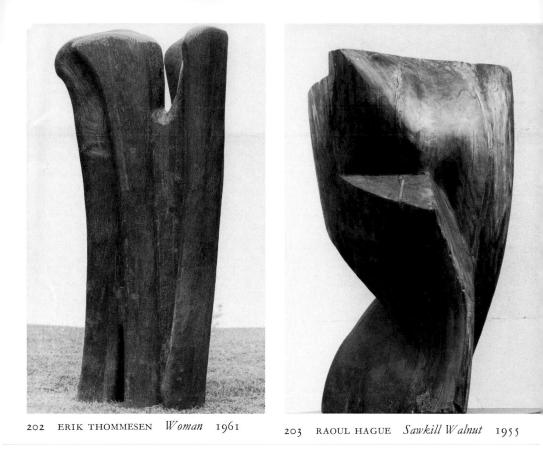

Brancusi himself said that 'it is while carving stone that you discover the spirit of your material and the properties peculiar to it. Your hand thinks and follows the thoughts of the material.'

This mystique of material, and of the correspondence of form and content, has had a widespread influence on the development of modern sculpture, and though it is not possible to trace the influence in every case directly to Brancusi (Arp, for example, though representing so many of the same virtues, probably had a quite independent development), nevertheless that influence has been decisive, and is often acknowledged. Barbara Hepworth, for example,

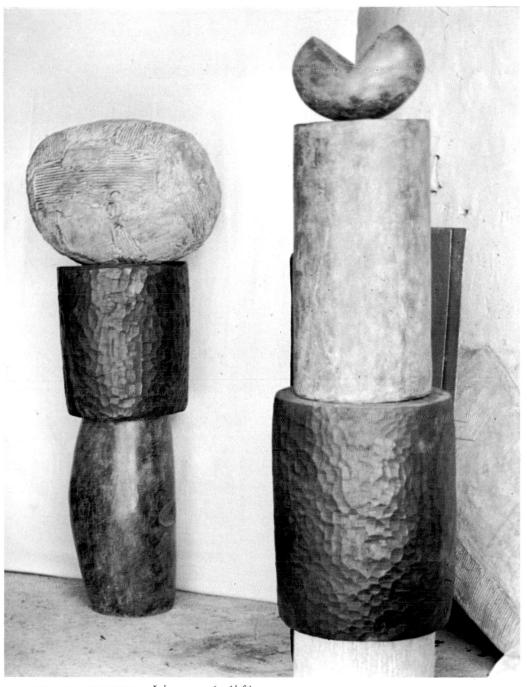

204 WILLIAM TURNBULL Llama 1961 (left)
205 WILLIAM TURNBULL Oedipus 1962 (right)

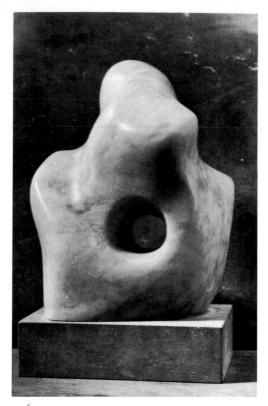

206 BARBARA HEPWORTH Pierced Form 1931

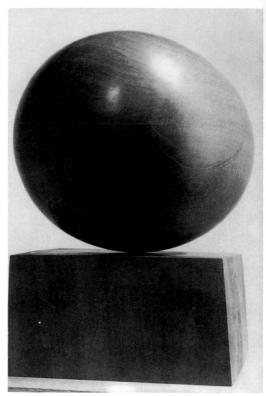

207 BARBARA HEPWORTH Single Form 1935

whose work has been inspired by the same ideal of 'the thinking hand discovering the thoughts of the material', has paid a very eloquent tribute to Brancusi; it must be quoted, if only because it reveals history at the moment of its making:

In 1932, Ben Nicholson and I visited the Rumanian sculptor Constantin Brancusi in his Paris studio. I took with me to show to Brancusi (and Arp, and Picasso the next day) photographs of my sculptures including ones of

206

the *Pierced Form* in alabaster 1931, and *Profile* 1932. In both these carvings I had been seeking a free assembly of

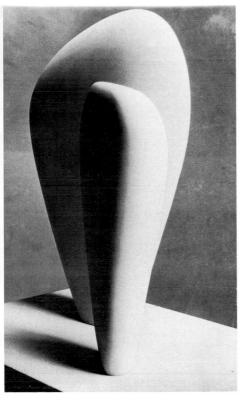

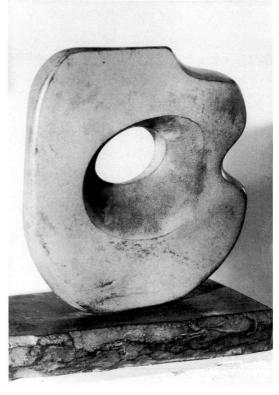

208 BARBARA HEPWORTH Two Forms 1937

209 BARBARA HEPWORTH Pierced Form (amulet) 1962

certain formal elements including space and calligraphy as well as weight and texture, and in *Pierced Form* I had felt the most intense pleasure in piercing the stone in order to make an abstract form and space; quite a different sensation from that of doing it for the purpose of realism. I was, therefore, looking for some sort of ratification of an idea which had germinated during the last two years and which has been the basis of my work ever since.

In Brancusi's studio I encountered the miraculous feeling of eternity mixed with beloved stone and stone dust. It is not easy to describe a vivid experience of this

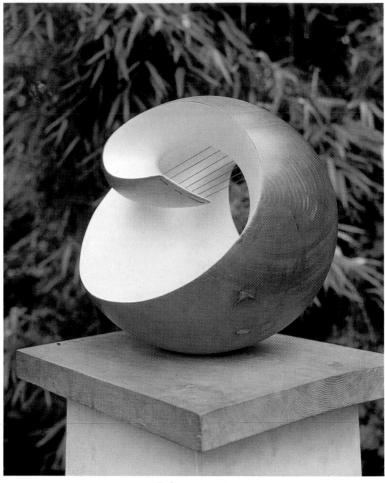

210 BARBARA HEPWORTH Pelagos 1946

order in a few words – the simplicity and dignity of the artist; the inspiration of the dedicated workshop with great millstones used as bases for classical forms; inches of accumulated dust and chips on the floor; the whole great studio filled with soaring forms and still, quiet forms, all in a state of perfection in purpose and loving execution, whether they were in marble, brass or wood – all this filled me with a sense of humility hitherto unknown to me.

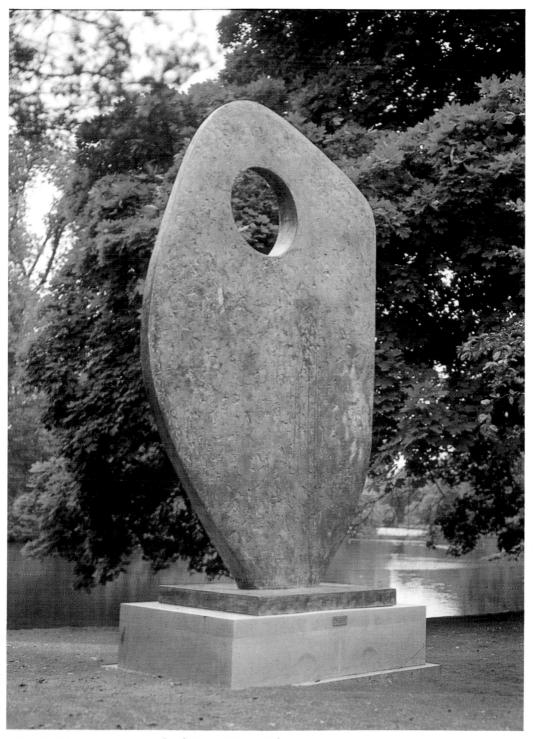

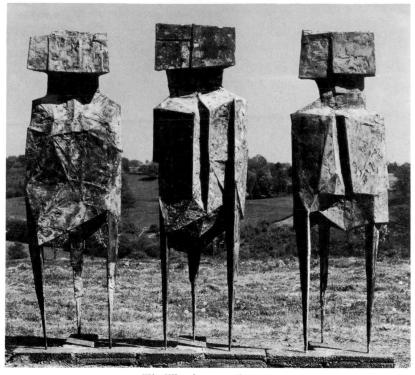

212 LYNN CHADWICK The Watchers 1960

213 LYNN CHADWICK Winged Figures 1962

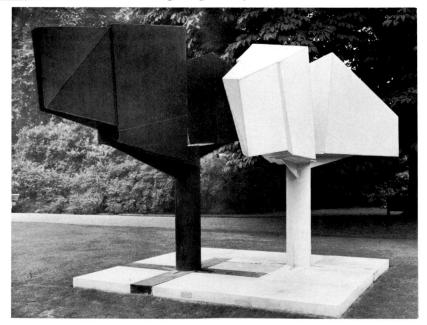

214 SEYMOUR LIPTON Mandrake 1959

I felt the power of Brancusi's integrated personality and clear approach to his material very strongly. Everything I saw in the studio-workshop itself demonstrated this equilibrium between the works in progress and the finished sculptures round the walls, and also the humanism, which seemed intrinsic in all the forms. The quiet, earthbound shapes of human heads or elliptical fish, soaring forms of birds, or the great eternal columns in wood, emphasized this complete unity of form and material. To me, bred in a more northern climate, where the approach to sculpture has appeared fettered by the gravity of monuments to the dead – it was a special revelation to see this work which belonged to the living joy of spontaneous, active, and elemental forms of sculpture.⁸

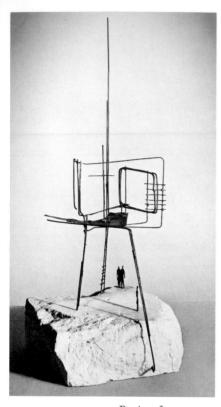

215 REG BUTLER Project for Monument to the Unknown Political Prisoner 1951–2

217 DAVID SMITH Royal Bird 1948

218 DAVID SMITH *Cubi IX* 1961

219 FRITZ WOTRUBA Figure with raised arms 1956–7

220 FRANÇOIS STAHLY Model for a Fountain

221 JOANNIS AVRAMIDIS Large Figure 1958

Barbara Hepworth's work has been a rich development of the inspiration she received on the occasion of her visit to Brancusi. She lacks Brancusi's heritage of folklore myths, from which he always drew his inspiration – instead she has gone directly to nature, to crystals and shells, to rocks and the form-weaving sea. Like Moore, and indeed Brancusi also, she has kept the human figure as a *point de repère*, an ideal form to which all forms must be assimilated, for our better instinctive comprehension. But the forms and rhythms in her most characteristic work are emancipated from even this restraint, and conform to Brancusi's definition: 'Beauty is absolute equity.'

222 LOUISE BOURGEOIS Sleeping Figure 1950-9

223 PETER STARTUP Falling Figure 1960

224 RUDOLF HOFLEHNER Doric Figure 1958

225 FRITZ WOTRUBA Reclining Figure 1960

226 MIRKO Composition with Chimera—1949

227 ÉTIENNE-MARTIN Lanleff, demeure no. 4 1962

Absolute equity is perhaps also an emancipation from the more irrational aspects of vitalism. One does not associate equity, or equilibrium or symmetry, with some of the more chthonic of Moore's figures - the Glenkiln Cross of 1955-6, 171 for example, or even the King and Queen of 1952-3. There is 172 an element in Moore's work, not present in Brancusi, Arp or Hepworth, which comes from a deeper level of the unconscious - the Shadow, as Jung called it, and this element is distinctive of the work of many other sculptors of the 139-42 vitalist tradition - of Alberto Giacometti, Germaine 146-8, 251 241, 186 Richier, Theodore Roszak, Luciano Minguzzi, Reg Butler, Lynn Chadwick - and the occasional sculpture of the 215-6, 212-3

28 ÉTIENNE-MARTIN Le grand Couple 1949 (right)

29 ÉTIENNE-MARTIN La Nuit 1951 (left)

230 ANDRÉ VOLTEN Architectonic Construction 1958

231 NICOLAS SCHÖFFER Spatiodynamique no. 19 1953

232 HANS AESCHBACHER *Figure XI* 1960

233 JACQUES SCHNIER Cubical Variations within rectangular Column 1961

painters Max Ernst and Joan Miró. All these artists are in search of effective images, images that mediate between the chaos of the unconscious and the 'absolute equity' or order which art imposes on this chaos, in so far as it is released in moments of 'inspiration'.

Brancusi is particularly fertile in images which seem to mediate between primeval forces and metaphysical order – his *Adam and Eve* is the best example, a columnar carving in which symbols of generation and fecundity are 'stylized' into precise geometric forms. Moore's *Glenkiln Cross* seems to have a similar significance, but the form remains irregular – even the 'cross' is blunted and humanized, and the pedestal

143-5, 152-5

234 GABRIEL KOHN Encliticus Urbanus · 1962

235 ROBERT ADAMS Maquette for architectural Screen 1956

236 HUBERT DALWOOD Una grande Liberta 1963

or shaft deformed. There seems to be little to choose between these two monuments, considered as 'effective images'. We must not confuse order with regularity or symmetry; there is an order that proceeds from the balance or significant arrangement of irregular elements. In general the modern preference, even in other arts like poetry and music is, for a principle of indeterminacy, for forms in dynamic rather than static relationship, for the fountain, as Arp said in one of his poems, that tells formal fables.

It is perhaps a vain effort to gather under the one rubric of vitalism so many of the disparate experiments of the modern sculptor. The case of Giacometti presents a typical

237 MARINO DI TEANA Espace et Masse libérés hommage à l'architecture 1957

238 CAREL VISSER Fugue 1957

239 BERNHARD LUGINBÜHL USRH (Space Clasp) 1962

dilemma for the historian. There is no artist of the present day so concerned for the formal fable - the mystery of the object's occupancy of space. I have already referred to the Surrealist phase of Giacometti's work, his 'transparent constructions' that create a profound sense of disguiet. Since then Giacometti has advanced very slowly into the mysterious realm of space. It may be that there are people for whom space is no mystery, but the great scientists like Einstein are not among them, and certainly not great artists like Giacometti. There is a sense in which the space between myself and another person in the room, or the tree on the horizon, is more mysterious than the person or the tree all vision is an uncertain mirage. 'The distance between one nostril and the other is like a Sahara, boundless and elusive.'9 Preoccupied as Giacometti has been with these subjective considerations, immaterial as are the figures modelled to give expression to an evanescent emotion, nevertheless the figures he has created are 'personnages' - they are not apparitions, but icons; objects that *materialize* the mirage, effective images of the numinous, of the threshold that divides the ego from reality.

To create an *icon*, a plastic symbol of the artist's inner sense of numinosity or mystery, or perhaps merely of the unknown dimensions of feeling and sensation, is the purpose of the great majority of modern sculptors – one thinks immediately of Germaine Richier and Étienne-Martin; of the British sculptors Armitage, Chadwick, Dalwood and Paolozzi; of the Italians Mirko and Minguzzi; of the Americans Theodore Roszak and David Smith; and of many others. Critically, of course, one would have many distinctions to make, and it might seem, for example, that now little in common is to be observed between the later humanistic sculpture of Reg Butler and the impersonal robots of Eduardo Paolozzi. But from a more general point of view a common aim would seem to emerge from their very different formal conceptions. Butler's comprehensive

251, 227-9 254-6, 212-13 236, 269-70

- 226, 186
- 241, 217-18

272-3

212

240 ANDRÉ BLOC Double interrogation 1958

241 THEODORE ROSZAK Night Flight 1958-62

242 FRITZ KOENIG Herd X 1958

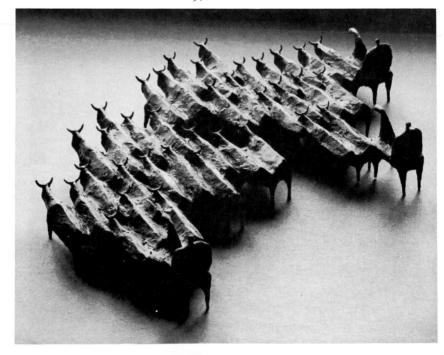

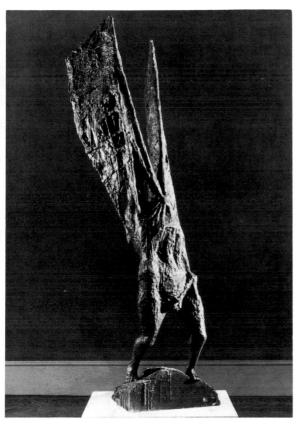

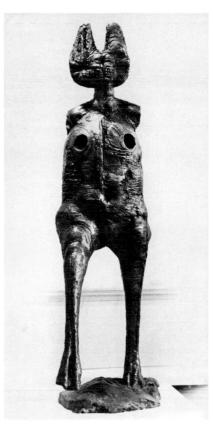

243 MICHAEL AYRTON Icarus III 1960

244 RALPH BROWN Stepping Woman 1962

definition of the aims of the student of art would serve as an equally comprehensive definition of the aims of the modern artist in general:

The anatomical organization not merely of human beings but of animals, plants, bacteria, crystals, rocks, machines and buildings. The simplicity and complexity of their forms, their articulation, the disposition of stresses and strains in living and non-living structures. Recognition of the qualities of things; their hardness and softness, heaviness and lightness, tautness and slackness, smoothness and roughness. Recognition of unities and similarities, rhythms and analogues, differences. The character of

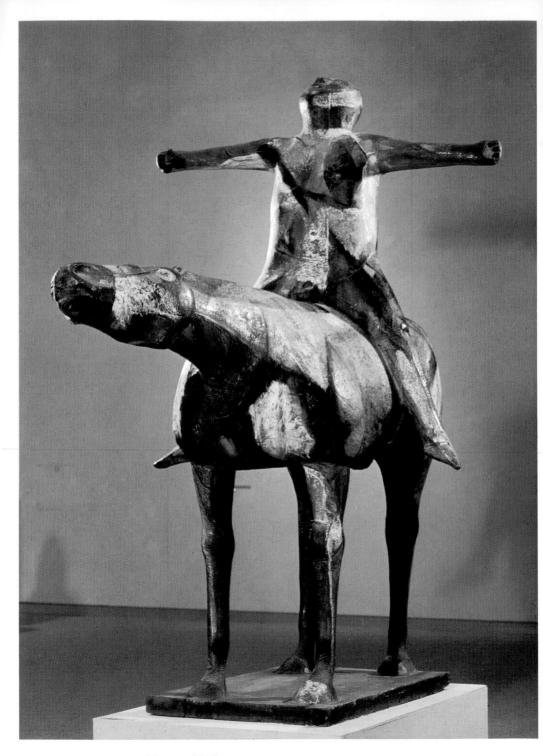

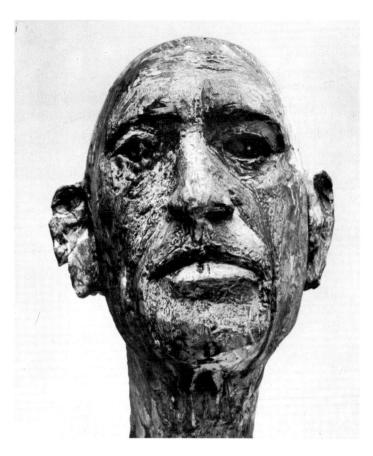

246 MARINO MARINI Portrait of Igor Stravinsky 1951

> space, the definition of space, the penetration of things into space. The nature of illumination, its determination of what we see (as opposed to what we know otherwise than by vision from a static point in space). The news value of colour. The way our reading of experience is controlled by the means by which we perceive.¹⁰

The last sentence in this list is perhaps the most important, for the quality of a work of art is always determined by a subtle interrelationship between purity of perception and the essence of things; that is to say, the 'essence', whether it is Brancusi's 'absolute equity' or Giacometti's 'liquid silver around me', or Paolozzi's 'rational order in the

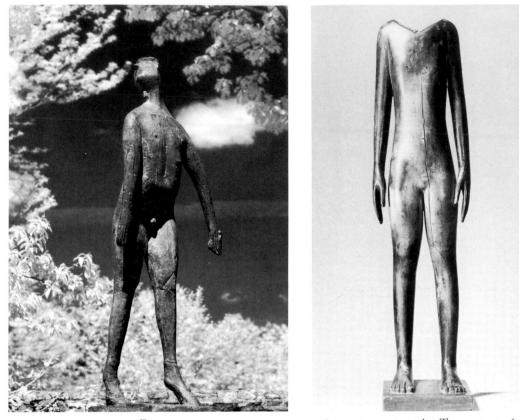

247 MARINO MARINI Dancer 1954

technological world' that is 'as fascinating as the fetishes of a Congo witch doctor', must be revealed by means which are strictly aesthetic. It is temptingly easy to interpret the many diverse phenomena of modern art as expressions of an 'Angst' or despair induced by the alienation prevailing in our technological civilization – a 'geometry of fear', as I once expressed it. In 1963 the city of Darmstadt organized an impressive exhibition entitled 'Zeugnisse der Angst in der moderner Kunst' – evidences of anxiety in modern art. It included, among the sculpture, the work of Giacomo Manzù, Marino Marini, Jacques Lipchitz, Max Ernst, Max Beckmann, Germaine Richier, Lynn Chadwick, Kenneth

²⁴⁸ EWALD MATARÉ Torso c. 1926

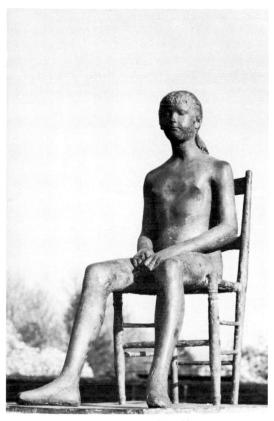

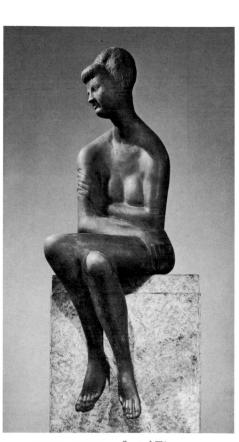

249 GIACOMO MANZU Girl in Chair 1955

250 EMILIO GRECO Seated Figure 1951

Armitage, Henry Moore, Reg Butler, Alberto Giacometti, Leonard Baskin, Theodore Roszak, Umberto Mastroianni and Agenore Fabbri – that is to say, the kind of sculpture I have been mainly concerned with in the present chapter. While one cannot question this general characteristic in the sculpture exhibited in Darmstadt, it is nevertheless based on 'a reading of experience' rather than on 'the means by which we perceive' – on the content rather than the form. There is no anxiety in the art of Brancusi, and anxiety is not an exclusive sentiment in the work of Moore, Hepworth or Butler, however much it may have been the settled mood of artists like Giacometti or Germaine Richier. Anxiety

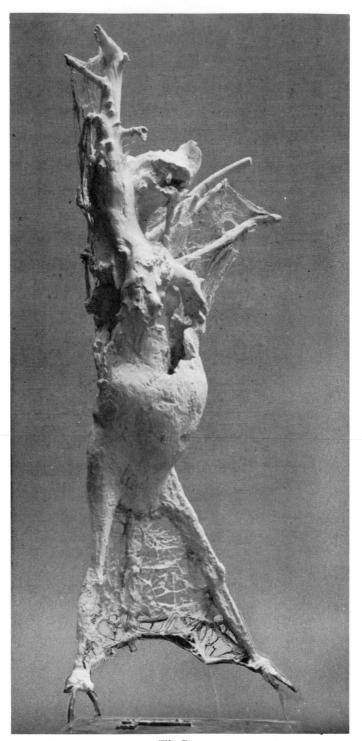

251 GERMAINE RICHIER The Bat 1952

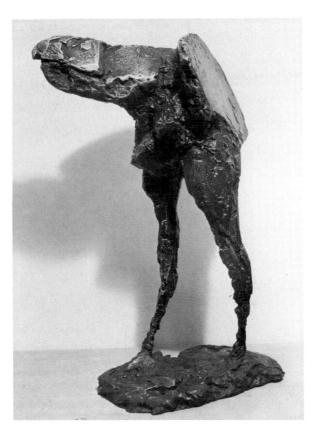

252 ELIZABETH FRINK I*larbinger Bird III* 1960

253 ROBERT CLATWORTHY Bull 1956-7

254 KENNETH ARMITAGE Walking Group 1951

(even as a pathological condition) is seldom unmixed with hope: the mind of man alternates between a sense of despair and a sense of glory. At the conclusion of an article which he contributed to the catalogue of the abovementioned Darmstadt Exhibition the German art critic,

255 KENNETH ARMITAGE Figure lying on its side (5th version) 1958-9

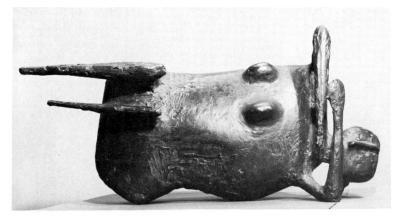

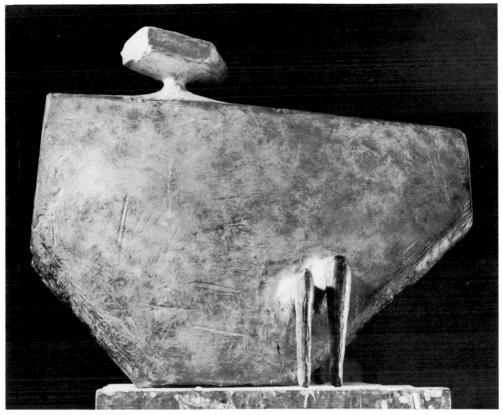

256 KENNETH ARMITAGE Slab Figure 1961

Werner Haftmann, made the following profound observation:

If I now once again look back over my whole presentation [of the exhibition], then it seems to me as if I must, as it were from behind, write everything again, and from a directly contrary point of view. For what I describe, that was just a partial aspect, not more than the reverse of a much more comprehensive whole. Anxiety – so we say – has as its opposite, 'the Utopian perspective'. But this bears the name of Hope. Under that sign everything would have to be written anew and seen anew. Such a task has not been assigned to me. The exhibition is

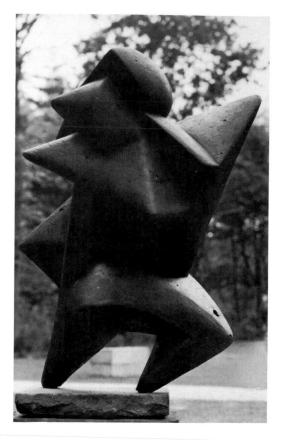

257 UMBERTO MASTROIANNI *Conquest* 1954

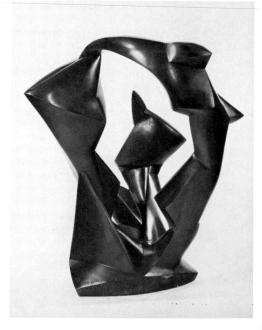

258 RUDOLF BELLING *Dreiklang* Model 1919, cast 1950

259 HANS P. FEDDERSEN Composition 1963

concerned with anxiety in our time. Its question is absolutely legitimate so long as we realize that it is only part of the question. This we know: that in any complete view of the question we must include the hopes as well as the anxieties of our time.¹¹

The artist unconsciously projects the anxieties of his age, but he would have no creative energy if he were completely filled with despair. Every artist acts on the assumption expressed by William Blake: *Energy is Eternal Delight*.

This chapter has been too discursive. I will conclude with a list of fifteen significant pieces of modern sculpture which,

260 BERNARD MEADOWS Large Flat Bird 1957

with the aid of the accompanying illustrations, will enable the reader to trace the chronological development of vitalism in modern sculpture.

4	I	1893–7	Rodin, Monument to Balzac.
3		1893	Medardo Rosso, Conversazione in Giardino.
			These two works, begun in the same year, are
			a first decisive departure from classical
			restraint in sculpture. The ideal is no longer
			'beauty' but 'vitality'.
54	II	1909–10	Picasso, Head of a Woman.
			A translation of the dynamics of Cubism into
			three-dimensional form.

261	RAOUL	UBAC	Relief

262 DUSAN DZAMONJA *Metal Sculpture, no. 3* 1959

III	1912	Umberto Boccioni, Development of a Bottle in	120
		Space.	
	1913	Ålexander Archipenko, Boxing Match.	124
		The object becomes an excuse for the re-	
		presentation of the concept of movement in	
		space.	
IV	1919	Brancusi, Bird in Space.	130
		Concept (flight) and vital form (bird)	
		perfectly fused.	
V	1928	Jacques Lipchitz, Reclining Nude with Guitar.	166
	1929	Henry Moore, Reclining Figure.	167
	/ /	The symbol is substituted for the concept:	
		archetypal form.	

227

58	VI	1930–1	Picasso, <i>Construction</i> (<i>Head</i>) (wrought iron). The first totem: the embodiment of vital forces in magical icons.
67	VII	1933	Alexander Calder, Mobile.
			Actual movement introduced into sculpture.
108	VIII	1937-8	Naum Gabo, Constructions in Space.
		■ 1 (5) (6)	Dematerialization of substance: space itself.
146	IX	1948–9	Alberto Giacometti, City Square.
			Evocation of the mystery of distances.
251	х	1952	Germaine Richier, The Bat, etc.
			Evocation of the sinister. Richier explored
			the processes of 'decomposition'.
171	XI	1955–6	Henry Moore, Glenkiln Cross.
			Moore's vitalism becomes identified with
			primeval or archetypal forces.
272	XII	1962	Eduardo Paolozzi, Hermaphroditic Idol.
			The totem, still vital, of mechanization.

For the sake of simplicity I have restricted this 'chart' to twelve stages of development, but it should be realized that the process was continuous, and that several other sculptors (Laurens, Pevsner, Miró, Butler, Marino Marini, Étienne-Martin, Chadwick, Armitage, Karl Hartung, François Stahly, and many others) have made decisive contributions to the vital image in modern sculpture.

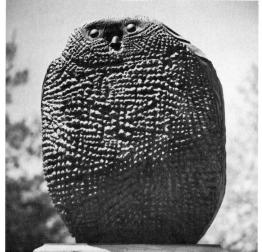

263 LEONARD BASKIN Owl 1960

A Diffusion of Styles

By comparison with the art of painting, the post-Second World War development of the art of sculpture shows a certain lack of cohesion or definition. In painting there has been an increasing emphasis on Abstract Expressionism and we have seen the emergence of a new school of 'action painting'. Action painting, though a distinct movement with a geographical location (the United States of America and more particularly the city of New York) is a 'logical' development of the Expressionist style, and what is distinctive about it (immersion in the medium, surrender to 'concrete pictorial sensations') is essentially painterly. The sculptor cannot paraphrase Pollock's well-known statement and say: 'When I am in my sculpture, I am not aware of what I'm doing.' The sculptor (despite some brave attempts by Étienne-Martin) must inevitably remain outside his sculpture, a conscious craftsman.

Nevertheless one can perhaps attempt some classification of all this post-war ferment in the art of sculpture, though admittedly, as I said in *A Concise History of Modern Painting*, this is a critical rather than an historical task. We are confronted by a diffusion of styles, the exploitation of inventions, the ceaseless experimentation with new materials, and not by the deployment of any coherent 'movements'. Styles or schools exist – or have existed: Impressionism, Post-Impressionism, Cubism, Constructivism, Surrealism, Expressionism, Abstract Expressionism; and the individual artist, according to his temperament, 'belongs' to one or another of them, much in the same manner as an individual Christian belongs to one of the Christian sects.

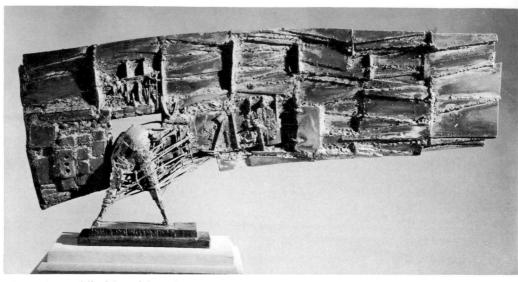

264 CÉSAR The Man of Saint-Denis 1958

What is distinctive about the post-war situation, particularly in sculpture, is a determination to belong to no movement, an artistic 'free thinking'. This attitude has perhaps always been characteristic of the great masters in any period. In our own time Picasso has been the springboard of several new movements but has consistently refused to be identified with any one of them. The sculpture of Henry Moore can be claimed, with good reasons, for Surrealism, but Moore himself does not subscribe to this or any other movement. But this does not mean that the artist, however great and independent, can dispense with his springboard. The situation has been described with his usual acumen by Harold Rosenberg:

In our era, it is the art movements that make possible continuity of style, that stimulate interchanges of ideas and perceptions among artists, that provide new points of departure for individual inventions. The criss-cross of the art movements through time and place binds modern art into a whole that provides the intellectual and imaginative background for individual paintings.¹ For individual sculptures, too, and it may be, as Rosenberg goes on to claim, that the present reaction against any collective manifestation is 'stiffened by the individualism that has become the militant creed of the post-war West. That the artist is capable of creating a thing that is entirely his own is, we are often told, the essential meaning of art in an age of mass production and conformism.'

Nevertheless – and this is the conclusion Mr Rosenberg comes to – movements redeem the individual artist and give a communal significance to his work. They do this, paradoxically, by intensifying the individualism of the genuine artist.

In the shared current, individuality, no longer sought for itself, is heightened. . . . Far from constricting the artist's imagination, the movement magnetizes under the motions of his hand insights and feelings from outside the self and perhaps beyond the consciousness. The living movement is a common direction of energies rather than a set of concepts, and any definition of it will apply to individual artists in it only to a limited degree – to the best artists least of all.

265 JULIUS SCHMIDT Cast Iron 1961

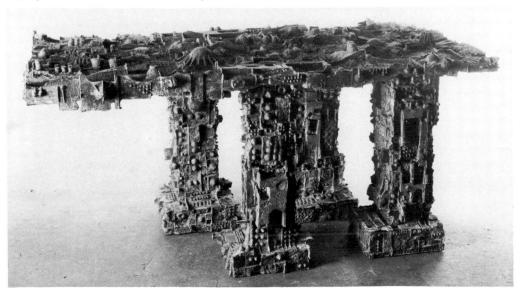

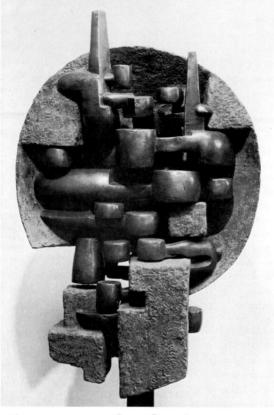

266 JAMES WINES Corona I 1962

It may be that the many movements in modern art will, to the historian a century hence, fuse into one movement -amovement like or allied to mannerism and romanticism. But a movement, if it is strong enough, always provokes a counter-movement, usually at an interval of time. I believe that the complexity of the modern scene is partly due to the co-existence of such movements and counter-movements, that the romanticism of a Picasso (not to complicate matters by considering the classicism of a Picasso) is matched in our time by the classicism of a Gabo, etc. Characteristic of our time, too, is a phenomenon which we might call sentimental

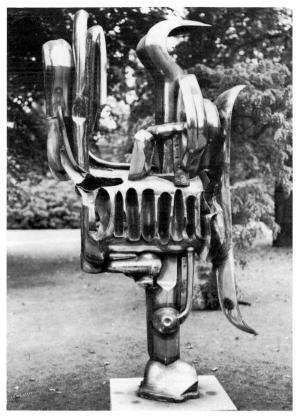

267 JASON SELEY Magister Ludi 1962

revivalism: the Dada movement of 1916–18 becomes the neo-dadaism of the present day, the only difference being that what was born in stress and motivated by revolutionary zeal is revived by choice and motivated by nostalgia. All the original movements of the modern period have either continued unbroken for half a century or have gone underground for a few years (i.e. lost their immediate appeal) to reappear stylistically identical but emotionally impoverished twenty or thirty years later.

In such circumstances it would serve no purpose to describe such revivals – it is better to refer work now produced to its stylistic origins, to relate a Rauschenberg

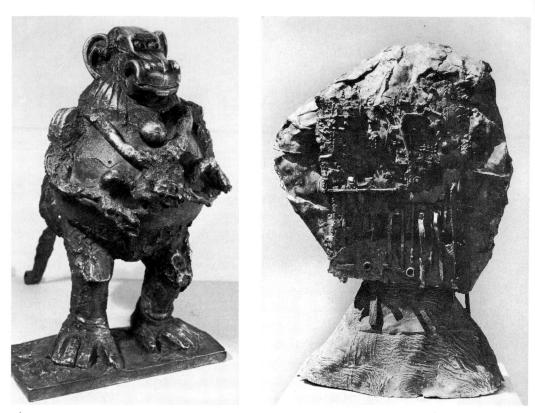

268 PABLO PICASSO Baboon and Young 1951

269 EDUARDO PAOLOZZI Head 1957

or a Westermann to a Schwitters or a Picabia. Among the hundreds of sculptors who have emerged since 1945, it seems to me that there is only one who might claim to have invented a new *style* – Eduardo Paolozzi. This is not to discount the originality of sculptors like César, Robert Müller, Fritz Wotruba, Germaine Richier, Theodore Roszak, Berto Lardera, Richard Lippold and many others; but it is possible to make original contributions to an existing movement, which I think all these sculptors do, without inventing a new idiom, which is what Paolozzi has done in his most recent 'engineered' constructions (*The City* of the Circle and the Square, 1963; Wittgenstein at Cassino, 1963;

273

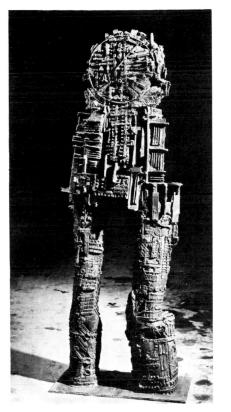

270 EDUARDO PAOLOZZI Japanese War God 1958

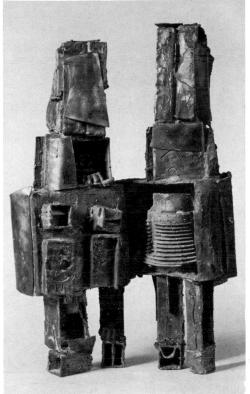

271 EVA RENÉE NELE The Couple 1961

The World divides into Facts, 1963; etc.). Until this recent development, which begins in 1961, it was still possible to relate Paolozzi's work to the work of Richier or César, and ultimately to Picasso's (*Baboon and Young*, 1951). But his 268 new images, functionless machine-tools or sterile computers, derive not, like his previous work, from the débris of industrialism, but from the rational order of technology. I have already quoted his statement that idols representing such an order 'can be as fascinating as the fetishes of a Congo witch doctor', but a mechanical fetish does not have the same function as a tribal fetish – or rather, it 'functions' in a totally different kind of society, a society whose mental

272 EDUARDO PAOLOZZI Hermaphroditic Idol, no. 1 1962

processes aspire to logical consistency. By naming some of these constructions 'idols', Paolozzi gives further encouragement to an animistic interpretation of his work; but what is consistent is the realized or incorporate contradiction: as if the mechanical computer had finally achieved a soul, and with that apotheosis ceased to function as a machine.

273 EDUARDO PAOLOZZI The City of the Circle and the Square 1963

Since the present sculptural activity throughout the Western world is not dominated by any unitary style, the historian can attempt only a descriptive classification. He then becomes aware of one astonishing development: the prevalence of metalwork. It would seem, judging from the works exhibited in commercial galleries, that almost four-fifths of

274 JOSÉ DE RIVERA *Construction, no. 35* 1956

275 ROBERT MÜLLER Archangel 1963

276 DAVID GOULD Welded Iron c. 1962

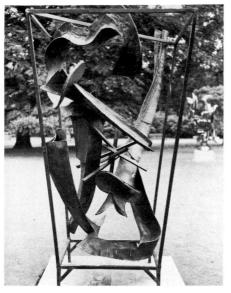

277 HERBERT FERBER Homage to Piranesi 1962–3

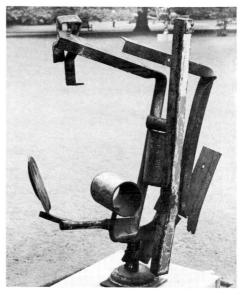

278 RICHARD STANKIEWICZ Untitled 1961

all contemporary sculpture is made of metal of some kind. It is possible to speak of a 'New Iron Age'.

Some of the reasons for this development have already been mentioned – the fact, above all, that we live in a civilization that is largely dependent on metallurgy for its machinery of production and distribution. It is true that latterly industry's dependence on natural metals has been challenged by the invention of various synthetic materials, a develop-

279 ANTHONY CARO Lock 1962

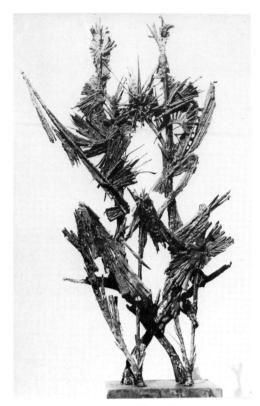

280 BRUNO GIORGI Two Amazons 1963

281 IBRAM LASSAW Counterpoint Castle 1957

ment which artists have also noticed and exploited; but metals such as bronze, steel, iron and aluminium remain the characteristic materials of our civilization and have decisive virtues for sculpture – they can be cut, welded, moulded, cast, polished or patinated, and the final result has a durability that exceeds all but the hardest stones.

282 HAROLD COUSINS Gothic Landscape 1962

283 GEORGE RICKEY Summer III 1962–3

284 BRIGITTE MEIER-DENNINGHOFF Gust of Wind 1960

Discounting the ideological motives that might lead the sculptor to the choice of metal (iron, etc., as materials with a certain symbolic appeal), the main justifications for this development would seem to be two: 1. accessibility of ready-made material; 2. ease of construction.

In the past fifty years suitable stone or wood for sculpture has become not only more difficult to obtain, but also far more costly. Against its cost one must balance the even higher cost of casting bronze, but in the development I am referring to, casting is not necessarily in question. Bronze casting is one of the oldest and most widespread of techniques in sculpture, but it was always conceived as a method

285 WALTER BODMER Metal Relief 1959

of giving permanence to objects previously moulded, and as an exploitation of the sensuous qualities of bronze as a material. But that is not the modern sculptor's approach to metal as a medium. It is true that sculptors like Moore and Giacometti, Marini and Lipchitz, still seek to exploit the sensuous qualities of bronze and attach great importance to its surface qualities. But in general this is not the motive of the modern sculptor in metal, who will even despise such

286 RICHARD LIPPOLD Variations within a Sphere, no. 10: The Sun 1953-6

288 MARY CALLERY A 1960

289 MARY VIEIRA Tension-Expansion (Rythmes dans l'Espace) 1959

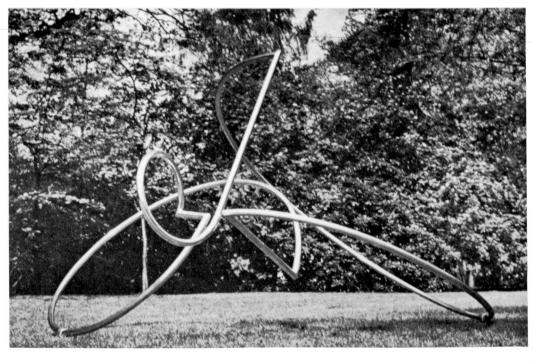

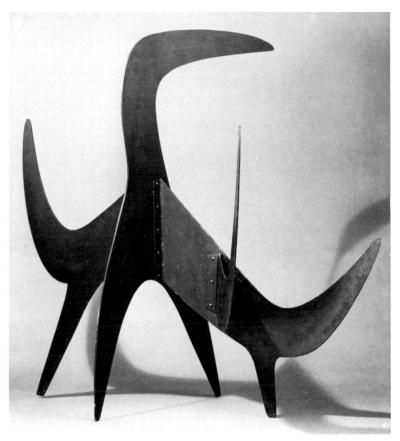

²⁹⁰ ALEXANDER CALDER Stabile (Le petit Nez) 1959

'finish' and seek to exploit the crude qualities of the wrought or cast material ('un art *brut*', to correspond with the same qualities in certain types of modern architecture).

Metals in general have certain unique qualities – they are *ductile*, which means that they can be drawn out into wires, and they are *malleable*, which means that they can be shaped into form by hammering; and they can be melted and cast, moulded into predetermined shapes or pressed. The modern sculptor takes advantage of all these possibilities, so we get wire sculpture (Picasso, Calder, Butler, Lassaw, Bodmer, Lippold, Kricke, David Smith, José de Rivera, Mary Vieira, Bill and many others), welded sheet iron

66-7, 215 281, 285-7 217, 274 289

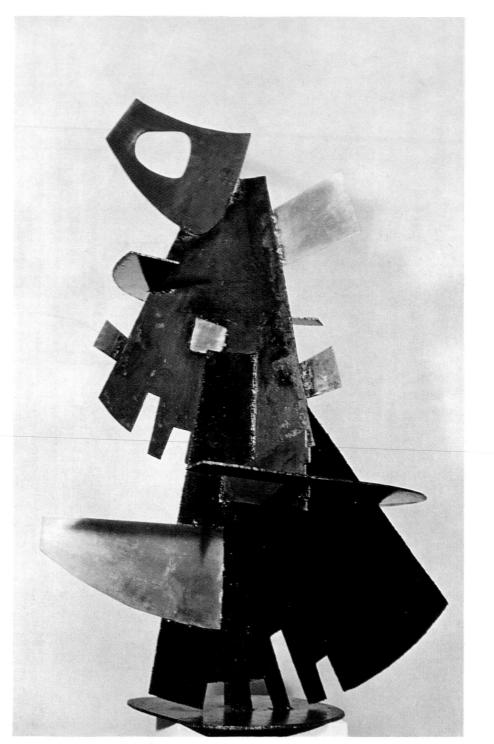

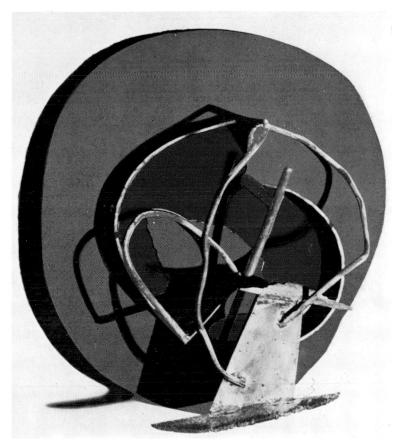

292 ROBERT JACOBSEN Noir Rouge 1962

(Lardera, Jacobsen, César, Müller, Stankiewicz, Kneale,) Hoflehner, etc.), wrought iron or steel (Baldessari, Uhlmann, Hoskin, Chillida) and many combinations and variations of these techniques (the works of Antoine Pevsner, for example, exploit a metal craftsmanship of great skill and subtlety; Chadwick has invented his own techniques for his castings). In general, metal is so docile that it will submit to any formal conception the sculptor may have, and it is this adaptability that explains its present general use.

291-2 264 275, 278 295, 224 301-2, 308 299, 113-14 212-13

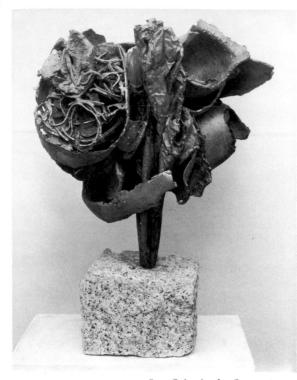

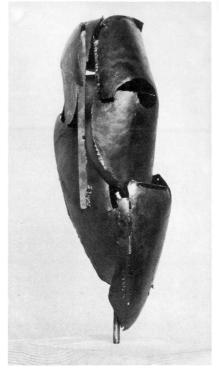

293 GIORGIO DE GIORGI La Colombe du Cap 1961

294 OSCAR WIGGLI Untitled 1962

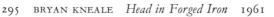

296 ROËL D'HAESE La Nuit de Saint Jean 1961

297 FRANCO GARELLI Non Lasciarmi 1962

298 EDGARDO MANNUCCI Resumption of idea, no. 3 1951-7

299 EDUARDO CHILLIDA Enclume de Rêve, no. 10 1962

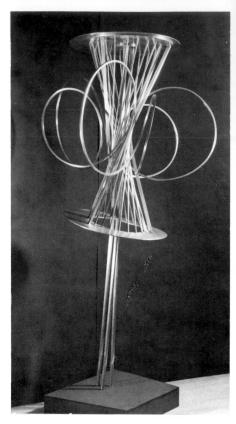

300 HANS UHLMANN Rondo 1958–9

One must then ask a devastating question: to what extent does the art remain in any traditional (or semantic) sense *sculpture*? From its inception in prehistoric times down through the ages and until comparatively recently sculpture was conceived as an art of solid form, of *mass*, and its virtues were related to spatial occupancy. It was for his restoration to the art of its characteristic virtues that Rodin was praised, and as we have seen, Rodin's followers, Maillol, Matisse, Bourdelle, Lehmbruck, Brancusi, Laurens, Arp (above all, Arp) and even Moore have been and are still sculptors in this traditional sense. What has been gained, and what has been lost, by this transition to a *linear* sculpture?

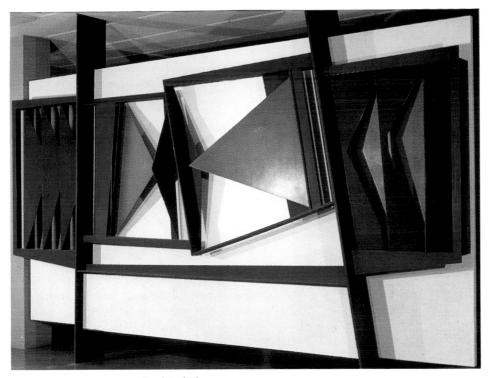

301 HANS UHLMANN Steel Relief 1959

302 HANS UHLMANN Sculpture for the Berlin Opera House 1961

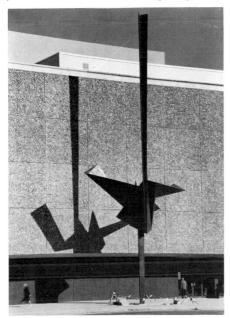

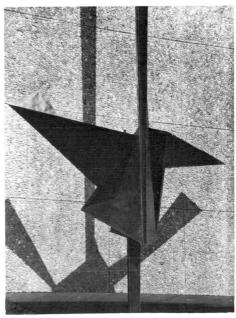

303 STEPHEN GILBERT Structure 1961 304 JAMES METCALF Ying Yang doré 1963

305 MAX BILL Endless Loop, no. 1 1947-9

306 WANDER BERTONI C (Imaginary Alphabet) 1954-5

Virtually everything, one must say, has been lost that has characterized the art of sculpture in the past. This new sculpture, essentially open in form, dynamic in intention, seeks to disguise its mass and ponderability. It is not cohesive but cursive – a scribble in the air. Far from seeking a point of rest and stability on a horizontal plane, it takes off the ground and seeks an ideal movement in space. Far from conforming to the ideal of *containment*, it is essentially articulated, and accosts the spectator with aggressive spikes. It may sometimes present a polished surface, but only to emphasize a predominant roughness. Further, to evade any suggestion of intentional craftsmanship, it will resort to scrap metal and use the machine hammers and compressors

307 GEORGE FULLARD The Patriot 1959-60

308 JOHN HOSKIN Boltedflat 1963

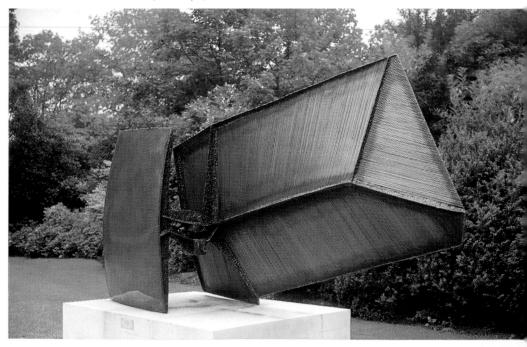

309 JEAN DUBUFFET Abrantegas 1960 310 LESLIE THORNTON The Martyr 1961

of the demolition yards to press such ready-made material into informal conglomerates (Chamberlain, César).

What is the destination of such horripilate shapes? A number of them inevitably find their way into museums of modern art; a few break with their aggressive forms the blank walls of functional buildings; others become 'decorative features' in parks or exhibitions. Some small pieces may be acquired by private collectors, but essentially this is a public art, a display art, and is directed, not to the private sensibility, but to the collective unconscious. Beauty, of course, is no longer the artist's aim; but even conceding the alternative virtue of vitality, one must still question the nature of that vitality. Moorc's ideal, while distinct from the traditional concept of beauty, conforms to what we might call the organic mode; he still finds his prototypes in natural objects. This is also partially true of the metalworkers; a bird's skeleton or a lobster is a natural form, and an 335-6

311 JEAN TINGUELY Monstranz 1960 312 SHINKICHI G. TAJIRI Relic from an Ossuary 1957

organically vital form. But the characteristic forms of the new iron age do not even have the structure of a skeleton: the figures of Germaine Richier, though they may refer to natural prototypes (e.g. *The Bat*, 1952) present their prototypes in a state of decay or disorganization.

251

Such artists, in short, are concerned with the effect known to philosophers of art as *terribilità*. Even in the eighteenth century a philosopher like Edmund Burke came to the conclusion that ugliness might be 'consistent enough with an idea of the sublime. But I would by no means insinuate [he added] that ugliness of itself is a sublime idea, unless united with such qualities as excite a strong terror.'² This is not the

313 FRANCESCO SOMAINI Grand blessé, no. 1 1960

314 PETER AGOSTINI Hurricane Veronica 1962

place to enter into a discussion of the place of ugliness in art,³ but it has a function for which adequate psychological explanations may be found. The whole conception of tragedy is based on a recognition of the shadow in our souls, the dark powers of hatred and aggression. But in tragedy, in its classical form, these dark powers are redeemed by heroism, and the soul is purged of its errors. One can still find catharsis in the terrible realism of Grünewald's *Crucifixion* or Goya's *Disasters of War*. There is no Goya or Grünewald among these sculptors in metal. But their works stick like burrs on our bourgeois sensibility, their function not catharsis but mortification.

315 ÉTIENNE HAJDU Delphine 1960 316 VOJIN BAKIĆ Deployed Form 1961

A survey of the many styles prevailing in sculpture today would reveal other types whose classification would be merely pedantic. There are various forms of eclecticism – for example, the Oriental influences that appear, quite naturally, in the sculpture of Isamu Noguchi. The influence of early Greek art (particularly of the subtle relief of Greek 315 *stele*) is found in Étienne Hajdu's work. Etruscan influences can be traced in the characteristic work of Marino Marini. Primitive or tribal sculpture continues to exert a general influence. All this is part of the eclecticism characteristic of modern art in general, and needs no further comment.

317 ISAMU NOGUCHI Black Sun 1961-2 (right)
318 ISAMU NOGUCHI Study from a Mill Stone 1961 (left)

319 HANS-JÖRG GISIGER Rhéa 1959

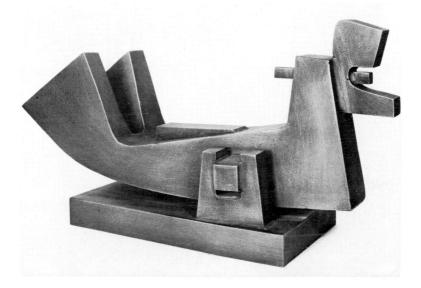

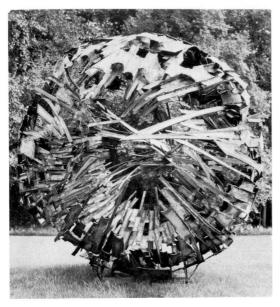

320 FRIEDERICH WERTHMANN *Entelechie II* 1960

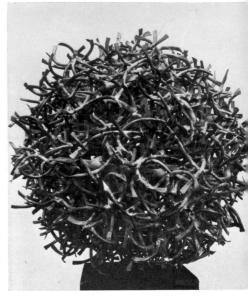

321 CLAIRE FALKENSTEIN Point as a set, no. 10 1962

322 QUINTO GHERMANDI Momento del volo 1960

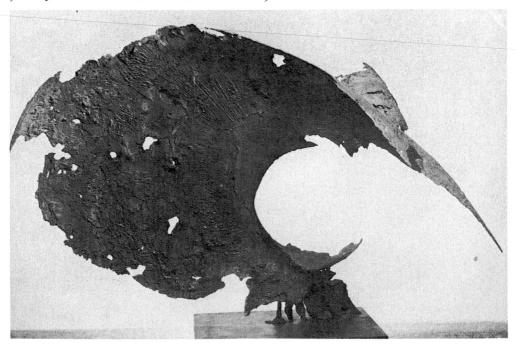

323 ILHAN KOMAN Miroir II 1962

324 HENRI-GEORGES ADAM Trois Pointes 1959

325 PIETRO CONSAGRA *Colloquio con la Moglie* 1960

326 HARRY BERTOIA Urn 1962

There remains another category which only doubtfully qualifies as sculpture in any sense of the word, but is usually included in exhibitions of sculpture – those 'assemblages' of diverse ready-made objects designed to amuse or shock rather than to create any aesthetic emotion. Historically they derive from the ready-mades of Marcel Duchamp, already mentioned, and from Man Ray's witty confrontation of incongruous objects.

In so far as such assemblages are relief constructions, they carry on the inventions of Schwitters (see page 145) who, in his Hanover *Merzbau* of c. 1924, created the prototype of all subsequent three-dimensional assemblages. The Surrealists extended the conception into the realms of fantasy (Ernst, Miró, Brauner, Paul Nash). With Joseph

125 134, 143-5 152-5 136-8

327 JOSEPH CORNELL Shadow Box. Interior white with yellow sand and 'sea-side' atmosphere

327 Cornell's 'boxes' a new and fertile invention was introduced, the idea of a 'compacted' treasury of curiosities. William C. Seitz has described them as 'the hermetic secrets of a silent and discreet Magus . . . hieratic talismans like the highly treasured possessions of a child – anything: a Haitian postage stamp, a clay pipe, a compass, even the Night'.⁴ But though such boxes occupy space and are displayed like sculptural objects, they approximate to furniture rather than to sculpture.

328

The same cannot be said of Louise Nevelson's assemblages, though these are often contained within a box-like frame. But others stand freely, without a frame, or are

264

28 LOUISE NEVELSON Royal Tide V 1960

329 LEONARDI LEONCILLO Sentimento del tempo 1961

even suspended in space. Her material is an individual choice – newel posts, chair or table legs, balusters and finials, pieces of moulding, simple blocks of wood. These are selected and mounted in compartments, and each compartment is a separate and satisfying composition. The 266

330 JOHN WARREN DAVIS Imago, no. 2 1963

whole assemblage may be left in its natural colour, or painted black or gold. The general effect is that of relief sculpturc, and from a strictly formal point of view there is nothing to distinguish a Nevelson construction from a relief by Nicola Pisano or Agostino di Duccio. Her work is serious and even

331 LUCIO FONTANA Concetto Spaziale 1962

332 ZOLTÁN KEMENY Banlieu des Anges 1958

333 BERNARD ROSENTHAL Riverrun 1959

334 PHILIPPE HIQUILY Calvary 1962

severe; which is perhaps more than can be said for a stack of compressed scrap automobile bodies, such as César and 335-6 Chamberlain offer us.

Here is a description of César at work:

... In a factory for the salvaging of metals in the suburbs of Paris I saw César in front of one of the latest American compressors, supervising the movements of the cranes, proportioning the heterogeneous loads, eagerly awaiting the results of each operation. Together we admired these calibrated bales weighing nearly a ton which are the product of the compression of a small lorry, a pile of bicycles or of a gigantic set of kitchen stoves.

335 JOHN CHAMBERLAIN Untitled 1960

. . . César sees in the result of this mechanical compression a *new stage of metal*, one subjected, so to speak, to a quintessential reduction. . . .

... For beyond the American neo-dadaist provocations his œuvre opens one of the roads to the *new realism*; it is high time that the public recognized that this realism is the essential achievement of this second half-century.⁵

336 CÉSAR Relief 1961

With this achievement we may take leave of the history of modern sculpture. Realism has had many definitions since it was first introduced as an aesthetic category rather more than a hundred years ago. It was then used (mainly in defence of Courbet) as a category opposed to idealism, and there can be few critics who would question its beneficial workings as a principle of art. But all categories of art, idealistic or

337 MATT RUGG Boomerang 1963

realistic, surrealistic or constructivist (a new form of idealism) must satisfy a simple test (or they are in no sense works of art): they must persist as objects of contemplation. For contemplation we might with some aesthetic justification substitute *fascination*, which would correspond to Henry Moore's distinction between beauty and vitality. But while contemplation leads to serenity and love, the fascination of the 'new realism' can only arouse horror and hatred. Ruskin, as usual, stated this truth in his incomparable way, and his prophetic words shall complete this brief history of a complex subject:

338 VICTOR PASMORE Relief construction in white, black and indian red 1962

The worst characters of modern work result from its constant appeal to our desire of change, and pathetic excitement; while the best features of the elder art appealed to love of contemplation. It would appear to be the subject of the truest artists to give permanence to images such as we should always desire to behold, and might behold without agitation; while the inferior branches of design are concerned with the acuter passions which depend on the turn of a narrative, or the course of an emotion. Where it is possible to unite these two sources of pleasure, and, as in the Assumption of Titian, an action of absorbing

interest is united with perfect and perpetual elements of beauty, the highest point of conception would appear to have been touched: but in the degree in which the interest of action supersedes beauty of form and colour, the art is lowered; and where real deformity enters, in any other degree than as a momentary shadow or opposing force, the art is illegitimate. Such art can exist only by accident, when a nation has forgotten or betrayed the eternal purposes of its genius, and gives birth to painters whom it cannot teach, and to teachers whom it will not hear. The best talents of all our English painters have been spent in endeavours to find room for the expression of feelings which no master guided to a worthy end, or to obtain the attention of a public whose mind was dead to natural beauty, by sharpness of satire, or variety of dramatic circumstance.6

Ruskin wrote this in 1854. I do not know which 'English painters' he had in mind; but the situation he describes is still the same, throughout the world: a public whose mind is dead to natural beauty, and artists driven by this prevailing apathy to give 'dramatic circumstance' to the expression of their feelings.

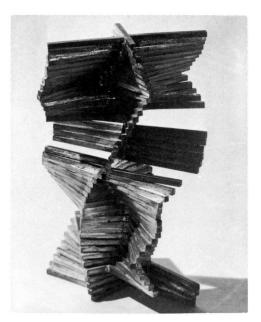

339 KENNETH MARTIN Oscillation 1962

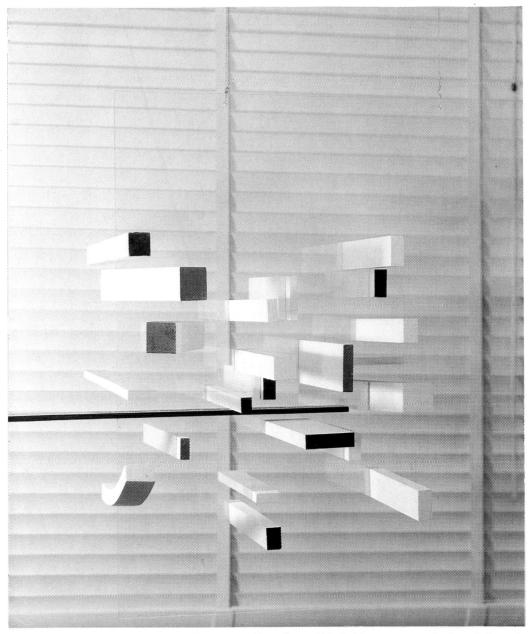

340 VICTOR PASMORE Abstract in white, ochre and black. Transparent projective relief 1963

Text References

Select Bibliography

List of Works Reproduced

Index

Text References

Chapter One

I The Listener, 8 November 1962, vol. LXVIII, No. 1754, p. 774.

2 The Tradition of the New, New York (Horizon), 1959; London (Thames & Hudson), 1962.

3 G. Baldinucci, Vocabulario Toscano dell'arte del disegno, Florence, 1681. Quoted from E. Kris, Psychoanalytic Explorations in Art, New York, 1952, pp. 189–90. Kris, in collaboration with E. H. Gombrich, devotes a chapter to 'The Principles of Caricature'.

4 Auguste Rodin, L'Art – entretiens réunis par Paul Gsell, Lausanne (Mermod), 1946.

5 Cf. John Rewald, *The History of Impressionism*, New York (Museum of Modern Art) and London (Mayflower Books), 1961, p. 551.

6 Rewald, ibid., pp. 336, 338.

7 Auguste Rodin, Berlin, 1903; Leipzig, 1913, trans. Jessie Lemont and Hans Trausil, London (Grey Walls Press), 1946, p. 45.

8 Andrew C. Ritchie (ed.), *Aristide Maillol*, Buffalo (Albright Art Gallery), 1945.

9 For an illuminating analysis of Rodin's relation to Rosso cf. Margaret Scolari Barr, *Medardo Rosso*, New York (Museum of Modern Art), 1963. Cf. also Albert E. Elsen, *Rodin*, New York (Museum of Modern Art), 1963, pp. 96, 105 (n. 26).

10 *The Art of Sculpture*, New York (Bollingen Series) and London (Faber & Faber), 1956, pp. 56, 67-8, 71.

11 Biographical Note in the catalogue of an exhibition of his work held at the Curt Valentin Gallery, October–November 1951. The catalogue also contains a charming letter to Valentin which reveals the sculptor's essential humanism better than any theoretical statement could do.

12 Both illustrated on p. 445 of *Post-Impressionism from van Gogh to Gauguin* by John Rewald, New York (Museum of Modern Art) and London (Mayflower Books), 1956.

13 From a contemporary review of the exhibition reprinted in J. K. Huysmans, L'Art moderne, Paris, 1883, 1902. Reference from Rewald, The History of Impressionism, op. cit., PP. 450, 479.

14 *Journal* (1889–1939), Paris, 1939, p. 202 (entry of 17 March).

15 Raymond Escholier, *Matisse from the Life*, trans. Geraldine and H. M. Colvile, London (Faber & Faber), 1960, p. 138.

16 Escholier, *ibid.*, pp. 140–1.

17 For the significance of 'haptic values' in sculpture, see my *Art of Sculpture*, *op. cit.*, pp. 30–1.

18 Alfred H. Barr, Jr., *Matisse: His Art and His Public*, New York (Museum of Modern Art), 1951, pp. 550-2.

19 Catalogue of a retrospective exhibition of Matisse's work held at the Museum of Art, Philadelphia, 1948.

Chapter Two

1 The Complete Letters of Vincent van Gogh, London (Thames & Hudson), 1958, vol. 3, p. 521. 2 Ibid., vol. 3, pp. 179-80. 3 The influence of primitive art on Gauguin appears chiefly in his paintings. Bernard Dorival has documented this aspect of Gauguin's art in 'Sources of the Art of Gauguin from Java, Egypt and Ancient Greece', Burlington Magazine, April 1951, vol. XCIII, pp. 118-23.

4 The autobiography of Alice B. Toklas, New York, 1933; London (Hutchinson & Co Ltd), 1960.

5 Whether similar developments in German Expressionist painting can be traced to the same origins is perhaps open to question. Certain of the German painters, Emil Nolde and Ernst Ludwig Kirchner, for example, had direct knowledge of African or Oceanic sculpture. Equally, of course, they had direct knowledge of the paintings of Van Gogh and Gauguin.

6 'Tribal Art and Modern Man', *The Tenth Muse*, London, 1957, pp. 309–10.

7 Cf. The Nature of Representation by Richard Bernheimer, New York University Press, 1961. This 'phenomenological inquiry' is a work of profound significance for the understanding of the concept of representation in the visual arts.

8 Particularly in *Art and Society*, New York and London (Faber & Faber), 3rd ed., 1956, and *Icon and Idea*, Cambridge, Mass., and London (Faber & Faber), 1955.

9 Abstraction and Empathy, 1908, trans. Michael Bullock, London (Routledge & Kegan Paul), p. 24.

Chapter Three

I For the origins and first use of the word, cf. John Golding, *Cubism: a History and Analysis 1907–14*, London (Faber & Faber), 2nd edition, 1968,

passim. Cf. also D.-H. Kahnweiler, *Entretiens*, Paris, 1961, p. 51: 'Mais celui qui a inventé le mot "cubisme" sans aucun doute . . . c'est Louis Vauxcelles. . . .'

2 Cf. Fernande Olivier, *Picasso and his Friends*. Trans. Jane Miller. London (Heinemann), 1964.

3 Jean Revol, 'Braque et Villon: message vivant de Cubisme', *La nouvelle revue française*, August-September 1961.

4 Cf. D.-H. Kahnweiler, op. cit., p. 78: 'Quand je dis les cubistes, évidemment il faut comprendre toujours que c'est Picasso dans "Les demoiselles d'Avignon" qui a commencé. . . . La moitié droite des "Demoiselles d'Avignon" est une première tentative absolument héroïque de resoudre tous ces problèmes à la fois car, en somme, on ne voulait pas seulement donner la forme exacte des objets mais aussi leur couleur exacte.' Cf. also Marie-Alain Coutourier, Se Garder libre (Journal, 1947-54), Paris, 1962, p. 158: 'Mars 53. . . . L'autre soir, chez Braque, je lui demande ce que Picasso et lui avaient dans le tête quand ils ont commencé à faire du cubisme.

"D'abord," me dit-il, "nous n'avons jamais fait de cubisme. Ce sont les autres, après nous, qui en ont fait."

'Je lui dis qu'il devrait parler, dire comment les choses se sont passées. Mais il me dit que c'est inutile. "Il n'y a rien à faire, on est en train de *faire* l'histoire du cubisme. Elle est absolument fausse. Mais il n'y a rien à faire: l'histoire se fait comme cela. Les gens qui écrivent l'histoire ne sont jamais ceux qui l'ont faite; et les seconds ne peuvent rien contre les premiers."' 5 Cf. Pierre Courthion, *Gargallo*: sculptures et dessins, Paris, 1937, p. 15 n.

6 Roland Penrose, *Picasso: His Life* and Work, London (Gollancz), 1958, p. 241.

7 Cf. Claude Levi-Strauss, La pensée sauvage, Paris, 1962, p. 21.

8 The Principles of Art, Oxford University Press, 1938, pp. 66, 68-9.

9 This date is given by Kahnweiler. Barr and Penrose give 1928, which would imply that they preceded the Boisgeloup period, and the assistance given by González. Picasso did not go to Boisgeloup until 1931.

10 D.-H. Kahnweiler, *The Sculptures of Picasso*, London (Rodney Phillips), 1949, p. 7.

11 Ill. Kahnweiler, ibid., pls. 9-11.

12 Ill. Camilla Gray, *The Great Experiment*: *Russian Art 1863–1922*, London (Thames & Hudson), 1962, pls. 121–5. All students of modern art are greatly indebted to this work, which for the first time gave a clear indication to the outer world of the course of artistic events in Russia up to 1922.

13 Cf. Camilla Gray, ibid., pp. 184-5.

14 Cf. Camilla Gray, ibid., pp. 147-8.

15 A Russian translation of Chapter VI of Kandinsky's *Über das Geistige in der Kunst* was published in 1912. Extracts had been read to a Congress of Russian Artists held in St Petersburg on 29–31 December 1911.

16 Cf. Camilla Gray, op. cit., p. 219.

17 Ill. Camilla Gray, *op. cit.*, pls. 174–7, 179.

18 Bauhaus 1919–1928, ed. Herbert Bayer, Walter Gropius, Ise Gropius, New York and London (Allen & Unwin), 1939, p. 18. 19 From a letter to Antony Kok. Cf. *de Stijl*, cat. 81, Stedelijk Museum, Amsterdam, 1951, p. 45.

20 'An intimate biography', catalogue of an exhibition of Vantongerloo's work at the Marlborough New London Gallery, November 1962. Ed. Max Bill, pp. 52–4.

21 Bauhaus 1919–1928, op. cit., p. 124.

22 Sibyl Moholy-Nagy, *Moholy-Nagy: experiment in totality*, New York, 1950, p. 205.

23 *The Art of Sculpture*, New York (Bollingen Series) and London (Faber & Faber), 1956, p. 71.

24 'Constructive Art: an Exchange of Letters between Naum Gabo and Herbert Read', *Horizon*, London, vol. x, No. 55, July 1944. Reprinted in *Gabo: Constructions Sculpture Paintings Drawings Engravings*, London (Lund Humphries), 1957, p. 171.

Chapter Four

1 Joshua C. Taylor, *Futurism* (New York Museum of Modern Art), 1961. Appendix B, p. 134, trans. Margaret Scolari Barr.

2 Ibid., p. 134.

3 Ibid., p. 87.

4 The earlier date is given by Carola Giedion-Welcker, *Contemporary Sculpture*, New York (George Wittenborn Inc.) and London (Faber & Faber), 1961, p. 65; the later date by Taylor, *op. cit.*, p. 101.

5 D.-H. Kahnweiler, *The Rise of Cubism*, trans. Henry Aronson, New York, 1949, pp. 21–2.

6 Read, op. cit., pp. 119-20.

7 *Arp*, edited with an introduction by James Thrall Soby, articles by Jean Hans Arp, Richard Huelsenbeck, Robert Melville, Carola Giedion-Welcker. New York (Museum of Modern Art), 1958, p. 13.

8 Essays on Contemporary Events, London (Kegan Paul), 1947, pp. 9–10.

9 Ill. C. Giedion-Welcker, *op. cit.*, p. 91, where also an *Objet Dad' Art* of 1919–20 by Max Ernst is illustrated. This too has not survived.

10 Robert Lebel, *Marcel Duchamp*. With chapters by Marcel Duchamp, André Breton and H. P. Roché. Trans. G. H. Hamilton, New York (Trianon Press), 1959; London (Collins), 1960.

11 Ibid., p. 36.

12 'Souvenirs' of H. P. Roché, in Lebel, *ibid.*, p. 84.

13 'Limits not Frontiers of Surrealism', *Surrealism*, London, 1936, p. 103.

14 Charbon d'Herbe, Paris, 1933. Quoted from C. Giedion-Welcker, op. cit., p. 97.

15 Ibid., p. 98. From Minotaure, 1933.

16 'Les peintures de Giacometti', Derrière le miroir, No. 65, May 1954.

17 C. Giedion-Welcker, *op. cit.*, p. 300.

Chapter Five

1 Sculpture & Drawings, vol. 1 (1957), p. xxxi. Originally contributed to Unit One, ed. Herbert Read, London, 1934.

2 *Picasso: Fifty Years of his Art*, New York (Museum of Modern Art), 1946, p. 150. 3 Sculptures & Drawings, vol. 1, p. xxxiv. First published in The Listener, 18 August 1937.

4 Ibid.

5 A recollection of Brancusi's own statement by A. Istrati, recorded by Ionel Jianou in *Brancusi*, London (Adam Books), 1963, p. 68.

6 Ibid., p. 69.

7 Ibid., p. 67.

8 Barbara Hepworth: Carvings & Drawings, with an Introduction by Herbert Read, London (Lund Humphries), 1952.

9 Giacometti's letter to Pierre Matisse, 1947.

10 Creative Development: Five Lectures to Students, London (Routledge & Kegan Paul), 1962, p. 58.

11 Zeugnisse der Angst in der modernen Kunst. Catalogue published by Professor Dr Hans-Gerhard Evers. Darmstadt, 1963, p. 97.

Chapter Six

1 'On Art Movements', The New Yorker, 5 October 1963, pp. 159–69. 2 A Philosophical Enquiry into the Origin of our Ideas of the Sublime and the Beautiful. Part III, p. xxi.

3 I have discussed the problem in 'Beauty and the Beast', *Eranos Jahrbuch*, Zurich, 1961, vol. xxx, pp. 175–210.

4 William C. Seitz, *The Art of Assemblage*, New York (Museum of Modern Art), 1961, p. 68. This volume gives a very complete survey of all this art of transformed 'ready-mades'.

5 Pierre Restany, from an exhibition catalogue, Hanover Gallery, London, 1960. Quoted by Seitz, *op. cit.*, p. 145. 6 *Giotto and his Works in Padua* (1854), p. 23.

Select Bibliography

A very comprehensive bibliography of modern sculpture has been compiled by Bernard Karpel of the Museum of Modern Art, New York, and is printed in Carola Giedion-Welcker's *Contemporary Sculpture* (see below). In this more select bibliography I have included only those books which the general reader might find useful for the further study of the subject.

General Works on the History and Theory of Sculpture

- BARR, Alfred H. Jr.: *Cubism and Abstract Art.* passim ill. New York (Museum of Modern Art), 1936.
- FOCILLON, Henri: The Life of Forms in Art. 94 pp. ill. New York (Wittenborn, Schultz, Inc.), 1948.
- GIEDION-WELCKER, Carola: Contemporary Sculpture: an Evolution in Volume and Space. 397 pp. ill. New York (George Wittenborn, Inc.) and London (Faber & Faber), revised edition, 1961.
- HILDEBRAND, Adolf: The Problem of Form in Painting and Sculpture. Trans. by Max Meyer and Robert Morris Ogden. New York (Haffner Publishing Company), 1945.
- MAILLARD, Robert (ed.): A Dictionary of Modern Sculpture. 320 pp. ill. London (Methuen), 1962.
- MOHOLY-NAGY, L.: The New Vision. 397 pp. ill. London and New York, revised edition, 1939. Latest edition, New York (Wittenborn, Schultz, Inc.), 1955.
- RAMSDEN, E. H.: Sculpture: Theme and Variations. 56 pp. plus 103 ill. London (Lund Humphrics), 1953.

- READ, Herbert: Art Now: an Introduction to the Theory of Modern Painting and Sculpture. 128 pp. ill. Paperback edition, London (Faber & Faber), 1963.
- READ, Herbert: *The Meaning of Art.* 197 pp. ill. London (Faber & Faber and Penguin Books). Latest edition, 1963.
- READ, Herbert: *The Art of Sculpture*. 152 pp. ill. New York (Bollingen Series) and London (Faber & Faber), 1956.
- RITCHIE, Andrew C.: Sculpture of the Twentieth Century. 238 pp. ill. New York (Museum of Modern Art) and London (Mayflower Books), 1953.
- SEYMOUR, Charles: Tradition and Experiment in Modern Sculpture. 86 pp. ill. Washington, D.C. (American University Press), 1949.
- VALENTINER, W. R.: Origins of Modern Sculpture. 180 pp. ill. New York (Wittenborn, Schultz, Inc.), 1946.
- WILENSKI, Reginald H.: *The Meaning* of Modern Sculpture. pp. 83–164, ill. New York (Stokes) and London (Faber & Faber), 1935.

Particular Studies

- AGUILERA-CERNI, Vicente: Julio González. Vol. 1 of the series 'Contributi alla storia dell'Arte', ed. Giuseppe Gatt. Rome (Edizione dell'Ateneo), 1962.
- BARR, Alfred H. Jr.: *Matisse: His Art and His Public.* 591 pp. ill. New York (Museum of Modern Art), 1951.
- BOCCIONI, Umberto: *Manifeste technique de la sculpture futuriste*, 11 April 1912.
- ELSEN, Albert E.: Rodin. 228 pp. ill. New York (Museum of Modern Art), 1963.
- GABO, Naum: A Retrospective View of Constructive Art. In 'Three Lectures on Modern Art', pp. 65–87. New York (Philosophical Library), 1949.
- Gabo; Constructions Sculpture Paintings Drawings Engravings. With introductory essays by Herbert Read and Leslie Martin. 193 pp. ill. London (Lund Humphries), 1957.
- Naum Gabo Antoine Pevsner. With an Introduction by Herbert Read. Texts by Ruth Olson and Abraham Chanin. 84 pp. ill. New York (Museum of Modern Art), 1948.
- GIEDION-WELCKER, Carola: Constantin Brancusi. New York (Braziller) and London (Mayflower Books), 1959.
- Julio González, Sculptures. 23 pp. ill. Paris, Musée National d'Art Moderne (Éd. des Musées nationaux), 1952.
- Julio González. 48 pp. ill. New York (Museum of Modern Art), 1958.
- GRAY, Camilla: The Great Experiment: Russian Art, 1863–1922. 327 pp.

ill. London (Thames & Hudson), 1962.

- GROHMANN, W.: Henry Moore. Berlin (Rembrandt) and London (Thames & Hudson), 1960.
- HAMMACHER, A. M.: Barbara Hepworth. London (Thames & Hudson), 1968.
- HEPWORTH, Barbara: Barbara Hepworth, Carvings and Drawings. With an Introduction by Herbert Read. 30 pp., 165 pl. London (Lund Humphries), 1952.
- HODIN, J. P.: Barbara Hepworth. New York and London (Lund Humphries), 1962.
- JIANOU, Ionel: *Brancusi*. 223 pp. ill. London (Adam Books), 1963.
- KAHNWEILER, Daniel-Henry: *The Sculptures of Picasso*. Photographs by Brassaï. 8 pp. plus 218 pl. London (Rodney Phillips), 1949.
- LEBEL, Robert: Marcel Duchamp. Trans. G. H. Hamilton. 192 pp. ill. New York (Trianon Press), 1959; London (Collins), 1960.
- Modern Sculpture from the Joseph H. Hirshborn Collection. 246 pp. ill. New York (The Solomon R. Guggenheim Museum), 1962.
- MOTHERWELL, Robert (ed.): *The Dada Painters and Poets.* pp. 136–40, 185–6, 207–11, 255–63, 306–15, 356–7 et passim ill. New York (Wittenborn, Schultz, Inc.), 1951.
- PENROSE, Roland: *Modern Sculptors; Picasso.* 16 pp., 32 ill. London (Zwemmer), 1961.
- READ, Herbert: *Henry Moore*. London (Zwemmer), 1934.
- READ, Herbert: *Henry Moore, Sculpture and Drawings.* Vol. 1, xliii + 278 pp. ill. 4th edition, 1957; vol. 11, xxiv + 116 pp. ill., 2nd

edition, 1965. London (Lund Humphries). Vol. 111 in preparation.

- READ, Herbert: *Henry Moore*. London (Thames & Hudson), 1965.
- REWALD, John: *Degas: Works in Sculpture*. 124 pp. 112 pl. New York (Pantheon), 1944.
- RITCHIE, Andrew C.: *Abstract Painting and Sculpture in America*. 159 pp. ill. New York (Museum of Modern Art), 1951.
- RODIN, Auguste: L'Art entretiens réunis par Paul Gsell. 318 pp. ill. Paris (Grasset), 1911; Lausanne (Mermod), 1946.

- Sculpture of the Twentieth Century. 240 pp. ill. New York (Museum of Modern Art) and London (Mayflower Books), 1958.
- SEITZ, William C.: *The Art of Assemblage*. 176 pp. ill. New York (Museum of Modern Art), 1961.
- soby, James Thrall (ed.): Jean Arp. 126 pp. ill. New York (Museum of Modern Art), 1958.
- sweeney, James Johnson: *Alexander Calder*. New York (Museum of Modern Art), 1951.
- The Unknown Political Prisoner. International Sculpture Competition sponsored by the Institute of Contemporary Arts. 24 pp. ill. London (Tate Gallery), 1953.

The following more recent works, both general and particular, may also prove useful:

- BURNHAM, Jack: Beyond Modern Sculpture. xii + 402 pp., ill. New York (George Braziller), 1968.
- GEIST, Sidney: Brancusi. A Study of the Sculpture. 248 pp., ill. London (Studio Vista), 1968.
- GRAY, Christopher: *Sculpture and Ceramics of Paul Gauguin*. Baltimore (The John Hopkins Press), 1963.
- HAMMACHER, A. M.: The Evolution of

Modern Sculpture. 383 pp., ill. London (Thames & Hudson), 1969.

- HEPWORTH, Barbara: The Complete Sculpture of Barbara Hepworth 1960-69 ed. Alan Bowness. 50 pp. + 167 pp. ill. London (Lund Humphries), 1971.
- READ, Herbert: Arp. 216 pp., ill. London (Thames & Hudson), 1968.

List of Works Reproduced

Entries are listed alphabetically under the names of artists. Measurements are given in inches, followed by centimetres within brackets. When three dimensions are given, these appear in the following order: height, width, depth. Each entry is followed by its plate number.

ADAM, Henri-Georges (b. Paris, 1904) Trois Pointes. 1959	ARMITAGE, Kenneth (b. Leeds, 1916) Walking Group. 1951
Bronze. $17\frac{3}{4} \times 13\frac{3}{4}$ (45 × 35)	Bronze. H.9 (23) 254
Collection the artist	=)4
Photo Pierre Joly—Véra Cardot, Paris 324	ARMITAGE, Kenneth Figure lying on its side (5th version). 1958-9
ADAMS, Robert (b. Northampton, Eng- land, 1917) Maquette for architectural Screen, 1956	Bronze. L. 32 (81·3) Collection British Council, London Photo Lidbrooke, London 255
Bronze. $29\frac{1}{2} \times 9$ (75 × 23) Collection and photo Gimpel Fils, London	ARMITAGE, Kenneth
AESCUBACHER Happ (b. Zurich 1006)	Slab Figure. 1961 Bronze. $28\frac{1}{2} \times 38$ (72 × 97) Collection Marlborough Fine Art Limited,
AESCHBACHER, Hans (b. Zurich, 1906) Figure XI. 1960 Brass. $H.9\frac{7}{8}$ (25)	London Photo Harriet Crowder, London 256
Collection and photo the artist 232	ARP, Hans (Jean) (Strasbourg, 1887-
AGOSTINI, Peter (b. New York, 1913) Hurricane Veronica. 1962 Plaster. H. 554 (140°5) Collection Stephen Redich Collegy, New	Basel, 1966) Madame Torso with wavy Hat. 1916 Wood $15\frac{7}{8} \times 10\frac{3}{8}$ (10.5 × 26.5) Rupf Foundation, Berne 132
Collection Stephen Radich Gallery, New York 314	ARP, Hans (Jean)
ANTHOONS, Willy (b. Mechlin, Bel- gium, 1911) Infinite Form. 1949–60 Euville stone. H.63 (160) Rijksmuseum Kröller-Müller, Otterlo	Forest. 1916 Painted wood. $12\frac{5}{2} \times 8\frac{1}{4} (32 \times 21)$ Collection Roland Penrose, London Photo John Webb, London 133
190	ARP, Hans (Jean) Shell and Head. 1933
ARCHIPENKO, Alexander (Kiev, 1887 —New York, 1964) Seated Mother. 1911	Bronze. $7\frac{7}{8} \times 9\frac{7}{8} \times 7\frac{1}{4}$ (20 × 25 × 18·5) Collection Peggy Guggenheim, Venice Photo Peter Cannon Brookes, London
Bronze. H. including base $23\frac{5}{8}$ (60) Stadt Kunstmuseum, Duisburg 73	5 1
ARCHIPENKO, Alexander Boxing Match. 1913 Terracotta. H. 31 8 (79)	ARP, Hans (Jean) Human Concretion. 1933 Bronze. 29½×22×13¾ (75×56×34) Photo Étienne Bertrand Weill, Paris 85
Collection Peggy Guggenheim, Venice Photo Peter Cannon Brookes, London I 24	ARP, Hans (Jean) Landmark. 1938 Wood lathe-turned and sawn. 23 $\frac{6}{8} imes 9\frac{7}{8} imes$
ARCHIPENKO, Alexander Woman with a Fan. 1914 Bronze polychrome. H. 25 ⁵ / ₈ (65) 70	$14\frac{1}{8}$ (60 × 25 × 36) Collection the artist Photo Étienne Bertrand Weill, Paris 48

287

ARP, Hans (Jean) Star. 1939-60 Marble. $22\frac{1}{2} \times 20\frac{1}{2} \times 3\frac{7}{8}$ (57×52×10) Collection Eduard Loeb, Paris Photo Étienne Bertrand Weill, Paris 149 ARP, Hans (Jean) Ptolemy I. 1953 Bronze. $40\frac{1}{2} \times 20\frac{7}{8} \times 16\frac{7}{8} (103 \times 53 \times 43)$ 49 ARP, Hans (Jean) Siamois. 1960 Laminated bronze. $15 \times 29\frac{7}{8} \times 41\frac{3}{8} (38 \times 76)$ × IOS Photo Étienne Bertrand Weill, Paris ISI AVRAMIDIS, Joannis (b. Batoum, Russia, 1922) Large Figure. 1958 Bronze. H. 774 (196) Rijksmuseum Kröller-Müller, Otterlo 22I AYRTON, Michael (b. London, 1921) Icarus III. 1960 Bronze. H. 56 (142.5) Private Collections, New York and Nairobi 243 BAKIĆ, Vojin (b. Bjelovar, Yugoslavia, 1915) Deployed Form. 1961 Aluminium. H. $15\frac{3}{4}(35)$ Drian Galleries, London 316 BALLA, Giacomo (Turin, 1871-Rome, 1958) Boccioni's Fist—Lines of Force. 1915 Wood and cardboard painted red. 33×31 \times 12 $\frac{1}{2}$ (84 \times 74 \times 31.5) Collection Mr and Mrs Harry Lewis Winston, Detroit Photo Lew Gilchrest Studios, Birmingham, Michigan 123 BARLACH, Ernst (Wedel, Holstein, 1870 -Rostock, 1938) Veiled Beggar Woman. 1919 Wood carving. H. 15 (38) Collection Lisa Arnhold, New York Photo Kunsthalle, Hamburg 17 BASKIN, Leonard (b. New Brunswick, New Jersey, 1922) Head of Barlach. 1959 Poplar wood. H. $17\frac{3}{4}$ (44.8) Collection Dr and Mrs Seymour Lifschutz, New Brunswick, New Jersey 16

BASKIN, Leonard Owl. 1960 Bronze. H. 201 (52) Collection Joseph H. Hirshhorn, New York 263 BELLING, Rudolf (b. Berlin, 1886) Dreiklang. Model 1919, cast 1950 Bronze. $35\frac{3}{8} \times 33\frac{1}{2}$ (90 × 85) Bayerische Staatsgemäldesammlungen, Munich 258 BENAZZI, Raffael (b. Rapperswil, Switzerland, 1933) Elmwood. 1962 $26 \times 16\frac{1}{8} (66 \times 41)$ Collection the artist Photo Eliette Mac Couch 198 BÉOTHY, Étienne (b. Heves, Hungary, 1897) Nocturno. 1956 Avodivé wood. H. 47¹/₄ (120) 188 BERTHOLD, Joachim (b. Eisenach, Germany, 1917) Stooping Woman. 1960 Bronze. H. 254 (64) Collection Mrs Gisela Berthold-Sames 179 BERTOIA, Harry (b. San Lorenzo, Italy, 1915) Urn. 1962 Bronze. 47×51 (120×130) Collection Mr and Mrs John S. Schulte, New York Photo John D. Schiff, New York 326 BERTONI, Wander (b. Codisotto, Italy, 1925) C (Imaginary Alphabet). 1954-5 $25\frac{5}{8} \times 17\frac{3}{4} \times 13\frac{3}{4}$ (65 × 45 × 35) Bronze. Museum of the Twentieth Century, Vienna 306 BILL, Max (b. Winterthur, Switzerland, 1908) Endless Loop, no. 1. 1947-9 Gilded copper on crystalline base. $9\frac{3}{4} \times 28$ $\times 8 (25 \times 71 \times 21)$ Collection Joseph H. Hirshhorn, New York Photo The Solomon R. Guggenheim Museum, New York 305 BLOC, André (b. Algiers, 1896) Double interrogation. 1958 Bronze. H. 275 (70) Photo Gilles Ehrmann, Bois-Colombes 240

BRANCUSI, Constantin BOCCIONI, Umberto (Reggio, Italy, 1882—Sorte, near Verona, 1916) Anti-Graceful (The Artist's Mother). 1912 Bronze. $22\frac{7}{8} \times 19\frac{5}{8} \times 15\frac{3}{4} (58 \times 50 \times 40)$ Galleria Nazionale d'Arte Moderna, Rome 118 BOCCIONI, Umberto Development of a Bottle in Space. 1912 Bronze. H. 15 (38) Aristide Maillol Fund, The Museum of Modern Art, New York I20 BOCCIONI, Umberto Unique Forms of Continuity in Space. 1913 Bronze. H. 43¹/₂ (110) The Museum of Modern Art, New York Photo Soichi Sunami, New York 117 BOCCIONI, Umberto Horse+Rider+House. 1914 Painted wood and cardboard. $31\frac{1}{2} \times 43\frac{1}{4}$ (80×110) Collection Peggy Guggenheim, Venice Photo Peter Cannon Brookes, London 116 BODMER, Walter (b. Basle, 1903) Metal Relief. 1959 $33\frac{1}{2} \times 27\frac{5}{8} (85 \times 70)$ Galerie Charles Lienhard, Zurich Photo Moeschlin and Baur 285 BONNARD, Pierre (Fontenay-aux-Roses, France, 1867– Le Cannet, 1947) Girl Bathing. c. 1923 Bronze. H. 101 (26.5) Collection Joseph H. Hirshhorn, New York Photo O. E. Nelson, New York 18 BOURDELLE, Antoine (Montauban, France, 1861—Vésinet, near Paris, 1929) Beethoven, grand masque tragique. 1901 Bronze. H. 325 (83) Musée Bourdelle, Paris Photo Marc Lavrillier, Paris 8 BOURGEOIS, Louise (b. Paris, 1911) Sleeping Figure. 1950-9 Bronze. H. $74\frac{1}{2}$ (89) The Museum of Modern Art, New York Photo John D. Schiff, New York 222 BRANCUSI, Constantin (Targujiu, Rumania, 1876—Paris, 1957) Sleeping Muse (1st version). 1906 Marble. $10\frac{7}{8} \times 15\frac{3}{4} (27.5 \times 40)$ Museum of Art, Bucharest 80

Sleeping Muse. 1909-10 Marble. $11 \times 11\frac{9}{4} \times 6\frac{1}{2} (28 \times 30 \times 16.5)$ Musée National d'Art Moderne, Paris 81 BRANCUSI, Constantin Bird. 1912 Marble on marble base. H. 243 (62). Base H.6 (15.5) Collection Louise and Walter Arensberg, Philadelphia Museum of Art 45 BRANCUSI, Constantin Mademoiselle Pogany. 1913 Bronze. $10\frac{5}{8} \times 7 \times 8$ (27 × 17.5 × 20.5) Musée National d'Art Moderne, Paris 83 BRANCUSI, Constantin Bird in Space. 1919

Polished bronze. H. 54 (137.5) The Museum of Modern Art, New York 130

BRANCUSI, Constantin

Adam and Eve. 1921

- Chestnut (one section) and old oak (two sections). H. 881 (224). Limestone base H. 54 (13.5)
- The Solomon R. Guggenheim Museum, New York 46

BRANCUSI, Constantin

Torso of a Young Man. 1924

- Polished brass. H. 18 (45.5). Original wood base H. 58½ (148)
- Collection Joseph H. Hirshhorn, New York
- Photo The Solomon R. Guggenheim Museum, New York 47
- BRAQUE, Georges (Argenteuil, France, 1882—Paris, 1963) Horse (Gelinotte). 1957

Bronze. H. 77/8 (20)

Galerie Maeght, Paris Photo Routhier, Paris

44

BRAUNER, Victor (Piatra-Neamiz, Rumania, 1903–Paris, 1966) Signe. 1963 Gilded bronze. $11\frac{3}{4} \times 7\frac{1}{8} (30 \times 18)$ Alexander Iolas Gallery, New York 138 BROWN, Ralph (b. Leeds, 1928)

Stepping Woman. 1962 Bronze. H. 36 (91.5) Leicester Galleries, London 244

CÉSAR (César Baldaccini) (b. Marseilles, 1921) The Man of Saint-Denis. 1958 Welded iron. Including base 20\$×43\$
(51×109·5) Tate Gallery, London 264
CÉSAR Relief. 1961 Compressed automobile. 86 ⁵ / ₈ ×78 ³ / ₄ (220× 200)
Galerie Claude Bernard, Paris 336
CHADWICK, Lynn (b. London, 1914) The Watchers. 1960 Bronze. H.92 (233·5) Collection London County Council Photo David Farrell, Gloucester 212
CHADWICK, Lynn Winged Figures. 1962 Painted iron. 120×216 (305×549)
Collection the artist Photo John Webb, London 213
CHAMBERLAIN, John (b. Rochester, Indiana, 1927) Untitled. 1960 Welded metal. $20 \times 16 \times 12$ ($50 \cdot 5 \times 40 \cdot 5 \times 30 \cdot 5$) Collection Joseph H. Hirshhorn, New York Photo Robert E. Mates, New York 335
CHILLIDA, Eduardo (b. St Sebastian,
Spain, 1924) Enclume de Rêve, no. 10. 1962 Iron on wooden base. H. 58 ³ / ₄ (149·5). H. without base 17 (43·5) Oeffentliche Kunstsammlung, Basle 299
CLARKE, Geoffrey (b. Darley Dale, England, 1924) Battersea Group. 1962 Sandcast pure aluminium. (1) $42 \times 138 \times 36$ (106 $5 \times 351 \times 92$); (2) $30 \times 126 \times 54$ (77
$\begin{array}{ccc} \times 320 \times 137); & (3) & 48 \times 156 \times 42 & (122 \times 397 \times 106) \\ \hline Collection the artist \\ Photo Crispin Eurich & 176 \end{array}$
CLATWORTHY, Robert (b. Somerset,
England, 1928) Bull. 1956–7 Bronze. H. including base 63 (160) Collection London County Council Photo Penny Tweedie, London 253

- CONSAGRA, Pietro (b. Mazara del Vallo,
- Sicily, 1920) Colloquio con la Moglie. 1960
- Wood. $61\frac{3}{4} \times 58\frac{1}{4}$ (157×148)
- Collection the artist
- Photo Galerie Charles Lienhard, Zurich
- CORNELL, Joseph (b. Nyack, New York, 1903)
- Shadow Box. Interior white with yellow sand and 'sea-side' atmosphere.
- Wooden box with glass front and brass rings, and deep frame. $5\frac{3}{4} \times 9 \times 3\frac{1}{4}$ (14.5 $\times 23 \times 8.5$)
- Hanover Gallery, London
- Photo John Webb, London 327
- COULENTIANOS, Costas (b. Athens, 1918)
- Le Mollard. 1961
- Aluminium. $66\frac{1}{2} \times 26\frac{3}{8} \times 25\frac{5}{8}$ (169×72× 65)
- Galerie de France, Paris 183
- COUSINS, Harold (b. Washington, 1916)
- Gothic Landscape. 1962
- Forged iron. $66\frac{1}{2} \times 30\frac{3}{4}$ (169 × 78) Roberts Gallery, Toronto 282
- DALWOOD, Hubert (b. Bristol, 1924)
- Una grande Liberta. 1963
- Aluminium, gilt and wood. $60 \times 30 \times 10\frac{3}{4}$ (153 × 77 × 27)
- Collection and photo Gimpel Fils, London 236
- DAUMIER, Honoré (Marseilles, 1808– Valmondois, France, 1878)
- L'Homme à tête plate. c. 1830-2
- Bronze. H. $5\frac{1}{2}$ (14)
- Collection Joseph H. Hirshhorn, New York
- Photo The Solomon R. Guggenheim Museum, New York I
- DEGAS, Edgar (Paris, 1834—Paris, 1917)
- The little Dancer of fourteen years.
- 1880-1
- Painted wax. H. 39 (99)
- Collection Mr and Mrs Paul Mellon, Upperville, Virginia 23
- DEGAS, Edgar
- Dancer, Arabesque over right leg, right arm in front. 1882–95
- Bronze. H.8 (20.5) 21

DEGAS, Edgar

325

- Pregnant Woman. c. 1896-1911
- Bronze. H. 16³/₄ (43)
- Collection Joseph H. Hirshhorn, New York
- Photo The Solomon R. Guggenheim Museum, New York 19
- DESPIAU, Charles (Mont-de-Marsan, France, 1874—Paris, 1946)
- Head of Madame Derain. 1922
- Bronze. H. 13 (33.5), base 6×6 (15.5 × 15.5)
- The Phillips Collection, Washington
- Photo J. H. Schaefer & Son, Baltimore 6
- DODEIGNE, Eugène (b. Rouvreux, near Liége, 1923)
- Torso in Soignies stone. 1961
- $32\frac{5}{8} \times 15\frac{3}{4} (83 \times 40)$
- Collection Pierre Loeb, Paris 178
- DUBUFFET, Jean (b. Le Havre, 1901) Abrantegas. 1960
- Plaster covered with painted paste. H.36¹/₄ (92)
- Private Collection
- Photo Galerie Daniel Cordier, Paris 309
- DUCHAMP, Marcel (Blainville, France, 1887—Neuilly, 1968)
- In advance of a broken arm—Ready-made.
- Snow shovel, wood and metal.
- Collection Société Anonyme, Yale University Art Gallery 135
- DUCHAMP-VILLON, Raymond (Damville, France, 1876—Cannes, 1918)
- Head of Baudelaire. 1911
- Bronze. H. 15¹/₂ (39.5)
- Collection Joseph H. Hirshhorn, New York
- Photo O. E. Nelson, New York 72

DUCHAMP-VILLON, Raymond Seated Woman. 1914

Bronze. H. $27\frac{1}{8}$ (69)

- Collection Joseph H. Hirshhorn, New York
- Photo The Solomon R. Guggenheim Museum, New York 74
- DUCHAMP-VILLON, Raymond Horse. 1914
- Bronze. H. 167/8 (43)
- Collection Peggy Guggenheim, Venice
- Photo Peter Cannon Brookes, London
 - 119
 - 291

DZAMONJA, Dusan (b. Strumica, Yugo- slavia, 1928) Metal Sculpture, no. 3. 1959 Iron and wood. H.63 (160) Galerie Charles Lienhard, Zurich 262	ÉTIENNE-MARTIN La Nuit. 1951 Bronze. 53½×31½ (136×80) Galerie Breteau, Paris Photo Leni Iselin 229
EPSTEIN, Jacob (New York, 1880— London, 1959) Rock Drill. 1913 Bronze. H. 27 ³ / ₄ (70 [.] 5) 158	FALKENSTEIN, Claire (b. Coos Bay, Oregon, 1909) Point as a set, no. 10. 1962 Copper. $29\frac{1}{2} \times 29\frac{1}{2} \times 29\frac{1}{2}$ (75 \times 75 \times 75) Private Collection, Lausanne
EPSTEIN, Jacob Jacob and the Angel. 1940 Alabaster. H. 84 (214) Collection Sidney Bernstein, London 159	Photo Galerie Stadler, Paris 321 FEDDERSEN, Hans P. Composition. 1963
ERNST, Max (b. Bruehl, near Cologne, 1891)	Bronze. H. 98 ³ / ₈ (250) Volksschule, Hilden, Germany 259
Fruit of a long Experience. 1919Painted wooden relief. $17\frac{3}{4} \times 15$ (45×38)Collection Roland Penrose, LondonPhoto John Webb, London134	FERBER, Herbert (b. New York, 1906)Homage to Piranesi. 1962–3Copper. 92×49 ($233 \cdot 5 \times 124 \cdot 5$)Collection the artistPhoto John Webb, London277
ERNST, Max Tête double: Oedipus. 1935	FIORI, Ernesto de (Rome, 1884—São
Plaster. H. 27 ¹ / ₂ (70) Whereabouts unknown I37	Paulo, 1945) The Soldier. 1918
ERNST, Max The Table is Set. 1944	Bronze. H. 50 ³ / ₈ (128) Kunsthalle, Hamburg 12
Bronze. $21\frac{5}{8} \times 21\frac{5}{8} (55 \times 55)$ Collection the artist 143	FONTANA, Lucio (b. Rosario di Santa Fè, Argentina, 1899) Concetta Spaziale. 1962
ERNST, Max Moon Mad. 1944	Ceramic Photo Carlo Orsi, Milan 331
Bronze. H. 38 (96.5) Collection Joseph H. Hirshhorn, New York	FRESNAYE, Roger de la (Le Mans, France, 1885—Grasse, France, 1925)
Photo The Solomon R. Guggenheim Museum, New York 144	Italian Girl. 1912 Bronze. $12\frac{1}{2} \times 24$ (31.5 × 61) Collection Joseph H. Hirshhorn, New
ERNST, Max The King playing with the Queen. 1944, cast 1954	York Photo M. Knoedler & Co., Inc., New York 69
Bronze. H. 34 ¹ / ₄ (87) Photo Rheinisches Bildarchiv, Stadt- museum, Cologne I45	FREUNDLICH, Otto (Stolp, Germany, 1878–Poland 1943)
ÉTIENNE-MARTIN (Martin Étienne) (b. Loriol, France, 1913) Lanleff, demeure no. 4. 1962 Plaster. $126 \times 51\frac{1}{8}$ (320×130)	Composition. 1933 Bronze. 90½×39⅔ (230×100) Rijksmuseum Kröller-Müller, Otterlo Photo Galerie Claude Bernard, Paris 86
Galerie Breteau, Paris 227	FRINK, Elizabeth (b. Thurlow, England, 1930)
ÉTIENNE-MARTIN Le grand Couple. 1949 Wood. $78\frac{3}{4} \times 31\frac{1}{2} (200 \times 80)$	Harbinger Bird III. 1960 Bronze. H. 17 (43·5) Collection Alexander Bernstein, London
Galerie Breteau, Paris Photo Leni Iselin 228	Photo Waddington Galleries, London 252

FULLARD, George (b. Sheffield, Eng-GABO, Naum Arch no. 2. 1960 land, 1924) The Patriot. 1959-60 Phosphor bronze. H. 18 (45.5) Painted wood. $70 \times 84\frac{1}{2}$ (177.5 × 214.5) Marlborough-Gerson Gallery, New York Collection the artist II2 Photo John Webb, London 307 GARELLI, Franco (b. Diano d'Albe, 1909) GABO, Naum (b. Briansk, Russia, 1890) Non Lasciarmi. 1962 Constructed Head, no. 2. 1916 Iron. H. 78³/₄ (200) Metal. H. $17\frac{3}{4}$ (45) Collection the artist 297 98 Collection the artist GARGALLO, Pablo (Mailla, Aragon, GABO, Naum 1881—Reus, Spain, 1934) Monument for a Physics Observatory. Picador. 1928 1922 Wrought iron. H. $9\frac{1}{2}$ (24) Plastic, metal, wood. H. 14 (35.5) Gift of A. Conger Goodyear, Museum of 102 Destroyed Modern Art, New York 56 Photo Soichi Sunami, New York GABO, Naum GAUDIER-BRZESKA, Henri (St Jean Column. 1923 de Brave, France, 1891-killed Western Plastic, metal, wood. H. 411 (105) Front, 1915) The Solomon R. Guggenheim Museum, Red Stone Dancer. 1914 New York 103 Waxed stone. $33\frac{1}{2} \times 8 \times 6$ (85 × 20 × 15) 78 Tate Gallery, London GABO, Naum Circular Relief. 1925 GAUGUIN, Paul (Paris, 1848-Atuana, Plastic on wood. Diam. $19\frac{1}{2}$ (49.5) Marquesas Islands, 1903) Collection the artist 104 Caribbean Woman (La Luxure). 1890-1 Wood carving. H. $27\frac{1}{2}$ (71) GABO, Naum J. F. Willumsens Museum, Frederikssund Spheric Theme. 1937 43 Opaque plastic. Diam. $22\frac{1}{2}(57)$ Collection the artist GHERMANDI, Quinto (b. Crevalcore, Photo E. Irving Blomstrann, Conn. 109 Bologna, 1916) Momento del volo. 1960 Bronze. $70\frac{7}{8} \times 47\frac{1}{4} \times 47\frac{1}{4}$ (180×120×120) GABO, Naum Construction in Space with crystalline 322 centre. 1938 GIACOMETTI, Alberto (Stampa, Swit-Plastic. W. 181 (47) zerland, 1901–1966) 108 Collection the artist Figure. 1928 Plaster GABO, Naum Photo Marc Vaux, Paris 139 Translucent Variation on Spheric Theme. 1951 version of 1937 original GIACOMETTI, Alberto Plastic. H. 223 (56.5) Man. 1929 The Solomon R. Guggenheim Museum, Bronze. H. 15 $\frac{3}{4}$ (40) New York IIO Collection Joseph H. Hirshhorn, New York 140 GABO, Naum GIACOMETTI, Alberto Construction in Space. 1953 Reclining Woman. 1929 Plastic, stainless steel springs, aluminium Painted bronze. L. 165/8 (42.5) base. H. 58 (147.5) Collection Joseph H. Hirshhorn, New Collection Mrs Miriam Gabo, Middlebury, Conn. York Photo The Solomon R. Guggenheim Photo Rudolph Burckhardt, New York Museum, New York 141 III

GIACOMETTI, Alberto The Palace at 4 a.m. 1932-3Construction in wood, glass, wire, string. $25 \times 28\frac{1}{2} \times 15\frac{3}{4}$ ($63:5 \times 71:5 \times 40$) The Museum of Modern Art, New York Photo Soichi Sunami, New York 142

GIACOMETTI, Alberto Man pointing. 1947 Bronze. H. including base 70 (178) Tate Gallery, London 147

GIACOMETTI, Alberto City Square. 1948–9 Bronze figurines. 5–6 (12·5–15·5) Collection Peggy Guggenheim, Venice Photo Perruzzi, Venice 146

GIACOMETTI, Alberto Monumental Head. 1960 Bronze. H. 37¹/₂ (95.5) Collection Joseph H. Hirshhorn, New York Photo Robert E. Mates, New York 148 GILBERT, Stephen (b. Scotland, 1910) Structure 15A. 1961 Polished aluminium. 48×20 (122 \times 50.5) Collection the artist Photo Étienne Bertrand Weill, Paris 303 GILIOLI, Émile (b. Paris, 1911) La Chimère. 1956 Polished Mexican Onyx. H. 12³/₄ (32.5) Collection Mr and Mrs Harry Lewis Winston, Detroit Photo Lew Gilchrest Studios, Birmingham, Michigan 199 GIORGI, Bruno (b. Mococo, Brazil, 1908) Two Amazons. 1963 Bronze. $31\frac{1}{2} \times 16\frac{7}{8} (80 \times 43)$ Collection the artist 280 GIORGI, Giorgio de (b. Genoa, 1918) La Colombe du Cap. 1961 Bronze on stone base (unique piece). $26\frac{1}{2} \times 20 \ (69.5 \times 50.5)$ Collection Mr and Mrs Harry Lewis Winston, Birmingham, U.S.A. (Mich.) Photo Joseph Klima Jr. 293 GISIGER, Hans-Jörg (b. Basle, 1919) Rhéa. 1959

Steel. $14\frac{3}{4} \times 27\frac{5}{8}$ (37.5 × 70) Collection the artist Photo Pierre Grandchamp

319

GONZALEZ, Julio (Barcelona, 1876-Arcueil, near Paris, 1942) Cabeza Llamada el Encapuchado. 1934 Bronze. H. 97/8 (25) Photo Galerie de France, Paris 57 GONZALEZ, Julio Hombre-Cactus, no. 2. 1939-40 Bronze. H. 31¹/₂ (80) Photo H. Guilbaud 60 GONZÁLEZ, Julio Mascara de Montserrat Gritando. 1936 Bronze. H. 198 (50) Photo H. Guilbaud 59 GOULD, David (b. New York, 1929) Welded Iron. c. 1962 H. 42 (106.5) Collection the artist Photo New Vision Centre, London 276 GRECO, Emilio (b. Catania, Sicily, 1913) Seated Figure. 1951, cast 1955 Bronze. H. 5218 (132.5) Tate Gallery, London 250 GRIS, Juan (José González) (Madrid, 1887—Boulogne-sur-Seine, 1927) Harlequin. 1917 Coloured plaster. H. 22 (56) Philadelphia Museum of Art Photo Galerie Louise Leiris, Paris 68 GUERRINI, Lorenzo (b. Milan, 1914) Mono macchina orizzontale. 1963 Stone of Bagnoregio. 61×63 (155 × 160) Collection the artist Photo Galerie Springer, Berlin 193 HAESE, Roël d' (b. Gramont, Belgium, 1921) La Nuit de Saint Jean. 1961 Bronze. $53\frac{1}{8} \times 51\frac{1}{8}$ (135 × 130) Galerie Claude Bernard, Paris Photo Luc Joubert, Paris 296 HAGUE, Raoul (b. Armenia, 1904) Sawkill Walnut. 1955 Walnut. H.42 (106.5) The Whitney Museum of American Art, New York Photo Oliver Baker, New York 203 HAJDU, Étienne (b. Turda, Rumania, 1907) Delphine. 1960 Marble. H. $20\frac{1}{2}$ (52) Collection M. Knoedler & Co. Inc., New York Photo Adolph Studly, New York 315

HARE, David (b. New York, 1917) Man with Drum, 1948	IPOUSTEGUY, Jean-Robert (b. Dun- sur-Meuse, France, 1920)
Bronze. H. $23\frac{5}{8}$ (60) 122	La Terre. 1962 Bronze. H. $68\frac{7}{8}$ (175) 180
HEILIGER, Bernhard (b. Stettin, 1915) Vegetative Sculpture, no. 1. 1956 Bronze. H. 78 (198) Staempfli Gallery Inc., New York Photo John D. Schiff, New York 150 HEPWORTH, Barbara (b. Wakefield, England, 1903) Pierced Form. 1931 Pink alabaster. II. 10 (25.5) Destroyed in the war Photo Paul Laib 206	JACOBSEN, Robert (b. Copenhagen, 1912) Noir Rouge. 1962 Wood and iron. 23 ¹ / ₄ ×21 ⁵ / ₅ (59×55) Galerie de France, Paris 292 JANČIĆ, Olga (b. Bitola, Macedonia, 1929) Doubled Form. 1962
HEPWORTH, Barbara	Plaster. 11×24 (28×61)Collection the artist201
Single Form. 1935 Satinwood, L. 12 (30.5) Destroyed 207	JESPERS, Oscar (b. Borgerhout, Bel- gium, 1887) Torso. c. 1921
HEPWORTH, Barbara Two Forms. 1937 White marble. H. 26 (66) Collection the artist 208	Freestone. H.48½ (123) Rijksmuseum Kröller-Müller, Otterlo 177
HEPWORTH, Barbara Pelagos. 1946 Wood with colour and strings. H. 16 (40·5) Collection the artist Photo John Webb, London 210	KEMENY, Zoltán (b. Banica, Hungary, 1907) Banlieu des Anges. 1958 Copper. H. 26 ³ / ₄ × 37 ³ / ₈ (68×95) Galerie Paul Facchetti, Paris 332
HEPWOR'I'H, Barbara Single Form (Memorial). $1961-2$ Bronze. $123 \times 78 \times 120$ ($312 \cdot 5 \times 198 \times 3^{04} \cdot 5$) Photo John Webb, London 211	 KNEALE, Bryan (b. Douglas, Isle of Man, 1930) Head in Forged Iron. 1961 24 × 8 (61 × 20·5) Redfern Gallery, London
HEPWORTH, Barbara Pierced Form (amulet). 1962 Bronze. H. 10½ (26·5). Edition of 9 Private Collections 209	Photo F. L. Kenett, London 295 KOENIG, Fritz (b. Würzburg, 1924) Herd X. 1958
HIQUILY, Philippe (b. Paris, 1925) Calvary. 1962 Forged iron. $29\frac{1}{2} \times 19\frac{5}{8}$ (75 × 50) Collection Institute of Contemporary Arts, London 334	Bronze. H. 17 ³ / ₄ (45) The Museum of Modern Art, New York Photo Galerie Gunther Franke, Munich 242 KOHN, Gabriel (b. Philadelphia, 1910)
HOFLEHNER, Rudolf (b. Linz, 1916) Doric Figure. 1958 Iron. H. 73§ (187) Kunsthaus, Zurich 224	Encliticus Urbanus. 1962 Wood. 50×38 (127×96·5) Marlborough-Gerson Gallery Inc., New York Photo O. E. Nelson, New York 234
HOSKIN, John (b. Cheltenham, England, 1927) Boltedflat. 1963 Steel. 49×96 (124 \cdot 5 \times 243 \cdot 5) Collection the artist	KOLBE, Georg (Waldheim, Germany, 1877—Berlin, 1947) Young Girl Standing. 1915 Bronze. H. 50% (128)
Photo John Webb, London 308	Mannheim Art Gallery 9
	295

KOLLWITZ, Käthe (Kaliningrad, Russia, 1867-Moritzburg, Germany, 1945) The Complaint. 1938 Bronze. $10\frac{1}{4} \times 9\frac{7}{8} (26.5 \times 25)$ Photo Bayerische Staatsgemäldesammlungen, Munich 15 KOMAN, Ilhan (b. Edirne, Turkey, 1921) Miroir II. 1962 Iron. H. 313 (80) Collection the artist 323 KOWALSKI, Piotr (b. Warsaw, 1927) Calotte 4. 1961 Concrete (5 pieces). H. 11 (28) Kunsthalle, Berne Photo Kurt Blum, Berne 200 KRICKE, Norbert (b. Düsseldorf, 1922) Space Sculpture. 1960 Steel. H. 275 (70) Collection Countess Jean de Beaumont, Paris Photo Galerie Karl Flinker, Paris 287 LARDERA, Berto (b. La Spezia, Italy, 1911) Slancio temerario, no. 2. 1958-9 Iron, steel and copper Galerije Grada Zagreba, Zagreb 29I LASSAW, Ibram (b. Alexandria, 1913) Counterpoint Castle. 1957 Bronze and copper. H. 39 (106.5) Kootz Gallery, New York 281 LAURENS, Henri (Paris, 1885-Paris, 1954) Composition in black and red sheet iron. 1914 $8 \times 11\frac{3}{4} (20.5 \times 30)$ Collection Madame Maurice Raynal, Paris IIS LAURENS, Henri Head. 1917 Stone. H. 25 5 (65) Stedelijk Museum, Amsterdam 7 I LAURENS, Henri Reclining Woman with raised arms. 1949 Bronze. L. $10\frac{1}{2}$ (26.5) Hanover Gallery, London 87 LE CORBUSIER, Charles Edouard (La Chaux-de-Fonds, Switzerland, 1887-1965) Ozon, Op. 1, 1947 Painted wood. H. 275 (70) Private Collection, Paris Photo Kurt Blum, Berne 105 LEHMBRUCK, Wilhelm (Meiderick, near Duisburg, 1881-Berlin, 1919) Young Man Seated. 1918 Bronze, H. 41 (104) Stadt Kunstmuseum, Duisburg 13 LEONCILLO, Leonardi (b. Spoleto, Italy, 1915) Sentimento del tempo. 1961 Red sandstone and enamel. $63 \times 19\frac{5}{8} \times 21\frac{5}{8}$ $(160 \times 50 \times 55)$ Galleria l'Attico, Rome 329 LIPCHITZ, Jacques (b. Druskieniki, Lithuania, 1891) Head. 1915 Bronze. H. $24\frac{1}{2}$ (62.5) Collection Joseph H. Hirshhorn, New York 75 LIPCHITZ, Jacques Guitar Player. 1918 Bronze. H. 28³/₈ (72) 76 Stadt Kunstmuseum, Duisburg LIPCHITZ, Jacques Figure. 1926-30 Bronze. H. 854 (217) Collection Joseph H. Hirshhorn, New York Photo The Solomon R. Guggenheim Museum, New York 79 LIPCHITZ, Jacques Reclining Nude with Guitar. 1928 Bronze. L. 27 (68.5) Collection Joseph H. Hirshhorn, New York Photo The Solomon R. Guggenheim Museum, New York 166 LIPCHITZ, Jacques Benediction I. 1942 Bronze. H. 42 (106.5) Collection Mr and Mrs Bernard J. Reis, New York Photo Eric Pollitzer, New York 84 LIPPOLD, Richard (b. Milwaukee, USA, 1915) Variations within a Sphere, no. 10: The Sun. 1953-6 Gold wire. $263\frac{3}{4} \times 131\frac{7}{8} \times 65\frac{7}{8}$ (670 × 335 × 167) Fletcher Fund, The Metropolitan Museum of Art, New York 286

LIPSI, Morice (b. Lodz, Poland, 1898) Volvic Stone. 1958 H.45‡ (115) Galerie Denise René, Paris 182	MARINI, Marino Portrait of Igor Stravinsky. 1951 Bronze. II. 12± (32°5) Kunsthalle, Hamburg 246
LIPTON, Seymour (b. New York, 1903) Mandrake. 1959 Bronze on monel metal. H. 36 (91.5) Collection Joseph H. Hirshhorn, New York	MARINI, Marino Dancer. 1954 Bronze. H.65½ (166·5) Collection Joseph H. Hirshhorn, New York
Photo The Solomon R. Guggenheim Museum, New York 214	Photo Robert E. Mates, New York 247
LUGINBÜHL, Bernhard (b. Berne, 1929) USRH (Space Clasp). 1962 Iron. H. 164 (41·5) Collection Mrs Heinz Schultz, New York Photo Grace Borgenicht Gallery, New York 239	MARTIN, Kenneth (b. Sheffield, Eng- land, 1905) Oscillation. 1962 Phosphor bronze. $5\frac{3}{4} \times 3\frac{1}{2} \times 3$ (14.5 × 9 × 7.5) Lord's Gallery, London 274
MAILLOL, Aristide (Banyuls-sur-Mer, France, 1861—Perpignan, 1944) Torso- of the Monument to Blanqui (Chained Action). c. 1905–6 Lead. H. 47½ (120·5) Tate Gallery, London 5	MARTINI, Arturo (Treviso, Italy, 1889 —Milan, 1947) Boy Drinking. 1926 Terracotta. Collection Arch. Mario Labò, Geneva 10
MALEVICH, Kasimir (Kiev, 1878–1935) Architectonics. 1924–8 Plaster, cardboard, wood, paint Present whereabouts unknown Photo Camilla Gray, London 97	MARTINS, Maria (b. Campanha, Brazil, 1900) Rituel du Rythme. 1958 Bronze. $355\frac{1}{4} \times 196\frac{7}{8}$ (750×500) Alvariadi Palace, Brasília Photo Marcel Gautherot, Rio de Janeiro
MANNUCCI, Edgardo (b. Fabriano, 1904) Resumption of idea no. 3. 1951–7 Aluminium. $55\frac{1}{8} \times 51\frac{1}{4} \times 19\frac{3}{4}$ (140×130.5 $\times 50.5$) Rijksmuseum Kröller-Müller, Otterlo Photo Jaap & Maarten d'Oliveira 298	185 MASTROIANNI, Umberto (b. Fontana Liri, near Rome, 1910) Conquest. 1954 Bronze. H. 453 (116) Rijksmuseum Kröller-Müller, Otterlo Photo Jaap & Maarten d'Oliveira 257
MANZÙ, Giacomo (b. Bergamo, 1908) Girl in Chair. 1955 Bronze. H.44 ³ /114) Collection Joseph H. Hirshhorn, New York Photo Robert E. Mates, New York 249	MATARÉ, Ewald (b. Aix-la-Chapelle, 1887) Torso. c. 1926 Wood. $20\frac{1}{2} \times 4\frac{3}{4} \times 4\frac{3}{8}$ (52.5 × 12.5 × 11.5) Stadt Kunstmuseum, Duisburg 248
MARCKS, Gerhard (b. Berlin, 1889) Freya. 1949 Bronze. H.66 ⁵ / ₈ (166·5) Gift of Curt Valentin, The Museum of Modern Art, New York Photo Soichi Sunami, New York II	MATISSE, Henri (Le Cateau, France, 1869—Nice, 1954) The Slave. 1900–3 Bronze. H. 36‡ (92) Cone Collection, Baltimore Museum of Art 24
MARINI, Marino (b. Pistoia, Italy, 1901) Horse and Rider. 1949–50 Polychrome wood. H. 71 (1805) Collection Krayenbühl, Zurich Photo Walter Dräyer, Zurich 245	MATISSE, Henri Madeleine I. 1901 Bronze. H. 23 ⁵ / ₈ (60) Cone Collection, Baltimore Museum of Art 25
	297

MATISSE, Henri Large Seated Nude. 1907 Bronze. H. 161 (41) Collection Joseph H. Hirshhorn, New York 29 MATISSE, Henri Reclining Nude I. 1907 Bronze. H. 132 (34.5) Art Cone Collection, Baltimore Museum of Art 33 MATISSE, Henri Decorative Figure. 1908 Bronze. H. 29 (75) Art Collection Joseph H. Hirshhorn, New York Photo O. E. Nelson, New York 27 MATISSE, Henri La Serpentine. 1909 Art Bronze. H. $22\frac{1}{4}$ (56.5) Baltimore Museum of Art 26 MATISSE, Henri The Back I. c. 1909 Bronze. H. 74 (188) Tate Gallery, London 36 MATISSE, Henri Jeanette V (Jeanne Vaderin, 5th state). 1910-11 Bronze. H. $22\frac{7}{8}$ (58) Lillie P. Bliss Bequest, The Museum of Modern Art, New York Photo Soichi Sunami, New York 28 MATISSE, Henri The Back II. c. 1913–14(?) 1919 Bronze. H. 735 (187) Tate Gallery, London 37 MATISSE, Henri The Back III. c. 1914 Bronze. H. 731 (186.5) Tate Gallery, London 38 MATISSE, Henri Seated Nude. 1925 Bronze. H. 311 (80) Cone Collection, Baltimore Museum of Art 30 MATISSE, Henri The Back IV. *c*. 1929 Bronze. H. 74 (188) York Photo Cauvin, Paris Tate Gallery, London 39

MATISSE, Henri Reclining Nude II. 1929 Bronze. H. 11¹/₈ (28.5) Tate Gallery, London 34 MATISSE, Henri Reclining Nude III. 1929 Bronze. H. $7\frac{7}{8}$ (20) Cone Collection, Baltimore Museum of 35 MATISSE, Henri Tiari with Necklace. 1930 Bronze. H. 81/2 (20.5) Cone Collection, Baltimore Museum of 3 I MATISSE, Henri Venus in a Shell. 1931 Bronze. H. 13 (33) Cone Collection, Baltimore Museum of 32 McWILLIAM, F. E. (b. Banbridge, Ireland, 1909) Puy de Dôme Figure. 1962 Bronze. $48 \times 96 \times 51$ (122 × 243 · 5 × 129 · 5) Faculty of Arts, Southampton University, England Photo John Webb, London 184 MEADOWS, Bernard (b. Norwich, 1915) Large Flat Bird. 1957 Bronze. H. 44 (111.5) Collection Gimpel Fils, London 260 MEDUNETZKY, Kasimir (b. Russia, 1899) Abstract Sculpture. Construction no. 557. Tin, brass, iron. H. 17³/₄ (45) Yale University Art Gallery, New Haven, Conn. Photo Camilla Gray, London 92 MEIER-DENNINGHOFF, Brigitte (b. Berlin, 1923) Gust of Wind, 1960 Brass and tin. $44 \times 41\frac{1}{4}$ (111.5 × 104.5) Staempfli Gallery, New York Photo John D. Schiff, New York 284 METCALF, James (b. New York, 1925) Ying Yang doré. 1963 Metal. H. 41³/₄ (106) Collection Joseph H. Hirshhorn, New

298

MINGUZZI, Luciano (b. Bologna, 1911)	MOORE, Henry (b. Castleford, near
The Shadows. 1956–7	Leeds, 1898)
Bronze. H. 70 (177.5)	Reclining Figure. 1929
Collection Joseph H. Hirshhorn, New	Brown Hornton stone. L. 33 (83.5)
York	City Art Gallery and Temple Newsam
Photo O. E. Nelson, New York 186	House, Leeds
	Photo the artist 167
MIRKO, Basaldella (b. Udini, Italy, 1910)	
Composition with Chimera. 1949	MOORE, Henry
Bronze. H. including base 28 (71)	Composition. 1931
Galleria Schneider, Rome 226	Cumberland alabaster. L. 16½ (42)
	Collection Mrs Irina Moore
MIRÓ, Joan (b. Barcelona, 1893)	Photo the artist 160
Bird. 1944–6	
Bronze. H. 7 ⁷ / ₈ (20)	MOORE, Henry
Galerie Maeght, Paris 153	Composition. 1931
	Blue Hornton stone. H. 19 (48.5)
MIRÓ, Joan	Collection Miss Mary Moore
Figurine. 1956	Photo the artist 164
Ceramic. H. $17\frac{3}{4}$ (45)	
Galerie Maeght, Paris 154	MOORE, Henry
0	Reclining Figure. 1938
MIRÓ, Joan	Bronze. H. $5\frac{1}{2}$ (14)
Man and Woman. 1956–61	Collection Peggy Guggenheim, Venice
Wrought iron, ceramic and wood. H.98	Photo Peter Cannon Brookes, London 52
(249)	MOODE H
Galerie Maeght, Paris	MOORE, Henry Bird Bashat, 1999
Photo Franco Cianetti 152	Bird Basket. 1939
4 -	Lignum vitae wood and string. $17 \times 13\frac{1}{2}$ (43.5 × 34.5)
MIRO, Joan	Collection Mrs Irina Moore
Ilead. 1961	Photo Lidbrooke, London 170
Ceramic. H. 24 (61)	
Galerie Maeght, Paris Photo Franco Cianetti 155	MOORE, Henry
Thoto Tranco Clanetti Tyy	Reclining Figure. 1945–6
MITCHELL Dania (h. Waaldstone	Elmwood. L. 75 (190.5)
MITCHELL, Denis (b. Wealdstone, England, 1912)	Collection Gordon Onslow-Ford
Gew Form. 1960	Photo the artist 165
Bronze. H. 12 (30.5)	
Waddington Galleries, London 187	MOORE, Henry
	Helmet Head, no. 2. 1950
MODIGLIANI, Amedeo (Livorno, Italy,	Bronze. H. 14 (35.5)
1884—Paris, 1920)	Private Collections
Head. 1912(?)	Photo Lidbrooke, London 169
Limestone. H. 25 (33)	
The Solomon R. Guggenheim Museum,	MOORE, Henry
New York 82	Time-Life Screen. 1952
	Portland stone. 318×120 (808×305)
MOHOLY-NAGY, László (Bacsbarsod,	Time-Life Building, London 168
Hungary, 1895—Chicago, 1946)	
Plexiglass and chromium-rod Sculpture.	MOORE, Henry
1946	King and Queen. 1952-3
H. $24\frac{1}{2}$ (62.5)	Bronze. H. $64\frac{1}{2}$ (163.5)
The Solomon R. Guggenheim Museum,	Collection W. J. Keswick, Glenkiln,
New York	Scotland
Photo Sibyl Moholy-Nagy 107	Photo the artist 172
	299
	-99

MOORE, Henry NEVELSON, Louise (b. Kiev, 1900) Royal Tide V. 1960 Internal and External Forms. 1953-4 Elmwood. H. 103 (261.5) Wood painted gold (21 compartments) $80\frac{3}{4} \times 102 (205 \times 259)$ Albright-Knox Art Gallery, Buffalo, USA Private Collection Photo the artist 156 328 Photo Robert David, Paris MOORE, Henry NOGUCHI, Isamu (b. Los Angeles, 1904) Glenkiln Cross. 1955–6 Study from a Mill Stone. 1961 Bronze. H. $132\frac{1}{4}(336)$ Granite. H. 25 (63.5) Collection W. J. Keswick, Glenkiln, Collection the artist 318 Scotland Photo the artist 171 NOGUCHI, Isamu Black Sun. 1961-2 MOORE, Henry Granite. H. 30 (76.5) Two-piece Reclining Figure, no. 1. 1959 Collection the artist 317 Bronze. 76×51 (193 × 129.8) Photo the artist 53 PAOLOZZI, Eduardo (b. Edinburgh, 1924) MOORE, Henry Head. 1957 Reclining Mother and Child. 1960-1 Bronze. H.38 (96.5) Bronze. $33\frac{1}{4} \times 86\frac{1}{2} (84.5 \times 219.5)$ Private Collection, USA Collection Mr and Mrs Harry Lewis, Winston, Birmingham, U.S.A. (Mich.) 161 Photo the artist Photo David Farrell, Gloucester 269 MOORE, Henry PAOLOZZI, Eduardo Standing Figure (Knife-Edge). 1961 Japanese War God. 1958 Bronze. H. 112 (284.5) Bronze. H. 60 (153) Photo the artist 157 Albright-Knox Art Gallery, Buffalo, USA Photo David Farrell, Gloucester 270 MOORE, Henry Three-piece Reclining Figure. 1961-2 PAOLOZZI, Eduardo Bronze. $59 \times 114 (150 \times 289.5)$ Hermaphroditic Idol, no. 1. 1962 Photo the artist 173 Aluminium. H. 72 (183) Collection the artist MOORE, Henry Photo David Farrell, Gloucester 227 Sculpture (Locking Piece). 1962 Bronze. H. 42 (106.5) PAOLOZZI, Eduardo The City of the Circle and the Square. Collection and photo the artist 174 1963 Aluminium. H. 84 (213.5) MULLER, Robert (b. Zurich, 1920) Tate Gallery, London Archangel. 1963 Photo Tudor Photos Ltd Iron. $61 \times 31\frac{1}{2} \times 23\frac{5}{8}$ (155 × 80 × 60) 273 Galerie de France, Paris Photo Luc Joubert, Paris PASMORE, Victor (b. Chesham, Eng-275 land, 1908) Relief construction in white, black and NASH, Paul (Dymchurch, England, 1889) —Boscombe, 1946) indian red. 1962 Painted wood and plastic. $24 \times 25 \times 11$ Found object interpreted. (Vegetable Kingdom). c. 1935 $(61 \times 63.5 \times 28)$ Wood. Collection Marlborough Fine Art Limited, Whereabouts unknown 136 London 338 PASMORE, Victor NELE, Eva Renée (b. Berlin, 1932) Abstract in white, ochre and black. Trans-The Couple. 1961 parent projective relief. 1963 Bronze. $21\frac{1}{2} \times 13\frac{3}{8} (54.5 \times 34)$ Bayerische Staatsgemäldesammlungen, Painted wood and plastic. $32 \times 35 \times 18$ Munich $(81.5 \times 89 \times 45)$ Collection Dr Rudolph Blum, Zurich Photo Galerie Otto van de Loo, Munich 271

PENALBA, Alicia (b. Buenos Aires,	PICASSO, Pablo
1918)	Head of a Woman. 1907
Forêt Noir, no. 2. 1960	Bronze. H. $5\frac{7}{8}$ (15)
Bronze. $38\frac{1}{8} \times 15\frac{3}{4} (97 \times 40)$	Photo Brassaï, Paris 41
Galerie Charles Lienhard, Zurich 191	DIGLOGO DIL
	PICASSO, Pablo
PEVSNER, Antoine (Orel, Russia, 1886	Head of a Woman. 1909–10
—Paris, 1962)	Bronze. H. 16 (40.5) Collection Joseph H. Hirshhorn, New
Head of a Woman (Construction). 1925	York
Wood and plastic. $14\frac{3}{4} \times 9\frac{1}{2} \times 9\frac{1}{2} (37.5 \times 24)$	Photo Brassaï, Paris 54
× 24) Collection André Lefebre, Paris	
Photo Marc Vaux, Paris 100	PICASSO, Pablo
	Glass of Absinthe. 1914
PEVSNER, Antoine	Painted bronze. H.8 ³ / ₄ (21.5)
Projection into Space. 1924	Collection Daniel-Henry Kahnweiler,
Oxidized bronze. $20\frac{1}{2} \times 23\frac{1}{4}$ (51×59)	Paris
Baltimore Museum of Art I3I	Photo Jacqueline Hyde, Paris 55
,	DICASSO D11
PEVSNER, Antoine	PICASSO, Pablo
Torso (Construction). 1924–6	Mandolin. 1914 Construction in wood. H.23½ (59·5)
Copper and plastic. H. 75 (190.5)	Collection the artist 88
Gift of Katherine S. Dreier, The Museum	
of Modern Art, New York 101	PICASSO, Pablo
	Bathing Woman. Design for a Monument.
PEVSNER, Antoine	Cannes 1927
Portrait of Marcel Duchamp. 1926	Charcoal drawing. $11\frac{3}{4} \times 8\frac{5}{8}$ (30×22).
Celluloid on zinc. $37 \times 25\frac{5}{8}$ (94×65)	Album page 162
Yale University Art Gallery, New Haven, Conn. 99	DIGLOGO DIL
Conn. 99	PICASSO, Pablo
PEVSNER, Antoine	Design for a Monument. 1929 Bronze. H. 10 ⁵ / ₈ (27)
Developable Surface. 1938	Collection the artist
Copper. $24\frac{3}{4} \times 20\frac{3}{4}$ (63 × 53)	Photo Brassaï, Paris 163
Collection O. Müller, Basle 113	,
	PICASSO, Pablo
PEVSNER, Antoine	Construction in wire. 1930
Column. 1952	H. $12\frac{5}{8}(32)$
Bronze and brass. $55\frac{3}{4} \times 15\frac{3}{4} \times 15\frac{3}{4}$ (141.5	Collection the artist
×40×40)	Photo Brassaï, Paris 66
Collection Baroness Lambert, Brussels	DICASSO D.11-
114	PICASSO, Pablo Construction (Head). 1930–1
PHILLIPS, Helen (b. Fresno, California,	Wrought iron. H. $39\frac{3}{8}$ (100)
1913)	Collection the artist 58
Moon. 1960	Someenen ine artist
Bronze. $36 \times 16 \times 16$ ($85 \times 40.5 \times 40.5$)	PICASSO, Pablo
Collection the artist	Stick-statuette. 1931
Photo Arno Mandello 196	Bronze. H. $7\frac{7}{8}$ (20)
	Photo Brassaï, Paris 61
PICASSO, Pablo (b. Malaga, Spain, 1881)	
Mask. 1901	PICASSO, Pablo
Bronze. H. $7\frac{3}{4}$ (19.5)	Stick-statuettes. 1931
Marlborough-Gerson Gallery, New York	Bronze. H. $7\frac{7}{8}$ (20) (<i>left</i>). Bronze. H. $7\frac{7}{8}$
Photo Rudolph Burckhardt, New York 40	(20) (<i>right</i>) Photo Brassaï, Paris 62
40	
	301

PICASSO, Pablo RICKEY, George (b. South Bend, Stick-statuettes. 1931 Indiana, 1907) Bronze. H. 161 (42) (left). Bronze. H. 161 Summer III. 1962-3 (41) (right) Stainless steel. H. 144 (366) Photo Brassaï, Paris 63 Collection Joseph H. Hirshhorn, New York Photo John Webb, London 283 PICASSO, Pablo Stick-statuettes. 1931 Bronze. H. $16\frac{1}{2}$ (42) (*left*). Bronze. H. $16\frac{7}{8}$ RIVERA, José de (b. West Baton Rouge, (43) (right) Louisiana, 1904) Photo Brassaï, Paris 64 Construction no. 35. 1956 Steel. H. $17\frac{3}{4}$ (45) PICASSO, Pablo Collection Joseph H. Hirshhorn, New York Stick-statuette. 1931 Photo O. E. Nelson, New York Bronze. H. $20\frac{1}{2}$ (51) 274 65 Photo Brassaï, Paris RODCHENKO, Alexander (St Peters-PICASSO, Pablo burg 1891—1956) Head of a Woman. 1951 Construction 1917 Bronze. H. $21\frac{1}{2}(54.5)$ Object destroyed Photo from the private archives of Collection Joseph H. Hirshhorn, New York Alfred H. Barr Jr., New York 90 Photo The Solomon R. Guggenheim Museum, New York 42 RODCHENKO, Alexander Construction of Distance. 1920 PICASSO, Pablo Wood. Baboon and Young. 1951 Private Collection Bronze. H. 21 (53.5) Photo from the private archives of Mrs Simon Guggenheim Fund, The Alfred H. Barr Jr., New York 94 Museum of Modern Art, New York 268 Photo Soichi Sunami, New York RODCHENKO, Alexander Hanging Construction. 1920 PICASSO, Pablo Wood. Bouquet. 1953 Whereabouts unknown Bronze. H. 24 (61) Photo from the private archives of Marlborough-Gerson Gallery, New York Alfred H. Barr Jr., New York 95 Photo Brenwasser 50 RODIN, Auguste (Paris, 1840-Meudon, RAY, Man (b. Philadelphia, 1890) 1917) Photograph The Age of Bronze. 1876-7 Mathematical Object. Kummer's plane Bronze. H. 714 (181) surface with sixteen points, of which Tate Gallery, London 2 eight are true 128 RENOIR, Auguste (Limoges, France, RODIN, Auguste Iris, Messenger of the Gods. 1890-1 1841—Cagnes, France, 1919) Standing Venus (Venus Victorious). 1914 Bronze. 33×34 ($83 \cdot 5 \times 86 \cdot 5$) Collection Joseph H. Hirshhorn, New Bronze. H. 72 (183) Tate Gallery, London York 20 22 RICHIER, Germaine (Grans, near Arles, RODIN, Auguste 1904—Paris, 1959) Monument to Balzac. 1893-7. Version of The Bat. 1952 1897 Plaster. H. 47 (119.5) Stucco. H. 1134 (289) Photo Peter Heman, Basle 25 I Musée Rodin, Paris 4

ROSATI, James (b. Washington, Penn., 1912) Delphi IV. 1961 Bronze. H. 27½ (69·5) Marlborough-Gerson Gallery, New York Photo Rudolph Burckhardt, New York 197	SCHMIDT, Julius (b. Stamford, Conn., 1923) Cast Iron. 1961 $18\frac{1}{2} \times 38\frac{1}{2}$ (47 × 97·5) Marlborough-Gerson Gallery, New York Photo Rudolph Burckhardt, New York 265
ROSENTHAL, Bernard (b. Highland Park, Illinois, 1914) Riverrun. 1959 Black aluminium. $87 \times 57\frac{5}{8}$ (221×151.5) 333 ROSSO, Medardo (Turin, 1858—Milan,	SCHNIER, Jacques (b. Constanza, Ru- mania, 1898) Cubical Variations within rectangular Column. 1961 Copper. 83×14×12 (210.5×35.5×30.5) Collection the artist 233
1928) Ecce Puer. 1906–7 Wax over plaster. H. 17 (43.5) Collection Mr and Mrs Harry Lewis Winston, Detroit Photo Oliver Baker, New York 7 ROSSO, Medardo	SCHÖFFER, Nicolas (b. Kolosca, Hungary, 1912)Spatiodynamique no. 19. 1953Brass and iron. $39\frac{3}{4} \times 28 \times 32\frac{5}{8}$ (101 × 71 × 83)Galerie Denise René, Paris231
Conversazione in Giardino. 1893 Bronze. $13 \times 26\frac{3}{8} \times 15\frac{7}{8}$ ($33 \times 67 \times 40.5$) Galleria Nazionale d'Arte Moderna, Rome 3	SCHWITTERS, Kurt (Hanover, 1887— Ambleside, England, 1948) Merzbau. Begun 1920, destroyed 1943 Photo Landesgalerie, Hanover 125
ROSZAK, Theodore (b. Poznan, Poland, 1907) Night Flight. 1958–62 Steel. 92×125 (238.5×317.5) Collection the atlist Photo Pierre Matisse Gallery, New York 241	SCHWITTERS, Kurt Autumn Crocus. 1926–8 Cast. Composition stone. H. 31½ (80) Lord's Gallery, London Photo John Webb, London 126
RUGG, Matt (b. Bridgwater, England, 1935) Boomerang. 1963 Wood construction. $39\frac{3}{4} \times 36\frac{3}{4}$ (101 × 93.5) Collection John Hubbard, Dorset 337 SALVATORE (Messina Salvatore) (b. Palermo, 1916)	SCHWITTERS, Kurt Ugly Girl. c. 1943–5 Painted wood and plaster. $10\frac{1}{4} \times 12\frac{1}{4} \times 9\frac{1}{4}$ $(26 \times 31 \times 23.5)$ Lord's Gallery, London Photo John Webb, London 127
Corrida Bronze. $94\frac{1}{2} \times 70\frac{7}{8} (240 \times 180)$ 181 SCHLEEH, Hans (b. Koenigsberg, Germany, 1928)	SELEY, Jason (b. Newark, New Jersey, USA, 1919) Magister Ludi. 1962 Chrome-plated steel (car bumpers). H. 96
Abstract Form in Serpentine. $27\frac{1}{2} \times 15 \times 7\frac{1}{2}$ (69.5 × 38 × 19) Dominion Gallery, Montreal 194	(243·5) Collection Governor Nelson D. Rocke- feller, New York Photo John Webb, London 267
SCHLEMMER, Oskar (Stuttgart, 1888— Baden-Baden, 1943) Abstrakte Rindplastik. 1921 Bronze gilded. H.41 (104 [.] 5) Bayerische Staatsgemäldesammlungen, Munich 121	SINTENIS, Renée (b. Glatz, Poland, 1888) Football Player. 1927 Bronze. H. 16 (40.5) Rijksmuseum Kröller-Müller, Otterlo 14
	202

SMITH, David (Decatur, USA, 1906-Albany, USA, 1965) Royal Bird. 1948 Stainless steel. $21\frac{3}{4} \times 59 \times 9$ (55.5×150× 23) Walker Art Center, Minneapolis 217 SMITH, David Cubi IX. 1961 Steel. $107 \times 51\frac{1}{2} (271.5 \times 130.5)$ Collection the artist Photo John Webb, London 218 SOMAINI, Francesco (b. Lomazzo, Como, 1926) Grand Blessé, no. 1. 1960 Lead (unique piece). $34 \times 60 \times 45$ (86.5 × 152.5×114.5). H. including base 72 (183)Collection Mr and Mrs Harry Lewis Winston, Detroit Photo Joseph Klima Jr. 313 STAHLY, François (b. Konstanz, Germany, 1911) Model for a Fountain for the University of St Gall, Switzerland Bronze. H. 2364 (600) Photo Leni Iselin 220 STANKIEWICZ, Richard (b. Philadelphia, 1922) Untitled. 1961 Iron and steel. H. 84(213.5)Stable Gallery, New York Photo John Webb, London 278 STARTUP, Peter (b. London, 1921) Falling Figure. 1960 Lime, sycamore and pine. H. 90 (228.5) Collection the artist Photo Alfred Lammer, London 223 TAJIRI, Shinkichi G. (b. Los Angeles, 1923) Relic from an Ossuary. 1957 Bronze. H. $13\frac{3}{4}(35)$ Collection the artist 312 TATLIN. Vladimir Evgrafovich (Kharkov, 1885-Moscow, 1953) Relief. 1915 Iron etc. Whereabouts unknown. Presumed destroyed Photo Camilla Gray, London 89

TATLIN, Vladimir Relief, 1914 Wood, glass, tin can etc. Whereabouts unknown. Presumed destroyed Photo Camilla Gray, London 91 TATLIN, Vladimir Monument to the Third International. 1919-20 Wood, iron, glass Remnants of this maquette are stored in the Russian Museum, Leningrad 96 Photo Camilla Gray, London TAUEBER-ARP, Sophie (Davos, Swit-zerland, 1889—Zurich, 1943) Last Construction, no. 8. 1942 Bronze relief. 14×14 ($35 \cdot 5 \times 35 \cdot 5$) Galerie Denise René, Paris Photo Étienne Bertrand Weill, Paris 129 TEANA, Marino di (b. Teana, Italy, 1920) Espace et Masse libérés - hommage à l'architecture. 1957 Steel. $41\frac{3}{8} \times 45\frac{1}{4} \times 15\frac{3}{4}$ (105 × 120 × 40) Galerie Denise René, Paris 237 THOMMESEN, Erik (b. Copenhagen, 1916) Woman. 1961 Black oak. H. 60% (154) Louisiana Museum 202 THORNTON, Leslie (b. Skipton, England, 1925) The Martyr. 1961 Steel and bronze. H. 691 (176.5) Collection and photo Gimpel Fils, London 310 TINGUELY, Jean (b. Basle, 1925) Monstranz. 1960 Junk-mobile. H. 36 (91.5) Staempfli Gallery, New York Photo John D. Schiff, New York 311 TURNBULL, William (b. Dundee, 1922) Llama. 1961 Bronze and rosewood. H. 61 (155) Private Collection, USA Photo Kim Lim 204 TURNBULL, William Oedipus. 1962 Bronze, rosewood and stone. H. 65 1 (166.5) Collection Weiner, USA Photo Kim Lim 205

UBAC, Raoul (b. Malmédy, France, 1910) Relief. Slate. H. 29½ (74.5)	VOULKOS, Peter H. (b. Bozeman, Montana, USA, 1924) Terracotta Sculpture.
Stadt Kunstmuseum, Duisburg 261	H. $29\frac{7}{8}$ (76) 175
UHLMANN, Hans (b. Berlin, 1900) Rondo. 1958–9 Brass. H. 59 (150) Collection the artist Photo Gnilka, Berlin 300	WARREN DAVIS, John (b. Christ- church, England, 1919) Imago, no. 2. 1963 Painted plaster. $96 \times 42 \times 36$ (243.5 × 106.5 ×91.5) Lord's Gallery, London
UHLMANN, Hans Steel Relief. 1959 Black, red and white coloured steel. $126 \times 196\frac{7}{6}$ (320×500) Physics Institute, Freiburg University	Photo John Webb, London 330 WERTHMANN, Friederich (b. Wupper- tal, Germany, 1927)
UHLMANN, Hans Sculpture for the Berlin Opera House. 1961	Entelechie II. 1960 Stainless steel welded. Diam. 78¼ (200) Collection August Thyssen-Hütte, Hamborn 320
Steel, chrome and nickel, coloured black. H.65'7 [§] / ₂ (20 m.) Photo Gnilka, Berlin 302	WIGGLI, Oscar (b. Soleure, Switzerland, 1927) Untitled. 1962
VANTONGERLOO, Georges (Ant- werp, 1886–Paris, 1965) Sculpture in Space: $y=ax^3-bx^3$. 1935	Iron. H. 11 ³ / ₄ (30) Collection Marcel Joray, Neuchâtel Photo the artist 294
Argentine. H.15 (38) Kunstmuseum, Basle 106	WINES, James (b. Chicago, 1932)
VIANI, Alberto (b. Quistello, Italy, 1906) Torso. 1956–62 Marble. H. 57½ (146) Galleria Odyssia, Rome Photo F. Tas 195	Corona I, 1962 Bronze and cement. 45 × 28 (114·5 × 71) Private Collection, Long Island, New York Photo Marlborough-Gerson Gallery, New York 266
VIEIRA, Mary (b. São Paulo, 1927) Tension-Expansion (Rythmes dans l'Espace). 1959 Aluminium. 66¼×99¼ (167·5×252) Middelheim Park, Antwerp 289	WOTRUBA, Fritz (b. Vienna, 1907) Figure with raised arms. 1956–7 Bronze. H. 70 [§] (179 [.] 5) Collection Joseph H. Hirshhorn, New York
VISSER, Carel Nicolaas (b. Papendrecht, near Rotterdam, 1928)	Photo The Solomon R. Guggenheim Museum, New York 219
Fugue. 1957 Iron. H. 11 ² (30) Collection I. M. Pei, New York Photo Jan Versnel, Amsterdam 238	WOTRUBA, Fritz Reclining Figure. 1960 Limestone. W. 55½ (140) Galerie Charles Lienhard, Zurich 225
VOLTEN, André (b. Andijk, Holland, 1925) Architectonic Construction. 1958 Metal. H. 254 (64) Rijksmuseum Kröller-Müller, Otterlo	ZADKINE, Ossip (Smolensk, 1890– Paris, 1967) Standing Woman. 1920 Bronze
Photo Hans Sibbelee, Amsterdam 230	Collection the artist 77

Index

Italic figures refer to pages on which illustrations appear

Aalto, Alvar, 114 Abstract art, 56, 63 Abstract Expressionism, 26, 229 'Abstraction-Création' group, 111 Action painting, 229 Adam, Henri-Georges, 262 Adams, Robert, 208 Aegean art, 84 Aeschbacher, Hans, 206 African art, 43, 51, 52, 59, 61, 66, 84, 85, 171, 181, 187 Agostini, Peter, 257 Albers, Josef, 105 Analytical Cubism, 89, 95, 123 Anglo-Saxon sculpture, 167 Anthoons, Willy, 186 Apollinaire, Guillaume, 59, 140 Archipenko, Alexander, 10, 73, 74, 115, 116, 125, 134, 173, 227 Armitage, Kenneth, 212, 219, 222, 223, 228 Arp, Hans (Jean), 18, 41, 53, 56, 58, 71, 82-4, 83, 135, 136, 147-51, 152, 153, 153, 160, 192, 204, 209, 250 Art nouveau, 26, 80 Avramidis, Joannis, 202 Ayrton, Michael, 215 Babylonian art, 84 Baer, Vico, 115 Bakić, Vojin, 258 Bakunin, Michael, 145 Baldessari, 247 Ball, Hugo, 148

Balla, Giacomo, 121, 124, 134, 135 Balzac, Honoré, 17, 18, 22 Barlach, Ernst, 25, 26, 27 Baroque art, 129, 187

Barr, Alfred H., Jr., 41, 63, 170

Barye, Antoine-Louis, 37 Baskin, Leonard, 27, 219, 228 Baudelaire, Charles, 142 Bauhaus, 27, 103-5 Beckmann, Max, 218 Beethoven, Ludwig van, 21 Bell, Quentin, 10 Belling, Rudolf, 224 Benazzi, Raffael, 190 Béothy, Étienne, 185 Bernard, Émile, 47 Berthold, Joachim, 181 Bertoia, Harry, 263 Bertoni, Wander, 253 Bill, Max, 107, 245, 252 Blake, William, 142, 225 Blanqui, Louis-Auguste, 19 Bloc, André, 213 Boccioni, Umberto, 23, 92, 110, 115, 117-19, 121, 121, 124, 125-30, 133-5, 138-40, 227 Bodmer, Walter, 242, 245 Bonnard, Pierre, 28-30, 28 Bourdelle, Antoine, 10, 20, 21, 27, 250 Bourgeois, Louise, 203 Brancusi, Constantin, 10, 50, 51, 58, 72, 78, 79-83, 81, 85, 116, 132, 141, 173, 182-4, 187-96, 199, 202, 204, 207, 217, 219, 227, 250 Brauner, Victor, 141, 263 Braque, Georges, 49, 56, 59-63, 115, 123, 136, 146 Breton, André, 156, 160, 162 Brown, Ralph, 215 Bruni, Lev, 91, 96 Buddhist art, 44 Burke, Edmund, 256 Butler, Reg, 200, 204, 212, 215, 219, 228, 245

Calder, Alexander, 69, 75, 162, 228, 245, 245 Callery, Mary, 244 Caricature, 12 Caro, Anthony, 239 Carpeaux, Jean-Baptiste, 11, 12 Carra, Carlo, 121, 135, 139 Carroll, Lewis, 142 Cascella, Andrea, 185 Cascella, Pietro, 186 Celtic art, 43 César (César Baldaccini), 230, 234, 235, 247, 255, 269, 270, 271 Cézanne, Paul, 9, 10, 15, 54, 59, 60, 62, 88, 115 Chadwick, Lynn, 198, 204, 212, 218, 228, 247 Chamberlain, John, 255, 269, 270 Chillida, Eduardo, 247, 250 Chinoiserie, 44 Clarke, Geoffrey, 179 Clatworthy, Robert, 221 Collingwood, R. G., 70, 71 Consagra, Pietro, 262 Constructivism, 14, 42, 70, 88-114, 142, 229 Cornell, Joseph, 264, 264 Coulentianos, Costas, 183 Courbet, Gustave, 271 Cousins, Harold, 240 Cubism, 9, 23, 28, 42, 54, 56, 59-69, 85-8, 115, 116, 123, 134-40, 142, 145, 146, 154, 229 Dada, 82, 142-56, 233 Dalou, Jules, 11, 12, 22 Dalwood, Hubert, 209, 212 Daumier, Honoré, 11, 11, 12 Degas, Edgar, 15, 23, 28, 28, 30-2, 30, 33, IIS Delaunay, Roger, 123, 124 Denis, Maurice, 32 Derain, André, 51 Derain, Mme, 20 Despiau, Charles, 20, 20, 21 Diaghilev, Serge, 11 Divisionism, 123, 137 Dodeigne, Eugène, 180 Doesburg, Theo van, 104 Donatello, 18 Dostoevsky, Fyodr, 98 Dubuffet, Jean, 255 Duccio, Agostino di, 267

Duchamp, Marcel, 109, 110, 134, 137, *138*, 141, 145, 147, 154–6, 263 Duchamp-Villon, Raymond, */4, 120* Dufy, Raoul, 140 Dynamism, 122, 129, 130, 134, 137, 138, 140, 141 Dzamonja, Dusan, *227*

Early Christian art, 43 Eclecticism, 15, 23, 43–58, 258 Egyptian art, 48, 52, 84, 181 Ehrenburg, Ilya, 102 Einstein, Albert, 212 Epstein, Jacob, 166, *166* Ernst, Max, 72, *137*, *140*, *145–7*, 149, 150, 153, 154, 160–2, 207, 218, 263 Escholier, Raymond, 32, 36 Étienne-Martin, *204*, *205*, 212, 228, 229 Etruscan art, 43, 52, 73, 181, 258 Expressionism, 26, 42, 45, 91, 100, 229 Exter, Alexandra, 92

Fabbri, Agenore, 219 Falkenstein, Claire, 260 Far Eastern art, 43, 52 Feddersen, Hans P., 225 Ferber, Herbert, 239 Filinov, Pavel, 92 Fiori, Ernesto de, 23, 24 Fontana, Lucio, 268 Fresnaye, Roger de la, 72 Freundlich, Otto, 84 Frink, Elizabeth, 221 Fullard, George, 254 Futurism, 23, 88–90, 92, 100, 115–42 Futurist manifestoes, 117–23, 135, 141

Gabo, Naum, 14, 58, 70, 78, 93–7, 96, 100, 101, 101, 102, 105–9, 109–14, 228, 232 Garelli, Franco, 249 Gargallo, Pablo, 62, 66 Gaudeir-Brzeska, Henri, 76 Gauguin, Paul, 28, 29, 44, 47, 47, 48, 50 Géricault, Théodore, 17 Ghermandi, Quinto, 260 Giacometti, Alberto, 72, 73, 75, 76, 142–4, 148, 149, 151, 158–61, 204, 209, 212, 217, 219, 228, 242 Gide, André, 32

Giedion-Welcker, Carola, 8, 160 Gilbert, Stephen, 252 Gilioli, Émile, 190 Giorgi, Bruno, 240 Giorgi, Giorgio de, 248 Gisiger, Hans-Jörg, 259 Goncharova, Natalia, 92 González, Julio, 10, 63, 64-7, 65 Gothic art, 25, 26, 45, 53, 181, 182 Gould, David, 238 Goya, 12, 257 Greco, Emilio, 219 Greek art, 26, 43, 44, 52, 181, 258 Gris, Juan, 72, 124 Gropius, Walter, 27, 103, 114 Grünewald, Mathis, 257 Gsell, Paul, 12 Guerrini, Lorenzo, 187 Guino, Richard, 30 Haese, Roël d', 249 Haftmann, Werner, 223 Hague, Raoul, 192 Hajdu, Étienne, 258, 258 Hare, David, 123 Häring, Hugo, 110 Hartung, Karl, 228 Hegel, Georg, 156 Heiliger, Bernhard, 152 Hennings, Emmy, 148 Hepworth, Barbara, 112, 192-6, 194-7, 199, 202, 204, 219 Hildebrand, Adolf, 24, 25 Hiquily, Philippe, 269 Hirshhorn, Joseph H., 8 Hoflehner, Rudolf, 203, 247 Hoskin, John, 247, 254 Huelsenbeck, Richard, 148 Huysmans, J.-K., 32 Ibsen, Henrik, 49, 98 Impressionism, 9, 10, 15-18, 20, 21, 31, 32, 37, 42, 87-9, 128, 229 Ingres, Jean Auguste Dominique, 115 Ipousteguy, Jean-Robert, 181 Jacobsen, Robert, 247, 247 Jančić, Olga, 191

Janco, Marcel, 148 Japanese art, 44 Jespers, Oscar, *180* Jianou, Ionel, 189, 191

Jugendstil, 26 Jung, Carl, 151, 204 Kahnweiler, Daniel-Henry, 62, 66, 75, 88, 136, 139 Kandinsky, Wassily, 91, 93, 101 Karpel, Bernard, 8 Kemeny, Zoltán, 268 Kneale, Bryan, 247, 248 Koenig, Fritz, 242 Kohn, Gabriel, 208 Kolbe, Georg, 22, 24 Kollwitz, Kathe, 26, 26, 27 Koman, Ilhan, 261 Kowalski, Piotr, 190 Kricke, Norbert, 243, 245 Lardera, Berto, 234, 246, 247 Larionov, Mikhail, 92 Lassaw, Ibram, 240, 245 Laurens, Henri, 10, 73, 74, 85, 116, 134, 228, 250 Laurens, Jean Paul, 19 Lebel, Robert, 154-6 Le Corbusier, Charles Edouard, 102, 102, 114 Léger, Fernand, 102, 146 Lehmbruck, Wilhelm, 24, 24, 250 Leoncillo, Leonardi, 266 Lerner, Abram, 8 Lipchitz, Jacques, 10, 75, 77, 82, 170, 218, 227, 242 Lippold, Richard, 76, 234, 242, 245 Lipsi, Morice, 183 Lipton, Seymour, 199 Lissitzky, Lazar, El, 101, 102 Luginbühl, Bernhard, 211 Magic, 70, 71, 76, 84, 156, 228 Maillol, Aristide, 10, 19, 20-3, 30, 34, 35, 250 Malevich, Kasimir, 89-92, 95 Manet, Edouard, 15 Mannerism, 12, 25, 232 Mannucci, Edgardo, 249 Manzù, Giacomo, 218, 219 Marcks, Gerhard, 23, 24, 26, 27 Marinetti, Filippo Tommaso, 117, 118, 144 Marini, Marino, 216-18, 218, 228, 242, 258 Martin, Kenneth, 274 Martini, Arturo, 22, 24

Martins, Maria, 184 Marx, Karl, 49 Mastroianni, Umberto, 219, 224 Mataré, Ewald, 218 Matisse, Henri, 28, 30-42, 34-41, 51, 140, 156, 250 McWilliam, F. E., 183 Meadows, Bernard, 226 Medunetzky, Kasimir, 91, 96 Meier-Denninghoff, Brigitte, 241 Menkov, 92 Mesopotamian art, 181 Messer, Thomas M., 8 Metcalf, James, 252 Mexican art, 52, 84, 171, 181 Michelangelo, 12, 14, 18, 28, 150 Middle Ages, 14, 26, 191 Milarepa, 79 Millet, Jean François, 48, 52 Minguzzi, Luciano, 184, 204, 212 Mirko (Basaldella Mirko), 204, 212 Miró, Joan, 157, 159, 161, 162, 170, 207, 228, 263 Mitchell, Denis, 185 Modigliani, Amedeo, 79, 80 Moholy-Nagy, László, 102, 103, 105-8 Mondrian, Piet, 104, 109, 112, 114, 232 Monet, Claude, 15 Moore, Henry, 14, 18, 41, 53, 56, 57, 58, 72, 78, 82-5, 162, 163, 164, 165, 166-84, 167, 169, 171-5, 177, 178, 202, 204, 207, 219, 227, 228, 230, 232, 242, 250, 255, 272 Müller, Robert, 234, 238, 247 Mussolini, 121 Nash, Paul, 139, 263 Nele, Eva Renée, 235 Neo-dadaism, 233, 270 Nevelson, Louise, 264-7, 265 Nicholson, Ben, 112, 194 Nietzsche, Friedrich, 49, 98, 142 Noguchi, Isamu, 258, 259 Nordic tradition, 25 Novalis, 142, 150 Oceanic art, 84 Orphism, 123 Oud, J. J., 104 Paolozzi, Eduardo, 212, 217, 228, 234-6, 234-7

Pasmore, Victor, 273, 275 Penalba, Alicia, 186 Penrose, Roland, 70, 154 Peruvian art, 84 Pevsner, Antoine, 93, 97, 97-9, 101, 109-13, 111, 113, 133, 141, 228, 247 Phidias, 14 Phillips, Helen, 189 Picabia, Francis, 145, 147, 234 Picasso, Pablo, 9, 10, 12, 43, 45, 46, 46, 51, 53, 56, 56, 58-76, 60, 61, 64, 66, 68, 79, 82, 84, 85, 86, 87, 88, 90, 91, 95, 115, 123, 133, 136, 146, 162, 163, 168, 168, 169, 170, 171, 173, 226, 228, 230, 232, 234, 235, 245 Pisano, Nicola, 267 Pissarro, Lucien, 15, 18 Pogany, Mlle, 80, 81 Pollock, Jackson, 229 Polynesian art, 43, 181 Popova, Liubov, 92 Post-Impressionism, 31, 32, 45, 89, 229 Prc-Columbian art, 43 Prehistoric art, 43 Primitive art, 43, 48, 50-2, 59 Puni, Ivan, 92 Rauschenberg, Robert, 233 Ray, Man, 128, 147, 263 Raynal, Maurice, 134 'Realistic' manifesto (1920), 111, 112 Renaissance, 24, 25, 36, 45, 187 Renoir, Auguste, 11, 15, 28-30, 29 Revol, Jean, 59 Rewald, John, 15, 29 Richier, Germaine, 204, 212, 218, 219, 220, 228, 234, 235, 256 Richter, Hans, 102 Rickey, George, 241 Rilke, Rainer Maria, 19 Rimbaud, Arthur, 142 Rivera, José de, 238, 245 Rivière, Georges, 15 Rodchenko, Alexander, 70, 75, 89, 92, 92, 93, 96, 101, 102 Rodin, Auguste, 10, 12-23, 13, 17, 28, 30, 31, 32, 33, 37, 79, 88, 156, 226, 250 Rohe, Mies van der, 114 Romanesque art, 43, 52, 53, 61, 173, 181 Romanticism, 45, 150, 232 Rosati, James, 190 Rosenberg, Harold, 12, 230, 231

Rosenthal, Bernard, 269 Rossellino, Antonio, 24 Rosso, Medardo, 16, 20, 22–4, 126, 128, 131, 133, 226 Roszak, Theodore, 204, 212, 214, 219, 234 Rouault, Georges, 140 Rugg, Matt, 272 Ruskin, John, 272, 274 Russolo, Luigi, 121

Salvatore (Messina Salvatore), 182 Sartre, Jean-Paul, 160 Schiller, Friedrich, 162 Schleeh, Hans, 188 Schlemmer, Oscar, 122 Schmidt, Julius, 231 Schnier, Jacques, 207 Schöffer, Nicolas, 206 Schwitters, Kurt, 71, 127-9, 145, 147, 153, 154, 160, 234, 263 Seitz, William C., 264 Seley, Jason, 233 Seurat, Georges Pierre, 18, 135 Severini, Gino, 121, 134, 139, 140 Shchukin, Sergei, 89 Sintenis, Renée, 24, 25 Smith, David, 201, 212, 245 Somaini, Francesco, 257 Spengler, Oswald, 98 Stahly, François, 202, 228 Stankiewicz, Richard, 239, 247 Startup, Peter, 203 Stein, Gertrude, 51 Stein, Sarah, 41, 42 Stijl, de, 104, 109 Stravinsky, Igor, 217 Strindberg, August, 98 Sumerian art, 84 Suprematism, 91, 100, 110 Surrealism, 9, 71, 72, 82, 142-62, 212, 229, 230, 263 Symbolism, 18 Synthetic Cubism, 95, 123-4

Tajiri, Shinkichi G., 256 Tanguy, Yves, 170 Tatlin, Vladimir, 70, 87, 89–95, 89, 95, 100–2, 104 Taueber-Arp, Sophie, 131 Taylor, Joshua C., 131, 133 Teana, Marino di, 210 Technical Manifesto (Boccioni), 92, 126–30, 135 *Terribilità*, 256, 257 Thommesen, Erik, 192 Thornton, Leslie, 255 Tinguely, Jean, 256 Titian, 273 Turnbull, William, 193 Tzara, Tristan, 148, 149

Ubac, Raoul, 227 Udaltsova, Nadezhda, 92 Uhlmann, Hans, 247, 250, 251

Vaderin, Jeanne, *36*, 38 Van Gogh, Theo, 48 Van Gogh, Vincent, 15, 44, 47–52 Vantongerloo, Georges, *102*, 104, 107, 108, 112 Viani, Alberto, *188* Vieira, Mary, *244*, 245 Visser, Carel, *210* Vitalism, 77, 162, 163–228, 232 Vlaminck, Maurice de, 51 Votlen, André, *206* Voulkos, Peter, *179*

Warren Davis, John, 267 Werthmann, Friederich, 260 Westermann, 234 Whistler, James Abbott McNeill, 44 Wiggli, Oscar, 248 Wines, James, 232 Wölfflin, Heinrich, 184 Worringer, Wilhelm, 58, 91 Wotruba, Fritz, 202, 203, 234

Yakulov, Georgy, 92

Zadkine, Ossip, 76 Zola, Émile, 23

D. H. Lawrence

Introduction and Notes by DR JEFF WALLACE Professor Emeritus at Cardiff Metropolitan University

WORDSWORTH CLASSICS

For my husband ANTHONY JOHN RANSON with love from your wife, the publisher. Eternally grateful for your unconditional love.

Readers who are interested in other titles from Wordsworth Editions are invited to visit our website at www.wordsworth-editions.com

First published in 1992 by Wordsworth Editions Limited 8B East Street, Ware, Hertfordshire sg12 ger New introduction and notes added in 1999

ISBN I 85326 007 X

Text © Wordsworth Editions Limited 1992 Introduction and notes © Jeff Wallace 1999

Wordsworth[®] is a registered trademark of Wordsworth Editions Limited

Wordsworth Editions is the company founded in 1987 by MICHAEL TRAYLER

All rights reserved. This publication may not be reproduced, stored in a retrieval system or transmitted, in any form or by any means, electronic, mechanical, photocopying, recording or otherwise, without the prior permission of the publishers.

Typeset in Great Britain by Antony Gray Printed and bound by Clays Ltd, Elcograf S.p.A.

GENERAL INTRODUCTION

Wordsworth Classics are inexpensive editions designed to appeal to the general reader and students. We commissioned teachers and specialists to write broad ranging, jargon-free Introductions and to provide Notes that would assist the understanding of our readers rather than interpret the stories for them. In the same spirit, because the pleasures of reading are inseparable from the surprises, secrets and revelations that all narratives contain, we strongly advise you to enjoy this book before turning to the Introduction.

Editorial Adviser KEITH CARABINE Rutherford College The University of Kent at Canterbury

INTRODUCTION

⁹Put out the lights, we shall see better' (p. 156). Readers of *Women in Love* might easily pass over this unobtrusive little paradox, given the circumstances in which it is uttered. Gerald Crich is about to dive again into the darkness of Willey Water, in a desperate attempt to save his drowning sister Diana. As evening falls on the Criches' water-party, the coloured lanterns create an atmosphere of ethereal beauty, until the reality of the accident harshly intrudes. 'Sudden and mechanical and belonging to the world of man', Gerald makes his practical request, as the same lanterns now prevent his eyes from adjusting to the darkness. The effort is, however, doomed to fail: the Criches are 'all . . . curiously bad at living' (p. 177).

Yet the paradox also effortlessly crystallises the novel's version of a whole cultural condition. Modern Western societies had for some time prided themselves upon a journey of seemingly inexorable progress which they defined, philosophically, as 'enlightenment'. This

philosophy was based on a belief in the emancipatory powers of human reason. Industry and technology, the fruits of reason, had made rapid advances, and seemed to promise an unending triumph over the forces of nature. While *Women in Love* was being written, however, Western Europe was destroying itself in a war which used industry and technology for the mechanised extinction of human life on an unparallelled scale. Some have since seen the war as the logical conclusion of the competitive development of advanced capitalist and imperialist powers. Enlightenment, then, had produced darkness; civilisation had produced barbarism. Better to put out the lights, so that we might begin to learn again how to see.

D. H. Lawrence (1885-1930) was grievously affected by the fact of the Great War, and the result was Women in Love, his most mature and profound work of fiction. In the light, or darkness, of war, the novel undertakes a reassessment of those values and institutions by which we define ourselves as 'human' and thereby attempt to distinguish ourselves from the rest of the natural order. But why, then, 'Women in Love'? Readers old and new have been led by this title to expect romance. What they find is indeed a kind of love story, complete with a tragic ending, but much else besides. For, like all great historical novelists, Lawrence understood that history is not simply a matter of abstract movements, wars, revolutions, monarchies and governments, but that it is made and registered in the practices of everyday personal life. Even in sexual relationship, in the most private and intimate domain of the personal, historical changes make their mark. Thus, in Women in Love, sexuality, marriage, family, friendship, and also work, education, art, and even our relations with animals, all come under the closest of scrutiny, constituting as they do the cherished values of a civilisation which had thrown itself into mechanised carnage. What, exactly, was it to be human?

Such questions make *Women in Love* a challenging and unsettling novel. Early reviewers did not always see the challenge as invigorating; they tended to wonder what exactly was going on between the four central characters, and suspected it was something of which they shouldn't approve. *The Rainbow*, 'sister' novel to *Women in Love*, had been banned on the grounds of obscenity after its publication in 1915, and Lawrence struggled for several years to find a publisher for *Women in Love* before its eventual appearance in 1921. General concensus seemed to be that, while the subject matter of the novel was relatively straightforward, the treatment was both baffling and unpalatable: in the terms of the Scottish novelist Catherine Carswell, the novel was easy to read, but hard to understand. Now, with whatever advantage critical hindsight brings, we can more clearly see how Lawrence was trying to do something radically new, both in terms of literary history and in terms of his own fictional development. The shock of the new can, of course, be painful.

In outline, the narrative of Women in Love does indeed possess a striking simplicity. Two sisters and grammar-school teachers, Ursula and Gudrun Brangwen, strike up relationships with two close friends. Rupert Birkin, a schools inspector, and Gerald Crich, a wealthy and influential mine-owner, in the East Midlands colliery area of Beldover. The fortunes of each pair are tracked for a brief period, though the dynamic always involves all four characters. Ursula and Birkin struggle into a relationship of some fulfilment, and are married; Gudrun and Crich experience increasing conflict, leading to a tragic conclusion. The four having taken a holiday together in the Tyrol, Crich, stung into violent conduct by Gudrun's intimacy with the German artist Loerke, walks alone into the mountains and is killed in the snow. The novel has no 'plot' as such, nor a sense of chronological or historical movement, other than a gradual ominous approach to this end; it's organisation is episodic, each chapter structured around a symbolic event or issue. The four central protagonists reveal themselves in the intense scenes and dialogues which unfold as their relationships develop through patterns of conflict and oscillation.

The dominant, nineteenth-century tradition of fictional realism, from which Lawrence drew, used devices such as elaborate plots and structures, authoritative or 'omniscient' narrative voice and detailed characterisation to suggest that the complex, mutually determining relationship between human individuals and their forms of social organisation could be analysed and understood. The Modernist aesthetic of the early twentieth century did not dispute this suggestion so much as question the means of achieving it: for novelists like Lawrence, Virginia Woolf and James Joyce, the techniques of realism had settled into something more like habit or formula, their knowingness an expression of the confidence of the nineteenth-century bourgeoisie, now inappropriate to the uncertainties and instabilites of a post-Victorian age. Hence, in these new fictions, plot begins to disappear, the principle of a complex ordering of events tending towards an intelligible end being replaced by loose impressionistic structures and open endings -"I don't believe that," he answered' (p. 421). Authoritative narrative perspective becomes harder to locate, as the boundaries between the narrative and the perpectives of the characters become blurred. The subjectivity of characters is, as it were, experienced more intensely, yet they are harder to know in an objective sense: Crich, for example, gets

extended realist treatment in Chapter XVII 'The Industrial Magnate', and readers of *The Rainbow* are well acquainted with Ursula, and to a lesser extent with Gudrun; but what do we know of Rupert Birkin's past? Early reviews suggest that the central characters in *Women in Love* were felt to be unconvincing, perhaps unrecognisable: their philosophising, and the highly idiosyncratic vocabulary developed by Lawrence to interpret their experiences, made them blend into one, so that more peripheral characters such as Hermione Roddice and Thomas Crich are instead singled out as distinct fictional creations.¹

The move towards Modernism is equally discernible in Lawrence's own fictional development up to Women in Love. In earlier novels such as The White Peacock (1911) and his masterpiece of autobiographical realism, Sons and Lovers (1913), Lawrence had established a reputation as a faithful yet experimentalist observer of the life of rural and workingclass communities. What set him apart from his contemporaries was, as the critic Raymond Williams has noted, that he wrote from within these communities.² Lawrence was born in 1885 in the Nottinghamshire mining village of Eastwood, the youngest of three sons in a family of five. His father worked as a 'butty' or ganger in the pit, his mother had middle-class origins; the tensions in their marriage, and the role of a certain youngest son between them, are vividly acted out in the Morel family of Sons and Lovers. As a beneficiary of the 1870 Education Act and a grammar-school scholarship boy, Lawrence was to become the first working-class novelist to see his work established with any lasting significance within the preponderantly bourgeois world of literary culture. In The Rainbow, he took on the ambitious task of charting the historical trajectory of a family, the Brangwens, across three generations, from mid- to late-nineteenth-century life on the Marsh Farm through to the emergence of the 'New Woman', granddaughter Ursula Brangwen, as she strikes out independently into the world of new opportunities in the early twentieth century. The chronological canvas of The Rainbow declares its allegiances both to realism and to community, yet the striking experimentalism of language, form and character in the novel suggested changing aesthetic priorities. By now - indeed, since the redrafting of Sons and Lovers in the second half of 1912 - Lawrence had taken up with Frieda Weekley, the wife of his university languages tutor and product of a German military family, and had embarked on an often penurious life of writing and travel. Distance, both literal and

2 See Raymond Williams

VIII

I Farmer, Vasey and Worthen (eds), p. lv. For full details of this and other references turn to the Bibliography at the end of this Introduction.

metaphorical, is established from his past life; and the influences of a greater cosmopolitanism and cultural diversity, and of his developing friendships and encounters within the literary intelligentsia, are registered clearly in the development of more abstract forms in his writing.

The result in Women in Love is that Lawrence no longer seems to write from within his originating community. The novel develops an aesthetic of distance, forever gazing at or looking in on others. "Who are those two Brangwens?" ' asks Gerald at the Breadalby gathering (p. 79), and is mocked by Birkin when he expresses surprise at the knowledge that they are schoolteachers and that their father is a handicrafts instructor. Ursula and Gudrun are transitional figures. attaining through education and culture the relatively unprecedented class mobility which allows them to forge relationships with men such as Birkin and Gerald. Hermione Roddice 'was really so strongly entrenched in her class superiority, she could come up and know people out of simple curiosity, as if they were creatures on exhibition' (p. 136); yet, from the moment that they secrete themselves safely behind the schoolyard wall in order to watch Laura Crich's wedding, Ursula and Gudrun are also observers, looking in on the social groups between which they are poised. The sisters, we note, are apart from, yet watching with, 'the group of uneasy, watchful common people . . . chiefly women, colliers' wives of the more shiftless sort . . . ' (p. 8), the same people whom we later find outside the pale of the Criches' water-party, 'looking at the festivity beyond, enviously, like souls not admitted to paradise' (p. 134). The narrative viewpoint here seems to endorse an interpretation of the 'common people' which is constantly in evidence, and which may not have endeared it to a contemporary working-class readership. Gudrun, the most consistent perpetrator, has had some success in the art world of metropolitan London, and returns to find Beldover 'like a country in an underworld', where the people 'are all ghouls, and everything is ghostly' (p. 7). Her horrified fascination becomes a 'nostalgia' to 'be among the people', to the extent that she is drawn out 'with the rest of the common women' to the Friday-evening markets where, 'like any other common lass', she finds her 'boy', the electrician Palmer. A 'horror of people in the mass' (or ' "un peu trop de mond" ', as Ursula encodes this in fashionable French for Gerald's sake) emerges as she recounts the details of a trip on a Thames steamer and her revulsion at the young boys running into the mud to beg for coins: "really, no vulture or jackal could dream of approaching them, for foulness"' (p. 138). Wryly, the narrative soon underlines her linguistic distance from the

mass, in the response to the offer of a personal picnic-basket for herself and her sister alone: "How fearfully good! How frightfully nice if you could!" '(p. 139).

If Gudrun is 'outside of life, an onlooker', Ursula is a 'partaker' (p. 141), yet still subject to the detachment her mobility entails. In Chapter xxvi, 'A Chair', she and Birkin visit the Monday jumble market; Ursula 'was superficially thrilled when she found herself out among the common people', who 'seemed stumpy and sordid', and on an impulse she decides to offer an antique chair they have just bought to a young couple – she a 'full-built, slightly blowsy city girl', he 'a still, mindless creature, hardly a man at all, a creature that the towns have produced ... a gutter presence'. After Ursula's 'rather dazzling' approach (' "Would you care for it? It's really *very* pretty – but – but ... " ' [p. 312]), the encounter proceeds haltingly, as the class tensions surrounding the conferral of the gift make themselves felt. The offer is, however, finally accepted. '"How strange they are!" ' concludes Ursula (p. 315), though Lawrence's witty manipulation of the couple's responses in dialect suggest how equally strange she and Birkin are to them.

At the other end of the novel's social spectrum, we watch in fascination with Ursula and Gudrun as the habits of the cultured and ruling classes are acted out. If the common people haunt the novel, so too does Hermione Roddice, 'ghastly' and 'sepulchral', 'pallid and preyed-upon like a ghost, like one attacked by the tomb-influences which dog us' (p. 75). At Breadalby, or in the London Pompadour, the kind of discussions take place which prompt Gerald to 'sniff the air with delight and prepare for action' (p. 71). To Ursula, however, drawn into the 'magic circle' of privilege and high culture, a sense of weary dissatisfaction is derived from the talk itself, which 'went on like a rattle of small artillery, always slightly sententious, with a sententiousness that was only emphasised by the continual crackling of a witticism, the continual spatter of verbal jest, designed to give a tone of flippancy to a stream of conversation that was all critical and general, a canal of conversation rather than a stream' (p. 70). Talk here is constructed, artificially, through techniques we observe in the MP Alexander Roddice, who had learned an 'easy, offhand hospitality' for his sister's friends, and who brings 'an atmosphere of the House of Commons' to the gathering - high politics and high culture combined: 'the Home Secretary had said such and such a thing, and he, Roddice, on the other hand, thought such and such a thing, and had said so-and-so to the PM' (p. 71). It is left to Gudrun to frame, in characteristic manner, the strangeness of it all, as Gerald, Sir Joshua, the Countess, Hermione and Miss Bradley bask on a wall after swimming: "Aren't they terrifying?

Aren't they really terrifying? Don't they look saurian? They are just like great lizards" ' (p. 85).

In the face of the grotesque unreality of these public contexts and social classes, *Women in Love* shows its four central characters attempting to carve out for themselves a more authentic, private world of feeling and relationship. It is perhaps not surprising, therefore, that the novel has been seen to signal a loss of belief on the part of a novelist such as Lawrence, a retreat away from the possibility of meaningful community and towards personal fulfilment in relationship and sexuality only. His friend Catherine Carswell wanted to know why Lawrence had this time chosen people who were 'so far removed from the general run...so sophisticated and "artistic" and spoiled' as his representatives of the modern world.³ Raymond Williams later summarised the novel as a 'masterpiece of loss'.⁴

Undoubtedly, Women in Love could be seen to dramatise a number of extremely pessimistic positions, pivoting on the failure of the 'human' and the inexorable reality of the death-process. Implicit throughout is the important semantic distinction that to 'exist' is not the same as to 'live'; the Gothic imagery attaching to working and ruling classes extends to cover 'humanity' as a kind of procession of the living-dead. "Humanity itself is dry-rotten, really" ', announces Birkin, to an Ursula who is rather gamely trying to get to know him, and is alternately repelled and fascinated by his views: "There are myriads of human beings hanging on the bush - and they look very nice and rosy, your healthy young men and women. But they are apples of Sodom . . . their insides are full of bitter, corrupt ash . . . I abhor humanity, I wish it was swept away. It could go, and there would be no absolute loss, if every human being perished tomorrow" ' (p. 107-8). Inevitably, he is intent on giving up his line of work: "I don't believe in the humanity I pretend to be part of, I don't care a straw for the social ideals I live by, I hate the dying organic form of social mankind - so it can't be anything but trumpery, to work at education" ' (p. 112). Birkin's courtship technique here leaves something to be desired: Ursula is beginning to want him to talk about 'love'. But later, whilst Birkin is convalescing in the South of France, Ursula is subject to the same disenchantment: she finds she can love only children and 'best of all' animals, whereas she 'had a profound grudge against the human being. That which the word "human" stood for was despicable and repugnant to her' (p. 211-12). The philosophical equivalent of these profoundly anti-enlightenment sentiments is Birkin's

3 Carswell, pp. 68-9

4 Raymond Williams, p. 182

'dark river of dissolution', the continuing process of corruption and destruction whose paradoxical centrality to 'life' we choose to mask or ignore: "When the stream of synthetic creation lapses, we find ourselves part of the inverse process, the blood of destructive creation. Aphrodite is born in the first spasm of universal dissolution – then the snakes and swans and lotus – marsh-flowers – and Gudrun and Gerald – born in the process of destructive creation" (p. 147–8).

Such ideas and debates cannot simply be explained as responses to the war. Rather, they draw on currents of thought about modernity which date back to the mid-nineteenth century, when the French poet Charles Baudelaire (1821-67) was publishing his Fleurs du mal (1857), an interpretation of the modern condition which Birkin's words echo. Women in Love is equally inconceivable without the organising concept of human beings as a distinct animal 'race' or 'species', one of many, within the natural order. The work of two key thinkers, Charles Darwin (1809-82) and Friedrich Nietzsche (1844-1900), both important in Lawrence's early intellectual development, must be considered in this context. In The Origin of Species (1859), Darwin forwarded an evolutionary theory of 'natural selection'. Challenging the creationist view of separate and divinely ordained species, Darwin posited a purely naturalistic process by which all organisms, from the unicellular to the most complex, human, variety, had evolved in a single continuum since the beginning of life on earth. On this theory, human life could either be seen to be evolving towards perfection or, like any other species, to be subject to the possibility of extinction. In Birkin's eyes, we recall, "man is one of the mistakes of creation - like the ichthyosauri" ' (p. 109). But why, then, a 'mistake'? For the German philosopher Nietzsche, 'man' was a 'mad unhappy animal' whose 'nature has not yet been fixed'.5 Here again, the human has evolved as a particular kind of animal, its distinguishing characteristic being an advanced, conceptual and linguistic intelligence. The latter was not, however, an unconditional advantage: the cost of thought was the ability to form ideas and illusions about ourselves over and above an 'animal' condition, and thus to render our nature uncertain, 'unfixed'. We were, in the title of one of his major works, 'human, all too human', the Apollonian, or intellectual, principle, having counterbalanced the Dionysian, or sensual. Nietzsche's impassioned critique fixed in particular on the ethics of Christianity, where the injunction to 'love' threatened to distort and unbalance the natural forces to which humanity as a species was also subject. Nothing

5 Nietzsche, Genealogy, p. 226; Beyond Good and Evil, p. 88

less than a stripping bare of the illusions and metaphysics by which we construct our sense of the 'human', a 'transvaluation of all values', was necessary if, paradoxically, the human species was to transcend the difficulties of the modern age. '"I only want us to *know* what we are"', says Birkin, in Nietzschean spirit (p. 148).

In the more immediate context of pre-war Britain, species-thinking fed anxiety about the 'degeneration' of the human stock of modern societies. Industrial regimes of work, the rise of mass urbanised and metropolitan societies, expanding literacy and educational opportunity, and a liberalisation of sexual morality, created fears that such progress occurred at the expense of the physical and psychological 'health', both of individuals and of the body politic. In Britain, these fears were sharpened by an awareness of the rapidly modernising strength of Germany as an adversarial power, set against the corresponding decline of Britain as first industrial nation. Across the political spectrum, the ideas of eugenics or the 'science' of race culture were seriously entertained, as the need was perceived to intervene in the reproduction and development of the 'race', to encourage the 'fit' and discourage the physically or mentally 'feeble' from breeding.

These contexts help us to understand how and why Women in Love can seem a novel about animals as much as about people. Creatures, and the complex human encounter with them, pervade the text: Gerald's Arab mare, Mino the stray cat, Looloo the pekinese and Bismarck the rabbit, Mrs Salmon's canaries, Highland cattle, and others. "How stupid anthropomorphism is!" ' (p. 229), thinks Ursula, in condemning Gudrun's description of birds as 'little Lloyd Georges'. Anthropomorphism here is that tendency to translate the otherness of animal nature into the terms of human perception. The narrative voice is, on occasions, as guilty of this as Gudrun: Mino blinks 'forbearingly, with a male, bored expression' (p. 261), Looloo sits with 'contemplative sadness' and 'grievous resignation' (p. 204). However, if domesticated and anthropomorphised animals stalk the text, still more do they abound linguistically, in metaphors of the obverse kind, the creaturely human. Gudrun cries 'like a sea-gull', Gerald is 'an amphibious beast', 'his head blunt and blind like a seal's', Birkin is a 'chameleon', Hermione has a 'horse-face', Loerke is 'some strange creature, a rabbit or a bat, or a brown seal': the text is saturated with such references to human creatureliness.

Animals anthropomorphised, humans animalised; *Women in Love* enacts a subtle dialectic, constantly reminding us that we are animals, yet showing how it is our 'nature' as animals to reinvent the natural in culture and language. In thus unsettling the boundaries between

WOMEN IN LOVE

human and animal, the novel guards vigilantly against any simple, backward-looking retrospect. '"Would you have us live without houses – return to nature?" ', enquires Gerald, after a typical Birkinian tirade against the modern world (p. 44). But there is no going back: anthropomorphism is an inescapable fact, condemning us to intervene in 'nature' in increasingly complex ways, and it is dramatised with savage irony in one of the novel's most intense early scenes. Enraged by Hermione's assertion that modern children are 'over-conscious, burdened to death with consciousness', Birkin launches a corrosive attack on his ex-lover:

'You are merely making words,' he said; 'knowledge means everything to you. Even your animalism, you want it in your head. You don't want to *be* an animal, you want to observe your own animal functions, to get a mental thrill out of them. It is all purely secondary – and more decadent than the most hide-bound intellectualism. What is it but the last and worst form of intellectualism, this love of yours for passion and the animal instincts?' [p. 33]

Could we turn back the evolutionary clock and 'return' to animality? Only an overactive human mind such as Hermione's could produce such a ridiculous idea. Yet the philosophies of Lawrence and Nietzsche have sometimes been prone to similar, reductive interpretations. We see the significance, therefore, of the shift towards abstract language and intellectual debate in *Women in Love*. Lawrence's earlier work established him to a large extent as a 'nature' writer; in this novel, however, vivid natural description makes way for a more selfconscious concern with how we *represent* nature, principally in the languages and techniques of art. In Nietzschean terms, there are no 'facts', only 'interpretations'. Ideas of nature, and artistic representations of it, are historical phenomena, responding and changing in complex relationship with the wider human world.

This is brought home to us most forcefully in the tragedy of Gerald Crich, whose success as an industrialist is dependent upon a distinctive attitude to the natural world. In the 'Coaldust' chapter, Gerald battles to keep his horse at the railway crossing despite the terror of a creature which, in the words of the enraged Ursula, is ' "ten times as sensitive as himself" (p. 96). Similarly, Gerald has mastered and subdued the living forces of production. Inheriting from his father a system whose dysfunctions are seen to be a direct result of the exercise of Christian compassion – 'he wanted his industry to be run on love' – Gerald develops a purely 'instrumentalist' view of humanity. People, workers, are simply a form of 'Matter' to be subjugated in the interests of the

XIV

INTRODUCTION

unobstructed functioning of the industrial machine. His modernising reforms ruthlessly dispense with old staff as 'so much lumber'; in the end he is hated by the colliers, but has created a system so 'perfect' that he himself is almost indispensable. Yet, Gerald does not know how to live: "I wish you'd tell me something that did matter" ', he requests of Birkin (p. 81). Sexual conquests and intellectual pursuits provide diversion, but cannot prevent those moments of existential fear, shared intermittently with the three other central characters, during which he doubts the substance of things, his own identity included. His affair with Gudrun, whose ironic, detached approach to her subject matter is the artistic correlative of Gerald's exploitative industrialism, is doomed from its ominously violent beginnings: neither can touch the other except in a spirit of instrumentality. Gudrun wounds and exposes Gerald, but he gives himself to the process without shame, feeling at least that the pain is a form of authentic contact. His death is less an 'accident' in the realist sense than a symbolic lapsing out - 'he went to sleep' - suggesting the extinction of human life in the icy wastes of abstraction and idealism to which the species had committed itself.

Does this then suggest a schematic quality to Women in Love, and the return of a kind of moralistic framework which Lawrence had ostensibly sought to expunge from his fiction? Should we set against the deathliness of Gerald and Gudrun the healthy, warm normality of their counterparts? The answer is surely not that simple. Gerald's dilemma is treated with compassion, and the complexity of the portrait can be measured against the later, cruder re-working of the emotionally crippled industrialist in the figure of the wheelchair-bound Clifford Chatterley.⁶ Increasingly, critics have drawn attention to the open and interrogative character of Women in Love, a pervading indeterminacy which makes it impossible to pin down any one view or position we are meant to endorse.7 The sentiments which Birkin attacks so viciously in Hermione are precisely those which, as F. R. Leavis pointed out many years ago, the world had been content to accept as Lawrentian 'doctrine'.⁸ Birkin himself has gained acceptance as the 'D. H. Lawrence' figure in the text. Yet the tracing of lines from life to art is always a precarious business, no more so than in a novel of such complexity. In her many dialogues with Birkin, Ursula's common-sense questioning frequently makes him look ridiculous and sententiously didactic. It is unnerving to find Birkin's rhetoric mocked so thoroughly by Halliday

6 See ed. Squires

7 See e.g. Ragussis, Fernihough

8 Leavis, p. 213

WOMEN IN LOVE

and his set in the Pompadour, in spite of Gudrun's rescue act: "Isn't that the letter about uniting the dark and the light – and the Flux of Corruption?" asked Maxim ... ' (p. 334). When Ursula launches her attack on Loerke's aesthetic of impersonality, the sense that she is echoing the novel's own critique is tempered by the fact that we are made to feel a sense of embarrassment at her lack of self-possession, the face 'flushed and transfigured' and the fingers 'twisting her handkerchief' (p. 377).

Through such devices, Women in Love attains a curious balancing act. It seems difficult to deny that the novel is a prophetic exercise of high seriousness, a critique in its own right of a botched civilisation. However, none of the positions it advances remains either uncriticised or unironised; the high seriousness is punctured, and alternative perpectives are always available. Thus the charge laid against Gudrun, that 'everything turned to irony with her' (p. 365), is not far short of a comment on the novel itself. The uniqueness of Lawrence's writing lies in a risky rhetorical transformation of the everyday, particularly in the realm of sexuality, which has laid him open to satire. Who can forget, or pass over with indifference, the rhapsodic description of Ursula's caresses: 'She closed her hands over the full, rounded body of his loins. as he stooped over her, she seemed to touch the quick of the mystery of darkness that was bodily him' (p. 273)? Afternoon tea at the Saracen's Head in Southwold can rarely have been like this. Yet the Pompadour scene opens out the possibility of satire at the expense of the narrative's own language, just as Will Brangwen's exasperation at Gudrun's waterparty costume - "Don't you think you might as well get yourself up for a Christmas cracker an' ha' done with it?" ' (p. 132-3) - provides comic recognition of the novel's curious obsession with the sisters' artificial plumage.

Thus the dark, violent and apocalyptic qualities of *Women in Love*, and the peculiar jargon of its idealised speculations about human sexuality, co-exist with a number of wry and ironic framing devices. Language, the distinguishing feature of the human animal, is the medium of this selfawareness, and if Birkin is the mouthpiece of anything, it is of the novel's reflexive sensitivity to the precarious power and subtlety of words. Birkin experiences great frustration in the struggle with meaning. He hates his own metaphors, knowing them to be the substance of anthropomorphism, and is 'irritated and weary of having a telling way of putting things' (p. 163). 'Moony' is a symbol of this frustration, a frantic attempt to dispel and fragment a meaning which always insists on reasserting itself (and again, Ursula's unseen presence puts a semi-comic frame around his eccentric behaviour). Nevertheless, language exists in intimate

INTRODUCTION

relationship with the forms of social and political, just as much as personal, life; if we fail to renew or scrutinise it, those forms similarly coalesce and decay. Thus, there can be no unguarded utterance of even the most basic terms of our vocabulary. Love? "The point about love . . . is that we hate the word because we have vulgarised it. It ought to be proscribed, tabooed from utterance, for many years, till we get a new, better idea" (p. 111). I? "How could he say 'I' when he was something new and unknown, not himself at all? This I, this old formula of the age, was a dead letter" (p. 323). There is a direct line between this linguistic questioning and the novel's testing out and trangression of human norms and institutions: the debate around marriage and its 'impossibility'; the conditions in which a love between Birkin and Gerald might be realised; even the 'bestiality' of the love between Ursula and Birkin in Chapter xxix, 'Continental'.

The optimism of Women in Love lies not in any cosy conclusions and predictions about the human condition, but precisely in our ability to call that condition into question. Complacent assumptions about the superiority of the 'human' had created barriers, between ourselves and the natural order to which we belong, between our 'selves' and our own creatureliness. We must, insists the novel, get into relation with the world; 'relatedness' looms ever larger in Lawrence's vocabulary, along with cognate terms such as 'touch' and 'tenderness' - things that can occur most successfully in the dark. Yet this is not, Lawrence wishes to persuade us, incompatible with the 'progress' of human knowledge. For him, the genre or art of fiction was the most delicate instrument available for the pursuit of an open and inquisitive epistemology: 'The novel is the highest example of subtle inter-relatedness that man has discovered.'9 Fittingly, then, Birkin's intellectual commitment is to language as a physical act, simultaneously human labour and birth, and creaturely metamorphosis:

He turned in confusion. There was always confusion in speech. Yet it must be spoken. Whichever way one moved, if one were to move forwards, one must break a way through. And to know, to give utterance, was to break a way through the walls of the prison as the infant in labour strives through the walls of the womb. There is no new movement now, without the breaking through of the old body, deliberately, in knowledge, in the struggle to get out. [p. 161]

> JEFF WALLACE Professor Fameritus at Cardiff Metropolitan University

9 Lawrence, Phoenix, p. 528

- Keith Brown (ed.), *Rethinking Lawrence*, Open University Press, Milton Keynes 1990 (a useful, accessible collection of new approaches to Lawrence)
- Catherine Carswell, The Savage Pilgimage, Chatto, London 1932
- Angela Carter, 'Lorenzo as Closet Queen', *Nothing Sacred*, Virago, London 1982 (a playful analysis of the preoccupation with stockings and women's clothing in *Women in Love*, carrying the important suggestion that Lawrence's own gender identity was not as 'straight' as it seems; link Linda Ruth Williams)
- Colin Clarke, *River of Dissolution: D. H. Lawrence and English Romanticism*, Routledge and Kegan Paul, London 1969 (important book on the discourses of corruption in Lawrence, linking him with a radical strain of Romanticism)

Charles Darwin, The Origin of Species, 1859; Wordsworth, Ware 1998

- Anne Fernihough, D.H. Lawrence: Aesthetics and Ideology, Clarendon Press, Oxford 1993 (a challenging, invigorating study of Lawrence's 'anti-imperialist aesthetics')
- Graham Holderness, *Women in Love*, Open University Press, Milton Keynes 1986 (excellent, detailed study guide to *Women in Love* for Open University students)
- Mark Kinkead-Weekes, D. H. Lawrence: Triumph to Exile 1912–1922, Cambridge University Press, 1996 (Volume II of the new threevolume Cambridge biography of D.H. Lawrence; indispensable)
- D. H. Lawrence, *Women in Love*, 1921; eds David Farmer, Lindeth Vasey and John Worthen, Cambridge University Press, 1987 (scholarly edition of the text, with extensive footnotes and textual apparatus)
- D. H. Lawrence, *Lady Chatterley's Lover*, 1928; ed. Michael Squires, Cambridge University Press, 1993
- D. H. Lawrence, *Phoenix: The Posthumous Papers*, 1936; ed. Edward D. McDonald, Penguin, Harmondsworth 1978
- F. R. Leavis, *D.H. Lawrence: Novelist*, 1955; Penguin, Harmondsworth 1964 (Leavis was the great academic champion of Lawrence's 'creative genius', and this is the first major critical work on Lawrence.)

- Howard Mills, 'Mischief or merriment, amazement and amusement and malice: *Women in Love*', *Lawrence and Comedy*, eds Paul Eggert and John Worthen, Cambridge University Press, 1996 (a recent essay on comedy in *Women in Love*)
- Friedrich Nietzsche, *The Birth of Tragedy* and *The Genealogy of Morals*, trans. Francis Golffing, Doubleday Anchor, New York 1956
- Friedrich Nietzsche, Beyond Good and Evil, trans. R. J. Hollingdale, Penguin, Harmondsworth 1990
- Tony Pinkney, *D.H. Lawrence*, Harvester Wheatsheaf, Hemel Hempstead 1990 (distinctive and unusual readings of Lawrence's work in the light of cultural history and contemporary literary theory)
- Michael Ragussis, *The Subterfuge of Art: Language and the Romantic Tradition*, The Johns Hopkins University Press, Baltimore and London 1978 (chapter on Lawrence contains extensive analysis of the language of *Women in Love*)
- Hilary Simpson, D.H. Lawrence and Feminism, Croom Helm, London 1982 (important historical study of Lawrence's encounter with feminism)
- Linda Ruth Williams, Sex in the Head: Visions of Femininity and Film in D. H. Lawrence, Harvester Wheatsheaf, Hemel Hempstead 1993 (a provocative new reading of Lawrence, focusing specifically on the themes of sight and blindness, light and dark in Lawrence, and developing Carter's insights on sexual orientation)
- Raymond Williams, *The English Novel from Dickens to Lawrence*, Chatto and Windus, London 1973 (important materialist analysis of Lawrence's position in the tradition of English realist fiction)

CONTENTS

	Cistan	
I	Sisters	3
II	Shortlands	17
III	Classroom	27
IV	Diver	36
v	In the Train	42
VI	Crême de Menthe	50
VII	Fetish	64
VIII	Breadalby	68
IX	Coaldust	93
x	Sketchbook	101
XI	An Island	104
XII	Carpeting	113
XIII	Mino	122
XIV	Water-party	132
xv	Sunday Evening	164
XVI	Man to Man	171
XVII	The Industrial Magnate	182
xvIII	Rabbit	202
XIX	Moony	211
xx	Gladiatorial	230
XXI	Threshold	240
XXII	Woman to Woman	253
XXIII	Excurse	262

xxviA Chair30xxviiFlitting31xxviiiGudrun in the Pompadour33xxixContinental33xxxSnowed Up38	XXIV	Death and Love	280
xxviiFlitting31xxviiiGudrun in the Pompadour33xxixContinental33xxxSnowed Up38	xxv	Marriage or Not	306
xxvIIIGudrun in the Pompadour33xxIXContinental33xxXSnowed Up38	XXVI	A Chair	309
xxix Continental 33 xxx Snowed Up 38	XXVII	Flitting	318
xxx Snowed Up 38	xxvIII	Gudrun in the Pompadour	332
	XXIX	Continental	337
xxxi Exeunt 41	xxx	Snowed Up	385
	XXXI	Exeunt	415

WOMEN IN LOVE

CHAPTER I

Sisters

URSULA AND GUDRUN Brangwen sat one morning in the windowbay of their father's house in Beldover, working and talking. Ursula was stitching a piece of brightly-coloured embroidery, and Gudrun was drawing upon a board which she held on her knee. They were mostly silent, talking as their thoughts strayed through their minds.

'Ursula,' said Gudrun, 'don't you *really want* to get married?' Ursula laid her embroidery in her lap and looked up. Her face was calm and considerate.

'I don't know,' she replied. 'It depends how you mean.'

Gudrun was slightly taken aback. She watched her sister for some moments.

'Well,' she said, ironically, 'it usually means one thing! But don't you think anyhow, you'd be – ' she darkened slightly – 'in a better position than you are in now.'

A shadow came over Ursula's face.

'I might,' she said. 'But I'm not sure.'

Again Gudrun paused, slightly irritated. She wanted to be quite definite.

'You don't think one needs the *experience* of having been married?' she asked.

'Do you think it need be an experience?' replied Ursula.

'Bound to be, in some way or other,' said Gudrun, coolly. 'Possibly undesirable, but bound to be an experience of some sort.'

'Not really,' said Ursula. 'More likely to be the end of experience.'

Gudrun sat very still, to attend to this.

'Of course,' she said, 'there's *that* to consider.' This brought the conversation to a close. Gudrun, almost angrily, took up her rubber and began to rub out part of her drawing. Ursula stitched absorbedly.

'You wouldn't consider a good offer?' asked Gudrun.

'I think I've rejected several,' said Ursula.

'Really!' Gudrun flushed dark - 'But anything really worth while? Have you really?'

'A thousand a year, and an awfully nice man. I liked him awfully,' said Ursula.

'Really! But weren't you fearfully tempted?'

'In the abstract but not in the concrete,' said Ursula. 'When it comes

to the point, one isn't even tempted – oh, if I were tempted, I'd marry like a shot. I'm only tempted *not* to.' The faces of both sisters suddenly lit up with amusement.

'Isn't it an amazing thing,' cried Gudrun, 'how strong the temptation is, not to!' They both laughed, looking at each other. In their hearts they were frightened.

There was a long pause, whilst Ursula stitched and Gudrun went on with her sketch. The sisters were women, Ursula twenty-six, and Gudrun twenty-five. But both had the remote, virgin look of modern girls, sisters of Artemis rather than of Hebe.¹ Gudrun was very beautiful, passive, soft-skinned, soft-limbed. She wore a dress of darkblue silky stuff, with ruches of blue and green linen lace in the neck and sleeves; and she had emerald-green stockings. Her look of confidence and diffidence contrasted with Ursula's sensitive expectancy. The provincial people, intimidated by Gudrun's perfect sang-froid and exclusive bareness of manner, said of her: 'She is a smart woman.' She had just come back from London, where she had spent several years, working at an art-school, as a student, and living a studio life.

'I was hoping now for a man to come along,' Gudrun said, suddenly catching her underlip between her teeth, and making a strange grimace, half sly smiling, half anguish. Ursula was afraid.

'So you have come home, expecting him here?' she laughed.

'Oh my dear,' cried Gudrun, strident, 'I wouldn't go out of my way to look for him. But if there did happen to come along a highly attractive individual of sufficient means – well – ' she tailed off ironically. Then she looked searchingly at Ursula, as if to probe her. 'Don't you find yourself getting bored?' she asked of her sister. 'Don't you find, that things fail to materialise? *Nothing materialises!* Everything withers in the bud.'

'What withers in the bud?' asked Ursula.

'Oh, everything – oneself – things in general.' There was a pause, whilst each sister vaguely considered her fate.

'It does frighten one,' said Ursula, and again there was a pause. 'But do you hope to get anywhere by just marrying?'

'It seems to be the inevitable next step,' said Gudrun. Ursula pondered this, with a little bitterness. She was a class mistress herself, in Willey Green Grammar School, as she had been for some years.

'I know,' she said, 'it seems like that when one thinks in the abstract. But really imagine it: imagine any man one knows, imagine him coming home to one every evening, and saying "Hello," and giving one a kiss – '

There was a blank pause.

'Yes,' said Gudrun, in a narrowed voice. 'It's just impossible. The man makes it impossible.'

'Of course there's children - ' said Ursula doubtfully.

Gudrun's face hardened.

'Do you *really* want children, Ursula?' she asked coldly. A dazzled, baffled look came on Ursula's face.

'One feels it is still beyond one,' she said.

'Do you feel like that?' asked Gudrun. 'I get no feeling whatever from the thought of bearing children.'

Gudrun looked at Ursula with a masklike, expressionless face. Ursula knitted her brows.

'Perhaps it isn't genuine,' she faltered. 'Perhaps one doesn't really want them, in one's soul – only superficially.' A hardness came over Gudrun's face. She did not want to be too definite.

'When one thinks of other people's children - ' said Ursula.

Again Gudrun looked at her sister, almost hostile.

'Exactly,' she said, to close the conversation.

The two sisters worked on in silence, Ursula having always that strange brightness of an essential flame that is caught, meshed, contravened. She lived a good deal by herself, to herself, working, passing on from day to day, and always thinking, trying to lay hold on life, to grasp it in her own understanding. Her active living was suspended, but underneath, in the darkness, something was coming to pass. If only she could break through the last integuments! She seemed to try and put her hands out, like an infant in the womb, and she could not, not yet. Still she had a strange prescience, an intimation of something yet to come.

She laid down her work and looked at her sister. She thought Gudrun so *charming*, so infinitely charming, in her softness and her fine, exquisite richness of texture and delicacy of line. There was a certain playfulness about her too, such a piquancy or ironic suggestion, such an untouched reserve. Ursula admired her with all her soul.

'Why did you come home, Prune?' she asked.

Gudrun knew she was being admired. She sat back from her drawing and looked at Ursula, from under her finely-curved lashes.

'Why did I come back, Ursula?' she repeated. 'I have asked myself a thousand times.'

'And don't you know?'

'Yes, I think I do. I think my coming back home was just reculer pour mieux sauter.²

And she looked with a long, slow look of knowledge at Ursula. 'I know!' cried Ursula, looking slightly dazzled and falsified, and as if she did not know. 'But where can one jump to?'

'Oh, it doesn't matter,' said Gudrun, somewhat superbly. 'If one jumps over the edge, one is bound to land somewhere.'

'But isn't it very risky?' asked Ursula.

A slow mocking smile dawned on Gudrun's face.

'Ah!' she said laughing. 'What is it all but words!' And so again she closed the conversation. But Ursula was still brooding.

'And how do you find home, now you have come back to it?' she asked.

Gudrun paused for some moments, coldly, before answering. Then, in a cold truthful voice, she said:

'I find myself completely out of it.'

'And father?'

Gudrun looked at Ursula, almost with resentment, as if brought to bay.

'I haven't thought about him: I've refrained,' she said coldly.

'Yes,' wavered Ursula; and the conversation was really at an end. The sisters found themselves confronted by a void, a terrifying chasm, as if they had looked over the edge.

They worked on in silence for some time, Gudrun's cheek was flushed with repressed emotion. She resented its having been called into being.

'Shall we go out and look at that wedding?' she asked at length, in a voice that was too casual.

'Yes!' cried Ursula, too eagerly, throwing aside her sewing and leaping up, as if to escape something, thus betraying the tension of the situation and causing a friction of dislike to go over Gudrun's nerves.

As she went upstairs, Ursula was aware of the house, of her home round about her. And she loathed it, the sordid, too-familiar place! She was afraid at the depth of her feeling against the home, the milieu, the whole atmosphere and condition of this obsolete life. Her feeling frightened her.

The two girls were soon walking swiftly down the main road of Beldover, a wide street, part shops, part dwelling-houses, utterly formless and sordid, without poverty. Gudrun, new from her life in Chelsea and Sussex, shrank cruelly from this amorphous ugliness of a small colliery town in the Midlands. Yet forward she went, through the whole sordid gamut of pettiness, the long amorphous, gritty street. She was exposed to every stare, she passed on through a stretch of torment. It was strange that she should have chosen to come back and test the full effect of this shapeless, barren ugliness upon herself. Why had she wanted to submit herself to it, did she still want to submit herself to it,

6

the insufferable torture of these ugly, meaningless people, this defaced countryside? She felt like a beetle toiling in the dust. She was filled with repulsion.

They turned off the main road, past a black patch of commongarden, where sooty cabbage stumps stood shameless. No one thought to be ashamed. No one was ashamed of it all.

'It is like a country in an underworld,' said Gudrun. 'The colliers bring it above-ground with them, shovel it up. Ursula, it's marvellous, it's really marvellous – it's really wonderful, another world. The people are all ghouls, and everything is ghostly. Everything is a ghoulish replica of the real world, a replica, a ghoul, all soiled, everything sordid. It's like being mad, Ursula.'

The sisters were crossing a black path through a dark, soiled field. On the left was a large landscape, a valley with collieries, and opposite hills with cornfields and woods, all blackened with distance, as if seen through a veil of crape. White and black smoke rose up in steady columns, magic within the dark air. Near at hand came the long rows of dwellings, approaching curved up the hill-slope, in straight lines along the brow of the hill. They were of darkened red brick, brittle, with dark slate roofs. The path on which the sisters walked was black, trodden-in by the feet of the recurrent colliers, and bounded from the field by iron fences; the stile that led again into the road was rubbed shiny by the moleskins of the passing miners. Now the two girls were going between some rows of dwellings, of the poorer sort. Women, their arms folded over their coarse aprons, standing gossiping at the end of their block, stared after the Brangwen sisters with that long, unwearying stare of aborigines; children called out names.

Gudrun went on her way half dazed. If this were human life, if these were human beings, living in a complete world, then what was her own world, outside? She was aware of her grass-green stockings, her large grass-green velour hat, her full soft coat, of a strong blue colour. And she felt as if she were treading in the air, quite unstable, her heart was contracted, as if at any minute she might be precipitated to the ground. She was afraid.

She clung to Ursula, who, through long usage was inured to this violation of a dark, uncreated, hostile world. But all the time her heart was crying, as if in the midst of some ordeal: 'I want to go back, I want to go away, I want not to know it, not to know that this exists.' Yet she must go forward.

Ursula could feel her suffering. 'You hate this, don't you?' she asked. 'It bewilders me,' stammered Gudrun. 'You won't stay long,' replied Ursula.

And Gudrun went along, grasping at release.

They drew away from the colliery region, over the curve of the hill, into the purer country of the other side, towards Willey Green. Still the faint glamour of blackness persisted over the fields and the wooded hills, and seemed darkly to gleam in the air. It was a spring day, chill, with snatches of sunshine. Yellow celandines showed out from the hedge-bottoms, and in the cottage gardens of Willey Green, currantbushes were breaking into leaf, and little flowers were coming white on the grey alyssum that hung over the stone walls.

Turning, they passed down the high-road, that went between high banks towards the church. There, in the lowest bend of the road, low under the trees, stood a little group of expectant people, waiting to see the wedding. The daughter of the chief mine-owner of the district, Thomas Crich, was getting married to a naval officer.

'Let us go back,' said Gudrun, swerving away. 'There are all those people.'

And she hung wavering in the road.

'Never mind them,' said Ursula, 'they're all right. They all know me, they don't matter.'

'But must we go through them?' asked Gudrun.

'They're quite all right, really,' said Ursula, going forward. And together the two sisters approached the group of uneasy, watchful common people. They were chiefly women, colliers' wives of the more shiftless sort. They had watchful, underworld faces.

The two sisters held themselves tense, and went straight towards the gate. The women made way for them, but barely sufficient, as if grudging to yield ground. The sisters passed in silence through the stone gateway and up the steps, on the red carpet, a policeman estimating their progress.

'What price the stockings!' said a voice at the back of Gudrun. A sudden fierce anger swept over the girl, violent and murderous. She would have liked them all annihilated, cleared away, so that the world was left clear for her. How she hated walking up the churchyard path, along the red carpet, continuing in motion, in their sight.

'I won't go into the church,' she said suddenly, with such final decision that Ursula immediately halted, turned round, and branched off up a small side path which led to the little private gate of the Grammar School, whose grounds adjoined those of the church.

Just inside the gate of the school shrubbery, outside the churchyard, Ursula sat down for a moment on the low stone wall under the laurel bushes, to rest. Behind her, the large red building of the school rose up peacefully, the windows all open for the holiday. Over the shrubs, before her, were the pale roofs and tower of the old church. The sisters were hidden by the foliage.

Gudrun sat down in silence. Her mouth was shut close, her face averted. She was regretting bitterly that she had ever come back. Ursula looked at her, and thought how amazingly beautiful she was, flushed with discomfiture. But she caused a constraint over Ursula's nature, a certain weariness. Ursula wished to be alone, freed from the tightness, the enclosure of Gudrun's presence.

'Are we going to stay here?' asked Gudrun.

'I was only resting a minute,' said Ursula, getting up as if rebuked. 'We will stand in the corner by the fives-court, we shall see everything from there.'

For the moment, the sunshine fell brightly into the churchyard, there was a vague scent of sap and of spring, perhaps of violets from off the graves. Some white daisies were out, bright as angels. In the air, the unfolding leaves of a copper-beech were blood-red.

Punctually at eleven o'clock, the carriages began to arrive. There was a stir in the crowd at the gate, a concentration as a carriage drove up, wedding guests were mounting up the steps and passing along the red carpet to the church. They were all gay and excited because the sun was shining.

Gudrun watched them closely, with objective curiosity. She saw each one as a complete figure, like a character in a book, or a subject in a picture, or a marionette in a theatre, a finished creation. She loved to recognise their various characteristics, to place them in their true light, give them their own surroundings, settle them for ever as they passed before her along the path to the church. She knew them, they wcre finished, sealed and stamped and finished with, for her. There was none that had anything unknown, unresolved, until the Criches themselves began to appear. Then her interest was piqued. Here was something not quite so preconcluded.

There came the mother, Mrs Crich, with her eldest son Gerald. She was a queer unkempt figure, in spite of the attempts that had obviously been made to bring her into line for the day. Her face was pale, yellowish, with a clear, transparent skin, she leaned forward rather, her features were strongly marked, handsome, with a tense, unseeing, predative look. Her colourless hair was untidy, wisps floating down on to her sac coat of dark blue silk, from under her blue silk hat. She looked like a woman with a monomania, furtive almost, but heavily proud.

Her son was of a fair, sun-tanned type, rather above middle height,

WOMEN IN LOVE

well-made, and almost exaggeratedly well-dressed. But about him also was the strange, guarded look, the unconscious glisten, as if he did not belong to the same creation as the people about him. Gudrun lighted on him at once. There was something northern about him that magnetised her. In his clear northern flesh and his fair hair was a glisten like sunshine refracted through crystals of ice. And he looked so new, unbroached, pure as an arctic thing. Perhaps he was thirty years old, perhaps more. His gleaming beauty, maleness, like a young, goodhumoured, smiling wolf, did not blind her to the significant, sinister stillness in his bearing, the lurking danger of his unsubdued temper. 'His totem is the wolf,' she repeated to herself. 'His mother is an old, unbroken wolf.' And then she experienced a keen paroxyism, a transport, as if she had made some incredible discovery, known to nobody else on earth. A strange transport took possession of her, all her veins were in a paroxysm of violent sensation. 'Good God!' she exclaimed to herself, 'what is this?' And then, a moment after, she was saying assuredly, 'I shall know more of that man.' She was tortured with desire to see him again, a nostalgia, a necessity to see him again, to make sure it was not all a mistake, that she was not deluding herself, that she really felt this strange and overwhelming sensation on his account, this knowledge of him in her essence, this powerful apprehension of him. 'Am I really singled out for him in some way, is there really some pale gold, arctic light that envelopes only us two?' she asked herself. And she could not believe it, she remained in a muse, scarcely conscious of what was going on around.

The bridesmaids were here, and yet the bridegroom had not come. Ursula wondered if something was amiss, and if the wedding would yet all go wrong. She felt troubled, as if it rested upon her. The chief bridesmaids had arrived. Ursula watched them come up the steps. One of them she knew, a tall, slow, reluctant woman with a weight of fair hair and a pale, long face. This was Hermione Roddice, a friend of the Criches. Now she came along, with her head held up, balancing an enormous flat hat of pale yellow velvet, on which were streaks of ostrich feathers, natural and grey. She drifted forward as if scarcely conscious, her long blanched face lifted up, not to see the world. She was rich. She wore a dress of silky, frail velvet, of pale vellow colour, and she carried a lot of small rose-coloured cyclamens. Her shoes and stockings were of brownish grey, like the feathers on her hat, her hair was heavy, she drifted along with a peculiar fixity of the hips, a strange unwilling motion. She was impressive, in her lovely pale-yellow and brownish-rose, yet macabre, something repulsive. People were silent when she passed, impressed, roused, wanting to jeer, yet for some

reason silenced. Her long, pale face, that she carried lifted up, somewhat in the Rossetti³ fashion, seemed almost drugged, as if a strange mass of thoughts coiled in the darkness within her, and she was never allowed to escape.

Ursula watched her with fascination. She knew her a little. She was the most remarkable woman in the Midlands. Her father was a Derbyshire Baronet of the old school, she was a woman of the new school, full of intellectuality, and heavy, nerve-worn with consciousness. She was passionately interested in reform, her soul was given up to the public cause. But she was a man's woman, it was the manly world that held her.

She had various intimacies of mind and soul with various men of capacity. Ursula knew, among these men, only Rupert Birkin, who was one of the school-inspectors of the county. But Gudrun had met others, in London. Moving with her artist friends in different kinds of society, Gudrun had already come to know a good many people of repute and standing. She had met Hermione twice, but they did not take to each other. It would be queer to meet again down here in the Midlands, where their social standing was so diverse, after they had known each other on terms of equality in the houses of sundry acquaintances in town. For Gudrun had been a social success, and had her friends among the slack aristocracy that keeps touch with the arts.

Hermione knew herself to be well-dressed; she knew herself to be the social equal, if not far the superior, of anyone she was likely to meet in Willey Green. She knew she was accepted in the world of culture and of intellect. She was a *Kulturträger*,⁴ a medium for the culture of ideas. With all that was highest, whether in society or in thought or in public action, or even in art, she was at one, she moved among the foremost, at home with them. No one could put her down, no one could make mock of her, because she stood among the first, and those that were against her were below her, either in rank, or in wealth, or in high association of thought and progress and understanding. So, she was invulnerable. All her life, she had sought to make herself invulnerable, unassailable, beyond reach of the world's judgment.

And yet her soul was tortured, exposed. Even walking up the path to the church, confident as she was that in every respect she stood beyond all vulgar judgment, knowing perfectly that her appearance was complete and perfect, according to the first standards, yet she suffered a torture, under her confidence and her pride, feeling herself exposed to wounds and to mockery and to despite. She always felt vulnerable, vulnerable, there was always a secret chink in her armour. She did not know herself what it was. It was a lack of robust self, she had no natural sufficiency, there was a terrible void, a lack, a deficiency of being within her.

And she wanted someone to close up this deficiency, to close it up for ever. She craved for Rupert Birkin. When he was there, she felt complete, she was sufficient, whole. For the rest of time she was established on the sand, built over a chasm, and, in spite of all her vanity and securities, any common maid-servant of positive, robust temper could fling her down this bottomless pit of insufficiency, by the slightest movement of jeering or contempt. And all the while the pensive, tortured woman piled up her own defences of æsthetic knowledge, and culture, and world-visions, and disinterestedness. Yet she could never stop up the terrible gap of insufficiency.

If only Birkin would form a close and abiding connection with her, she would be safe during this fretful voyage of life. He could make her sound and triumphant, triumphant over the very angels of heaven. If only he would do it! But she was tortured with fear, with misgiving. She made herself beautiful, she strove so hard to come to that degree of beauty and advantage, when he should be convinced. But always there was a deficiency.

He was perverse too. He fought her off, he always fought her off. The more she strove to bring him to her, the more he battled her back. And they had been lovers now, for years. Oh, it was so wearying, so aching; she was so tired. But still she believed in herself. She knew he was trying to leave her. She knew he was trying to break away from her finally, to be free. But still she believed in her strength to keep him, she believed in her own higher knowledge. His own knowledge was high, she was the central touchstone of truth. She only needed his conjunction with her.

And this, this conjunction with her, which was his highest fulfilment also, with the perverseness of a wilful child he wanted to deny. With the wilfulness of an obstinate child, he wanted to break the holy connection that was between them.

He would be at this wedding; he was to be groom's man. He would be in the church, waiting. He would know when she came. She shuddered with nervous apprehension and desire as she went through the church-door. He would be there, surely he would see how beautiful her dress was, surely he would see how she had made herself beautiful for him. He would understand, he would be able to see how she was made for him, the first, how she was, for him, the highest. Surely at last he would be able to accept his highest fate, he would not deny her.

In a little convulsion of too-tired yearning, she entered the church and looked slowly along her cheeks for him, her slender body convulsed with agitation. As best man, he would be standing beside the altar. She looked slowly, deferring in her certainty.

And then, he was not there. A terrible storm came over her, as if she were drowning. She was possessed by a devastating hopelessness. And she approached mechanically to the altar. Never had she known such a pang of utter and final hopelessness. It was beyond death, so utterly null, desert.

The bridegroom and the groom's man had not yet come. There was a growing consternation outside. Ursula felt almost responsible. She could not bear it that the bride should arrive, and no groom. The wedding must not be a fiasco, it must not.

But here was the bride's carriage, adorned with ribbons and cockades. Gaily the grey horses curvetted to their destination at the churchgate, a laughter in the whole movement. Here was the quick of all laughter and pleasure. The door of the carriage was thrown open, to let out the very blossom of the day. The people on the roadway murmured faintly with the discontented murmuring of a crowd.

The father stepped out first into the air of the morning, like a shadow. He was a tall, thin, careworn man, with a thin black beard that was touched with grey. He waited at the door of the carriage patiently, self-obliterated.

In the opening of the doorway was a shower of fine foliage and flowers, a whiteness of satin and lace, and a sound of a gay voice saying:

'How do I get out?'

A ripple of satisfaction ran through the expectant people. They pressed near to receive her, looking with zest at the stooping blond head with its flower buds, and at the delicate, white, tentative foot that was reaching down to the step of the carriage. There was a sudden foaming rush, and the bride like a sudden surf-rush, floating all white beside her father in the morning shadow of trees, her veil flowing with laughter.

'That's done it!' she said.

She put her hand on the arm of her care-worn, sallow father, and frothing her light draperies, proceeded over the eternal red carpet. Her father, mute and yellowish, his black beard making him look more careworn, mounted the steps stiffly, as if his spirit were absent; but the laughing mist of the bride went along with him undiminished.

And no bridegroom had arrived! It was intolerable for her. Ursula, her heart strained with anxiety, was watching the hill beyond; the white, descending road, that should give sight of him. There was a carriage. It was running. It had just come into sight. Yes, it was he. Ursula turned towards the bride and the people, and, from her place of

WOMEN IN LOVE

vantage, gave an inarticulate cry. She wanted to warn them that he was coming. But her cry was inarticulate and inaudible, and she flushed deeply, between her desire and her wincing confusion.

The carriage rattled down the hill, and drew near. There was a shout from the people. The bride, who had just reached the top of the steps, turned round gaily to see what was the commotion. She saw a confusion among the people, a cab pulling up, and her lover dropping out of the carriage, and dodging among the horses and into the crowd.

'Tibs! Tibs!' she cried in her sudden, mocking excitement, standing high on the path in the sunlight and waving her bouquet. He, dodging with his hat in his hand, had not heard.

'Tibs!' she cried again, looking down to him.

He glanced up, unaware, and saw the bride and her father standing on the path above him. A queer, startled look went over his face. He hesitated for a moment. Then he gathered himself together for a leap, to overtake her.

'Ah-h-h' came her strange, intaken cry, as, on the reflex, she started, turned and fled, scudding with an unthinkable swift beating of her white feet and fraying of her white garments, towards the church. Like a hound the young man was after her, leaping the steps and swinging past her father, his supple haunches working like those of a hound that bears down on the quarry.

'Ay, after her!' cried the vulgar women below, carried suddenly into the sport.

She, her flowers shaken from her like froth, was steadying herself to turn the angle of the church. She glanced behind, and with a wild cry of laughter and challenge, veered, poised, and was gone beyond the grey stone buttress. In another instant the bridegroom, bent forward as he ran, had caught the angle of the silent stone with his hand, and had swung himself out of sight, his supple, strong loins vanishing in pursuit.

Instantly cries and exclamations of excitement burst from the crowd at the gate. And then Ursula noticed again the dark, rather stooping figure of Mr Crich, waiting suspended on the path, watching with expressionless face the flight to the church. It was over, and he turned round to look behind him, at the figure of Rupert Birkin, who at once came forward and joined him.

'We'll bring up the rear,' said Birkin, a faint smile on his face.

'Ay!' replied the father laconically. And the two men turned together up the path.

Birkin was as thin as Mr Crich, pale and ill-looking. His figure was narrow but nicely made. He went with a slight trail of one foot, which came only from self-consciousness. Although he was dressed correctly for his part, yet there was an innate incongruity which caused a slight ridiculousness in his appearance. His nature was clever and separate, he did not fit at all in the conventional occasion. Yet he subordinated himself to the common idea, travestied himself.

He affected to be quite ordinary, perfectly and marvellously commonplace. And he did it so well, taking the tone of his surroundings, adjusting himself quickly to his interlocutor and his circumstance, that he achieved a verisimilitude of ordinary commonplaceness that usually propitiated his onlookers for the moment, disarmed them from attacking his singleness.

Now he spoke quite easily and pleasantly to Mr Crich, as they walked along the path; he played with situations like a man on a tightrope: but always on a tight-rope, pretending nothing but ease.

'I'm sorry we are so late,' he was saying. 'We couldn't find a buttonhook, so it took us a long time to button our boots. But you were to the moment.'

'We are usually to time,' said Mr Crich.

'And I'm always late,' said Birkin. 'But today I was *really* punctual, only accidentally not so. I'm sorry.'

The two men were gone, there was nothing more to see, for the time. Ursula was left thinking about Birkin. He piqued her, attracted her, and annoyed her.

She wanted to know him more. She had spoken with him once or twice, but only in his official capacity as inspector. She thought he seemed to acknowledge some kinship between her and him, a natural, tacit understanding, a using of the same language. But there had been no time for the understanding to develop. And something kept her from him, as well as attracted her to him. There was a certain hostility, a hidden ultimate reserve in him, cold and inaccessible.

Yet she wanted to know him.

'What do you think of Rupert Birkin?' she asked, a little reluctantly, of Gudrun. She did not want to discuss him.

'What do I think of Rupert Birkin?' repeated Gudrun. 'I think he's attractive – decidedly attractive. What I can't stand about him is his way with other people – his way of treating any little fool as if she were his greatest consideration. One feels so awfully sold, oneself.'

'Why does he do it?' said Ursula.

'Because he has no real critical faculty – of people, at all events,' said Gudrun. 'I tell you, he treats any little fool as he treats me or you – and it's such an insult.'

'Oh, it is,' said Ursula. 'One must discriminate.'

'One must discriminate,' repeated Gudrun. 'But he's a wonderful

chap, in other respects - a marvellous personality. But you can't trust him.'

'Yes,' said Ursula vaguely. She was always forced to assent to Gudrun's pronouncements, even when she was not in accord altogether.

The sisters sat silent, waiting for the wedding party to come out. Gudrun was impatient of talk. She wanted to think about Gerald Crich. She wanted to see if the strong feeling she had got from him was real. She wanted to have herself ready.

Inside the church, the wedding was going on. Hermione Roddice was thinking only of Birkin. He stood near her. She seemed to gravitate physically towards him. She wanted to stand touching him. She could hardly be sure he was near her, if she did not touch him. Yet she stood subjected through the wedding service.

She had suffered so bitterly when he did not come, that still she was dazed. Still she was gnawed as by a neuralgia, tormented by his potential absence from her. She had awaited him in a faint delirium of nervous torture. As she stood bearing herself pensively, the rapt look on her face, that seemed spiritual, like the angels, but which came from torture, gave her a certain poignancy that tore his heart with pity. He saw her bowed head, her rapt face, the face of an almost demoniacal ecstatic. Feeling him looking, she lifted her face and sought his eyes, her own beautiful grey eyes flaring him a great signal. But he avoided her look, she sank her head in torment and shame, the gnawing at her heart going on. And he too was tortured with shame, and ultimate dislike, and with acute pity for her, because he did not want to meet her eyes, he did not want to receive her flare of recognition.

The bride and bridegroom were married, the party went into the vestry. Hermione crowded involuntarily up against Birkin, to touch him. And he endured it.

Outside, Gudrun and Ursula listened for their father's playing on the organ. He would enjoy playing a wedding march. Now the married pair were coming! The bells were ringing, making the air shake. Ursula wondered if the trees and the flowers could feel the vibration, and what they thought of it, this strange motion in the air. The bride was quite demure on the arm of the bridegroom, who stared up into the sky before him, shutting and opening his eyes unconsciously, as if he were neither here nor there. He looked rather comical, blinking and trying to be in the scene, when emotionally he was violated by his exposure to a crowd. He looked a typical naval officer, manly, and up to his duty.

Birkin came with Hermione. She had a rapt, triumphant look, like the fallen angels restored, yet still subtly demoniacal, now she held Birkin by the arm. And he was expressionless, neutralised, possessed by her as if it were his fate, without question.

Gerald Crich came, fair, good-looking, healthy, with a great reserve of energy. He was erect and complete, there was a strange stealth glistening through his amiable, almost happy appearance. Gudrun rose sharply and went away. She could not bear it. She wanted to be alone, to know this strange, sharp inoculation that had changed the whole temper of her blood.

CHAPTER II

Shortlands

THE BRANGWENS went home to Beldover, the wedding-party gathered at Shortlands, the Criches' home. It was a long, low old house, a sort of manor farm, that spread along the top of a slope just beyond the narrow little lake of Willey Water. Shortlands looked across a sloping meadow that might be a park, because of the large, solitary trees that stood here and there, across the water of the narrow lake, at the wooded hill that successfully hid the colliery valley beyond, but did not quite hide the rising smoke. Nevertheless, the scene was rural and picturesque, very peaceful, and the house had a charm of its own.

It was crowded now with the family and the wedding guests. The father, who was not well, withdrew to rest. Gerald was host. He stood in the homely entrance hall, friendly and easy, attending to the men. He seemed to take pleasure in his social functions, he smiled, and was abundant in hospitality.

The women wandered about in a little confusion, chased hither and thither by the three married daughters of the house. All the while there could be heard the characteristic, imperious voice of one Crich woman or another calling 'Helen, come here a minute,' 'Marjory, I want you – here.' 'Oh, I say, Mrs Witham – .' There was a great rustling of skirts, swift glimpses of smartly-dressed women, a child danced through the hall and back again, a maidservant came and went hurriedly.

Meanwhile the men stood in calm little groups, chatting, smoking, pretending to pay no heed to the rustling animation of the women's world. But they could not really talk, because of the glassy ravel of women's excited, cold laughter and running voices. They waited, uneasy, suspended, rather bored. But Gerald remained as if genial and happy, unaware that he was waiting or unoccupied, knowing himself the very pivot of the occasion.

Suddenly Mrs Crich came noiselessly into the room, peering about

with her strong, clear face. She was still wearing her hat, and her sac coat of blue silk.

'What is it, mother?' said Gerald.

'Nothing, nothing!' she answered vaguely. And she went straight towards Birkin, who was talking to a Crich brother-in-law.

'How do you do, Mr Birkin,' she said, in her low voice, that seemed to take no count of her guests. She held out her hand to him.

'Oh Mrs Crich,' replied Birkin, in his readily-changing voice, 'I couldn't come to you before.'

'I don't know half the people here,' she said, in her low voice. Her son-in-law moved uneasily away.

'And you don't like strangers?' laughed Birkin. 'I myself can never see why one should take account of people, just because they happen to be in the room with one: why *should* I know they are there?'

'Why indeed, why indeed!' said Mrs Crich, in her low, tense voice. 'Except that they *are* there. *I* don't know people whom I find in the house. The children introduce them to me – "Mother, this is Mr Soand-so." I am no further. What has Mr So-and-so to do with his own name? – and what have I to do with either him or his name?'

She looked up at Birkin. She startled him. He was flattered too that she came to talk to him, for she took hardly any notice of anybody. He looked down at her tense clear face, with its heavy features, but he was afraid to look into her heavy-seeing blue eyes. He noticed instead how her hair looped in slack, slovenly strands over her rather beautiful ears, which were not quite clean. Neither was her neck perfectly clean. Even in that he seemed to belong to her, rather than to the rest of the company; though, he thought to himself, he was always well washed, at any rate at the neck and ears.

He smiled faintly, thinking these things. Yet he was tense, feeling that he and the elderly, estranged woman were conferring together like traitors, like enemies within the camp of the other people. He resembled a deer, that throws one ear back upon the trail behind, and one ear forward, to know what is ahead.

'People don't really matter,' he said, rather unwilling to continue.

The mother looked up at him with sudden, dark interrogation, as if doubting his sincerity.

'How do you mean, matter?' she asked sharply.

'Not many people are anything at all,' he answered, forced to go deeper than he wanted to. 'They jingle and giggle. It would be much better if they were just wiped out. Essentially, they don't exist, they aren't there.'

She watched him steadily while he spoke.

18

'But we didn't imagine them,' she said sharply.

'There's nothing to imagine, that's why they don't exist.'

'Well,' she said, 'I would hardly go as far as that. There they are, whether they exist or no. It doesn't rest with me to decide on their existence. I only know that I can't be expected to take count of them all. You can't expect me to know them, just because they happen to be there. As far as I go they might as well not be there.'

'Exactly,' he replied.

'Mightn't they?' she asked again.

'Just as well,' he repeated. And there was a little pause.

'Except that they *are* there, and that's a nuisance,' she said. 'There are my sons-in-law,' she went on, in a sort of monologue. 'Now Laura's got married, there's another. And I really don't know John from James yet. They come up to me and call me mother. I know what they will say – "how are you, mother?" I ought to say, "I am not your mother, in any sense." But what is the use? There they are. I have had children of my own. I suppose I know them from another woman's children.'

'One would suppose so,' he said.

She looked at him, somewhat surprised, forgetting perhaps that she was talking to him. And she lost her thread.

She looked round the room, vaguely. Birkin could not guess what she was looking for, nor what she was thinking. Evidently she noticed her sons.

'Are my children all there?' she asked him abruptly.

He laughed, startled, afraid perhaps.

'I scarcely know them, except Gerald,' he replied.

'Gerald!' she exclaimed. 'He's the most wanting of them all. You'd never think it, to look at him now, would you?'

'No,' said Birkin.

The mother looked across at her eldest son, stared at him heavily for some time.

'Ay,' she said, in an incomprehensible monosyllable, that sounded profoundly cynical. Birkin felt afraid, as if he dared not realise. And Mrs Crich moved away, forgetting him. But she returned on her traces.

'I should like him to have a friend,' she said. 'He has never had a friend.'

Birkin looked down into her eyes, which were blue, and watching heavily. He could not understand them. 'Am I my brother's keeper?' he said to himself, almost flippantly.

Then he remembered, with a slight shock, that that was Cain's⁵ cry. And Gerald was Cain, if anybody. Not that he was Cain, either, although he had slain his brother. There was such a thing as pure accident, and the consequences did not attach to one, even though one had killed one's brother in such wise. Gerald as a boy had accidentally killed his brother. What then? Why seek to draw a brand and a curse across the life that had caused the accident? A man can live by accident, and die by accident. Or can he not? Is every man's life subject to pure accident, is it only the race, the genus, the species, that has a universal reference? Or is this not true, is there no such thing as pure accident? Has *everything* that happens a universal significance? Has it? Birkin, pondering as he stood there, had forgotten Mrs Crich, as she had forgotten him.

He did not believe that there was any such thing as accident. It all hung together, in the deepest sense.

Just as he had decided this, one of the Crich daughters came up, saying:

'Won't you come and take your hat off, mother dear? We shall be sitting down to eat in a minute, and it's a formal occasion, darling, isn't it?' She drew her arm through her mother's, and they went away. Birkin immediately went to talk to the nearest man.

The gong sounded for the luncheon. The men looked up, but no move was made to the dining-room. The women of the house seemed not to feel that the sound had meaning for them. Five minutes passed by. The elderly manservant, Crowther, appeared in the doorway exasperatedly. He looked with appeal at Gerald. The latter took up a large, curved conch shell, that lay on a shelf, and without reference to anybody, blew a shattering blast. It was a strange rousing noise, that made the heart beat. The summons was almost magical. Everybody came running, as if at a signal. And then the crowd in one impulse moved to the dining-room.

Gerald waited a moment, for his sister to play hostess. He knew his mother would pay no attention to her duties. But his sister merely crowded to her seat. Therefore the young man, slightly too dictatorial, directed the guests to their places.

There was a moment's lull, as everybody looked at the *bors d'oeuvres* that were being handed round. And out of this lull, a girl of thirteen or fourteen, with her long hair down her back, said in a calm, self-possessed voice:

'Gerald, you forget father, when you make that unearthly noise.'

'Do I?' he answered. And then, to the company, 'Father is lying down, he is not quite well.'

'How is he, really?' called one of the married daughters, peeping round the immense wedding cake that towered up in the middle of the table shedding its artificial flowers.

'He has no pain, but he feels tired,' replied Winifred, the girl with the hair down her back.

The wine was filled, and everybody was talking boisterously. At the far end of the table sat the mother, with her loosely-looped hair. She had Birkin for a neighbour. Sometimes she glanced fiercely down the rows of faces, bending forwards and staring unceremoniously. And she would say in a low voice to Birkin:

'Who is that young man?'

'I don't know,' Birkin answered discreetly.

'Have I seen him before?' she asked.

'I don't think so. *I* haven't,' he replied. And she was satisfied. Her eyes closed wearily, a peace came over her face, she looked like a queen in repose. Then she started, a little social smile came on her face, for a moment she looked the pleasant hostess. For a moment she bent graciously, as if everyone were welcome and delightful. And then immediately the shadow came back, a sullen, eagle look was on her face, she glanced from under her brows like a sinister creature at bay, hating them all.

'Mother,' called Diana, a handsome girl a little older than Winifred, 'I may have wine, mayn't I?'

'Yes, you may have wine,' replied the mother automatically, for she was perfectly indifferent to the question.

And Diana beckoned to the footman to fill her glass.

'Gerald shouldn't forbid me,' she said calmly, to the company at large.

'All right, Di,' said her brother amiably. And she glanced challenge at him as she drank from her glass.

There was a strange freedom, that almost amounted to anarchy, in the house. It was rather a resistance to authority, than liberty. Gerald had some command, by mere force of personality, not because of any granted position. There was a quality in his voice, amiable but dominant, that cowed the others, who were all younger than he.

Hermione was having a discussion with the bridegroom about nationality.

'No,' she said, 'I think that the appeal to patriotism is a mistake. It is like one house of business rivalling another house of business.'

'Well you can hardly say that, can you?' exclaimed Gerald, who had a real *passion* for discussion. 'You couldn't call a race a business concern, could you? – and nationality roughly corresponds to race, I think. I think it is *meant* to.'

There was a moment's pause. Gerald and Hermione were always

strangely but politely and evenly inimical.

'Do you think race corresponds with nationality?' she asked musingly, with expressionless indecision.

Birkin knew she was waiting for him to participate. And dutifully he spoke up.

'I think Gerald is right – race is the essential element in nationality, in Europe at least,' he said.

Again Hermione paused, as if to allow this statement to cool. Then she said with strange assumption of authority:

'Yes, but even so, is the patriotic appeal an appeal to the racial instinct? Is it not rather an appeal to the proprietory instinct, the *commercial* instinct? And isn't this what we mean by nationality?'

'Probably,' said Birkin, who felt that such a discussion was out of place and out of time.

But Gerald was now on the scent of argument.

'A race may have its commercial aspect,' he said. 'In fact it must. It is like a family. You *must* make provision. And to make provision you have got to strive against other families, other nations. I don't see why you shouldn't.'

Again Hermione made a pause, domineering and cold, before she replied: 'Yes, I think it is always wrong to provoke a spirit of rivalry. It makes bad blood. And bad blood accumulates.'

'But you can't do away with the spirit of emulation altogether?' said Gerald. 'It is one of the necessary incentives to production and improvement.'

'Yes,' came Hermione's sauntering response. 'I think you can do away with it.'

'I must say,' said Birkin, 'I detest the spirit of emulation.' Hermione was biting a piece of bread, pulling it from between her teeth with her fingers, in a slow, slightly derisive movement. She turned to Birkin.

'You do hate it, yes,' she said, intimate and gratified.

'Detest it,' he repeated.

'Yes,' she murmured, assured and satisfied.

'But,' Gerald insisted, 'you don't allow one man to take away his neighbour's living, so why should you allow one nation to take away the living from another nation?'

There was a long slow murmur from Hermione before she broke into speech, saying with a laconic indifference:

'It is not always a question of possessions, is it? It is not all a question of goods?'

Gerald was nettled by this implication of vulgar materialism.

'Yes, more or less,' he retorted. 'If I go and take a man's hat from off

his head, that hat becomes a symbol of that man's liberty. When he fights me for his hat, he is fighting me for his liberty.'

Hermione was nonplussed.

'Yes,' she said, irritated. 'But that way of arguing by imaginary instances is not supposed to be genuine, is it? A man does *not* come and take my hat from off my head, does he?'

'Only because the law prevents him,' said Gerald.

'Not only,' said Birkin. 'Ninety-nine men out of a hundred don't want my hat.'

'That's a matter of opinion,' said Gerald.

'Or the hat,' laughed the bridegroom.

'And if he does want my hat, such as it is,' said Birkin, 'why, surely it is open to me to decide, which is a greater loss to me, my hat, or my liberty as a free and indifferent man. If I am compelled to offer fight, I lose the latter. It is a question which is worth more to me, my pleasant liberty of conduct, or my hat.'

'Yes,' said Hermione, watching Birkin strangely. 'Yes.'

'But would you let somebody come and snatch your hat off your head?' the bride asked of Hermione.

The face of the tall straight woman turned slowly and as if drugged to this new speaker.

'No,' she replied, in a low inhuman tone, that seemed to contain a chuckle. 'No, I shouldn't let anybody take my hat off my head.'

'How would you prevent it?' asked Gerald.

'I don't know,' replied Hermione slowly. 'Probably I should kill him.'

There was a strange chuckle in her tone, a dangerous and convincing humour in her bearing.

'Of course,' said Gerald, 'I can see Rupert's point. It is a question to him whether his hat or his peace of mind is more important.'

'Peace of body,' said Birkin.

'Well, as you like there,' replied Gerald. 'But how are you going to decide this for a nation?'

'Heaven preserve me,' laughed Birkin.

'Yes, but suppose you have to?' Gerald persisted.

'Then it is the same. If the national crown-piece is an old hat, then the thieving gent may have it.'

'But can the national or racial hat be an old hat?' insisted Gerald.

'Pretty well bound to be, I believe,' said Birkin.

'I'm not so sure,' said Gerald.

'I don't agree, Rupert,' said Hermione.

'All right,' said Birkin.

'I'm all for the old national hat,' laughed Gerald.

WOMEN IN LOVE

'And a fool you look in it,' cried Diana, his pert sister who was just in her teens.

'Oh, we're quite out of our depths with these old hats,' cried Laura Crich. 'Dry up now, Gerald. We're going to drink toasts. Let us drink toasts. Toasts – glasses, glasses – now then, toasts! Speech! Speech!'

Birkin, thinking about race or national death, watched his glass being filled with champagne. The bubbles broke at the rim, the man withdrew, and feeling a sudden thirst at the sight of the fresh wine, Birkin drank up his glass. A queer little tension in the room roused him. He felt a sharp constraint.

'Did I do it by accident, or on purpose?' he asked himself. And he decided that, according to the vulgar phrase, he had done it 'accidentally on purpose.' He looked round at the hired footman. And the hired footman came, with a silent step of cold servant-like disapprobation. Birkin decided that he detested toasts, and footmen, and assemblies, and mankind altogether, in most of its aspects. Then he rose to make a speech. But he was somehow disgusted.

At length it was over, the meal. Several men strolled out into the garden. There was a lawn, and flower-beds, and at the boundary an iron fence shutting off the little field or park. The view was pleasant; a highroad curving round the edge of a low lake, under the trees. In the spring air, the water gleamed and the opposite woods were purplish with new life. Charming Jersey cattle came to the fence, breathing hoarsely from their velvet muzzles at the human beings, expecting perhaps a crust.

Birkin leaned on the fence. A cow was breathing wet hotness on his hand.

'Pretty cattle, very pretty,' said Marshall, one of the brothers-in-law. 'They give the best milk you can have.'

'Yes,' said Birkin.

'Eh, my little beauty, eh, my beauty!' said Marshall, in a queer high falsetto voice, that caused the other man to have convulsions of laughter in his stomach.

'Who won the race, Lupton?' he called to the bridegroom, to hide the fact that he was laughing.

The bridegroom took his cigar from his mouth.

'The race?' he exclaimed. Then a rather thin smile came over his face. He did not want to say anything about the flight to the church door. 'We got there together. At least she touched first, but I had my hand on her shoulder.'

'What's this?' asked Gerald.

Birkin told him about the race of the bride and the bridegroom.

'H'm!' said Gerald, in disapproval. 'What made you late then?'

'Lupton would talk about the immortality of the soul,' said Birkin, 'and then he hadn't got a button-hook.'

'Oh God!' cried Marshall. 'The immortality of the soul on your wedding day! Hadn't you got anything better to occupy your mind?'

'What's wrong with it?' asked the bridegroom, a clean-shaven naval man, flushing sensitively.

'Sounds as if you were going to be executed instead of married. *The immortality of the soul!*' repeated the brother-in-law, with most killing emphasis.

But he fell quite flat.

'And what did you decide?' asked Gerald, at once pricking up his ears at the thought of a metaphysical discussion.

'You don't want a soul today, my boy,' said Marshall. 'It'd be in your road.'

'Christ! Marshall, go and talk to somebody else,' cried Gerald, with sudden impatience.

'By God, I'm willing,' said Marshall, in a temper. 'Too much bloody soul and talk altogether – '

He withdrew in a dudgeon, Gerald staring after him with angry eyes, that grew gradually calm and amiable as the stoutly-built form of the other man passed into the distance.

'There's one thing, Lupton,' said Gerald, turning suddenly to the bridegroom. 'Laura won't have brought such a fool into the family as Lottie did.'

'Comfort yourself with that,' laughed Birkin.

'I take no notice of them,' laughed the bridegroom.

'What about this race then - who began it?' Gerald asked.

'We were late. Laura was at the top of the churchyard steps when our cab came up. She saw Lupton bolting towards her. And she fled. But why do you look so cross? Does it hurt your sense of the family dignity?'

'It does, rather,' said Gerald. 'If you're doing a thing, do it properly, and if you're not going to do it properly, leave it alone.'

'Very nice aphorism,' said Birkin.

'Don't you agree?' asked Gerald.

'Quite,' said Birkin. 'Only it bores me rather, when you become aphoristic.'

'Damn you, Rupert, you want all the aphorisms your own way,' said Gerald.

'No. I want them out of the way, and you're always shoving them in it.'

Gerald smiled grimly at this humorism. Then he made a little gesture of dismissal, with his eyebrows.

'You don't believe in having any standard of behaviour at all, do you?' he challenged Birkin, censoriously.

'Standard – no. I hate standards. But they're necessary for the common ruck. Anybody who is anything can just be himself and do as he likes.'

'But what do you mean by being himself?' said Gerald. 'Is that an aphorism or a cliché?'

'I mean just doing what you want to do. I think it was perfect good form in Laura to bolt from Lupton to the church door. It was almost a masterpiece in good form. It's the hardest thing in the world to act spontaneously on one's impulses – and it's the only really gentlemanly thing to do – provided you're fit to do it.'

'You don't expect me to take you seriously, do you?' asked Gerald.

'Yes, Gerald, you're one of the very few people I do expect that of.'

'Then I'm afraid I can't come up to your expectations here, at any rate. You think people should just do as they like.'

'I think they always do. But I should like them to like the purely individual thing in themselves, which makes them act in singleness. And they only like to do the collective thing.'

'And I,' said Gerald grimly, 'shouldn't like to be in a world of people who acted individually and spontaneously, as you call it. We should have everybody cutting everybody else's throat in five minutes.'

'That means you would like to be cutting everybody's throat,' said Birkin.

'How does that follow?' asked Gerald crossly.

'No man,' said Birkin, 'cuts another man's throat unless he wants to cut it, and unless the other man wants it cutting. This is a complete truth. It takes two people to make a murder: a murderer and a murderee. And a murderee is a man who is murderable. And a man who is murderable is a man who in a profound if hidden lust desires to be murdered.'

'Sometimes you talk pure nonsense,' said Gerald to Birkin. 'As a matter of fact, none of us wants our throat cut, and most other people would like to cut it for us – some time or other –'

'It's a nasty view of things, Gerald,' said Birkin, 'and no wonder you are afraid of yourself and your own unhappiness.'

'How am I afraid of myself?' said Gerald; 'and I don't think I am unhappy.'

'You seem to have a lurking desire to have your gizzard slit, and imagine every man has his knife up his sleeve for you,' Birkin said. 'How do you make that out?' said Gerald.

'From you,' said Birkin.

There was a pause of strange enmity between the two men, that was very near to love. It was always the same between them; always their talk brought them into a deadly nearness of contact, a strange, perilous intimacy which was either hate or love, or both. They parted with apparent unconcern, as if their going apart were a trivial occurrence. And they really kept it to the level of trivial occurrence. Yet the heart of each burned from the other. They burned with each other, inwardly. This they would never admit. They intended to keep their relationship a casual free-and-easy friendship, they were not going to be so unmanly and unnatural as to allow any heart-burning between them. They had not the faintest belief in deep relationship between men and men, and their disbelief prevented any development of their powerful but suppressed friendliness.

CHAPTER III

Classroom

A SCHOOL-DAY was drawing to a close. In the classroom the last lesson was in progress, peaceful and still. It was elementary botany. The desks were littered with catkins, hazel and willow, which the children had been sketching. But the sky had come overdark, as the end of the afternoon approached: there was scarcely light to draw any more. Ursula stood in front of the class, leading the children by questions to understand the structure and the meaning of the catkins.

A heavy, copper-coloured beam of light came in at the west window, gilding the outlines of the children's heads with red gold, and falling on the wall opposite in a rich, ruddy illumination. Ursula, however, was scarcely conscious of it. She was busy, the end of the day was here, the work went on as a peaceful tide that is at flood, hushed to retire.

This day had gone by like so many more, in an activity that was like a trance. At the end there was a little haste, to finish what was in hand. She was pressing the children with questions, so that they should know all they were to know, by the time the gong went. She stood in shadow in front of the class, with catkins in her hand, and she leaned towards the children, absorbed in the passion of instruction.

She heard, but did not notice the click of the door. Suddenly she started. She saw, in the shaft of ruddy, copper-coloured light near her, the face of a man. It was gleaming like fire, watching her, waiting for her to be aware. It startled her terribly. She thought she was going to faint. All her suppressed, subconscious fear sprang into being, with anguish.

'Did I startle you?' said Birkin, shaking hands with her. 'I thought you had heard me come in.'

'No,' she faltered, scarcely able to speak. He laughed, saying he was sorry. She wondered why it amused him.

'It is so dark,' he said. 'Shall we have the light?'

And moving aside, he switched on the strong electric lights. The classroom was distinct and hard, a strange place after the soft dim magic that filled it before he came. Birkin turned curiously to look at Ursula. Her eyes were round and wondering, bewildered, her mouth quivered slightly. She looked like one who is suddenly wakened. There was a living, tender beauty, like a tender light of dawn shining from her face. He looked at her with a new pleasure, feeling gay in his heart, irresponsible.

'You are doing catkins?' he asked, picking up a piece of hazel from a scholar's desk in front of him. 'Are they as far out as this? I hadn't noticed them this year.'

He looked absorbedly at the tassel of hazel in his hand.

'The red ones too!' he said, looking at the flickers of crimson that came from the female bud.

Then he went in among the desks, to see the scholars' books. Ursula watched his intent progress. There was a stillness in his motion that hushed the activities of her heart. She seemed to be standing aside in arrested silence, watching him move in another, concentrated world. His presence was so quiet, almost like a vacancy in the corporate air.

Suddenly he lifted his face to her, and her heart quickened at the flicker of his voice.

'Give them some crayons, won't you?' he said, 'so that they can make the gynaecious flowers red, and the androgynous yellow. I'd chalk them in plain, chalk in nothing else, merely the red and the yellow. Outline scarcely matters in this case. There is just the one fact to emphasise.'

'I haven't any crayons,' said Ursula.

'There will be some somewhere - red and yellow, that's all you want.'

Ursula sent out a boy on a quest.

'It will make the books untidy,' she said to Birkin, flushing deeply.

'Not very,' he said. 'You must mark in these things obviously. It's the fact you want to emphasise, not the subjective impression to record. What's the fact? - red little spiky stigmas of the female flower,

dangling yellow male catkin, yellow pollen flying from one to the other. Make a pictorial record of the fact, as a child does when drawing a face – two eyes, one nose, mouth with teeth – so – ' And he drew a figure on the blackboard.

At that moment another vision was seen through the glass panels of the door. It was Hermione Roddice. Birkin went and opened to her.

'I saw your car,' she said to him. 'Do you mind my coming to find you? I wanted to see you when you were on duty.'

She looked at him for a long time, intimate and playful, then she gave a short little laugh. And then only she turned to Ursula, who, with all the class, had been watching the little scene between the lovers.

'How do you do, Miss Brangwen,' sang Hermione, in her low, odd, singing fashion, that sounded almost as if she were poking fun. 'Do you mind my coming in?'

Her grey, almost sardonic eyes rested all the while on Ursula, as if summing her up.

'Oh no,' said Ursula.

'Are you *sure?*' repeated Hermione, with complete sang froid, and an odd, half-bullying effrontery.

'Oh no, I like it awfully,' laughed Ursula, a little bit excited and bewildered, because Hermione seemed to be compelling her, coming very close to her, as if intimate with her; and yet, how could she be intimate?

This was the answer Hermione wanted. She turned satisfied to Birkin.

'What are you doing?' she sang, in her casual, inquisitive fashion.

'Catkins,' he replied.

'Really!' she said. 'And what do you learn about them?' She spoke all the while in a mocking, half teasing fashion, as if making game of the whole business. She picked up a twig of the catkin, piqued by Birkin's attention to it.

She was a strange figure in the classroom, wearing a large, old cloak of greenish cloth, on which was a raised pattern of dull gold. The high collar, and the inside of the cloak, was lined with dark fur. Beneath she had a dress of fine lavender-coloured cloth, trimmed with fur, and her hat was close-fitting, made of fur and of the dull, green-and-gold figured stuff. She was tall and strange, she looked as if she had come out of some new, bizarre picture.

'Do you know the little red ovary flowers, that produce the nuts? Have you ever noticed them?' he asked her. And he came close and pointed them out to her, on the sprig she held.

'No,' she replied. 'What are they?'

'Those are the little seed-producing flowers, and the long catkins, they only produce pollen, to fertilise them.'

'Do they, do they!' repeated Hermione, looking closely.

'From those little red bits, the nuts come; if they receive pollen from the long danglers.'

'Little red flames, little red flames,' murmured Hermione to herself. And she remained for some moments looking only at the small buds out of which the red flickers of the stigma issued.

'Aren't they beautiful? I think they're so beautiful,' she said, moving close to Birkin, and pointing to the red filaments with her long, white finger.

'Had you never noticed them before?' he asked.

'No, never before,' she replied.

'And now you will always see them,' he said.

'Now I shall always see them,' she repeated. 'Thank you so much for showing me. I think they're so beautiful – little red flames – '

Her absorption was strange, almost rhapsodic. Both Birkin and Ursula were suspended. The little red pistillate flowers had some strange, almost mystic-passionate attraction for her.

The lesson was finished, the books were put away, at last the class was dismissed. And still Hermione sat at the table, with her chin in her hand, her elbow on the table, her long white face pushed up, not attending to anything. Birkin had gone to the window, and was looking from the brilliantly-lighted room on to the grey, colourless outside, where rain was noiselessly falling. Ursula put away her things in the cupboard.

At length Hermione rose and came near to her.

'Your sister has come home?' she said.

'Yes,' said Ursula.

'And does she like being back in Beldover?'

'No,' said Ursula.

'No, I wonder she can bear it. It takes all my strength, to bear the ugliness of this district, when I stay here. Won't you come and see me? Won't you come with your sister to stay at Breadalby for a few days? -do -'

'Thank you very much,' said Ursula.

'Then I will write to you,' said Hermione. 'You think your sister will come? I should be so glad. I think she is wonderful. I think some of her work is really wonderful. I have two water-wagtails, carved in wood, and painted – perhaps you have seen it?'

'No,' said Ursula.

'I think it is perfectly wonderful - like a flash of instinct.'

30

'Her little carvings are strange,' said Ursula.

'Perfectly beautiful - full of primitive passion - '

'Isn't it queer that she always likes little things? – she must always work small things, that one can put between one's hands, birds and tiny animals. She likes to look through the wrong end of the opera glasses, and see the world that way – why is it, do you think?'

Hermione looked down at Ursula with that long, detached scrutinising gaze that excited the younger woman.

'Yes,' said Hermione at length. 'It is curious. The little things seem to be more subtle to her -'

'But they aren't, are they? A mouse isn't any more subtle than a lion, is it?'

Again Hermione looked down at Ursula with that long scrutiny, as if she were following some train of thought of her own, and barely attending to the other's speech.

'I don't know,' she replied.

'Rupert, Rupert,' she sang mildly, calling him to her. He approached in silence.

'Are little things more subtle than big things?' she asked, with the odd grunt of laughter in her voice, as if she were making game of him in the question.

'Dunno,' he said.

'I hate subtleties,' said Ursula.

Hermione looked at her slowly.

'Do you?' she said.

'I always think they are a sign of weakness,' said Ursula, up in arms, as if her prestige were threatened.

Hermione took no notice. Suddenly her face puckered, her brow was knit with thought, she seemed twisted in troublesome effort for utterance.

'Do you really think, Rupert,' she asked, as if Ursula were not present, 'do you really think it is worth while? Do you really think the children are better for being roused to consciousness?'

A dark flash went over his face, a silent fury. He was hollow-cheeked and pale, almost unearthly. And the woman, with her serious, conscience-harrowing question tortured him on the quick.

'They are not roused to consciousness,' he said. 'Consciousness comes to them, willy-nilly.'

'But do you think they are better for having it quickened, stimulated? Isn't it better that they should remain unconscious of the hazel, isn't it better that they should see as a whole, without all this pulling to pieces, all this knowledge?'

'Would you rather, for yourself, know or not know, that the little red flowers are there, putting out for the pollen?' he asked harshly. His voice was brutal, scornful, cruel.

Hermione remained with her face lifted up, abstracted. He hung silent in irritation.

'I don't know,' she replied, balancing mildly. 'I don't know.'

'But knowing is everything to you, it is all your life,' he broke out. She slowly looked at him.

'Is it?' she said.

'To know, that is your all, that is your life – you have only this, this knowledge,' he cried. 'There is only one tree, there is only one fruit, in your mouth.'

Again she was some time silent.

'Is there?' she said at last, with the same untouched calm. And then in a tone of whimsical inquisitiveness: 'What fruit, Rupert?'

'The eternal apple,'6 he replied in exasperation, hating his own metaphors.

'Yes,' she said. There was a look of exhaustion about her. For some moments there was silence. Then, pulling herself together with a convulsed movement, Hermione resumed, in a sing-song, casual voice:

'But leaving me apart, Rupert; do you think the children are better, richer, happier, for all this knowledge; do you really think they are? Or is it better to leave them untouched, spontaneous. Hadn't they better be animals, simple animals, crude, violent, *anything*, rather than this self-consciousness, this incapacity to be spontaneous.'

They thought she had finished. But with a queer rumbling in her throat she resumed, 'Hadn't they better be anything than grow up crippled, crippled in their souls, crippled in their feelings – so thrown back – so turned back on themselves – incapable – 'Hermione clenched her fist like one in a trance – 'of any spontaneous action, always deliberate, always burdened with choice, never carried away.'

Again they thought she had finished. But just as he was going to reply, she resumed her queer rhapsody – 'never carried away, out of themselves, always conscious, always self-conscious, always aware of themselves. Isn't *anything* better than this? Better be animals, mere animals with no mind at all, than this, this *nothingness* – '

'But do you think it is knowledge that makes us unliving and selfconscious?' he asked irritably.

She opened her eyes and looked at him slowly.

'Yes,' she said. She paused, watching him all the while, her eyes vague. Then she wiped her fingers across her brow, with a vague weariness. It irritated him bitterly. 'It is the mind,' she said, 'and that is death.' She raised her eyes slowly to him: 'Isn't the mind – ' she said, with the convulsed movement of her body, 'isn't it our death? Doesn't it destroy all our spontaneity, all our instincts? Are not the young people growing up today, really dead before they have a chance to live?'

'Not because they have too much mind, but too little,' he said brutally.

'Are you *sure?*' she cried. 'It seems to me the reverse. They are overconscious, burdened to death with consciousness.'

'Imprisoned within a limited, false set of concepts,' he cried.

But she took no notice of this, only went on with her own rhapsodic interrogation.

'When we have knowledge, don't we lose everything but knowledge?' she asked pathetically. 'If I know about the flower, don't I lose the flower and have only the knowledge? Aren't we exchanging the substance for the shadow, aren't we forfeiting life for this dead quality of knowledge? And what does it mean to me, after all? What does all this knowing mean to me? It means nothing.'

'You are merely making words,' he said; 'knowledge means everything to you. Even your animalism, you want it in your head. You don't want to be an animal, you want to observe your own animal functions, to get a mental thrill out of them. It is all purely secondary – and more decadent than the most hide-bound intellectualism. What is it but the worst and last form of intellectualism, this love of yours for passion and the animal instincts? Passion and the instincts – you want them hard enough, but through your head, in your consciousness. It all takes place in your head, under that skull of yours. Only you won't be conscious of what *actually* is: you want the lie that will match the rest of your furniture.'

Hermione set hard and poisonous against this attack. Ursula stood covered with wonder and shame. It frightened her, to see how they hated each other.

'It's all that Lady of Shalott⁷ business,' he said, in his strong abstract voice. He seemed to be charging her before the unseeing air. 'You've got that mirror, your own fixed will, your immortal understanding, your own tight conscious world, and there is nothing beyond it. There, in the mirror, you must have everything. But now you have come to all your conclusions, you want to go back and be like a savage, without knowledge. You want a life of pure sensation and "passion."'

He quoted the last word satirically against her. She sat convulsed with fury and violation, speechless, like a stricken pythoness of the Greek oracle.⁸

'But your passion is a lie,' he went on violently. 'It isn't passion at all, it is your *will*. It's your bullying will. You want to clutch things and have them in your power. You want to have things in your power. And why? Because you haven't got any real body, any dark sensual body of life. You have no sensuality. You have only your will and your conceit of consciousness, and your lust for power, to *know*.'

He looked at her in mingled hate and contempt, also in pain because she suffered, and in shame because he knew he tortured her. He had an impulse to kneel and plead for forgiveness. But a bitterer red anger burned up to fury in him. He became unconscious of her, he was only a passionate voice speaking.

'Spontaneous!' he cried. 'You and spontaneity! You, the most deliberate thing that ever walked or crawled! You'd be verily deliberately spontaneous – that's you. Because you want to have everything in your own volition, your deliberate voluntary consciousness. You want it all in that loathsome little skull of yours, that ought to be cracked like a nut. For you'll be the same till it is cracked, like an insect in its skin. If one cracked your skull perhaps one might get a spontaneous, passionate woman out of you, with real sensuality. As it is, what you want is pornography – looking at yourself in mirrors, watching your naked animal actions in mirrors, so that you can have it all in your consciousness, make it all mental.'

There was a sense of violation in the air, as if too much was said, the unforgivable. Yet Ursula was concerned now only with solving her own problems, in the light of his words. She was pale and abstracted.

'But do you really want sensuality?' she asked, puzzled.

Birkin looked at her, and became intent in his explanation.

'Yes,' he said, 'that and nothing else, at this point. It is a fulfilment – the great dark knowledge you can't have in your head – the dark involuntary being. It is death to one's self – but it is the coming into being of another.'

'But how? How can you have knowledge not in your head?' she asked, quite unable to interpret his phrases.

'In the blood,' he answered; 'when the mind and the known world is drowned in darkness everything must go - there must be the deluge. Then you find yourself a palpable body of darkness, a demon -'

'But why should I be a demon -?' she asked.

' "Woman wailing for her demon lover"9 - 'he quoted - 'why, I don't know.'

Hermione roused herself as from a death – annihilation.

'He is such a *dreadful* satanist, isn't he?' she drawled to Ursula, in a queer resonant voice, that ended on a shrill little laugh of pure ridicule.

The two women were jeering at him, jeering him into nothingness. The laugh of the shrill, triumphant female sounded from Hermione, jeering him as if he were a neuter.

'No,' he said. 'You are the real devil who won't let life exist.'

She looked at him with a long, slow look, malevolent, supercilious.

'You know all about it, don't you?' she said, with slow, cold, cunning mockery.

'Enough,' he replied, his face fixing fine and clear like steel. A horrible despair, and at the same time a sense of release, liberation, came over Hermione. She turned with a pleasant intimacy to Ursula.

'You are sure you will come to Breadalby?' she said, urging.

'Yes, I should like to very much,' replied Ursula.

Hermione looked down at her, gratified, reflecting, and strangely absent, as if possessed, as if not quite there.

'I'm so glad,' she said, pulling herself together. 'Some time in about a fortnight. Yes? I will write to you here, at the school, shall I? Yes. And you'll be sure to come? Yes. I shall be so glad. Good-bye! Good-bye!'

Hermione held out her hand and looked into the eyes of the other woman. She knew Ursula as an immediate rival, and the knowledge strangely exhilarated her. Also she was taking leave. It always gave her a sense of strength, advantage, to be departing and leaving the other behind. Moreover she was taking the man with her, if only in hate.

Birkin stood aside, fixed and unreal. But now, when it was his turn to bid good-bye, he began to speak again.

'There's the whole difference in the world,' he said, 'between the actual sensual being, and the vicious mental-deliberate profligacy our lot goes in for. In our night-time, there's always the electricity switched on, we watch ourselves, we get it all in the head, really. You've got to lapse out before you can know what sensual reality is, lapse into unknowingness, and give up your volition. You've got to do it. You've got to learn not-to-be, before you can come into being.

'But we have got such a conceit of ourselves – that's where it is. We are so conceited, and so unproud. We've got no pride, we're all conceit, so conceited in our own papier-mâché realised selves. We'd rather die than give up our little self-righteous self-opinionated self-will.'

There was silence in the room. Both women were hostile and resentful. He sounded as if he were addressing a meeting. Hermione merely paid no attention, stood with her shoulders tight in a shrug of dislike.

Ursula was watching him as if furtively, not really aware of what she was seeing. There was a great physical attractiveness in him – a curious hidden richness, that came through his thinness and his pallor like

another voice, conveying another knowledge of him. It was in the curves of his brows and his chin, rich, fine, exquisite curves, the powerful beauty of life itself. She could not say what it was. But there was a sense of richness and of liberty.

'But we are sensual enough, without making ourselves so, aren't we?' she asked, turning to him with a certain golden laughter flickering under her greenish eyes, like a challenge. And immediately the queer, careless, terribly attractive smile came over his eyes and brows, though his mouth did not relax.

'No,' he said, 'we aren't. We're too full of ourselves.'

'Surely it isn't a matter of conceit,' she cried.

'That and nothing else.'

She was frankly puzzled.

'Don't you think that people are most conceited of all about their sensual powers?' she asked.

'That's why they aren't sensual – only sensuous – which is another matter. They're *always* aware of themselves – and they're so conceited, that rather than release themselves, and live in another world, from another centre, they'd – '

'You want your tea, don't you,' said Hermione, turning to Ursula with a gracious kindliness. 'You've worked all day -'

Birkin stopped short. A spasm of anger and chagrin went over Ursula. His face set. And he bade good-bye, as if he had ceased to notice her.

They were gone. Ursula stood looking at the door for some moments. Then she put out the lights. And having done so, she sat down again in her chair, absorbed and lost. And then she began to cry, bitterly, bitterly weeping: but whether for misery or joy, she never knew.

CHAPTER IV

Diver

THE WEEK passed away. On the Saturday it rained, a soft drizzling rain that held off at times. In one of the intervals Gudrun and Ursula set out for a walk, going towards Willey Water. The atmosphere was grey and translucent, the birds sang sharply on the young twigs, the earth would be quickening and hastening in growth. The two girls walked swiftly, gladly, because of the soft, subtle rush of morning that filled the wet haze. By the road the black-thorn was in blossom, white and wet, its tiny amber grains burning faintly in the white smoke of blossom. Purple twigs were darkly luminous in the grey air, high hedges glowed like living shadows, hovering nearer, coming into creation. The morning was full of a new creation.

When the sisters came to Willey Water, the lake lay all grey and visionary, stretching into the moist, translucent vista of trees and meadow. Fine electric activity in sound came from the dumbles below the road, the birds piping one against the other, and water mysteriously plashing, issuing from the lake.

The two girls drifted swiftly along. In front of them, at the corner of the lake, near the road, was a mossy boat-house under a walnut tree, and a little landing-stage where a boat was moored, wavering like a shadow on the still grey water, below the green, decayed poles. All was shadowy with coming summer.

Suddenly, from the boat-house, a white figure ran out, frightening in its swift sharp transit, across the old landing-stage. It launched in a white arc through the air, there was a bursting of the water, and among the smooth ripples a swimmer was making out to space, in a centre of faintly heaving motion. The whole otherworld, wet and remote, he had to himself. He could move into the pure translucency of the grey, uncreated water.

Gudrun stood by the stone wall, watching.

'How I envy him,' she said, in low, desirous tones.

'Ugh!' shivered Ursula. 'So cold!'

'Yes, but how good, how really fine, to swim out there!' The sisters stood watching the swimmer move further into the grey, moist, full space of the water, pulsing with his own small, invading motion, and arched over with mist and dim woods.

'Don't you wish it were you?' asked Gudrun, looking at Ursula.

'I do,' said Ursula. 'But I'm not sure - it's so wet.'

'No,' said Gudrun, reluctantly. She stood watching the motion on the bosom of the water, as if fascinated. He, having swum a certain distance, turned round and was swimming on his back, looking along the water at the two girls by the wall. In the faint wash of motion, they could see his ruddy face, and could feel him watching them.

'It is Gerald Crich,' said Ursula.

'I know,' replied Gudrun.

And she stood motionless gazing over the water at the face which washed up and down on the flood, as he swam steadily. From his separate element he saw them and he exulted to himself because of his own advantage, his possession of a world to himself. He was immune and perfect. He loved his own vigorous, thrusting motion, and the violent impulse of the very cold water against his limbs, buoying him up. He could see the girls watching him a way off, outside, and that pleased him. He lifted his arm from the water, in a sign to them.

'He is waving,' said Ursula.

'Yes,' replied Gudrun. They watched him. He waved again, with a strange movement of recognition across the difference.

'Like a Nibelung,' laughed Ursula. Gudrun said nothing, only stood still looking over the water.

Gerald suddenly turned, and was swimming away swiftly, with a side stroke. He was alone now, alone and immune in the middle of the waters, which he had all to himself. He exulted in his isolation in the new element, unquestioned and unconditioned. He was happy, thrusting with his legs and all his body, without bond or connection anywhere, just himself in the watery world.

Gudrun envied him almost painfully. Even this momentary possession of pure isolation and fluidity seemed to her so terribly desirable that she felt herself as if damned, out there on the high-road.

'God, what it is to be a man!' she cried.

'What?' exclaimed Ursula in surprise.

'The freedom, the liberty, the mobility!' cried Gudrun, strangely flushed and brilliant. 'You're a man, you want to do a thing, you do it. You haven't the *thousand* obstacles a woman has in front of her.'

Ursula wondered what was in Gudrun's mind, to occasion this outburst. She could not understand.

'What do you want to do?' she asked.

'Nothing,' cried Gudrun, in swift refutation. 'But supposing I did. Supposing I want to swim up that water. It is impossible, it is one of the impossibilities of life, for me to take my clothes off now and jump in. But isn't it *ridiculous*, doesn't it simply prevent our living!'

She was so hot, so flushed, so furious, that Ursula was puzzled.

The two sisters went on, up the road. They were passing between the trees just below Shortlands. They looked up at the long, low house, dim and glamorous in the wet morning, its cedar trees slanting before the windows. Gudrun seemed to be studying it closely.

'Don't you think it's attractive, Ursula?' asked Gudrun.

'Very,' said Ursula. 'Very peaceful and charming.'

'It has form, too - it has a period.'

'What period?'

'Oh, eighteenth century, for certain; Dorothy Wordsworth and Jane Austen, don't you think?'

Ursula laughed.

'Don't you think so?' repeated Gudrun.

38

'Perhaps. But I don't think the Criches fit the period. I know Gerald is putting in a private electric plant, for lighting the house, and is making all kinds of latest improvements.'

Gudrun shrugged her shoulders swiftly.

'Of course,' she said, 'that's quite inevitable.'

'Quite,' laughed Ursula. 'He is several generations of youngness at one go. They hate him for it. He takes them all by the scruff of the neck, and fairly flings them along. He'll have to die soon, when he's made every possible improvement, and there will be nothing more to improve. He's got go, anyhow.'

'Certainly, he's got go,' said Gudrun. 'In fact I've never seen a man that showed signs of so much. The unfortunate thing is, where does his go go to, what becomes of it?'

'Oh I know,' said Ursula. 'It goes in applying the latest appliances!' 'Exactly,' said Gudrun.

'You know he shot his brother?' said Ursula.

'Shot his brother?' cried Gudrun, frowning as if in disapprobation.

'Didn't you know? Oh yes! – I thought you knew. He and his brother were playing together with a gun. He told his brother to look down the gun, and it was loaded, and blew the top of his head off. Isn't it a horrible story?'

'How fearful!' cried Gudrun. 'But it is long ago?'

'Oh yes, they were quite boys,' said Ursula. 'I think it is one of the most horrible stories I know.'

'And he of course did not know that the gun was loaded?'

'Yes. You see it was an old thing that had been lying in the stable for years. Nobody dreamed it would ever go off, and of course, no one imagined it was loaded. But isn't it dreadful, that it should happen?'

'Frightful!' cried Gudrun. 'And isn't it horrible too to think of such a thing happening to one, when one was a child, and having to carry the responsibility of it all through one's life. Imagine it, two boys playing together – then this comes upon them, for no reason whatever – out of the air. Ursula, it's very frightening! Oh, it's one of the things I can't bear. Murder, that is thinkable, because there's a will behind it. But a thing like that to *bappen* to one – '

'Perhaps there was an unconscious will behind it,' said Ursula. 'This playing at killing has some primitive *desire* for killing in it, don't you think?'

'Desire!' said Gudrun, coldly, stiffening a little. 'I can't see that they were even playing at killing. I suppose one boy said to the other, "You look down the barrel while I pull the trigger, and see what happens." It seems to me the purest form of accident.'

'No,' said Ursula. 'I couldn't pull the trigger of the emptiest gun in the world, not if some-one were looking down the barrel. One instinctively doesn't do it - one can't." I fulling Gudrun was silent for some moments, in sharp disagreement.

'Of course,' she said coldly. 'If one is a woman, and grown up, one's instinct prevents one. But I cannot see how that applies to a couple of boys playing together.'

Her voice was cold and angry.

'Yes,' persisted Ursula. At that moment they heard a woman's voice a few yards off say loudly:

'Oh damn the thing!' They went forward and saw Laura Crich and Hermione Roddice in the field on the other side of the hedge, and Laura Crich struggling with the gate, to get out. Ursula at once hurried up and helped to lift the gate.

'Thanks so much,' said Laura, looking up flushed and amazon-like, vet rather confused. 'It isn't right on the hinges.'

'No,' said Ursula. 'And they're so heavy.'

'Surprising!' cried Laura.

'How do you do,' sang Hermione, from out of the field, the moment she could make her voice heard. 'It's nice now. Are you going for a walk? Yes. Isn't the young green beautiful? So beautiful - quite burning. Good morning - good morning - you'll come and see me? thank you so much - next week - yes - good-bye, g-o-o-d b-y-e.'

Gudrun and Ursula stood and watched her slowly waving her head up and down, and waving her hand slowly in dismissal, smiling a strange affected smile, making a tall queer, frightening figure, with her heavy fair hair slipping to her eyes. Then they moved off, as if they had been dismissed like inferiors. The four women parted.

As soon as they had gone far enough, Ursula said, her cheeks burning, 'I do think she's impudent.'

'Who, Hermione Roddice?' asked Gudrun. 'Why?'

'The way she treats one - impudence!'

'Why, Ursula, what did you notice that was so impudent?' asked Gudrun rather coldly.

'Her whole manner. Oh, it's impossible, the way she tries to bully one. Pure bullying. She's an impudent woman. "You'll come and see me," as if we should be falling over ourselves for the privilege.'

'I can't understand, Ursula, what you are so much put out about,' said Gudrun, in some exasperation. 'One knows those women are impudent - these free women who have emancipated themselves from the aristocracy.'

'But it is so unnecessary - so vulgar,' cried Ursula.

'No, I don't see it. And if I did – pour moi, elle n'existe pas.¹⁰ I don't grant her the power to be impudent to me.'

'Do you think she likes you?' asked Ursula.

'Well, no, I shouldn't think she did.'

'Then why does she ask you to go to Breadalby and stay with her?' Gudrun lifted her shoulders in a low shrug.

'After all, she's got the sense to know we're not just the ordinary run,' said Gudrun. 'Whatever she is, she's not a fool. And I'd rather have somebody I detested, than the ordinary woman who keeps to her own set. Hermione Roddice does risk herself in some respects.'

Ursula pondered this for a time.

'I doubt it,' she replied. 'Really she risks nothing. I suppose we ought to admire her for knowing she *can* invite us – school teachers – and risk nothing.'

'Precisely!' said Gudrun. 'Think of the myriads of women that daren't do it. She makes the most of her privileges – that's something. I suppose, really, we should do the same, in her place.'

'No,' said Ursula. 'No. It would bore me. I couldn't spend my time playing her games. It's infra dig.'

The two sisters were like a pair of scissors, snipping off everything that came athwart them; or like a knife and a whetstone, the one sharpened against the other.

'Of course,' cried Ursula suddenly, 'she ought to thank her stars if we will go and see her. You are perfectly beautiful, a thousand times more beautiful than ever she is or was, and to my thinking, a thousand times more beautifully dressed, for she never looks fresh and natural, like a flower, always old, thought-out; and we *are* more intelligent than most people.'

'Undoubtedly!' said Gudrun.

'And it ought to be admitted, simply,' said Ursula.

'Certainly it ought,' said Gudrun. 'But you'll find that the really chic thing is to be so absolutely ordinary, so perfectly commonplace and like the person in the street, that you really are a masterpiece of humanity, not the person in the street actually, but the artistic creation of her -'

'How awful!' cried Ursula.

'Yes, Ursula, it is awful, in most respects. You daren't be anything that isn't amazingly a terre,¹¹ so much a terre that it is the artistic creation of ordinariness.'

'It's very dull to create oneself into nothing better,' laughed Ursula.

'Very dull!' retorted Gudrun. 'Really Ursula, it is dull, that's just the word. One longs to be high-flown, and make speeches like Corneille,¹² after it.'

Gudrun was becoming flushed and excited over her own cleverness. 'Strut,' said Ursula. 'One wants to strut, to be a swan among geese.' 'Exactly,' cried Gudrun, 'a swan among geese.'

'They are all so busy playing the ugly duckling,' cried Ursula, with mocking laughter. 'And I don't feel a bit like a humble and pathetic ugly duckling. I do feel like a swan among geese – I can't help it. They make one feel so. And I don't care what *they* think of me. *Je m'en fiche*.'¹³

Gudrun looked up at Ursula with a queer, uncertain envy and dislike. 'Of course, the only thing to do is to despise them all – just all,' she

said.

The sisters went home again, to read and talk and work, and wait for Monday, for school. Ursula often wondered what else she waited for, besides the beginning and end of the school week, and the beginning and end of the holidays. This was a whole life! Sometimes she had periods of tight horror, when it seemed to her that her life would pass away, and be gone, without having been more than this. But she never really accepted it. Her spirit was active, her life like a shoot that is growing steadily, but which has not yet come above ground.

CHAPTER V

In the Train

ONE DAY at this time Birkin was called to London. He was not very fixed in his abode. He had rooms in Nottingham, because his work lay chiefly in that town. But often he was in London, or in Oxford. He moved about a great deal, his life seemed uncertain, without any definite rhythm, any organic meaning.

On the platform of the railway station he saw Gerald Crich, reading a newspaper, and evidently waiting for the train. Birkin stood some distance off, among the people. It was against his instinct to approach anybody.

From time to time, in a manner characteristic of him, Gerald lifted his head and looked round. Even though he was reading the newspaper closely, he must keep a watchful eye on his external surroundings. There seemed to be a dual consciousness running in him. He was thinking vigorously of something he read in the newspaper, and at the same time his eye ran over the surfaces of the life round him, and he missed nothing. Birkin, who was watching him, was irritated by his duality. He noticed too, that Gerald seemed always to be at bay against everybody, in spite of his queer, genial, social manner when roused. Now Birkin started violently at seeing this genial look flash on to Gerald's face, at seeing Gerald approaching with hand outstretched.

'Hallo, Rupert, where are you going?'

'London. So are you, I suppose.'

'Yes-'

Gerald's eyes went over Birkin's face in curiosity.

'We'll travel together if you like,' he said.

'Don't you usually go first?' asked Birkin.

'I can't stand the crowd,' replied Gerald. 'But third'll be all right. There's a restaurant car, we can have some tea.'

The two men looked at the station clock, having nothing further to say.

'What were you reading in the paper?' Birkin asked.

Gerald looked at him quickly.

'Isn't it funny, what they *do* put in the newspapers,' he said. 'Here are two leaders – ' he held out his *Daily Telegraph*, 'full of the ordinary newspaper cant – ' he scanned the columns down – 'and then there's this little – I dunno what you'd call it, essay, almost – appearing with the leaders, and saying there must arise a man who will give new values to things, give us new truths, a new attitude to life, or else we shall be a crumbling nothingness in a few years, a country in ruin – '

'I suppose that's a bit of newspaper cant, as well,' said Birkin.

'It sounds as if the man meant it, and quite genuinely,' said Gerald.

'Give it to me,' said Birkin, holding out his hand for the paper.

The train came, and they went on board, sitting on either side a little table, by the window, in the restaurant car. Birkin glanced over his paper, then looked up at Gerald, who was waiting for him.

'I believe the man means it,' he said, 'as far as he means anything.'

'And do you think it's true? Do you think we really want a new gospel?' asked Gerald.

Birkin shrugged his shoulders.

'I think the people who say they want a new religion are the last to accept anything new. They want novelty right enough. But to stare straight at this life that we've brought upon ourselves, and reject it, absolutely smash up the old idols of ourselves, that we sh'll never do. You've got very badly to want to get rid of the old, before anything new will appear – even in the self.'

Gerald watched him closely.

'You think we ought to break up this life, just start and let fly?' he asked.

'This life. Yes I do. We've got to bust it completely, or shrivel inside it, as in a tight skin. For it won't expand any more.' There was a queer little smile in Gerald's eyes, a look of amusement, calm and curious.

'And how do you propose to begin? I suppose you mean, reform the whole order of society?' he asked.

Birkin had a slight, tense frown between the brows. He too was impatient of the conversation.

'I don't propose at all,' he replied. 'When we really want to go for something better, we shall smash the old. Until then, any sort of proposal, or making proposals, is no more than a tiresome game for self-important people.'

The little smile began to die out of Gerald's eyes, and he said, looking with a cool stare at Birkin:

'So you really think things are very bad?'

'Completely bad.'

The smile appeared again.

'In what way?'

'Every way,' said Birkin. 'We are such dreary liars. Our one idea is to lie to ourselves. We have an ideal of a perfect world, clean and straight and sufficient. So we cover the earth with foulness; life is a blotch of labour, like insects scurrying in filth, so that your collier can have a pianoforte in his parlour, and you can have a butler and a motor-car in your up-to-date house, and as a nation we can sport the Ritz, or the Empire, Gaby Deslys¹⁴ and the Sunday newspapers. It is very dreary.'

Gerald took a little time to re-adjust himself after this tirade.

'Would you have us live without houses - return to nature?' he asked.

'I would have nothing at all. People only do what they want to do - and what they are capable of doing. If they were capable of anything else, there would be something else.'

Again Gerald pondered. He was not going to take offence at Birkin.

'Don't you think the collier's *pianoforte*, as you call it, is a symbol for something very real, a real desire for something higher, in the collier's life?'

'Higher!' cried Birkin. 'Yes. Amazing heights of upright grandeur. It makes him so much higher in his neighbouring collier's eyes. He sees himself reflected in the neighbouring opinion, like in a Brocken mist, several feet taller on the strength of the pianoforte, and he is satisfied. He lives for the sake of that Brocken spectre,¹⁵ the reflection of himself in the human opinion. You do the same. If you are of high importance to humanity you are of high importance to yourself. That is why you work so hard at the mines. If you can produce coal to cook five thousand dinners a day, you are five thousand times more important than if you cooked only your own dinner.'

'I suppose I am,' laughed Gerald.

'Can't you see,' said Birkin, 'that to help my neighbour to eat is no more than eating myself. "I eat, thou eatest, he eats, we eat, you eat, they eat" – and what then? Why should every man decline the whole verb. First person singular is enough for me.'

'You've got to start with material things,' said Gerald. Which statement Birkin ignored.

'And we've got to live for *something*, we're not just cattle that can graze and have done with it,' said Gerald.

'Tell me,' said Birkin. 'What do you live for?'

Gerald's face went baffled.

'What do I live for?' he repeated. 'I suppose I live to work, to produce something, in so far as I am a purposive being. Apart from that, I live because I am living.'

'And what's your work? Getting so many more thousands of tons of coal out of the earth every day. And when we've got all the coal we want, and all the plush furniture, and pianofortes, and the rabbits are all stewed and eaten, and we're all warm and our bellies are filled and we're listening to the young lady performing on the pianoforte – what then? What then, when you've made a real fair start with your material things?'

Gerald sat laughing at the words and the mocking humour of the other man. But he was cogitating too.

'We haven't got there yet,' he replied. 'A good many people are still waiting for the rabbit and the fire to cook it.'

'So while you get the coal I must chase the rabbit?' said Birkin, mocking at Gerald.

'Something like that,' said Gerald.

Birkin watched him narrowly. He saw the perfect good-humoured callousness, even strange, glistening malice, in Gerald, glistening through the plausible ethics of productivity.

'Gerald,' he said, 'I rather hate you.'

'I know you do,' said Gerald. 'Why do you?'

Birkin mused inscrutably for some minutes.

'I should like to know if you are conscious of hating me,' he said at last. 'Do you ever consciously detest me – hate me with mystic hate? There are odd moments when I hate you starrily.'

Gerald was rather taken aback, even a little disconcerted. He did not quite know what to say.

'I may, of course, hate you sometimes,' he said. 'But I'm not aware of it – never acutely aware of it, that is.'

'So much the worse,' said Birkin.

Gerald watched him with curious eyes. He could not quite make him out.

'So much the worse, is it?' he repeated.

There was a silence between the two men for some time, as the train ran on. In Birkin's face was a little irritable tension, a sharp knitting of the brows, keen and difficult. Gerald watched him warily, carefully, rather calculatingly, for he could not decide what he was after.

Suddenly Birkin's eyes looked straight and overpowering into those of the other man.

'What do you think is the aim and object of your life, Gerald?' he asked.

Again Gerald was taken aback. He could not think what his friend was getting at. Was he poking fun, or not?

'At this moment, I couldn't say off-hand,' he replied, with faintly ironic humour.

'Do you think love is the be-all and the end-all of life?' Birkin asked, with direct, attentive seriousness.

'Of my own life?' said Gerald.

'Yes.'

There was a really puzzled pause.

'I can't say,' said Gerald. 'It hasn't been, so far.'

'What has your life been, so far?'

'Oh - finding out things for myself - and getting experiences - and making things go.'

Birkin knitted his brows like sharply moulded steel.

'I find,' he said, 'that one needs some one *really* pure single activity – I should call love a single pure activity. But I *don't* really love anybody – not now.'

'Have you ever really loved anybody?' asked Gerald.

'Yes and no,' replied Birkin.

'Not finally?' said Gerald.

'Finally – finally – no,' said Birkin.

'Nor I,' said Gerald.

'And do you want to?' said Birkin.

Gerald looked with a long, twinkling, almost sardonic look into the eyes of the other man.

'I don't know,' he said.

'I do – I want to love,' said Birkin.

'You do?'

'Yes. I want the finality of love.'

'The finality of love,' repeated Gerald. And he waited for a moment.

'Just one woman?' he added. The evening light, flooding yellow along the fields, lit up Birkin's face with a tense, abstract steadfastness. Gerald still could not make it out.

'Yes, one woman,' said Birkin.

But to Gerald it sounded as if he were insistent rather than confident.

'I don't believe a woman, and nothing but a woman, will ever make my life,' said Gerald.

'Not the centre and core of it – the love between you and a woman?' asked Birkin.

Gerald's eyes narrowed with a queer dangerous smile as he watched the other man.

'I never quite feel it that way,' he said.

'You don't? Then wherein does life centre, for you?'

'I don't know – that's what I want somebody to tell me. As far as I can make out, it doesn't centre at all. It is artificially held *together* by the social mechanism.'

Birkin pondered as if he would crack something.

'I know,' he said, 'it just doesn't centre. The old ideals are dead as nails – nothing there. It seems to me there remains only this perfect union with a woman – sort of ultimate marriage – and there isn't anything else.'

'And you mean if there isn't the woman, there's nothing?' said Gerald.

'Pretty well that - seeing there's no God.'

'Then we're hard put to it,' said Gerald. And he turned to look out of the window at the flying, golden landscape.

Birkin could not help seeing how beautiful and soldierly his face was, with a certain courage to be indifferent.

'You think its heavy odds against us?' said Birkin.

'If we've got to make our life up out of a woman, one woman, woman only, yes, I do,' said Gerald. 'I don't believe I shall ever make up *my* life, at that rate.'

Birkin watched him almost angrily.

'You are a born unbeliever,' he said.

'I only feel what I feel,' said Gerald. And he looked again at Birkin almost sardonically, with his blue, manly, sharp-lighted eyes. Birkin's eyes were at the moment full of anger. But swiftly they became troubled, doubtful, then full of a warm, rich affectionateness and laughter.

'It troubles me very much, Gerald,' he said, wrinkling his brows.

'I can see it does,' said Gerald, uncovering his mouth in a manly, quick, soldierly laugh.

Gerald was held unconsciously by the other man. He wanted to be near him, he wanted to be within his sphere of influence. There was something very congenial to him in Birkin. But yet, beyond this, he did not take much notice. He felt that he, himself, Gerald, had harder and more durable truths than any the other man knew. He felt himself older, more knowing. It was the quick-changing warmth and venality and brilliant warm utterance he loved in his friend. It was the rich play of words and quick interchange of feelings he enjoyed. The real content of the words he never really considered: he himself knew better.

Birkin knew this. He knew that Gerald wanted to be *fond* of him without taking him seriously. And this made him go hard and cold. As the train ran on, he sat looking at the land, and Gerald fell away, became as nothing to him.

Birkin looked at the land, at the evening, and was thinking: 'Well, if mankind is destroyed, if our race is destroyed like Sodom,¹⁶ and there is this beautiful evening with the luminous land and trees, I am satisfied. That which informs it all is there, and can never be lost. After all, what is mankind but just one expression of the incomprehensible. And if mankind passes away, it will only mean that this particular expression is completed and done. That which is expressed, and that which is to be expressed, cannot be diminished. There it is, in the shining evening. Let mankind pass away – time it did. The creative utterances will not cease, they will only be there. Humanity doesn't embody the utterance of the incomprehensible any more. Humanity is a dead letter. There will be a new embodiment, in a new way. Let humanity disappear as quick as possible.'

Gerald interrupted him by asking,

'Where are you staying in London?'

Birkin looked up.

'With a man in Soho. I pay part of the rent of a flat, and stop there when I like.'

'Good idea - have a place more or less your own,' said Gerald.

'Yes. But I don't care for it much. I'm tired of the people I am bound to find there.'

'What kind of people?'

'Art – music – London Bohemia¹⁷ – the most pettifogging calculating Bohemia that ever reckoned its pennies. But there are a few decent people, decent in some respects. They are really very thorough rejecters of the world – perhaps they live only in the gesture of rejection and negation – but negatively something, at any rate.'

'What are they? - painters, musicians?'

'Painters, musicians, writers – hangers-on, models, advanced young people, anybody who is openly at outs with the conventions, and belongs to nowhere particularly. They are often young fellows down from the University, and girls who are living their own lives, as they say.'

'All loose?' said Gerald.

Birkin could see his curiosity roused.

'In one way. Most bound, in another. For all their shockingness, all on one note.'

He looked at Gerald, and saw how his blue eyes were lit up with a little flame of curious desire. He saw too how good-looking he was. Gerald was attractive, his blood seemed fluid and electric. His blue eyes burned with a keen, yet cold light, there was a certain beauty, a beautiful passivity in all his body, his moulding.

'We might see something of each other – I am in London for two or three days,' said Gerald.

'Yes,' said Birkin, 'I don't want to go to the theatre, or the music hall – you'd better come round to the flat, and see what you can make of Halliday and his crowd.'

'Thanks - I should like to,' laughed Gerald. 'What are you doing tonight?'

'I promised to meet Halliday at the Pompadour. It's a bad place, but there is nowhere else.'

'Where is it?' asked Gerald.

'Piccadilly Circus.'

'Oh yes - well, shall I come round there?'

'By all means, it might amuse you.'

The evening was falling. They had passed Bedford. Birkin watched the country, and was filled with a sort of hopelessness. He always felt this, on approaching London.

His dislike of mankind, of the mass of mankind, amounted almost to an illness.

"Where the quiet coloured end of evening smiles Miles and miles – " '¹⁸

he was murmuring to himself, like a man condemned to death. Gerald, who was very subtly alert, wary in all his senses, leaned forward and asked smilingly:

'What were you saying?' Birkin glanced at him, laughed, and repeated:

"Where the quiet coloured end of evening smiles, Miles and miles,

Over pastures where the something something sheep Half asleep – "'

Gerald also looked now at the country. And Birkin, who, for some reason was now tired and dispirited, said to him:

'I always feel doomed when the train is running into London. I feel such a despair, so hopeless, as if it were the end of the world.'

'Really!' said Gerald. 'And does the end of the world frighten you?' Birkin lifted his shoulders in a slow shrug.

'I don't know,' he said. 'It does while it hangs imminent and doesn't fall. But people give me a bad feeling – very bad.'

There was a roused glad smile in Gerald's eyes.

'Do they?' he said. And he watched the other man critically.

In a few minutes the train was running through the disgrace of outspread London. Everybody in the carriage was on the alert, waiting to escape. At last they were under the huge arch of the station, in the tremendous shadow of the town. Birkin shut himself together – he was in now.

The two men went together in a taxi-cab.

'Don't you feel like one of the damned?' asked Birkin, as they sat in a little, swiftly-running enclosure, and watched the hideous great street.

'No,' laughed Gerald.

'It is real death,' said Birkin.

CHAPTER VI

Crême de Menthe

THEY MET again in the café several hours later. Gerald went through the push doors into the large, lofty room where the faces and heads of the drinkers showed dimly through the haze of smoke, reflected more dimly, and repeated ad infinitum in the great mirrors on the walls, so that one seemed to enter a vague, dim world of shadowy drinkers humming within an atmosphere of blue tobacco smoke. There was, however, the red plush of the seats to give substance within the bubble of pleasure.

Gerald moved in his slow, observant, glistening-attentive motion down between the tables and the people whose shadowy faces looked up as he passed. He seemed to be entering in some strange element, passing into an illuminated new region, among a host of licentious souls. He was pleased, and entertained. He looked over all the dim, evanescent, strangely illuminated faces that bent across the tables. Then he saw Birkin rise and signal to him.

At Birkin's table was a girl with dark, soft, fluffy hair cut short in the artist fashion, hanging level and full almost like the Egyptian princess's. She was small and delicately made, with warm colouring and large, dark hostile eyes. There was a delicacy, almost a beauty in all her form, and at the same time a certain attractive grossness of spirit, that made a little spark leap instantly alight in Gerald's eyes.

Birkin, who looked muted, unreal, his presence left out, introduced her as Miss Darrington. She gave her hand with a sudden, unwilling movement, looking all the while at Gerald with a dark, exposed stare. A glow came over him as he sat down.

The waiter appeared. Gerald glanced at the glasses of the other two. Birkin was drinking something green, Miss Darrington had a small liqueur glass that was empty save for a tiny drop.

'Won't you have some more -?'

'Brandy,' she said, sipping her last drop and putting down the glass. The waiter disappeared.

'No,' she said to Birkin. 'He doesn't know I'm back. He'll be terrified when he sees me here.'

She spoke her r's like w's, lisping with a slightly babyish pronunciation which was at once affected and true to her character. Her voice was dull and toneless.

'Where is he then?' asked Birkin.

'He's doing a private show at Lady Snellgrove's,' said the girl. 'Warens is there too.'

There was a pause.

'Well, then,' said Birkin, in a dispassionate protective manner, 'what do you intend to do?'

The girl paused sullenly. She hated the question.

'I don't intend to do anything,' she replied. 'I shall look for some sittings tomorrow.'

'Who shall you go to?' asked Birkin.

'I shall go to Bentley's first. But I believe he's angwy with me for running away.'

'That is from the Madonna?'

'Yes. And then if he doesn't want me, I know I can get work with Carmarthen.'

'Carmarthen?'

'Lord Carmarthen - he does photographs.'

'Chiffon and shoulders -'

'Yes. But he's awfully decent.' There was a pause.

'And what are you going to do about Julius?' he asked.

'Nothing,' she said. 'I shall just ignore him.'

'You've done with him altogether?' But she turned aside her face sullenly, and did not answer the question.

Another young man came hurrying up to the table.

'Hallo Birkin! Hallo Pussum, when did you come back?' he said eagerly.

'Today.'

'Does Halliday know?'

'I don't know. I don't care either.'

'Ha-ha! The wind still sits in that quarter, does it? Do you mind if I come over to this table?'

'I'm talking to Wupert, do you mind?' she replied, coolly and yet appealingly, like a child.

'Open confession - good for the soul, eh?' said the young man. 'Well, so long.'

And giving a sharp look at Birkin and at Gerald, the young man moved off, with a swing of his coat skirts.

All this time Gerald had been completely ignored. And yet he felt that the girl was physically aware of his proximity. He waited, listened, and tried to piece together the conversation.

'Are you staying at the flat?' the girl asked, of Birkin.

'For three days,' replied Birkin. 'And you?'

'I don't know yet. I can always go to Bertha's.' There was a silence.

Suddenly the girl turned to Gerald, and said, in a rather formal, polite voice, with the distant manner of a woman who accepts her position as a social inferior, yet assumes intimate *camaraderie* with the male she addresses:

'Do you know London well?'

'I can hardly say,' he laughed. 'I've been up a good many times, but I was never in this place before.'

'You're not an artist, then?' she said, in a tone that placed him an outsider.

'No,' he replied.

'He's a soldier, and an explorer, and a Napoleon of industry,' said Birkin, giving Gerald his credentials for Bohemia.

'Are you a soldier?' asked the girl, with a cold yet lively curiosity.

'No, I resigned my commission,' said Gerald, 'some years ago.'

'He was in the last war,' ¹⁹ said Birkin.

'Were you really?' said the girl.

'And then he explored the Amazon,' said Birkin, 'and now he is ruling over coal-mines.'

The girl looked at Gerald with steady, calm curiosity. He laughed, hearing himself described. He felt proud too, full of male strength. His blue, keen eyes were lit up with laughter, his ruddy face, with its sharp fair hair, was full of satisfaction, and glowing with life. He piqued her.

'How long are you staying?' she asked him.

'A day or two,' he replied. 'But there is no particular hurry.'

Still she stared into his face with that slow, full gaze which was so curious and so exciting to him. He was acutely and delightfully conscious of himself, of his own attractiveness. He felt full of strength, able to give off a sort of electric power. And he was aware of her dark, hot-looking eves upon him. She had beautiful eves, dark, fully-opened, hot, naked in their looking at him. And on them there seemed to float a film of disintegration, a sort of misery and sullenness, like oil on water. She wore no hat in the heated café, her loose, simple jumper was strung on a string round her neck. But it was made of rich peach-coloured crêpe-de-chine, that hung heavily and softly from her young throat and her slender wrists. Her appearance was simple and complete, really beautiful, because of her regularity and form, her soft dark hair falling full and level on either side of her head, her straight, small, softened features, Egyptian in the slight fulness of their curves, her slender neck and the simple, rich-coloured smock hanging on her slender shoulders. She was very still, almost null, in her manner, apart and watchful.

She appealed to Gerald strongly. He felt an awful, enjoyable power over her, an instinctive cherishing very near to cruelty. For she was a victim. He felt that she was in his power, and he was generous. The electricity was turgid and voluptuously rich, in his limbs. He would be able to destroy her utterly in the strength of his discharge. But she was waiting in her separation, given.

They talked banalities for some time. Suddenly Birkin said:

'There's Julius!' and he half rose to his feet, motioning to the newcomer. The girl, with a curious, almost evil motion, looked round over her shoulder without moving her body. Gerald watched her dark, soft hair swing over her ears. He felt her watching intensely the man who was approaching, so he looked too. He saw a pale, full-built young man with rather long, solid fair hair hanging from under his black hat, moving cumbrously down the room, his face lit up with a smile at once naive and warm, and vapid. He approached towards Birkin, with a haste of welcome.

It was not till he was quite close that he perceived the girl. He recoiled, went pale, and said, in a high squealing voice:

'Pussum, what are you doing here?'

The café looked up like animals when they hear a cry. Halliday hung motionless, an almost imbecile smile flickering palely on his face. The girl only stared at him with a black look in which flared an unfathomable hell of knowledge, and a certain impotence. She was limited by him.

'Why have you come back?' repeated Halliday, in the same high, hysterical voice. 'I told you not to come back.'

The girl did not answer, only stared in the same viscous, heavy fashion, straight at him, as he stood recoiled, as if for safety, against the next table.

'You know you wanted her to come back - come and sit down,' said Birkin to him.

'No I didn't want her to come back, and I told her not to come back. What have you come for, Pussum?'

'For nothing from you,' she said in a heavy voice of resentment.

'Then why have you come back at *all*?' cried Halliday, his voice rising to a kind of squeal.

'She comes as she likes,' said Birkin. 'Are you going to sit down, or are you not?'

'No, I won't sit down with Pussum,' cried Halliday.

'I won't hurt you, you needn't be afraid,' she said to him, very curtly, and yet with a sort of protectiveness towards him, in her voice.

Halliday came and sat at the table, putting his hand on his heart, and crying:

'Oh, it's given me such a turn! Pussum, I wish you wouldn't do these things. Why did you come back?'

'Not for anything from you,' she repeated.

'You've said that before,' he cried in a high voice.

She turned completely away from him, to Gerald Crich, whose eyes were shining with a subtle amusement.

'Were you ever vewy much afwaid of the savages?' she asked in her calm, dull childish voice.

'No – never very much afraid. On the whole they're harmless – they're not born yet, you can't feel really afraid of them. You know you can manage them.'

'Do you weally? Aren't they very fierce?'

'Not very. There aren't many fierce things, as a matter of fact. There aren't many things, neither people nor animals, that have it in them to be really dangerous.'

'Except in herds,' interrupted Birkin.

'Aren't there really?' she said. 'Oh, I thought savages were all so dangerous, they'd have your life before you could look round.'

'Did you?' he laughed. 'They are over-rated, savages. They're too much like other people, not exciting, after the first acquaintance.'

'Oh, it's not so very wonderfully brave then, to be an explorer?'

'No. It's more a question of hardships than of terrors.'

'Oh! And weren't you ever afraid?'

'In my life? I don't know. Yes, I'm afraid of some things – of being shut up, locked up anywhere – or being fastened. I'm afraid of being bound hand and foot.'

She looked at him steadily with her dark eyes, that rested on him and roused him so deeply, that it left his upper self quite calm. It was rather delicious, to feel her drawing his self-revelations from him, as from the very innermost dark marrow of his body. She wanted to know. And her dark eyes seemed to be looking through into his naked organism. He felt, she was compelled to him, she was fated to come into contact with him, must have the seeing him and knowing him. And this roused a curious exultance. Also he felt, she must relinquish herself into his hands, and be subject to him. She was so profane, slave-like, watching him, absorbed by him. It was not that she was interested in what he said; she was absorbed by his self-revelation, by *bim*, she wanted the secret of him, the experience of his male being.

Gerald's face was lit up with an uncanny smile, full of light and rousedness, yet unconscious. He sat with his arms on the table, his sunbrowned, rather sinister hands, that were animal and yet very shapely and attractive, pushed forward towards her. And they fascinated her. And she knew, she watched her own fascination.

Other men had come to the table, to talk with Birkin and Halliday. Gerald said in a low voice, apart, to Pussum:

'Where have you come back from?'

'From the country,' replied Pussum, in a very low, yet fully resonant voice. Her face closed hard. Continually she glanced at Halliday, and then a black flare came over her eyes. The heavy, fair young man ignored her completely; he was really afraid of her. For some moments she would be unaware of Gerald. He had not conquered her yet.

'And what has Halliday to do with it?' he asked, his voice still muted. She would not answer for some seconds. Then she said, unwillingly:

'He made me go and live with him, and now he wants to throw me over. And yet he won't let me go to anybody else. He wants me to live hidden in the country. And then he says I persecute him, that he can't get rid of me.'

'Doesn't know his own mind,' said Gerald.

'He hasn't any mind, so he can't know it,' she said. 'He waits for what somebody tells him to do. He never does anything he wants to do

himself - because he doesn't know what he wants. He's a perfect baby.'

Gerald looked at Halliday for some moments, watching the soft, rather degenerate face of the young man. Its very softness was an attraction; it was a soft, warm, corrupt nature, into which one might plunge with gratification.

'But he has no hold over you, has he?' Gerald asked.

'You see he *made* me go and live with him, when I didn't want to,' she replied. 'He came and cried to me, tears, you never saw so many, saying *he couldn't* bear it unless I went back to him. And he wouldn't go away, he would have stayed for ever. He made me go back. Then every time he behaves in this fashion. And now I'm going to have a baby, he wants to give me a hundred pounds and send me into the country, so that he would never see me nor hear of me again. But I'm not going to do it, after - '

A queer look came over Gerald's face.

'Are you going to have a child?' he asked incredulous. It seemed, to look at her, impossible, she was so young and so far in spirit from any child-bearing.

She looked full into his face, and her dark, inchoate eyes had now a furtive look, and a look of a knowledge of evil, dark and indomitable. A flame ran secretly to his heart.

'Yes,' she said. 'Isn't it beastly?'

'Don't you want it?' he asked.

'I don't,' she replied emphatically.

'But - ' he said, 'how long have you known?'

'Ten weeks,' she said.

All the time she kept her dark, inchoate eyes full upon him. He remained silent, thinking. Then, switching off and becoming cold, he asked, in a voice full of considerate kindness:

'Is there anything we can eat here? Is there anything you would like?' 'Yes,' she said, 'I should adore some oysters.'

'All right,' he said. 'We'll have oysters.' And he beckoned to the waiter.

Halliday took no notice, until the little plate was set before her. Then suddenly he cried:

'Pussum, you can't eat oysters when you're drinking brandy.'

'What has it go to do with you?' she asked.

'Nothing, nothing,' he cried. 'But you can't eat oysters when you're drinking brandy.'

'I'm not drinking brandy,' she replied, and she sprinkled the last drops of her liqueur over his face. He gave an odd squeal. She sat looking at him, as if indifferent.

56

'Pussum, why do you do that?' he cried in panic. He gave Gerald the impression that he was terrified of her, and that he loved his terror. He seemed to relish his own horror and hatred of her, turn it over and extract every flavour from it, in real panic. Gerald thought him a strange fool, and yet piquant.

'But Pussum,' said another man, in a very small, quick Eton voice, 'you promised not to hurt him.'

'I haven't hurt him,' she answered.

'What will you drink?' the young man asked. He was dark, and smooth-skinned, and full of a stealthy vigour.

'I don't like porter, Maxim,' she replied.

'You must ask for champagne,' came the whispering, gentlemanly voice of the other.

Gerald suddenly realised that this was a hint to him.

'Shall we have champagne?' he asked, laughing.

'Yes please, dwy,' she lisped childishly.

Gerald watched her eating the oysters. She was delicate and finicking in her eating, her fingers were fine and seemed very sensitive in the tips, so she put her food apart with fine, small motions, she ate carefully, delicately. It pleased him very much to see her, and it irritated Birkin. They were all drinking champagne. Maxim, the prim young Russian with the smooth, warm-coloured face and black, oiled hair was the only one who seemed to be perfectly calm and sober. Birkin was white and abstract, unnatural, Gerald was smiling with a constant bright, amused, cold light in his eyes, leaning a little protectively towards the Pussum, who was very handsome, and soft, unfolded like some red lotus in dreadful flowering nakedness, vainglorious now, flushed with wine and with the excitement of men. Halliday looked foolish. One glass of wine was enough to make him drunk and giggling. Yet there was always a pleasant, warm naiveté about him, that made him attractive.

'I'm not afwaid of anything except black-beetles,' said the Pussum, looking up suddenly and staring with her black eyes, on which there seemed an unseeing film of flame, fully upon Gerald. He laughed dangerously, from the blood. Her childish speech caressed his nerves, and her burning, filmed eyes, turned now full upon him, oblivious of all her antecedents, gave him a sort of licence.

'I'm not,' she protested. 'I'm not afraid of other things. But blackbeetles – ugh!' she shuddered convulsively, as if the very thought were too much to bear.

'Do you mean,' said Gerald, with the punctiliousness of a man who has been drinking, 'that you are afraid of the sight of a black-beetle, or

you are afraid of a black-beetle biting you, or doing you some harm?' 'Do they bite?' cried the girl.

'How perfectly loathsome!' exclaimed Halliday.

'I don't know,' replied Gerald, looking round the table. 'Do blackbeetles bite? But that isn't the point. Are you afraid of their biting, or is it a metaphysical antipathy?'

The girl was looking full upon him all the time with inchoate eyes.

'Oh, I think they're beastly, they're horrid,' she cried. 'If I see one, it gives me the creeps all over. If one were to crawl on me, I'm *sure* I should die – I'm sure I should.'

'I hope not,' whispered the young Russian.

'I'm sure I should, Maxim,' she asseverated.

'Then one won't crawl on you,' said Gerald, smiling and knowing. In some strange way he understood her.

'It's metaphysical, as Gerald says,' Birkin stated.

There was a little pause of uneasiness.

'And are you afraid of nothing else, Pussum?' asked the young Russian, in his quick, hushed, elegant manner.

'Not weally,' she said. 'I am afwaid of some things, but not weally the same. I'm not afwaid of *blood*.'

'Not afwaid of blood!' exclaimed a young man with a thick, pale, jeering face, who had just come to the table and was drinking whisky.

The Pussum turned on him a sulky look of dislike, low and ugly.

'Aren't you really afraid of blud?' the other persisted, a sneer all over his face.

'No, I'm not,' she retorted.

'Why, have you ever seen blood, except in a dentist's spittoon?' jeered the young man.

'I wasn't speaking to you,' she replied rather superbly.

'You can answer me, can't you?' he said.

For reply, she suddenly jabbed a knife across his thick, pale hand. He started up with a vulgar curse.

'Show's what you are,' said the Pussum in contempt.

'Curse you,' said the young man, standing by the table and looking down at her with acrid malevolence.

'Stop that,' said Gerald, in quick, instinctive command.

The young man stood looking down at her with sardonic contempt, a cowed, self-conscious look on his thick, pale face. The blood began to flow from his hand.

'Oh, how horrible, take it away!' squealed Halliday, turning green and averting his face.

'D'you feel ill?' asked the sardonic young man, in some concern. 'Do

58

you feel ill, Julius? Garn, it's nothing, man, don't give her the pleasure of letting her think she's performed a feat – don't give her the satisfaction, man – it's just what she wants.'

'Oh!' squealed Halliday.

'He's going to cat,²⁰ Maxim,' said the Pussum warningly. The suave young Russian rose and took Halliday by the arm, leading him away. Birkin, white and diminished, looked on as if he were displeased. The wounded, sardonic young man moved away, ignoring his bleeding hand in the most conspicuous fashion.

'He's an awful coward, really,' said the Pussum to Gerald. 'He's got such an influence over Julius.'

'Who is he?' asked Gerald.

'He's a Jew, really. I can't bear him.'

'Well, he's quite unimportant. But what's wrong with Halliday?'

'Julius's the most awful coward you've ever seen,' she cried. 'He always faints if I lift a knife – he's tewwified of me.'

'H'm!' said Gerald.

'They're all afwaid of me,' she said. 'Only the Jew thinks he's going to show his courage. But he's the biggest coward of them all, really, because he's afwaid what people will think about him – and Julius doesn't care about that.'

'They've a lot of valour between them,' said Gerald good-humouredly.

The Pussum looked at him with a slow, slow smile. She was very handsome, flushed, and confident in dreadful knowledge. Two little points of light glinted on Gerald's eyes.

'Why do they call you Pussum, because you're like a cat?' he asked her.

'I expect so,' she said.

The smile grew more intense on his face.

'You are, rather; or a young, female panther.'

'Oh God, Gerald!' said Birkin, in some disgust.

They both looked uneasily at Birkin.

'You're silent tonight, Wupert,' she said to him, with a slight insolence, being safe with the other man.

Halliday was coming back, looking forlorn and sick.

'Pussum,' he said, 'I wish you wouldn't do these things - Oh!' He sank in his chair with a groan.

'You'd better go home,' she said to him.

'I will go home,' he said. 'But won't you all come along. Won't you come round to the flat?' he said to Gerald. 'I should be so glad if you would. Do – that'll be splendid. I say?' He looked round for a waiter. 'Get me a taxi.' Then he groaned again. 'Oh I do feel – perfectly

ghastly! Pussum, you see what you do to me.'

'Then why are you such an idiot?' she said with sullen calm.

'But I'm not an idiot! Oh, how awful! Do come, everybody, it will be so splendid. Pussum, you are coming. What? Oh but you *must* come, yes, you must. What? Oh, my dear girl, don't make a fuss now, I feel perfectly – Oh, it's so ghastly – Ho! – er! Oh!'

'You know you can't drink,' she said to him, coldly.

'I tell you it isn't drink – it's your disgusting behaviour, Pussum, it's nothing else. Oh, how awful! Libidnikov, do let us go.'

'He's only drunk one glass - only one glass,' came the rapid, hushed voice of the young Russian.

They all moved off to the door. The girl kept near to Gerald, and seemed to be at one in her motion with him. He was aware of this, and filled with demon-satisfaction that his motion held good for two. He held her in the hollow of his will, and she was soft, secret, invisible in her stirring there.

They crowded five of them into the taxi-cab. Halliday lurched in first, and dropped into his seat against the other window. Then the Pussum took her place, and Gerald sat next to her. They heard the young Russian giving orders to the driver, then they were all seated in the dark, crowded close together, Halliday groaning and leaning out of the window. They felt the swift, muffled motion of the car.

The Pussum sat near to Gerald, and she seemed to become soft, subtly to infuse herself into his bones, as if she were passing into him in a black, electric flow. Her being suffused into his veins like a magnetic darkness, and concentrated at the base of his spine like a fearful source of power. Meanwhile her voice sounded out reedy and nonchalant, as she talked indifferently with Birkin and with Maxim. Between her and Gerald was this silence and this black, electric comprehension in the darkness. Then she found his hand, and grasped it in her own firm, small clasp. It was so utterly dark, and yet such a naked statement, that rapid vibrations ran through his blood and over his brain, he was no longer responsible. Still her voice rang on like a bell, tinged with a tone of mockery. And as she swung her head, her fine mane of hair just swept his face, and all his nerves were on fire, as with a subtle friction of electricity. But the great centre of his force held steady, a magnificent pride to him, at the base of his spine.

They arrived at a large block of buildings, went up in a lift, and presently a door was being opened for them by a Hindu. Gerald looked in surprise, wondering if he were a gentleman, one of the Hindus down from Oxford, perhaps. But no, he was the man-servant.

'Make tea, Hasan,' said Halliday.

60

'There is a room for me?' said Birkin.

To both of which questions the man grinned, and murmured.

He made Gerald uncertain, because, being tall and slender and reticent, he looked like a gentleman.

'Who is your servant?' he asked of Halliday. 'He looks a swell.'

'Oh yes – that's because he's dressed in another man's clothes. He's anything but a swell, really. We found him in the road, starving. So I took him here, and another man gave him clothes. He's anything but what he seems to be – his only advantage is that he can't speak English and can't understand it, so he's perfectly safe.'

'He's very dirty,' said the young Russian swiftly and silently.

Directly, the man appeared in the doorway.

'What is it?' said Halliday.

The Hindu grinned, and murmured shyly:

'Want to speak to master.'

Gerald watched curiously. The fellow in the doorway was goodlooking and clean-limbed, his bearing was calm, he looked elegant, aristocratic. Yet he was half a savage, grinning foolishly. Halliday went out into the corridor to speak with him.

'What?' they heard his voice. 'What? What do you say? Tell me again. What? Want money? Want *more* money? But what do you want money for?' There was the confused sound of the Hindu's talking, then Halliday appeared in the room, smiling also foolishly, and saying:

'He says he wants money to buy underclothing. Can anybody lend me a shilling? Oh thanks, a shilling will do to buy all the underclothes he wants.' He took the money from Gerald and went out into the passage again, where they heard him saying, 'You can't want more money, you had three and six yesterday. You mustn't ask for any more. Bring the tea in quickly.'

Gerald looked round the room. It was an ordinary London sittingroom in a flat, evidently taken furnished, rather common and ugly. But there were several negro statues, wood-carvings from West Africa,²¹ strange and disturbing, the carved negroes looked almost like the fœtus of a human being. One was a woman sitting naked in a strange posture, and looking tortured, her abdomen stuck out. The young Russian explained that she was sitting in child-birth, clutching the ends of the band that hung from her neck, one in each hand, so that she could bear down, and help labour. The strange, transfixed, rudimentary face of the woman again reminded Gerald of a fœtus, it was also rather wonderful, conveying the suggestion of the extreme of physical sensation, beyond the limits of mental consciousness.

'Aren't they rather obscene?' he asked, disapproving.

'I don't know,' murmured the other rapidly. 'I have never defined the obscene. I think they are very good.'

Gerald turned away. There were one or two new pictures in the room, in the Futurist manner;²² there was a large piano. And these, with some ordinary London lodging-house furniture of the better sort, completed the whole.

The Pussum had taken off her hat and coat, and was seated on the sofa. She was evidently quite at home in the house, but uncertain, suspended. She did not quite know her position. Her alliance for the time being was with Gerald, and she did not know how far this was admitted by any of the men. She was considering how she should carry off the situation. She was determined to have her experience. Now, at this eleventh hour, she was not to be baulked. Her face was flushed as with battle, her eye was brooding but inevitable.

The man came in with tea and a bottle of Kümmel. He set the tray on a little table before the couch.

'Pussum,' said Halliday, 'pour out the tea.'

She did not move.

'Won't you do it?' Halliday repeated, in a state of nervous apprehension.

'I've not come back here as it was before,' she said. 'I only came because the others wanted me to, not for your sake.'

'My dear Pussum, you know you are your own mistress. I don't want you to do anything but use the flat for your own convenience – you know it, I've told you so many times.'

She did not reply, but silently, reservedly reached for the tea-pot. They all sat round and drank tea. Gerald could feel the electric connection between him and her so strongly, as she sat there quiet and withheld, that another set of conditions altogether had come to pass. Her silence and her immutability perplexed him. *How* was he going to come to her? And yet he felt it quite inevitable. He trusted completely to the current that held them. His perplexity was only superficial, new conditions reigned, the old were surpassed; here one did as one was possessed to do, no matter what it was.

Birkin rose. It was nearly one o'clock.

'I'm going to bed,' he said. 'Gerald, I'll ring you up in the morning at your place or you ring me up here.'

'Right,' said Gerald, and Birkin went out.

When he was well gone, Halliday said in a stimulated voice, to Gerald:

'I say, won't you stay here - oh do!'

'You can't put everybody up,' said Gerald.

'Oh but I can, perfectly - there are three more beds besides mine - do

stay, won't you. Everything is quite ready – there is always somebody here – I always put people up – I love having the house crowded.'

'But there are only two rooms,' said the Pussum, in a cold, hostile voice, 'now Rupert's here.'

'I know there are only two rooms,' said Halliday, in his odd, high way of speaking. 'But what does that matter?'

He was smiling rather foolishly, and he spoke eagerly, with an insinuating determination.

'Julius and I will share one room,' said the Russian in his discreet, precise voice. Halliday and he were friends since Eton.

'It's very simple,' said Gerald, rising and pressing back his arms, stretching himself. Then he went again to look at one of the pictures. Every one of his limbs was turgid with electric force, and his back was tense like a tiger's, with slumbering fire. He was very proud.

The Pussum rose. She gave a black look at Halliday, black and deadly, which brought the rather foolishly pleased smile to that young man's face. Then she went out of the room, with a cold good-night to them all generally.

There was a brief interval, they heard a door close, then Maxim said, in his refined voice:

'That's all right.'

He looked significantly at Gerald, and said again, with a silent nod:

'That's all right - you're all right.'

Gerald looked at the smooth, ruddy, comely face, and at the strange, significant eyes, and it seemed as if the voice of the young Russian, so small and perfect, sounded in the blood rather than in the air.

'I'm all right then,' said Gerald.

'Yes! Yes! You're all right,' said the Russian.

Halliday continued to smile, and to say nothing.

Suddenly the Pussum appeared again in the door, her small, childish face looking sullen and vindictive.

'I know you want to catch me out,' came her cold, rather resonant voice. 'But I don't care, I don't care how much you catch me out.'

She turned and was gone again. She had been wearing a loose dressing-gown of purple silk, tied round her waist. She looked so small and childish and vulnerable, almost pitiful. And yet the black looks of her eyes made Gerald feel drowned in some potent darkness that almost frightened him.

The men lit another cigarette and talked casually.

CHAPTER VII

Fetish

IN THE MORNING Gerald woke late. He had slept heavily. Pussum was still asleep, sleeping childishly and pathetically. There was something small and curled up and defenceless about her, that roused an unsatisfied flame of passion in the young man's blood, a devouring avid pity. He looked at her again. But it would be too cruel to wake her. He subdued himself, and went away.

Hearing voices coming from the sitting-room, Halliday talking to Libidnikov, he went to the door and glanced in. He had on a silk wrap of a beautiful bluish colour, with an amethyst hem.

To his surprise he saw the two young men by the fire, stark naked. Halliday looked up, rather pleased.

'Good-morning,' he said. 'Oh – did you want towels?' And stark naked he went out into the hall, striding a strange, white figure between the unliving furniture. He came back with the towels, and took his former position, crouching seated before the fire on the fender.

'Don't you love to feel the fire on your skin?' he said.

'It is rather pleasant,' said Gerald.

'How perfectly splendid it must be to be in a climate where one could do without clothing altogether,' said Halliday.

'Yes,' said Gerald, 'if there weren't so many things that sting and bite.'

'That's a disadvantage,' murmured Maxim.

Gerald looked at him, and with a slight revulsion saw the human animal, golden skinned and bare, somehow humiliating. Halliday was different. He had a rather heavy, slack, broken beauty, white and firm. He was like a Christ in a Pietà.²³ The animal was not there at all, only the heavy, broken beauty. And Gerald realised how Halliday's eyes were beautiful too, so blue and warm and confused, broken also in their expression. The fireglow fell on his heavy, rather bowed shoulders, he sat slackly crouched on the fender, his face was uplifted, weak, perhaps slightly disintegrate, and yet with a moving beauty of its own.

'Of course,' said Maxim, 'you've been in hot countries where the people go about naked.'

'Oh really!' exclaimed Halliday. 'Where?' 'South America – Amazon,' said Gerald.

'Oh but how perfectly splendid! It's one of the things I want most to do – to live from day to day without *ever* putting on any sort of clothing whatever. If I could do that, I should feel I had lived.'

'But why?' said Gerald. 'I can't see that it makes so much difference.' 'Oh, I think it would be perfectly splendid. I'm sure life would be entirely another thing – entirely different, and perfectly wonderful.'

'But why?' asked Gerald. 'Why should it?'

'Oh – one would *feel* things instead of merely looking at them. I should feel the air move against me, and feel the things I touched, instead of having only to look at them. I'm sure life is all wrong because it has become much too visual – we can neither hear nor feel nor understand, we can only see. I'm sure that is entirely wrong.'

'Yes, that is true, that is true,' said the Russian.

Gerald glanced at him, and saw him, his suave, golden coloured body with the black hair growing fine and freely, like tendrils, and his limbs like smooth plant-stems. He was so healthy and well-made, why did he make one ashamed, why did one feel repelled? Why should Gerald even dislike it, why did it seem to him to detract from his own dignity. Was that all a human being amounted to? So uninspired! thought Gerald.

Birkin suddenly appeared in the doorway, in white pyjamas and wet hair, and a towel over his arm. He was aloof and white, and somehow evanescent.

'There's the bath-room now, if you want it,' he said generally, and was going away again, when Gerald called:

'I say, Rupert!'

'What?' The single white figure appeared again, a presence in the room.

'What do you think of that figure there? I want to know,' Gerald asked.

Birkin, white and strangely ghostly, went over to the carved figure of the negro woman in labour. Her nude, protuberant body crouched in a strange, clutching posture, her hands gripping the ends of the band, above her breast.

'It is art,' said Birkin.

'Very beautiful, it's very beautiful,' said the Russian.

They all drew near to look. Gerald looked at the group of men, the Russian golden and like a water-plant, Halliday tall and heavily, brokenly beautiful, Birkin very white and indefinite, not to be assigned, as he looked closely at the carven woman. Strangely elated, Gerald also lifted his eyes to the face of the wooden figure. And his heart contracted. He saw vividly with his spirit the grey, forward-stretching face of the negro woman, African and tense, abstracted in utter physical stress. It was a terrible face, void, peaked, abstracted almost into meaninglessness by the weight of sensation beneath. He saw the Pussum in it. As in a dream, he knew her.

'Why is it art?' Gerald asked, shocked, resentful.

'It conveys a complete truth,' said Birkin. 'It contains the whole truth of that state, whatever you feel about it.'

'But you can't call it high art,' said Gerald.

'High! There are centuries and hundreds of centuries of development in a straight line, behind that carving; it is an awful pitch of culture, of a definite sort.'

'What culture?' Gerald asked, in opposition. He hated the sheer African thing.

'Pure culture in sensation, culture in the physical consciousness, really ultimate *physical* consciousness, mindless, utterly sensual. It is so sensual as to be final, supreme.'

But Gerald resented it. He wanted to keep certain illusions, certain ideas like clothing.

'You like the wrong things, Rupert,' he said, 'things against yourself.' 'Oh, I know, this isn't everything,' Birkin replied, moving away.

When Gerald went back to his room from the bath, he also carried his clothes. He was so conventional at home, that when he was really away, and on the loose, as now, he enjoyed nothing so much as full outrageousness. So he strode with his blue silk wrap over his arm and felt defiant.

The Pussum lay in her bed, motionless, her round, dark eyes like black, unhappy pools. He could only see the black, bottomless pools of her eyes. Perhaps she suffered. The sensation of her inchoate suffering roused the old sharp flame in him, a mordant pity, a passion almost of cruelty.

'You are awake now,' he said to her.

'What time is it?' came her muted voice.

She seemed to flow back, almost like liquid, from his approach, to sink helplessly away from him. Her inchoate look of a violated slave, whose fulfilment lies in her further and further violation, made his nerves quiver with acutely desirable sensation. After all, his was the only will, she was the passive substance of his will. He tingled with the subtle, biting sensation. And then he knew, he must go away from her, there must be pure separation between them.

It was a quiet and ordinary breakfast, the four men all looking very clean and bathed. Gerald and the Russian were both correct and *comme* *il faut*²⁴ in appearance and manner, Birkin was gaunt and sick, and looked a failure in his attempt to be a properly dressed man, like Gerald and Maxim. Halliday wore tweeds and a green flannel shirt, and a rag of a tie, which was just right for him. The Hindu brought in a great deal of soft toast, and looked exactly the same as he had looked the night before, statically the same.

At the end of the breakfast the Pussum appeared, in a purple silk wrap with a shimmering sash. She had recovered herself somewhat, but was mute and lifeless still. It was a torment to her when anybody spoke to her. Her face was like a small, fine mask, sinister too, masked with unwilling suffering. It was almost midday. Gerald rose and went away to his business, glad to get out. But he had not finished. He was coming back again at evening, they were all dining together, and he had booked seats for the party, excepting Birkin, at a music-hall.

At night they came back to the flat very late again, again flushed with drink. Again the man-servant – who invariably disappeared between the hours of ten and twelve at night – came in silently and inscrutably with tea, bending in a slow, strange, leopard-like fashion to put the tray softly on the table. His face was immutable, aristocratic-looking, tinged slightly with grey under the skin; he was young and good-looking. But Birkin felt a slight sickness, looking at him, and feeling the slight greyness as an ash or a corruption, in the aristocratic inscrutability of expression a nauseating, bestial stupidity.

Again they talked cordially and rousedly together. But already a certain friability was coming over the party, Birkin was mad with irritation, Halliday was turning in an insane hatred against Gerald, the Pussum was becoming hard and cold, like a flint knife, and Halliday was laying himself out to her. And her intention, ultimately, was to capture Halliday, to have complete power over him.

In the morning they all stalked and lounged about again. But Gerald could feel a strange hostility to himself, in the air. It roused his obstinacy, and he stood up against it. He hung on for two more days. The result was a nasty and insane scene with Halliday on the fourth evening. Halliday turned with absurd animosity upon Gerald, in the café. There was a row. Gerald was on the point of knocking-in Halliday's face; when he was filled with sudden disgust and indifference, and he went away, leaving Halliday in a foolish state of gloating triumph, the Pussum hard and established, and Maxim standing clear. Birkin was absent, he had gonc out of town again.

Gerald was piqued because he had left without giving the Pussum money. It was true, she did not care whether he gave her money or not, and he knew it. But she would have been glad of ten pounds, and he would have been very glad to give them to her. Now he felt in a false position. He went away chewing his lips to get at the ends of his short clipped moustache. He knew the Pussum was merely glad to be rid of him. She had got her Halliday whom she wanted. She wanted him completely in her power. Then she would marry him. She wanted to marry him. She had set her will on marrying Halliday. She never wanted to hear of Gerald again; unless, perhaps, she were in difficulty; because after all, Gerald was what she called a man, and these others, Halliday, Libidnikov, Birkin, the whole Bohemian set, they were only half men. But it was half men she could deal with. She felt sure of herself with them. The real men, like Gerald, put her in her place too much.

Still, she respected Gerald, she really respected him. She had managed to get his address, so that she could appeal to him in time of distress. She knew he wanted to give her money. She would perhaps write to him on that inevitable rainy day.

CHAPTER VIII

Breadalby

BREADALBY was a Georgian²⁵ house with Corinthian pillars, standing among the softer, greener hills of Derbyshire, not far from Cromford. In front, it looked over a lawn, over a few trees, down to a string of fishponds in the hollow of the silent park. At the back were trees, among which were to be found the stables, and the big kitchen garden, behind which was a wood.

It was a very quiet place, some miles from the high-road, back from the Derwent Valley, outside the show scenery. Silent and forsaken, the golden stucco showed between the trees, the house-front looked down the park, unchanged and unchanging.

Of late, however, Hermione had lived a good deal at the house. She had turned away from London, away from Oxford, towards the silence of the country. Her father was mostly absent, abroad, she was either alone in the house, with her visitors, of whom there were always several, or she had with her her brother, a bachelor, and a Liberal member of Parliament.²⁶ He always came down when the House was not sitting, seemed always to be present in Breadalby, although he was most conscientious in his attendance to duty.

The summer was just coming in when Ursula and Gudrun went to stay the second time with Hermione. Coming along in the car, after they had entered the park, they looked across the dip, where the fishponds lay in silence, at the pillared front of the house, sunny and small like an English drawing of the old school, on the brow of the green hill, against the trees. There were small figures on the green lawn, women in lavender and yellow moving to the shade of the enormous, beautifully balanced cedar tree.

'Isn't it complete!' said Gudrun. 'It is as final as an old aquatint.' She spoke with some resentment in her voice, as if she were captivated unwillingly, as if she must admire against her will.

'Do you love it?' asked Ursula.

'I don't love it, but in its way, I think it is quite complete.'

The motor-car ran down the hill and up again in one breath, and they were curving to the side door. A parlour-maid appeared, and then Hermione, coming forward with her pale face lifted, and her hands outstretched, advancing straight to the new-comers, her voice singing:

'Here you are - I'm so glad to see you - ' she kissed Gudrun - 'so glad to see you - ' she kissed Ursula and remained with her arm round her. 'Are you very tired?'

'Not at all tired,' said Ursula.

'Are you tired, Gudrun?'

'Not at all, thanks,' said Gudrun.

'No - ' drawled Hermione. And she stood and looked at them. The two girls were embarrassed because she would not move into the house, but must have her little scene of welcome there on the path. The servants waited.

'Come in,' said Hermione at last, having fully taken in the pair of them. Gudrun was the more beautiful and attractive, she had decided again, Ursula was more physical, more womanly. She admired Gudrun's dress more. It was of green poplin, with a loose coat above it, of broad, dark-green and dark-brown stripes. The hat was of a pale, greenish straw, the colour of new hay, and it had a plaited ribbon of black and orange, the stockings were dark green, the shoes black. It was a good get-up, at once fashionable and individual. Ursula, in dark blue, was more ordinary, though she also looked well.

Hermione herself wore a dress of prune-coloured silk, with coral beads and coral coloured stockings. But her dress was both shabby and soiled, even rather dirty.

'You would like to see your rooms now, wouldn't you! Yes. We will go up now, shall we?'

Ursula was glad when she could be left alone in her room. Hermione lingered so long, made such a stress on one. She stood so near to one, pressing herself near upon one, in a way that was most embarrassing

and oppressive. She seemed to hinder one's workings.

Lunch was served on the lawn, under the great tree, whose thick, blackish boughs came down close to the grass. There were present a young Italian woman, slight and fashionable, a young, athletic-looking Miss Bradley, a learned, dry Baronet of fifty, who was always making witticisms and laughing at them heartily in a harsh, horse-laugh, there was Rupert Birkin, and then a woman secretary, a Fräulein März, young and slim and pretty.

The food was very good, that was one thing. Gudrun, critical of everything, gave it her full approval. Ursula loved the situation, the white table by the cedar tree, the scent of new sunshine, the little vision of the leafy park, with far-off deer feeding peacefully. There seemed a magic circle drawn about the place, shutting out the present, enclosing the delightful, precious past, trees and deer and silence, like a dream.

But in spirit she was unhappy. The talk went on like a rattle of small artillery, always slightly sententious, with a sententiousness that was only emphasised by the continual crackling of a witticism, the continual spatter of verbal jest, designed to give a tone of flippancy to a stream of conversation that was all critical and general, a canal of conversation rather than a stream.

The attitude was mental and very wearying. Only the elderly sociologist, whose mental fibre was so tough as to be insentient, seemed to be thoroughly happy. Birkin was down in the mouth. Hermione appeared, with amazing persistence, to wish to ridicule him and make him look ignominious in the eyes of everybody. And it was surprising how she seemed to succeed, how helpless he seemed against her. He looked completely insignificant. Ursula and Gudrun, both very unused, were mostly silent, listening to the slow, rhapsodic sing-song of Hermione, or the verbal sallies of Sir Joshua, or the prattle of Fräulein, or the responses of the other two women.

Luncheon was over, coffee was brought out on the grass, the party left the table and sat about in lounge chairs, in the shade or in the sunshine as they wished. Fräulein departed into the house, Hermione took up her embroidery, the little Contessa took a book, Miss Bradley was weaving a basket out of fine grass, and there they all were on the lawn in the early summer afternoon, working leisurely and spattering with half-intellectual, deliberate talk.

Suddenly there was the sound of the brakes and the shutting off of a motor-car.

'There's Salsie!' sang Hermione, in her slow, amusing sing-song. And laying down her work, she rose slowly, and slowly passed over the lawn, round the bushes, out of sight.

'Who is it?' asked Gudrun.

'Mr Roddice – Miss Roddice's brother – at least, I suppose it's he,' said Sir Joshua.

'Salsie, yes, it is her brother,' said the little Contessa, lifting her head for a moment from her book, and speaking as if to give information, in her slightly deepened, guttural English.

They all waited. And then round the bushes came the tall form of Alexander Roddice, striding romantically like a Meredith hero who remembers Disraeli.²⁷ He was cordial with everybody, he was at once a host, with an easy, offhand hospitality that he had learned for Hermione's friends. He had just come down from London, from the House. At once the atmosphere of the House of Commons made itself felt over the lawn: the Home Secretary had said such and such a thing, and he, Roddice, on the other hand, thought such and such a thing, and had said so-and-so to the PM.

Now Hermione came round the bushes with Gerald Crich. He had come along with Alexander. Gerald was presented to everybody, was kept by Hermione for a few moments in full view, then he was led away, still by Hermione. He was evidently her guest of the moment.

There had been a split in the Cabinet; the minister for Education had resigned owing to adverse criticism. This started a conversation on education.

'Of course,' said Hermione, lifting her face like a rhapsodist, 'there *can* be no reason, no *excuse* for education, except the joy and beauty of knowledge in itself.' She seemed to rumble and ruminate with subterranean thoughts for a minute, then she proceeded: 'Vocational education *isn't* education, it is the close of education.'

Gerald, on the brink of discussion, sniffed the air with delight and prepared for action.

'Not necessarily,' he said. 'But isn't education really like gymnastics, isn't the end of education the production of a well-trained, vigorous, energetic mind?'

'Just as athletics produce a healthy body, ready for anything,' cried Miss Bradley, in hearty accord.

Gudrun looked at her in silent loathing.

'Well - ' rumbled Hermione, 'I don't know. To me the pleasure of knowing is so great, so *wonderful* - nothing has meant so much to me in all life, as certain knowledge - no, I am sure - nothing.'

'What knowledge, for example, Hermione?' asked Alexander.

Hermione lifted her face and rumbled -

'M-m-m - I don't know . . . But one thing was the stars, when I

really understood something about the stars. One feels so uplifted, so unbounded . . . '

Birkin looked at her in a white fury.

'What do you want to feel unbounded for?' he said sarcastically. 'You don't want to *be* unbounded.'

Hermione recoiled in offence.

'Yes, but one does have that limitless feeling,' said Gerald. 'It's like getting on top of the mountain and seeing the Pacific.'

'Silent, upon a peak in Dariayn,'²⁸ murmured the Italian, lifting her face for a moment from her book.

'Not necessarily in Darien,' said Gerald, while Ursula began to laugh.

Hermione waited for the dust to settle, and then she said, untouched:

'Yes, it is the greatest thing in life – to *know*. It is really to be happy, to be *free*.'

'Knowledge is, of course, liberty,' said Mattheson.

'In compressed tabloids,' said Birkin, looking at the dry, stiff little body of the Baronet. Immediately Gudrun saw the famous sociologist as a flat bottle, containing tabloids of compressed liberty. That pleased her. Sir Joshua was labelled and placed forever in her mind.

'What does that mean, Rupert?' sang Hermione, in a calm snub.

'You can only have knowledge, strictly,' he replied, 'of things concluded, in the past. It's like bottling the liberty of last summer in the bottled gooseberries.'

'Can one have knowledge only of the past?' asked the Baronet, pointedly. 'Could we call our knowledge of the laws of gravitation for instance, knowledge of the past?'

'Yes,' said Birkin.

'There is a most beautiful thing in my book,' suddenly piped the little Italian woman. 'It says the man came to the door and threw his eyes down the street.'

There was a general laugh in the company. Miss Bradley went and looked over the shoulder of the Contessa.

'See!' said the Contessa.

'Bazarov came to the door and threw his eyes hurriedly down the street,' she read.

Again there was a loud laugh, the most startling of which was the Baronet's, which rattled out like a clatter of falling stones.

'What is the book?' asked Alexander, promptly.

'Fathers and Sons,²⁹ by Turgenev,' said the little foreigner, pronouncing every syllable distinctly. She looked at the cover, to verify herself.

'An old American edition,' said Birkin.

72

'Ha! – of course – translated from the French,' said Alexander, with a fine declamatory voice. 'Bazarov ouvra la porte et jeta les yeux dans la rue.'

He looked brightly round the company.

'I wonder what the "hurriedly" was,' said Ursula.

They all began to guess.

And then, to the amazement of everybody, the maid came hurrying with a large tea-tray. The afternoon had passed so swiftly.

After tea, they were all gathered for a walk.

'Would you like to come for a walk?' said Hermione to each of them, one by one. And they all said yes, feeling somehow like prisoners marshalled for exercise. Birkin only refused.

'Will you come for a walk, Rupert?'

'No, Hermione.'

'But are you sure?'

'Quite sure.' There was a second's hesitation.

'And why not?' sang Hermione's question. It made her blood run sharp, to be thwarted in even so trifling a matter. She intended them all to walk with her in the park.

'Because I don't like trooping off in a gang,' he said.

Her voice rumbled in her throat for a moment. Then she said, with a curious stray calm:

'Then we'll leave a little boy behind, if he's sulky.'

And she looked really gay, while she insulted him. But it merely made him stiff.

She trailed off to the rest of the company, only turning to wave her handkerchief to him, and to chuckle with laughter, singing out:

'Good-bye, good-bye, little boy.'

'Good-bye, impudent hag,' he said to himself.

They all went through the park. Hermione wanted to show them the wild daffodils on a little slope. 'This way, this way,' sang her leisurely voice at intervals. And they had all to come this way. The daffodils were pretty, but who could see them? Ursula was stiff all over with resentment by this time, resentment of the whole atmosphere. Gudrun, mocking and objective, watched and registered everything.

They looked at the shy deer, and Hermione talked to the stag, as if he too were a boy she wanted to wheedle and fondle. He was male, so she must exert some kind of power over him. They trailed home by the fish-ponds, and Hermione told them about the quarrel of two male swans, who had striven for the love of the one lady. She chuckled and laughed as she told how the ousted lover had sat with his head buried under his wing, on the gravel. When they arrived back at the house, Hermione stood on the lawn and sang out, in a strange, small, high voice that carried very far:

'Rupert! Rupert!' The first syllable was high and slow, the second dropped down. 'Roo-o-opert.'

But there was no answer. A maid appeared.

'Where is Mr Birkin, Alice?' asked the mild straying voice of Hermione. But under the straying voice, what a persistent, almost insane *will*!

'I think he's in his room, madam.'

'Is he?'

Hermione went slowly up the stairs, along the corridor, singing out in her high, small call:

'Ru-oo-pert! Ru-oo pert!'

She came to his door, and tapped, still crying: 'Roo-pert.'

'Yes,' sounded his voice at last.

'What are you doing?'

The question was mild and curious.

There was no answer. Then he opened the door.

'We've come back,' said Hermione. 'The daffodils are so beautiful.'

'Yes,' he said, 'I've seen them.'

She looked at him with her long, slow, impassive look, along her cheeks.

'Have you?' she echoed. And she remained looking at him. She was stimulated above all things by this conflict with him, when he was like a sulky boy, helpless, and she had him safe at Breadalby. But underneath she knew the split was coming, and her hatred of him was subconscious and intense.

'What were you doing?' she reiterated, in her mild, indifferent tone. He did not answer, and she made her way, almost unconsciously into his room. He had taken a Chinese drawing of geese from the boudoir, and was copying it, with much skill and vividness.

'You are copying the drawing,' she said, standing near the table, and looking down at his work. 'Yes. How beautifully you do it! You like it very much, don't you?'

'It's a marvellous drawing,' he said.

'Is it? I'm so glad you like it, because I've always been fond of it. The Chinese Ambassador gave it me.'

'I know,' he said.

'But why do you copy it?' she asked, casual and sing-song. 'Why not do something original?'

'I want to know it,' he replied. 'One gets more of China, copying this picture, than reading all the books.'

74

'And what do you get?'

She was at once roused, she laid as it were violent hands on him, to extract his secrets from him. She *must* know. It was a dreadful tyranny, an obsession in her, to know all he knew. For some time he was silent, hating to answer her. Then, compelled, he began:

'I know what centres they live from – what they perceive and feel – the hot, stinging centrality of a goose in the flux of cold water and mud – the curious bitter stinging heat of a goose's blood, entering their own blood like an inoculation of corruptive fire – fire of the cold-burning mud – the lotus mystery.'

Hermione looked at him along her narrow, pallid cheeks. Her eyes were strange and drugged, heavy under their heavy, drooping lids. Her thin bosom shrugged convulsively. He stared back at her, devilish and unchanging. With another strange, sick convulsion, she turned away, as if she were sick, could feel dissolution setting-in in her body. For with her mind she was unable to attend to his words, he caught her, as it were, beneath all her defences, and destroyed her with some insidious occult potency.

'Yes,' she said, as if she did not know what she were saying. 'Yes,' and she swallowed, and tried to regain her mind. But she could not, she was witless, decentralised. Use all her will as she might, she could not recover. She suffered the ghastliness of dissolution, broken and gone in a horrible corruption. And he stood and looked at her unmoved. She strayed out, pallid and preyed-upon like a ghost, like one attacked by the tomb-influences which dog us. And she was gone like a corpse, that has no presence, no connection. He remained hard and vindictive.

Hermione came down to dinner strange and sepulchral, her eyes heavy and full of sepulchral darkness, strength. She had put on a dress of stiff old greenish brocade, that fitted tight and made her look tall and rather terrible, ghastly. In the gay light of the drawing-room she was uncanny and oppressive. But seated in the half-light of the diningroom, sitting stiffly before the shaded candles on the table, she seemed a power, a presence. She listened and attended with a drugged attention.

The party was gay and extravagant in appearance, everybody had put on evening dress except Birkin and Joshua Mattheson. The little Italian Contessa wore a dress of tissue, of orange and gold and black velvet in soft wide stripes, Gudrun was emerald green with strange net-work, Ursula was in yellow with dull silver veiling, Miss Bradley was of grey, crimson and jet, Fräulein März wore pale blue. It gave Hermione a sudden convulsive sensation of pleasure, to see these rich colours under the candle-light. She was aware of the talk going on, ceaselessly, Joshua's voice dominating; of the ceaseless pitter-patter of women's light laughter and responses; of the brilliant colours and the white table and the shadow above and below; and she seemed in a swoon of gratification, convulsed with pleasure and yet sick, like a *revenant*.³⁰ She took very little part in the conversation, yet she heard it all, it was all hers.

They all went together into the drawing-room, as if they were one family, easily, without any attention to ceremony. Fraulein handed the coffee, everybody smoked cigarettes, or else long warden pipes of white clay, of which a sheaf was provided.

Will you smoke? – cigarettes or pipe?' asked Fräulein prettily. There was a circle of people, Sir Joshua with his eighteenth-century appearance, Gerald the amused, handsome young Englishman, Alexander tall and the handsome politician, democratic and lucid, Hermione strange like a long Cassandra,³¹ and the women lurid with colour, all dutifully smoking their long white pipes, and sitting in a half-moon in the comfortable, soft-lighted drawing-room, round the logs that flickered on the marble hearth.

The talk was very often political or sociological, and interesting, curiously anarchistic. There was an accumulation of powerful force in the room, powerful and destructive. Everything seemed to be thrown into the melting pot, and it seemed to Ursula they were all witches, helping the pot to bubble. There was an elation and a satisfaction in it all, but it was cruelly exhausting for the new-comers, this ruthless mental pressure, this powerful, consuming, destructive mentality that emanated from Joshua and Hermione and Birkin and dominated the rest.

But a sickness, a fearful nausea gathered possession of Hermione. There was a lull in the talk, as it was arrested by her unconscious but all-powerful will.

'Salsie, won't you play something?' said Hermione, breaking off completely. 'Won't somebody dance? Gudrun, you will dance, won't you? I wish you would. Anche tu, Palestra, ballerai? – si, per piacere.³² You too, Ursula.'

Hermione rose and slowly pulled the gold-embroidered band that hung by the mantel, clinging to it for a moment, then releasing it suddenly. Like a priestess she looked, unconscious, sunk in a heavy half-trance.

A servant came, and soon reappeared with armfuls of silk robes and shawls and scarves, mostly oriental, things that Hermione, with her love for beautiful extravagant dress, had collected gradually.

'The three women will dance together,' she said.

'What shall it be?' asked Alexander, rising briskly.

'Vergini Delle Rocchette,'33 said the Contessa at once.

'They are so languid,' said Ursula.

'The three witches from Macbeth,' suggested Fräulein usefully. It was finally decided to do Naomi and Ruth and Orpah.³⁴ Ursula was Naomi, Gudrun was Ruth, the Contessa was Orpah. The idea was to make a little ballet, in the style of the Russian Ballet of Pavlova and Nijinsky.³⁵

The Contessa was ready first, Alexander went to the piano, a space was cleared. Orpah, in beautiful oriental clothes, began slowly to dance the death of her husband. Then Ruth came, and they wept together, and lamented, then Naomi came to comfort them. It was all done in dumb show, the women danced their emotion in gesture and motion. The little drama went on for a quarter of an hour.

Ursula was beautiful as Naomi. All her men were dead, it remained to her only to stand alone in indomitable assertion, demanding nothing. Ruth, woman-loving, loved her. Orpah, a vivid, sensational, subtle widow, would go back to the former life, a repetition. The interplay between the women was real and rather frightening. It was strange to see how Gudrun clung with heavy, desperate passion to Ursula, yet smiled with subtle malevolence against her, how Ursula accepted silently, unable to provide any more either for herself or for the other, but dangerous and indomitable, refuting her grief.

Hermione loved to watch. She could see the Contessa's rapid, stoatlike sensationalism, Gudrun's ultimate but treacherous cleaving to the woman in her sister, Ursula's dangerous helplessness, as if she were helplessly weighted, and unreleased.

'That was very beautiful,' everybody cried with one accord. But Hermione writhed in her soul, knowing what she could not know. She cried out for more dancing, and it was her will that set the Contessa and Birkin moving mockingly in Malbrouk.

Gerald was excited by the desperate cleaving of Gudrun to Naomi. The essence of that female, subterranean recklessness and mockery penetrated his blood. He could not forget Gudrun's lifted, offered, cleaving, reckless, yet withal mocking weight. And Birkin, watching like a hermit crab from its hole, had seen the brilliant frustration and helplessness of Ursula. She was rich, full of dangerous power. She was like a strange unconscious bud of powerful womanhood. He was unconsciously drawn to her. She was his future.

Alexander played some Hungarian music, and they all danced, seized by the spirit. Gerald was marvellously exhilarated at finding himself in motion, moving towards Gudrun, dancing with feet that could not yet escape from the waltz and the two-step, but feeling his force stir along

his limbs and his body, out of captivity. He did not know yet how to dance their convulsive, rag-time sort of dancing, but he knew how to begin. Birkin, when he could get free from the weight of the people present, whom he disliked, danced rapidly and with a real gaiety. And how Hermione hated him for this irresponsible gaiety.

'Now I see,' cried the Contessa excitedly, watching his purely gay motion, which he had all to himself. 'Mr Birkin, he is a changer.'

Hermione looked at her slowly, and shuddered, knowing that only a foreigner could have seen and have said this.

'Cosa vuol'dire, Palestra?'36 she asked, sing-song.

'Look,' said the Contessa, in Italian. 'He is not a man, he is a chameleon, a creature of change.'

'He is not a man, he is treacherous, not one of us,' said itself over in Hermione's consciousness. And her soul writhed in the black subjugation to him, because of his power to escape, to exist, other than she did, because he was not consistent, not a man, less than a man. She hated him in a despair that shattered her and broke her down, so that she suffered sheer dissolution like a corpse, and was unconscious of everything save the horrible sickness of dissolution that was taking place within her, body and soul.

The house being full, Gerald was given the smaller room, really the dressing-room, communicating with Birkin's bedroom. When they all took their candles and mounted the stairs, where the lamps were burning subduedly, Hermione captured Ursula and brought her into her own bedroom, to talk to her. A sort of constraint came over Ursula in the big, strange bedroom. Hermione seemed to be bearing down on her, awful and inchoate, making some appeal. They were looking at some Indian silk shirts, gorgeous and sensual in themselves, their shape, their almost corrupt gorgeousness. And Hermione came near, and her bosom writhed, and Ursula was for a moment blank with panic. And for a moment Hermione's haggard eyes saw the fear on the face of the other, there was again a sort of crash, a crashing down. And Ursula picked up a shirt of rich red and blue silk, made for a young princess of fourteen, and was crying mechanically:

'Isn't it wonderful – who would dare to put those two strong colours together – '

Then Hermione's maid entered silently and Ursula, overcome with dread, escaped, carried away by powerful impulse.

Birkin went straight to bed. He was feeling happy, and sleepy. Since he had danced he was happy. But Gerald would talk to him. Gerald, in evening dress, sat on Birkin's bed when the other lay down, and must talk.

78

'Who are those two Brangwens?' Gerald asked.

'They live in Beldover.'

'In Beldover! Who are they then?'

'Teachers in the Grammar School.'

There was a pause.

'They are!' exclaimed Gerald at length. 'I thought I had seen them before.'

'It disappoints you?' said Birkin.

'Disappoints me! No - but how is it Hermione has them here?'

'She knew Gudrun in London – that's the younger one, the one with the darker hair – she's an artist – does sculpture and modelling.'

'She's not a teacher in the Grammar School, then – only the other?' 'Both – Gudrun art mistress. Ursula a class mistress.'

'And what's the father?'

'Handicraft instructor in the schools.'

'Really!'

'Class-barriers are breaking down!'

Gerald was always uneasy under the slightly jeering tone of the other.

'That their father is handicraft instructor in a school! What does it matter to me?'

Birkin laughed. Gerald looked at his face, as it lay there laughing and bitter and indifferent on the pillow, and he could not go away.

'I don't suppose you will see very much more of Gudrun, at least. She is a restless bird, she'll be gone in a week or two,' said Birkin.

'Where will she go?'

'London, Paris, Rome – heaven knows. I always expect her to sheer off to Damascus or San Francisco; she's a bird of paradise. God knows what she's got to do with Beldover. It goes by contraries, like dreams.'

Gerald pondered for a few moments.

'How do you know her so well?' he asked.

'I knew her in London,' he replied, 'in the Algernon Strange set. She'll know about Pussum and Libidnikov and the rest – even if she doesn't know them personally. She was never quite that set – more conventional, in a way. I've known her for two years, I suppose.'

'And she makes money, apart from her teaching?' asked Gerald.

'Some – irregularly. She can sell her models. She has a certain réclame.'

'How much for?'

'A guinea, ten guineas.'

'And are they good? What are they?'

'I think sometimes they are marvellously good. That is hers, those

two wagtails in Hermione's boudoir - you've seen them - they are carved in wood and painted.'

'I thought it was savage carving again.'

'No, hers. That's what they are – animals and birds, sometimes odd small people in everyday dress, really rather wonderful when they come off. They have a sort of funniness that is quite unconscious and subtle.'

'She might be a well-known artist one day?' mused Gerald.

'She might. But I think she won't. She drops her art if anything else catches her. Her contrariness prevents her taking it seriously – she must never be too serious, she feels she might give herself away. And she won't give herself away – she's always on the defensive. That's what I can't stand about her type. By the way, how did things go off with Pussum after I left you? I haven't heard anything.'

'Oh, rather disgusting. Halliday turned objectionable, and I only just saved myself from jumping in his stomach, in a real old-fashioned row.'

Birkin was silent.

'Of course,' he said, 'Julius is somewhat insane. On the one hand he's had religious mania, and on the other, he is fascinated by obscenity. Either he is a pure servant, washing the feet of Christ, or else he is making obscene drawings of Jesus – action and reaction – and between the two, nothing. He is really insane. He wants a pure lily, another girl, with a baby face, on the one hand, and on the other, he *must* have the Pussum, just to defile himself with her.'

'That's what I can't make out,' said Gerald. 'Does he love her, the Pussum, or doesn't he?'

'He neither does nor doesn't. She is the harlot, the actual harlot of adultery to him. And he's got a craving to throw himself into the filth of her. Then he gets up and calls on the name of the lily of purity, the baby-faced girl, and so enjoys himself all round. It's the old story – action and reaction, and nothing between.'

'I don't know,' said Gerald, after a pause, 'that he does insult the Pussum so very much. She strikes me as being rather foul.'

'But I thought you liked her,' exclaimed Birkin. 'I always felt fond of her. I never had anything to do with her, personally, that's true.'

'I liked her all right, for a couple of days,' said Gerald. 'But a week of her would have turned me over. There's a certain smell about the skin of those women, that in the end is sickening beyond words – even if you like it at first.'

'I know,' said Birkin. Then he added, rather fretfully, 'But go to bed, Gerald. God knows what time it is.'

Gerald looked at his watch, and at length rose off the bed, and went to his room. But he returned in a few minutes, in his shirt.

80

'One thing,' he said, seating himself on the bed again. 'We finished up rather stormily, and I never had time to give her anything.'

'Money?' said Birkin. 'She'll get what she wants from Halliday or from one of her acquaintances.'

'But then,' said Gerald, 'I'd rather give her her dues and settle the account.'

'She doesn't care.'

'No, perhaps not. But one feels the account is left open, and one would rather it were closed.'

'Would you?' said Birkin. He was looking at the white legs of Gerald, as the latter sat on the side of the bed in his shirt. They were white-skinned, full, muscular legs, handsome and decided. Yet they moved Birkin with a sort of pathos, tenderness, as if they were childish.

'I think I'd rather close the account,' said Gerald, repeating himself vaguely.

'It doesn't matter one way or another,' said Birkin.

'You always say it doesn't matter,' said Gerald, a little puzzled, looking down at the face of the other man affectionately.

'Neither does it,' said Birkin.

'But she was a decent sort, really - '

'Render unto Cæsarina the things that are Cæsarina's,^{'37} said Birkin, turning aside. It seemed to him Gerald was talking for the sake of talking. 'Go away, it wearies me – it's too late at night,' he said.

'I wish you'd tell me something that *did* matter,' said Gerald, looking down all the time at the face of the other man, waiting for something. But Birkin turned his face aside.

'All right then, go to sleep,' said Gerald, and he laid his hand affectionately on the other man's shoulder, and went away.

In the morning when Gerald awoke and heard Birkin move, he called out: 'I still think I ought to give the Pussum ten pounds.'

'Oh God!' said Birkin, 'don't be so matter-of-fact. Close the account in your own soul, if you like. It is there you can't close it.'

'How do you know I can't?'

'Knowing you.'

Gerald meditated for some moments.

'It seems to me the right thing to do, you know, with the Pussums, is to pay them.'

'And the right thing for mistresses: keep them. And the right thing for wives: live under the same roof with them. Integer vitae scelerisque purus - '³⁸ said Birkin.

'There's no need to be nasty about it,' said Gerald.

'It bores me. I'm not interested in your peccadilloes.'

'And I don't care whether you are or not - I am.'

The morning was again sunny. The maid had been in and brought the water, and had drawn the curtains. Birkin, sitting up in bed, looked lazily and pleasantly out on the park, that was so green and deserted, romantic, belonging to the past. He was thinking how lovely, how sure, how formed, how final all the things of the past were – the lovely accomplished past – this house, so still and golden, the park slumbering its centuries of peace. And then, what a snare and a delusion, this beauty of static things – what a horrible, dead prison Breadalby really was, what an intolerable confinement, the peace! Yet it was better than the sordid scrambling conflict of the present. If only one might create the future after one's own heart – for a little pure truth, a little unflinching application of simple truth to life, the heart cried out ceaselessly.

'I can't see what you will leave me at all, to be interested in,' came Gerald's voice from the lower room. 'Neither the Pussums, nor the mines, nor anything else.'

'You be interested in what you can, Gerald. Only I'm not interested myself,' said Birkin.

'What am I to do at all, then?' came Gerald's voice.

'What you like. What am I to do myself?'

In the silence Birkin could feel Gerald musing this fact.

'I'm blest if I know,' came the good-humoured answer.

'You see,' said Birkin, 'part of you wants the Pussum, and nothing but the Pussum, part of you wants the mines, the business, and nothing but the business – and there you are – all in bits – '

'And part of me wants something else,' said Gerald, in a queer, quiet, real voice.

'What?' said Birkin, rather surprised.

'That's what I hoped you could tell me,' said Gerald.

There was a silence for some time.

'I can't tell you – I can't find my own way, let alone yours. You might marry,' Birkin replied.

'Who - the Pussum?' asked Gerald.

'Perhaps,' said Birkin. And he rose and went to the window.

'That is your panacea,' said Gerald. 'But you haven't even tried it on yourself yet, and you are sick enough.'

'I am,' said Birkin. 'Still, I shall come right.'

'Through marriage?'

'Yes,' Birkin answered obstinately.

'And no,' added Gerald. 'No, no, no, my boy.'

There was a silence between them, and a strange tension of hostility.

They always kept a gap, a distance between them, they wanted always to be free each of the other. Yet there was a curious heart-straining towards each other.

'Salvator femininus,' 39 said Gerald, satirically.

'Why not?' said Birkin.

'No reason at all,' said Gerald, 'if it really works. But whom will you marry?'

'A woman,' said Birkin.

'Good,' said Gerald.

Birkin and Gerald were the last to come down to breakfast. Hermione liked everybody to be early. She suffered when she felt her day was diminished, she felt she had missed her life. She seemed to grip the hours by the throat, to force her life from them. She was rather pale and ghastly, as if left behind, in the morning. Yet she had her power, her will was strangely pervasive. With the entrance of the two young men a sudden tension was felt.

She lifted her face, and said, in her amused sing-song:

'Good morning! Did you sleep well? I'm so glad.'

And she turned away, ignoring them. Birkin, who knew her well, saw that she intended to discount his existence.

'Will you take what you want from the sideboard?' said Alexander, in a voice slightly suggesting disapprobation. 'I hope the things aren't cold. Oh no! Do you mind putting out the flame under the chafingdish, Rupert? Thank you.'

Even Alexander was rather authoritative where Hermione was cool. He took his tone from her, inevitably. Birkin sat down and looked at the table. He was so used to this house, to this room, to this atmosphere, through years of intimacy, and now he felt in complete opposition to it all, it had nothing to do with him. How well he knew Hermione, as she sat there, erect and silent and somewhat bemused, and yet so potent, so powerful! He knew her statically, so finally, that it was almost like a madness. It was difficult to believe one was not mad, that one was not a figure in the hall of kings in some Egyptian tomb, where the dead all sat immemorial and tremendous. How utterly he knew Joshua Mattheson, who was talking in his harsh, yet rather mincing voice, endlessly, endlessly, always with a strong mentality working, always interesting, and yet always known, everything he said known beforehand, however novel it was, and clever. Alexander the upto-date host, so bloodlessly free-and-easy, Fräulein so prettily chiming in just as she should, the little Italian Countess taking notice of everybody, only playing her little game, objective and cold, like a weasel watching everything, and extracting her own amusement, never giving herself in the slightest; then Miss Bradley, heavy and rather subservient, treated with cool, almost amused contempt by Hermione, and therefore slighted by everybody – how known it all was, like a game with the figures set out, the same figures, the Queen of chess, the knights, the pawns, the same now as they were hundreds of years ago, the same figures moving round in one of the innumerable permutations that make up the game. But the game is known, its going on is like a madness, it is so exhausted.

There was Gerald, an amused look on his face; the game pleased him. There was Gudrun, watching with steady, large, hostile eyes; the game fascinated her, and she loathed it. There was Ursula, with a slightly startled look on her face, as if she were hurt, and the pain were just outside her consciousness.

Suddenly Birkin got up and went out.

'That's enough,' he said to himself involuntarily.

Hermione knew his motion, though not in her consciousness. She lifted her heavy eyes and saw him lapse suddenly away, on a sudden, unknown tide, and the waves broke over her. Only her indomitable will remained static and mechanical, she sat at the table making her musing, stray remarks. But the darkness had covered her, she was like a ship that has gone down. It was finished for her too, she was wrecked in the darkness. Yet the unfailing mechanism of her will worked on, she had that activity.

'Shall we bathe this morning?' she said, suddenly looking at them all. 'Splendid,' said Joshua. 'It is a perfect morning.'

'Oh, it is beautiful,' said Fräulein.

'Yes, let us bathe,' said the Italian woman.

'We have no bathing suits,' said Gerald.

'Have mine,' said Alexander. 'I must go to church and read the lessons. They expect me.'

'Are you a Christian?' asked the Italian Countess, with sudden interest.

'No,' said Alexander. T'm not. But I believe in keeping up the old institutions.'

'They are so beautiful,' said Fräulein daintily.

'Oh, they are,' cried Miss Bradley.

They all trailed out on to the lawn. It was a sunny, soft morning in early summer, when life ran in the world subtly, like a reminiscence. The church bells were ringing a little way off, not a cloud was in the sky, the swans were like lilies on the water below, the peacocks walked with long, prancing steps across the shadow and into the sunshine of the grass. One wanted to swoon into the by-gone perfection of it all. 'Good-bye,' called Alexander, waving his gloves cheerily, and he disappeared behind the bushes, on his way to church.

'Now,' said Hermione, 'shall we all bathe?'

'I won't,' said Ursula.

'You don't want to?' said Hermione, looking at her slowly.

'No. I don't want to,' said Ursula.

'Nor I,' said Gudrun.

'What about my suit?' asked Gerald.

'I don't know,' laughed Hermione, with an odd, amused intonation. 'Will a handkerchief do – a large handkerchief?'

'That will do,' said Gerald.

'Come along then,' sang Hermione.

The first to run across the lawn was the little Italian, small and like a cat, her white legs twinkling as she went, ducking slightly her head, that was tied in a gold silk kerchief. She tripped through the gate and down the grass, and stood, like a tiny figure of ivory and bronze, at the water's edge, having dropped off her towelling, watching the swans, which came up in surprise. Then out ran Miss Bradley, like a large, soft plum in her dark-blue suit. Then Gerald came, a scarlet silk kerchief round his loins, his towels over his arms. He seemed to flaunt himself a little in the sun, lingering and laughing, strolling easily, looking white but natural in his nakedness. Then came Sir Joshua, in an overcoat, and lastly Hermione, striding with stiff grace from out of a great mantle of purple silk, her head tied up in purple and gold. Handsome was her stiff, long body, her straight-stepping white legs, there was a static magnificence about her as she let the cloak float loosely away from her striding. She crossed the lawn like some strange memory, and passed slowly and statelily towards the water.

There were three ponds, in terraces descending the valley, large and smooth and beautiful, lying in the sun. The water ran over a little stone wall, over small rocks, splashing down from one pond to the level below. The swans had gone out on to the opposite bank, the reeds smelled sweet, a faint breeze touched the skin.

Gerald had dived in, after Sir Joshua, and had swum to the end of the pond. There he climbed out and sat on the wall. There was a dive, and the little Countess was swimming like a rat, to join him. They both sat in the sun, laughing and crossing their arms on their breasts. Sir Joshua swam up to them, and stood near them, up to his arm-pits in the water. Then Hermione and Miss Bradley swam over, and they sat in a row on the embankment.

'Aren't they terrifying? Aren't they really terrifying?' said Gudrun. 'Don't they look saurian? They are just like great lizards. Did you ever

see anything like Sir Joshua? But really, Ursula, he belongs to the primeval world, when great lizards crawled about.'

Gudrun looked in dismay on Sir Joshua, who stood up to the breast in the water, his long, greyish hair washed down into his eyes, his neck set into thick, crude shoulders. He was talking to Miss Bradley, who, seated on the bank above, plump and big and wet, looked as if she might roll and slither in the water almost like one of the slithering sealions in the Zoo.

Ursula watched in silence. Gerald was laughing happily, between Hermione and the Italian. He reminded her of Dionysos,⁴⁰ because his hair was really yellow, his figure so full and laughing. Hermione, in her large, stiff, sinister grace, leaned near him, frightening, as if she were not responsible for what she might do. He knew a certain danger in her, a convulsive madness. But he only laughed the more, turning often to the little Countess, who was flashing up her face at him.

They all dropped into the water, and were swimming together like a shoal of seals. Hermione was powerful and unconscious in the water, large and slow and powerful. Palestra was quick and silent as a water rat, Gerald wavered and flickered, a white natural shadow. Then, one after the other, they waded out, and went up to the house.

But Gerald lingered a moment to speak to Gudrun.

'You don't like the water?' he said.

She looked at him with a long, slow inscrutable look, as he stood before her negligently, the water standing in beads all over his skin.

'I like it very much,' she replied.

He paused, expecting some sort of explanation.

'And you swim?'

'Yes, I swim.'

Still he would not ask her why she would not go in then. He could feel something ironic in her. He walked away, piqued for the first time.

'Why wouldn't you bathe?' he asked her again, later, when he was once more the properly-dressed young Englishman.

She hesitated a moment before answering, opposing his persistence. 'Because I didn't like the crowd,' she replied.

He laughed, her phrase seemed to re-echo in his consciousness. The flavour of her slang was piquant to him. Whether he would or not, she signified the real world to him. He wanted to come up to her standards, fulfil her expectations. He knew that her criterion was the only one that mattered. The others were all outsiders, instinctively, whatever they might be socially. And Gerald could not help it, he was bound to strive to come up to her criterion, fulfil her idea of a man and a human-being.

After lunch, when all the others had withdrawn, Hermione and

Gerald and Birkin lingered, finishing their talk. There had been some discussion, on the whole quite intellectual and artificial, about a new state, a new world of man. Supposing this old social state *were* broken and destroyed, then, out of the chaos, what then?

The great social idea, said Sir Joshua, was the *social* equality of man. No, said Gerald, the idea was, that every man was fit for his own little bit of a task – let him do that, and then please himself. The unifying principle was the work in hand. Only work, the business of production, held men together. It was mechanical, but then society *was* a mechanism. Apart from work they were isolated, free to do as they liked.

'Oh!' cried Gudrun. 'Then we shan't have names any more – we shall be like the Germans, nothing but Herr Obermeister and Herr Untermeister. I can imagine it – "I am Mrs Colliery-Manager Crich – I am Mrs Member-of-Parliament Roddice. I am Miss Art-Teacher Brangwen." Very pretty that.'

'Things would work very much better, Miss Art-Teacher Brangwen,' said Gerald.

'What things, Mr Colliery-Manager Crich? The relation between you and me, *par exemple*?'

'Yes, for example,' cried the Italian. 'That which is between men and women - !'

'That is non-social,' said Birkin, sarcastically.

'Exactly,' said Gerald. 'Between me and a woman, the social question does not enter. It is my own affair.'

'A ten-pound note on it,' said Birkin.

'You don't admit that a woman is a social being?' asked Ursula of Gerald.

'She is both,' said Gerald. 'She is a social being, as far as society is concerned. But for her own private self, she is a free agent, it is her own affair, what she does.'

'But won't it be rather difficult to arrange the two halves?' asked Ursula.

'Oh no,' replied Gerald. 'They arrange themselves naturally – we see it now, everywhere.'

'Don't you laugh so pleasantly till you're out of the wood,' said Birkin.

Gerald knitted his brows in momentary irritation.

'Was I laughing?' he said.

'*If*,' said Hermione at last, 'we could only realise, that in the *spirit* we are all one, all equal in the spirit, all brothers there – the rest wouldn't matter, there would be no more of this carping and envy and this struggle for power, which destroys, only destroys.'

This speech was received in silence, and almost immediately the party rose from the table. But when the others had gone, Birkin turned round in bitter declamation, saying:

'It is just the opposite, just the contrary, Hermione. We are all different and unequal in spirit – it is only the *social* differences that are based on accidental material conditions. We are all abstractly or mathematically equal, if you like. Every man has hunger and thirst, two eyes, one nose and two legs. We're all the same in point of number. But spiritually, there is pure difference and neither equality nor inequality counts. It is upon these two bits of knowledge that you must found a state. Your democracy is an absolute lie – your brotherhood of man is a pure falsity, if you apply it further than the mathematical abstraction. We all drank milk first, we all eat bread and meat, we all want to ride in motor-cars – therein lies the beginning and the end of the brotherhood of man. But no equality.

'But I, myself, who am myself, what have I to do with equality with any other man or woman? In the spirit, I am as separate as one star is from another, as different in quality and quantity. Establish a state on *that*. One man isn't any better than another, not because they are equal, but because they are intrinsically *other*, that there is no term of comparison. The minute you begin to compare, one man is seen to be far better than another, all the inequality you can imagine is there by nature. I want every man to have his share in the world's goods, so that I am rid of his importunity, so that I can tell him: "Now you've got what you want – you've got your fair share of the world's gear. Now, you one-mouthed fool, mind yourself and don't obstruct me.'

Hermione was looking at him with leering eyes, along her cheeks. He could feel violent waves of hatred and loathing of all he said, coming out of her. It was dynamic hatred and loathing, coming strong and black out of the unconsciousness. She heard his words in her unconscious self, *consciously* she was as if deafened, she paid no heed to them.

'It sounds like megalomania, Rupert,' said Gerald, genially.

Hermione gave a queer, grunting sound. Birkin stood back.

'Yes, let it,' he said suddenly, the whole tone gone out of his voice, that had been so insistent, bearing everybody down. And he went away.

But he felt, later, a little compunction. He had been violent, cruel with poor Hermione. He wanted to recompense her, to make it up. He had hurt her, he had been vindictive. He wanted to be on good terms with her again.

He went into her boudoir, a remote and very cushiony place. She was sitting at her table writing letters. She lifted her face abstractedly when he entered, watched him go to the sofa, and sit down. Then she looked down at her paper again.

He took up a large volume which he had been reading before, and became minutely attentive to his author. His back was towards Hermione. She could not go on with her writing. Her whole mind was a chaos, darkness breaking in upon it, and herself struggling to gain control with her will, as a swimmer struggles with the swirling water. But in spite of her efforts she was borne down, darkness seemed to break over her, she felt as if her heart was bursting. The terrible tension grew stronger and stronger, it was most fearful agony, like being walled up.

And then she realised that his presence was the wall, his presence was destroying her. Unless she could break out, she must die most fearfully, walled up in horror. And he was the wall. She must break down the wall – she must break him down before her, the awful obstruction of him who obstructed her life to the last. It must be done, or she must perish most horribly.

Terribly shocks ran over her body, like shocks of electricity, as if many volts of electricity suddenly struck her down. She was aware of him sitting silently there, an unthinkable evil obstruction. Only this blotted out her mind, pressed out her very breathing, his silent, stooping back, the back of his head.

A terrible voluptuous thrill ran down her arms – she was going to know her voluptuous consummation. Her arms quivered and were strong, immeasurably and irresistibly strong. What delight, what delight in strength, what delirium of pleasure! She was going to have her consummation of voluptuous ecstasy at last. It was coming! In utmost terror and agony, she knew it was upon her now, in extremity of bliss. Her hand closed on a blue, beautiful ball of lapis lazuli that stood on her desk for a paper-weight. She rolled it round in her hand as she rose silently. Her heart was a pure flame in her breast, she was purely unconscious in ecstasy. She moved towards him and stood behind him for a moment in ecstasy. He, closed within the spell, remained motionless and unconscious.

Then swiftly, in a flame that drenched down her body like fluid lightning and gave her a perfect, unutterable consummation, unutterable satisfaction, she brought down the ball of jewel stone with all her force, crash on his head. But her fingers were in the way and deadened the blow. Nevertheless, down went his head on the table on which his book lay, the stone slid aside and over his ear, it was one convulsion of pure bliss for her, lit up by the crushed pain of her fingers. But it was not somehow complete. She lifted her arm high to aim once more, straight down on the head that lay dazed on the table. She must smash it, it must be smashed before her ecstasy was consummated, fulfilled for ever. A thousand lives, a thousand deaths mattered nothing now, only the fulfilment of this perfect ecstasy.

She was not swift, she could only move slowly. A strong spirit in him woke him and made him lift his face and twist to look at her. Her arm was raised, the hand clasping the ball of lapis lazuli. It was her left hand, he realised again with horror that she was left-handed. Hurriedly, with a burrowing motion, he covered his head under the thick volume of Thucydides, and the blow came down, almost breaking his neck, and shattering his heart.

He was shattered, but he was not afraid. Twisting round to face her he pushed the table over and got away from her. He was like a flask that is smashed to atoms, he seemed to himself that he was all fragments, smashed to bits. Yet his movements were perfectly coherent and clear, his soul was entire and unsurprised.

he'S \rightarrow 'No you don't, Hermione,' he said in a low voice. 'I <u>don't let you.</u>' some ful He saw her standing tall and livid and attentive, the stone clenched regardy tense in her hand.

'Stand away and let me go,' he said, drawing near to her.

As if pressed back by some hand, she stood away, watching him all the time without changing, like a neutralised angel confronting him.

'It is no good,' he said, when he had gone past her. 'It isn't I who will die. You hear?'

He kept his face to her as he went out, lest she should strike again. While he was on his guard, she dared not move. And he was on his guard, she was powerless. So he had gone, and left her standing.

She remained perfectly rigid, standing as she was for a long time. Then she staggered to the couch and lay down, and went heavily to sleep. When she awoke, she remembered what she had done, but it seemed to her, she had only hit him, as any woman might do, because he tortured her. She was perfectly right. She knew that, spiritually, she was right. In her own infallible purity, she had done what must be done. She was right, she was pure. A drugged, almost sinister religious expression became permanent on her face.

Birkin, barely conscious, and yet perfectly direct in his motion, went out of the house and straight across the park, to the open country, to the hills. The brilliant day had become overcast, spots of rain were falling. He wandered on to a wild valley-side, where were thickets of hazel, many flowers, tufts of heather, and little clumps of young firtrees, budding with soft paws. It was rather wet everywhere, there was a stream running down at the bottom of the valley, which was gloomy, or seemed gloomy. He was aware that he could not regain his

Mati

consciousness, that he was moving in a sort of darkness.

Yet he wanted something. He was happy in the wet hillside, that was overgrown and obscure with bushes and flowers. He wanted to touch them all, to saturate himself with the touch of them all. He took off his clothes, and sat down naked among the primroses, moving his feet softly among the primroses, his legs, his knees, his arms right up to the arm-pits, lying down and letting them touch his belly, his breasts. It was such a fine, cool, subtle touch all over him, he seemed to saturate himself with their contact.

But they were too soft. He went through the long grass to a clump of young fir-trees, that were no higher than a man. The soft sharp boughs beat upon him, as he moved in keen pangs against them, threw little cold showers of drops on his belly, and beat his loins with their clusters of soft-sharp needles. There was a thistle which pricked him vividly, but not too much, because all his movements were too discriminate and soft. To lie down and roll in the sticky, cool young hyacinths, to lie on one's belly and cover one's back with handfuls of fine wet grass, soft as a breath, soft and more delicate and more beautiful than the touch of any woman; and then to sting one's thigh against the living dark bristles of the fir-boughs; and then to feel the light whip of the hazel on one's shoulders, stinging, and then to clasp the silvery birch-trunk against one's breast, its smoothness, its hardness, its vital knots and ridges - this was good, this was all very good, very satisfying. Nothing else would do, nothing else would satisfy, except this coolness and subtlety of vegetation travelling into one's blood. How fortunate he was, that there was this lovely, subtle, responsive vegetation, waiting for him, as he waited for it; how fulfilled he was, how happy!

As he dried himself a little with his handkerchief, he thought about Hermione and the blow. He could feel a pain on the side of his head. But after all, what did it matter? What did Hermione matter, what did people matter altogether? There was this perfect cool loneliness, so lovely and fresh and unexplored. Really, what a mistake he had made, thinking he wanted people, thinking he wanted a woman. He did not want a woman – not in the least. The leaves and the primroses and the trees, they were really lovely and cool and desirable, they really came into the blood and were added on to him. He was enrichened now immeasurably, and so glad.

It was quite right of Hermione to want to kill him. What had he to do with her? Why should he pretend to have anything to do with human beings at all? Here was his world, he wanted nobody and nothing but the lovely, subtle, responsive vegetation, and himself, his own living self.

It was necessary to go back into the world. That was true. But that did not matter, so one knew where one belonged. He knew now where he belonged. This was his place, his marriage place. The world was extraneous.

He climbed out of the valley, wondering if he were mad. But if so, he preferred his own madness, to the regular sanity. He rejoiced in his own madness, he was free. He did not want that old sanity of the world, which was become so repulsive. He rejoiced in the new-found world of his madness. It was so fresh and delicate and so satisfying.

As for the certain grief he felt at the same time, in his soul, that was only the remains of an old ethic, that bade a human being adhere to humanity. But he was weary of the old ethic, of the human being, and of humanity. He loved now the soft, delicate vegetation, that was so cool and perfect. He would overlook the old grief, he would put away the old ethic, he would be free in his new state.

He was aware of the pain in his head becoming more and more difficult every minute. He was walking now along the road to the nearest station. It was raining and he had no hat. But then plenty of cranks went out nowadays without hats, in the rain.

He wondered again how much of his heaviness of heart, a certain depression, was due to fear, fear lest anybody should have seen him naked lying against the vegetation. What a dread he had of mankind, of other people! It amounted almost to horror, to a sort of dream terror – his horror of being observed by some other people. If he were on an island, like Alexander Selkirk,⁴¹ with only the creatures and the trees, he would be free and glad, there would be none of this heaviness, this misgiving. He could love the vegetation and be quite happy and unquestioned, by himself.

He had better send a note to Hermione: she might trouble about him, and he did not want the onus of this. So at the station, he wrote saying:

I will go on to town – I don't want to come back to Breadalby for the present. But it is quite all right – I don't want you to mind having biffed me, in the least. Tell the others it is just one of my moods. You were quite right, to biff me – because I know you wanted to. So there's the end of it.

In the train, however, he felt ill. Every motion was insufferable pain, and he was sick. He dragged himself from the station into a cab, feeling his way step by step, like a blind man, and held up only by a dim will.

For a week or two he was ill, but he did not let Hermione know, and she thought he was sulking; there was a complete estrangement between them. She became rapt, abstracted in her conviction of exclusive righteousness. She lived in and by her own self-esteem, conviction of her own rightness of spirit.

CHAPTER IX

Coaldust

GOING HOME from school in the afternoon, the Brangwen girls descended the hill between the picturesque cottages of Willey Green till they came to the railway crossing. There they found the gate shut, because the colliery train was rumbling nearer. They could hear the small locomotive panting hoarsely as it advanced with caution between the embankments. The one-legged man in the little signal-hut by the road stared out from his security, like a crab from a snail-shell.

Whilst the two girls waited, Gerald Crich trotted up on a red Arab mare. He rode well and softly, pleased with the delicate quivering of the creature between his knees. And he was very picturesque, at least in Gudrun's eyes, sitting soft and close on the slender red mare, whose long tail flowed on the air. He saluted the two girls, and drew up at the crossing to wait for the gate, looking down the railway for the approaching train. In spite of her ironic smile at his picturesqueness, Gudrun liked to look at him. He was well-set and easy, his face with its warm tan showed up his whitish, coarse moustache, and his blue eyes were full of sharp light as he watched the distance.

The locomotive chuffed slowly between the banks, hidden. The mare did not like it. She began to wince away, as if hurt by the unknown noise. But Gerald pulled her back and held her head to the gate. The sharp blasts of the chuffing engine broke with more and more force on her. The repeated sharp blows of unknown, terrifying noise struck through her till she was rocking with terror. She recoiled like a spring let go. But a glistening, half-smiling look came into Gerald's face. He brought her back again, inevitably.

The noise was released, the little locomotive with her clanking steel connecting-rod emerged on the highroad, clanking sharply. The mare rebounded like a drop of water from hot iron. Ursula and Gudrun pressed back into the hedge, in fear. But Gerald was heavy on the mare, and forced her back. It seemed as if he sank into her magnetically, and could thrust her back against herself.

'The fool!' cried Ursula loudly. 'Why doesn't he ride away till it's gone by?'

Gudrun was looking at him with black-dilated, spellbound eyes. But he sat glistening and obstinate, forcing the wheeling mare, which spun and swerved like a wind, and yet could not get out of the grasp of his will, nor escape from the mad clamour of terror that resounded through her, as the trucks thumped slowly, heavily, horrifying, one after the other, one pursuing the other, over the rails of the crossing.

The locomotive, as if wanting to see what could be done, put on the brakes, and back came the trucks rebounding on the iron buffers, striking like horrible cymbals, clashing nearer and nearer in frightful strident concussions. The mare opened her mouth and rose slowly, as if lifted up on a wind of terror. Then suddenly her fore feet struck out, as she convulsed herself utterly away from the horror. Back she went, and the two girls clung to each other, feeling she must fall backwards on top of him. But he leaned forward, his face shining with fixed amusement, and at last he brought her down, sank her down, and was bearing her back to the mark. But as strong as the pressure of his compulsion was the repulsion of her utter terror, throwing her back away from the railway, so that she spun round and round, on two legs, as if she were in the centre of some whirlwind. It made Gudrun faint with poignant dizziness, which seemed to penetrate to her heart.

'No -! No -! Let her go! Let her go, you fool, you fool -!' cried Ursula at the top of her voice, completely outside herself. And Gudrun hated her bitterly for being outside herself. It was unendurable that Ursula's voice was so powerful and naked.

A sharpened look came on Gerald's face. He bit himself down on the mare like a keen edge biting home, and *forced* her round. She roared as she breathed, her nostrils were two wide, hot holes, her mouth was apart, her eyes frenzied. It was a repulsive sight. But he held on her unrelaxed, with an almost mechanical relentlessness, keen as a sword pressing in to her. Both man and horse were sweating with violence. Yet he seemed calm as a ray of cold sunshine.

Meanwhile the eternal trucks were rumbling on, very slowly, treading one after the other, one after the other, like a disgusting dream that has no end. The connecting chains were grinding and squeaking as the tension varied, the mare pawed and struck away mechanically now, her terror fulfilled in her, for now the man encompassed her; her paws were blind and pathetic as she beat the air, the man closed round her, and brought her down, almost as if she were part of his own physique.

'And she's bleeding! She's bleeding!' cried Ursula, frantic with

opposition and hatred of Gerald. She alone understood him perfectly, in pure opposition.

Gudrun looked and saw the trickles of blood on the sides of the mare, and she turned white. And then on the very wound the bright spurs came down, pressing relentlessly. The world reeled and passed into nothingness for Gudrun, she could not know any more.

When she recovered, her soul was calm and cold, without feeling. The trucks were still rumbling by, and the man and the mare were still fighting. But she herself was cold and separate, she had no more feeling for them. She was quite hard and cold and indifferent.

They could see the top of the hooded guard's-van approaching, the sound of the trucks was diminishing, there was hope of relief from the intolerable noise. The heavy panting of the half-stunned mare sounded automatically, the man seemed to be relaxing confidently, his will bright and unstained. The guard's-van came up, and passed slowly, the guard staring out in his transition on the spectacle in the road. And, through the man in the closed wagon, Gudrun could see the whole scene spectacularly, isolated and momentary, like a vision isolated in eternity.

Lovely, grateful silence seemed to trail behind the receding train. How sweet the silence is! Ursula looked with hatred on the buffers of the diminishing wagon. The gatekeeper stood ready at the door of his hut, to proceed to open the gate. But Gudrun sprang suddenly forward, in front of the struggling horse, threw off the latch and flung the gates asunder, throwing one-half to the keeper, and running with the other half, forwards. Gerald suddenly let go the horse and leaped forwards, almost on to Gudrun. She was not afraid. As he jerked aside the mare's head, Gudrun cried, in a strange, high voice, like a gull, or like a witch screaming out from the side of the road:

'I should think you're proud.'

The words were distinct and formed. The man, twisting aside on his dancing horse, looked at her in some surprise, some wondering interest. Then the mare's hoofs had danced three times on the drumlike sleepers of the crossing, and man and horse were bounding springily, unequally up the road.

The two girls watched them go. The gate-keeper hobbled thudding over the logs of the crossing, with his wooden leg. He had fastened the gate. Then he also turned, and called to the girls:

'A masterful young jockey, that; 'll have his own road, if ever anybody would.'

'Yes,' cried Ursula, in her hot, overbearing voice. 'Why couldn't he take the horse away, till the trucks had gone by? He's a fool, and a

bully. Does he think it's manly, to torture a horse? It's a living thing, why should he bully it and torture it?'

There was a pause, then the gate-keeper shook his head, and replied:

'Yes, it's as nice a little mare as you could set eyes on – beautiful little thing, beautiful. Now you couldn't see his father treat any animal like that – not you. They're as different as they welly can be, Gerald Crich and his father – two different men, different made.'

Then there was a pause.

'But why does he do it?' cried Ursula, 'why does he? Does he think he's grand, when he's bullied a sensitive creature, ten times as sensitive as himself?'

Again there was a cautious pause. Then again the man shook his head, as if he would say nothing, but would think the more.

'I expect he's got to train the mare to stand to anything,' he replied. 'A pure-bred Harab – not the sort of breed as is used to round here – different sort from our sort altogether. They say as he got her from Constantinople.'

'He would!' said Ursula. 'He'd better have left her to the Turks, I'm sure they would have had more decency towards her.'

The man went in to drink his can of tea, the girls went on down the lane, that was deep in soft black dust. Gudrun was as if numbed in her mind by the sense of indomitable soft weight of the man, bearing down into the living body of the horse: the strong, indomitable thighs of the blond man clenching the palpitating body of the mare into pure control; a sort of soft white magnetic domination from the loins and thighs and calves, enclosing and encompassing the mare heavily into unutterable subordination, soft blood-subordination, terrible.

On the left, as the girls walked silently, the coal-mine lifted its great mounds and its patterned head-stocks, the black railway with the trucks at rest looked like a harbour just below, a large bay of railroad with anchored wagons.

Near the second level-crossing, that went over many bright rails, was a farm belonging to the collieries, and a great round globe of iron, a disused boiler, huge and rusty and perfectly round, stood silently in a paddock by the road. The hens were pecking round it, some chickens were balanced on the drinking trough, wagtails flew away in among trucks, from the water.

On the other side of the wide crossing, by the road-side, was a heap of pale-grey stones for mending the roads, and a cart standing, and a middle-aged man with whiskers round his face was leaning on his shovel, talking to a young man in gaiters, who stood by the horse's head. Both men were facing the crossing.

96

They saw the two girls appear, small, brilliant figures in the near distance, in the strong light of the late afternoon. Both wore light, gay summer dresses, Ursula had an orange-coloured knitted coat, Gudrun a pale yellow, Ursula wore canary yellow stockings, Gudrun bright rose, the figures of the two women seemed to glitter in progress over the wide bay of the railway crossing, white and orange and yellow and rose glittering in motion across a hot world silted with coaldust.

The two men stood quite still in the heat, watching. The elder was a short, hard-faced energetic man of middle age, the younger a labourer of twenty-three or so. They stood in silence watching the advance of the sisters. They watched whilst the girls drew near, and whilst they passed, and whilst they receded down the dusty road, that had dwellings on one side, and dusty young corn on the other.

Then the elder man, with the whiskers round his face, said in a prurient manner to the young man:

'What price that, eh? She'll do, won't she?'

'Which?' asked the young man, eagerly, with laugh.

'Her with the red stockings. What d'you say? I'd give my week's wages for five minutes; what! - just for five minutes.'

Again the young man laughed.

'Your missis 'ud have summat to say to you,' he replied.

Gudrun had turned round and looked at the two men. They were to her sinister creatures, standing watching after her, by the heap of pale grey slag. She loathed the man with whiskers round his face.

'You're first class, you are,' the man said to her, and to the distance.

'Do you think it would be worth a week's wages?' said the younger man, musing.

'Do I? I'd put 'em bloody-well down this second -'

The younger man looked after Gudrun and Ursula objectively, as if he wished to calculate what there might be, that was worth his week's wages. He shook his head with fatal misgiving.

'No,' he said. 'It's not worth that to me.'

'Isn't?' said the old man. 'By God, if it isn't to me!'

And he went on shovelling his stones.

The girls descended between the houses with slate roofs and blackish brick walls. The heavy gold glamour of approaching sunset lay over all the colliery district, and the ugliness overlaid with beauty was like a narcotic to the senses. On the roads silted with black dust, the rich light fell more warmly, more heavily, over all the amorphous squalor a kind of magic was cast, from the glowing close of day.

'It has a foul kind of beauty, this place,' said Gudrun, evidently suffering from fascination. 'Can't you feel in some way, a thick, hot

attraction in it? I can. And it quite stupifies me.'

They were passing between blocks of miners' dwellings. In the back yards of several dwellings, a miner could be seen washing himself in the open on this hot evening, naked down to the loins, his great trousers of moleskin slipping almost away. Miners already cleaned were sitting on their heels, with their backs near the walls, talking and silent in pure physical well-being, tired, and taking physical rest. Their voices sounded out with strong intonation, and the broad dialect was curiously caressing to the blood. It seemed to envelop Gudrun in a labourer's caress, there was in the whole atmosphere a resonance of physical men, a glamorous thickness of labour and maleness, surcharged in the air. But it was universal in the district, and therefore unnoticed by the inhabitants.

To Gudrun, however, it was potent and half-repulsive. She could never tell why Beldover was so utterly different from London and the south, why one's whole feelings were different, why one seemed to live in another sphere. Now she realised that this was the world of powerful, underworld men who spent most of their time in the darkness. In their voices she could hear the voluptuous resonance of darkness, the strong, dangerous underworld, mindless, inhuman. They sounded also like strange machines, heavy, oiled. The voluptuousness was like that of machinery, cold and iron.

It was the same every evening when she came home, she seemed to move through a wave of disruptive force, that was given off from the presence of thousands of vigorous, underworld, half-automatised colliers, and which went to the brain and the heart, awaking a fatal desire, and a fatal callousness.

There came over her a nostalgia for the place. She hated it, she knew how utterly cut off it was, how hideous and how sickeningly mindless. Sometimes she beat her wings like a new Daphne,⁴² turning not into a tree but a machine. And yet, she was overcome by the nostalgia. She struggled to get more and more into accord with the atmosphere of the place, she craved to get her satisfaction of it.

She felt herself drawn out at evening into the main street of the town, that was uncreated and ugly, and yet surcharged with this same potent atmosphere of intense, dark callousness. There were always miners about. They moved with their strange, distorted dignity, a certain beauty, and unnatural stillness in their bearing, a look of abstraction and half resignation in their pale, often gaunt faces. They belonged to another world, they had a strange glamour, their voices were full of an intolerable deep resonance, like a machine's burring, a music more maddening than the siren's long ago.

98

She found herself, with the rest of the common women, drawn out on Friday evenings to the little market. Friday was pay-day for the colliers, and Friday night was market night. Every woman was abroad, every man was out, shopping with his wife, or gathering with his pals. The pavements were dark for miles around with people coming in, the little market-place on the crown of the hill, and the main street of Beldover were black with thickly-crowded men and women.

It was dark, the market-place was hot with kerosene flares, which threw a ruddy light on the grave faces of the purchasing wives, and on the pale abstract faces of the men. The air was full of the sound of criers and of people talking, thick streams of people moved on the pavements towards the solid crowd of the market. The shops were blazing and packed with women, in the streets were men, mostly men, miners of all ages. Money was spent with almost lavish freedom.

The carts that came could not pass through. They had to wait, the driver calling and shouting, till the dense crowd would make way. Everywhere, young fellows from the outlying districts were making conversation with the girls, standing in the road and at the corners. The doors of the public-houses were open and full of light, men passed in and out in a continual stream, everywhere men were calling out to one another, or crossing to meet one another, or standing in little gangs and circles, discussing, endlessly discussing. The sense of talk, buzzing, jarring, half-secret, the endless mining and political wrangling, vibrated in the air like discordant machinery. And it was their voices which affected Gudrun almost to swooning. They aroused a strange, nostalgic ache of desire, something almost demoniacal, never to be fulfilled.

Like any other common girl of the district, Gudrun strolled up and down, up and down the length of the brilliant two-hundred paces of the pavement nearest the market-place. She knew it was a vulgar thing to do; her father and mother could not bear it; but the nostalgia came over her, she must be among the people. Sometimes she sat among the louts in the cinema: rakish-looking, unattractive louts they were. Yet she must be among them.

And, like any other common lass, she found her 'boy.' It was an electrician, one of the electricians introduced according to Gerald's new scheme. He was an earnest, clever man, a scientist with a passion for sociology. He lived alone in a cottage, in lodgings, in Willey Green. He was a gentleman, and sufficiently well-to-do. His landlady spread the reports about him; he *would* have a large wooden tub in his bedroom, and every time he came in from work, he *would* have pails and pails of water brought up, to bathe in, then he put on clean shirt

and under-clothing *every* day, and clean silk socks; fastidious and exacting he was in these respects, but in every other way, most ordinary and unassuming.

Gudrun knew all these things. The Brangwen's house was one to which the gossip came naturally and inevitably. Palmer was in the first place a friend of Ursula's. But in his pale, elegant, serious face there showed the same nostalgia that Gudrun felt. He too must walk up and down the street on Friday evening. So he walked with Gudrun, and a friendship was struck up between them. But he was not in love with Gudrun; he really wanted Ursula, but for some strange reason, nothing could happen between her and him. He liked to have Gudrun about, as a fellow-mind - but that was all. And she had no real feeling for him. He was a scientist, he had to have a woman to back him. But he was really impersonal, he had the fineness of an elegant piece of machinery. He was too cold, too destructive to care really for women, too great an egoist. He was polarised by the men. Individually he detested and despised them. In the mass they fascinated him, as machinery fascinated him. They were a new sort of machinery to him - but incalculable, incalculable.

So Gudrun strolled the streets with Palmer, or went to the cinema with him. And his long, pale, rather elegant face flickered as he made his sarcastic remarks. There they were, the two of them: two elegants in one sense: in the other sense, two units, absolutely adhering to the people, teeming with the distorted colliers. The same secret seemed to be working in the souls of all alike, Gudrun, Palmer, the rakish young bloods, the gaunt, middle-aged men. All had a secret sense of power, and of inexpressible destructiveness, and of fatal half-heartedness, a sort of rottenness in the will.

Sometimes Gudrun would start aside, see it all, see how she was sinking in. And then she was filled with a fury of contempt and anger. She felt she was sinking into one mass with the rest – all so close and intermingled and breathless. It was horrible. She stifled. She prepared for flight, feverishly she flew to her work. But soon she let go. She started off into the country – the darkish, glamorous country. The spell was beginning to work again.

CHAPTER X

Sketchbook

ONE MORNING the sisters were sketching by the side of Willey Water, at the remote end of the lake. Gudrun had waded out to a gravelly shoal, and was seated like a Buddhist, staring fixedly at the water-plants that rose succulent from the mud of the low shores. What she could see was mud, soft, oozy, watery mud, and from its festering chill, waterplants rose up, thick and cool and fleshy, very straight and turgid, thrusting out their leaves at right angles, and having dark lurid colours, dark green and blotches of black-purple and bronze. But she could feel their turgid fleshy structure as in a sensuous vision, she *knew* how they rose out of the mud, she *knew* how they thrust out from themselves, how they stood stiff and succulent against the air.

Ursula was watching the butterflies, of which there were dozens near the water, little blue ones suddenly snapping out of nothingness into a jewel-life, a large black-and-red one standing upon a flower and breathing with his soft wings, intoxicatingly, breathing pure, ethereal sunshine; two white ones wrestling in the low air; there was a halo round them; ah, when they came tumbling nearer they were orangetips, and it was the orange that had made the halo. Ursula rose and drifted away, unconscious like the butterflies.

Gudrun, absorbed in a stupor of apprehension of surging waterplants, sat crouched on the shoal, drawing, not looking up for a long time, and then staring unconsciously, absorbedly at the rigid, naked, succulent stems. Her feet were bare, her hat lay on the bank opposite.

She started out of her trance, hearing the knocking of oars. She looked round. There was a boat with a gaudy Japanese parasol, and a man in white, rowing. The woman was Hermione, and the man was Gerald. She knew it instantly. And instantly she perished in the keen *frisson* of anticipation, an electric vibration in her veins, intense, much more intense than that which was always humming low in the atmosphere of Beldover.

Gerald was her escape from the heavy slough of the pale, underworld, automatic colliers. He started out of the mud. He was master. She saw his back, the movement of his white loins. But not that – it was the whiteness he seemed to enclose as he bent forwards, rowing. He seemed to stoop to something. His glistening, whitish hair seemed like the electricity of the sky.

'There's Gudrun,' came Hermione's voice floating distinct over the water. 'We will go and speak to her. Do you mind?'

Gerald looked round and saw the girl standing by the water's edge, looking at him. He pulled the boat towards her, magnetically, without thinking of her. In his world, his conscious world, she was still nobody. He knew that Hermione had a curious pleasure in treading down all the social differences, at least apparently, and he left it to her.

'How do you do, Gudrun?' sang Hermione, using the Christian name in the fashionable manner. 'What are you doing?'

'How do you do, Hermione? I was sketching.'

'Were you?' The boat drifted nearer, till the keel ground on the bank. 'May we see? I should like to so much.'

It was no use resisting Hermione's deliberate intention.

'Well - ' said Gudrun reluctantly, for she always hated to have her unfinished work exposed - 'there's nothing in the least interesting.'

'Isn't there? But let me see, will you?'

Gudrun reached out the sketchbook, Gerald stretched from the boat to take it. And as he did so, he remembered Gudrun's last words to him, and her face lifted up to him as he sat on the swerving horse. An intensification of pride went over his nerves, because he felt, in some way she was compelled by him. The exchange of feeling between them was strong and apart from their consciousness.

And as if in a spell, Gudrun was aware of his body, stretching and surging like the marsh-fire, stretching towards her, his hand coming straight forward like a stem. Her voluptuous, acute apprehension of him made the blood faint in her veins, her mind went dim and unconscious. And he rocked on the water perfectly, like the rocking of phosphorescence. He looked round at the boat. It was drifting off a little. He lifted the oar to bring it back. And the exquisite pleasure of slowly arresting the boat, in the heavy-soft water, was complete as a swoon.

'That's what you have done,' said Hermione, looking searchingly at the plants on the shore, and comparing with Gudrun's drawing. Gudrun looked round in the direction of Hermione's long, pointing finger. 'That is it, isn't it?' repeated Hermione, needing confirmation.

'Yes,' said Gudrun automatically, taking no real heed.

'Let me look,' said Gerald, reaching forward for the book. But Hermione ignored him, he must not presume, before she had finished. But he, his will as unthwarted and as unflinching as hers, stretched forward till he touched the book. A little shock, a storm of revulsion against him, shook Hermione unconsciously. She released the book when he had not properly got it, and it tumbled against the side of the boat and bounced into the water.

'There!' sang Hermione, with a strange ring of malevolent victory. 'I'm so sorry, so awfully sorry. Can't you get it, Gerald?'

This last was said in a note of anxious sneering that made Gerald's veins tingle with fine hate for her. He leaned far out of the boat, reaching down into the water. He could feel his position was ridiculous, his loins exposed behind him.

'It is of no importance,' came the strong, clanging voice of Gudrun. She seemed to touch him. But he reached further, the boat swayed violently. Hermione, however, remained unperturbed. He grasped the book, under the water, and brought it up, dripping.

'I'm so dreadfully sorry - dreadfully sorry,' repeated Hermione. 'I'm afraid it was all my fault.'

'It's of no importance – really, I assure you – it doesn't matter in the least,' said Gudrun loudly, with emphasis, her face flushed scarlet. And she held out her hand impatiently for the wet book, to have done with the scene. Gerald gave it to her. He was not quite himself.

'I'm so dreadfully sorry,' repeated Hermione, till both Gerald and Gudrun were exasperated. 'Is there nothing that can be done?'

'In what way?' asked Gudrun, with cool irony.

'Can't we save the drawings?'

There was a moment's pause, wherein Gudrun made evident all her refutation of Hermione's persistence.

'I assure you,' said Gudrun, with cutting distinctness, 'the drawings are quite as good as ever they were, for my purpose. I want them only for reference.'

'But can't I give you a new book? I wish you'd let me do that. I feel so truly sorry. I feel it was all my fault.'

'As far as I saw,' said Gudrun, 'it wasn't your fault at all. If there was any *fault*, it was Mr Crich's. But the whole thing is *entirely* trivial, and it really is ridiculous to take any notice of it.'

Gerald watched Gudrun closely, whilst she repulsed Hermione. There was a body of cold power in her. He watched her with an insight that amounted to clairvoyance. He saw her a dangerous, hostile spirit, that could stand undiminished and unabated. It was so finished, and of such perfect gesture, moreover.

'I'm awfully glad if it doesn't matter,' he said; 'if there's no real harm done.'

She looked back at him, with her fine blue eyes, and signalled full into his spirit, as she said, her voice ringing with intimacy almost caressive now it was addressed to him:

'Of course, it doesn't matter in the least.'

The bond was established between them, in that look, in her tone. In her tone, she made the understanding clear – they were of the same kind, he and she, a sort of diabolic freemasonry subsisted between them. Henceforward, she knew, she had her power over him. Wherever they met, they would be secretly associated. And he would be helpless in the association with her. Her soul exulted.

'Good-bye! I'm so glad you forgive me. Gooood-bye!'

Hermione sang her farewell, and waved her hand. Gerald automatically took the oar and pushed off. But he was looking all the time, with a glimmering, subtly-smiling admiration in his eyes, at Gudrun, who stood on the shoal shaking the wet book in her hand. She turned away and ignored the receding boat. But Gerald looked back as he rowed, beholding her, forgetting what he was doing.

'Aren't we going too much to the left?' sang Hermione, as she sat ignored under her coloured parasol.

Gerald looked round without replying, the oars balanced and glancing in the sun.

'I think it's all right,' he said good-humouredly, beginning to row again without thinking of what he was doing. And Hermione disliked him extremely for his good-humoured obliviousness, she was nullified, she could not regain ascendancy.

CHAPTER XI

An Island

MEANWHILE Ursula had wandered on from Willey Water along the course of the bright little stream. The afternoon was full of larks' singing. On the bright hill-sides was a subdued smoulder of gorse. A few forget-me-nots flowered by the water. There was a rousedness and a glancing everywhere.

She strayed absorbedly on, over the brooks. She wanted to go to the mill-pond above. The big mill-house was deserted, save for a labourer and his wife who lived in the kitchen. So she passed through the empty farm-yard and through the wilderness of a garden, and mounted the bank by the sluice. When she got to the top, to see the old, velvety surface of the pond before her, she noticed a man on the bank, tinkering with a punt. It was Birkin sawing and hammering away.

She stood at the head of the sluice, looking at him. He was unaware of anybody's presence. He looked very busy, like a wild animal, active and intent. She felt she ought to go away, he would not want her. He seemed to be so much occupied. But she did not want to go away. Therefore she moved along the bank till he would look up.

Which he soon did. The moment he saw her, he dropped his tools and came torward, saying.

'How do you do? I'm making the punt water-tight. Tell me if you think it is right.'

She went along with him.

'You are your father's daughter, so you can tell me if it will do,' he said.

She bent to look at the patched punt.

'I am sure I am my father's daughter,' she said, fearful of having to judge. 'But I don't know anything about carpentry. It *looks* right, don't you think?'

'Yes, I think. I hope it won't let me to the bottom, that's all. Though even so, it isn't a great matter, I should come up again. Help me to get it into the water, will you?'

With combined efforts they turned over the heavy punt and set it afloat.

'Now,' he said, 'I'll try it and you can watch what happens. Then if it carries, I'll take you over to the island.'

'Do,' she cried, watching anxiously.

The pond was large, and had that perfect stillness and the dark lustre of very deep water. There were two small islands overgrown with bushes and a few trees, towards the middle. Birkin pushed himself off, and veered clumsily in the pond. Luckily the punt drifted so that he could catch hold of a willow bough, and pull it to the island.

'Rather overgrown,' he said, looking into the interior, 'but very nice. I'll come and fetch you. The boat leaks a little.'

In a moment he was with her again, and she stepped into the wet punt.

'It'll float us all right,' he said, and manoeuvred again to the island.

They landed under a willow tree. She shrank from the little jungle of rank plants before her, evil-smelling figwort and hemlock. But he explored into it.

'I shall mow this down,' he said, 'and then it will be romantic – like Paul et Virginie.'⁴³

'Yes, one could have lovely Watteau picnics here,' cried Ursula with enthusiasm.

His face darkened.

'I don't want Watteau⁴⁴ picnics here,' he said.

'Only your Virginie,' she laughed.

'Virginie enough,' he smiled wryly. 'No, I don't want her either.'

Ursula looked at him closely. She had not seen him since Breadalby. He was very thin and hollow, with a ghastly look in his face.

'You have been ill; haven't you?' she asked, rather repulsed.

'Yes,' he replied coldly.

They had sat down under the willow tree, and were looking at the pond, from their retreat on the island.

'Has it made you frightened?' she asked.

'What of?' he asked, turning his eyes to look at her. Something in him, inhuman and unmitigated, disturbed her, and shook her out of her ordinary self.

'It is frightening to be very ill, isn't it?' she said.

'It isn't pleasant,' he said. 'Whether one is really afraid of death, or not, I have never decided. In one mood, not a bit, in another, very much.'

'But doesn't it make you feel ashamed? I think it makes one so ashamed, to be ill – illness is so terribly humiliating, don't you think?'

He considered for some minutes.

'May-be,' he said. 'Though one knows all the time one's life isn't really right, at the source. That's the humiliation. I don't see that the illness counts so much, after that. One is ill because one doesn't live properly - can't. It's the failure to live that makes one ill, and humiliates one.'

'But do you fail to live?' she asked, almost jeering.

'Why yes – I don't make much of a success of my days. One seems always to be bumping one's nose against the blank wall ahead.'

Ursula laughed. She was frightened, and when she was frightened she always laughed and pretended to be jaunty.

'Your poor nose!' she said, looking at that feature of his face.

'No wonder it's ugly,' he replied.

She was silent for some minutes, struggling with her own selfdeception. It was an instinct in her, to deceive herself.

'But I'm happy - I think life is awfully jolly,' she said.

'Good,' he answered, with a certain cold indifference.

She reached for a bit of paper which had wrapped a small piece of chocolate she had found in her pocket, and began making a boat. He watched her without heeding her. There was something strangely pathetic and tender in her moving, unconscious finger-tips, that were agitated and hurt, really.

I do enjoy things - don't you?' she asked.

'Oh yes! But it infuriates me that I can't get right, at the really growing part of me. I feel all tangled and messed up, and I can't get

106

straight anyhow. I don't know what really to *do*. One must do something somewhere.'

'Why should you always be *doing?*' she retorted. 'It is so plebeian. I think it is much better to be really patrician, and to do nothing but just be oneself, like a walking flower.'

'I quite agree,' he said, 'if one has burst into blossom. But I can't get my flower to blossom anyhow. Either it is blighted in the bud, or has got the smother-fly, or it isn't nourished. Curse it, it isn't even a bud. It is a contravened knot.'

Again she laughed. He was so very fretful and exasperated. But she was anxious and puzzled. How was one to get out, anyhow. There must be a way out somewhere.

There was a silence, wherein she wanted to cry. She reached for another bit of chocolate paper, and began to fold another boat.

'And why is it,' she asked at length, 'that there is no flowering, no dignity of human life now?'

'The whole idea is dead. Humanity itself is dry-rotten, really. There are myriads of human beings hanging on the bush – and they look very nice and rosy, your healthy young men and women. But they are apples of Sodom,⁴⁵ as a matter of fact, Dead Sea Fruit, gall-apples. It isn't true that they have any significance – their insides are full of bitter, corrupt ash.'

'But there are good people,' protested Ursula.

'Good enough for the life of today. But mankind is a dead tree, covered with fine brilliant galls of people.'

Ursula could not help stiffening herself against this, it was too picturesque and final. But neither could she help making him go on.

'And if it is so, *wby* is it?' she asked, hostile. They were rousing each other to a fine passion of opposition.

'Why, why are people all balls of bitter dust? Because they won't fall off the tree when they're ripe. They hang on to their old positions when the position is over-past, till they become infested with little worms and dry-rot.'

There was a long pause. His voice had become hot and very sarcastic. Ursula was troubled and bewildered, they were both oblivious of everything but their own immersion.

'But even if everybody is wrong – where are you right?' she cried, 'where are you any better?'

'I? – I'm not right,' he cried back. 'At least my only rightness lies in the fact that I know it. I detest what I am, outwardly. I loathe myself as a human being. Humanity is a huge aggregate lie, and a huge lie is less than a small truth. Humanity is less, far less than the individual,

because the individual may sometimes be capable of truth, and humanity is a tree of lies. And they say that love is the greatest thing; they persist in *saying* this, the foul liars, and just look at what they do! Look at all the millions of people who repeat every minute that love is the greatest, and charity is the greatest – and see what they are doing all the time. By their works ye shall know them, for dirty liars and cowards, who daren't stand by their own actions, much less by their own words.'

'But,' said Ursula sadly, 'that doesn't alter the fact that love is the greatest, does it? What they *do* doesn't alter the truth of what they say, does it?'

'Completely, because if what they say *were* true, then they couldn't help fulfilling it. But they maintain a lie, and so they run amok at last. It's a lie to say that love is the greatest. You might as well say that hate is the greatest, since the opposite of everything balances. What people want is hate – hate and nothing but hate. And in the name of righteousness and love, they get it. They distil themselves with nitroglycerine, all the lot of them, out of very love. It's the lie that kills. If we want hate, let us have it – death, murder, torture, violent destruction – let us have it: but not in the name of love. But I abhor humanity, I wish it was swept away. It could go, and there would be no *absolute* loss, if every human being perished tomorrow. The reality would be untouched. Nay, it would be better. The real tree of life would then be rid of the most ghastly, heavy crop of Dead Sea Fruit, the intolerable burden of myriad simulacra of people, an infinite weight of mortal lies.'

'So you'd like everybody in the world destroyed?' said Ursula.

'I should indeed.'

'And the world empty of people?'

'Yes truly. You yourself, don't you find it a beautiful clean thought, a world empty of people, just uninterrupted grass, and a hare sitting up?'

The pleasant sincerity of his voice made Ursula pause to consider her own proposition. And really it *was* attractive: a clean, lovely, humanless world. It was the *really* desirable. Her heart hesitated, and exulted. But still, she was dissatisfied with *him*.

'But,' she objected, 'you'd be dead yourself, so what good would it do you?'

I would die like a shot, to know that the earth would really be cleaned of all the people. It is the most beautiful and freeing thought. Then there would *never* be another foul humanity created, for a universal defilement.'

'No,' said Ursula, 'there would be nothing.'

'What! Nothing? Just because humanity was wiped out? You flatter

yourself. There'd be everything.'

'But how, if there were no people?'

'Do you think that creation depends on *man*! It merely doesn't. There are the trees and the grass and birds. I much prefer to think of the lark rising up in the morning upon a human-less world. Man is a mistake, he must go. There is the grass, and hares and adders, and the unseen hosts, actual angels that go about freely when a dirty humanity doesn't interrupt them – and good pure-tissued demons: very nice.'

It pleased Ursula, what he said, pleased her very much, as a phantasy. Of course it was only a pleasant fancy. She herself knew too well the actuality of humanity, its hideous actuality. She knew it could not disappear so cleanly and conveniently. It had a long way to go yet, a long and hideous way. Her subtle, feminine, demoniacal soul knew it well.

'If only man was swept off the face of the earth, creation would go on so marvellously, with a new start, non-human. Man is one of the mistakes of creation – like the ichthyosauri. If only he were gone again, think what lovely things would come out of the liberated days; – things straight out of the fire.'

'But man will never be gone,' she said, with insidious, diabolical knowledge of the horrors of persistence. 'The world will go with him.'

'Ah no,' he answered, 'not so. I believe in the proud angels and the demons that are our fore-runners. They will destroy us, because we are not proud enough. The ichthyosauri were not proud: they crawled and floundered as we do. And besides, look at elder-flowers and bluebells – they are a sign that pure creation takes place – even the butterfly. But humanity never gets beyond the caterpillar stage – it rots in the chrysalis, it never will have wings. It is anti-creation, like monkeys and baboons.'

Ursula watched him as he talked. There seemed a certain impatient fury in him, all the while, and at the same time a great amusement in everything, and a final tolerance. And it was this tolerance she mistrusted, not the fury. She saw that, all the while, in spite of himself, he would have to be trying to save the world. And this knowledge, whilst it comforted her heart somewhere with a little self-satisfaction, stability, yet filled her with a certain sharp contempt and hate of him. She wanted him to herself, she hated the Salvator Mundi⁴⁶ touch. It was something diffuse and generalised about him, which she could not stand. He would behave in the same way, say the same things, give himself as completely to anybody who came along, anybody and everybody who liked to appeal to him. It was despicable, a very insidious form of prostitution.

'But,' she said, 'you believe in individual love, even if you don't

believe in loving humanity -?'

'I don't believe in love at all – that is, any more than I believe in hate, or in grief. Love is one of the emotions like all the others – and so it is all right whilst you feel it But I can't see how it becomes an absolute. It is just part of human relationships, no more. And it is only part of *any* human relationship. And why one should be required *always* to feel it, any more than one always feels sorrow or distant joy, I cannot conceive. Love isn't a desideratum – it is an emotion you feel or you don't feel, according to circumstance.'

'Then why do you care about people at all?' she asked, 'if you don't believe in love? Why do you bother about humanity?'

'Why do I? Because I can't get away from it.'

'Because you love it,' she persisted.

It irritated him.

'If I do love it,' he said, 'it is my disease.'

'But it is a disease you don't want to be cured of,' she said, with some cold sneering.

He was silent now, feeling she wanted to insult him.

'And if you don't believe in love, what *do* you believe in?' she asked mocking. 'Simply in the end of the world, and grass?'

He was beginning to feel a fool.

'I believe in the unseen hosts,' he said.

'And nothing else? You believe in nothing visible, except grass and birds? Your world is a poor show.'

'Perhaps it is,' he said, cool and superior now he was offended, assuming a certain insufferable aloof superiority, and withdrawing into his distance.

Ursula disliked him. But also she felt she had lost something. She looked at him as he sat crouched on the bank. There was a certain priggish Sunday-school stiffness over him, priggish and detestable. And yet, at the same time, the moulding of him was so quick and attractive, it gave such a great sense of freedom: the moulding of his brows, his chin, his whole physique, something so alive, somewhere, in spite of the look of sickness.

And it was this duality in feeling which he created in her, that made a fine hate of him quicken in her bowels. There was his wonderful, desirable life-rapidity, the rare quality of an utterly desirable man: and there was at the same time this ridiculous, mean effacement into a Salvator Mundi and a Sunday-school teacher, a prig of the stiffest type.

He looked up at her. He saw her face strangely enkindled, as if suffused from within by a powerful sweet fire. His soul was arrested in wonder. She was enkindled in her own living fire. Arrested in wonder

IIO

and in pure, perfect attraction, he moved towards her. She sat like a strange queen, almost supernatural in her glowing smiling richness.

'The point about love,' he said, his consciousness quickly adjusting itself, 'is that we hate the word because we have vulgarised it. It ought to be proscribed, tabooed from utterance, for many years, till we get a new, better idea.'

There was a beam of understanding between them.

'But it always means the same thing,' she said.

'Ah God, no, let it not mean that any more,' he cried. 'Let the old meanings go.'

'But still it is love,' she persisted. A strange, wicked yellow light shone at him in her eyes.

He hesitated, baffled, withdrawing.

'No,' he said, 'it isn't. Spoken like that, never in the world. You've no business to utter the word.'

'I must leave it to you, to take it out of the Ark of the Covenant⁴⁷ at the right moment,' she mocked.

Again they looked at each other. She suddenly sprang up, turned her back to him, and walked away. He too rose slowly and went to the water's edge, where, crouching, he began to amuse himself unconsciously. Picking a daisy he dropped it on the pond, so that the stem was a keel, the flower floated like a little water lily, staring with its open face up to the sky. It turned slowly round, in a slow, slow Dervish dance, as it veered away.

He watched it, then dropped another daisy into the water, and after that another, and sat watching them with bright, absolved eyes, crouching near on the bank. Ursula turned to look. A strange feeling possessed her, as if something were taking place. But it was all intangible. And some sort of control was being put on her. She could not know. She could only watch the brilliant little discs of the daisies veering slowly in travel on the dark, lustrous water. The little flotilla was drifting into the light, a company of white specks in the distance.

'Do let us go to the shore, to follow them,' she said, afraid of being any longer imprisoned on the island. And they pushed off in the punt.

She was glad to be on the free land again. She went along the bank towards the sluice. The daisies were scattered broadcast on the pond, tiny radiant things, like an exaltation, points of exaltation here and there. Why did they move her so strongly and mystically?

'Look,' he said, 'your boat of purple paper is escorting them, and they are a convoy of rafts.'

Some of the daisies came slowly towards her, hesitating, making a shy bright little cotillion on the dark clear water. Their gay bright candour

moved her so much as they came near, that she was almost in tears.

'Why are they so lovely,' she cried. 'Why do I think them so lovely?'

'They are nice flowers,' he said, her emotional tones putting a constraint on him.

'You know that a daisy is a company of florets, a concourse, become individual. Don't the botanists put it highest in the line of development? I believe they do.'

'The compositæ, yes, I think so,' said Ursula, who was never very sure of anything. Things she knew perfectly well, at one moment, seemed to become doubtful the next.

'Explain it so, then,' he said. 'The daisy is a perfect little democracy, so it's the highest of flowers, hence its charm.'

'No,' she cried, 'no - never. It isn't democratic.'

'No,' he admitted. 'It's the golden mob of the proletariat, surrounded by a showy white fence of the idle rich.'

'How hateful - your hateful social orders!' she cried.

'Quite! It's a daisy - we'll leave it alone.'

'Do. Let it be a dark horse for once,' she said: 'if anything can be a dark horse to you,' she added satirically.

They stood aside, forgetful. As if a little stunned, they both were motionless, barely conscious. The little conflict into which they had fallen had torn their consciousness and left them like two impersonal forces, there in contact.

He became aware of the lapse. He wanted to say something, to get on to a new more ordinary footing.

'You know,' he said, 'that I am having rooms here at the mill? Don't you think we can have some good times?'

'Oh are you?' she said, ignoring all his implication of admitted intimacy.

He adjusted himself at once, became normally distant.

'If I find I can live sufficiently by myself,' he continued, 'I shall give up my work altogether. It has become dead to me. I don't believe in the humanity I pretend to be part of, I don't care a straw for the social ideals I live by, I hate the dying organic form of social mankind – so it can't be anything but trumpery, to work at education. I shall drop it as soon as I am clear enough – tomorrow perhaps – and be by myself.'

'Have you enough to live on?' asked Ursula.

'Yes - I've about four hundred a year. That makes it easy for me.'

There was a pause.

'And what about Hermione?' asked Ursula.

'That's over, finally - a pure failure, and never could have been anything else.'

II2

'But you still know each other?'

'We could hardly pretend to be strangers, could we?'

There was a stubborn pause.

'But isn't that a half-measure?' asked Ursula at length.

'I don't think so,' he said. 'You'll be able to tell me if it is.'

Again there was a pause of some minutes' duration. He was thinking. 'One must throw everything away, everything – let everything go, to get the one last thing one wants,' he said.

'What thing?' she asked in challenge.

'I don't know - freedom together,' he said.

She had wanted him to say 'love.'

There was heard a loud barking of the dogs below. He seemed disturbed by it. She did not notice. Only she thought he seemed uneasy.

'As a matter of fact,' he said, in rather a small voice, 'I believe that is Hermione come now, with Gerald Crich. She wanted to see the rooms before they are furnished.'

'I know,' said Ursula. 'She will superintend the furnishing for you.' 'Probably. Does it matter?'

'Oh no, I should think not,' said Ursula. 'Though personally, I can't bear her. I think she is a lie, if you like, you who are always talking about lies.' Then she ruminated for a moment, when she broke out: 'Yes, and I do mind if she furnishes your rooms – I do mind. I mind that you keep her hanging on at all.'

He was silent now, frowning.

'Perhaps,' he said. 'I don't *want* her to furnish the rooms here – and I don't keep her hanging on. Only, I needn't be churlish to her, need I? At any rate, I shall have to go down and see them now. You'll come, won't you?'

'I don't think so,' she said coldly and irresolutely.

'Won't you? Yes do. Come and see the rooms as well. Do come.'

CHAPTER XII

Carpeting

HE SET OFF down the bank, and she went unwillingly with him. Yet she would not have stayed away, either.

'We know each other well, you and I, already,' he said. She did not answer.

In the large darkish kitchen of the mill, the labourer's wife was

talking shrilly to Hermione and Gerald, who stood, he in white and she in a glistening bluish foulard, strangely luminous in the dusk of the room; whilst from the cages on the walls, a dozen or more canaries sang at the top of their voices. The cages were all placed round a small square window at the back, where the sunshine came in, a beautiful beam, filtering through green leaves of a tree. The voice of Mrs Salmon shrilled against the noise of the birds, which rose ever more wild and triumphant, and the woman's voice went up and up against them, and the birds replied with wild animation.

'Here's Rupert!' shouted Gerald in the midst of the din. He was suffering badly, being very sensitive in the ear.

'O-o-h them birds, they won't let you speak - !' shrilled the labourer's wife in disgust. 'I'll cover them up.'

And she darted here and there, throwing a duster, an apron, a towel, a table-cloth over the cages of the birds.

'Now will you stop it, and let a body speak for your row,' she said, still in a voice that was too high.

The party watched her. Soon the cages were covered, they had a strange funereal look. But from under the towels odd defiant trills and bubblings still shook out.

'Oh, they won't go on,' said Mrs Salmon reassuringly. 'They'll go to sleep now.'

'Really,' said Hermione, politely.

'They will,' said Gerald. 'They will go to sleep automatically, now the impression of evening is produced.'

'Are they so easily deceived?' cried Ursula.

'Oh, yes,' replied Gerald. 'Don't you know the story of Fabre,⁴⁸ who, when he was a boy, put a hen's head under her wing, and she straight away went to sleep? It's quite true.'

'And did that make him a naturalist?' asked Birkin.

'Probably,' said Gerald.

Meanwhile Ursula was peeping under one of the cloths. There sat the canary in a corner, bunched and fluffed up for sleep.

'How ridiculous!' she cried. 'It really thinks the night has come! How absurd! Really, how can one have any respect for a creature that is so easily taken in!'

'Yes,' sang Hermione, coming also to look. She put her hand on Ursula's arm and chuckled a low laugh. 'Yes, doesn't he look comical?' she chuckled. 'Like a stupid husband.'

Then, with her hand still on Ursula's arm, she drew her away, saying, in her mild sing-song:

'How did you come here? We saw Gudrun too.'

114

'I came to look at the pond,' said Ursula, 'and I found Mr Birkin there.'

'Did you? This is quite a Brangwen land, isn't it!'

'I'm afraid I hoped so,' said Ursula. 'I ran here for refuge, when I saw you down the lake, just putting off.'

'Did you! And now we've run you to earth.'

Hermione's eyelids lifted with an uncanny movement, amused but overwrought. She had always her strange, rapt look, unnatural and irresponsible.

'I was going on,' said Ursula. 'Mr Birkin wanted me to see the rooms. Isn't it delightful to live here? It is perfect.'

'Yes,' said Hermione, abstractedly. Then she turned right away from Ursula, ceased to know her existence.

'How do you feel, Rupert?' she sang in a new, affectionate tone, to Birkin.

'Very well,' he replied.

'Were you quite comfortable?' The curious, sinister, rapt look was on Hermione's face, she shrugged her bosom in a convulsed movement, and seemed like one half in a trance.

'Quite comfortable,' he replied.

There was a long pause, whilst Hermione looked at him for a long time, from under her heavy, drugged eyelids.

'And you think you'll be happy here?' she said at last.

'I'm sure I shall.'

'I'm sure I shall do anything for him as I can,' said the labourer's wife. 'And I'm sure our master will; so I *bope* he'll find himself comfortable.'

Hermione turned and looked at her slowly.

'Thank you so much,' she said, and then she turned completely away again. She recovered her position, and lifting her face towards him, and addressing him exclusively, she said:

'Have you measured the rooms?'

'No,' he said, 'I've been mending the punt.'

'Shall we do it now?' she said slowly, balanced and dispassionate.

'Have you got a tape measure, Mrs Salmon?' he said, turning to the woman.

'Yes sir, I think I can find one,' replied the woman, bustling immediately to a basket. 'This is the only one I've got, if it will do.'

Hermione took it, though it was offered to him.

'Thank you so much,' she said. 'It will do very nicely. Thank you so much.' Then she turned to Birkin, saying with a little gay movement: 'Shall we do it now, Rupert?'

'What about the others, they'll be bored,' he said reluctantly.

'Do you mind?' said Hermione, turning to Ursula and Gerald vaguely.

'Not in the least,' they replied.

'Which room shall we do first?' she said, turning again to Birkin, with the same gaiety, now she was going to *do* something with him.

'We'll take them as they come,' he said.

'Should I be getting your teas ready, while you do that?' said the labourer's wife, also gay because *she* had something to do.

'Would you?' said Hermione, turning to her with the curious motion of intimacy that seemed to envelop the woman, draw her almost to Hermione's breast, and which left the others standing apart. 'I should be so glad. Where shall we have it?'

'Where would you like it? Shall it be in here, or out on the grass?'

'Where shall we have tea?' sang Hermione to the company at large.

'On the bank by the pond. And we'll carry the things up, if you'll just get them ready, Mrs Salmon,' said Birkin.

'All right,' said the pleased woman.

The party moved down the passage into the front room. It was empty, but clean and sunny. There was a window looking on to the tangled front garden.

'This is the dining room,' said Hermione. 'We'll measure it this way, Rupert – you go down there – '

'Can't I do it for you,' said Gerald, coming to take the end of the tape.

'No, thank you,' cried Hermione, stooping to the ground in her bluish, brilliant foulard. It was a great joy to her to *do* things, and to have the ordering of the job, with Birkin. He obeyed her subduedly. Ursula and Gerald looked on. It was a peculiarity of Hermione's, that at every moment, she had one intimate, and turned all the rest of those present into onlookers. This raised her into a state of triumph.

They measured and discussed in the dining-room, and Hermione decided what the floor coverings must be. It sent her into a strange, convulsed anger, to be thwarted. Birkin always let her have her way, for the moment.

Then they moved across, through the hall, to the other front room, that was a little smaller than the first.

'This is the study,' said Hermione. 'Rupert, I have a rug that I want you to have for here. Will you let me give it to you? Do - I want to give it you.'

'What is it like?' he asked ungraciously.

'You haven't seen it. It is chiefly rose red, then blue, a metallic, mid-

blue, and a very soft dark blue. I think you would like it. Do you think you would?'

'It sounds very nice,' he replied. 'What is it? Oriental? With a pile?'

'Yes. Persian! It is made of camel's hair, silky. I think it is called Bergamos – twelve feet by seven – . Do you think it will do?'

'It would do,' he said. 'But why should you give me an expensive rug? I can manage perfectly well with my old Oxford Turkish.'

'But may I give it to you? Do let me.'

'How much did it cost?'

She looked at him, and said:

'I don't remember. It was quite cheap.'

He looked at her, his face set.

'I don't want to take it, Hermione,' he said.

'Do let me give it to the rooms,' she said, going up to him and putting her hand on his arm lightly, pleadingly. 'I shall be so disappointed.'

'You know I don't want you to give me things,' he repeated helplessly.

'I don't want to give you *things*,' she said teasingly. 'But will you have this?'

'All right,' he said, defeated, and she triumphed.

They went upstairs. There were two bedrooms to correspond with the rooms downstairs. One of them was half furnished, and Birkin had evidently slept there. Hermione went round the room carefully, taking in every detail, as if absorbing the evidence of his presence, in all the inanimate things. She felt the bed and examined the coverings.

'Are you sure you were quite comfortable?' she said, pressing the pillow.

'Perfectly,' he replied coldly.

'And were you warm? There is no down quilt. I am sure you need one. You mustn't have a great pressure of clothes.'

'I've got one,' he said. 'It is coming down.'

They measured the rooms, and lingered over every consideration. Ursula stood at the window and watched the woman carrying the tea up the bank to the pond. She hated the palaver Hermione made, she wanted to drink tea, she wanted anything but this fuss and business.

At last they all mounted the grassy bank, to the picnic. Hermione poured out tea. She ignored now Ursula's presence. And Ursula, recovering from her ill-humour, turned to Gerald saying:

'Oh, I hated you so much the other day, Mr Crich.'

'What for?' said Gerald, wincing slightly away.

'For treating your horse so badly. Oh, I hated you so much!'

'What did he do?' sang Hermione.

'He made his lovely sensitive Arab horse stand with him at the railway-crossing whilst a horrible lot of trucks went by; and the poor thing, she was in a perfect frenzy, a perfect agony. It was the most horrible sight you can imagine.'

'Why did you do it, Gerald?' asked Hermione, calm and interrogative. 'She must learn to stand – what use is she to me in this country, if she shies and goes off every time an engine whistles.'

'But why inflict unnecessary torture?' said Ursula. 'Why make her stand all that time at the crossing? You might just as well have ridden back up the road, and saved all that horror. Her sides were bleeding where you had spurred her. It was too horrible -!'

Gerald stiffened.

'I have to use her,' he replied. 'And if I'm going to be sure of her at *all*, she'll have to learn to stand noises.'

'Why should she?' cried Ursula in a passion. 'She is a living creature, why should she stand anything, just because you choose to make her? She has as much right to her own being, as you have to yours.'

'There I disagree,' said Gerald. 'I consider that mare is there for my use. Not because I bought her, but because that is the natural order. It is more natural for a man to take a horse and use it as he likes, than for him to go down on his knees to it, begging it to do as it wishes, and to fulfil its own marvellous nature.'

Ursula was just breaking out, when Hermione lifted her face and began, in her musing sing-song:

I do think – I do really think we must have the *courage* to use the lower animal life for our needs. I do think there is something wrong, when we look on every living creature as if it were ourselves. I do feel, that it is false to project our own feelings on every animate creature. It is a lack of discrimination, a lack of criticism.'

'Quite,' said Birkin sharply. 'Nothing is so detestable as the maudlin attributing of human feelings and consciousness to animals.'

'Yes,' said Hermione, wearily, 'we must really take a position. Either we are going to use the animals, or they will use us.'

'That's a fact,' said Gerald. 'A horse has got a will like a man, though it has no *mind* strictly. And if your will isn't master, then the horse is master of you. And this is a thing I can't help. I can't help being master of the horse.'

'If only we could learn how to use our will,' said Hermione, 'we could do anything. The will can cure anything, and put anything right. That I am convinced of – if only we use the will properly, intelligibly.'

'What do you mean by using the will properly?' said Birkin.

'A very great doctor taught me,' she said, addressing Ursula and Gerald vaguely. 'He told me for instance, that to cure oneself of a bad habit, one should *force* oneself to do it, when one would not do it – make oneself do it – and then the habit would disappear.'

'How do you mean?' said Gerald.

'If you bite your nails, for example. Then, when you don't want to bite your nails, bite them, make yourself bite them. And you would find the habit was broken.'

'Is that so?' said Gerald.

'Yes. And in so many things, I have *made* myself well. I was a very queer and nervous girl. And by learning to use my will, simply by using my will, I *made* myself right.'

Ursula looked all the while at Hermione, as she spoke in her slow, dispassionate, and yet strangely tense voice. A curious thrill went over the younger woman. Some strange, dark, convulsive power was in Hermione, fascinating and repelling.

'It is fatal to use the will like that,' cried Birkin harshly, 'disgusting. Such a will is an obscenity.'

Hermione looked at him for a long time, with her shadowed, heavy eyes. Her face was soft and pale and thin, almost phosphorescent, her jaw was lean.

'I'm sure it isn't,' she said at length. There always seemed an interval, a strange split between what she seemed to feel and experience, and what she actually said and thought. She seemed to catch her thoughts at length from off the surface of a maelstrom of chaotic black emotions and reactions, and Birkin was always filled with repulsion, she caught so infallibly, her will never failed her. Her voice was always dispassionate and tense, and perfectly confident. Yet she shuddered with a sense of nausea, a sort of seasickness that always threatened to overwhelm her mind. But her mind remained unbroken, her will was still perfect. It almost sent Birkin mad. But he would never, never dare to break her will, and let loose the maelstrom of her subconsciousness, and see her in her ultimate madness. Yet he was always striking at her.

'And of course,' he said to Gerald, 'horses *haven't* got a complete will, like human beings. A horse has no *one* will. Every horse, strictly, has two wills. With one will, it wants to put itself in the human power completely – and with the other, it wants to be free, wild. The two wills sometimes lock – you know that, if ever you've felt a horse bolt, while you've been driving it.'

'I have felt a horse bolt while I was driving it,' said Gerald, 'but it didn't make me know it had two wills. I only knew it was frightened.'

Hermione had ceased to listen. She simply became oblivious when

these subjects were started.

'Why should a horse want to put itself in the human power?' asked Ursula. 'That is quite incomprehensible to me. I don't believe it ever wanted it.'

'Yes it did. It's the last, perhaps highest, love-impulse: resign your will to the higher being,' said Birkin.

'What curious notions you have of love,' jeered Ursula.

'And woman is the same as horses: two wills act in opposition inside her. With one will, she wants to subject herself utterly. With the other she wants to bolt, and pitch her rider to perdition.'

'Then I'm a bolter,' said Ursula, with a burst of laughter.

'It's a dangerous thing to domesticate even horses, let alone women,' said Birkin. 'The dominant principle has some rare antagonists.'

'Good thing too,' said Ursula.

'Quite,' said Gerald, with a faint smile. 'There's more fun.'

Hermione could bear no more. She rose, saying in her easy singsong:

'Isn't the evening beautiful! I get filled sometimes with such a great sense of beauty, that I feel I can hardly bear it.'

Ursula, to whom she had appealed, rose with her, moved to the last impersonal depths. And Birkin seemed to her almost a monster of hateful arrogance. She went with Hermione along the bank of the pond, talking of beautiful, soothing things, picking the gentle cowslips.

'Wouldn't you like a dress,' said Ursula to Hermione, 'of this yellow spotted with orange – a cotton dress?'

'Yes,' said Hermione, stopping and looking at the flower, letting the thought come home to her and soothe her. 'Wouldn't it be pretty? I should *love* it.'

And she turned smiling to Ursula, in a feeling of real affection.

But Gerald remained with Birkin, wanting to probe him to the bottom, to know what he meant by the dual will in horses. A flicker of excitement danced on Gerald's face.

Hermione and Ursula strayed on together, united in a sudden bond of deep affection and closeness.

'I really do not want to be forced into all this criticism and analysis of life. I really *do* want to see things in their entirety, with their beauty left to them, and their wholeness, their natural holiness. Don't you feel it, don't you feel you *can't* be tortured into any more knowledge?' said Hermione, stopping in front of Ursula, and turning to her with clenched fists thrust downwards.

'Yes,' said Ursula. 'I do. I am sick of all this poking and prying.'

'I'm so glad you are. Sometimes,' said Hermione, again stopping

arrested in her progress and turning to Ursula, 'sometimes I wonder if I *ought* to submit to all this realisation, if I am not being weak in rejecting it. But I feel I *can't* – *I can't*. It seems to destroy *everything*. All the beauty and the – and the true holiness is destroyed – and I feel I can't live without them.'

'And it would be simply wrong to live without them,' cried Ursula. 'No, it is so *irreverent* to think that everything must be realised in the head. Really, something must be left to the Lord, there always is and always will be.'

'Yes,' said Hermione, reassured like a child, 'it should, shouldn't it? And Rupert – ' she lifted her face to the sky, in a muse – 'he *can* only tear things to pieces. He really *is* like a boy who must pull everything to pieces to see how it is made. And I can't think it is right – it does seem so irreverent, as you say.'

'Like tearing open a bud to see what the flower will be like,' said Ursula.

'Yes. And that kills everything, doesn't it? It doesn't allow any possibility of flowering.'

'Of course not,' said Ursula. 'It is purely destructive.'

'It is, isn't it!'

Hermione looked long and slow at Ursula, seeming to accept confirmation from her. Then the two women were silent. As soon as they were in accord, they began mutually to mistrust each other. In spite of herself, Ursula felt herself recoiling from Hermione. It was all she could do to restrain her revulsion.

They returned to the men, like two conspirators who have withdrawn to come to an agreement. Birkin looked up at them. Ursula hated him for his cold watchfulness. But he said nothing.

'Shall we be going?' said Hermione. 'Rupert, you are coming to Shortlands to dinner? Will you come at once, will you come now, with us?'

'I'm not dressed,' replied Birkin. 'And you know Gerald stickles for convention.'

'I don't stickle for it,' said Gerald. 'But if you'd got as sick as I have of rowdy go-as-you-please in the house, you'd prefer it if people were peaceful and conventional, at least at meals.'

'All right,' said Birkin.

'But can't we wait for you while you dress?' persisted Hermione. 'If you like.'

He rose to go indoors. Ursula said she would take her leave.

'Only,' she said, turning to Gerald, 'I must say that, however man is lord of the beast and the fowl, I still don't think he has any right to

violate the feelings of the inferior creation. I still think it would have been much more sensible and nice of you if you'd trotted back up the road while the train went by, and been considerate.'

'I see,' said Gerald, smiling, but somewhat annoyed. 'I must remember another time.'

'They all think I'm an interfering female,' thought Ursula to herself, as she went away. But she was in arms against them.

She ran home plunged in thought. She had been very much moved by Hermione, she had really come into contact with her, so that there was a sort of league between the two women. And yet she could not bear her. But she put the thought away. 'She's really good,' she said to herself. 'She really wants what is right.' And she tried to feel at one with Hermione, and to shut off from Birkin. She was strictly hostile to him. But she was held to him by some bond, some deep principle. This at once irritated her and saved her.

Only now and again, violent little shudders would come over her, out of her subconsciousness, and she knew it was the fact that she had stated her challenge to Birkin, and he had, consciously or unconsciously, accepted. It was a fight to the death between them – or to new life: though in what the conflict lay, no one could say.

CHAPTER XIII

Mino

THE DAYS went by, and she received no sign. Was he going to ignore her, was he going to take no further notice of her secret? A dreary weight of anxiety and acrid bitterness settled on her. And yet Ursula knew she was only deceiving herself, and that he would proceed. She said no word to anybody.

Then, sure enough, there came a note from him, asking if she would come to tea with Gudrun, to his rooms in town.

'Why does he ask Gudrun as well?' she asked herself at once. 'Does he want to protect himself, or does he think I would not go alone?'

She was tormented by the thought that he wanted to protect himself. But at the end of all, she only said to herself:

'I don't want Gudrun to be there, because I want him to say something more to me. So I shan't tell Gudrun anything about it, and I shall go alone. Then I shall know.'

She found herself sitting on the tram-car, mounting up the hill going out of the town, to the place where he had his lodging. She seemed to

122

have passed into a kind of dream world, absolved from the conditions of actuality. She watched the sordid streets of the town go by beneath her, as if she were a spirit disconnected from the material universe. What had it all to do with her? She was palpitating and formless within the flux of the ghost life. She could not consider any more, what anybody would say of her or think about her. People had passed out of her range, she was absolved. She had fallen strange and dim, out of the sheath of the material life, as a berry falls from the only world it has ever known, down out of the sheath on to the real unknown.

Birkin was standing in the middle of the room, when she was shown in by the landlady. He too was moved outside himself. She saw him agitated and shaken, a frail, unsubstantial body silent like the node of some violent force, that came out from him and shook her almost into a swoon.

'You are alone?' he said.

'Yes - Gudrun could not come.'

He instantly guessed why.

And they were both seated in silence, in the terrible tension of the room. She was aware that it was a pleasant room, full of light and very restful in its form – aware also of a fuchsia tree, with dangling scarlet and purple flowers.

'How nice the fuchsias are!' she said, to break the silence.

'Aren't they! Did you think I had forgotten what I said?'

A swoon went over Ursula's mind.

'I don't want you to remember it - if you don't want to,' she struggled to say, through the dark mist that covered her.

There was silence for some moments.

'No,' he said. 'It isn't that. Only – if we are going to know each other, we must pledge ourselves for ever. If we are going to make a relationship, even of friendship, there must be something final and infallible about it.'

There was a clang of mistrust and almost anger in his voice. She did not answer. Her heart was too much contracted. She could not have spoken.

Seeing she was not going to reply, he continued, almost bitterly, giving himself away:

'I can't say it is love I have to offer – and it isn't love I want. It is something much more impersonal and harder – and rarer.'

There was a silence, out of which she said:

'You mean you don't love me?'

She suffered furiously, saying that.

Yes, if you like to put it like that. Though perhaps that isn't true. I

don't know. At any rate, I don't feel the emotion of love for you - no, and I don't want to. Because it gives out in the last issues.'

'Love gives out in the last issues?' she asked, feeling numb to the lips.

'Yes, it does. At the very last, one is alone, beyond the influence of love. There is a real impersonal me, that is beyond love, beyond any emotional relationship. So it is with you. But we want to delude ourselves that love is the root. It isn't. It is only the branches. The root is beyond love, a naked kind of isolation, an isolated me, that does *not* meet and mingle, and never can.'

She watched him with wide, troubled eyes. His face was incandescent in its abstract earnestness.

'And you mean you can't love?' she asked, in trepidation.

'Yes, if you like. I have loved. But there is a beyond, where there is not love.'

She could not submit to this. She felt it swooning over her. But she could not submit.

'But how do you know - if you have never really loved?' she asked.

'It is true, what I say; there is a beyond, in you, in me, which is further than love, beyond the scope, as stars are beyond the scope of vision, some of them.'

'Then there is no love,' cried Ursula.

'Ultimately, no, there is something else. But, ultimately, there is no love.'

Ursula was given over to this statement for some moments. Then she half rose from her chair, saying, in a final, repellent voice:

"Then let me go home - what am I doing here?"

'There is the door,' he said. 'You are a free agent.'

He was suspended finely and perfectly in this extremity. She hung motionless for some seconds, then she sat down again.

'If there is no love, what is there?' she cried, almost jeering.

'Something,' he said, looking at her, battling with his soul, with all his might.

'What?'

He was silent for a long time, unable to be in communication with her while she was in this state of opposition.

'There is,' he said, in a voice of pure abstraction; 'a final me which is stark and impersonal and beyond responsibility. So there is a final you. And it is there I would want to meet you – not in the emotional, loving plane – but there beyond, where there is no speech and no terms of agreement. There we are two stark, unknown beings, two utterly strange creatures, I would want to approach you, and you me. And there could be no obligation, because there is no standard for action

124

there, because no understanding has been reaped from that plane. It is quite inhuman, – so there can be no calling to book, in any form whatsoever – because one is outside the pale of all that is accepted, and nothing known applies. One can only follow the impulse, taking that which lies in front, and responsible for nothing, asked for nothing, giving nothing, only each taking according to the primal desire.'

Ursula listened to this speech, her mind dumb and almost senseless, what he said was so unexpected and so untoward.

'It is just purely selfish,' she said.

'If it is pure, yes. But it isn't selfish at all. Because I don't *know* what I want of you. I deliver *myself* over to the unknown, in coming to you, I am without reserves or defences, stripped entirely, into the unknown. Only there needs the pledge between us, that we will both cast off everything, cast off ourselves even, and cease to be, so that that which is perfectly ourselves can take place in us.'

She pondered along her own line of thought.

'But it is because you love me, that you want me?' she persisted.

'No it isn't. It is because I believe in you - if I do believe in you.'

'Aren't you sure?' she laughed, suddenly hurt.

He was looking at her steadfastly, scarcely heeding what she said.

'Yes, I must believe in you, or else I shouldn't be here saying this,' he replied. 'But that is all the proof I have. I don't feel any very strong belief at this particular moment.'

She disliked him for this sudden relapse into weariness and faithlessness.

'But don't you think me good-looking?' she persisted, in a mocking voice.

He looked at her, to see if he felt that she was good-looking.

'I don't feel that you're good-looking,' he said.

'Not even attractive?' she mocked, bitingly.

He knitted his brows in sudden exasperation.

'Don't you see that it's not a question of visual appreciation in the least,' he cried. 'I don't *want* to see you. I've seen plenty of women, I'm sick and weary of seeing them. I want a woman I don't see.'

'I'm sorry I can't oblige you by being invisible,' she laughed.

'Yes,' he said, 'you are invisible to me, if you don't force me to be visually aware of you. But I don't want to see you or hear you.'

'What did you ask me to tea for, then?' she mocked.

But he would take no notice of her. He was talking to himself.

'I want to find you, where you don't know your own existence, the you that your common self denies utterly. But I don't want your good looks, and I don't want your womanly feelings, and I don't want your thoughts nor opinions nor your ideas – they are all bagatelles to me.'

191.0

'You are very conceited, Monsieur,' she mocked. 'How do you know what my womanly feelings are, or my thoughts or my ideas? You don't even know what I think of you now.'

'Nor do I care in the slightest.'

'I think you are very silly. I think you want to tell me you love me, and you go all this way round to do it.'

'All right,' he said, looking up with sudden exasperation. 'Now go away then, and leave me alone. I don't want any more of your meretricious persiflage.'

'Is it really persiflage?' she mocked, her face really relaxing into laughter. She interpreted it, that he had made a deep confession of love to her. But he was so absurd in his words, also.

They were silent for many minutes, she was pleased and elated like a child. His concentration broke, he began to look at her simply and naturally.

'What I want is a strange conjunction with you - ' he said quietly; 'not meeting and mingling - you are quite right - but an equilibrium, a pure balance of two single beings - as the stars balance each other.'

She looked at him. He was very earnest, and earnestness was always rather ridiculous, commonplace, to her. It made her feel unfree and uncomfortable. Yet she liked him so much. But why drag in the stars.

'Isn't this rather sudden?' she mocked.

He began to laugh.

'Best to read the terms of the contract, before we sign,' he said.

A young grey cat that had been sleeping on the sofa jumped down and stretched, rising on its long legs, and arching its slim back. Then it sat considering for a moment, erect and kingly. And then, like a dart, it had shot out of the room, through the open window-doors, and into the garden.

'What's he after?' said Birkin, rising.

The young cat trotted lordly down the path, waving his tail. He was an ordinary tabby with white paws, a slender young gentleman. A crouching, fluffy, brownish-grey cat was stealing up the side of the fence. The Mino walked statelily up to her, with manly nonchalance. She crouched before him and pressed herself on the ground in humility, a fluffy soft outcast, looking up at him with wild eyes that were green and lovely as great jewels. He looked casually down on her. So she crept a few inches further, proceeding on her way to the back door, crouching in a wonderful, soft, self-obliterating manner, and moving like a shadow.

He, going statelily on his slim legs, walked after her, then suddenly, for pure excess, he gave her a light cuff with his paw on the side of her face. She ran off a few steps, like a blown leaf along the ground, then crouched unobtrusively, in submissive, wild patience. The Mino pretended to take no notice of her. He blinked his eyes superbly at the landscape. In a minute she drew herself together and moved softly, a fleecy brown-grey shadow, a few paces forward. She began to quicken her pace, in a moment she would be gone like a dream, when the young grey lord sprang before her, and gave her a light handsome cuff. She subsided at once, submissively.

'She is a wild cat,' said Birkin. 'She has come in from the woods.'

The eyes of the stray cat flared round for a moment, like great green fires staring at Birkin. Then she had rushed in a soft swift rush, half way down the garden. There she paused to look round. The Mino turned his face in pure superiority to his master, and slowly closed his eyes, standing in statuesque young perfection. The wild cat's round, green, wondering eyes were staring all the while like uncanny fires. Then again, like a shadow, she slid towards the kitchen.

In a lovely springing leap, like a wind, the Mino was upon her, and had boxed her twice, very definitely, with a white, delicate fist. She sank and slid back, unquestioning. He walked after her, and cuffed her once or twice, leisurely, with sudden little blows of his magic white paws.

'Now why does he do that?' cried Ursula in indignation.

'They are on intimate terms,' said Birkin.

'And is that why he hits her?'

'Yes,' laughed Birkin, 'I think he wants to make it quite obvious to her.'

'Isn't it horrid of him!' she cried; and going out into the garden she called to the Mino:

'Stop it, don't bully. Stop hitting her.'

The stray cat vanished like a swift, invisible shadow. The Mino glanced at Ursula, then looked from her disdainfully to his master.

'Are you a bully, Mino?' Birkin asked.

The young slim cat looked at him, and slowly narrowed its eyes. Then it glanced away at the landscape, looking into the distance as if completely oblivious of the two human beings.

'Mino,' said Ursula, 'I don't like you. You are a bully like all males.'

'No,' said Birkin, 'he is justified. He is not a bully. He is only insisting to the poor stray that she shall acknowledge him as a sort of fate, her own fate: because you can see she is fluffy and promiscuous as the wind. I am with him entirely. He wants superfine stability.'

'Yes, I know!' cried Ursula. 'He wants his own way - I know what your fine words work down to - bossiness, I call it, bossiness.'

The young cat again glanced at Birkin in disdain of the noisy woman.

'I quite agree with you, Miciotto,' said Birkin to the cat. 'Keep your male dignity, and your higher understanding.'

Again the Mino narrowed his eyes as if he were looking at the sun. Then, suddenly affecting to have no connection at all with the two people, he went trotting off, with assumed spontaneity and gaiety, his tail erect, his white feet blithe.

'Now he will find the belle sauvage once more, and entertain her with his superior wisdom,' laughed Birkin.

Ursula looked at the man who stood in the garden with his hair blowing and his eyes smiling ironically, and she cried:

'Oh it makes me so cross, this assumption of male superiority! And it is such a lie! One wouldn't mind if there were any justification for it.'

'The wild cat,' said Birkin, 'doesn't mind. She perceives that it is justified.'

'Does she!' cried Ursula. 'And tell it to the Horse Marines.'

'To them also.'

'It is just like Gerald Crich with his horse – a lust for bullying – a real Wille zur Macht⁴⁹ – so base, so petty.'

'I agree that the Wille zur Macht is a base and petty thing. But with the Mino, it is the desire to bring this female cat into a pure stable equilibrium, a transcendent and abiding *rapport* with the single male. Whereas without him, as you see, she is a mere stray, a fluffy sporadic bit of chaos. It is a volonté de pouvoir, if you like, a will to ability, taking pouvoir as a verb.'

'Ah -! Sophistries! It's the old Adam.'

'Oh yes. Adam kept Eve in the indestructible paradise, when he kept her single with himself, like a star in its orbit.'

'Yes – yes – ' cried Ursula, pointing her finger at him. 'There you are – a star in its orbit! A satellite – a satellite of Mars – that's what she is to be! There – there – you've given yourself away! You want a satellite, Mars and his satellite! You've said it – you've said it – you've dished yourself!'

He stood smiling in frustration and amusement and irritation and admiration and love. She was so quick, and so lambent, like discernible fire, and so vindictive, and so rich in her dangerous flamy sensitiveness.

'I've not said it at all,' he replied, 'if you will give me a chance to speak.'

'No, no!' she cried. 'I won't let you speak. You've said it, a satellite, you're not going to wriggle out of it. You've said it.'

'You'll never believe now that I *haven't* said it,' he answered. 'I neither implied nor indicated nor mentioned a satellite, nor intended a satellite, never.'

'You prevaricator!' she cried, in real indignation.

128

'Tea is ready, sir,' said the landlady from the doorway.

They both looked at her, very much as the cats had looked at them, a little while before.

'Thank you, Mrs Daykin.'

An interrupted silence fell over the two of them, a moment of breach.

'Come and have tea,' he said.

'Yes, I should love it,' she replied, gathering herself together.

They sat facing each other across the tea table.

'I did not say, nor imply, a satellite. I meant two single equal stars balanced in conjunction -'

'You gave yourself away, you gave away your little game completely,' she cried, beginning at once to eat. He saw that she would take no further heed of his expostulation, so he began to pour the tea.

'What good things to eat!' she cried.

'Take your own sugar,' he said.

He handed her her cup. He had everything so nice, such pretty cups and plates, painted with mauve-lustre and green, also shapely bowls and glass plates, and old spoons, on a woven cloth of pale grey and black and purple. It was very rich and fine. But Ursula could see Hermione's influence.

'Your things are so lovely!' she said, almost angrily.

'I like them. It gives me real pleasure to use things that are attractive in themselves – pleasant things. And Mrs Daykin is good. She thinks everything is wonderful, for my sake.'

'Really,' said Ursula, 'landladies are better than wives, nowadays. They certainly *care* a great deal more. It is much more beautiful and complete here now, than if you were married.'

'But think of the emptiness within,' he laughed.

'No,' she said. 'I am jealous that men have such perfect landladies and such beautiful lodgings. There is nothing left them to desire.'

'In the house-keeping way, we'll hope not. It is disgusting, people marrying for a home.'

'Still,' said Ursula, 'a man has very little need for a woman now, has he?'

'In outer things, maybe – except to share his bed and bear his children. But essentially, there is just the same need as there ever was. Only nobody takes the trouble to be essential.'

'How essential?' she said.

'I do think,' he said, 'that the world is only held together by the mystic conjunction, the ultimate unison between people – a bond. And the immediate bond is between man and woman.'

'But it's such old hat,' said Ursula. 'Why should love be a bond? No, I'm not having any.'

'If you are walking westward,' he said, 'you forfeit the northern and eastward and southern direction. If you admit a unison, you forfeit all the possibilities of chaos.'

'But love is freedom,' she declared.

'Don't cant to me,' he replied. 'Love is a direction which excludes all other directions. It's a freedom *together*, if you like.'

'No,' she said, 'love includes everything.'

'Sentimental cant,' he replied. 'You want the state of chaos, that's all. It is ultimate nihilism, this freedom-in-love business, this freedom which is love and love which is freedom. As a matter of fact, if you enter into a pure unison, it is irrevocable, and it is never pure till it is irrevocable. And when it is irrevocable, it is one way, like the path of a star.'

'Ha!' she cried bitterly. 'It is the old dead morality.'

'No,' he said, 'it is the law of creation. One is committed. One must commit oneself to a conjunction with the other – for ever. But it is not selfless – it is a maintaining of the self in mystic balance and integrity – like a star balanced with another star.'

'I don't trust you when you drag in the stars,' she said. 'If you were quite true, it wouldn't be necessary to be so far-fetched.'

'Don't trust me then,' he said, angry. 'It is enough that I trust myself.'

'And that is where you make another mistake,' she replied. 'You *don't* trust yourself. You don't fully believe yourself what you are saying. You don't really want this conjunction, otherwise you wouldn't talk so much about it, you'd get it.'

He was suspended for a moment, arrested.

'How?' he said.

'By just loving,' she retorted in defiance.

He was still a moment, in anger. Then he said:

'I tell you, I don't believe in love like that. I tell you, you want love to administer to your egoism, to subserve you. Love is a process of subservience with you – and with everybody. I hate it.'

'No,' she cried, pressing back her head like a cobra, her eyes flashing. 'It is a process of pride -I want to be proud -'

'Proud and subservient, proud and subservient, I know you,' he retorted dryly. 'Proud and subservient, then subservient to the proud – I know you and your love. It is a tick-tack, tick-tack, a dance of opposites.'

'Are you sure?' she mocked wickedly, 'what my love is?'

130

'Yes, I am,' he retorted.

'So cocksure!' she said. 'How can anybody ever be right, who is so cocksure? It shows you are wrong.'

He was silent in chagrin.

They had talked and struggled till they were both wearied out.

'Tell me about yourself and your people,' he said.

And she told him about the Brangwens, and about her mother, and about Skrebensky, her first love, and about her later experiences. He sat very still, watching her as she talked. And he seemed to listen with reverence. Her face was beautiful and full of baffled light as she told him all the things that had hurt her or perplexed her so deeply. He seemed to warm and comfort his soul at the beautiful light of her nature.

'If she *really* could pledge herself,' he thought to himself, with passionate insistence but hardly any hope. Yet a curious little irresponsible laughter appeared in his heart.

'We have all suffered so much,' he mocked, ironically.

She looked up at him, and a flash of wild gaiety went over her face, a strange flash of yellow light coming from her eyes.

'Haven't we!' she cried, in a high, reckless cry. 'It is almost absurd, isn't it?'

'Quite absurd,' he said. 'Suffering bores me, any more.'

'So it does me.'

He was almost afraid of the mocking recklessness of her splendid face. Here was one who would go to the whole lengths of heaven or hell, whichever she had to go. And he mistrusted her, he was afraid of a woman capable of such abandon, such dangerous thoroughness of destructivity. Yet he chuckled within himself also.

She came over to him and put her hand on his shoulder, looking down at him with strange golden-lighted eyes, very tender, but with a curious devilish look lurking underneath.

'Say you love me, say "my love" to me,' she pleaded

He looked back into her eyes, and saw. His face flickered with sardonic comprehension.

'I love you right enough,' he said, grimly. 'But I want it to be something else.'

'But why? But why?' she insisted, bending her wonderful luminous face to him. 'Why isn't it enough?'

'Because we can go one better,' he said, putting his arms round her.

'No, we can't,' she said, in a strong, voluptuous voice of yielding. 'We can only love each other. Say "my love" to me, say it, say it.'

She put her arms round his neck. He enfolded her, and kissed her

subtly, murmuring in a subtle voice of love, and irony, and submission:

'Yes, - my love, yes, - my love. Let love be enough then. I love you then - I love you. I'm bored by the rest.'

'Yes,' she murmured, nestling very sweet and close to him.

CHAPTER XIV

Water-party

EVERY YEAR Mr Crich gave a more or less public water-party on the lake. There was a little pleasure-launch on Willey Water and several rowing boats, and guests could take tea either in the marquee that was set up in the grounds of the house, or they could picnic in the shade of the great walnut tree at the boat-house by the lake. This year the staff of the Grammar-School was invited, along with the chief officials of the firm. Gerald and the younger Criches did not care for this party, but it had become customary now, and it pleased the father, as being the only occasion when he could gather some people of the district together in festivity with him. For he loved to give pleasures to his dependents and to those poorer than himself. But his children preferred the company of their own equals in wealth. They hated their inferiors' humility or gratitude or awkwardness.

Nevertheless they were willing to attend at this festival, as they had done almost since they were children, the more so, as they all felt a little guilty now, and unwilling to thwart their father any more, since he was so ill in health. Therefore, quite cheerfully Laura prepared to take her mother's place as hostess, and Gerald assumed responsibility for the amusements on the water.

Birkin had written to Ursula saying he expected to see her at the party, and Gudrun, although she scorned the patronage of the Criches, would nevertheless accompany her mother and father if the weather were fine.

The day came blue and full of sunshine, with little wafts of wind. The sisters both wore dresses of white crêpe, and hats of soft grass. But Gudrun had a sash of brilliant black and pink and yellow colour wound broadly round her waist, and she had pink silk stockings, and black and pink and yellow decoration on the brim of her hat, weighing it down a little. She carried also a yellow silk coat over her arm, so that she looked remarkable, like a painting from the Salon. Her appearance was a sore trial to her father, who said angrily:

'Don't you think you might as well get yourself up for a Christmas

cracker, an' ha' done with it?'

But Gudrun looked handsome and brilliant, and she wore her clothes in pure defiance. When people stared at her, and giggled after her, she made a point of saying loudly, to Ursula:

'Regarde, regarde ces gens-lá! Ne sont-ils pas des hiboux incroyables?'⁵⁰ And with the words of French in her mouth, she would look over her shoulder at the giggling party.

'No, really, it's impossible!' Ursula would reply distinctly. And so the two girls took it out of their universal enemy. But their father became more and more enraged.

Ursula was all snowy white, save that her hat was pink, and entirely without trimming, and her shoes were dark red, and she carried an orange-coloured coat. And in this guise they were walking all the way to Shortlands, their father and mother going in front.

They were laughing at their mother, who, dressed in a summer material of black and purple stripes, and wearing a hat of purple straw, was setting forth with much more of the shyness and trepidation of a young girl than her daughters ever felt, walking demurely beside her husband, who, as usual, looked rather crumpled in his best suit, as if he were the father of a young family and had been holding the baby whilst his wife got dressed.

'Look at the young couple in front,' said Gudrun calmly. Ursula looked at her mother and father, and was suddenly seized with uncontrollable laughter. The two girls stood in the road and laughed till the tears ran down their faces, as they caught sight again of the shy, unworldly couple of their parents going on ahead.

'We are roaring at you, mother,' called Ursula, helplessly following after her parents.

Mrs Brangwen turned round with a slightly puzzled, exasperated look. 'Oh indeed!' she said. 'What is there so very funny about *me*, I should like to know?'

She could not understand that there could be anything amiss with her appearance. She had a perfect calm sufficiency, an easy indifference to any criticism whatsoever, as if she were beyond it. Her clothes were always rather odd, and as a rule slip-shod, yet she wore them with a perfect ease and satisfaction. Whatever she had on, so long as she was barely tidy, she was right, beyond remark; such an aristocrat she was by instinct.

'You look so stately, like a country Baroness,' said Ursula, laughing with a little tenderness at her mother's naive puzzled air.

'Just like a country Baroness!' chimed in Gudrun. Now the mother's natural hauteur became self-conscious, and the girls shrieked again.

'Go home, you pair of idiots, great giggling idiots!' cried the father inflamed with irritation.

'Mm-m-er!' booed Ursula, pulling a face at his crossness.

The yellow lights danced in his eyes, he leaned forward in real rage.

'Don't be so silly as to take any notice of the great gabies,' said Mrs Brangwen, turning on her way.

'T'll see if I'm going to be followed by a pair of giggling yelling jackanapes - 'he cried vengefully.

The girls stood still, laughing helplessly at his fury, upon the path beside the hedge.

'Why you're as silly as they are, to take any notice,' said Mrs Brangwen also becoming angry now he was really enraged.

'There are some people coming, father,' cried Ursula, with mocking warning. He glanced round quickly, and went on to join his wife, walking stiff with rage. And the girls followed, weak with laughter.

When the people had passed by, Brangwen cried in a loud, stupid voice:

'I'm going back home if there's any more of this. I'm damned if I'm going to be made a fool of in this fashion, in the public road.'

He was really out of temper. At the sound of his blind, vindictive voice, the laughter suddenly left the girls, and their hearts contracted with contempt. They hated his words 'in the public road.' What did they care for the public road? But Gudrun was conciliatory.

'But we weren't laughing to *burt* you,' she cried, with an uncouth gentleness which made her parents uncomfortable. 'We were laughing because we're fond of you.'

We'll walk on in front, if they are so touchy,' said Ursula, angry. And in this wise they arrived at Willey Water. The lake was blue and fair, the meadows sloped down in sunshine on one side, the thick dark woods dropped steeply on the other. The little pleasure-launch was fussing out from the shore, twanging its music, crowded with people, flapping its paddles. Near the boat-house was a throng of gaily-dressed persons, small in the distance. And on the high-road, some of the common people were standing along the hedge, looking at the festivity beyond, enviously, like souls not admitted to paradise.

'My eye!' said Gudrun, sotto voce, looking at the motley of guests, 'there's a pretty crowd if you like! Imagine yourself in the midst of that, my dear.'

Gudrun's apprehensive horror of people in the mass unnerved Ursula. 'It looks rather awful,' she said anxiously.

'And imagine what they'll be like - *imagine!*' said Gudrun, still in that unnerving, subdued voice. Yet she advanced determinedly.

'I suppose we can get away from them,' said Ursula anxiously.

'We're in a pretty fix if we can't,' said Gudrun. Her extreme ironic loathing and apprehension was very trying to Ursula.

'We needn't stay,' she said.

'I certainly shan't stay five minutes among that little lot,' said Gudrun. They advanced nearer, till they saw policemen at the gates.

'Policemen to keep you in, too!' said Gudrun. 'My word, this is a beautiful affair.'

'We'd better look after father and mother,' said Ursula anxiously.

'Mother's *perfectly* capable of getting through this little celebration,' said Gudrun with some contempt.

But Ursula knew that her father felt uncouth and angry and unhappy, so she was far from her ease. They waited outside the gate till their parents came up. The tall, thin man in his crumpled clothes was unnerved and irritable as a boy, finding himself on the brink of this social function. He did not feel a gentleman, he did not feel anything except pure exasperation.

Ursula took her place at his side, they gave their tickets to the policeman, and passed in on to the grass, four abreast; the tall, hot, ruddy-dark man with his narrow boyish brow drawn with irritation, the fresh-faced, easy woman, perfectly collected though her hair was slipping on one side, then Gudrun, her eyes round and dark and staring, her full soft face impassive, almost sulky, so that she seemed to be backing away in antagonism even whilst she was advancing; and then Ursula, with the odd, brilliant, dazzled look on her face, that always came when she was in some false situation.

Birkin was the good angel. He came smiling to them with his affected social grace, that somehow was never *quite* right. But he took off his hat and smiled at them with a real smile in his eyes, so that Brangwen cried out heartily in relief:

'How do you do? You're better, are you?'

'Yes, I'm better. How do you do, Mrs Brangwen? I know Gudrun and Ursula very well.'

His eyes smiled full of natural warmth. He had a soft, flattering manner with women, particularly with women who were not young.

'Yes,' said Mrs Brangwen, cool but yet gratified. 'I have heard them speak of you often enough.'

He laughed. Gudrun looked aside, feeling she was being belittled. People were standing about in groups, some women were sitting in the shade of the walnut tree, with cups of tea in their hands, a waiter in evening dress was hurrying round, some girls were simpering with parasols, some young men, who had just come in from rowing, were sitting cross-legged on the grass, coatless, their shirt-sleeves rolled up in manly fashion, their hands resting on their white flannel trousers, their gaudy ties floating about, as they laughed and tried to be witty with the young damsels.

'Why,' thought Gudrun churlishly, 'don't they have the manners to put their coats on, and not to assume such intimacy in their appearance.'

She abhorred the ordinary young man, with his hair plastered back, and his easy-going chumminess.

Hermione Roddice came up, in a handsome gown of white lace, trailing an enormous silk shawl blotched with great embroidered flowers, and balancing an enormous plain hat on her head. She looked striking, astonishing, almost macabre, so tall, with the fringe of her great cream-coloured vividly-blotched shawl trailing on the ground after her, her thick hair coming low over her eyes, her face strange and long and pale, and the blotches of brilliant colour drawn round her.

'Doesn't she look *weird*?' Gudrun heard some girls titter behind her. And she could have killed them.

'How do you do!' sang Hermione, coming up very kindly, and glancing slowly over Gudrun's father and mother. It was a trying moment, exasperating for Gudrun. Hermione was really so strongly entrenched in her class superiority, she could come up and know people out of simple curiosity, as if they were creatures on exhibition. Gudrun would do the same herself. But she resented being in the position when somebody might do it to her.

Hermione, very remarkable, and distinguishing the Brangwens very much, led them along to where Laura Crich stood receiving the guests.

'This is Mrs Brangwen,' sang Hermione, and Laura, who wore a stiff embroidered linen dress, shook hands and said she was glad to see her. Then Gerald came up, dressed in white, with a black and brown blazer, and looking handsome. He too was introduced to the Brangwen parents, and immediately he spoke to Mrs Brangwen as if she were a lady, and to Brangwen as if he were *not* a gentleman. Gerald was so obvious in his demeanour. He had to shake hands with his left hand, because he had hurt his right, and carried it, bandaged up, in the pocket of his jacket. Gudrun was *very* thankful that none of her party asked him what was the matter with the hand.

The steam launch was fussing in, all its music jingling, people calling excitedly from on board. Gerald went to see to the debarkation, Birkin was getting tea for Mrs Brangwen, Brangwen had joined a Grammar-School group, Hermione was sitting down by their mother, the girls went to the landing-stage to watch the launch come in.

She hooted and tooted gaily, then her paddles were silent, the ropes

were thrown ashore, she drifted in with a little bump. Immediately the passengers crowded excitedly to come ashore.

'Wait a minute, wait a minute,' shouted Gerald in sharp command.

They must wait till the boat was tight on the ropes, till the small gangway was put out. Then they streamed ashore, clamouring as if they had come from America.

'Oh it's so nice!' the young girls were crying. 'It's quite lovely.'

The waiters from on board ran out to the boat-house with baskets, the captain lounged on the little bridge. Seeing all safe, Gerald came to Gudrun and Ursula.

'You wouldn't care to go on board for the next trip, and have tea there?' he asked.

'No thanks,' said Gudrun coldly.

'You don't care for the water?'

'For the water? Yes, I like it very much.'

He looked at her, his eyes searching.

'You don't care for going on a launch, then?'

She was slow in answering, and then she spoke slowly.

'No,' she said. 'I can't say that I do.' Her colour was high, she seemed angry about something.

'Un peu trop de monde,'51 said Ursula, explaining.

'Eh? Trop de monde!' He laughed shortly. 'Yes there's a fair number of 'em.'

Gudrun turned on him brilliantly.

'Have you ever been from Westminster Bridge to Richmond on one of the Thames steamers?' she cried.

'No,' he said, 'I can't say I have.'

Well, it's one of the most *vile* experiences I've ever had.' She spoke rapidly and excitedly, the colour high in her cheeks. 'There was absolutely nowhere to sit down, nowhere, a man just above sang "Rocked in the Cradle of the Deep"⁵² the *whole* way; he was blind and he had a small organ, one of those portable organs, and he expected money; so you can imagine what *that* was like; there came a constant smell of luncheon from below, and puffs of hot oily machinery; the journey took hours and hours and hours; and for miles, literally for miles, dreadful boys ran with us on the shore, in that *awful* Thames mud, going in *up to the waist* – they had their trousers turned back, and they went up to their hips in that indescribable Thames mud, their faces always turned to us, and screaming, exactly like carrion creatures, screaming " 'Ere y'are sir, 'ere y'are sir, 'ere y'are sir," exactly like some foul carrion objects, perfectly obscene; and paterfamilias on board, laughing when the boys went right down in that awful mud, occasionally throwing them a ha'penny. And if you'd seen the intent look on the faces of these boys, and the way they darted in the filth when a coin was flung – really, no vulture or jackal could dream of approaching them, for foulness. I *never* would go on a pleasure boat again – never.'

Gerald watched her all the time she spoke, his eyes glittering with faint rousedness. It was not so much what she said; it was she herself who roused him, roused him with a small, vivid pricking.

'Of course,' he said, 'every civilised body is bound to have its vermin.' 'Why?' cried Ursula. 'I don't have vermin.'

'And it's not that – it's the *quality* of the whole thing – paterfamilias laughing and thinking it sport, and throwing the ha'pennies, and materfamilias spreading her fat little knees and eating, continually eating – 'replied Gudrun.

'Yes,' said Ursula. 'It isn't the boys so much who are vermin; it's the people themselves, the whole body politic, as you call it.'

Gerald laughed.

'Never mind,' he said. 'You shan't go on the launch.'

Gudrun flushed quickly at his rebuke.

There were a few moments of silence. Gerald, like a sentinel, was watching the people who were going on to the boat. He was very goodlooking and self-contained, but his air of soldierly alertness was rather irritating.

'Will you have tea here then, or go across to the house, where there's a tent on the lawn?' he asked.

'Can't we have a rowing boat, and get out?' asked Ursula, who was always rushing in too fast.

'To get out?' smiled Gerald.

'You see,' cried Gudrun, flushing at Ursula's outspoken rudeness, 'we don't know the people, we are almost *complete* strangers here.'

'Oh, I can soon set you up with a few acquaintances,' he said easily.

Gudrun looked at him, to see if it were ill-meant. Then she smiled at him.

'Ah,' she said, 'you know what we mean. Can't we go up there, and explore that coast?' She pointed to a grove on the hillock of the meadow-side, near the shore half way down the lake. 'That looks perfectly lovely. We might even bathe. Isn't it beautiful in this light. Really, it's like one of the reaches of the Nile – as one imagines the Nile.'

Gerald smiled at her factitious enthusiasm for the distant spot.

'You're sure it's far enough off?' he asked ironically, adding at once: 'Yes, you might go there, if we could get a boat. They seem to be all out.'

He looked round the lake and counted the rowing boats on its surface.

138

'How lovely it would be!' cried Ursula wistfully.

'And don't you want tea?' he said.

'Oh,' said Gudrun, 'we could just drink a cup, and be off.'

He looked from one to the other, smiling. He was somewhat offended – yet sporting.

'Can you manage a boat pretty well?' he asked.

'Yes,' replied Gudrun, coldly, 'pretty well.'

'Oh yes,' cried Ursula. 'We can both of us row like water-spiders.'

'You can? There's a light little canoe of mine, that I didn't take out for fear somebody should drown themselves. Do you think you'd be safe in that?'

'Oh perfectly,' said Gudrun.

'What an angel!' cried Ursula.

'Don't, for my sake, have an accident – because I'm responsible for the water.'

'Sure,' pledged Gudrun.

'Besides, we can both swim quite well,' said Ursula.

'Well – then I'll get them to put you up a tea-basket, and you can picnic all to yourselves, – that's the idea, isn't it?'

'How fearfully good! How frightfully nice if you could!' cried Gudrun warmly, her colour flushing up again. It made the blood stir in his veins, the subtle way she turned to him and infused her gratitude into his body.

'Where's Birkin?' he said, his eyes twinkling. 'He might help me to get it down.'

'But what about your hand? Isn't it hurt?' asked Gudrun, rather muted, as if avoiding the intimacy. This was the first time the hurt had been mentioned. The curious way she skirted round the subject sent a new, subtle caress through his veins. He took his hand out of his pocket. It was bandaged. He looked at it, then put it in his pocket again. Gudrun quivered at the sight of the wrapped up paw.

'Oh I can manage with one hand. The canoe is as light as a feather,' he said. 'There's Rupert! – Rupert!'

Birkin turned from his social duties and came towards them.

'What have you done to it?' asked Ursula, who had been aching to put the question for the last half hour.

'To my hand?' said Gerald. 'I trapped it in some machinery.'

'Ugh!' said Ursula. 'And did it hurt much?'

'Yes,' he said. 'It did at the time. It's getting better now. It crushed the fingers.'

'Oh,' cried Ursula, as if in pain, 'I hate people who hurt themselves. I can *feel* it.' And she shook her hand.

'What do you want?' said Birkin.

The two men carried down the slim brown boat, and set it on the water.

'You're quite sure you'll be safe in it?' Gerald asked.

'Quite sure,' said Gudrun. 'I wouldn't be so mean as to take it, if there was the slightest doubt. But I've had a canoe at Arundel, and I assure you I'm perfectly safe.'

So saying, having given her word like a man, she and Ursula entered the frail craft, and pushed gently off. The two men stood watching them. Gudrun was paddling. She knew the men were watching her, and it made her slow and rather clumsy. The colour flew in her face like a flag.

'Thanks awfully,' she called back to him, from the water, as the boat slid away. 'It's lovely – like sitting in a leaf.'

He laughed at the fancy. Her voice was shrill and strange, calling from the distance. He watched her as she paddled away. There was something childlike about her, trustful and deferential, like a child. He watched her all the while, as she rowed. And to Gudrun it was a real delight, in make-belief, to be the childlike, clinging woman to the man who stood there on the quay, so good-looking and efficient in his white clothes, and moreover the most important man she knew at the moment. She did not take any notice of the wavering, indistinct, lambent Birkin, who stood at his side. One figure at a time occupied the field of her attention.

The boat rustled lightly along the water. They passed the bathers whose striped tents stood between the willows of the meadow's edge, and drew along the open shore, past the meadows that sloped golden in the light of the already late afternoon. Other boats were stealing under the wooded shore opposite, they could hear people's laughter and voices. But Gudrun rowed on towards the clump of trees that balanced perfect in the distance, in the golden light.

The sisters found a little place where a tiny stream flowed into the lake, with reeds and flowery marsh of pink willow herb, and a gravelly bank to the side. Here they ran delicately ashore, with their frail boat, the two girls took off their shoes and stockings and went through the water's edge to the grass. The tiny ripples of the lake were warm and clear, they lifted their boat on to the bank, and looked round with joy. They were quite alone in a forsaken little stream-mouth, and on the knoll just behind was the clump of trees.

'We will bathe just for a moment,' said Ursula, 'and then we'll have tea.'

They looked round. Nobody could notice them, or could come up in

time to see them. In less than a minute Ursula had thrown off her clothes and had slipped naked into the water, and was swimming out. Quickly, Gudrun joined her. They swam silently and blissfully for a few minutes, circling round their little stream-mouth. Then they slipped ashore and ran into the grove again, like nymphs.

'How lovely it is to be free,' said Ursula, running swiftly here and there between the tree trunks, quite naked, her hair blowing loose. The grove was of beech-trees, big and splendid, a steel-grey scaffolding of trunks and boughs, with level sprays of strong green here and there, whilst through the northern side the distance glimmered open as through a window.

When they had run and danced themselves dry, the girls quickly dressed and sat down to the fragrant tea. They sat on the northern side of the grove, in the yellow sunshine facing the slope of the grassy hill, alone in a little wild world of their own. The tea was hot and aromatic, there were delicious little sandwiches of cucumber and of caviare, and winy cakes.

'Are you happy, Prune?' cried Ursula in delight, looking at her sister. 'Ursula, I'm perfectly happy,' replied Gudrun gravely, looking at the westering sun.

'So am I.'

When they were together, doing the things they enjoyed, the two sisters were quite complete in a perfect world of their own. And this was one of the perfect moments of freedom and delight, such as children alone know, when all seems a perfect and blissful adventure.

When they had finished tea, the two girls sat on, silent and serene. Then Ursula, who had a beautiful strong voice, began to sing to herself, softly: 'Annchen von Tharau.'⁵³ Gudrun listened, as she sat beneath the trees, and the yearning came into her heart. Ursula seemed so peaceful and sufficient unto herself, sitting there unconsciously crooning her song, strong and unquestioned at the centre of her own universe. And Gudrun felt herself outside. Always this desolating, agonised feeling, that she was outside of life, an onlooker, whilst Ursula was a partaker, caused Gudrun to suffer from a sense of her own negation, and made her, that she must always demand the other to be aware of her, to be in connection with her.

'Do you mind if I do Dalcroze⁵⁴ to that tune, Hurtler?' she asked in a curious muted tone, scarce moving her lips.

'What did you say?' asked Ursula, looking up in peaceful surprise.

'Will you sing while I do Dalcroze?' said Gudrun, suffering at having to repeat herself.

Ursula thought a moment, gathering her straying wits together.

'While you do -?' she asked vaguely.

'Dalcroze movements,' said Gudrun, suffering tortures of selfconsciousness, even because of her sister.

'Oh Dalcroze! I couldn't catch the name. Do - I should love to see you,' cried Ursula, with childish surprised brightness. 'What shall I sing?'

'Sing anything you like, and I'll take the rhythm from it.'

But Ursula could not for her life think of anything to sing. However, she suddenly began, in a laughing, teasing voice:

'My love - is a high-born lady - '

Gudrun, looking as if some invisible chain weighed on her hands and feet, began slowly to dance in the eurythmic manner, pulsing and fluttering rhythmically with her feet, making slower, regular gestures with her hands and arms, now spreading her arms wide, now raising them above her head, now flinging them softly apart, and lifting her face, her feet all the time beating and running to the measure of the song, as if it were some strange incantation, her white, rapt form drifting here and there in a strange impulsive rhapsody, seeming to be lifted on a breeze of incantation, shuddering with strange little runs. Ursula sat on the grass, her mouth open in her singing, her eyes laughing as if she thought it was a great joke, but a yellow light flashing up in them, as she caught some of the unconscious ritualistic suggestion of the complex shuddering and waving and drifting of her sister's white form, that was clutched in pure, mindless, tossing rhythm, and a will set powerful in a kind of hypnotic influence.

'My love is a high-born lady – She is-s-s – rather dark than shady – ' rang out Ursula's laughing, satiric song, and quicker, fiercer went Gudrun in the dance, stamping as if she were trying to throw off some bond, flinging her hands suddenly and stamping again, then rushing with face uplifted and throat full and beautiful, and eyes half closed, sightless. The sun was low and yellow, sinking down, and in the sky floated a thin, ineffectual moon.

Ursula was quite absorbed in her song, when suddenly Gudrun stopped and said mildly, ironically:

'Ursula!'

'Yes?' said Ursula, opening her eyes out of the trance.

Gudrun was standing still and pointing, a mocking smile on her face, towards the side.

'Ugh!' cried Ursula in sudden panic, starting to her feet.

'They're quite all right,' rang out Gudrun's sardonic voice.

On the left stood a little cluster of Highland cattle, vividly coloured and fleecy in the evening light, their horns branching into the sky, pushing forward their muzzles inquisitively, to know what it was all about. Their eyes glittered through their tangle of hair, their naked nostrils were full of shadow.

'Won't they do anything?' cried Ursula in fear.

Gudrun, who was usually frightened of cattle, now shook her head in a queer, half-doubtful, half-sardonic motion, a faint smile round her mouth.

'Don't they look charming, Ursula?' cried Gudrun, in a high, strident voice, something like the scream of a seagull.

'Charming,' cried Ursula in trepidation. 'But won't they do anything to us?'

Again Gudrun looked back at her sister with an enigmatic smile, and shook her head.

'I'm sure they won't,' she said, as if she had to convince herself also, and yet, as if she were confident of some secret power in herself, and had to put it to the test. 'Sit down and sing again,' she called in her high, strident voice.

'I'm frightened,' cried Ursula, in a pathetic voice, watching the group of sturdy short cattle, that stood with their knees planted, and watched with their dark, wicked eyes, through the matted fringe of their hair. Nevertheless, she sank down again, in her former posture.

'They are quite safe,' came Gudrun's high call. 'Sing something, you've only to sing something.'

It was evident she had a strange passion to dance before the sturdy, handsome cattle.

Ursula began to sing, in a false quavering voice:

'Way down in Tennessee - '55

She sounded purely anxious. Nevertheless, Gudrun, with her arms outspread and her face uplifted, went in a strange palpitating dance towards the cattle, lifting her body towards them as if in a spell, her feet pulsing as if in some little frenzy of unconscious sensation, her arms, her wrists, her hands stretching and heaving and falling and reaching and reaching and falling, her breasts lifted and shaken towards the cattle, her throat exposed as in some voluptuous ecstasy towards them, whilst she drifted imperceptibly nearer, an uncanny white figure, towards them, carried away in its own rapt trance, ebbing in strange fluctuations upon the cattle, that waited, and ducked their heads a little in sudden contraction from her, watching all the time as if hypnotised, their bare horns branching in the clear light, as the white figure of the woman ebbed upon them, in the slow, hypnotising convulsion of the dance. She could feel them just in front of her, it was as if she had the electric pulse from their breasts running into her hands. Soon she

would touch them, actually touch them. A terrible shiver of fear and pleasure went through her. And all the while, Ursula, spell-bound, kept up her high-pitched thin, irrelevant song, which pierced the fading evening like an incantation.

Gudrun could hear the cattle breathing heavily with helpless fear and fascination. Oh, they were brave little beasts, these wild Scotch bullocks, wild and fleecy. Suddenly one of them snorted, ducked its head, and backed.

'Hue! Hi-eee!' came a sudden loud shout from the edge of the grove. The cattle broke and fell back quite spontaneously, went running up the hill, their fleece waving like fire to their motion. Gudrun stood suspended out on the grass, Ursula rose to her feet.

It was Gerald and Birkin come to find them, and Gerald had cried out to frighten off the cattle.

'What do you think you're doing?' he now called, in a high, wondering vexed tone.

'Why have you come?' came back Gudrun's strident cry of anger.

'What do you think you were doing?' Gerald repeated, auto-matically.

'We were doing eurythmics,' laughed Ursula, in a shaken voice.

Gudrun stood aloof looking at them with large dark eyes of resentment, suspended for a few moments. Then she walked away up the hill, after the cattle, which had gathered in a little, spell-bound cluster higher up.

'Where are you going?' Gerald called after her. And he followed her up the hill-side. The sun had gone behind the hill, and shadows were clinging to the earth, the sky above was full of travelling light.

'A poor song for a dance,' said Birkin to Ursula, standing before her with a sardonic, flickering laugh on his face. And in another second, he was singing softly to himself, and dancing a grotesque step-dance in front of her, his limbs and body shaking loose, his face flickering palely, a constant thing, whilst his feet beat a rapid mocking tattoo, and his body seemed to hang all loose and quaking in between, like a shadow.

'I think we've all gone mad,' she said, laughing rather frightened.

'Pity we aren't madder,' he answered, as he kept up the incessant shaking dance. Then suddenly he leaned up to her and kissed her fingers lightly, putting his face to hers and looking into her eyes with a pale grin. She stepped back, affronted.

'Offended - ?' he asked ironically, suddenly going quite still and reserved again. 'I thought you liked the light fantastic.'

'Not like that,' she said, confused and bewildered, almost affronted. Yet somewhere inside her she was fascinated by the sight of his loose, vibrating body, perfectly abandoned to its own dropping and swinging,

144

and by the pallid, sardonic-smiling face above. Yet automatically she stiffened herself away, and disapproved. It seemed almost an obscenity, in a man who talked as a rule so very seriously.

'Why not like that?' he mocked. And immediately he dropped again into the incredibly rapid, slack-waggling dance, watching her malevolently. And moving in the rapid, stationary dance, he came a little nearer, and reached forward with an incredibly mocking, satiric gleam on his face, and would have kissed her again, had she not started back.

'No, don't!' she cried, really afraid.

'Cordelia⁵⁶ after all,' he said satirically. She was stung, as if this were an insult. She knew he intended it as such, and it bewildered her.

'And you,' she cried in retort, 'why do you always take your soul in your mouth, so frightfully full?'

'So that I can spit it out the more readily,' he said, pleased by his own retort.

Gerald Crich, his face narrowing to an intent gleam, followed up the hill with quick strides, straight after Gudrun. The cattle stood with their noses together on the brow of a slope, watching the scene below, the men in white hovering about the white forms of the women, watching above all Gudrun, who was advancing slowly towards them. She stood a moment, glancing back at Gerald, and then at the cattle.

Then in a sudden motion, she lifted her arms and rushed sheer upon the long-horned bullocks, in shuddering irregular runs, pausing for a second and looking at them, then lifting her hands and running forward with a flash, till they ceased pawing the ground, and gave way, snorting with terror, lifting their heads from the ground and flinging themselves away, galloping off into the evening, becoming tiny in the distance, and still not stopping.

Gudrun remained staring after them, with a mask-like defiant face.

'Why do you want to drive them mad?' asked Gerald, coming up with her.

She took no notice of him, only averted her face from him. 'It's not safe, you know,' he persisted. 'They're nasty, when they do turn.'

'Turn where? Turn away?' she mocked loudly.

'No,' he said, 'turn against you.'

'Turn against me?' she mocked.

He could make nothing of this.

'Anyway, they gored one of the farmer's cows to death, the other day,' he said.

'What do I care?' she said.

'I cared though,' he replied, 'seeing that they're my cattle.'

'How are they yours! You haven't swallowed them. Give me one of

them now,' she said, holding out her hand.

'You know where they are,' he said, pointing over the hill. 'You can have one if you'd like it sent to you later on.'

She looked at him inscrutably.

'You think I'm afraid of you and your cattle, don't you?' she asked.

His eyes narrowed dangerously. There was a faint domineering smile on his face.

'Why should I think that?' he said.

She was watching him all the time with her dark, dilated, inchoate eyes. She leaned forward and swung round her arm, catching him a light blow on the face with the back of her hand.

'That's why,' she said, mocking.

And she felt in her soul an unconquerable desire for deep violence against him. She shut off the fear and dismay that filled her conscious mind. She wanted to do as she did, she was not going to be afraid.

He recoiled from the slight blow on his face. He became deadly pale, and a dangerous flame darkened his eyes. For some seconds he could not speak, his lungs were so suffused with blood, his heart stretched almost to bursting with a great gush of ungovernable emotion. It was as if some reservoir of black emotion had burst within him, and swamped him.

'You have struck the first blow,' he said at last, forcing the words from his lungs, in a voice so soft and low, it sounded like a dream within her, not spoken in the outer air.

'And I shall strike the last,' she retorted involuntarily, with confident assurance. He was silent, he did not contradict her.

She stood negligently, staring away from him, into the distance. On the edge of her consciousness the question was asking itself, automatically:

Why are you behaving in this *impossible* and ridiculous fashion.' But she was sullen, she half shoved the question out of herself. She could not get it clean away, so she felt self-conscious.

Gerald, very pale, was watching her closely. His eyes were lit up with intent lights, absorbed and gleaming. She turned suddenly on him.

'It's you who make me behave like this, you know,' she said, almost suggestive.

'I? How?' he said.

But she turned away, and set off towards the lake. Below, on the water, lanterns were coming alight, faint ghosts of warm flame floating in the pallor of the first twilight. The earth was spread with darkness, like lacquer, overhead was a pale sky, all primrose, and the lake was pale as milk in one part. Away at the landing stage, tiniest points of coloured rays were stringing themselves in the dusk. The launch was being illuminated. All round, shadow was gathering from the trees.

146

Gerald, white like a presence in his summer clothes, was following down the open grassy slope. Gudrun waited for him to come up. Then she softly put out her hand and touched him, saying softly:

'Don't be angry with me.'

A flame flew over him, and he was unconscious. Yet he stammered: 'I'm not angry with you. I'm in love with you.'

His mind was gone, he grasped for sufficient mechanical control, to save himself. She laughed a silvery little mockery, yet intolerably caressive.

'That's one way of putting it,' she said.

The terrible swooning burden on his mind, the awful swooning, the loss of all his control, was too much for him. He grasped her arm in his one hand, as if his hand were iron.

'It's all right, then, is it?' he said, holding her arrested.

She looked at the face with the fixed eyes, set before her, and her blood ran cold.

'Yes, it's all right,' she said softly, as if drugged, her voice crooning and witch-like.

He walked on beside her, a striding, mindless body. But he recovered a little as he went. He suffered badly. He had killed his brother when a boy, and was set apart, like Cain.

They found Birkin and Ursula sitting together by the boats, talking and laughing. Birkin had been teasing Ursula.

'Do you smell this little marsh?' he said, sniffing the air. He was very sensitive to scents, and quick in understanding them.

'It's rather nice,' she said.

'No,' he replied, 'alarming.'

'Why alarming?' she laughed.

'It see thes and see thes, a river of darkness,' he said, 'putting forth lilies and snakes, and the ignis fatuus, and rolling all the time onward. That's what we never take into count – that it rolls onwards.'

I hat's what we never take into count – that it rolls onwards.

'What does?'

'The other river, the black river. We always consider the silver river of life, rolling on and quickening all the world to a brightness, on and on to heaven, flowing into a bright eternal sea, a heaven of angels thronging. But the other is our real reality - '

'But what other? I don't see any other,' said Ursula.

'It is your reality, nevertheless,' he said; 'that dark river of dissolution. You see it rolls in us just as the other rolls – the black river of corruption. And our flowers are of this – our sea-born Aphrodite,⁵⁷ all our white phosphorescent flowers of sensuous perfection, all our reality, nowadays.'

'You mean that Aphrodite is really deathly?' asked Ursula.

'I mean she is the flowering mystery of the death-process, yes,' he replied. 'When the stream of synthetic creation lapses, we find ourselves part of the inverse process, the blood of destructive creation. Aphrodite is born in the first spasm of universal dissolution – then the snakes and swans and lotus – marsh-flowers – and Gudrun and Gerald – born in the process of destructive creation.'

'And you and me - ?' she asked.

'Probably,' he replied. 'In part, certainly. Whether we are that, in toto, I don't yet know.'

'You mean we are flowers of dissolution – fleurs du mal?⁵⁸ I don't feel as if I were,' she protested.

He was silent for a time.

'I don't feel as if we were, *altogether*,' he replied. 'Some people are pure flowers of dark corruption – lilies. But there ought to be some roses, warm and flamy. You know Herakleitos⁵⁹ says "a dry soul is best." I know so well what that means. Do you?'

'T'm not sure,' Ursula replied. 'But what if people are all flowers of dissolution – when they're flowers at all – what difference does it make?'

'No difference – and all the difference. Dissolution rolls on, just as production does,' he said. 'It is a progressive process – and it ends in universal nothing – the end of the world, if you like. But why isn't the end of the world as good as the beginning?'

'I suppose it isn't,' said Ursula, rather angry.

'Oh yes, ultimately,' he said. 'It means a new cycle of creation after – but not for us. If it is the end, then we are of the end – fleurs du mal if you like. If we are fleurs du mal, we are not roses of happiness, and there you are.'

'But I think I am,' said Ursula. 'I think I am a rose of happiness.'

'Ready-made?' he asked ironically.

'No-real,' she said, hurt.

'If we are the end, we are not the beginning,' he said.

'Yes we are,' she said. 'The beginning comes out of the end.'

'After it, not out of it. After us, not out of us.'

'You are a devil, you know, really,' she said. 'You want to destroy our hope. You *want us* to be deathly.'

'No,' he said, 'I only want us to know what we are.'

'Ha!' she cried in anger. 'You only want us to know death.'

'You're quite right,' said the soft voice of Gerald, out of the dusk behind.

Birkin rose. Gerald and Gudrun came up. They all began to smoke,

in the moments of silence. One after another, Birkin lighted their cigarettes. The match flickered in the twilight, and they were all smoking peacefully by the water-side. The lake was dim, the light dying from off it, in the midst of the dark land. The air all round was intangible, neither here nor there, and there was an unreal noise of banjoes, or suchlike music.

As the golden swim of light overhead died out, the moon gained brightness, and seemed to begin to smile forth her ascendancy. The dark woods on the opposite shore melted into universal shadow. And amid this universal under-shadow, there was a scattered intrusion of lights. Far down the lake were fantastic pale strings of colour, like beads of wan fire, green and red and yellow. The music came out in a little puff, as the launch, all illuminated, veered into the great shadow, stirring her outlines of half-living lights, puffing out her music in little drifts.

All were lighting up. Here and there, close against the faint water, and at the far end of the lake, where the water lay milky in the last whiteness of the sky, and there was no shadow, solitary, frail flames of lanterns floated from the unseen boats. There was a sound of oars, and a boat passed from the pallor into the darkness under the wood, where her lanterns seemed to kindle into fire, hanging in ruddy lovely globes. And again, in the lake, shadowy red gleams hovered in reflection about the boat. Everywhere were these noiseless ruddy creatures of fire drifting near the surface of the water, caught at by the rarest, scarce visible reflections.

Birkin brought the lanterns from the bigger boat, and the four shadowy white figures gathered round, to light them. Ursula held up the first, Birkin lowered the light from the rosy, glowing cup of his hands, into the depths of the lantern. It was kindled, and they all stood back to look at the great blue moon of light that hung from Ursula's hand, casting a strange gleam on her face. It flickered, and Birkin went bending over the well of light. His face shone out like an apparition, so unconscious, and again, something demoniacal. Ursula was dim and veiled, looming over him.

'That is all right,' said his voice softly.

She held up the lantern. It had a flight of storks streaming through a turquoise sky of light, over a dark earth.

'This is beautiful,' she said.

'Lovely,' echoed Gudrun, who wanted to hold one also, and lift it up full of beauty.

'Light one for me,' she said. Gerald stood by her, incapacitated. Birkin lit the lantern she held up. Her heart beat with anxiety, to see

how beautiful it would be. It was primrose yellow, with tall straight flowers growing darkly from their dark leaves, lifting their heads into the primrose day, while butterflies hovered about them, in the pure clear light.

Gudrun gave a little cry of excitement, as if pierced with delight.

'Isn't it beautiful, oh, isn't it beautiful!'

Her soul was really pierced with beauty, she was translated beyond herself. Gerald leaned near to her, into her zone of light, as if to see. He came close to her, and stood touching her, looking with her at the primrose-shining globe. And she turned her face to his, that was faintly bright in the light of the lantern, and they stood together in one luminous union, close together and ringed round with light, all the rest excluded.

Birkin looked away, and went to light Ursula's second lantern. It had a pale ruddy sea-bottom, with black crabs and sea-weed moving sinuously under a transparent sea, that passed into flamy ruddiness above.

'You've got the heavens above, and the waters under the earth,' said Birkin to her.

'Anything but the earth itself,' she laughed, watching his live hands that hovered to attend to the light.

'I'm dying to see what my second one is,' cried Gudrun, in a vibrating rather strident voice, that seemed to repel the others from her.

Birkin went and kindled it. It was of a lovely deep blue colour, with a red floor, and a great white cuttle-fish flowing in white soft streams all over it. The cuttle-fish had a face that stared straight from the heart of the light, very fixed and coldly intent.

'How truly terrifying!' exclaimed Gudrun, in a voice of horror. Gerald, at her side, gave a low laugh.

'But isn't it really fearful!' she cried in dismay.

Again he laughed, and said:

'Change it with Ursula, for the crabs.'

Gudrun was silent for a moment.

'Ursula,' she said, 'could you bear to have this fearful thing?'

'I think the colouring is lovely,' said Ursula.

'So do I,' said Gudrun. 'But could you *bear* to have it swinging to your boat? Don't you want to destroy it at *once*?'

'Oh no,' said Ursula. 'I don't want to destroy it.'

'Well do you mind having it instead of the crabs? Are you sure you don't mind?'

Gudrun came forward to exchange lanterns.

'No,' said Ursula, yielding up the crabs and receiving the cuttle-fish.

150

Yet she could not help feeling rather resentful at the way in which Gudrun and Gerald should assume a right over her, a precedence.

'Come then,' said Birkin. 'I'll put them on the boats.'

He and Ursula were moving away to the big boat.

'I suppose you'll row me back, Rupert,' said Gerald, out of the pale shadow of the evening.

'Won't you go with Gudrun in the canoe?' said Birkin. 'It'll be more interesting.'

There was a moment's pause. Birkin and Ursula stood dimly, with their swinging lanterns, by the water's edge. The world was all illusive.

'Is that all right?' said Gudrun to him.

'It'll suit *me* very well,' he said. 'But what about you, and the rowing? I don't see why you should pull me.'

'Why not?' she said. 'I can pull you as well as I could pull Ursula.'

By her tone he could tell she wanted to have him in the boat to herself, and that she was subtly gratified that she should have power over them both. He gave himself, in a strange, electric submission.

She handed him the lanterns, whilst she went to fix the cane at the end of the canoe. He followed after her, and stood with the lanterns dangling against his white-flannelled thighs, emphasising the shadow around.

'Kiss me before we go,' came his voice softly from out of the shadow above.

She stopped her work in real, momentary astonishment.

'But why?' she exclaimed, in pure surprise.

'Why?' he echoed, ironically.

And she looked at him fixedly for some moments. Then she leaned forward and kissed him, with a slow, luxurious kiss, lingering on the mouth. And then she took the lanterns from him, while he stood swooning with the perfect fire that burned in all his joints.

They lifted the canoe into the water, Gudrun took her place, and Gerald pushed off.

'Are you sure you don't hurt your hand, doing that?' she asked, solicitous. 'Because I could have done it *perfectly*.'

'I don't hurt myself,' he said in a low, soft voice, that caressed her with inexpressible beauty.

And she watched him as he sat near her, very near to her, in the stern of the canoe, his legs coming towards hers, his feet touching hers. And she paddled softly, lingeringly, longing for him to say something meaningful to her. But he remained silent.

'You like this, do you?' she said, in a gentle, solicitous voice.

He laughed shortly.

'There is a space between us,' he said, in the same low, unconscious voice, as if something were speaking out of him. And she was as if magically aware of their being balanced in separation, in the boat. She swooned with acute comprehension and pleasure.

'But I'm very near,' she said caressively, gaily.

'Yet distant, distant,' he said.

Again she was silent with pleasure, before she answered, speaking with a reedy, thrilled voice:

'Yet we cannot very well change, whilst we are on the water.' She caressed him subtly and strangely, having him completely at her mercy.

A dozen or more boats on the lake swung their rosy and moon-like lanterns low on the water, that reflected as from a fire. In the distance, the steamer twanged and thrummed and washed with her faintlysplashing paddles, trailing her strings of coloured lights, and occasionally lighting up the whole scene luridly with an effusion of fireworks, Roman candles and sheafs of stars and other simple effects, illuminating the surface of the water, and showing the boats creeping round, low down. Then the lovely darkness fell again, the lanterns and the little threaded lights glimmered softly, there was a muffled knocking of oars and a waving of music.

Gudrun paddled almost imperceptibly. Gerald could see, not far ahead, the rich blue and the rose globes of Ursula's lanterns swaying softly cheek to cheek as Birkin rowed, and iridescent, evanescent gleams chasing in the wake. He was aware, too, of his own delicately coloured lights casting their softness behind him.

Gudrun rested her paddle and looked round. The canoe lifted with the lightest ebbing of the water. Gerald's white knees were very near to her.

'Isn't it beautiful!' she said softly, as if reverently.

She looked at him, as he leaned back against the faint crystal of the lantern-light. She could see his face, although it was a pure shadow. But it was a piece of twilight. And her breast was keen with passion for him, he was so beautiful in his male stillness and mystery. It was a certain pure effluence of maleness, like an aroma from his softly, firmly moulded contours, a certain rich perfection of his presence, that touched her with an ecstasy, a thrill of pure intoxication. She loved to look at him. For the present she did not want to touch him, to know the further, satisfying substance of his living body. He was purely intangible, yet so near. Her hands lay on the paddle like slumber, she only wanted to see him, like a crystal shadow, to feel his essential presence.

'Yes,' he said vaguely. 'It is very beautiful.'

He was listening to the faint near sounds, the dropping of waterdrops from the oar-blades, the slight drumming of the lanterns behind him, as they rubbed against one another, the occasional rustling of Gudrun's full skirt, an alien land noise. His mind was almost submerged, he was almost transfused, lapsed out for the first time in his life, into the things about him. For he always kept such a keen attentiveness, concentrated and unyielding in himself. Now he had let go, imperceptibly he was melting into oneness with the whole. It was like pure, perfect sleep, his first great sleep of life. He had been so insistent, so guarded, all his life. But here was sleep, and peace, and perfect lapsing out.

'Shall I row to the landing-stage?' asked Gudrun wistfully.

'Anywhere,' he answered. 'Let it drift.'

'Tell me then, if we are running into anything,' she replied, in that very quiet, toneless voice of sheer intimacy.

'The lights will show,' he said.

So they drifted almost motionless, in silence. He wanted silence, pure and whole. But she was uneasy yet for some word, for some assurance.

'Nobody will miss you?' she asked, anxious for some communication. 'Miss me?' he echoed. 'No! Why?'

'I wondered if anybody would be looking for you.'

'Why should they look for me?' And then he remembered his manners. 'But perhaps you want to get back,' he said, in a changed voice.

'No, I don't want to get back,' she replied. 'No, I assure you.'

'You're quite sure it's all right for you?'

'Perfectly all right.'

And again they were still. The launch twanged and hooted, somebody was singing. Then as if the night smashed, suddenly there was a great shout, a confusion of shouting, warring on the water, then the horrid noise of paddles reversed and churned violently.

Gerald sat up, and Gudrun looked at him in fear.

'Somebody in the water,' he said, angrily, and desperately, looking keenly across the dusk. 'Can you row up?'

'Where, to the launch?' asked Gudrun, in nervous panic.

'Yes.'

'You'll tell me if I don't steer straight,' she said, in nervous apprehension.

'You keep pretty level,' he said, and the canoe hastened forward.

The shouting and the noise continued, sounding horrid through the dusk, over the surface of the water.

'Wasn't this *bound* to happen?' said Gudrun, with heavy hateful irony. But he hardly heard, and she glanced over her shoulder to see her way. The half-dark waters were sprinkled with lovely bubbles of swaying lights, the launch did not look far off. She was rocking her lights in the early night. Gudrun rowed as hard as she could. But now that it was a serious matter, she seemed uncertain and clumsy in her stroke, it was difficult to paddle swiftly. She glanced at his face. He was looking fixedly into the darkness, very keen and alert and single in himself, instrumental. Her heart sank, she seemed to die a death. 'Of course,' she said to herself, 'nobody will be drowned. Of course they won't. It would be too extravagant and sensational.' But her heart was cold, because of his sharp impersonal face. It was as if he belonged naturally to dread and catastrophe, as if he were himself again.

Then there came a child's voice, a girl's high, piercing shriek:

'Di - Di - Di - Di - Oh Di - Oh Di - Oh Di!'

The blood ran cold in Gudrun's veins.

'It's Diana, is it,' muttered Gerald. 'The young monkey, she'd have to be up to some of her tricks.'

And he glanced again at the paddle, the boat was not going quickly enough for him. It made Gudrun almost helpless at the rowing, this nervous stress. She kept up with all her might. Still the voices were calling and answering.

'Where, where? There you are – that's it. Which? No – No-o-o. Damn it all, here, *bere* – ' Boats were hurrying from all directions to the scene, coloured lanterns could be seen waving close to the surface of the lake, reflections swaying after them in uneven haste. The steamer hooted again, for some unknown reason. Gudrun's boat was travelling quickly, the lanterns were swinging behind Gerald.

And then again came the child's high, screaming voice, with a note of weeping and impatience in it now:

'Di - Oh Di - Oh Di - Di - !'

It was a terrible sound, coming through the obscure air of the evening.

'You'd be better if you were in bed, Winnie,' Gerald muttered to himself.

He was stooping unlacing his shoes, pushing them off with the foot. Then he threw his soft hat into the bottom of the boat.

'You can't go into the water with your hurt hand,' said Gudrun, panting, in a low voice of horror.

'What? It won't hurt.'

He had struggled out of his jacket, and had dropped it between his feet. He sat bare-headed, all in white now. He felt the belt at his waist. They were nearing the launch, which stood still big above them, her myriad lamps making lovely darts, and sinuous running tongues of ugly red and green and yellow light on the lustrous dark water, under the shadow.

'Oh get her out! Oh Di, *darling!* Oh get her out! Oh Daddy, Oh Daddy!' moaned the child's voice, in distraction. Somebody was in the water, with a life belt. Two boats paddled near, their lanterns swinging ineffectually, the boats nosing round.

'Hi there - Rockley! - hi there!'

'Mr Gerald!' came the captain's terrified voice. 'Miss Diana's in the water.'

'Anybody gone in for her?' came Gerald's sharp voice.

'Young Doctor Brindell, sir.'

'Where?'

'Can't see no signs of them, sir. Everybody's looking, but there's nothing so far.'

There was a moment's ominous pause.

'Where did she go in?'

'I think – about where that boat is,' came the uncertain answer, 'that one with red and green lights.'

'Row there,' said Gerald quietly to Gudrun.

'Get her out, Gerald, oh get her out,' the child's voice was crying anxiously. He took no heed.

'Lean back that way,' said Gerald to Gudrun, as he stood up in the frail boat. 'She won't upset.'

In another moment, he had dropped clean down, soft and plumb, into the water. Gudrun was swaying violently in her boat, the agitated water shook with transient lights, she realised that it was faintly moonlight, and that he was gone. So it was possible to be gone. A terrible sense of fatality robbed her of all feeling and thought. She knew he was gone out of the world, there was merely the same world, and absence, his absence. The night seemed large and vacuous. Lanterns swayed here and there, people were talking in an undertone on the launch and in the boats. She could hear Winifred moaning: 'Ob do find her Gerald, do find her,' and someone trying to comfort the child. Gudrun paddled aimlessly here and there. The terrible, massive, cold, boundless surface of the water terrified her beyond words. Would he never come back? She felt she must jump into the water too, to know the horror also.

She started, hearing someone say: 'There he is.' She saw the movement of his swimming, like a water-rat. And she rowed involuntarily to him. But he was near another boat, a bigger one. Still she

rowed towards him. She must be very near. She saw him – he looked like a seal. He looked like a seal as he took hold of the side of the boat. His fair hair was washed down on his round head, his face seemed to glisten suavely. She could hear him panting.

Then he clambered into the boat. Oh, and the beauty of the subjection of his loins, white and dimly luminous as be climbed over the side of the boat, made her want to die, to die. The beauty of his dim and luminous loins as be climbed into the boat, his back rounded and soft – ah, this was too much for her, too final a vision. She knew it, and it was fatal. The terrible hopelessness of fate, and of beauty, such beauty!

He was not like a man to her, he was an incarnation, a great phase of life. She saw him press the water out of his face, and look at the bandage on his hand. And she knew it was all no good, and that she would never go beyond him, he was the final approximation of life to her.

'Put the lights out, we shall see better,' came his voice, sudden and mechanical and belonging to the world of man. She could scarcely believe there was a world of man. She leaned round and blew out her lanterns. They were difficult to blow out. Everywhere the lights were gone save the coloured points on the sides of the launch. The blueygrey, early night spread level around, the moon was overhead, there were shadows of boats here and there.

Again there was a splash, and he was gone under. Gudrun sat, sick at heart, frightened of the great, level surface of the water, so heavy and deadly. She was so alone, with the level, unliving field of the water stretching beneath her. It was not a good isolation, it was a terrible, cold separation of suspense. She was suspended upon the surface of the insidious reality until such time as she also should disappear beneath it.

Then she knew, by a stirring of voices, that he had climbed out again, into a boat. She sat wanting connection with him. Strenuously she claimed her connection with him, across the invisible space of the water. But round her heart was an isolation unbearable, through which nothing would penetrate.

'Take the launch in. It's no use keeping her there. Get lines for the dragging,' came the decisive, instrumental voice, that was full of the sound of the world.

The launch began gradually to beat the waters.

'Gerald! Gerald!' came the wild crying voice of Winifred. He did not answer. Slowly the launch drifted round in a pathetic, clumsy circle, and slunk away to the land, retreating into the dimness. The wash of her paddles grew duller. Gudrun rocked in her light boat, and dipped the paddle automatically to steady herself.

156

'Gudrun?' called Ursula's voice.

'Ursula!'

The boats of the two sisters pulled together.

'Where is Gerald?' said Gudrun.

'He's dived again,' said Ursula plaintively. 'And I know he ought not, with his hurt hand and everything.'

'I'll take him in home this time,' said Birkin.

The boats swayed again from the wash of steamer. Gudrun and Ursula kept a look-out for Gerald.

'There he is!' cried Ursula, who had the sharpest eyes. He had not been long under. Birkin pulled towards him, Gudrun following. He swam slowly, and caught hold of the boat with his wounded hand. It slipped, and he sank back.

'Why don't you help him?' cried Ursula sharply.

He came again, and Birkin leaned to help him in to the boat. Gudrun again watched Gerald climb out of the water, but this time slowly, heavily, with the blind clambering motions of an amphibious beast, clumsy. Again the moon shone with faint luminosity on his white wet figure, on the stooping back and the rounded loins. But it looked defeated now, his body, it clambered and fell with slow clumsiness. He was breathing hoarsely too, like an animal that is suffering. He sat slack and motionless in the boat, his head blunt and blind like a seal's, his whole appearance inhuman, unknowing. Gudrun shuddered as she mechanically followed his boat. Birkin rowed without speaking to the landing-stage.

'Where are you going?' Gerald asked suddenly, as if just waking up.

'Home,' said Birkin.

'Oh no!' said Gerald imperiously. 'We can't go home while they're in the water. Turn back again, I'm going to find them.' The women were frightened, his voice was so imperative and dangerous, almost mad, not to be opposed.

'No!' said Birkin. 'You can't.' There was a strange fluid compulsion in his voice. Gerald was silent in a battle of wills. It was as if he would kill the other man. But Birkin rowed evenly and unswerving, with an inhuman inevitability.

'Why should you interfere?' said Gerald, in hate.

Birkin did not answer. He rowed towards the land. And Gerald sat mute, like a dumb beast, panting, his teeth chattering, his arms inert, his head like a seal's head.

They came to the landing-stage. Wet and naked-looking, Gerald climbed up the few steps. There stood his father, in the night.

'Father!' he said.

'Yes my boy? Go home and get those things off.'

'We shan't save them, father,' said Gerald.

'There's hope yet, my boy.'

'I'm afraid not. There's no knowing where they are. You can't find them. And there's a current, as cold as hell.'

'We'll let the water out,' said the father. 'Go home you and look to yourself. See that he's looked after, Rupert,' he added in a neutral voice.

'Well father, I'm sorry. I'm sorry. I'm afraid it's my fault. But it can't be helped; I've done what I could for the moment. I could go on diving, of course – not much, though – and not much use – '

He moved away barefoot, on the planks of the platform. Then he trod on something sharp.

'Of course, you've got no shoes on,' said Birkin.

'His shoes are here!' cried Gudrun from below. She was making fast her boat.

Gerald waited for them to be brought to him. Gudrun came with them. He pulled them on his feet.

'If you once die,' he said, 'then when it's over, it's finished. Why come to life again? There's room under that water there for thousands.'

'Two is enough,' she said murmuring.

He dragged on his second shoe. He was shivering violently, and his jaw shook as he spoke.

'That's true,' he said, 'maybe. But it's curious how much room there seems, a whole universe under there; and as cold as hell, you're as helpless as if your head was cut off.' He could scarcely speak, he shook so violently. 'There's one thing about our family, you know,' he continued. 'Once anything goes wrong, it can never be put right again – not with us. I've noticed it all my life – you can't put a thing right, once it has gone wrong.'

They were walking across the high-road to the house.

'And do you know, when you are down there, it is so cold, actually, and so endless, so different really from what it is on top, so endless – you wonder how it is so many are alive, why we're up here. Are you going? I shall see you again, shan't I? Good-night, and thank you. Thank you very much!'

The two girls waited a while, to see if there were any hope. The moon shone clearly overhead, with almost impertinent brightness, the small dark boats clustered on the water, there were voices and subdued shouts. But it was all to no purpose. Gudrun went home when Birkin returned. He was commissioned to open the sluice that let out the water from the lake, which was pierced at one end, near the high-road, thus serving as a reservoir to supply with water the distant mines, in case of necessity. 'Come with me,' he said to Ursula, 'and then I will walk home with you, when I've done this.'

He called at the water-keeper's cottage and took the key of the sluice. They went through a little gate from the high-road, to the head of the water, where was a great stone basin which received the overflow, and a flight of stone steps descended into the depths of the water itself. At the head of the steps was the lock of the sluice-gate.

The night was silver-grey and perfect, save for the scattered restless sound of voices. The grey sheen of the moonlight caught the stretch of water, dark boats plashed and moved. But Ursula's mind ceased to be receptive, everything was unimportant and unreal.

Birkin fixed the iron handle of the sluice, and turned it with a wrench. The cogs began slowly to rise. He turned and turned, like a slave, his white figure became distinct. Ursula looked away. She could not bear to see him winding heavily and laboriously, bending and rising mechanically like a slave, turning the handle.

Then, a real shock to her, there came a loud splashing of water from out of the dark, tree-filled hollow beyond the road, a splashing that deepened rapidly to a harsh roar, and then became a heavy, booming noise of a great body of water falling solidly all the time. It occupied the whole of the night, this great steady booming of water, everything was drowned within it, drowned and lost. Ursula seemed to have to struggle for her life. She put her hands over her ears, and looked at the high bland moon.

'Can't we go now?' she cried to Birkin, who was watching the water on the steps, to see if it would get any lower. It seemed to fascinate him. He looked at her and nodded.

The little dark boats had moved nearer, people were crowding curiously along the hedge by the high-road, to see what was to be seen. Birkin and Ursula went to the cottage with the key, then turned their backs on the lake. She was in great haste. She could not bear the terrible crushing boom of the escaping water.

'Do you think they are dead?' she cried in a high voice, to make herself heard.

'Yes,' he replied.

'Isn't it horrible!'

He paid no heed. They walked up the hill, further and further away from the noise.

'Do you mind very much?' she asked him.

'I don't mind about the dead,' he said, 'once they are dead. The worst of it is, they cling on to the living, and won't let go.'

She pondered for a time.

'Yes,' she said. 'The *fact* of death doesn't really seem to matter much, does it?'

'No,' he said. 'What does it matter if Diana Crich is alive or dead?' 'Doesn't it?' she said, shocked.

'No, why should it? Better she were dead – she'll be much more real. She'll be positive in death. In life she was a fretting, negated thing.'

'You are rather horrible,' murmured Ursula.

'No! I'd rather Diana Crich were dead. Her living somehow, was all wrong. As for the young man, poor devil – he'll find his way out quickly instead of slowly. Death is all right – nothing better.'

'Yet you don't want to die,' she challenged him.

He was silent for a time. Then he said, in a voice that was frightening to her in its change:

'I should like to be through with it – I should like to be through with the death process.'

'And aren't you?' asked Ursula nervously.

They walked on for some way in silence, under the trees. Then he said, slowly, as if afraid:

'There is life which belongs to death, and there is life which isn't death. One is tired of the life that belongs to death – our kind of life. But whether it is finished, God knows. I want love that is like sleep, like being born again, vulnerable as a baby that just comes into the world.'

Ursula listened, half attentive, half avoiding what he said. She seemed to catch the drift of his statement, and then she drew away. She wanted to hear, but she did not want to be implicated. She was reluctant to yield there, where he wanted her, to yield as it were her very identity.

'Why should love be like sleep?' she asked sadly.

'I don't know. So that it is like death - I do want to die from this life - and yet it is more than life itself. One is delivered over like a naked infant from the womb, all the old defences and the old body gone, and new air around one, that has never been breathed before.'

She listened, making out what he said. She knew, as well as he knew, that words themselves do not convey meaning, that they are but a gesture we make, a dumb show like any other. And she seemed to feel his gesture through her blood, and she drew back, even though her desire sent her forward.

'But,' she said gravely, 'didn't you say you wanted something that was *not* love – something beyond love?'

160

He turned in confusion. There was always confusion in speech. Yet it must be spoken. Whichever way one moved, if one were to move forwards, one must break a way through. And to know, to give utterance, was to break a way through the walls of the prison as the infant in labour strives through the walls of the womb. There is no new movement now, without the breaking through of the old body, deliberately, in knowledge, in the struggle to get out.

'I don't want love,' he said. 'I don't want to know you. I want to be gone out of myself, and you to be lost to yourself, so we are found different. One shouldn't talk when one is tired and wretched. One Hamletises, and it seems a lie. Only believe me when I show you a bit of healthy pride and insouciance. I hate myself serious.'

'Why shouldn't you be serious?' she said.

He thought for a minute, then he said, sulkily:

'I don't know.' Then they walked on in silence, at outs. He was vague and lost.

'Isn't it strange,' she said, suddenly putting her hand on his arm, with a loving impulse, 'how we always talk like this! I suppose we do love each other, in some way.'

'Oh yes,' he said; 'too much.'

She laughed almost gaily.

'You'd have to have it your own way, wouldn't you?' she teased. 'You could never take it on trust.'

He changed, laughed softly, and turned and took her in his arms, in the middle of the road.

'Yes,' he said softly.

And he kissed her face and brow, slowly, gently, with a sort of delicate happiness which surprised her extremely, and to which she could not respond. They were soft, blind kisses, perfect in their stillness. Yet she held back from them. It was like strange moths, very soft and silent, settling on her from the darkness of her soul. She was uneasy. She drew away.

'Isn't somebody coming?' she said.

So they looked down the dark road, then set off again walking towards Beldover. Then suddenly, to show him she was no shallow prude, she stopped and held him tight, hard against her, and covered his face with hard, fierce kisses of passion. In spite of his otherness, the old blood beat up in him.

'Not this, not this,' he whimpered to himself, as the first perfect mood of softness and sleep-loveliness ebbed back away from the rushing of passion that came up to his limbs and over his face as she drew him. And soon he was a perfect hard flame of passionate desire for her. Yet in the small core of the flame was an unyielding anguish of another thing. But this also was lost; he only wanted her, with an extreme desire that seemed inevitable as death, beyond question.

Then, satisfied and shattered, fulfilled and destroyed, he went home away from her, drifting vaguely through the darkness, lapsed into the old fire of burning passion. Far away, far away, there seemed to be a small lament in the darkness. But what did it matter? What did it matter, what did anything matter save this ultimate and triumphant experience of physical passion, that had blazed up anew like a new spell of life. I was becoming quite dead-alive, nothing but a word-bag,' he said in triumph, scorning his other self. Yet somewhere far off and small, the other hovered.

The men were still dragging the lake when he got back. He stood on the bank and heard Gerald's voice. The water was still booming in the night, the moon was fair, the hills beyond were elusive. The lake was sinking. There came the raw smell of the banks, in the night air.

Up at Shortlands there were lights in the windows, as if nobody had gone to bed. On the landing-stage was the old doctor, the father of the young man who was lost. He stood quite silent, waiting. Birkin also stood and watched, Gerald came up in a boat.

'You still here, Rupert?' he said. 'We can't get them. The bottom slopes, you know, very steep. The water lies between two very sharp slopes, with little branch valleys, and God knows where the drift will take you. It isn't as if it was a level bottom. You never know where you are, with the dragging.'

'Is there any need for you to be working?' said Birkin. 'Wouldn't it be much better if you went to bed?'

'To bed! Good God, do you think I should sleep? We'll find 'em, before I go away from here.'

'But the men would find them just the same without you - why should you insist?'

Gerald looked up at him. Then he put his hand affectionately on Birkin's shoulder, saying:

'Don't you bother about me, Rupert. If there's anybody's health to think about, it's yours, not mine. How do you feel yourself?'

'Very well. But you, you spoil your own chance of life – you waste your best self.'

Gerald was silent for a moment. Then he said:

'Waste it? What else is there to do with it?'

'But leave this, won't you? You force yourself into horrors, and put a mill-stone of beastly memories round your neck. Come away now.'

'A mill-stone of beastly memories!' Gerald repeated. Then he put his

hand again affectionately on Birkin's shoulder. 'God, you've got such a telling way of putting things, Rupert, you have.'

Birkin's heart sank. He was irritated and weary of having a telling way of putting things.

'Won't you leave it? Come over to my place'- he urged as one urges a drunken man.

'No,' said Gerald coaxingly, his arm across the other man's shoulder. 'Thanks very much, Rupert – I shall be glad to come tomorrow, if that'll do. You understand, don't you? I want to see this job through. But I'll come tomorrow, right enough. Oh, I'd rather come and have a chat with you than – than do anything else, I verily believe. Yes, I would. You mean a lot to me, Rupert, more than you know.'

'What do I mean, more than I know?' asked Birkin irritably. He was acutely aware of Gerald's hand on his shoulder. And he did not want this altercation. He wanted the other man to come out of the ugly misery.

'I'll tell you another time,' said Gerald coaxingly.

'Come along with me now - I want you to come,' said Birkin.

There was a pause, intense and real. Birkin wondered why his own heart beat so heavily. Then Gerald's fingers gripped hard and communicative into Birkin's shoulder, as he said:

'No, I'll see this job through, Rupert. Thank you – I know what you mean. We're all right, you know, you and me.'

'I may be all right, but I'm sure you're not, mucking about here,' said Birkin. And he went away.

The bodies of the dead were not recovered till towards dawn. Diana had her arms tight round the neck of the young man, choking him.

'She killed him,' said Gerald.

The moon sloped down the sky and sank at last. The lake was sunk to quarter size, it had horrible raw banks of clay, that smelled of raw rottenish water. Dawn roused faintly behind the eastern hill. The water still boomed through the sluice.

As the birds were whistling for the first morning, and the hills at the back of the desolate lake stood radiant with the new mists, there was a straggling procession up to Shortlands, men bearing the bodies on a stretcher, Gerald going beside them, the two grey-bearded fathers following in silence. Indoors the family was all sitting up, waiting. Somebody must go to tell the mother, in her room. The doctor in secret struggled to bring back his son, till he himself was exhausted.

Over all the outlying district was a hush of dreadful excitement on that Sunday morning. The colliery people felt as if this catastrophe had happened directly to themselves, indeed they were more shocked and frightened than if their own men had been killed. Such a tragedy in Shortlands, the high home of the district! One of the young mistresses, persisting in dancing on the cabin roof of the launch, wilful young madam, drowned in the midst of the festival, with the young doctor! Everywhere on the Sunday morning, the colliers wandered about, discussing the calamity. At all the Sunday dinners of the people, there seemed a strange presence. It was as if the angel of death were very near, there was a sense of the supernatural in the air. The men had excited, startled faces, the women looked solemn, some of them had been crying. The children enjoyed the excitement at first. There was an intensity in the air, almost magical. Did all enjoy it? Did all enjoy the thrill?

Gudrun had wild ideas of rushing to comfort Gerald. She was thinking all the time of the perfect comforting, reassuring thing to say to him. She was shocked and frightened, but she put that away, thinking of how she should deport herself with Gerald: act her part. That was the real thrill: how she should act her part.

Ursula was deeply and passionately in love with Birkin, and she was capable of nothing. She was perfectly callous about all the talk of the accident, but her estranged air looked like trouble. She merely sat by herself, whenever she could, and longed to see him again. She wanted him to come to the house, – she would not have it otherwise, he must come at once. She was waiting for him. She stayed indoors all day, waiting for him to knock at the door. Every minute, she glanced automatically at the window. He would be there.

CHAPTER XV

Sunday Evening

As THE DAY wore on, the life-blood seemed to ebb away from Ursula, and within the emptiness a heavy despair gathered. Her passion seemed to bleed to death, and there was nothing. She sat suspended in a state of complete nullity, harder to bear than death.

'Unless something happens,' she said to herself, in the perfect lucidity of final suffering, 'I shall die. I am at the end of my line of life.'

She sat crushed and obliterated in a darkness that was the border of death. She realised how all her life she had been drawing nearer and nearer to this brink, where there was no beyond, from which one had to leap like Sappho⁶⁰ into the unknown. The knowledge of the imminence of death was like a drug. Darkly, without thinking at all, she

knew that she was near to death. She had travelled all her life along the line of fulfilment, and it was nearly concluded. She knew all she had to know, she had experienced all she had to experience, she was fulfilled in a kind of bitter ripeness, there remained only to fall from the tree into death. And one must fulfil one's development to the end, must carry the adventure to its conclusion. And the next step was over the border into death. So it was then! There was a certain peace in the knowledge.

After all, when one was fulfilled, one was happiest in falling into death, as a bitter fruit plunges in its ripeness downwards. Death is a great consummation, a consummating experience. It is a development from life. That we know, while we are yet living. What then need we think for further? One can never see beyond the consummation. It is enough that death is a great and conclusive experience. Why should we ask what comes after the experience, when the experience is still unknown to us? Let us die, since the great experience is the one that follows now upon all the rest, death, which is the next great crisis in front of which we have arrived. If we wait, if we baulk the issue, we do but hang about the gates in undignified uneasiness. There it is, in front of us, as in front of Sappho, the illimitable space. Thereinto goes the journey. Have we not the courage to go on with our journey, must we cry 'I daren't'? On ahead we will go, into death, and whatever death may mean. If a man can see the next step to be taken, why should he fear the next but one? Why ask about the next but one? Of the next step we are certain. It is the step into death.

'I shall die – I shall quickly die,' said Ursula to herself, clear as if in a trance, clear, calm, and certain beyond human certainty. But somewhere behind, in the twilight, there was a bitter weeping and a hopelessness. That must not be attended to. One must go where the unfaltering spirit goes, there must be no baulking the issue, because of fear. No baulking the issue, no listening to the lesser voices. If the deepest desire be now, to go on into the unknown of death, shall one forfeit the deepest truth for one more shallow?

'Then let it end,' she said to herself. It was a decision. It was not a question of taking one's life – she would *never* kill herself, that was repulsive and violent. It was a question of *knowing* the next step. And the next step led into the space of death. Did it? – or was there –?

Her thoughts drifted into unconsciousness, she sat as if asleep beside the fire. And then the thought came back. The space o' death! Could she give herself to it? Ah yes – it was a sleep. She had had enough. So long she had held out; and resisted. Now was the time to relinquish, not to resist any more.

In a kind of spiritual trance, she yielded, she gave way, and all was

dark. She could feel, within the darkness, the terrible assertion of her body, the unutterable anguish of dissolution, the only anguish that is too much, the far-off, awful nausea of dissolution set in within the body.

'Does the body correspond so immediately with the spirit?' she asked herself. And she knew, with the clarity of ultimate knowledge, that the body is only one of the manifestations of the spirit, the transmutation of the integral spirit is the transmutation of the physical body as well. Unless I set my will, unless I absolve myself from the rhythm of life, fix myself and remain static, cut off from living, absolved within my own will. But better die than live mechanically a life that is a repetition of repetitions. To die is to move on with the invisible. To die is also a joy, a joy of submitting to that which is greater than the known, namely, the pure unknown. That is a joy. But to live mechanised and cut off within the motion of the will, to live as an entity absolved from the unknown, that is shameful and ignominious. There is no ignominy in death. There is complete ignominy in an unreplenished, mechanised life. Life indeed may be ignominious, shameful to the soul. But death is never a shame. Death itself, like the illimitable space, is beyond our sullying.

Tomorrow was Monday. Monday, the beginning of another schoolweek! Another shameful, barren school-week, mere routine and mechanical activity. Was not the adventure of death infinitely preferable? Was not death infinitely more lovely and noble than such a life? A life of barren routine, without inner meaning, without any real significance. How sordid life was, how it was a terrible shame to the soul, to live now! How much cleaner and more dignified to be dead! One could not bear any more of this shame of sordid routine and mechanical nullity. One might come to fruit in death. She had had enough. For where was life to be found? No flowers grow upon busy machinery, there is no sky to a routine, there is no space to a rotary motion. And all life was a rotary motion, mechanised, cut off from reality. There was nothing to look for from life - it was the same in all countries and all peoples. The only window was death. One could look out on to the great dark sky of death with elation, as one had looked out of the classroom window as a child, and seen perfect freedom in the outside. Now one was not a child, and one knew that the soul was a prisoner within this sordid vast edifice of life, and there was no escape, save in death.

But what a joy! What a gladness to think that whatever humanity did, it could not seize hold of the kingdom of death, to nullify that. The sea they turned into a murderous alley and a soiled road of commerce, disputed like the dirty land of a city every inch of it. The air they claimed too, shared it up, parcelled it out to certain owners, they trespassed in the air to fight for it. Everything was gone, walled in, with spikes on top of the walls, and one must ignominiously creep between the spiky walls through a labyrinth of life.

But the great, dark, illimitable kingdom of death, there humanity was put to scorn. So much they could do upon earth, the multifarious little gods that they were. But the kingdom of death put them all to scorn, they dwindled into their true vulgar silliness in face of it.

How beautiful, how grand and perfect death was, how good to look forward to. There one would wash off all the lies and ignominy and dirt that had been put upon one here, a perfect bath of cleanness and glad refreshment, and go unknown, unquestioned, unabased. After all, one was rich, if only in the promise of perfect death. It was a gladness above all, that this remained to look forward to, the pure inhuman otherness of death.

Whatever life might be, it could not take away death, the inhuman transcendent death. Oh, let us ask no question of it, what it is or is not. To know is human, and in death we do not know, we are not human. And the joy of this compensates for all the bitterness of knowledge and the sordidness of our humanity. In death we shall not be human, and we shall not know. The promise of this is our heritage, we look forward like heirs to their majority.

Ursula sat quite still and quite forgotten, alone by the fire in the drawing-room. The children were playing in the kitchen, all the others were gone to church. And she was gone into the ultimate darkness of her own soul.

She was startled by hearing the bell ring, away in the kitchen, the children came scudding along the passage in delicious alarm.

'Ursula, there's somebody.'

'I know. Don't be silly,' she replied. She too was startled, almost frightened. She dared hardly go to the door.

Birkin stood on the threshold, his rain-coat turned up to his ears. He had come now, now she was gone far away. She was aware of the rainy night behind him.

'Oh is it you?' she said.

'I am glad you are at home,' he said in a low voice, entering the house.

'They are all gone to church.'

He took off his coat and hung it up. The children were peeping at him round the corner.

'Go and get undressed now, Billy and Dora,' said Ursula. 'Mother will be back soon, and she'll be disappointed if you're not in bed.'

The children, in a sudden angelic mood, retired without a word. Birkin and Ursula went into the drawing-room.

The fire burned low. He looked at her and wondered at the luminous delicacy of her beauty, and the wide shining of her eyes. He watched from a distance, with wonder in his heart, she seemed transfigured with light.

'What have you been doing all day?' he asked her.

'Only sitting about,' she said.

He looked at her. There was a change in her. But she was separate from him. She remained apart, in a kind of brightness. They both sat silent in the soft light of the lamp. He felt he ought to go away again, he ought not to have come. Still he did not gather enough resolution to move. But he was *de trop*, her mood was absent and separate.

Then there came the voices of the two children calling shyly outside the door, softly, with self-excited timidity:

'Ursula! Ursula!'

She rose and opened the door. On the threshold stood the two children in their long nightgowns, with wide-eyed, angelic faces. They were being very good for the moment, playing the rôle perfectly of two obedient children.

'Shall you take us to bed!' said Billy, in a loud whisper.

'Why you *are* angels tonight,' she said softly. 'Won't you come and say good-night to Mr Birkin?'

The children merged shyly into the room, on bare feet. Billy's face was wide and grinning, but there was a great solemnity of being good in his round blue eyes. Dora, peeping from the floss of her fair hair, hung back like some tiny Dryad, that has no soul.

'Will you say good-night to me?' asked Birkin, in a voice that was strangely soft and smooth. Dora drifted away at once, like a leaf lifted on a breath of wind. But Billy went softly forward, slow and willing, lifting his pinched-up mouth implicitly to be kissed. Ursula watched the full, gathered lips of the man gently touch those of the boy, so gently. Then Birkin lifted his fingers and touched the boy's round, confiding cheek, with a faint touch of love. Neither spoke. Billy seemed angelic like a cherub boy, or like an acolyte, Birkin was a tall, grave angel looking down to him.

'Are you going to be kissed?' Ursula broke in, speaking to the little girl. But Dora edged away like a tiny Dryad that will not be touched.

'Won't you say good-night to Mr Birkin? Go, he's waiting for you,' said Ursula. But the girl-child only made a little motion away from him.

'Silly Dora, silly Dora!' said Ursula.

Birkin felt some mistrust and antagonism in the small child. He

could not understand it.

'Come then,' said Ursula. 'Let us go before mother comes.' 'Who'll hear us say our prayers?' asked Billy anxiously.

'Whom you like.'

'Won't you?'

'Yes, I will.'

'Ursula?'

'Well Billy?'

'Is it whom you like?'

'That's it.'

'Well what is whom?'

'It's the accusative of who.'

There was a moment's contemplative silence, then the confiding: 'Is it?'

Birkin smiled to himself as he sat by the fire. When Ursula came down he sat motionless, with his arms on his knees. She saw him, how he was motionless and ageless, like some crouching idol, some image of a deathly religion. He looked round at her, and his face, very pale and unreal, seemed to gleam with a whiteness almost phosphorescent.

'Don't you feel well?' she asked, in indefinable repulsion.

'I hadn't thought about it.'

'But don't you know without thinking about it?'

He looked at her, his eyes dark and swift, and he saw her revulsion. He did not answer her question.

'Don't you know whether you are unwell or not, without thinking about it?' she persisted.

'Not always,' he said coldly.

'But don't you think that's very wicked?'

'Wicked?'

'Yes. I think it's *criminal* to have so little connection with your own body that you don't even know when you are ill.'

He looked at her darkly.

'Yes,' he said.

'Why don't you stay in bed when you are seedy? You look perfectly ghastly.'

'Offensively so?' he asked ironically.

'Yes, quite offensive. Quite repelling.'

'Ah!! Well that's unfortunate.'

'And it's raining, and it's a horrible night. Really, you shouldn't be forgiven for treating your body like it – you *ought* to suffer, a man who takes as little notice of his body as that.'

'- takes as little notice of his body as that,' he echoed mechanically.

This cut her short, and there was silence.

The others came in from church, and the two had the girls to face, then the mother and Gudrun, and then the father and the boy.

'Good-evening,' said Brangwen, faintly surprised. 'Came to see me, did you?'

'No,' said Birkin, 'not about anything, in particular, that is. The day was dismal, and I thought you wouldn't mind if I called in.'

'It *has* been a depressing day,' said Mrs Brangwen sympathetically. At that moment the voices of the children were heard calling from upstairs: 'Mother! Mother!' She lifted her face and answered mildly into the distance: 'I shall come up to you in a minute, Doysie.' Then to Birkin: 'There is nothing fresh at Shortlands, I suppose? Ah,' she sighed, 'no, poor things, I should think not.'

'You've been over there today, I suppose?' asked the father.

'Gerald came round to tea with me, and I walked back with him. The house is overexcited and unwholesome, I thought.'

'I should think they were people who hadn't much restraint,' said Gudrun.

'Or too much,' Birkin answered.

'Oh yes, I'm sure,' said Gudrun, almost vindictively, 'one or the other.'

'They all feel they ought to behave in some unnatural fashion,' said Birkin. 'When people are in grief, they would do better to cover their faces and keep in retirement, as in the old days.'

'Certainly!' cried Gudrun, flushed and inflammable. 'What can be worse than this public grief – what is more horrible, more false! If grief is not private, and hidden, what is?'

'Exactly,' he said. 'I felt ashamed when I was there and they were all going about in a lugubrious false way, feeling they must not be natural or ordinary.'

'Well - ' said Mrs Brangwen, offended at this criticism, 'it isn't so easy to bear a trouble like that.'

And she went upstairs to the children.

He remained only a few minutes longer, then took his leave. When he was gone Ursula felt such a poignant hatred of him, that all her brain seemed turned into a sharp crystal of fine hatred. Her whole nature seemed sharpened and intensified into a pure dart of hate. She could not imagine what it was. It merely took hold of her, the most poignant and ultimate hatred, pure and clear and beyond thought. She could not think of it at all, she was translated beyond herself. It was like a possession. She felt she was possessed. And for several days she went about possessed by this exquisite force of hatred against him. It surpassed anything she had ever known before, it seemed to throw her out of the world into some terrible region where nothing of her old life held good. She was quite lost and dazed, really dead to her own life.

It was so completely incomprehensible and irrational. She did not know *wby* she hated him, her hate was quite abstract. She had only realised with a shock that stunned her, that she was overcome by this pure transportation. He was the enemy, fine as a diamond, and as hard and jewel-like, the quintessence of all that was inimical.

She thought of his face, white and purely wrought, and of his eyes that had such a dark, constant will of assertion, and she touched her own forehead, to feel if she were mad, she was so transfigured in white flame of essential hate.

It was not temporal, her hatred, she did not hate him for this or for that; she did not want to do anything to him, to have any connection with him. Her relation was ultimate and utterly beyond words, the hate was so pure and gemlike. It was as if he were a beam of essential enmity, a beam of light that did not only destroy her, but denied her altogether, revoked her whole world. She saw him as a clear stroke of uttermost contradiction, a strange gem-like being whose existence defined her own non-existence. When she heard he was ill again, her hatred only intensified itself a few degrees, if that were possible. It stunned her and annihilated her, but she could not escape it. She could not escape this transfiguration of hatred that had come upon her.

CHAPTER XVI

Man to Man

HE LAY sick and unmoved, in pure opposition to everything. He knew how near to breaking was the vessel that held his life. He knew also how strong and durable it was. And he did not care. Better a thousand times take one's chance with death, than accept a life one did not want. But best of all to persist and persist and persist for ever, till one were satisfied in life.

He knew that Ursula was referred back to him. He knew his life rested with her. But he would rather not live than accept the love she proffered. The old way of love seemed a dreadful bondage, a sort of conscription. What it was in him he did not know, but the thought of love, marriage, and children, and a life lived together, in the horrible privacy of domestic and connubial satisfaction, was repulsive. He wanted something clearer, more open, cooler, as it were. The hot

narrow intimacy between man and wife was abhorrent. The way they shut their doors, these married people, and shut themselves in to their own exclusive alliance with each other, even in love, disgusted him. It was a whole community of mistrustful couples insulated in private houses or private rooms, always in couples, and no further life, no further immediate, no disinterested relationship admitted: a kaleidoscope of couples, disjoined, separatist, meaningless entities of married couples. True, he hated promiscuity even worse than marriage, and a liaison was only another kind of coupling, reactionary from the legal marriage. Reaction was a greater bore than action.

On the whole, he hated sex, it was such a limitation. It was sex that turned a man into a broken half of a couple, the woman into the other broken half. And he wanted to be single in himself, the woman single in herself. He wanted sex to revert to the level of the other appetites, to be regarded as a functional process, not as a fulfilment. He believed in sex marriage. But beyond this, he wanted a further conjunction, where man had being and woman had being, two pure beings, each constituting the freedom of the other, balancing each other like two poles of one force, like two angels, or two demons.

He wanted so much to be free, not under the compulsion of any need for unification, or tortured by unsatisfied desire. Desire and aspiration should find their object without all this torture, as now, in a world of plenty of water, simple thirst is inconsiderable, satisfied almost unconsciously. And he wanted to be with Ursula as free as with himself, single and clear and cool, yet balanced, polarised with her. The merging, the clutching, the mingling of love was become madly abhorrent to him.

But it seemed to him, woman was always so horrible and clutching, she had such a lust for possession, a greed of self-importance in love. She wanted to have, to own, to control, to be dominant. Everything must be referred back to her, to Woman, the Great Mother of everything, out of whom proceeded everything and to whom everything must finally be rendered up.

It filled him with almost insane fury, this calm assumption of the Magna Mater, that all was hers, because she had borne it. Man was hers because she had borne him. A Mater Dolorosa, she had borne him, a Magna Mater, she now claimed him again, soul and body, sex, meaning, and all. He had a horror of the Magna Mater, she was detestable.⁶¹

She was on a very high horse again, was woman, the Great Mother. Did he not know it in Hermione. Hermione, the humble, the subservient, what was she all the while but the Mater Dolorosa, in her

subservience, claiming with horrible, insidious arrogance and female tyranny, her own again, claiming back the man she had borne in suffering. By her very suffering and humility she bound her son with chains, she held him her everlasting prisoner.

And Ursula, Ursula was the same – or the inverse. She too was the awful, arrogant queen of life, as if she were a queen bee on whom all the rest depended. He saw the yellow flare in her eyes, he knew the unthinkable overweening assumption of primacy in her. She was unconscious of it herself. She was only too ready to knock her head on the ground before a man. But this was only when she was so certain of her man, that she could worship him as a woman worships her own infant, with a worship of perfect possession.

It was intolerable, this possession at the hands of woman. Always a man must be considered as the broken off fragment of a woman, and the sex was the still aching scar of the laceration. Man must be added on to a woman, before he had any real place or wholeness.

And why? Why should we consider ourselves, men and women, as broken fragments of one whole? It is not true. We are not broken fragments of one whole. Rather we are the singling away into purity and clear being, of things that were mixed. Rather the sex is that which remains in us of the mixed, the unresolved. And passion is the further separating of this mixture, that which is manly being taken into the being of the man, that which is womanly passing to the woman, till the two are clear and whole as angels, the admixture of sex in the highest sense surpassed, leaving two single beings constellated together like two stars.

In the old age, before sex was, we were mixed, each one a mixture. The process of singling into individuality resulted into the great polarisation of sex. The womanly drew to one side, the manly to the other. But the separation was imperfect even them. And so our worldcycle passes. There is now to come the new day, when we are beings each of us, fulfilled in difference. The man is pure man, the woman pure woman, they are perfectly polarised. But there is no longer any of the horrible merging, mingling self-abnegation of love. There is only the pure duality of polarisation, each one free from any contamination of the other. In each, the individual is primal, sex is subordinate, but perfectly polarised. Each has a single, separate being, with its own laws. The man has his pure freedom, the woman hers. Each acknowledges the perfection of the polarised sex-circuit. Each admits the different nature in the other.

So Birkin meditated whilst he was ill. He liked sometimes to be ill enough to take to his bed. For then he got better very quickly, and things came to him clear and sure.

Whilst he was laid up, Gerald came to see him. The two men had a deep, uneasy feeling for each other. Gerald's eyes were quick and restless, his whole manner tense and impatient, he seemed strung up to some activity. According to conventionality, he wore black clothes, he looked formal, handsome and *comme il faut*. His hair was fair almost to whiteness, sharp like splinters of light, his face was keen and ruddy, his body seemed full of northern energy. Gerald really loved Birkin, though he never quite believed in him. Birkin was too unreal; – clever, whimsical, wonderful, but not practical enough. Gerald felt that his own understanding was much sounder and safer. Birkin was delightful, a wonderful spirit, but after all, not to be taken seriously, not quite to be counted as a man among men.

'Why are you laid up again?' he asked kindly, taking the sick man's hand. It was always Gerald who was protective, offering the warm shelter of his physical strength.

'For my sins, I suppose,' Birkin said, smiling a little ironically.

'For your sins? Yes, probably that is so. You should sin less, and keep better in health?'

'You'd better teach me.'

He looked at Gerald with ironic eyes.

'How are things with you?' asked Birkin.

'With me?' Gerald looked at Birkin, saw he was serious, and a warm light came into his eyes.

'I don't know that they're any different. I don't see how they could be. There's nothing to change.'

'I suppose you are conducting the business as successfully as ever, and ignoring the demand of the soul.'

'That's it,' said Gerald. 'At least as far as the business is concerned. I couldn't say about the soul, I'm sure.'

'No.'

'Surely you don't expect me to?' laughed Gerald.

'No. How are the rest of your affairs progressing, apart from the business?'

'The rest of my affairs? What are those? I couldn't say; I don't know what you refer to.'

'Yes, you do,' said Birkin. 'Are you gloomy or cheerful? And what about Gudrun Brangwen?'

'What about her?' A confused look came over Gerald. 'Well,' he added, 'I don't know. I can only tell you she gave me a hit over the face last time I saw her.'

'A hit over the face! What for?'

'That I couldn't tell you, either.'

'Really! But when?'

'The night of the party – when Diana was drowned. She was driving the cattle up the hill, and I went after her – you remember.'

'Yes, I remember. But what made her do that? You didn't definitely ask her for it, I suppose?'

'I? No, not that I know of. I merely said to her, that it was dangerous to drive those Highland bullocks – as it *is*. She turned in such a way, and said – "I suppose you think I'm afraid of you and your cattle, don't you?" So I asked her "why," and for answer she flung me a back-hander across the face.'

Birkin laughed quickly, as if it pleased him. Gerald looked at him, wondering, and began to laugh as well, saying:

'I didn't laugh at the time, I assure you. I was never so taken aback in my life.'

'And weren't you furious?'

'Furious? I should think I was. I'd have murdered her for two pins.'

'H'm!' ejaculated Birkin. 'Poor Gudrun, wouldn't she suffer afterwards for having given herself away!' He was hugely delighted.

'Would she suffer?' asked Gerald, also amused now.

Both men smiled in malice and amusement.

'Badly, I should think; seeing how self-conscious she is.'

'She is self-conscious, is she? Then what made her do it? For I certainly think it was quite uncalled-for, and quite unjustified.'

'I suppose it was a sudden impulse.'

'Yes, but how do you account for her having such an impulse? I'd done her no harm.'

Birkin shook his head.

'The Amazon⁶² suddenly came up in her, I suppose,' he said.

'Well,' replied Gerald, 'I'd rather it had been the Orinoco.'

They both laughed at the poor joke. Gerald was thinking how Gudrun had said she would strike the last blow too. But some reserve made him keep this back from Birkin.

'And you resent it?' Birkin asked.

'I don't resent it. I don't care a tinker's curse about it.' He was silent a moment, then he added, laughing, 'No, I'll see it through, that's all. She seemed sorry afterwards.'

'Did she? You've not met since that night?'

Gerald's face clouded.

'No,' he said. 'We've been – you can imagine how it's been, since the accident.'

'Yes. Is it calming down?'

'I don't know. It's a shock, of course. But I don't believe mother minds. I really don't believe she takes any notice. And what's so funny, she used to be all for the children – nothing mattered, nothing whatever mattered but the children. And now, she doesn't take any more notice than if it was one of the servants.'

'No? Did it upset you very much?'

'It's a shock. But I don't feel it very much, really. I don't feel any different. We've all got to die, and it doesn't seem to make any great difference, anyhow, whether you die or not. I can't feel any *grief* you know. It leaves me cold. I can't quite account for it.'

'You don't care if you die or not?' asked Birkin.

Gerald looked at him with eyes blue as the blue-fibred steel of a weapon. He felt awkward, but indifferent. As a matter of fact, he did care terribly, with a great fear.

'Oh,' he said, 'I don't want to die, why should I? But I never trouble. The question doesn't seem to be on the carpet for me at all. It doesn't interest me, you know.'

'*Timor mortis conturbat me*,'⁶³ quoted Birkin, adding – 'No, death doesn't really seem the point any more. It curiously doesn't concern one. It's like an ordinary tomorrow.'

Gerald looked closely at his friend. The eyes of the two men met, and an unspoken understanding was exchanged.

Gerald narrowed his eyes, his face was cool and unscrupulous as he looked at Birkin, impersonally, with a vision that ended in a point in space, strangely keen-eyed and yet blind.

'If death isn't the point,' he said, in a strangely abstract, cold, fine voice – 'what is?' He sounded as if he had been found out.

'What is?' re-echoed Birkin. And there was a mocking silence.

'There's a long way to go, after the point of intrinsic death, before we disappear,' said Birkin.

'There is,' said Gerald. 'But what sort of way?' He seemed to press the other man for knowledge which he himself knew far better than Birkin did.

'Right down the slopes of degeneration – mystic, universal degeneration. There are many stages of pure degradation to go through: agelong. We live on long after our death, and progressively, in progressive devolution.'

Gerald listened with a faint, fine smile on his face, all the time, as if, somewhere, he knew so much better than Birkin, all about this: as if his own knowledge were direct and personal, whereas Birkin's was a matter of observation and inference, not quite hitting the nail on the head: – though aiming near enough at it. But he was not going to give himself away. If Birkin could get at the secrets, let him. Gerald would never help him. Gerald would be a dark horse to the end.

'Of course,' he said, with a startling change of conversation, 'it is father who really feels it. It will finish him. For him the world collapses. All his care now is for Winnie – he must save Winnie. He says she ought to be sent away to school, but she won't hear of it, and he'll never do it. Of course she *is* in rather a queer way. We're all of us curiously bad at living. We can do things – but we can't get on with life at all. It's curious – a family failing.'

'She oughtn't to be sent away to school,' said Birkin, who was considering a new proposition.

'She oughtn't. Why?'

'She's a queer child – a special child, more special even than you. And in my opinion special children should never be sent away to school. Only moderately ordinary children should be sent to school – so it seems to me.'

'I'm inclined to think just the opposite. I think it would probably make her more normal if she went away and mixed with other children.'

'She wouldn't mix, you see. *You* never really mixed, did you? And she wouldn't be willing even to pretend to. She's proud, and solitary, and naturally apart. If she has a single nature, why do you want to make her gregarious?'

'No, I don't want to make her anything. But I think school would be good for her.'

'Was it good for you?'

Gerald's eyes narrowed uglily. School had been torture to him. Yet he had not questioned whether one should go through this torture. He seemed to believe in education through subjection and torment.

'I hated it at the time, but I can see it was necessary,' he said. 'It brought me into line a bit – and you can't live unless you do come into line somewhere.'

'Well,' said Birkin, 'I begin to think that you can't live unless you keep entirely out of the line. It's no good trying to toe the line, when your one impulse is to smash up the line. Winnie is a special nature, and for special natures you must give a special world.'

'Yes, but where's your special world?' said Gerald.

'Make it. Instead of chopping yourself down to fit the world, chop the world down to fit yourself. As a matter of fact, two exceptional people make another world. You and I, we make another, separate world. You don't *want* a world same as your brothers-in-law. It's just the special quality you value. Do you *want* to be normal or ordinary! It's a lie. You want to be free and extraordinary, in an extraordinary world of liberty.'

Gerald looked at Birkin with subtle eyes of knowledge. But he would never openly admit what he felt. He knew more than Birkin, in one direction – much more. And this gave him his gentle love for the other man, as if Birkin were in some way young, innocent, child-like: so amazingly clever, but incurably innocent.

'Yet you are so banal as to consider me chiefly a freak,' said Birkin pointedly.

'A freak!' exclaimed Gerald, startled. And his face opened suddenly, as if lighted with simplicity, as when a flower opens out of the cunning bud. 'No – I never consider you a freak.' And he watched the other man with strange eyes, that Birkin could not understand. 'I feel,' Gerald continued, 'that there is always an element of uncertainty about you – perhaps you are uncertain about yourself. But I'm never sure of you. You can go away and change as easily as if you had no soul.'

He looked at Birkin with penetrating eyes. Birkin was amazed. He thought he had all the soul in the world. He stared in amazement. And Gerald, watching, saw the amazing attractive goodliness of his eyes, a young, spontaneous goodness that attracted the other man infinitely, yet filled him with bitter chagrin, because he mistrusted it so much. He knew Birkin could do without him – could forget, and not suffer. This was always present in Gerald's consciousness, filling him with bitter unbelief: this consciousness of the young, animal-like spontaneity of detachment. It seemed almost like hypocrisy and lying, sometimes, oh, often, on Birkin's part, to talk so deeply and importantly.

Quite other things were going through Birkin's mind. Suddenly he saw himself confronted with another problem – the problem of love and eternal conjunction between two men. Of course this was necessary – it had been a necessity inside himself all his life – to love a man purely and fully. Of course he had been loving Gerald all along, and all along denying it.

He lay in the bed and wondered, whilst his friend sat beside him, lost in brooding. Each man was gone in his own thoughts.

'You know how the old German knights used to swear a *Blutbruderschaft*,'⁶⁴ he said to Gerald, with quite a new happy activity in his eyes.

'Make a little wound in their arms, and rub each other's blood into the cut?' said Gerald.

'Yes – and swear to be true to each other, of one blood, all their lives. That is what we ought to do. No wounds, that is obsolete. But we ought to swear to love each other, you and I, implicitly, and perfectly, finally, without any possibility of going back on it.'

He looked at Gerald with clear, happy eyes of discovery. Gerald looked down at him, attracted, so deeply bondaged in fascinated attraction, that he was mistrustful, resenting the bondage, hating the attraction.

'We will swear to each other, one day, shall we?' pleaded Birkin. 'We will swear to stand by each other – be true to each other – ultimately – infallibly – given to each other, organically – without possibility of taking back.'

Birkin sought hard to express himself. But Gerald hardly listened. His face shone with a certain luminous pleasure. He was pleased. But he kept his reserve. He held himself back.

'Shall we swear to each other, one day?' said Birkin, putting out his hand towards Gerald.

Gerald just touched the extended fine, living hand, as if withheld and afraid.

'We'll leave it till I understand it better,' he said, in a voice of excuse. Birkin watched him. A little sharp disappointment, perhaps a touch of contempt came into his heart.

'Yes,' he said. 'You must tell me what you think, later. You know what I mean? Not sloppy emotionalism. An impersonal union that leaves one free.'

They lapsed both into silence. Birkin was looking at Gerald all the time. He seemed now to see, not the physical, animal man, which he usually saw in Gerald, and which usually he liked so much, but the man himself, complete, and as if fated, doomed, limited. This strange sense of fatality in Gerald, as if he were limited to one form of existence, one knowledge, one activity, a sort of fatal halfness, which to himself seemed wholeness, always overcame Birkin after their moments of passionate approach, and filled him with a sort of contempt, or boredom. It was the insistence on the limitation which so bored Birkin in Gerald. Gerald could never fly away from himself, in real indifferent gaiety. He had a clog, a sort of monomania.

There was silence for a time. Then Birkin said, in a lighter tone, letting the stress of the contact pass:

'Can't you get a good governess for Winifred? - somebody exceptional?'

'Hermione Roddice suggested we should ask Gudrun to teach her to draw and to model in clay. You know Winnie is astonishingly clever with that plasticine stuff. Hermione declares she is an artist.' Gerald spoke in the usual animated, chatty manner, as if nothing unusual had passed. But Birkin's manner was full of reminder.

'Really! I didn't know that. Oh well then, if Gudrun would teach her,

it would be perfect – couldn't be anything better – if Winifred is an artist. Because Gudrun somewhere is one. And every true artist is the salvation of every other.'

'I thought they got on so badly, as a rule.'

'Perhaps. But only artists produce for each other the world that is fit to live in. If you can arrange *that* for Winifred, it is perfect.'

'But you think she wouldn't come?'

I don't know. Gudrun is rather self-opinionated. She won't go cheap anywhere. Or if she does, she'll pretty soon take herself back. So whether she would condescend to do private teaching, particularly here, in Beldover, I don't know. But it would be just the thing. Winifred has got a special nature. And if you can put into her way the means of being self-sufficient, that is the best thing possible. She'll never get on with the ordinary life. You find it difficult enough yourself, and she is several skins thinner than you are. It is awful to think what her life will be like unless she does find a means of expression, some way of fulfilment. You can see what mere leaving it to fate brings. You can see how much marriage is to be trusted to – look at your own mother.'

'Do you think mother is abnormal?'

'No! I think she only wanted something more, or other than the common run of life. And not getting it, she has gone wrong perhaps.'

'After producing a brood of wrong children,' said Gerald gloomily.

'No more wrong than any of the rest of us,' Birkin replied. 'The most normal people have the worst subterranean selves, take them one by one.'

'Sometimes I think it is a curse to be alive,' said Gerald with sudden impotent anger.

'Well,' said Birkin, 'why not! Let it be a curse sometimes to be alive – at other times it is anything but a curse. You've got plenty of zest in it really.'

'Less than you'd think,' said Gerald, revealing a strange poverty in his look at the other man.

There was silence, each thinking his own thoughts.

'I don't see what she has to distinguish between teaching at the Grammar School, and coming to teach Win,' said Gerald.

'The difference between a public servant and a private one. The only nobleman today, king and only aristocrat, is the public, the public. You are quite willing to serve the public – but to be a private tutor -'

'I don't want to serve either - '

'No! And Gudrun will probably feel the same.'

Gerald thought for a few minutes. Then he said:

'At all events, father won't make her feel like a private servant. He will be fussy and grateful enough.'

'So he ought. And so ought all of you. Do you think you can hire a woman like Gudrun Brangwen with money? She is your equal like anything – probably your superior.'

'Is she?' said Gerald.

'Yes, and if you haven't the guts to know it, I hope she'll leave you to your own devices.'

'Nevertheless,' said Gerald, 'if she is my equal, I wish she weren't a teacher, because I don't think teachers as a rule are my equal.'

'Nor do I, damn them. But am I a teacher because I teach, or a parson because I preach?'

Gerald laughed. He was always uneasy on this score. He did not *want* to claim social superiority, yet he *would* not claim intrinsic personal superiority, because he would never base his standard of values on pure being. So he wobbled upon a tacit assumption of social standing. No, Birkin wanted him to accept the fact of intrinsic difference between human beings, which he did not intend to accept. It was against his social honour, his principle. He rose to go.

T've been neglecting my business all this while,' he said smiling.

'I ought to have reminded you before,' Birkin replied, laughing and mocking.

'I knew you'd say something like that,' laughed Gerald, rather uneasily.

'Did you?'

'Yes, Rupert. It wouldn't do for us all to be like you are – we should soon be in the cart. When I am above the world, I shall ignore all businesses.'

'Of course, we're not in the cart now,' said Birkin, satirically.

'Not as much as you make out. At any rate, we have enough to eat and drink – '

'And be satisfied,' added Birkin.

Gerald came near the bed and stood looking down at Birkin whose throat was exposed, whose tossed hair fell attractively on the warm brow, above the eyes that were so unchallenged and still in the satirical face. Gerald, full-limbed and turgid with energy, stood unwilling to go, he was held by the presence of the other man. He had not the power to go away.

'So,' said Birkin. 'Good-bye.' And he reached out his hand from under the bed-clothes, smiling with a glimmering look.

'Good-bye,' said Gerald, taking the warm hand of his friend in a firm grasp. 'I shall come again. I miss you down at the mill.'

'I'll be there in a few days,' said Birkin.

The eyes of the two men met again. Gerald's, that were keen as a hawk's, were suffused now with warm light and with unadmitted love, Birkin looked back as out of a darkness, unsounded and unknown, yet with a kind of warmth, that seemed to flow over Gerald's brain like a fertile sleep.

'Good-bye then. There's nothing I can do for you?'

'Nothing, thanks.'

Birkin watched the black-clothed form of the other man move out of the door, the bright head was gone, he turned over to sleep.

CHAPTER XVII

The Industrial Magnate

IN BELDOVER, there was both for Ursula and for Gudrun an interval. It seemed to Ursula as if Birkin had gone out of her for the time, he had lost his significance, he scarcely mattered in her world. She had her own friends, her own activities, her own life. She turned back to the old ways with zest, away from him.

And Gudrun, after feeling every moment in all her veins conscious of Gerald Crich, connected even physically with him, was now almost indifferent to the thought of him. She was nursing new schemes for going away and trying a new form of life. All the time, there was something in her urging her to avoid the final establishing of a relationship with Gerald. She felt it would be wiser and better to have no more than a casual acquaintance with him.

She had a scheme for going to St Petersburg, where she had a friend who was a sculptor like herself, and who lived with a wealthy Russian whose hobby was jewel-making. The emotional, rather rootless life of the Russians appealed to her. She did not want to go to Paris. Paris was dry, and essentially boring. She would like to go to Rome, Munich, Vienna, or to St Petersburg or Moscow. She had a friend in St Petersburg and a friend in Munich. To each of these she wrote, asking about rooms.

She had a certain amount of money. She had come home partly to save, and now she had sold several pieces of work, she had been praised in various shows. She knew she could become quite the 'go' if she went to London. But she knew London, she wanted something else. She had seventy pounds, of which nobody knew anything. She would move soon, as soon as she heard from her friends. Her nature, in spite of her apparent placidity and calm, was profoundly restless.

The sisters happened to call in a cottage in Willey Green to buy honey. Mrs Kirk, a stout, pale, sharp-nosed woman, sly, honied, with something shrewish and cat-like beneath, asked the girls into her toocosy, too tidy kitchen. There was a cat-like comfort and cleanliness everywhere.

'Yes, Miss Brangwen,' she said, in her slightly whining, insinuating voice, 'and how do you like being back in the old place, then?'

Gudrun, whom she addressed, hated her at once.

'I don't care for it,' she replied abruptly.

'You don't? Ay, well, I suppose you found a difference from London. You like life, and big, grand places. Some of us has to be content with Willey Green and Beldover. And what do you think of our Grammar School, as there's so much talk about?'

'What do I think of it?' Gudrun looked round at her slowly. 'Do you mean, do I think it's a good school?'

'Yes. What is your opinion of it?'

"I do think it's a good school."

Gudrun was very cold and repelling. She knew the common people hated the school.

'Ay, you do, then! I've heard so much, one way and the other. It's nice to know what those that's in it feel. But opinions vary, don't they? Mr Crich up at Highclose is all for it. Ay, poor man, I'm afraid he's not long for this world. He's very poorly.'

'Is he worse?' asked Ursula.

'Eh, yes – since they lost Miss Diana. He's gone off to a shadow. Poor man, he's had a world of trouble.'

'Has he?' asked Gudrun, faintly ironic.

'He has, a world of trouble. And as nice and kind a gentleman as ever you could wish to meet. His children don't take after him.'

'I suppose they take after their mother?' said Ursula.

'In many ways.' Mrs Kirk lowered her voice a little. 'She was a proud haughty lady when she came into these parts – my word, she was that! She mustn't be looked at, and it was worth your life to speak to her.' The woman made a dry, sly face.

'Did you know her when she was first married?'

Yes, I knew her. I nursed three of her children. And proper little terrors they were, little fiends – that Gerald was a demon if ever there was one, a proper demon, ay, at six months old.' A curious malicious, sly tone came into the woman's voice.

'Really,' said Gudrun.

'That wilful, masterful - he'd mastered one nurse at six months.

Kick, and scream, and struggle like a demon. Many's the time I've pinched his little bottom for him, when he was a child in arms. Ay, and he'd have been better if he'd had it pinched oftener. But she wouldn't have them corrected – no-o, wouldn't hear of it. I can remember the rows she had with Mr Crich, my word. When he'd got worked up, properly worked up till he could stand no more, he'd lock the study door and whip them. But she paced up and down all the while like a tiger outside, like a tiger, with very murder in her face. She had a face that could *look* death. And when the door was opened, she'd go in with her hands lifted – "What have you been doing to *my* children, you coward." She was like one out of her mind. I believe he was frightened of her; he had to be driven mad before he'd lift a finger. Didn't the servants have a life of it! And didn't we used to be thankful when one of them caught it. They were the torment of your life.'

'Really!' said Gudrun.

'In every possible way. If you wouldn't let them smash their pots on the table, if you wouldn't let them drag the kitten about with a string round its neck, if you wouldn't give them whatever they asked for, every mortal thing – then there was a shine on, and their mother coming in asking – "What's the matter with him? What have you done to him? What is it, Darling?" And then she'd turn on you as if she'd trample you under her feet. But she didn't trample on me. I was the only one that could do anything with her demons – for she wasn't going to be bothered with them herself. No, *she* took no trouble for them. But they must just have their way, they mustn't be spoken to. And Master Gerald was the beauty. I left when he was a year and a half, I could stand no more. But I pinched his little bottom for him when he was in arms, I did, when there was no holding him, and I'm not sorry I did –'

Gudrun went away in fury and loathing. The phrase, 'I pinched his little bottom for him,' sent her into a white, stony fury. She could not bear it, she wanted to have the woman taken out at once and strangled. And yet there the phrase was lodged in her mind for ever, beyond escape. She felt, one day, she would *bave* to tell him, to see how he took it. And she loathed herself for the thought.

But at Shortlands the life-long struggle was coming to a close. The father was ill and was going to die. He had bad internal pains, which took away all his attentive life, and left him with only a vestige of his consciousness. More and more a silence came over him, he was less and less acutely aware of his surroundings. The pain seemed to absorb his activity. He knew it was there, he knew it would come again. It was like something lurking in the darkness within him. And he had not the power, or the will, to seek it out and to know it. There it remained in the darkness, the great pain, tearing him at times, and then being silent. And when it tore him he crouched in silent subjection under it, and when it left him alone again, he refused to know of it. It was within the darkness, let it remain unknown. So he never admitted it, except in a secret corner of himself, where all his never-revealed fears and secrets were accumulated. For the rest, he had a pain, it went away, it made no difference. It even stimulated him, excited him.

But it gradually absorbed his life. Gradually it drew away all his potentiality, it bled him into the dark, it weaned him of life and drew him away into the darkness. And in this twilight of his life little remained visible to him. The business, his work, that was gone entirely. His public interests had disappeared as if they had never been. Even his family had become extraneous to him, he could only remember, in some slight non-essential part of himself, that such and such were his children. But it was historical fact, not vital to him. He had to make an effort to know their relation to him. Even his wife barely existed. She indeed was like the darkness, like the pain within him. By some strange association, the darkness that contained the pain and the darkness that contained his wife were identical. All his thoughts and understandings became blurred and fused, and now his wife and the consuming pain were the same dark secret power against him, that he never faced. He never drove the dread out of its lair within him. He only knew that there was a dark place, and something inhabiting this darkness which issued from time to time and rent him. But he dared not penetrate and drive the beast into the open. He had rather ignore its existence. Only, in his vague way, the dread was his wife, the destroyer, and it was the pain, the destruction, a darkness which was one and both.

He very rarely saw his wife. She kept her room. Only occasionally she came forth, with her head stretched forward, and in her low, possessed voice, she asked him how he was. And he answered her, in the habit of more than thirty years: 'Well, I don't think I'm any the worse, dear.' But he was frightened of her, underneath this safeguard of habit, frightened almost to the verge of death.

But all his life, he had been so constant to his lights, he had never broken down. He would die even now without breaking down, without knowing what his feelings were, towards her. All his life, he had said: 'Poor Christiana, she has such a strong temper.' With unbroken will, he had stood by this position with regard to her, he had substituted pity for all his hostility, pity had been his shield and his safeguard, and his infallible weapon. And still, in his consciousness, he was sorry for her, her nature was so violent and so impatient.

But now his pity, with his life, was wearing thin, and the dread almost

amounting to horror, was rising into being. But before the armour of his pity really broke, he would die, as an insect when its shell is cracked. This was his final resource. Others would live on, and know the living death, the ensuing process of hopeless chaos. He would not. He denied death its victory.

He had been so constant to his lights, so constant to charity, and to his love for his neighbour. Perhaps he had loved his neighbour even better than himself – which is going one further than the commandment. Always, this flame had burned in his heart, sustaining him through everything, the welfare of the people. He was a large employer of labour, he was a great mine-owner. And he had never lost this from his heart, that in Christ he was one with his workmen. Nay, he had felt inferior to them, as if they through poverty and labour were nearer to God than he. He had always the unacknowledged belief, that it was his workmen, the miners, who held in their hands the means of salvation. To move nearer to God, he must move towards his miners, his life must gravitate towards theirs. They were, unconsciously, his idol, his God made manifest. In them he worshipped the highest, the great, sympathetic, mindless Godhead of humanity.

And all the while, his wife had opposed him like one of the great demons of hell. Strange, like a bird of prey, with the fascinating beauty and abstraction of a hawk, she had beat against the bars of his philanthropy, and like a hawk in a cage, she had sunk into silence. By force of circumstance, because all the world combined to make the cage unbreakable, he had been too strong for her, he had kept her prisoner. And because she was his prisoner, his passion for her had always remained keen as death. He had always loved her, loved her with intensity. Within the cage, she was denied nothing, she was given all licence.

But she had gone almost mad. Of wild and overweening temper, she could not bear the humiliation of her husband's soft, half-appealing kindness to everybody. He was not deceived by the poor. He knew they came and sponged on him, and whined to him, the worse sort; the majority, luckily for him, were much too proud to ask for anything, much too independent to come knocking at his door. But in Beldover, as everywhere else, there were the whining, parasitic, foul human beings who come crawling after charity, and feeding on the living body of the public like lice. A kind of fire would go over Christiana Crich's brain, as she saw two more pale-faced, creeping women in objectionable black clothes, cringing lugubriously up the drive to the door. She wanted to set the dogs on them, 'Hi Rip! Hi Ring! Ranger! At 'em boys, set 'em off.' But Crowther, the butler, with all the rest of the

servants, was Mr Crich's man. Nevertheless, when her husband was away, she would come down like a wolf on the crawling supplicants; 'What do you people want? There is nothing for you here. You have no business on the drive at all. Simpson, drive them away and let no more of them through the gate.'

The servants had to obey her. And she would stand watching with an eye like the eagle's, whilst the groom in clumsy confusion drove the lugubrious persons down the drive, as if they were rusty fowls, scuttling before him.

But they learned to know, from the lodge-keeper, when Mrs Crich was away, and they timed their visits. How many times, in the first years, would Crowther knock softly at the door: 'Person to see you, sir.'

'What name?'

'Grocock, sir.'

'What do they want?' The question was half impatient, half gratified. He liked hearing appeals to his charity.

'About a child, sir.'

'Show them into the library, and tell them they shouldn't come after eleven o'clock in the morning.'

'Why do you get up from dinner? – send them off,' his wife would say abruptly.

'Oh, I can't do that. It's no trouble just to hear what they have to say.'

'How many more have been here today? Why don't you establish open house for them? They would soon oust me and the children.'

'You know dear, it doesn't hurt me to hear what they have to say. And if they really are in trouble – well, it is my duty to help them out of it.'

'It's your duty to invite all the rats in the world to gnaw at your bones.'

'Come, Christiana, it isn't like that. Don't be uncharitable.'

But she suddenly swept out of the room, and out to the study. There sat the meagre charity-seekers, looking as if they were at the doctor's.

'Mr Crich can't see you. He can't see you at this hour. Do you think he is your property, that you can come whenever you like? You must go away, there is nothing for you here.'

The poor people rose in confusion. But Mr Crich, pale and blackbearded and deprecating, came behind her, saying:

'Yes, I don't like you coming as late as this. I'll hear any of you in the morning part of the day, but I can't really do with you after. What's amiss then, Gittens. How is your Missis?'

'Why, she's sunk very low, Mester Crich, she's a'most gone, she is - '

Sometimes, it seemed to Mrs Crich as if her husband were some subtle funeral bird, feeding on the miseries of the people. It seemed to

her he was never satisfied unless there was some sordid tale being poured out to him, which he drank in with a sort of mournful, sympathetic satisfaction. He would have no *raison d'être* if there were no lugubrious miseries in the world, as an undertaker would have no meaning if there were no funerals.

Mrs Crich recoiled back upon herself, she recoiled away from this world of creeping democracy. A band of tight, baleful exclusion fastened round her heart, her isolation was fierce and hard, her antagonism was passive but terribly pure, like that of a hawk in a cage. As the years went on, she lost more and more count of the world, she seemed rapt in some glittering abstraction, almost purely unconscious. She would wander about the house and about the surrounding country, staring keenly and seeing nothing. She rarely spoke, she had no connection with the world. And she did not even think. She was consumed in a fierce tension of opposition, like the negative pole of a magnet.

And she bore many children. For, as time went on, she never opposed her husband in word or deed. She took no notice of him, externally. She submitted to him, let him take what he wanted and do as he wanted with her. She was like a hawk that sullenly submits to everything. The relation between her and her husband was wordless and unknown, but it was deep, awful, a relation of utter inter-destruction. And he, who triumphed in the world, he became more and more hollow in his vitality, the vitality was bled from within him, as by some haemorrhage. She was hulked like a hawk in a cage, but her heart was fierce and undiminished within her, though her mind was destroyed.

So to the last he would go to her and hold her in his arms sometimes, before his strength was all gone. The terrible white, destructive light that burned in her eyes only excited and roused him. Till he was bled to death, and then he dreaded her more than anything. But he always said to himself, how happy he had been, how he had loved her with a pure and consuming love ever since he had known her. And he thought of her as pure, chaste; the white flame which was known to him alone, the flame of her sex, was a white flower of snow to his mind. She was a wonderful white snow-flower, which he had desired infinitely. And now he was dying with all his ideas and interpretations intact. They would only collapse when the breath left his body. Till then they would be pure truths for him. Only death would show the perfect completeness of the lie. Till death, she was his white snow-flower. He had subdued her, and her subjugation was to him an infinite chastity in her, a virginity which he could never break, and which dominated him as by a spell.

She had let go the outer world, but within herself she was unbroken and unimpaired. She only sat in her room like a moping, dishevelled hawk, motionless, mindless. Her children, for whom she had been so fierce in her youth, now meant scarcely anything to her. She had lost all that, she was quite by herself. Only Gerald, the gleaming, had some existence for her. But of late years, since he had become head of the business, he too was forgotten. Whereas the father, now he was dying, turned for compassion to Gerald. There had always been opposition between the two of them. Gerald had feared and despised his father, and to a great extent had avoided him all through boyhood and young manhood. And the father had felt very often a real dislike of his eldest son, which, never wanting to give way to, he had refused to acknowledge. He had ignored Gerald as much as possible, leaving him alone.

Since, however, Gerald had come home and assumed responsibility in the firm, and had proved such a wonderful director, the father, tired and weary of all outside concerns, had put all his trust of these things in his son, implicitly, leaving everything to him, and assuming a rather touching dependence on the young enemy. This immediately roused a poignant pity and allegiance in Gerald's heart, always shadowed by contempt and by unadmitted enmity. For Gerald was in reaction against Charity; and yet he was dominated by it, it assumed supremacy in the inner life, and he could not confute it. So he was partly subject to that which his father stood for, but he was in reaction against it. Now he could not save himself. A certain pity and grief and tenderness for his father overcame him, in spite of the deeper, more sullen hostility.

The father won shelter from Gerald through compassion. But for love he had Winifred. She was his youngest child, she was the only one of his children whom he had ever closely loved. And her he loved with all the great, overweening, sheltering love of a dying man. He wanted to shelter her infinitely, infinitely, to wrap her in warmth and love and shelter, perfectly. If he could save her she should never know one pain, one grief, one hurt. He had been so right all his life, so constant in his kindness and his goodness. And this was his last passionate righteousness, his love for the child Winifred. Some things troubled him yet. The world had passed away from him, as his strength ebbed. There were no more poor and injured and humble to protect and succour. These were all lost to him. There were no more sons and daughters to trouble him, and to weigh on him as an unnatural responsibility. These too had faded out of reality All these things had fallen out of his hands, and left him free.

There remained the covert fear and horror of his wife, as she sat mindless and strange in her room, or as she came forth with slow,

prowling step, her head bent forward. But this he put away. Even his life-long righteousness, however, would not quite deliver him from the inner horror. Still, he could keep it sufficiently at bay. It would never break forth openly. Death would come first.

Then there was Winifred! If only he could be sure about her, if only he could be sure. Since the death of Diana, and the development of his illness, his craving for surety with regard to Winifred amounted almost to obsession. It was as if, even dying, he must have some anxiety, some responsibility of love, of Charity, upon his heart.

She was an odd, sensitive, inflammable child, having her father's dark hair and quiet bearing, but being quite detached, momentaneous. She was like a changeling indeed, as if her feelings did not matter to her, really. She often seemed to be talking and plaving like the gavest and most childish of children, she was full of the warmest, most delightful affection for a few things - for her father, and for her animals in particular. But if she heard that her beloved kitten Leo had been run over by the motor-car she put her head on one side, and replied, with a faint contraction like resentment on her face: 'Has he?' Then she took no more notice. She only disliked the servant who would force bad news on her, and wanted her to be sorry. She wished not to know, and that seemed her chief motive. She avoided her mother, and most of the members of her family. She loved her Daddy, because he wanted her always to be happy, and because he seemed to become young again, and irresponsible in her presence. She liked Gerald, because he was so self-contained. She loved people who would make life a game for her. She had an amazing instinctive critical faculty, and was a pure anarchist, a pure aristocrat at once. For she accepted her equals wherever she found them, and she ignored with blithe indifference her inferiors, whether they were her brothers and sisters, or whether they were wealthy guests of the house, or whether they were the common people or the servants. She was quite single and by herself, deriving from nobody. It was as if she were cut off from all purpose or continuity, and existed simply moment by moment.

The father, as by some strange final illusion, felt as if all his fate depended on his ensuring to Winifred her happiness. She who could never suffer, because she never formed vital connections, she who could lose the dearest things of her life and be just the same the next day, the whole memory dropped out, as if deliberately, she whose will was so strangely and easily free, anarchistic, almost nihilistic, who like a soulless bird flits on its own will, without attachment or responsibility beyond the moment, who in her every motion snapped the threads of

serious relationship with blithe, free hands, really nihilistic, because never troubled, she must be the object of her father's final passionate solicitude.

When Mr Crich heard that Gudrun Brangwen might come to help Winifred with her drawing and modelling he saw a road to salvation for his child. He believed that Winifred had talent, he had seen Gudrun, he knew that she was an exceptional person. He could give Winifred into her hands as into the hands of a right being. Here was a direction and a positive force to be lent to his child, he need not leave her directionless and defenceless. If he could but graft the girl on to some tree of utterance before he died, he would have fulfilled his responsibility. And here it could be done. He did not hesitate to appeal to Gudrun.

Meanwhile, as the father drifted more and more out of life, Gerald experienced more and more a sense of exposure. His father after all had stood for the living world to him. Whilst his father lived Gerald was not responsible for the world. But now his father was passing away, Gerald found himself left exposed and unready before the storm of living, like the mutinous first mate of a ship that has lost his captain, and who sees only a terrible chaos in front of him. He did not inherit an established order and a living idea. The whole unifying idea of mankind seemed to be dying with his father, the centralising force that had held the whole together seemed to collapse with his father, the parts were ready to go asunder in terrible disintegration. Gerald was as if left on board of a ship that was going asunder beneath his feet, he was in charge of a vessel whose timbers were all coming apart.

He knew that all his life he had been wrenching at the frame of life to break it apart. And now, with something of the terror of a destructive child, he saw himself on the point of inheriting his own destruction. And during the last months, under the influence of death, and of Birkin's talk, and of Gudrun's penetrating being, he had lost entirely that mechanical certainty that had been his triumph. Sometimes spasms of hatred came over him, against Birkin and Gudrun and that whole set. He wanted to go back to the dullest conservatism, to the most stupid of conventional people. He wanted to revert to the strictest Toryism. But the desire did not last long enough to carry him into action.

During his childhood and his boyhood he had wanted a sort of savagedom. The days of Homer were his ideal, when a man was chief of an army of heroes, or spent his years in wonderful Odyssey. He hated remorselessly the circumstances of his own life, so much that he never really saw Beldover and the colliery valley. He turned his face

entirely away from the blackened mining region that stretched away on the right hand of Shortlands, he turned entirely to the country and the woods beyond Willey Water. It was true that the panting and rattling of the coal mines could always be heard at Shortlands. But from his earliest childhood, Gerald had paid no heed to this. He had ignored the whole of the industrial sea which surged in coal-blackened tides against the grounds of the house. The world was really a wilderness where one hunted and swam and rode. He rebelled against all authority. Life was a condition of savage freedom.

Then he had been sent away to school, which was so much death to him. He refused to go to Oxford, choosing a German university. He had spent a certain time at Bonn, at Berlin, and at Frankfurt. There, a curiosity had been aroused in his mind. He wanted to see and to know, in a curious objective fashion, as if it were an amusement to him. Then he must try war. Then he must travel into the savage regions that had so attracted him.

The result was, he found humanity very much alike everywhere, and to a mind like his, curious and cold, the savage was duller, less exciting than the European. So he took hold of all kinds of sociological ideas, and ideas of reform. But they never went more than skin-deep, they were never more than a mental amusement. Their interest lay chiefly in the reaction against the positive order, the destructive reaction.

He discovered at last a real adventure in the coal-mines. His father asked him to help in the firm. Gerald had been educated in the science of mining, and it had never interested him. Now, suddenly, with a sort of exultation, he laid hold of the world.

There was impressed photographically on his consciousness the great industry. Suddenly, it was real, he was part of it. Down the valley ran the colliery railway, linking mine with mine. Down the railway ran the trains, short trains of heavily laden trucks, long trains of empty wagons, each one bearing in big white letters the initials:

'C.B.&Co.'

These white letters on all the wagons he had seen since his first childhood, and it was as if he had never seen them, they were so familiar, and so ignored. Now at last he saw his own name written on the wall. Now he had a vision of power.

So many wagons, bearing his initial, running all over the country. He saw them as he entered London in the train, he saw them at Dover. So far his power ramified. He looked at Beldover, at Selby, at Whatmore, at Lethley Bank, the great colliery villages which depended entirely on his mines. They were hideous and sordid, during his childhood they had been sores in his consciousness. And now he saw them with pride.

Four raw new towns, and many ugly industrial hamlets were crowded under his dependence. He saw the stream of miners flowing along the causeways from the mines at the end of the afternoon, thousands of blackened, slightly distorted human beings with red mouths, all moving subjugate to his will. He pushed slowly in his motor-car through the little market-top on Friday nights in Beldover, through a solid mass of human beings that were making their purchases and doing their weekly spending. They were all subordinate to him. They were ugly and uncouth, but they were his instruments. He was the God of the machine. They made way for his motor-car automatically, slowly.

He did not care whether they made way with alacrity, or grudgingly. He did not care what they thought of him. His vision had suddenly crystallised. Suddenly he had conceived the pure instrumentality of mankind. There had been so much humanitarianism, so much talk of sufferings and feelings. It was ridiculous. The sufferings and feelings of individuals did not matter in the least. They were mere conditions, like the weather. What mattered was the pure instrumentality of the individual. As a man as of a knife: does it cut well? Nothing else mattered.

Everything in the world has its function, and is good or not good in so far as it fulfils this function more or less perfectly. Was a miner a good miner? Then he was complete. Was a manager a good manager? That was enough. Gerald himself, who was responsible for all this industry, was he a good director? If he were, he had fulfilled his life. The rest was by-play.

The mines were there, they were old. They were giving out, it did not pay to work the seams. There was talk of closing down two of them. It was at this point that Gerald arrived on the scene.

He looked around. There lay the mines. They were old, obsolete. They were like old lions, no more good. He looked again. Pah! the mines were nothing but the clumsy efforts of impure minds. There they lay, abortions of a half-trained mind. Let the idea of them be swept away. He cleared his brain of them, and thought only of the coal in the under earth. How much was there?

There was plenty of coal. The old workings could not get at it, that was all. Then break the neck of the old workings. The coal lay there in its seams, even though the seams were thin. There it lay, inert matter, as it had always lain, since the beginning of time, subject to the will of man. The will of man was the determining factor. Man was the archgod of earth. His mind was obedient to serve his will. Man's will was the absolute, the only absolute. And it was his will to subjugate Matter to his own ends. The subjugation itself was the point, the fight was the be-all, the fruits of victory were mere results. It was not for the sake of money that Gerald took over the mines. He did not care about money, fundamentally. He was neither ostentatious nor luxurious, neither did he care about social position, not finally. What he wanted was the pure fulfilment of his own will in the struggle with the natural conditions. His will was now, to take the coal out of the earth, profitably. The profit was merely the condition of victory, but the victory itself lay in the feat achieved. He vibrated with zest before the challenge. Every day he was in the mines, examining, testing, he consulted experts, he gradually gathered the whole situation into his mind, as a general grasps the plan of his campaign.

Then there was need for a complete break. The mines were run on an old system, an obsolete idea. The initial idea had been, to obtain as much money from the earth as would make the owners comfortably rich, would allow the workmen sufficient wages and good conditions. and would increase the wealth of the country altogether. Gerald's father, following in the second generation, having a sufficient fortune, had thought only of the men. The mines, for him, were primarily great fields to produce bread and plenty for all the hundreds of human beings gathered about them. He had lived and striven with his fellow owners to benefit the men every time. And the men had been benefited in their fashion. There were few poor, and few needy. All was plenty, because the mines were good and easy to work. And the miners, in those days, finding themselves richer than they might have expected. felt glad and triumphant. They thought themselves well-off, they congratulated themselves on their good-fortune, they remembered how their fathers had starved and suffered, and they felt that better times had come. They were grateful to those others, the pioneers, the new owners, who had opened out the pits, and let forth this stream of plenty.

But man is never satisfied, and so the miners, from gratitude to their owners, passed on to murmuring. Their sufficiency decreased with knowledge, they wanted more. Why should the master be so out-ofall-proportion rich?

There was a crisis when Gerald was a boy, when the Masters' Federation closed down the mines because the men would not accept a reduction. This lock-out had forced home the new conditions to Thomas Crich. Belonging to the Federation, he had been compelled by his honour to close the pits against his men. He, the father, the Patriarch, was forced to deny the means of life to his sons, his people. He, the rich man who would hardly enter heaven because of his possessions, must now turn upon the poor, upon those who were nearer Christ than himself, those who were humble and despised and closer to perfection, those who were manly and noble in their labours, and must say to them: 'Ye shall neither labour nor eat bread.'⁶⁵

It was this recognition of the state of war which really broke his heart. He wanted his industry to be run on love. Oh, he wanted love to be the directing power even of the mines. And now, from under the cloak of love, the sword was cynically drawn, the sword of mechanical necessity.

This really broke his heart. He must have the illusion and now the illusion was destroyed. The men were not against *bim*, but they were against the masters. It was war, and willy nilly he found himself on the wrong side, in his own conscience. Seething masses of miners met daily, carried away by a new religious impulse. The idea flew through them: 'All men are equal on earth,' and they would carry the idea to its material fulfilment. After all, is it not the teaching of Christ? And what is an idea, if not the germ of action in the material world. 'All men are equal in spirit, they are all sons of God. Whence then this obvious *disquality?*' It was a religious creed pushed to its material conclusion. Thomas Crich at least had no answer. He could but admit, according to his sincere tenets, that the disquality was wrong. But he could not give up his goods, which were the stuff of disquality. So the men would fight for their rights. The last impulses of the last religious passion left on earth, the passion for equality, inspired them.

Seething mobs of men marched about, their faces lighted up as for holy war, with a smoke of cupidity. How disentangle the passion for equality from the passion of cupidity, when begins the fight for equality of possessions? But the God was the machine. Each man claimed equality in the Godhead of the great productive machine. Every man equally was part of this Godhead. But somehow, somewhere, Thomas Crich knew this was false. When the machine is the Godhead, and production or work is worship, then the most mechanical mind is purest and highest, the representative of God on earth. And the rest are subordinate, each according to his degree.

Riots broke out, Whatmore pit-head was in flames. This was the pit furthest in the country, near the woods. Soldiers came. From the windows of Shortlands, on that fatal day, could be seen the flare of fire in the sky not far off, and now the little colliery train, with the workmen's carriages which were used to convey the miners to the distant Whatmore, was crossing the valley full of soldiers, full of redcoats. Then there was the far-off sound of firing, then the later news that the mob was dispersed, one man was shot dead, the fire was put out.

Gerald, who was a boy, was filled with the wildest excitement and delight. He longed to go with the soldiers to shoot the men. But he was not allowed to go out of the lodge gates. At the gates were stationed sentries with guns. Gerald stood near them in delight, whilst gangs of derisive miners strolled up and down the lanes, calling and jeering:

'Now then, three ha'porth o' coppers, let's see thee shoot thy gun.' Insults were chalked on the walls and the fences, the servants left.

And all this while Thomas Crich was breaking his heart, and giving away hundreds of pounds in charity. Everywhere there was free food, a surfeit of free food. Anybody could have bread for asking, and a loaf cost only three-ha'pence. Every day there was a free tea somewhere, the children had never had so many treats in their lives. On Friday afternoon great basketfuls of buns and cakes were taken into the schools, and great pitchers of milk, the school children had what they wanted. They were sick with eating too much cake and milk.

And then it came to an end, and the men went back to work. But it was never the same as before. There was a new situation created, a new idea reigned. Even in the machine, there should be equality. No part should be subordinate to any other part: all should be equal. The instinct for chaos had entered. Mystic equality lies in abstraction, not in having or in doing, which are processes. In function and process, one man, one part, must of necessity be subordinate to another. It is a condition of being. But the desire for chaos had risen, and the idea of mechanical equality was the weapon of disruption which should execute the will of man, the will for chaos.

Gerald was a boy at the time of the strike, but he longed to be a man, to fight the colliers. The father however was trapped between two halftruths, and broken. He wanted to be a pure Christian, one and equal with all men. He even wanted to give away all he had, to the poor. Yet he was a great promoter of industry, and he knew perfectly that he must keep his goods and keep his authority. This was as divine a necessity in him, as the need to give away all he possessed – more divine, even, since this was the necessity he acted upon. Yet because he did *not* act on the other ideal, it dominated him, he was dying of chagrin because he must forfeit it. He wanted to be a father of loving kindness and sacrificial benevolence. The colliers shouted to him about his thousands a year. They would not be deceived.

When Gerald grew up in the ways of the world, he shifted the position. He did not care about the equality. The whole Christian attitude of love and self-sacrifice was old hat. He knew that position and authority were the right thing in the world, and it was useless to

cant about it. They were the right thing, for the simple reason that they were functionally necessary. They were not the be-all and the end-all. It was like being part of a machine. He himself happened to be a controlling, central part, the masses of men were the parts variously controlled. This was merely as it happened. As well get excited because a central hub drives a hundred outer wheels or because the whole universe wheels round the sun. After all, it would be mere silliness to say that the moon and the earth and Saturn and Jupiter and Venus have just as much right to be the centre of the universe, each of them separately, as the sun. Such an assertion is made merely in the desire of chaos.

Without bothering to *think* to a conclusion, Gerald jumped to a conclusion. He abandoned the whole democratic-equality problem as a problem of silliness. What mattered was the great social productive machine. Let that work perfectly, let it produce a sufficiency of everything, let every man be given a rational portion, greater or less according to his functional degree or magnitude, and then, provision made, let the devil supervene, let every man look after his own amusements and appetites, so long as he interfered with nobody.

So Gerald set himself to work, to put the great industry in order. In his travels, and in his accompanying readings, he had come to the conclusion that the essential secret of life was harmony. He did not define to himself at all clearly what harmony was. The word pleased him, he felt he had come to his own conclusions. And he proceeded to put his philosophy into practice by forcing order into the established world, translating the mystic word harmony into the practical word organisation.

Immediately he *saw* the firm, he realised what he could do. He had a fight to fight with Matter, with the earth and the coal it enclosed. This was the sole idea, to turn upon the inanimate matter of the underground, and reduce it to his will. And for this fight with matter, one must have perfect instruments in perfect organisation, a mechanism so subtle and harmonious in its workings that it represents the single mind of man, and by its relentless repetition of given movement, will accomplish a purpose irresistibly, inhumanly. It was this inhuman principle in the mechanism he wanted to construct that inspired Gerald with an almost religious exaltation. He, the man, could interpose a perfect, changeless, godlike medium between himself and the Matter he had to subjugate. There were two opposites, his will and the resistant Matter of the earth. And between these he could establish the very expression of his will, the incarnation of his power, a great and perfect machine, a system, an activity of pure order, pure mechanical repetition, repetition ad infinitum, hence eternal and infinite. He found his eternal and his infinite in the pure machine-principle of perfect co-ordination into one pure, complex, infinitely repeated motion, like the spinning of a wheel; but a productive spinning, as the revolving of the universe may be called a productive spinning, a productive repetition through eternity, to infinity. And this is the Godmotion, this productive repetition ad infinitum. And Gerald was the God of the machine, Deus ex machina.⁶⁶ And the whole productive will of man was the Godhead.

He had his life-work now, to extend over the earth a great and perfect system in which the will of man ran smooth and unthwarted, timeless, a Godhead in process. He had to begin with the mines. The terms were given: first the resistant Matter of the underground; then the instruments of its subjugation, instruments human and metallic; and finally his own pure will, his own mind. It would need a marvellous adjustment of myriad instruments, human, animal, metallic, kinetic, dynamic, a marvellous casting of myriad tiny wholes into one great perfect entirety. And then, in this case there was perfection attained, the will of the highest was perfectly fulfilled, the will of mankind was perfectly enacted; for was not mankind mystically contra-distinguished against inanimate Matter, was not the history of mankind just the history of the conquest of the one by the other?

The miners were overreached. While they were still in the toils of divine equality of man, Gerald had passed on, granted essentially their case, and proceeded in his quality of human being to fulfil the will of mankind as a whole. He merely represented the miners in a higher sense when he perceived that the only way to fulfil perfectly the will of man was to establish the perfect, inhuman machine. But he represented them very essentially, they were far behind, out of date, squabbling for their material equality. The desire had already transmuted into this new and greater desire, for a perfect intervening mechanism between man and Matter, the desire to translate the Godhead into pure mechanism.

As soon as Gerald entered the firm, the convulsion of death ran through the old system. He had all his life been tortured by a furious and destructive demon, which possessed him sometimes like an insanity. This temper now entered like a virus into the firm, and there were cruel eruptions. Terrible and inhuman were his examinations into every detail; there was no privacy he would spare, no old sentiment but he would turn it over. The old grey managers, the old grey clerks, the doddering old pensioners, he looked at them, and removed them as so much lumber. The whole concern seemed like a hospital of invalid employees. He had no emotional qualms. He arranged what pensions were necessary, he looked for efficient substitutes, and when these were found, he substituted them for the old hands.

'I've a pitiful letter here from Letherington,' his father would say, in a tone of deprecation and appeal. 'Don't you think the poor fellow might keep on a little longer. I always fancied he did very well.'

'I've got a man in his place now, father. He'll be happier out of it, believe me. You think his allowance is plenty, don't you?'

'It is not the allowance that he wants, poor man. He feels it very much, that he is superannuated. Says he thought he had twenty more years of work in him yet.'

'Not of this kind of work I want. He doesn't understand.'

The father sighed. He wanted not to know any more. He believed the pits would have to be overhauled if they were to go on working. And after all, it would be worst in the long run for everybody, if they must close down. So he could make no answer to the appeals of his old and trusty servants, he could only repeat 'Gerald says.'

So the father drew more and more out of the light. The whole frame of the real life was broken for him. He had been right according to his lights. And his lights had been those of the great religion. Yet they seemed to have become obsolete, to be superseded in the world. He could not understand. He only withdrew with his lights into an inner room, into the silence. The beautiful candles of belief, that would not do to light the world any more, they would still burn sweetly and sufficiently in the inner room of his soul, and in the silence of his retirement.

Gerald rushed into the reform of the firm, beginning with the office. It was needful to economise severely, to make possible the great alterations he must introduce.

'What are these widows' coals?' he asked.

'We have always allowed all widows of men who worked for the firm a load of coals every three months.'

'They must pay cost price henceforward. The firm is not a charity institution, as everybody seems to think.'

Widows, these stock figures of sentimental humanitarianism, he felt a dislike at the thought of them. They were almost repulsive. Why were they not immolated on the pyre of the husband, like the sati⁶⁷ in India? At any rate, let them pay the cost of their coals.

In a thousand ways he cut down the expenditure, in ways so fine as to be hardly noticeable to the men. The miners must pay for the cartage of their coals, heavy cartage too; they must pay for their tools, for the sharpening, for the care of lamps, for the many trifling things that

made the bill of charges against every man mount up to a shilling or so in the week. It was not grasped very definitely by the miners, though they were sore enough. But it saved hundreds of pounds every week for the firm.

Gradually Gerald got hold of everything. And then began the great reform. Expert engineers were introduced in every department. An enormous electric plant was installed, both for lighting and for haulage underground, and for power. The electricity was carried into every mine. New machinery was brought from America, such as the miners had never seen before, great iron men, as the cutting machines were called, and unusual appliances. The working of the pits was thoroughly changed, all the control was taken out of the hands of the miners, the butty system⁶⁸ was abolished. Everything was run on the most accurate and delicate scientific method, educated and expert men were in control everywhere, the miners were reduced to mere mechanical instruments. They had to work hard, much harder than before, the work was terrible and heart-breaking in its mechanicalness.

But they submitted to it all. The joy went out of their lives, the hope seemed to perish as they became more and more mechanised. And vet they accepted the new conditions. They even got a further satisfaction out of them. At first they hated Gerald Crich, they swore to do something to him, to murder him. But as time went on, they accepted everything with some fatal satisfaction. Gerald was their high priest, he represented the religion they really felt. His father was forgotten already. There was a new world, a new order, strict, terrible, inhuman, but satisfying in its very destructiveness. The men were satisfied to belong to the great and wonderful machine, even whilst it destroyed them. It was what they wanted. It was the highest that man had produced, the most wonderful and superhuman. They were exalted by belonging to this great and superhuman system which was beyond feeling or reason, something really godlike. Their hearts died within them, but their souls were satisfied. It was what they wanted. Otherwise Gerald could never have done what he did. He was just ahead of them in giving them what they wanted, this participation in a great and perfect system that subjected life to pure mathematical principles. This was a sort of freedom, the sort they really wanted. It was the first great step in undoing, the first great phase of chaos, the substitution of the mechanical principle for the organic, the destruction of the organic purpose, the organic unity, and the subordination of every organic unit to the great mechanical purpose. It was pure organic disintegration and pure mechanical organisation. This is the first and finest state of chaos.

Gerald was satisfied. He knew the colliers said they hated him. But

he had long ceased to hate them. When they streamed past him at evening, their heavy boots slurring on the pavement wearily, their shoulders slightly distorted, they took no notice of him, they gave him no greeting whatever, they passed in a grey-black stream of unemotional acceptance. They were not important to him, save as instruments, nor he to them, save as a supreme instrument of control. As miners they had their being, he had his being as director. He admired their qualities. But as men, personalities, they were just accidents, sporadic little unimportant phenomena. And tacitly, the men agreed to this. For Gerald agreed to it in himself.

He had succeeded. He had converted the industry into a new and terrible purity. There was a greater output of coal than ever, the wonderful and delicate system ran almost perfectly. He had a set of really clever engineers, both mining and electrical, and they did not cost much. A highly educated man cost very little more than a workman. His managers, who were all rare men, were no more expensive than the old bungling fools of his father's days, who were merely colliers promoted. His chief manager, who had twelve hundred a year, saved the firm at least five thousand. The whole system was now so perfect that Gerald was hardly necessary any more.

It was so perfect that sometimes a strange fear came over him, and he did not know what to do. He went on for some years in a sort of trance of activity. What he was doing seemed supreme, he was almost like a divinity. He was a pure and exalted activity.

But now he had succeeded – he had finally succeeded. And once or twice lately, when he was alone in the evening and had nothing to do, he had suddenly stood up in terror, not knowing what he was. And he went to the mirror and looked long and closely at his own face, at his own eyes, seeking for something. He was afraid, in mortal dry fear, but he knew not what of. He looked at his own face. There it was, shapely and healthy and the same as ever, yet somehow, it was not real, it was a mask. He dared not touch it, for fear it should prove to be only a composition mask. His eyes were blue and keen as ever, and as firm in their sockets. Yet he was not sure that they were not blue false bubbles that would burst in a moment and leave clear annihilation. He could see the darkness in them, as if they were only bubbles of darkness. He was afraid that one day he would break down and be a purely meaningless babble lapping round a darkness.

But his will yet held good, he was able to go away and read, and think about things. He liked to read books about the primitive man, books of anthropology, and also works of speculative philosophy. His mind was very active. But it was like a bubble floating in the darkness. At any

moment it might burst and leave him in chaos. He would not die. He knew that. He would go on living, but the meaning would have collapsed out of him, his divine reason would be gone. In a strangely indifferent, sterile way, he was frightened. But he could not react even to the fear. It was as if his centres of feeling were drying up. He remained calm, calculative and healthy, and quite freely deliberate, even whilst he felt, with faint, small but final sterile horror, that his mystic reason was breaking, giving way now, at this crisis.

And it was a strain. He knew there was no equilibrium. He would have to go in some direction, shortly, to find relief. Only Birkin kept the fear definitely off him, saved him his quick sufficiency in life, by the odd mobility and changeableness which seemed to contain the quintessence of faith. But then Gerald must always come away from Birkin, as from a Church service, back to the outside real world of work and life. There it was, it did not alter, and words were futilities. He had to keep himself in reckoning with the world of work and material life. And it became more and more difficult, such a strange pressure was upon him, as if the very middle of him were a vacuum, and outside were an awful tension.

He had found his most satisfactory relief in women. After a debauch with some desperate woman, he went on quite easy and forgetful. The devil of it was, it was so hard to keep up his interest in women nowadays. He didn't care about them any more. A Pussum was all right in her way, but she was an exceptional case, and even she mattered extremely little. No, women, in that sense, were useless to him any more. He felt that his *mind* needed acute stimulation, before he could be physically roused.

CHAPTER XVIII

Rabbit

GUDRUN KNEW that it was a critical thing for her to go to Shortlands. She knew it was equivalent to accepting Gerald Crich as a lover. And though she hung back, disliking the condition, yet she knew she would go on. She equivocated. She said to herself, in torment recalling the blow and the kiss, 'after all, what is it? What is a kiss? What even is a blow? It is an instant, vanished at once. I can go to Shortlands just for a time, before I go away, if only to see what it is like.' For she had an insatiable curiosity to see and to know everything.

She also wanted to know what Winifred was really like. Having

heard the child calling from the steamer in the night, she felt some mysterious connection with her.

Gudrun talked with the father in the library. Then he sent for his daughter. She came accompanied by Mademoiselle.

'Winnie, this is Miss Brangwen, who will be so kind as to help you with your drawing and making models of your animals,' said the father.

The child looked at Gudrun for a moment with interest, before she came forward and with face averted offered her hand. There was a complete *sang froid* and indifference under Winifred's childish reserve, a certain irresponsible callousness.

'How do you do?' said the child, not lifting her face.

'How do you do?' said Gudrun.

Then Winifred stood aside, and Gudrun was introduced to Mademoiselle.

'You have a fine day for your walk,' said Mademoiselle, in a bright manner.

'Quite fine,' said Gudrun.

Winifred was watching from her distance. She was as if amused, but rather unsure as yet what this new person was like. She saw so many new persons, and so few who became real to her. Mademoiselle was of no count whatever, the child merely put up with her, calmly and easily, accepting her little authority with faint scorn, compliant out of childish arrogance of indifference.

'Well, Winifred,' said the father, 'aren't you glad Miss Brangwen has come? She makes animals and birds in wood and in clay, that the people in London write about in the papers, praising them to the skies.'

Winifred smiled slightly.

'Who told you, Daddie?' she asked.

'Who told me? Hermione told me, and Rupert Birkin.'

'Do you know them?' Winifred asked of Gudrun, turning to her with faint challenge.

'Yes,' said Gudrun.

Winifred readjusted herself a little. She had been ready to accept Gudrun as a sort of servant. Now she saw it was on terms of friendship they were intended to meet. She was rather glad. She had so many half inferiors, whom she tolerated with perfect good-humour.

Gudrun was very calm. She also did not take these things very seriously. A new occasion was mostly spectacular to her. However, Winifred was a detached, ironic child, she would never attach herself. Gudrun liked her and was intrigued by her. The first meetings went off with a certain humiliating clumsiness. Neither Winifred nor her instructress had any social grace.

Soon, however, they met in a kind of make-belief world. Winifred

did not notice human beings unless they were like herself, playful and slightly mocking. She would accept nothing but the world of amusement, and the serious people of her life were the animals she had for pets. On those she lavished, almost ironically, her affection and her companionship. To the rest of the human scheme she submitted with a faint bored indifference.

She had a pekinese dog called Looloo, which she loved.

'Let us draw Looloo,' said Gudrun, 'and see if we can get his Looliness, shall we?'

'Darling!' cried Winifred, rushing to the dog, that sat with contemplative sadness on the hearth, and kissing its bulging brow. 'Darling one, will you be drawn? Shall its mummy draw its portrait?' Then she chuckled gleefully, and turning to Gudrun, said: 'Oh let's!'

They proceeded to get pencils and paper, and were ready.

'Beautifullest,' cried Winifred, hugging the dog, 'sit still while its mummy draws its beautiful portrait.' The dog looked up at her with grievous resignation in its large, prominent eyes. She kissed it fervently, and said: 'I wonder what mine will be like. It's sure to be awful.'

As she sketched she chuckled to herself, and cried out at times:

'Oh darling, you're so beautiful!'

And again chuckling, she rushed to embrace the dog, in penitence, as if she were doing him some subtle injury. He sat all the time with the resignation and fretfulness of ages on his dark velvety face. She drew slowly, with a wicked concentration in her eyes, her head on one side, an intense stillness over her. She was as if working the spell of some enchantment. Suddenly she had finished. She looked at the dog, and then at her drawing, and then cried, with real grief for the dog, and at the same time with a wicked exultation:

'My beautiful, why did they?'

She took her paper to the dog, and held it under his nose. He turned his head aside as in chagrin and mortification, and she impulsively kissed his velvety bulging forehead.

's a Loolie, 's a little Loozie! Look at his portrait, darling, look at his portrait, that his mother has done of him.' She looked at her paper and chuckled. Then, kissing the dog once more, she rose and came gravely to Gudrun, offering her the paper.

It was a grotesque little diagram of a grotesque little animal, so wicked and so comical, a slow smile came over Gudrun's face, unconsciously. And at her side Winifred chuckled with glee, and said:

'It isn't like him, is it? He's much lovelier than that. He's so beautiful – mmm, Looloo, my sweet darling.' And she flew off to embrace the chagrined little dog. He looked up at her with reproachful, saturnine

eyes, vanquished in his extreme agedness of being. Then she flew back to her drawing, and chuckled with satisfaction.

'It isn't like him, is it?' she said to Gudrun.

'Yes, it's very like him,' Gudrun replied.

The child treasured her drawing, carried it about with her, and showed it, with a silent embarrassment, to everybody.

'Look,' she said, thrusting the paper into her father's hand.

'Why that's Looloo!' he exclaimed. And he looked down in surprise, hearing the almost inhuman chuckle of the child at his side.

Gerald was away from home when Gudrun first came to Shortlands. But the first morning he came back he watched for her. It was a sunny, soft morning, and he lingered in the garden paths, looking at the flowers that had come out during his absence. He was clean and fit as ever, shaven, his fair hair scrupulously parted at the side, bright in the sunshine, his short, fair moustache closely clipped, his eyes with their humorous kind twinkle, which was so deceptive. He was dressed in black, his clothes sat well on his well-nourished body. Yet as he lingered before the flower-beds in the morning sunshine, there was a certain isolation, a fear about him, as of something wanting.

Gudrun came up quickly, unseen. She was dressed in blue, with woollen yellow stockings, like the Bluecoat boys.⁶⁹ He glanced up in surprise. Her stockings always disconcerted him, the pale-yellow stockings and the heavy heavy black shoes. Winifred, who had been playing about the garden with Mademoiselle and the dogs, came flitting towards Gudrun. The child wore a dress of black-and-white stripes. Her hair was rather short, cut round and hanging level in her neck.

'We're going to do Bismarck,⁷⁰ aren't we?' she said, linking her hand through Gudrun's arm.

'Yes, we're going to do Bismarck. Do you want to?'

'Oh yes – oh I do! I want most awfully to do Bismarck. He looks *so* splendid this morning, so *fierce*. He's almost as big as a lion.' And the child chuckled sardonically at her own hyperbole. 'He's a real king, he really is.'

'Bon jour, Mademoiselle,' said the little French governess, wavering up with a slight bow, a bow of the sort that Gudrun loathed, insolent.

'Winifred veut tant faire le portrait de Bismarck – ! Oh, mais toute la matinée – "We will do Bismarck this morning!"–Bismarck, Bismarck, toujours Bismarck! C'est un lapin, n'est-ce pas, mademoiselle?'

'Oui, c'est un grand lapin blanc et noir. Vous ne l'avez pas vu?' said Gudrun in her good, but rather heavy French.

'Non, mademoiselle, Winifred n'a jamais voulu me le faire voir. Tant

de fois je le lui ai demandé, "Qu'est ce donc que ce Bismarck, Winifred?" Mais elle n'a pas voulu me le dire. Son Bismarck, c'était un mystère.'

'Oui, c'est un mystère, vraiment un mystère! Miss Brangwen, say that Bismarck is a mystery,' cried Winifred.

'Bismarck, is a mystery, Bismarck, c'est un mystère, der Bismarck, er ist ein Wunder,' said Gudrun, in mocking incantation.

'Ja, er ist ein Wunder,' repeated Winifred, with odd seriousness, under which lay a wicked chuckle.

'Ist er auch ein Wunder?' came the slightly insolent sneering of Mademoiselle.

'Doch!' said Winifred briefly, indifferent.

'Doch ist er nicht ein König. Beesmarck, he was not a king, Winifred, as you have said. He was only – il n'était que chancelier.'

'Qu'est ce qu'un chancelier?' said Winifred, with slightly contemptuous indifference.

'A chancelier is a chancellor, and a chancellor is, I believe, a sort of judge,' said Gerald coming up and shaking hands with Gudrun. 'You'll have made a song of Bismarck soon,' said he.

Mademoiselle waited, and discreetly made her inclination, and her greeting.

'So they wouldn't let you see Bismarck, Mademoiselle?' he said.

'Non, Monsieur.'71

'Ay, very mean of them. What are you going to do to him, Miss Brangwen? I want him sent to the kitchen and cooked.'

'Oh no,' cried Winifred.

'We're going to draw him,' said Gudrun.

'Draw him and quarter him and dish him up,' he said, being purposely fatuous.

'Oh no,' cried Winifred with emphasis, chuckling.

Gudrun detected the tang of mockery in him, and she looked up and smiled into his face. He felt his nerves caressed. Their eyes met in knowledge.

'How do you like Shortlands?' he asked.

'Oh, very much,' she said, with nonchalance.

'Glad you do. Have you noticed these flowers?'

He led her along the path. She followed intently. Winifred came, and the governess lingered in the rear. They stopped before some veined salpiglossis flowers.

'Aren't they wonderful?' she cried, looking at them absorbedly. Strange how her reverential, almost ecstatic admiration of the flowers caressed his nerves. She stooped down, and touched the trumpets, with

infinitely fine and delicate-touching finger-tips. It filled him with ease to see her. When she rose, her eyes, hot with the beauty of the flowers, looked into his.

'What are they?' she asked.

'Sort of petunia, I suppose,' he answered. 'I don't really know them.' 'They are quite strangers to me,' she said.

They stood together in a false intimacy, a nervous contact. And he was in love with her.

She was aware of Mademoiselle standing near, like a little French beetle, observant and calculating. She moved away with Winifred, saying they would go to find Bismarck.

Gerald watched them go, looking all the while at the soft, full, still body of Gudrun, in its silky cashmere. How silky and rich and soft her body must be. An excess of appreciation came over his mind, she was the all-desirable, the all-beautiful. He wanted only to come to her, nothing more. He was only this, this being that should come to her, and be given to her.

At the same time he was finely and acutely aware of Mademoiselle's neat, brittle finality of form. She was like some elegant beetle with thin ankles, perched on her high heels, her glossy black dress perfectly correct, her dark hair done high and admirably. How repulsive her completeness and her finality was! He loathed her.

Yet he did admire her. She was perfectly correct. And it did rather annoy him, that Gudrun came dressed in startling colours, like a macaw, when the family was in mourning. Like a macaw she was! He watched the lingering way she took her feet from the ground. And her ankles were pale yellow, and her dress a deep blue. Yet it pleased him. It pleased him very much. He felt the challenge in her very attire – she challenged the whole world. And he smiled as to the note of a trumpet.

Gudrun and Winifred went through the house to the back, where were the stables and the out-buildings. Everywhere was still and deserted. Mr Crich had gone out for a short drive, the stableman had just led round Gerald's horse. The two girls went to the hutch that stood in a corner, and looked at the great black-and-white rabbit.

'Isn't he beautiful! Oh, do look at him listening! Doesn't he look silly!' she laughed quickly, then added 'Oh, do let's do him listening, do let us, he listens with so much of himself; – don't you darling Bismarck?'

'Can we take him out?' said Gudrun.

'He's very strong. He really is extremely strong.' She looked at Gudrun, her head on one side, in odd calculating mistrust.

'But we'll try, shall we?'

'Yes, if you like. But he's a fearful kicker!'

They took the key to unlock the door. The rabbit exploded in a wild rush round the hutch.

'He scratches most awfully sometimes,' cried Winifred in excitement. 'Oh do look at him, isn't he wonderful!' The rabbit tore round the hutch in a hurry. 'Bismarck!' cried the child, in rousing excitement. 'How *dreadful* you are! You are beastly.' Winifred looked up at Gudrun with some misgiving in her wild excitement. Gudrun smiled sardonically with her mouth. Winifred made a strange crooning noise of unaccountable excitement. 'Now he's still!' she cried, seeing the rabbit settled down in a far corner of the hutch. 'Shall we take him now?' she whispered excitedly, mysteriously, looking up at Gudrun and edging very close. 'Shall we get him now? – ' she chuckled wickedly to herself.

They unlocked the door of the hutch. Gudrun thrust in her arm and seized the great, lusty rabbit as it crouched still, she grasped its long ears. It set its four feet flat, and thrust back. There was a long scraping sound as it was hauled forward, and in another instant it was in mid-air, lunging wildly, its body flying like a spring coiled and released, as it lashed out, suspended from the ears. Gudrun held the black-and-white tempest at arms' length, averting her face. But the rabbit was magically strong, it was all she could do to keep her grasp. She almost lost her presence of mind.

'Bismarck, Bismarck, you are behaving terribly,' said Winifred in a rather frightened voice, 'Oh, do put him down, he's beastly.'

Gudrun stood for a moment astounded by the thunder-storm that had sprung into being in her grip. Then her colour came up, a heavy rage came over her like a cloud. She stood shaken as a house in a storm, and utterly overcome. Her heart was arrested with fury at the mindlessness and the bestial stupidity of this struggle, her wrists were badly scored by the claws of the beast, a heavy cruelty welled up in her.

Gerald came round as she was trying to capture the flying rabbit under her arm. He saw, with subtle recognition, her sullen passion of cruelty.

'You should let one of the men do that for you,' he said hurrying up. 'Oh, he's *so* horrid!' cried Winifred, almost frantic.

He held out his nervous, sinewy hand and took the rabbit by the ears, from Gudrun.

'It's most *fearfully* strong,' she cried, in a high voice, like the crying a seagull, strange and vindictive.

The rabbit made itself into a ball in the air, and lashed out, flinging itself into a bow. It really seemed demoniacal. Gudrun saw Gerald's body tighten, saw a sharp blindness come into his eyes.

'I know these beggars of old,' he said.

The long, demon-like beast lashed out again, spread on the air as if it were flying, looking something like a dragon, then closing up again, inconceivably powerful and explosive. The man's body, strung to its efforts, vibrated strongly. Then a sudden sharp, white-edged wrath came up in him. Swift as lightning he drew back and brought his free hand down like a hawk on the neck of the rabbit. Simultaneously, there came the unearthly abhorrent scream of a rabbit in the fear of death. It made one immense writhe, tore his wrists and his sleeves in a final convulsion, all its belly flashed white in a whirlwind of paws, and then he had slung it round and had it under his arm, fast. It cowered and skulked. His face was gleaming with a smile.

You wouldn't think there was all that force in a rabbit,' he said, looking at Gudrun. And he saw her eyes black as night in her pallid face, she looked almost unearthly. The scream of the rabbit, after the violent tussle, seemed to have torn the veil of her consciousness. He looked at her, and the whitish, electric gleam in his face intensified.

'I don't really like him,' Winifred was crooning. 'I don't care for him as I do for Loozie. He's hateful really.'

A smile twisted Gudrun's face, as she recovered. She knew she was revealed. 'Don't they make the most fearful noise when they scream?' she cried, the high note in her voice, like a sea-gull's cry.

'Abominable,' he said.

'He shouldn't be so silly when he has to be taken out,' Winifred was saying, putting out her hand and touching the rabbit tentatively, as it skulked under his arm, motionless as if it were dead.

'He's not dead, is he Gerald?' she asked.

'No, he ought to be,' he said.

'Yes, he ought!' cried the child, with a sudden flush of amusement. And she touched the rabbit with more confidence. 'His heart is beating so fast. Isn't he funny? He really is.'

'Where do you want him?' asked Gerald.

'In the little green court,' she said.

Gudrun looked at Gerald with strange, darkened eyes, strained with underworld knowledge, almost supplicating, like those of a creature which is at his mercy, yet which is his ultimate victor. He did not know what to say to her. He felt the mutual hellish recognition. And he felt he ought to say something, to cover it. He had the power of lightning in his nerves, she seemed like a soft recipient of his magical, hideous white fire. He was unconfident, he had qualms of fear.

'Did he hurt you?' he asked.

'No,' she said.

WOMEN IN LOVE

'He's an insensible beast,' he said, turning his face away.

They came to the little court, which was shut in by old red walls in whose crevices wall-flowers were growing. The grass was soft and fine and old, a level floor carpeting the court, the sky was blue overhead. Gerald tossed the rabbit down. It crouched still and would not move. Gudrun watched it with faint horror.

'Why doesn't it move?' she cried.

'It's skulking,' he said.

She looked up at him, and a slight sinister smile contracted her white face.

'Isn't it a *fool*!' she cried. 'Isn't it a sickening *fool*?' The vindictive mockery in her voice made his brain quiver. Glancing up at him, into his eyes, she revealed again the mocking, white-cruel recognition. There was a league between them, abhorrent to them both. They were implicated with each other in abhorrent mysteries.

'How many scratches have you?' he asked, showing his hard forearm, white and hard and torn in red gashes.

'How really vile!' she cried, flushing with a sinister vision. 'Mine is nothing.'

She lifted her arm and showed a deep red score down the silken white flesh.

'What a devil!' he exclaimed. But it was as if he had had knowledge of her in the long red rent of her forearm, so silken and soft. He did not want to touch her. He would have to make himself touch her, deliberately. The long, shallow red rip seemed torn across his own brain, tearing the surface of his ultimate consciousness, letting through the forever unconscious, unthinkable red ether of the beyond, the obscene beyond.

'It doesn't hurt you very much, does it?' he asked, solicitous.

'Not at all,' she cried.

And suddenly the rabbit, which had been crouching as if it were a flower, so still and soft, suddenly burst into life. Round and round the court it went, as if shot from a gun, round and round like a furry meteorite, in a tense hard circle that seemed to bind their brains. They all stood in amazement, smiling uncannily, as if the rabbit were obeying some unknown incantation. Round and round it flew, on the grass under the old red walls like a storm.

And then quite suddenly it settled down, hobbled among the grass, and sat considering, its nose twitching like a bit of fluff in the wind. After having considered for a few minutes, a soft bunch with a black, open eye, which perhaps was looking at them, perhaps was not, it hobbled calmly forward and began to nibble the grass with that mean motion of a rabbit's quick eating.

'It's mad,' said Gudrun. 'It is most decidedly mad.'

He laughed.

'The question is,' he said, 'what is madness? I don't suppose it is rabbit-mad.'

'Don't you think it is?' she asked.

'No. That's what it is to be a rabbit.'

There was a queer, faint, obscene smile over his face. She looked at him and saw him, and knew that he was initiate as she was initiate. This thwarted her, and contravened her, for the moment.

'God be praised we aren't rabbits,' she said, in a high, shrill voice.

The smile intensified a little, on his face.

'Not rabbits?' he said, looking at her fixedly.

Slowly her face relaxed into a smile of obscene recognition.

'Ah Gerald,' she said, in a strong, slow, almost man-like way. ' – All that, and more.' Her eyes looked up at him with shocking nonchalance.

He felt again as if she had torn him across the breast, dully, finally. He turned aside.

'Eat, eat my darling!' Winifred was softly conjuring the rabbit, and creeping forward to touch it. It hobbled away from her. 'Let its mother stroke its fur then, darling, because it is so mysterious – '

CHAPTER XIX

Moony

AFTER HIS ILLNESS Birkin went to the south of France for a time. He did not write, nobody heard anything of him. Ursula, left alone, felt as if everything were lapsing out. There seemed to be no hope in the world. One was a tiny little rock with the tide of nothingness rising higher and higher She herself was real, and only herself – just like a rock in a wash of flood-water. The rest was all nothingness. She was hard and indifferent, isolated in herself.

There was nothing for it now, but contemptuous, resistant indifference. All the world was lapsing into a grey wish-wash of nothingness, she had no contact and no connection anywhere. She despised and detested the whole show. From the bottom of her heart, from the bottom of her soul, she despised and detested people, adult people. She loved only children and animals: children she loved passionately, but coldly. They made her want to hug them, to protect them, to give them life. But this very love, based on pity and despair, was only a bondage and a pain to her. She loved best of all the animals, that were single and unsocial as she herself was. She loved the horses and cows in the field. Each was single and to itself, magical. It was not referred away to some detestable social principle. It was incapable of soulfulness and tragedy, which she detested so profoundly.

She could be very pleasant and flattering, almost subservient, to people she met. But no one was taken in. Instinctively each felt her contemptuous mockery of the human being in himself, or herself. She had a profound grudge against the human being. That which the word 'human' stood for was despicable and repugnant to her.

Mostly her heart was closed in this hidden, unconscious strain of contemptuous ridicule. She thought she loved, she thought she was full of love. This was her idea of herself. But the strange brightness of her presence, a marvellous radiance of intrinsic vitality, was a luminousness of supreme repudiation, nothing but repudiation.

Yet, at moments, she yielded and softened, she wanted pure love, only pure love. This other, this state of constant unfailing repudiation, was a strain, a suffering also. A terrible desire for pure love overcame her again.

She went out one evening, numbed by this constant essential suffering. Those who are timed for destruction must die now. The knowledge of this reached a finality, a finishing in her. And the finality released her. If fate would carry off in death or downfall all those who were timed to go, why need she trouble, why repudiate any further. She was free of it all, she could seek a new union elsewhere.

Ursula set off to Willey Green, towards the mill. She came to Willey Water. It was almost full again, after its period of emptiness. Then she turned off through the woods. The night had fallen, it was dark. But she forgot to be afraid, she who had such great sources of fear. Among the trees, far from any human beings, there was a sort of magic peace. The more one could find a pure loneliness, with no taint of people, the better one felt. She was in reality terrified, horrified in her apprehension of people.

She started, noticing something on her right hand, between the tree trunks. It was like a great presence, watching her, dodging her. She started violently. It was only the moon, risen through the thin trees. But it seemed so mysterious, with its white and deathly smile. And there was no avoiding it. Night or day, one could not escape the sinister face, triumphant and radiant like this moon, with a high smile. She hurried on, cowering from the white planet. She would just see the pond at the mill before she went home.

Not wanting to go through the yard, because of the dogs, she turned

off along the hill-side to descend on the pond from above. The moon was transcendent over the bare, open space, she suffered from being exposed to it. There was a glimmer of nightly rabbits across the ground. The night was as clear as crystal, and very still. She could hear a distant coughing of a sheep.

So she swerved down to the steep, tree-hidden bank above the pond, where the alders twisted their roots. She was glad to pass into the shade out of the moon. There she stood, at the top of the fallen-away bank, her hand on the rough trunk of a tree, looking at the water, that was perfect in its stillness, floating the moon upon it. But for some reason she disliked it. It did not give her anything. She listened for the hoarse rustle of the sluice. And she wished for something else out of the night, she wanted another night, not this moon-brilliant hardness. She could feel her soul crying out in her, lamenting desolately.

She saw a shadow moving by the water. It would be Birkin. He had come back then, unawares. She accepted it without remark, nothing mattered to her. She sat down among the roots of the alder tree, dim and veiled, hearing the sound of the sluice like dew distilling audibly into the night. The islands were dark and half revealed, the reeds were dark also, only some of them had a little frail fire of reflection. A fish leaped secretly, revealing the light in the pond. This fire of the chill night breaking constantly on to the pure darkness, repelled her. She wished it were perfectly dark, perfectly, and noiseless and without motion. Birkin, small and dark also, his hair tinged with moonlight, wandered nearer. He was quite near, and yet he did not exist in her. He did not know she was there. Supposing he did something he would not wish to be seen doing, thinking he was quite private? But there, what did it matter? What did the small privacies matter? How could it matter, what he did? How can there be any secrets, we are all the same organisms? How can there be any secrecy, when everything is known to all of us?

He was touching unconsciously the dead husks of flowers as he passed by, and talking disconnectedly to himself.

'You can't go away,' he was saying. 'There is no away. You only withdraw upon yourself.'

He threw a dead flower-husk on to the water.

'An antiphony – they lie, and you sing back to them. There wouldn't have to be any truth, if there weren't any lies. Then one needn't assert anything – '

He stood still, looking at the water, and throwing upon it the husks of the flowers.

'Cybele - curse her! The accursed Syria Dea!⁷² Does one begrudge it

her? What else is there -?'

Ursula wanted to laugh loudly and hysterically, hearing his isolated voice speaking out. It was so ridiculous.

He stood staring at the water. Then he stooped and picked up a stone, which he threw sharply at the pond. Ursula was aware of the bright moon leaping and swaying, all distorted, in her eyes. It seemed to shoot out arms of fire like a cuttle-fish, like a luminous polyp, palpitating strongly before her.

And his shadow on the border of the pond, was watching for a few moments, then he stooped and groped on the ground. Then again there was a burst of sound, and a burst of brilliant light, the moon had exploded on the water, and was flying asunder in flakes of white and dangerous fire. Rapidly, like white birds, the fires all broken rose across the pond, fleeing in clamorous confusion, battling with the flock of dark waves that were forcing their way in. The furthest waves of light, fleeing out, seemed to be clamouring against the shore for escape, the waves of darkness came in heavily, running under towards the centre. But at the centre, the heart of all, was still a vivid, incandescent quivering of a white moon not quite destroyed, a white body of fire writhing and striving and not even now broken open, not vet violated. It seemed to be drawing itself together with strange, violent pangs, in blind effort. It was getting stronger, it was re-asserting itself, the inviolable moon. And the rays were hastening in in thin lines of light, to return to the strengthened moon, that shook upon the water in triumphant reassumption.

Birkin stood and watched, motionless, till the pond was almost calm, the moon was almost serene. Then, satisfied of so much, he looked for more stones. She felt his invisible tenacity. And in a moment again, the broken lights scattered in explosion over her face, dazzling her; and then, almost immediately, came the second shot. The moon leapt up white and burst through the air. Darts of bright light shot asunder, darkness swept over the centre. There was no moon, only a battlefield of broken lights and shadows, running close together. Shadows, dark and heavy, struck again and again across the place where the heart of the moon had been, obliterating it altogether. The white fragments pulsed up and down, and could not find where to go, apart and brilliant on the water like the petals of a rose that a wind has blown far and wide.

Yet again, they were flickering their way to the centre, finding the path blindly, enviously. And again, all was still, as Birkin and Ursula watched. The waters were loud on the shore. He saw the moon regathering itself insidiously, saw the heart of the rose intertwining vigorously and blindly, calling back the scattered fragments, winning

home the fragments, in a pulse and in effort of return.

And he was not satisfied. Like a madness, he must go on. He got large stones, and threw them, one after the other, at the white-burning centre of the moon, till there was nothing but a rocking of hollow noise, and a pond surged up, no moon any more, only a few broken flakes tangled and glittering broadcast in the darkness, without aim or meaning, a darkened confusion, like a black and white kaleidoscope tossed at random. The hollow night was rocking and crashing with noise, and from the sluice came sharp, regular flashes of sound. Flakes of light appeared here and there, glittering tormented among the shadows, far off, in strange places; among the dripping shadow of the willow on the island. Birkin stood and listened and was satisfied.

Ursula was dazed, her mind was all gone. She felt she had fallen to the ground and was spilled out, like water on the earth. Motionless and spent she remained in the gloom. Though even now she was aware, unseeing, that in the darkness was a little tumult of ebbing flakes of light, a cluster dancing secretly in a round, twining and coming steadily together. They were gathering a heart again, they were coming once more into being. Gradually the fragments caught together re-united, heaving, rocking, dancing, falling back as in panic, but working their way home again persistently, making semblance of fleeing away when they had advanced, but always flickering nearer, a little closer to the mark, the cluster growing mysteriously larger and brighter, as gleam after gleam fell in with the whole, until a ragged rose, a distorted, frayed moon was shaking upon the waters again, re-asserted, renewed, trying to recover from its convulsion, to get over the disfigurement and the agitation, to be whole and composed, at peace.

Birkin lingered vaguely by the water. Ursula was afraid that he would stone the moon again. She slipped from her seat and went down to him, saying:

'You won't throw stones at it any more, will you?'

'How long have you been there?'

'All the time. You won't throw any more stones, will you?'

'I wanted to see if I could make it be quite gone off the pond,' he said. 'Yes, it was horrible, really. Why should you hate the moon? It hasn't done you any harm, has it?'

'Was it hate?' he said.

And they were silent for a few minutes.

'When did you come back?' she said.

'Today.'

'Why did you never write?'

'I could find nothing to say.'

'Why was there nothing to say?'

'I don't know. Why are there no daffodils now?'

'No.'

Again there was a space of silence. Ursula looked at the moon. It had gathered itself together, and was quivering slightly.

'Was it good for you, to be alone?' she asked.

'Perhaps. Not that I know much. But I got over a good deal. Did you do anything important?'

'No. I looked at England, and thought I'd done with it.'

'Why England?' he asked in surprise.

'I don't know, it came like that.'

'It isn't a question of nations,' he said. 'France is far worse.'

'Yes, I know. I felt I'd done with it all.'

They went and sat down on the roots of the trees, in the shadow. And being silent, he remembered the beauty of her eyes, which were sometimes filled with light, like spring, suffused with wonderful promise. So he said to her, slowly, with difficulty:

'There is a golden light in you, which I wish you would give me.' It was as if he had been thinking of this for some time.

She was startled, she seemed to leap clear of him. Yet also she was pleased.

'What kind of a light,' she asked.

But he was shy, and did not say any more. So the moment passed for this time. And gradually a feeling of sorrow came over her.

'My life is unfulfilled,' she said.

'Yes,' he answered briefly, not wanting to hear this.

'And I feel as if nobody could ever really love me,' she said.

But he did not answer.

'You think, don't you,' she said slowly, 'that I only want physical things? It isn't true. I want you to serve my spirit.'

'I know you do. I know you don't want physical things by themselves. But, I want you to give me – to give your spirit to me – that golden light which is you – which you don't know – give it me – '

After a moment's silence she replied:

'But how can I, you don't love me! You only want your own ends. You don't want to serve *me*, and yet you want me to serve you. It is so one-sided!'

It was a great effort to him to maintain this conversation, and to press for the thing he wanted from her, the surrender of her spirit.

'It is different,' he said. 'The two kinds of service are so different. I serve you in another way – not through *yourself* – somewhere else. But I want us to be together without bothering about ourselves – to be really together because we *are* together, as if it were a phenomenon, not a thing we have to maintain by our own effort.'

'No,' she said, pondering. 'You are just egocentric. You never have any enthusiasm, you never come out with any spark towards me. You want yourself, really, and your own affairs. And you want me just to be there, to serve you.'

But this only made him shut off from her.

'Ah well,' he said, 'words make no matter, any way. The thing is between us, or it isn't.'

'You don't even love me,' she cried.

'I do,' he said angrily. 'But I want – ' His mind saw again the lovely golden light of spring transfused through her eyes, as through some wonderful window. And he wanted her to be with him there, in this world of proud indifference. But what was the good of telling her he wanted this company in proud indifference. What was the good of talking, any way? It must happen beyond the sound of words. It was merely ruinous to try to work her by conviction. This was a paradisal bird that could never be netted, it must fly by itself to the heart.

'I always think I am going to be loved – and then I am let down. You *don't* love me, you know. You don't want to serve me. You only want yourself.'

A shiver of rage went over his veins, at this repeated: 'You don't want to serve me.' All the paradisal disappeared from him.

'No,' he said, irritated, 'I don't want to serve you, because there is nothing there to serve. What you want me to serve, is nothing, mere nothing. It isn't even you, it is your mere female quality. And I wouldn't give a straw for your female ego - it's a rag doll.'

'Ha!' she laughed in mockery. 'That's all you think of me, is it? And then you have the impudence to say you love me.'

She rose in anger, to go home.

'You want the paradisal unknowing,' she said, turning round on him as he still sat half-visible in the shadow. 'I know what that means, thank you. You want me to be your thing, never to criticise you or to have anything to say for myself. You want me to be a mere *thing* for you! No thank you! If you want that, there are plenty of women who will give it to you. There are plenty of women who will lie down for you to walk over them -go to them then, if that's what you want -go to them.'

'No,' he said, outspoken with anger. 'I want you to drop your assertive *will*, your frightened apprehensive self-insistence, that is what I want. I want you to trust yourself so implicitly, that you can let yourself go.'

'Let myself go!' she re-echoed in mockery. 'I can let myself go, easily

WOMEN IN LOVE

enough. It is you who can't let yourself go, it is you who hang on to yourself as if it were your only treasure. *You – you* are the Sunday school teacher – *You* – you preacher.'

The amount of truth that was in this made him stiff and unheeding of her.

'I don't mean let yourself go in the Dionysic ecstatic way,' he said. 'I know you can do that. But I hate ecstasy, Dionysic or any other. It's like going round in a squirrel cage. I want you not to care about yourself, just to be there and not to care about yourself, not to insist – be glad and sure and indifferent.'

'Who insists?' she mocked. 'Who is it that keeps on insisting? It isn't me!'

There was a weary, mocking bitterness in her voice. He was silent for some time.

'I know,' he said. 'While ever either of us insists to the other, we are all wrong. But there we are, the accord doesn't come.'

They sat in stillness under the shadow of the trees by the bank. The night was white around them, they were in the darkness, barely conscious.

Gradually, the stillness and peace came over them. She put her hand tentatively on his. Their hands clasped softly and silently, in peace.

'Do you really love me?' she said.

He laughed.

'I call that your war-cry,' he replied, amused.

'Why!' she cried, amused and really wondering.

'Your insistence – Your war-cry – "A Brangwen, A Brangwen" – an old battle-cry. Yours is, "Do you love me? Yield knave, or die." '

'No,' she said, pleading, 'not like that. Not like that. But I must know that you love me, mustn't I?'

'Well then, know it and have done with it.'

'But do you?'

'Yes, I do. I love you, and I know it's final. It is final, so why say any more about it.'

She was silent for some moments, in delight and doubt.

'Are you sure?' she said, nestling happily near to him.

'Quite sure - so now have done - accept it and have done.'

She was nestled quite close to him.

'Have done with what?' she murmured, happily.

'With bothering,' he said.

She clung nearer to him. He held her close, and kissed her softly, gently. It was such peace and heavenly freedom, just to fold her and kiss her gently, and not to have any thoughts or any desires or any will, just to be still with her, to be perfectly still and together, in a peace that was not sleep, but content in bliss. To be content in bliss, without desire or insistence anywhere, this was heaven: to be together in happy stillness.

For a long time she nestled to him, and he kissed her softly, her hair, her face, her ears, gently, softly, like dew falling. But this warm breath on her ears disturbed her again, kindled the old destructive fires. She cleaved to him, and he could feel his blood changing like quicksilver.

'But we'll be still, shall we?' he said.

'Yes,' she said, as if submissively.

And she continued to nestle against him.

But in a little while she drew away and looked at him.

'I must be going home,' she said.

'Must you - how sad,' he replied.

She leaned forward and put up her mouth to be kissed.

'Are you really sad?' she murmured, smiling.

'Yes,' he said, 'I wish we could stay as we were, always.'

'Always! Do you?' she murmured, as he kissed her. And then, out of a full throat, she crooned 'Kiss me! Kiss me!' And she cleaved close to him. He kissed her many times. But he too had his idea and his will. He wanted only gentle communion, no other, no passion now. So that soon she drew away, put on her hat and went home.

The next day however, he felt wistful and yearning. He thought he had been wrong, perhaps. Perhaps he had been wrong to go to her with an idea of what he wanted. Was it really only an idea, or was it the interpretation of a profound yearning? If the latter, how was it he was always talking about sensual fulfilment? The two did not agree very well.

Suddenly he found himself face to face with a situation. It was as simple as this: fatally simple. On the one hand, he knew he did not want a further sensual experience - something deeper, darker, than ordinary life could give. He remembered the African fetishes he had seen at Halliday's so often. There came back to him one, a statuette about two feet high, a tall, slim, elegant figure from West Africa, in dark wood, glossy and suave. It was a woman, with hair dressed high, like a melon-shaped dome. He remembered her vividly: she was one of his soul's intimates. Her body was long and elegant, her face was crushed tiny like a beetle's, she had rows of round heavy collars, like a column of quoits, on her neck. He remembered her: her astonishing cultured elegance, her diminished, beetle face, the astounding long elegant body, on short, ugly legs, with such protuberant buttocks, so weighty and unexpected below her slim long loins. She knew what he himself did not know. She had thousands of years of purely sensual, purely unspiritual knowledge behind her. It must have been thousands

of years since her race had died, mystically: that is, since the relation between the senses and the outspoken mind had broken, leaving the experience all in one sort, mystically sensual. Thousands of years ago, that which was imminent in himself must have taken place in these Africans: the goodness, the holiness, the desire for creation and productive happiness must have lapsed, leaving the single impulse for knowledge in one sort, mindless progressive knowledge through the senses, knowledge arrested and ending in the senses, mystic knowledge in disintegration and dissolution, knowledge such as the beetles have, which live purely within the world of corruption and cold dissolution. This was why her face looked like a beetle's: this was why the Egyptians worshipped the ball-rolling scarab:⁷³ because of the principle of knowledge in dissolution and corruption.

There is a long way we can travel, after the death-break: after that point when the soul in intense suffering breaks, breaks away from its organic hold like a leaf that falls. We fall from the connection with life and hope, we lapse from pure integral being, from creation and liberty, and we fall into the long, long African process of purely sensual understanding, knowledge in the mystery of dissolution.

He realised now that this is a long process – thousands of years it takes, after the death of the creative spirit. He realised that there were great mysteries to be unsealed, sensual, mindless, dreadful mysteries, far beyond the phallic cult. How far, in their inverted culture, had these West Africans gone beyond phallic knowledge? Very, very far. Birkin recalled again the female figure: the elongated, long, long body, the curious unexpected heavy buttocks, he long, imprisoned neck, the face with tiny features like a beetle's. This was far beyond any phallic knowledge, sensual subtle realities far beyond the scope of phallic investigation.

There remained this way, this awful African process, to be fulfilled. It would be done differently by the white races. The white races, having the arctic north behind them, the vast abstraction of ice and snow, would fulfil a mystery of ice-destructive knowledge, snow-abstract annihilation. Whereas the West Africans, controlled by the burning death-abstraction of the Sahara, had been fulfilled in sun-destruction, the putrescent mystery of sun-rays.

Was this then all that remained? Was there left now nothing but to break off from the happy creative being, was the time up? Is our day of creative life finished? Does there remain to us only the strange, awful afterwards of the knowledge in dissolution, the African knowledge, but different in us, who are blond and blue-eyed from the north?

Birkin thought of Gerald. He was one of these strange white

wonderful demons from the north, fulfilled in the destructive frost mystery. And was he fated to pass away in this knowledge, this one process of frost-knowledge, death by perfect cold? Was he a messenger, an omen of the universal dissolution into whiteness and snow?

Birkin was frightened. He was tired too, when he had reached this length of speculation. Suddenly his strange, strained attention gave way, he could not attend to these mysteries any more. There was another way, the way of freedom. There was the paradisal entry into pure, single being, the individual soul taking precedence over love and desire for union, stronger than any pangs of emotion, a lovely state of free proud singleness, which accepted the obligation of the permanent connection with others, and with the other, submits to the yoke and leash of love, but never forfeits its own proud individual singleness, even while it loves and yields.

There was the other way, the remaining way. And he must run to follow it. He thought of Ursula, how sensitive and delicate she really was, her skin so over-fine, as if one skin were wanting. She was really so marvellously gentle and sensitive. Why did he ever forget it? He must go to her at once. He must ask her to marry him. They must marry at once, and so make a definite pledge, enter into a definite communion. He must set out at once and ask her, this moment. There was no moment to spare.

He drifted on swiftly to Beldover, half-unconscious of his own movement. He saw the town on the slope of the hill, not straggling, but as if walled-in with the straight, final streets of miners' dwellings, making a great square, and it looked like Jerusalem to his fancy. The world was all strange and transcendent.

Rosalind opened the door to him. She started slightly, as a young girl will, and said:

'Oh, I'll tell father.'

With which she disappeared, leaving Birkin in the hall, looking at some reproductions from Picasso, lately introduced by Gudrun. He was admiring the almost wizard, sensuous apprehension of the earth, when Will Brangwen appeared, rolling down his shirt sleeves.

'Well,' said Brangwen, 'I'll get a coat.' And he too disappeared for a moment. Then he returned, and opened the door of the drawingroom, saying:

'You must excuse me, I was just doing a bit of work in the shed. Come inside, will you.'

Birkin entered and sat down. He looked at the bright, reddish face of the other man, at the narrow brow and the very bright eyes, and at the rather sensual lips that unrolled wide and expansive under the black cropped moustache. How curious it was that this was a human being! What Brangwen thought himself to be, how meaningless it was, confronted with the reality of him. Birkin could see only a strange, inexplicable, almost patternless collection of passions and desires and suppressions and traditions and mechanical ideas, all cast unfused and disunited into this slender, bright-faced man of nearly fifty, who was as unresolved now as he was at twenty, and as uncreated. How could he be the parent of Ursula, when he was not created himself. He was not a parent. A slip of living flesh had been transmitted through him, but the spirit had not come from him. The spirit had not come from any ancestor, it had come out of the unknown. A child is the child of the mystery, or it is uncreated.

'The weather's not so bad as it has been,' said Brangwen, after waiting a moment. There was no connection between the two men.

'No,' said Birkin. 'It was full moon two days ago.'

'Oh! You believe in the moon then, affecting the weather?'

'No, I don't think I do. I don't really know enough about it.'

'You know what they say? The moon and the weather may change together, but the change of the moon won't change the weather.'

'Is that it?' said Birkin. 'I hadn't heard it.'

There was a pause. Then Birkin said:

'Am I hindering you? I called to see Ursula, really. Is she at home?' 'I don't believe she is. I believe she's gone to the library. I'll just see.'

Birkin could hear him enquiring in the dining-room.

'No,' he said, coming back. 'But she won't be long. You wanted to speak to her?'

Birkin looked across at the other man with curious calm, clear eyes.

'As a matter of fact,' he said, 'I wanted to ask her to marry me.'

A point of light came on the golden-brown eyes of the elder man.

'O-oh?' he said, looking at Birkin, then dropping his eyes before the calm, steadily watching look of the other: 'Was she expecting you then?'

'No,' said Birkin.

'No? I didn't know anything of this sort was on foot - ' Brangwen smiled awkwardly.

Birkin looked back at him, and said to himself: 'I wonder why it should be "on foot"!' Aloud he said:

'No, it's perhaps rather sudden.' At which, thinking of his relationship with Ursula, he added – 'but I don't know – '

'Quite sudden, is it? Oh!' said Brangwen, rather baffled and annoyed. 'In one way,' replied Birkin, ' – not in another.'

There was a moment's pause, after which Brangwen said:

'Well, she pleases herself -'

'Oh yes!' said Birkin, calmly.

A vibration came into Brangwen's strong voice, as he replied:

'Though I shouldn't want her to be in too big a hurry, either. It's no good looking round afterwards, when it's too late.'

'Oh, it need never be too late,' said Birkin, 'as far as that goes.' 'How do you mean?' asked the father.

'If one repents being married, the marriage is at an end,' said Birkin. 'You think so?'

'Yes.'

'Ay, well that may be your way of looking at it.'

Birkin, in silence, thought to himself: 'So it may. As for your way of looking at it, William Brangwen, it needs a little explaining.'

'I suppose,' said Brangwen, 'you know what sort of people we are? What sort of a bringing-up she's had?'

' "She",' thought Birkin to himself, remembering his childhood's corrections, 'is the cat's mother.'

'Do I know what sort of a bringing-up she's had?' he said aloud.

He seemed to annoy Brangwen intentionally.

'Well,' he said, 'she's had everything that's right for a girl to have – as far as possible, as far as we could give it her.'

'I'm sure she has,' said Birkin, which caused a perilous full-stop. The father was becoming exasperated. There was something naturally irritant to him in Birkin's mere presence.

'And I don't want to see her going back on it all,' he said, in a clanging voice.

'Why?' said Birkin.

This monosyllable exploded in Brangwen's brain like a shot.

'Why! I don't believe in your new-fangled ways and new-fangled ideas – in and out like a frog in a gallipot. It would never do for me.'

Birkin watched him with steady emotionless eyes. The radical antagonism in the two men was rousing.

'Yes, but are my ways and ideas new-fangled?' asked Birkin.

'Are they?' Brangwen caught himself up. 'I'm not speaking of you in particular,' he said. 'What I mean is that my children have been brought up to think and do according to the religion I was brought up in myself, and I don't want to see them going away from *that*.'

There was a dangerous pause.

'And beyond that - ?' asked Birkin.

The father hesitated, he was in a nasty position.

'Eh? What do you mean? All I want to say is that my daughter' – he tailed off into silence, overcome by futility. He knew that in some way

he was off the track.

'Of course,' said Birkin, 'I don't want to hurt anybody or influence anybody. Ursula does exactly as she pleases.'

There was a complete silence, because of the utter failure in mutual understanding. Birkin felt bored. Her father was not a coherent human being, he was a roomful of old echoes. The eyes of the younger man rested on the face of the elder. Brangwen looked up, and saw Birkin looking at him. His face was covered with inarticulate anger and humiliation and sense of inferiority in strength.

'And as for beliefs, that's one thing,' he said. 'But I'd rather see my daughters dead tomorrow than that they should be at the beck and call of the first man that likes to come and whistle for them.'

A queer painful light came into Birkin's eyes.

'As to that,' he said, 'I only know that it's much more likely that it's I who am at the beck and call of the woman, than she at mine.'

Again there was a pause. The father was somewhat bewildered.

'I know,' he said, 'she'll please herself – she always has done. I've done my best for them, but that doesn't matter. They've got themselves to please, and if they can help it they'll please nobody *but* themselves. But she's a right to consider her mother, and me as well – '

Brangwen was thinking his own thoughts.

'And I tell you this much, I would rather bury them, than see them getting into a lot of loose ways such as you see everywhere nowadays. I'd rather bury them -'

'Yes but, you see,' said Birkin slowly, rather wearily, bored again by this new turn, 'they won't give either you or me the chance to bury them, because they're not to be buried.'

Brangwen looked at him in a sudden flare of impotent anger.

'Now, Mr Birkin,' he said, 'I don't know what you've come here for, and I don't know what you're asking for. But my daughters are my daughters – and it's my business to look after them while I can.'

Birkin's brows knitted suddenly, his eyes concentrated in mockery. But he remained perfectly stiff and still. There was a pause.

'I've nothing against your marrying Ursula,' Brangwen began at length. 'It's got nothing to do with me, she'll do as she likes, me or no me.'

Birkin turned away, looking out of the window and letting go his consciousness. After all, what good was this? It was hopeless to keep it up. He would sit on till Ursula came home, then speak to her, then go away. He would not accept trouble at the hands of her father. It was all unnecessary, and he himself need not have provoked it.

The two men sat in complete silence, Birkin almost unconscious of

his own whereabouts. He had come to ask her to marry him – well then, he would wait on, and ask her. As for what she said, whether she accepted or not, he did not think about it. He would say what he had come to say, and that was all he was conscious of. He accepted the complete insignificance of this household, for him. But everything now was as if fated. He could see one thing ahead, and no more. From the rest, he was absolved entirely for the time being. It had to be left to fate and chance to resolve the issues.

At length they heard the gate. They saw her coming up the steps with a bundle of books under her arm. Her face was bright and abstracted as usual, with the abstraction, that look of being not quite *there*, not quite present to the facts of reality, that galled her father so much. She had a maddening faculty of assuming a light of her own, which excluded the reality, and within which she looked radiant as if in sunshine.

They heard her go into the dining-room, and drop her armful of books on the table.

'Did you bring me that Girl's Own?' cried Rosalind.

'Yes, I brought it. But I forgot which one it was you wanted.'

'You would,' cried Rosalind angrily. 'It's right for a wonder.'

Then they heard her say something in a lowered tone.

'Where?' cried Ursula.

Again her sister's voice was muffled.

Brangwen opened the door, and called, in his strong, brazen voice: 'Ursula.'

She appeared in a moment, wearing her hat.

'Oh how do you do!' she cried, seeing Birkin, and all dazzled as if taken by surprise. He wondered at her, knowing she was aware of his presence. She had her queer, radiant, breathless manner, as if confused by the actual world, unreal to it, having a complete bright world of her self alone.

'Have I interrupted a conversation?' she asked.

'No, only a complete silence,' said Birkin.

'Oh,' said Ursula, vaguely, absent. Their presence was not vital to her, she was withheld, she did not take them in. It was a subtle insult that never failed to exasperate her father.

'Mr Birkin came to speak to you, not to me,' said her father.

'Oh, did he!' she exclaimed vaguely, as if it did not concern her. Then, recollecting herself, she turned to him rather radiantly, but still quite superficially, and said: 'Was it anything special?'

'I hope so,' he said, ironically.

'- To propose to you, according to all accounts,' said her father.

'Oh,' said Ursula.

'Oh,' mocked her father, imitating her. 'Have you nothing more to say?'

She winced as if violated.

'Did you really come to propose to me?' she asked of Birkin, as if it were a joke.

'Yes,' he said. 'I suppose I came to propose.' He seemed to fight shy of the last word.

'Did you?' she cried, with her vague radiance. He might have been saying anything whatsoever. She seemed pleased.

'Yes,' he answered. 'I wanted to - I wanted you to agree to marry me.'

She looked at him. His eyes were flickering with mixed lights, wanting something of her, yet not wanting it. She shrank a little, as if she were exposed to his eyes, and as if it were a pain to her. She darkened, her soul clouded over, she turned aside. She had been driven out of her own radiant, single world. And she dreaded contact, it was almost unnatural to her at these times.

'Yes,' she said vaguely, in a doubting, absent voice.

Birkin's heart contracted swiftly, in a sudden fire of bitterness. It all meant nothing to her. He had been mistaken again. She was in some self-satisfied world of her own. He and his hopes were accidentals, violations to her. It drove her father to a pitch of mad exasperation. He had had to put up with this all his life, from her.

'Well, what do you say?' he cried.

She winced. Then she glanced down at her father, half-frightened, and she said:

'I didn't speak, did I?' as if she were afraid she might have committed herself.

'No,' said her father, exasperated. 'But you needn't look like an idiot. You've got your wits, haven't you?'

She ebbed away in silent hostility.

'I've got my wits, what does that mean?' she repeated, in a sullen voice of antagonism.

'You heard what was asked you, didn't you?' cried her father in anger.

'Of course I heard.'

'Well then, can't you answer?' thundered her father.

'Why should I?'

At the impertinence of this retort, he went stiff. But he said nothing.

'No,' said Birkin, to help out the occasion, 'there's no need to answer at once. You can say when you like.'

Her eyes flashed with a powerful light.

'Why should I say anything?' she cried. 'You do this off your *own* bat, it has nothing to do with me. Why do you both want to bully me?'

'Bully you! Bully you!' cried her father, in bitter, rancorous anger. 'Bully you! Why, it's a pity you can't be bullied into some sense and decency. Bully you! *You'll* see to that, you self-willed creature.'

She stood suspended in the middle of the room, her face glimmering and dangerous. She was set in satisfied defiance. Birkin looked up at her. He too was angry.

'But none is bullying you,' he said, in a very soft dangerous voice also.

'Oh yes,' she cried. 'You both want to force me into something.'

'That is an illusion of yours,' he said ironically.

'Illusion!' cried her father. 'A self-opinionated fool, that's what she is.' Birkin rose, saying:

'However, we'll leave it for the time being.'

And without another word, he walked out of the house.

'You fool! You fool!' her father cried to her, with extreme bitterness. She left the room, and went upstairs, singing to herself. But she was terribly fluttered, as after some dreadful fight. From her window, she could see Birkin going up the road. He went in such a blithe drift of rage, that her mind wondered over him. He was ridiculous, but she was afraid of him. She was as if escaped from some danger.

Her father sat below, powerless in humiliation and chagrin. It was as if he were possessed with all the devils, after one of these unaccountable conflicts with Ursula. He hated her as if his only reality were in hating her to the last degree. He had all hell in his heart. But he went away, to escape himself. He knew he must despair, yield, give in to despair, and have done.

Ursula's face closed, she completed herself against them all. Recoiling upon herself, she became hard and self-completed, like a jewel. She was bright and invulnerable, quite free and happy, perfectly liberated in her self-possession. Her father had to learn not to see her blithe obliviousness, or it would have sent him mad. She was so radiant with all things, in her possession of perfect hostility.

She would go on now for days like this, in this bright frank state of seemingly pure spontaneity, so essentially oblivious of the existence of anything but herself, but so ready and facile in her interest. Ah it was a bitter thing for a man to be near her, and her father cursed his fatherhood. But he must learn not to see her, not to know.

She was perfectly stable in resistance when she was in this state: so bright and radiant and attractive in her pure opposition, so very pure, and yet mistrusted by everybody, disliked on every hand. It was her voice, curiously clear and repellent, that gave her away. Only Gudrun was in accord with her. It was at these times that the intimacy between the two sisters was most complete, as if their intelligence were one. They felt a strong, bright bond of understanding between them, surpassing everything else. And during all these days of blind bright abstraction and intimacy of his two daughters, the father seemed to breathe an air of death, as if he were destroyed in his very being. He was irritable to madness, he could not rest, his daughters seemed to be destroying him. But he was inarticulate and helpless against them. He was forced to breathe the air of his own death. He cursed them in his soul, and only wanted, that they should be removed from him.

They continued radiant in their easy female transcendancy, beautiful to look at. They exchanged confidences, they were intimate in their revelations to the last degree, giving each other at last every secret. They withheld nothing, they told everything, till they were over the border of evil. And they armed each other with knowledge, they extracted the subtlest flavours from the apple of knowledge. It was curious how their knowledge was complementary, that of each to that of the other.

Ursula saw her men as sons, pitied their yearning and admired their courage, and wondered over them as a mother wonders over her child, with a certain delight in their novelty. But to Gudrun, they were the opposite camp. She feared them and despised them, and respected their activities even overmuch.

'Of course,' she said easily, 'there is a quality of life in Birkin which is quite remarkable. There is an extraordinary rich spring of life in him, really amazing, the way he can give himself to things. But there are so many things in life that he simply doesn't know. Either he is not aware of their existence at all, or he dismisses them as merely negligible – things which are vital to the other person. In a way, he is not clever enough, he is too intense in spots.'

'Yes,' cried Ursula, 'too much of a preacher. He is really a priest.'

'Exactly! He can't hear what anybody else has to say – he simply cannot hear. His own voice is so loud.'

'Yes. He cries you down.'

'He cries you down,' repeated Gudrun. 'And by mere force of violence. And of course it is hopeless. Nobody is convinced by violence. It makes talking to him impossible – and living with him I should think would be more than impossible.'

'You don't think one could live with him' asked Ursula.

'I think it would be too wearing, too exhausting. One would be shouted down every time, and rushed into his way without any choice. He would want to control you entirely. He cannot allow that there is any other mind than his own. And then the real clumsiness of his mind is its lack of self-criticism. No, I think it would be perfectly intolerable.'

'Yes,' assented Ursula vaguely. She only half agreed with Gudrun. 'The nuisance is,' she said, 'that one would find almost any man intolerable after a fortnight.'

'It's perfectly dreadful,' said Gudrun. 'But Birkin – he is too positive. He couldn't bear it if you called your soul your own. Of him that is strictly true.'

'Yes,' said Ursula. 'You must have bis soul.'

'Exactly! And what can you conceive more deadly?' This was all so true, that Ursula felt jarred to the bottom of her soul with ugly distaste.

She went on, with the discord jarring and jolting through her, in the most barren of misery.

Then there started a revulsion from Gudrun. She finished life off so thoroughly, she made things so ugly and so final. As a matter of fact, even if it were as Gudrun said, about Birkin, other things were true as well. But Gudrun would draw two lines under him and cross him out like an account that is settled. There he was, summed up, paid for, settled, done with. And it was such a lie. This finality of Gudrun's, this dispatching of people and things in a sentence, it was all such a lie. Ursula began to revolt from her sister.

One day as they were walking along the lane, they saw a robin sitting on the top twig of a bush, singing shrilly. The sisters stood to look at him. An ironical smile flickered on Gudrun's face.

'Doesn't he feel important?' smiled Gudrun.

'Doesn't he!' exclaimed Ursula, with a little ironical grimace. 'Isn't he a little Lloyd George⁷⁴ of the air!'

'Isn't he! Little Lloyd George of the air! That's just what they are,' cried Gudrun in delight. Then for days, Ursula saw the persistent, obtrusive birds as stout, short politicians lifting up their voices from the platform, little men who must make themselves heard at any cost.

But even from this there came the revulsion. Some yellowhammers suddenly shot along the road in front of her. And they looked to her so uncanny and inhuman, like flaring yellow barbs shooting through the air on some weird, living errand, that she said to herself: 'After all, it is impudence to call them little Lloyd Georges. They are really unknown to us, they are the unknown forces. It is impudence to look at them as if they were the same as human beings. They are of another world. How stupid anthropomorphism is! Gudrun is really impudent, insolent, making herself the measure of everything, making everything come down to human standards. Rupert is quite right, human beings are boring, painting the universe with their own image. The universe is non-human, thank God.' It seemed to her irreverence, destructive of all true life, to make little Lloyd Georges of the birds. It was such a lie towards the robins, and such a defamation. Yet she had done it herself. But under Gudrun's influence: so she exonerated herself.

So she withdrew away from Gudrun and from that which she stood for, she turned in spirit towards Birkin again. She had not seen him since the fiasco of his proposal. She did not want to, because she did not want the question of her acceptance thrust upon her. She knew what Birkin meant when he asked her to marry him; vaguely, without putting it into speech, she knew. She knew what kind of love, what kind of surrender he wanted. And she was not at all sure that this was the kind of love that she herself wanted. She was not at all sure that it was this mutual unison in separateness that she wanted. She wanted unspeakable intimacies. She wanted to have him, utterly, finally to have him as her own, oh, so unspeakably, in intimacy. To drink him down ah, like a life-draught. She made great professions, to herself, of her willingness to warm his foot-soles between her breasts, after the fashion of the nauseous Meredith poem.75 But only on condition that he, her lover, loved her absolutely, with complete self-abandon. And subtly enough, she knew he would never abandon himself finally to her. He did not believe in final self-abandonment. He said it openly. It was his challenge. She was prepared to fight him for it. For she believed in an absolute surrender to love. She believed that love far surpassed the individual. He said the individual was more than love, or than any relationship. For him, the bright, single soul accepted love as one of its conditions, a condition of its own equilibrium. She believed that love was everything. Man must render himself up to her. He must be quaffed to the dregs by her. Let him be her man utterly, and she in return would be his humble slave - whether she wanted it or not.

CHAPTER XX

Gladiatorial

AFTER the fiasco of the proposal, Birkin had hurried blindly away from Beldover, in a whirl of fury. He felt he had been a complete fool, that the whole scene had been a farce of the first water. But that did not trouble him at all. He was deeply, mockingly angry that Ursula persisted always in this old cry: 'Why do you want to bully me?' and in her bright, insolent abstraction.

He went straight to Shortlands. There he found Gerald standing with his back to the fire, in the library, as motionless as a man is, who is completely and emptily restless, utterly hollow. He had done all the work he wanted to do – and now there was nothing. He could go out in the car, he could run to town. But he did not want to go out in the car, he did not want to run to town, he did not want to call on the Thirlbys. He was suspended motionless, in an agony of inertia, like a machine that is without power.

This was very bitter to Gerald, who had never known what boredom was, who had gone from activity to activity, never at a loss. Now, gradually, everything seemed to be stopping in him. He did not want any more to do the things that offered. Something dead within him just refused to respond to any suggestion. He cast over in his mind, what it would be possible to do, to save himself from this misery of nothingness, relieve the stress of this hollowness. And there were only three things left, that would rouse him, make him live. One was to drink or smoke hashish, the other was to be soothed by Birkin, and the third was women. And there was no-one for the moment to drink with. Nor was there a woman. And he knew Birkin was out. So there was nothing to do but to bear the stress of his own emptiness.

When he saw Birkin his face lit up in a sudden, wonderful smile.

'By God, Rupert,' he said, 'I'd just come to the conclusion that nothing in the world mattered except somebody to take the edge off one's being alone: the right somebody.'

The smile in his eyes was very astonishing, as he looked at the other man. It was the pure gleam of relief. His face was pallid and even haggard.

'The right woman, I suppose you mean,' said Birkin spitefully.

'Of course, for choice. Failing that, an amusing man.'

He laughed as he said it. Birkin sat down near the fire.

'What were you doing?' he asked.

'I? Nothing. I'm in a bad way just now, everything's on edge, and I can neither work nor play. I don't know whether it's a sign of old age, I'm sure.'

'You mean you are bored?'

'Bored, I don't know. I can't apply myself. And I feel the devil is either very present inside me, or dead.'

Birkin glanced up and looked in his eyes.

'You should try hitting something,' he said.

Gerald smiled.

'Perhaps,' he said. 'So long as it was something worth hitting.'

'Quite!' said Birkin, in his soft voice. There was a long pause during

which each could feel the presence of the other.

'One has to wait,' said Birkin.

'Ah God! Waiting! What are we waiting for?'

'Some old Johnny says there are three cures for *ennui*, sleep, drink, and travel,' said Birkin.

'All cold eggs,' said Gerald. 'In sleep, you dream, in drink you curse, and in travel you yell at a porter. No, work and love are the two. When you're not at work you should be in love.'

'Be it then,' said Birkin.

'Give me the object,' said Gerald. 'The possibilities of love exhaust themselves.'

'Do they? And then what?'

'Then you die,' said Gerald.

'So you ought,' said Birkin.

'I don't see it,' replied Gerald. He took his hands out of his trousers pockets, and reached for a cigarette. He was tense and nervous. He lit the cigarette over a lamp, reaching forward and drawing steadily. He was dressed for dinner, as usual in the evening, although he was alone.

'There's a third one even to your two,' said Birkin. 'Work, love, and fighting. You forget the fight.'

'I suppose I do,' said Gerald. 'Did you ever do any boxing -?'

'No, I don't think I did,' said Birkin.

'Ay –' Gerald lifted his head and blew the smoke slowly into the air. 'Why?' said Birkin.

'Nothing. I thought we might have a round. It is perhaps true, that I want something to hit. It's a suggestion.'

'So you think you might as well hit me?' said Birkin.

'You? Well ! Perhaps - ! In a friendly kind of way, of course.'

'Quite!' said Birkin, bitingly.

Gerald stood leaning back against the mantel-piece. He looked down at Birkin, and his eyes flashed with a sort of terror like the eyes of a stallion, that are bloodshot and overwrought, turned glancing backwards in a stiff terror.

'I feel that if I don't watch myself, I shall find myself doing something silly,' he said.

'Why not do it?' said Birkin coldly.

Gerald listened with quick impatience. He kept glancing down at Birkin, as if looking for something from the other man.

'I used to do some Japanese wrestling,' said Birkin. 'A Jap lived in the same house with me in Heidelberg, and he taught me a little. But I was never much good at it.'

'You did!' exclaimed Gerald. 'That's one of the things I've never ever

seen done. You mean jiu-jitsu, I suppose?'

'Yes. But I am no good at those things - they don't interest me.'

'They don't? They do me. What's the start?'

'I'll show you what I can, if you like,' said Birkin.

'You will?' A queer, smiling look tightened Gerald's face for a moment, as he said, 'Well, I'd like it very much.'

'Then we'll try jiu-jitsu. Only you can't do much in a starched shirt.'

'Then let us strip, and do it properly. Hold a minute – 'He rang the bell, and waited for the butler.

'Bring a couple of sandwiches and a syphon,' he said to the man, 'and then don't trouble me any more tonight – or let anybody else.'

The man went. Gerald turned to Birkin with his eyes lighted.

'And you used to wrestle with a Jap?' he said. 'Did you strip?'

'Sometimes.'

'You did! What was he like then, as a wrestler?'

'Good, I believe. I am no judge. He was very quick and slippery and full of electric fire. It is a remarkable thing, what a curious sort of fluid force they seem to have in them, those people – not like a human grip – like a polyp – '

Gerald nodded.

'I should imagine so,' he said, 'to look at them. They repel me, rather.'

'Repel and attract, both. They are very repulsive when they are cold, and they look grey. But when they are hot and roused, there is a definite attraction – a curious kind of full electric fluid – like eels.'

'Well - yes - probably.'

The man brought in the tray and set it down.

'Don't come in any more,' said Gerald.

The door closed.

'Well then,' said Gerald; 'shall we strip and begin? Will you have a drink first?'

'No, I don't want one.'

'Neither do I.'

Gerald fastened the door and pushed the furniture aside. The room was large, there was plenty of space, it was thickly carpeted. Then he quickly threw off his clothes, and waited for Birkin. The latter, white and thin, came over to him. Birkin was more a presence than a visible object, Gerald was aware of him completely, but not really visually. Whercas Gerald himself was concrete and noticeable, a piece of pure final substance.

'Now,' said Birkin, 'I will show you what I learned, and what I remember. You let me take you so - ' And his hands closed on the

naked body of the other man. In another moment, he had Gerald swung over lightly and balanced against his knee, head downwards. Relaxed, Gerald sprang to his feet with eyes glittering.

'That's smart,' he said. 'Now try again.'

So the two men began to struggle together. They were very dissimilar. Birkin was tall and narrow, his bones were very thin and fine. Gerald was much heavier and more plastic. His bones were strong and round, his limbs were rounded, all his contours were beautifully and fully moulded. He seemed to stand with a proper, rich weight on the face of the earth, whilst Birkin seemed to have the centre of gravitation in his own middle. And Gerald had a rich, frictional kind of strength, rather mechanical, but sudden and invincible, whereas Birkin was abstract as to be almost intangible. He impinged invisibly upon the other man, scarcely seeming to touch him, like a garment, and then suddenly piercing in a tense fine grip that seemed to penetrate into the very quick of Gerald's being.

They stopped, they discussed methods, they practised grips and throws, they became accustomed to each other, to each other's rhythm, they got a kind of mutual physical understanding. And then again they had a real struggle. They seemed to drive their white flesh deeper and deeper against each other, as if they would break into a oneness. Birkin had a great subtle energy, that would press upon the other man with an uncanny force, weigh him like a spell put upon him. Then it would pass, and Gerald would heave free, with white, heaving, dazzling movements.

So the two men entwined and wrestled with each other, working nearer and nearer. Both were white and clear, but Gerald flushed smart red where he was touched, and Birkin remained white and tense. He seemed to penetrate into Gerald's more solid, more diffuse bulk, to interfuse his body through the body of the other, as if to bring it subtly into subjection, always seizing with some rapid necromantic foreknowledge every motion of the other flesh, converting and counteracting it, playing upon the limbs and trunk of Gerald like some hard wind. It was as if Birkin's whole physical intelligence interpenetrated into Gerald's body, as if his fine, sublimated energy entered into the flesh of the fuller man, like some potency, casting a fine net, a prison, through the muscles into the very depths of Gerald's physical being.

So they wrestled swiftly, rapturously, intent and mindless at last, two essential white figures working into a tighter closer oneness of struggle, with a strange, octopus-like knotting and flashing of limbs in the subdued light of the room; a tense white knot of flesh gripped in silence between the walls of old brown books. Now and again came a sharp

gasp of breath, or a sound like a sigh, then the rapid thudding of movement on the thickly-carpeted floor, then the strange sound of flesh escaping under flesh. Often, in the white interlaced knot of violent living being that swayed silently, there was no head to be seen, only the swift, tight limbs, the solid white backs, the physical junction of two bodies clinched into oneness. Then would appear the gleaming, ruffled head of Gerald, as the struggle changed, then for a moment the dun-coloured, shadow-like head of the other man would lift up from the conflict, the eyes wide and dreadful and sightless.

At length Gerald lay back inert on the carpet, his breast rising in great slow panting, whilst Birkin kneeled over him, almost unconscious. Birkin was much more exhausted. He caught little, short breaths, he could scarcely breathe any more. The earth seemed to tilt and sway, and a complete darkness was coming over his mind. He did not know what happened. He slid forward quite unconscious, over Gerald, and Gerald did not notice. Then he was half-conscious again, aware only of the strange tilting and sliding of the world. The world was sliding, everything was sliding off into the darkness. And he was sliding, endlessly, endlessly away.

He came to consciousness again, hearing an immense knocking outside. What could be happening, what was it, the great hammerstroke resounding through the house? He did not know. And then it came to him that it was his own heart beating. But that seemed impossible, the noise was outside. No, it was inside himself, it was his own heart. And the beating was painful, so strained, surcharged. He wondered if Gerald heard it. He did not know whether he were standing or lying or falling.

When he realised that he had fallen prostrate upon Gerald's body he wondered, he was surprised. But he sat up, steadying himself with his hand and waiting for his heart to become stiller and less painful. It hurt very much, and took away his consciousness.

Gerald however was still less conscious than Birkin. They waited dimly, in a sort of not-being, for many uncounted, unknown minutes.

'Of course – ' panted Gerald, 'I didn't have to be rough – with you – I had to keep back – my force – '

Birkin heard the sound as if his own spirit stood behind him, outside him, and listened to it. His body was in a trance of exhaustion, his spirit heard thinly. His body could not answer. Only he knew his heart was getting quieter. He was divided entirely between his spirit, which stood outside, and knew, and his body, that was a plunging, unconscious stroke of blood.

'I could have thrown you - using violence - ' panted Gerald. 'But you

beat me right enough.'

'Yes,' said Birkin, hardening his throat and producing the words in the tension there, 'you're much stronger than I – you could beat me – easily.'

Then he relaxed again to the terrible plunging of his heart and his blood.

'It surprised me,' panted Gerald, 'what strength you've got. Almost supernatural.'

'For a moment,' said Birkin.

He still heard as if it were his own disembodied spirit hearing, standing at some distance behind him. It drew nearer however, his spirit. And the violent striking of blood in his chest was sinking quieter, allowing his mind to come back. He realised that he was leaning with all his weight on the soft body of the other man. It startled him, because he thought he had withdrawn. He recovered himself, and sat up. But he was still vague and unestablished. He put out his hand to steady himself. It touched the hand of Gerald, that was lying out on the floor. And Gerald's hand closed warm and sudden over Birkin's, they remained exhausted and breathless, the one hand clasped closely over the other. It was Birkin whose hand, in swift response, had closed in a strong, warm clasp over the hand of the other. Gerald's clasp had been sudden and momentaneous.

The normal consciousness however was returning, ebbing back. Birkin could breathe almost naturally again. Gerald's hand slowly withdrew, Birkin slowly, dazedly rose to his feet and went towards the table. He poured out a whiskey and soda. Gerald also came for a drink.

'It was a real set-to, wasn't it?' said Birkin, looking at Gerald with darkened eyes.

'God, yes,' said Gerald. He looked at the delicate body of the other man, and added: 'It wasn't too much for you, was it?'

'No. One ought to wrestle and strive and be physically close. It makes one sane.'

'You do think so?'

'I do. Don't you?'

'Yes,' said Gerald.

There were long spaces of silence between their words. The wrestling had some deep meaning to them – an unfinished meaning.

'We are mentally, spiritually intimate, therefore we should be more or less physically intimate too – it is more whole.'

'Certainly it is,' said Gerald. Then he laughed pleasantly, adding: 'It's rather wonderful to me.' He stretched out his arms handsomely.

'Yes,' said Birkin. 'I don't know why one should have to justify oneself.'

'No.'

The two men began to dress.

'I think also that you are beautiful,' said Birkin to Gerald, 'and that is enjoyable too. One should enjoy what is given.'

'You think I am beautiful – how do you mean, physically?' asked Gerald, his eyes glistening.

'Yes. You have a northern kind of beauty, like light refracted from snow – and a beautiful, plastic form. Yes, that is there to enjoy as well. We should enjoy everything.'

Gerald laughed in his throat, and said:

'That's certainly one way of looking at it. I can say this much, I feel better. It has certainly helped me. Is this the Bruderschaft you wanted?'

'Perhaps. Do you think this pledges anything?'

'I don't know,' laughed Gerald.

'At any rate, one feels freer and more open now – and that is what we want.'

'Certainly,' said Gerald.

They drew to the fire, with the decanters and the glasses and the food.

'I always eat a little before I go to bed,' said Gerald. 'I sleep better.'

'I should not sleep so well,' said Birkin.

'No? There you are, we are not alike. I'll put a dressing-gown on.' Birkin remained alone, looking at the fire. His mind had reverted to Ursula. She seemed to return again into his consciousness. Gerald came down wearing a gown of broad-barred, thick black-and-green silk, brilliant and striking.

'You are very fine,' said Birkin, looking at the full robe.

'It was a caftan in Bokhara,' said Gerald. 'I like it.'

'I like it too.'

Birkin was silent, thinking how scrupulous Gerald was in his attire, how expensive too. He wore silk socks, and studs of fine workmanship, and silk underclothing, and silk braces. Curious! This was another of the differences between them. Birkin was careless and unimaginative about his own appearance.

'Of course you,' said Gerald, as if he had been thinking; 'there's something curious about you. You're curiously strong. One doesn't expect it, it is rather surprising.'

Birkin laughed. He was looking at the handsome figure of the other man, blond and comely in the rich robe, and he was half thinking of the difference between it and himself – so different; as far, perhaps, apart as man from woman, yet in another direction. But really it was Ursula, it was the woman who was gaining ascendance over Birkin's being, at this

WOMEN IN LOVE

moment. Gerald was becoming dim again, lapsing out of him.

'Do you know,' he said suddenly, 'I went and proposed to Ursula Brangwen tonight, that she should marry me.'

He saw the blank shining wonder come over Gerald's face. 'You did?'

'Yes. Almost formally – speaking first to her father, as it should be, in the world – though that was accident – or mischief.'

Gerald only stared in wonder, as if he did not grasp.

'You don't mean to say that you seriously went and asked her father to let you marry her?'

'Yes,' said Birkin, 'I did.'

'What, had you spoken to her before about it, then?'

'No, not a word. I suddenly thought I would go there and ask her – and her father happened to come instead of her – so I asked him first.'

'If you could have her?' concluded Gerald.

'Ye-es, that.'

'And you didn't speak to her?'

'Yes. She came in afterwards. So it was put to her as well.'

'It was! And what did she say then? You're an engaged man?'

'No, - she only said she didn't want to be bullied into answering.' 'She what?'

'Said she didn't want to be bullied into answering.'

"Said she didn't want to be bullied into answering!" Why, what did she mean by that?"

Birkin raised his shoulders. 'Can't say,' he answered. 'Didn't want to be bothered just then, I suppose.'

'But is this really so? And what did you do then?'

'I walked out of the house and came here.'

'You came straight here?'

'Yes.'

Gerald stared in amazement and amusement. He could not take it in. 'But is this really true, as you say it now?'

'Word for word.'

'It is?'

He leaned back in his chair, filled with delight and amusement.

'Well, that's good,' he said. 'And so you came here to wrestle with your good angel, did you?'

'Did I?' said Birkin.

'Well, it looks like it. Isn't that what you did?'

Now Birkin could not follow Gerald's meaning.

'And what's going to happen?' said Gerald. 'You're going to keep open the proposition, so to speak?'

'I suppose so. I vowed to myself I would see them all to the devil. But I suppose I shall ask her again, in a little while.'

Gerald watched him steadily.

'So you're fond of her then?' he asked.

'I think - I love her,' said Birkin, his face going very still and fixed.

Gerald glistened for a moment with pleasure, as if it were something done specially to please him. Then his face assumed a fitting gravity, and he nodded his head slowly.

'You know,' he said, 'I always believed in love - true love. But where does one find it nowadays?'

'I don't know,' said Birkin.

'Very rarely,' said Gerald. Then, after a pause, 'I've never felt it myself – not what I should call love. I've gone after women – and been keen enough over some of them. But I've never felt *love*. I don't believe I've ever felt as much *love* for a woman, as I have for you – not *love*. You understand what I mean?'

'Yes. I'm sure you've never loved a woman.'

'You feel that, do you? And do you think I ever shall? You understand what I mean?' He put his hand to his breast, closing his fist there, as if he would draw something out. 'I mean that – that I can't express what it is, but I know it.'

'What is it, then?' asked Birkin.

'You see, I can't put it into words. I mean, at any rate, something abiding, something that can't change - '

His eyes were bright and puzzled.

'Now do you think I shall ever feel that for a woman?' he said, anxiously.

Birkin looked at him, and shook his head.

'I don't know,' he said. 'I could not say.'

Gerald had been on the *qui vive*, as awaiting his fate. Now he drew back in his chair.

'No,' he said, 'and neither do I, and neither do I.'

'We are different, you and I,' said Birkin. 'I can't tell your life.'

'No,' said Gerald, 'no more can I. But I tell you – I begin to doubt it!' 'That you will ever love a woman?'

'Well - yes - what you would truly call love - '

'You doubt it?'

'Well – I begin to.'

There was a long pause.

'Life has all kinds of things,' said Birkin. 'There isn't only one road.'

'Yes, I believe that too. I believe it. And mind you, I don't care how it is with me – I don't care how it is – so long as I don't feel – ' he paused,

WOMEN IN LOVE

and a blank, barren look passed over his face, to express his feeling - ' so long as I feel I've *lived*, somehow - and I don't care how it is - but I want to feel that - '

'Fulfilled,' said Birkin.

'We-ell, perhaps it is fulfilled; I don't use the same words as you.' 'It is the same.'

CHAPTER XXI

Threshold

GUDRUN WAS AWAY in London, having a little show of her work, with a friend, and looking round, preparing for flight from Beldover. Come what might she would be on the wing in a very short time. She received a letter from Winifred Crich, ornamented with drawings.

'Father also has been to London, to be examined by the doctors. It made him very tired. They say he must rest a very great deal, so he is mostly in bed. He brought me a lovely tropical parrot in faience,⁷⁶ of Dresden ware, also a man ploughing, and two mice climbing up a stalk, also in faiënce. The mice were Copenhagen ware. They are the best, but mice don't shine so much, otherwise they are very good, their tails are slim and long. They all shine nearly like glass. Of course it is the glaze, but I don't like it. Gerald likes the man ploughing the best, his trousers are torn, he is ploughing with an ox, being I suppose a German peasant. It is all grey and white, white shirt and grey trousers, but very shiny and clean. Mr Birkin likes the girl best, under the hawthorn blossom, with a lamb, and with daffodils painted on her skirts, in the drawing room. But that is silly, because the lamb is not a real lamb, and she is silly too.

'Dear Miss Brangwen, are you coming back soon, you are very much missed here. I enclose a drawing of father sitting up in bed. He says he hopes you are not going to forsake us. Oh dear Miss Brangwen, I am sure you won't. Do come back and draw the ferrets, they are the most lovely noble darlings in the world. We might carve them in hollywood, playing against a background of green leaves. Oh do let us, for they are most beautiful.

'Father says we might have a studio. Gerald says we could easily have a beautiful one over the stables, it would only need windows to be put in the slant of the roof, which is a simple matter. Then you could stay here all day and work, and we could live in the studio, like two real artists, like the man in the picture in the hall, with the frying-pan and the walls all covered with drawings. I long to be free, to live the free life

of an artist. Even Gerald told father that only an artist is free, because he lives in a creative world of his own - '

Gudrun caught the drift of the family intentions, in this letter. Gerald wanted her to be attached to the household at Shortlands, he was using Winifred as his stalking-horse. The father thought only of his child, he saw a rock of salvation in Gudrun. And Gudrun admired him for his perspicacity. The child, moreover, was really exceptional. Gudrun was quite content. She was quite willing, given a studio, to spend her days at Shortlands. She disliked the Grammar School already thoroughly, she wanted to be free. If a studio were provided, she would be free to go on with her work, she would await the turn of events with complete serenity. And she was really interested in Winifred, she would be quite glad to understand the girl.

So there was quite a little festivity on Winifred's account, the day Gudrun returned to Shortlands.

'You should make a bunch of flowers to give to Miss Brangwen when she arrives,' Gerald said smiling to his sister.

'Oh no,' cried Winifred, 'it's silly.'

'Not at all. It is a very charming and ordinary attention.'

'Oh, it is silly,' protested Winifred, with all the extreme *mauvaise homte*⁷⁷ of her years. Nevertheless, the idea appealed to her. She wanted very much to carry it out. She flitted round the green-houses and the conservatory looking wistfully at the flowers on their stems. And the more she looked, the more she *longed* to have a bunch of the blossoms she saw, the more fascinated she became with her little vision of ceremony, and the more consumedly shy and self-conscious she grew, till she was almost beside herself. She could not get the idea out of her mind. It was as if some haunting challenge prompted her, and she had not enough courage to take it up. So again she drifted into the greenhouses, looking at the lovely roses in their pots, and at the virginal cyclamens, and at the mystic white clusters of a creeper. The beauty, oh the beauty of them, and oh the paradisal bliss, if she should have a perfect bouquet and could give it to Gudrun the next day. Her passion and her complete indecision almost made her ill.

At last she slid to her father's side.

'Daddie - ' she said.

'What, my precious?'

But she hung back, the tears almost coming to her eyes, in her sensitive confusion. Her father looked at her, and his heart ran hot with tenderness, an anguish of poignant love.

'What do you want to say to me, my love?'

'Daddie - !' her eyes smiled laconically - 'isn't it silly if I give Miss

Brangwen some flowers when she comes?'

The sick man looked at the bright, knowing eyes of his child, and his heart burned with love.

'No, darling, that's not silly. It's what they do to queens.'

This was not very reassuring to Winifred. She half suspected that queens in themselves were a silliness. Yet she so wanted her little romantic occasion.

'Shall I then?' she asked.

'Give Miss Brangwen some flowers? Do, Birdie. Tell Wilson I say you are to have what you want.'

The child smiled a small, subtle, unconscious smile to herself, in anticipation of her way.

'But I won't get them till tomorrow,' she said.

'Not till tomorrow, Birdie. Give me a kiss then -'

Winifred silently kissed the sick man, and drifted out of the room. She again went the round of the green-houses and the conservatory, informing the gardener, in her high, peremptory, simple fashion, of what she wanted, telling him all the blooms she had selected.

'What do you want these for?' Wilson asked.

'I want them,' she said. She wished servants did not ask questions.

'Ay, you've said as much. But what do you want them for, for decoration, or to send away, or what?'

'I want them for a presentation bouquet.'

'A presentation bouquet! Who's coming then? - the Duchess of Portland?'

'No.'

'Oh, not her? Well you'll have a rare poppy-show if you put all the things you've mentioned into your bouquet.'

'Yes, I want a rare poppy-show.'

'You do! Then there's no more to be said.'

The next day Winifred, in a dress of silvery velvet, and holding a gaudy bunch of flowers in her hand, waited with keen impatience in the schoolroom, looking down the drive for Gudrun's arrival. It was a wet morning. Under her nose was the strange fragrance of hot-house flowers, the bunch was like a little fire to her, she seemed to have a strange new fire in her heart. This slight sense of romance stirred her like an intoxicant.

At last she saw Gudrun coming, and she ran downstairs to warn her father and Gerald. They, laughing at her anxiety and gravity, came with her into the hall. The man-servant came hastening to the door, and there he was, relieving Gudrun of her umbrella, and then of her raincoat. The welcoming party hung back till their visitor entered the

hall.

Gudrun was flushed with the rain, her hair was blown in loose little curls, she was like a flower just opened in the rain, the heart of the blossom just newly visible, seeming to emit a warmth of retained sunshine. Gerald winced in spirit, seeing her so beautiful and unknown. She was wearing a soft blue dress, and her stockings were of dark red.

Winifred advanced with odd, stately formality.

'We are so glad you've come back,' she said. 'These are your flowers.' She presented the bouquet.

'Mine!' cried Gudrun. She was suspended for a moment, then a vivid flush went over her, she was as if blinded for a moment with a flame of pleasure. Then her eyes, strange and flaming, lifted and looked at the father, and at Gerald. And again Gerald shrank in spirit, as if it would be more than he could bear, as her hot, exposed eyes rested on him. There was something so revealed, she was revealed beyond bearing, to his eyes. He turned his face aside. And he felt he would not be able to avert her. And he writhed under the imprisonment.

Gudrun put her face into the flowers.

'But how beautiful they are!' she said, in a muffled voice. Then, with a strange, suddenly revealed passion, she stooped and kissed Winifred.

Mr Crich went forward with his hand held out to her.

'I was afraid you were going to run away from us,' he said, playfully. Gudrun looked up at him with a luminous, roguish, unknown face.

'Really!' she replied. 'No, I didn't want to stay in London.' Her voice seemed to imply that she was glad to get back to Shortlands, her tone was warm and subtly caressing.

'That is a good thing,' smiled the father. 'You see you are very welcome here among us.'

Gudrun only looked into his face with dark-blue, warm, shy eyes. She was unconsciously carried away by her own power.

'And you look as if you came home in every possible triumph,' Mr Crich continued, holding her hand.

'No,' she said, glowing strangely. 'I haven't had any triumph till I came here.'

'Ah, come, come! We're not going to hear any of those tales. Haven't we read notices in the newspaper, Gerald?'

'You came off pretty well,' said Gerald to her, shaking hands. 'Did you sell anything?'

'No,' she said, 'not much.'

'Just as well,' he said.

She wondered what he meant. But she was all aglow with her reception, carried away by this little flattering ceremonial on her

behalf.

'Winifred,' said the father, 'have you a pair of shoes for Miss Brangwen? You had better change at once -'

Gudrun went out with her bouquet in her hand.

'Quite a remarkable young woman,' said the father to Gerald, when she had gone.

'Yes,' replied Gerald briefly, as if he did not like the observation.

Mr Crich liked Gudrun to sit with him for half an hour. Usually he was ashy and wretched, with all the life gnawed out of him. But as soon as he rallied, he liked to make believe that he was just as before, quite well and in the midst of life – not of the outer world, but in the midst of a strong essential life. And to this belief, Gudrun contributed perfectly. With her, he could get by stimulation those precious half-hours of strength and exaltation and pure freedom, when he seemed to live more than he had ever lived.

She came to him as he lay propped up in the library. His face was like yellow wax, his eyes darkened, as it were sightless. His black beard, now streaked with grey, seemed to spring out of the waxy flesh of a corpse. Yet the atmosphere about him was energetic and playful. Gudrun subscribed to this, perfectly. To her fancy, he was just an ordinary man. Only his rather terrible appearance was photographed upon her soul, away beneath her consciousness. She knew that, in spite of his playfulness, his eyes could not change from their darkened vacancy, they were the eyes of a man who is dead.

'Ah, this is Miss Brangwen,' he said, suddenly rousing as she entered, announced by the man-servant. 'Thomas, put Miss Brangwen a chair here – that's right.' He looked at her soft, fresh face with pleasure. It gave him the illusion of life. 'Now, you will have a glass of sherry and a little piece of cake. Thomas – '

'No thank you,' said Gudrun. And as soon as she had said it, her heart sank horribly. The sick man seemed to fall into a gap of death, at her contradiction. She ought to play up to him, not to contravene him. In an instant she was smiling her rather roguish smile.

'I don't like sherry very much,' she said. 'But I like almost anything else.'

The sick man caught at this straw instantly.

'Not sherry! No! Something else! What then? What is there, Thomas?'

'Port wine - curaçao - '

'I would love some curaçao – ' said Gudrun, looking at the sick man confidingly.

'You would. Well then Thomas, curaçao - and a little cake, or a

'A biscuit,' said Gudrun. She did not want anything, but she was wise.

'Yes.'

He waited till she was settled with her little glass and her biscuit. Then he was satisfied.

'You have heard the plan,' he said with some excitement, 'for a studio for Winifred, over the stables?'

'No!' exclaimed Gudrun, in mock wonder.

'Oh! - I thought Winnie wrote it to you, in her letter!'

'Oh – yes – of course. But I thought perhaps it was only her own little idea – ' Gudrun smiled subtly, indulgently. The sick man smiled also, elated.

'Oh no. It is a real project. There is a good room under the roof of the stables – with sloping rafters. We had thought of converting it into a studio.'

'How very nice that would be!' cried Gudrun, with excited warmth. The thought of the rafters stirred her.

'You think it would? Well, it can be done.'

'But how perfectly splendid for Winifred! Of course, it is just what is needed, if she is to work at all seriously. One must have one's workshop, otherwise one never ceases to be an amateur.'

'Is that so? Yes. Of course, I should like you to share it with Winifred.'

'Thank you so much.'

Gudrun knew all these things already, but she must look shy and very grateful, as if overcome.

'Of course, what I should like best, would be if you could give up your work at the Grammar School, and just avail yourself of the studio, and work there – well, as much or as little as you liked – '

He looked at Gudrun with dark, vacant eyes. She looked back at him as if full of gratitude. These phrases of a dying man were so complete and natural, coming like echoes through his dead mouth.

'And as to your earnings – you don't mind taking from me what you have taken from the Education Committee, do you? I don't want you to be a loser.'

'Oh,' said Gudrun, 'if I can have the studio and work there, I can earn money enough, really I can.'

'Well,' he said, pleased to be the benefactor, 'we can see about all that. You wouldn't mind spending your days here?'

'If there were a studio to work in,' said Gudrun, 'I could ask for nothing better.'

'Is that so?'

He was really very pleased. But already he was getting tired. She could see the grey, awful semi-consciousness of mere pain and dissolution coming over him again, the torture coming into the vacancy of his darkened eyes. It was not over yet, this process of death. She rose softly saying:

'Perhaps you will sleep. I must look for Winifred.'

She went out, telling the nurse that she had left him. Day by day the tissue of the sick man was further and further reduced, nearer and nearer the process came, towards the last knot which held the human being in its unity. But this knot was hard and unrelaxed, the will of the dying man never gave way. He might be dead in nine-tenths, yet the remaining tenth remained unchanged, till it too was torn apart. With his will he held the unit of himself firm, but the circle of his power was ever and ever reduced, it would be reduced to a point at last, then swept away.

To adhere to life, he must adhere to human relationships, and he caught at every straw. Winifred, the butler, the nurse, Gudrun, these were the people who meant all to him, in these last resources. Gerald, in his father's presence, stiffened with repulsion. It was so, to a less degree, with all the other children except Winifred. They could not see anything but the death, when they looked at their father. It was as if some subterranean dislike overcame them. They could not see the familiar face, hear the familiar voice. They were overwhelmed by the antipathy of visible and audible death. Gerald could not breathe in his father's presence. He must get out at once. And so, in the same way, the father could not bear the presence of his son. It sent a final irritation through the soul of the dying man.

The studio was made ready, Gudrun and Winifred moved in. They enjoyed so much the ordering and the appointing of it. And now they need hardly be in the house at all. They had their meals in the studio, they lived there safely. For the house was becoming dreadful. There were two nurses in white, flitting silently about, like heralds of death. The father was confined to his bed, there was a come and go of *sottovoce* sisters and brothers and children.

Winifred was her father's constant visitor. Every morning, after breakfast, she went into his room when he was washed and propped up in bed, to spend half an hour with him.

'Are you better, Daddie?' she asked him invariably.

And invariably he answered:

'Yes, I think I'm a little better, pet.'

She held his hand in both her own, lovingly and protectively. And

this was very dear to him.

She ran in again as a rule at lunch time, to tell him the course of events, and every evening, when the curtains were drawn, and his room was cosy, she spent a long time with him. Gudrun was gone home, Winifred was alone in the house: she liked best to be with her father. They talked and prattled at random, he always as if he were well, just the same as when he was going about. So that Winifred, with a child's subtle instinct for avoiding the painful things, behaved as if nothing serious was the matter. Instinctively, she withheld her attention, and was happy. Yet in her remoter soul, she knew as well as the adults knew: perhaps better.

Her father was quite well in his make-belief with her. But when she went away, he relapsed under the misery of his dissolution. But still there were these bright moments, though as his strength waned, his faculty for attention grew weaker, and the nurse had to send Winifred away, to save him from exhaustion.

He never admitted that he was going to die. He knew it was so, he knew it was the end. Yet even to himself he did not admit it. He hated the fact, mortally. His will was rigid. He could not bear being overcome by death. For him, there was no death. And yet, at times, he felt a great need to cry out and to wail and complain. He would have liked to cry aloud to Gerald, so that his son should be horrified out of his composure. Gerald was instinctively aware of this, and he recoiled, to avoid any such thing. This uncleanness of death repelled him too much. One should die quickly, like the Romans, one should be master of one's fate in dying as in living. He was convulsed in the clasp of this death of his father's, as in the coils of the great serpent of Laocoön.⁷⁸ The great serpent had got the father, and the son was dragged into the embrace of horrifying death along with him. He resisted always. And in some strange way, he was a tower of strength to his father.

The last time the dying man asked to see Gudrun he was grey with near death. Yet he must see someone, he must, in the intervals of consciousness, catch into connection with the living world, lest he should have to accept his own situation. Fortunately he was most of his time dazed and half gone. And he spent many hours dimly thinking of the past, as it were, dimly re-living his old experiences. But there were times even to the end when he was capable of realising what was happening to him in the present, the death that was on him. And these were the times when he called in outside help, no matter whose. For to realise this death that he was dying was a death beyond death, never to be borne. It was an admission never to be made.

Gudrun was shocked by his appearance, and by the darkened, almost

disintegrated eyes, that still were unconquered and firm.

'Well,' he said in his weakened voice, 'and how are you and Winifred getting on?'

'Oh, very well indeed,' replied Gudrun.

There were slight dead gaps in the conversation, as if the ideas called up were only elusive straws floating on the dark chaos of the sick man's dying.

"The studio answers all right?" he said.

'Splendid. It couldn't be more beautiful and perfect,' said Gudrun. She waited for what he would say next.

'And you think Winifred has the makings of a sculptor?'

It was strange how hollow the words were, meaningless.

'I'm sure she has. She will do good things one day.'

'Ah! Then her life won't be altogether wasted, you think?'

Gudrun was rather surprised.

'Sure it won't!' she exclaimed softly.

'That's right.'

Again Gudrun waited for what he would say.

'You find life pleasant, it is good to live, isn't it?' he asked, with a pitiful faint smile that was almost too much for Gudrun.

'Yes,' she smiled – she would lie at random – 'I get a pretty good time I believe.'

'That's right. A happy nature is a great asset.'

Again Gudrun smiled, though her soul was dry with repulsion. Did one have to die like this – having the life extracted forcibly from one, whilst one smiled and made conversation to the end? Was there no other way? Must one go through all the horror of this victory over death, the triumph of the integral will, that would not be broken till it disappeared utterly? One must, it was the only way. She admired the self-possession and the control of the dying man exceedingly. But she loathed the death itself. She was glad the everyday world held good, and she need not recognise anything beyond.

'You are quite all right here? – nothing we can do for you? – nothing you find wrong in your position?'

'Except that you are too good to me,' said Gudrun.

'Ah, well, the fault of that lies with yourself,' he said, and he felt a little exultation, that he had made this speech.

He was still so strong and living! But the nausea of death began to creep back on him, in reaction.

Gudrun went away, back to Winifred. Mademoiselle had left, Gudrun stayed a good deal at Shortlands, and a tutor came in to carry on Winifred's education. But he did not live in the house, he was

connected with the Grammar School.

One day, Gudrun was to drive with Winifred and Gerald and Birkin to town, in the car. It was a dark, showery day. Winifred and Gudrun were ready and waiting at the door. Winifred was very quiet, but Gudrun had not noticed. Suddenly the child asked, in a voice of unconcern:

'Do you think my father's going to die, Miss Brangwen?'

Gudrun started.

'I don't know,' she replied.

'Don't you truly?'

'Nobody knows for certain. He may die, of course.'

The child pondered a few moments, then she asked:

'But do you think he will die?'

It was put almost like a question in geography or science, insistent, as if she would force an admission from the adult. The watchful, slightly triumphant child was almost diabolical.

'Do I think he will die?' repeated Gudrun. 'Yes, I do.'

But Winifred's large eyes were fixed on her, and the girl did not move.

'He is very ill,' said Gudrun.

A small smile came over Winifred's face, subtle and sceptical.

'I don't believe he will,' the child asserted, mockingly, and she moved away into the drive. Gudrun watched the isolated figure, and her heart stood still. Winifred was playing with a little rivulet of water, absorbedly as if nothing had been said.

'I've made a proper dam,' she said, out of the moist distance.

Gerald came to the door from out of the hall behind.

'It is just as well she doesn't choose to believe it,' he said.

Gudrun looked at him. Their eyes met; and they exchanged a sardonic understanding.

'Just as well,' said Gudrun.

He looked at her again, and a fire flickered up in his eyes.

'Best to dance while Rome burns,⁷⁹ since it must burn, don't you think?' he said.

She was rather taken aback. But, gathering herself together, she replied:

'Oh - better dance than wail, certainly.'

'So I think.'

And they both felt the subterranean desire to let go, to fling away everything, and lapse into a sheer unrestraint, brutal and licentious. A strange black passion surged up pure in Gudrun. She felt strong. She felt her hands so strong, as if she could tear the world asunder with

WOMEN IN LOVE

them. She remembered the abandonments of Roman licence,⁸⁰ and her heart grew hot. She knew she wanted this herself also – or something, something equivalent. Ah, if that which was unknown and suppressed in her were once let loose, what an orgiastic and satisfying event it would be. And she wanted it, she trembled slightly from the proximity of the man, who stood just behind her, suggestive of the same black licentiousness that rose in herself. She wanted it with him, this unacknowledged frenzy. For a moment the clear perception of this preoccupied her, distinct and perfect in its final reality. Then she shut it off completely, saying:

'We might as well go down to the lodge after Winifred – we can get in the car there.'

'So we can,' he answered, going with her.

They found Winifred at the lodge admiring the litter of purebred white puppies. The girl looked up, and there was a rather ugly, unseeing cast in her eyes as she turned to Gerald and Gudrun. She did not want to see them.

'Look!' she cried. 'Three new puppies! Marshall says this one seems perfect. Isn't it a sweetling? But it isn't so nice as its mother.' She turned to caress the fine white bull-terrier bitch that stood uneasily near her.

'My dearest Lady Crich,' she said, 'you are beautiful as an angel on earth. Angel – angel – don't you think she's good enough and beautiful enough to go to heaven, Gudrun? They will be in heaven, won't they – and *especially* my darling Lady Crich! Mrs Marshall, I say!'

'Yes, Miss Winifred?' said the woman, appearing at the door.

'Oh do call this one Lady Winifred, if she turns out perfect, will you? Do tell Marshall to call it Lady Winifred.'

'I'll tell him - but I'm afraid that's a gentleman puppy, Miss Winifred.'

'Oh no?' There was the sound of a car. 'There's Rupert!' cried the child, and she ran to the gate.

Birkin, driving his car, pulled up outside the lodge gate.

'We're ready!' cried Winifred. 'I want to sit in front with you, Rupert. May I?'

'I'm afraid you'll fidget about and fall out,' he said.

'No I won't. I do want to sit in front next to you. It makes my feet so lovely and warm, from the engines.'

Birkin helped her up, amused at sending Gerald to sit by Gudrun in the body of the car.

'Have you any news, Rupert?' Gerald called, as they rushed along the lanes.

'News?' exclaimed Birkin.

'Yes.' Gerald looked at Gudrun, who sat by his side, and he said, his eyes narrowly laughing, 'I want to know whether I ought to congratulate him, but I can't get anything definite out of him.'

Gudrun flushed deeply.

'Congratulate him on what?' she asked.

'There was some mention of an engagement – at least, he said something to me about it.'

Gudrun flushed darkly.

'You mean with Ursula?' she said, in challenge.

'Yes. That is so, isn't it?'

'I don't think there's any engagement,' said Gudrun, coldly.

'That so? Still no developments, Rupert?' he called.

'Where? Matrimonial? No.'

'How's that?' called Gudrun.

Birkin glanced quickly round. There was irritation in his eyes also.

'Why?' he replied. 'What do you think of it, Gudrun?'

'Oh,' she cried, determined to fling her stone also into the pool, since they had begun, 'I don't think she wants an engagement. Naturally, she's a bird that prefers the bush.' Gudrun's voice was clear and gonglike. It reminded Rupert of her father's, so strong and vibrant.

'And I,' said Birkin, his face playful but yet determined, 'I want a binding contract, and am not keen on love, particularly free love.'

They were both amused. Why this public avowal? Gerald seemed suspended a moment, in amusement.

'Love isn't good enough for you?' he called.

'No!' shouted Birkin.

'Ha, well that's being over-refined,' said Gerald, and the car ran through the mud.

'What's the matter, really?' said Gerald, turning to Gudrun.

This was an assumption of a sort of intimacy that irritated Gudrun almost like an affront. It seemed to her that Gerald was deliberately insulting her, and infringing on the decent privacy of them all.

'What is it?' she said, in her high, repellent voice. 'Don't ask me! – I know nothing about *ultimate* marriage, I assure you: or even penultimate.'

'Only the ordinary unwarrantable brand!' replied Gerald. 'Just so – same here. I am no expert on marriage, and degrees of ultimateness. It seems to be a bee that buzzes loudly in Rupert's bonnet.'

'Exactly! But that is his trouble, exactly! Instead of wanting a woman for herself, he wants his *ideas* fulfilled. Which, when it comes to actual practice, is not good enough.'

'Oh no. Best go slap for what's womanly in woman, like a bull at a

gate.' Then he seemed to glimmer in himself. 'You think love is the ticket, do you?' he asked.

'Certainly, while it lasts – you only can't insist on permanency,' came Gudrun's voice, strident above the noise.

'Marriage or no marriage, ultimate or penultimate or just so-so? – take the love as you find it.'

'As you please, or as you don't please,' she echoed. 'Marriage is a social arrangement, I take it, and has nothing to do with the question of love.'

His eyes were flickering on her all the time. She felt as is he were kissing her freely and malevolently. It made the colour burn in her cheeks, but her heart was quite firm and unfailing.

'You think Rupert is off his head a bit?' Gerald asked.

Her eyes flashed with acknowledgment.

'As regards a woman, yes,' she said, 'I do. There is such a thing as two people being in love for the whole of their lives – perhaps. But marriage is neither here nor there, even then. If they are in love, well and good. If not – why break eggs about it!'

'Yes,' said Gerald. 'That's how it strikes me. But what about Rupert?'

'I can't make out – neither can he nor anybody. He seems to think that if you marry you can get through marriage into a third heaven, or something – all very vague.'

'Very! And who wants a third heaven? As a matter of fact, Rupert has a great yearning to be *safe* – to tie himself to the mast.'

'Yes. It seems to me he's mistaken there too,' said Gudrun. 'I'm sure a mistress is more likely to be faithful than a wife – just because she is her *own* mistress. No – he says he believes that a man and wife can go further than any other two beings – but *where*, is not explained. They can know each other, heavenly and hellish, but particularly hellish, so perfectly that they go beyond heaven and hell – into – there it all breaks down – into nowhere.'

'Into Paradise, he says,' laughed Gerald.

Gudrun shrugged her shoulders. 'Je m'en fiche of your Paradise!' she said.

'Not being a Mohammedan,'⁸¹ said Gerald. Birkin sat motionless, driving the car, quite unconscious of what they said. And Gudrun, sitting immediately behind him, felt a sort of ironic pleasure in thus exposing him.

'He says,' she added, with a grimace of irony, 'that you can find an eternal equilibrium in marriage, if you accept the unison, and still leave yourself separate, don't try to fuse.'

'Doesn't inspire me,' said Gerald.

'That's just it,' said Gudrun.

I believe in love, in a real *abandon*, if you're capable of it,' said Gerald.

'So do I,' said she.

'And so does Rupert, too - though he is always shouting.'

'No,' said Gudrun. 'He won't abandon himself to the other person. You can't be sure of him. That's the trouble I think.'

'Yet he wants marriage! Marriage - et puis?'82

'Le paradis!' mocked Gudrun.

Birkin, as he drove, felt a creeping of the spine, as if somebody was threatening his neck. But he shrugged with indifference. It began to rain. Here was a change. He stopped the car and got down to put up the hood.

CHAPTER XXII

Woman to Woman

THEY CAME to the town, and left Gerald at the railway station. Gudrun and Winifred were to come to tea with Birkin, who expected Ursula also. In the afternoon, however, the first person to turn up was Hermione. Birkin was out, so she went in the drawing-room, looking at his books and papers, and playing on the piano. Then Ursula arrived. She was surprised, unpleasantly so, to see Hermione, of whom she had heard nothing for some time.

'It is a surprise to see you,' she said.

'Yes,' said Hermione - 'I've been away at Aix - '

'Oh, for your health?'

'Yes.'

The two women looked at each other. Ursula resented Hermione's long, grave, downward-looking face. There was something of the stupidity and the unenlightened self-esteem of a horse in it. 'She's got a horse-face,' Ursula said to herself, 'she runs between blinkers.' It did seem as if Hermione, like the moon, had only one side to her penny. There was no obverse. She stared out all the time on the narrow, but to her, complete world of the extant consciousness. In the darkness, she did not exist. Like the moon, one half of her was lost to life. Her self was all in her head, she did not know what it was spontaneously to run or move, like a fish in the water, or a weasel on the grass. She must always *know*.

But Ursula only suffered from Hermione's one-sidedness. She only

WOMEN IN LOVE

felt Hermione's cool evidence, which seemed to put her down as nothing. Hermione, who brooded and brooded till she was exhausted with the ache of her effort at consciousness, spent and ashen in her body, who gained so slowly and with such effort her final and barren conclusions of knowledge, was apt, in the presence of other women. whom she thought simply female, to wear the conclusions of her bitter assurance like jewels which conferred on her an unquestionable distinction, established her in a higher order of life. She was apt, mentally, to condescend to women such as Ursula, whom she regarded as purely emotional. Poor Hermione, it was her one possession, this aching certainty of hers, it was her only justification. She must be confident here, for God knows, she felt rejected and deficient enough elsewhere. In the life of thought, of the spirit, she was one of the elect. And she wanted to be universal. But there was a devastating cynicism at the bottom of her. She did not believe in her own universals - they were sham. She did not believe in the inner life - it was a trick, not a reality. She did not believe in the spiritual world - it was an affectation. In the last resort, she believed in Mammon,⁸³ the flesh, and the devil these at least were not sham. She was a priestess without belief, without conviction, suckled in a creed outworn, and condemned to the reiteration of mysteries that were not divine to her. Yet there was no escape. She was a leaf upon a dying tree. What help was there then, but to fight still for the old, withered truths, to die for the old, outworn belief, to be a sacred and inviolate priestess of desecrated mysteries? The old great truths had been true. And she was a leaf of the old great tree of knowledge that was withering now. To the old and last truth then she must be faithful even though cynicism and mockery took place at the bottom of her soul.

'I am so glad to see you,' she said to Ursula, in her slow voice, that was like an incantation. 'You and Rupert have become quite friends?'

'Oh yes,' said Ursula. 'He is always somewhere in the background.'

Hermione paused before she answered. She saw perfectly well the other woman's vaunt: it seemed truly vulgar.

'Is he?' she said slowly, and with perfect equanimity. 'And do you think you will marry?'

The question was so calm and mild, so simple and bare and dispassionate that Ursula was somewhat taken aback, rather attracted. It pleased her almost like a wickedness. There was some delightful naked irony in Hermione.

'Well,' replied Ursula, 'He wants to, awfully, but I'm not so sure.'

Hermione watched her with slow calm eyes. She noted this new expression of vaunting. How she envied Ursula a certain unconscious

positivity! even her vulgarity!

'Why aren't you sure?' she asked, in her easy sing song. She was perfectly at her ease, perhaps even rather happy in this conversation. 'You don't really love him?'

Ursula flushed a little at the mild impertinence of this question. And yet she could not definitely take offence. Hermione seemed so calmly and sanely candid. After all, it was rather great to be able to be so sane.

'He says it isn't love he wants,' she replied.

'What is it then?' Hermione was slow and level.

'He wants me really to accept him in marriage.'

Hermione was silent for some time, watching Ursula with slow, pensive eyes.

'Does he?' she said at length, without expression. Then, rousing, 'And what is it you don't want? You don't want marriage?'

'No – I don't – not really. I don't want to give the sort of *submission* he insists on. He wants me to give myself up – and I simply don't feel that I *can* do it.'

Again there was a long pause, before Hermione replied:

'Not if you don't want to.' Then again there was silence. Hermione shuddered with a strange desire. Ah, if only he had asked *her* to subserve him, to be his slave! She shuddered with desire.

'You see I can't -'

'But exactly in what does - '

They had both begun at once, they both stopped. Then, Hermione, assuming priority of speech, resumed as if wearily:

"To what does he want you to submit?"

'He says he wants me to accept him non-emotionally, and finally -I really don't know what he means. He says he wants the demon part of himself to be mated – physically – not the human being. You see he says one thing one day, and another the next – and he always contradicts himself – '

'And always thinks about himself, and his own dissatisfaction,' said Hermione slowly.

'Yes,' cried Ursula. 'As if there were no-one but himself concerned. That makes it so impossible.'

But immediately she began to retract.

'He insists on my accepting God knows what in *bim*,' she resumed. 'He wants me to accept *bim* as – as an absolute – But it seems to me he doesn't want to *give* anything. He doesn't want real warm intimacy – he won't have it – he rejects it. He won't let me think, really, and he won't let me *feel* – he hates feelings.'

There was a long pause, bitter for Hermione. Ah, if only he would

have made this demand of her? Her he *drove* into thought, drove inexorably into knowledge – and then execrated her for it.

'He wants me to sink myself,' Ursula resumed, 'not to have any being of my own -'

'Then why doesn't he marry an odalisk?'⁸⁴ said Hermione in her mild sing-song, 'if it is that he wants.' Her long face looked sardonic and amused.

'Yes,' said Ursula vaguely. After all, the tiresome thing was, he did not want an odalisk, he did not want a slave. Hermione would have been his slave – there was in her a horrible desire to prostrate herself before a man – a man who worshipped her, however, and admitted her as the supreme thing. He did not want an odalisk. He wanted a woman to *take* something from him, to give herself up so much that she could take the last realities of him, the last facts, the last physical facts, physical and unbearable.

And if she did, would he acknowledge her? Would he be able to acknowledge her through everything, or would he use her just as his instrument, use her for his own private satisfaction, not admitting her? That was what the other men had done. They had wanted their own show, and they would not admit her, they turned all she was into nothingness. Just as Hermione now betrayed herself as a woman. Hermione was like a man, she believed only in men's things. She betrayed the woman in herself. And Birkin, would he acknowledge, or would he deny her?

'Yes,' said Hermione, as each woman came out of her own separate reverie. 'It would be a mistake – I think it would be a mistake – '

'To marry him?' asked Ursula.

'Yes,' said Hermione slowly – 'I think you need a man – soldierly, strong-willed – ' Hermione held out her hand and clenched it with rhapsodic intensity. 'You should have a man like the old heroes – you need to stand behind him as he goes into battle, you need to see his strength, and to *hear* his shout – . You need a man physically strong, and virile in his will, *not* a sensitive man – .' There was a break, as if the pythoness had uttered the oracle, and now the woman went on, in a rhapsody-wearied voice: 'And you see, Rupert isn't this, he isn't. He is frail in health and body, he needs great, great care. Then he is so changeable and unsure of himself – it requires the greatest patience and understanding to help him. And I don't think you are patient. You would have to be prepared to suffer – dreadfully. I can't *tell* you how much suffering it would take to make him happy. He lives an *intensely* spiritual life, at times – too, too wonderful. And then come the reactions. I can't speak of what I have been through with him. We have been together so long, I really do know him, I do know what he is. And I feel I must say it; I feel it would be perfectly *disastrous* for you to marry him – for you even more than for him.' Hermione lapsed into bitter reverie. 'He is so uncertain, so unstable – he wearies, and then reacts. I couldn't *tell* you what his re-actions are. I couldn't *tell* you the agony of them. That which he affirms and loves one day – a little later he turns on it in a fury of destruction. He is never constant, always this awful, dreadful reaction. Always the quick change from good to bad, bad to good. And nothing is so devastating, nothing – '

'Yes,' said Ursula humbly, 'you must have suffered.'

An unearthly light came on Hermione's face. She clenched her hand like one inspired.

'And one must be willing to suffer – willing to suffer for him hourly, daily – if you are going to help him, if he is to keep true to anything at all - '

'And I don't *want* to suffer hourly and daily,' said Ursula. 'I don't, I should be ashamed. I think it is degrading not to be happy.'

Hermione stopped and looked at her a long time.

'Do you?' she said at last. And this utterance seemed to her a mark of Ursula's far distance from herself. For to Hermione suffering was the greatest reality, come what might. Yet she too had a creed of happiness.

'Yes,' she said. 'One should be happy -' But it was a matter of will.

Yes,' said Hermione, listlessly now, 'I can only feel that it would be disastrous, disastrous – at least, to marry in a hurry. Can't you be together without marriage? Can't you go away and live somewhere without marriage? I do feel that marriage would be fatal, for both of you. I think for you even more than for him – and I think of his health – '

'Of course,' said Ursula, 'I don't care about marriage – it isn't really important to me – it's he who wants it.'

'It is his idea for the moment,' said Hermione, with that weary finality, and a sort of *si jeunesse savait*⁸⁵ infallibility.

There was a pause. Then Ursula broke into faltering challenge.

'You think I'm merely a physical woman, don't you?'

'No indeed,' said Hermione. 'No, indeed! But I think you are vital and young – it isn't a question of years, or even of experience – it is almost a question of race. Rupert is race-old, he comes of an old race – and you seem to me so young, you come of a young, inexperienced race.'

'Do I!' said Ursula. 'But I think he is awfully young, on one side.'

'Yes, perhaps childish in many respects. Nevertheless -'

They both lapsed into silence. Ursula was filled with deep resentment and a touch of hopelessness. 'It isn't true,' she said to herself, silently addressing her adversary. 'It isn't true. And it is *you* who want a physically strong, bullying man, not I. It is you who want an unsensitive man, not I. You *don't* know anything about Rupert, not really, in spite of the years you have had with him. You don't give him a woman's love, you give him an ideal love, and that is why he reacts away from you. You don't know. You only know the dead things. Any kitchen maid would know something about him, you don't know. What do you think your knowledge is but dead understanding, that doesn't mean a thing. You are so false, and untrue, how could you know anything? What is the good of your talking about love – you untrue spectre of a woman! How can you know anything, when you don't believe? You don't believe in yourself and your own womanhood, so what good is your conceited, shallow cleverness – !'

The two women sat on in antagonistic silence. Hermione felt injured, that all her good intention, all her offering, only left the other woman in vulgar antagonism. But then, Ursula could not understand, never would understand, could never be more than the usual jealous and unreasonable female, with a good deal of powerful female emotion, female attraction, and a fair amount of female understanding, but no mind. Hermione had decided long ago that where there was no mind, it was useless to appeal for reason - one had merely to ignore the ignorant. And Rupert - he had now reacted towards the strongly female, healthy, selfish woman - it was his reaction for the time being there was no helping it all. It was all a foolish backward and forward, a violent oscillation that would at length be too violent for his coherency, and he would smash and be dead. There was no saving him. This violent and directionless reaction between animalism and spiritual truth would go on in him till he tore himself in two between the opposite directions, and disappeared meaninglessly out of life. It was no good - he too was without unity, without mind, in the ultimate stages of living; not quite man enough to make a destiny for a woman.

They sat on till Birkin came in and found them together. He felt at once the antagonism in the atmosphere, something radical and insuperable, and he bit his lip. But he affected a bluff manner.

'Hello, Hermione, are you back again? How do you feel?'

'Oh, better. And how are you - you don't look well - '

'Oh! – I believe Gudrun and Winnie Crich are coming in to tea. At least they said they were. We shall be a tea-party. What train did you come by, Ursula?'

It was rather annoying to see him trying to placate both women at once. Both women watched him, Hermione with deep resentment and pity for him, Ursula very impatient. He was nervous and apparently in quite good spirits, chattering the conventional commonplaces. Ursula was amazed and indignant at the way he made small-talk; he was adept as any fat^{86} in Christendom. She became quite stiff, she would not answer. It all seemed to her so false and so belittling. And still Gudrun did not appear.

'I think I shall go to Florence for the winter,' said Hermione at length.

'Will you?' he answered. 'But it is so cold there.'

'Yes, but I shall stay with Palestra. It is quite comfortable.'

'What takes you to Florence?'

'I don't know,' said Hermione slowly. Then she looked at him with her slow, heavy gaze. 'Barnes is starting his school of æsthetics, and Olandese is going to give a set of discourses on the Italian national policy – '

'Both rubbish,' he said.

'No, I don't think so,' said Hermione.

'Which do you admire, then?'

'I admire both. Barnes is a pioneer. And then I am interested in Italy, in her coming to national consciousness.'

'I wish she'd come to something different from national consciousness, then,' said Birkin; 'especially as it only means a sort of commercial-industrial consciousness. I hate Italy and her national rant. And I think Barnes is an amateur.'

Hermione was silent for some moments, in a state of hostility. But yet, she had got Birkin back again into her world! How subtle her influence was, she seemed to start his irritable attention into her direction exclusively, in one minute. He was her creature.

'No,' she said, 'you are wrong.' Then a sort of tension came over her, she raised her face like the pythoness inspired with oracles, and went on, in rhapsodic manner: 'Il Sandro mi scrive che ha accolto il piu grande entusiasmo, tutti i giovani, e fanciulle e ragazzi, sono tutti – '⁸⁷ She went on in Italian, as if, in thinking of the Italians she thought in their language.

He listened with a shade of distaste to her rhapsody, then he said:

'For all that, I don't like it. Their nationalism is just industrialism – that and a shallow jealousy I detest so much.'

'I think you are wrong – I think you are wrong – 'said Hermione. 'It seems to me purely spontaneous and beautiful, the modern Italian's *passion*, for it is a passion, for Italy, L'Italia – '

'Do you know Italy well?' Ursula asked of Hermione. Hermione hated to be broken in upon in this manner. Yet she answered mildly:

'Yes, pretty well. I spent several years of my girlhood there, with my mother. My mother died in Florence.'

'Oh.'

There was a pause, painful to Ursula and to Birkin. Hermione however seemed abstracted and calm. Birkin was white, his eyes glowed as if he were in a fever, he was far too over-wrought. How Ursula suffered in this tense atmosphere of strained wills! Her head seemed bound round by iron bands.

Birkin rang the bell for tea. They could not wait for Gudrun any longer. When the door was opened, the cat walked in.

'Micio! Micio!' called Hermione, in her slow, deliberate sing-song. The young cat turned to look at her, then, with his slow and stately walk he advanced to her side.

'Vieni – vieni quá,' Hermione was saying, in her strange caressive, protective voice, as if she were always the elder, the mother superior. 'Vieni dire Buon' Giorno alla zia. Mi ricorde, mi ricorde bene – non he vero, piccolo? E vero che mi ricordi? E vero?' And slowly she rubbed his head, slowly and with ironic indifference.

'Does he understand Italian?' said Ursula, who knew nothing of the language.

'Yes,' said Hermione at length. 'His mother was Italian. She was born in my waste-paper basket in Florence, on the morning of Rupert's birthday. She was his birthday present.'

Tea was brought in. Birkin poured out for them. It was strange how inviolable was the intimacy which existed between him and Hermione. Ursula felt that she was an outsider. The very tea-cups and the old silver was a bond between Hermione and Birkin. It seemed to belong to an old, past world which they had inhabited together, and in which Ursula was a foreigner. She was almost a parvenue in their old cultured milieu. Her convention was not their convention, their standards were not her standards. But theirs were established, they had the sanction and the grace of age. He and she together, Hermione and Birkin, were people of the same old tradition, the same withered deadening culture. And she, Ursula, was an intruder. So they always made her feel.

Hermione poured a little cream into a saucer. The simple way she assumed her rights in Birkin's room maddened and discouraged Ursula. There was a fatality about it, as if it were bound to be. Hermione lifted the cat and put the cream before him. He planted his two paws on the edge of the table and bent his gracious young head to drink.

'Siccuro che capisce italiano,' sang Hermione, 'non l'avrà dimenticato, la lingua della Mamma.'

She lifted the cat's head with her long, slow, white fingers, not letting him drink, holding him in her power. It was always the same, this joy in

power she manifested, peculiarly in power over any male being. He blinked forbearingly, with a male, bored expression, licking his whiskers. Hermione laughed in her short, grunting fashion.

'Ecco, il bravo ragazzo, come è superbo, questo!'

She made a vivid picture, so calm and strange with the cat. She had a true static impressiveness, she was a social artist in some ways.

The cat refused to look at her, indifferently avoided her fingers, and began to drink again, his nose down to the cream, perfectly balanced, as he lapped with his odd little click.

'It's bad for him, teaching him to eat at table,' said Birkin.

'Yes,' said Hermione, easily assenting.

Then, looking down at the cat, she resumed her old, mocking, humorous sing-song.

"Ti imparano fare brutte cose, brutte cose - "

She lifted the Mino's white chin on her forefinger, slowly. The young cat looked round with a supremely forbearing air, avoided seeing anything, withdrew his chin, and began to wash his face with his paw. Hermione grunted her laughter, pleased.

'Bel giovanotto - ' she said.

The cat reached forward again and put his fine white paw on the edge of the saucer. Hermione lifted it down with delicate slowness. This deliberate, delicate carefulness of movement reminded Ursula of Gudrun.

'No! Non è permesso di mettere il zampino nel tondinetto. Non piace al babbo. Un signor gatto così selvatico – !'⁸⁸

And she kept her finger on the softly planted paw of the cat, and her voice had the same whimsical, humorous note of bullying.

Ursula had her nose out of joint. She wanted to go away now. It all seemed no good. Hermione was established for ever, she herself was ephemeral and had not yet even arrived.

'I will go now,' she said suddenly.

Birkin looked at her almost in fear - he so dreaded her anger. 'But there is no need for such hurry,' he said.

'Yes,' she answered. 'I will go.' And turning to Hermione, before there was time to say any more, she held out her hand and said 'Good-bye.'

'Good-bye - ' sang Hermione, detaining the band. 'Must you really go now?'

'Yes, I think I'll go,' said Ursula, her face set, and averted from Hermione's eyes.

'You think you will -'

But Ursula had got her hand free. She turned to Birkin with a quick, almost jeering: 'Good-bye,' and she was opening the door before he had time to do it for her.

When she got outside the house she ran down the road in fury and agitation. It was strange, the unreasoning rage and violence Hermione roused in her, by her very presence. Ursula knew she gave herself away to the other woman, she knew she looked ill-bred, uncouth, exaggerated. But she did not care. She only ran up the road, lest she should go back and jeer in the faces of the two she had left behind. For they outraged her.

CHAPTER XXIII

Excurse

NEXT DAY Birkin sought Ursula out. It happened to be the half-day at the Grammar School. He appeared towards the end of the morning, and asked her, would she drive with him in the afternoon. She consented. But her face was closed and unresponding, and his heart sank.

The afternoon was fine and dim. He was driving the motor-car, and she sat beside him. But still her face was closed against him, unresponding. When she became like this, like a wall against him, his heart contracted.

His life now seemed so reduced, that he hardly cared any more. At moments it seemed to him he did not care a straw whether Ursula or Hermione or anybody else existed or did not exist. Why bother! Why strive for a coherent, satisfied life? Why not drift on in a series of accidents – like a picaresque novel? Why not? Why bother about human relationships? Why take them seriously – male or female? Why form any serious connections at all? Why not be casual, drifting along, taking all for what it was worth?

And yet, still, he was damned and doomed to the old effort at serious living.

'Look,' he said, 'what I bought.' The car was running along a broad white road, between autumn trees.

He gave her a little bit of screwed-up paper. She took it and opened it. 'How lovely,' she cried.

She examined the gift.

'How perfectly lovely!' she cried again. 'But why do you give them me?' She put the question offensively.

His face flickered with bored irritation. He shrugged his shoulders slightly.

'I wanted to,' he said, coolly.

'But why? Why should you?'

'Am I called on to find reasons?' he asked.

There was a silence, whilst she examined the rings that had been screwed up in the paper.

'I think they are *beautiful*,' she said, 'especially this. This is wonderful -' It was a round opal, red and fiery, set in a circle of tiny rubies.

'You like that best?' he said.

'I think I do.'

'I like the sapphire,' he said.

'This?'

It was a rose-shaped, beautiful sapphire, with small brilliants.

'Yes,' she said, 'it is lovely.' She held it in the light. 'Yes, perhaps it is the best - '

'The blue - ' he said.

'Yes, wonderful -'

He suddenly swung the car out of the way of a farm-cart. It tilted on the bank. He was a careless driver, yet very quick. But Ursula was frightened. There was always that something regardless in him which terrified her. She suddenly felt he might kill her, by making some dreadful accident with the motor-car. For a moment she was stony with fear.

'Isn't it rather dangerous, the way you drive?' she asked him.

'No, it isn't dangerous,' he said. And then, after a pause: 'Don't you like the yellow ring at all?'

It was a squarish topaz set in a frame of steel, or some other similar mineral, finely wrought.

'Yes,' she said, 'I do like it. But why did you buy these rings?'

'I wanted them. They are second-hand.'

'You bought them for yourself?'

'No. Rings look wrong on my hands.'

'Why did you buy them then?'

'I bought them to give to you.'

'But why? Surely you ought to give them to Hermione! You belong to her.'

He did not answer. She remained with the jewels shut in her hand. She wanted to try them on her fingers, but something in her would not let her. And moreover, she was afraid her hands were too large, she shrank from the mortification of a failure to put them on any but her little finger. They travelled in silence through the empty lanes.

Driving in a motor-car excited her, she forgot his presence even.

'Where are we?' she asked suddenly.

'Not far from Worksop.'

'And where are we going?'

'Anywhere.'

It was the answer she liked.

She opened her hand to look at the rings. They gave her *sucb* pleasure, as they lay, the three circles, with their knotted jewels, entangled in her palm. She would have to try them on. She did so secretly, unwilling to let him see, so that he should not know her finger was too large for them. But he saw nevertheless. He always saw, if she wanted him not to. It was another of his hateful, watchful characteristics.

Only the opal, with its thin wire loop, would go on her ring finger. And she was superstitious. No, there was ill-portent enough, she would not accept this ring from him in pledge.

'Look,' she said, putting forward her hand, that was half-closed and shrinking. 'The others don't fit me.'

He looked at the red-glinting, soft stone, on her over-sensitive skin. 'Yes,' he said.

'But opals are unlucky, aren't they?' she said wistfully.

'No. I prefer unlucky things. Luck is vulgar. Who wants what *luck* would bring? I don't.'

'But why?' she laughed.

And, consumed with a desire to see how the other rings would look on her hand, she put them on her little finger.

'They can be made a little bigger,' he said.

'Yes,' she replied, doubtfully. And she sighed. She knew that, in accepting the rings, she was accepting a pledge. Yet fate seemed more than herself. She looked again at the jewels. They were very beautiful to her eyes – not as ornament, or wealth, but as tiny fragments of loveliness.

'I'm glad you bought them,' she said, putting her hand, half unwillingly, gently on his arm.

He smiled, slightly. He wanted her to come to him. But he was angry at the bottom of his soul, and indifferent. He knew she had a passion for him, really. But it was not finally interesting. There were depths of passion when one became impersonal and indifferent, unemotional. Whereas Ursula was still at the emotional personal level – always so abominably personal. He had taken her as he had never been taken himself. He had taken her at the roots of her darkness and shame – like a demon, laughing over the fountain of mystic corruption which was one of the sources of her being, laughing, shrugging, accepting, accepting finally. As for her, when would she so much go beyond herself as to accept him at the quick of death? She now became quite happy. The motor-car ran on, the afternoon was soft and dim. She talked with lively interest, analysing people and their motives – Gudrun, Gerald. He answered vaguely. He was not very much interested any more in personalities and in people – people were all different, but they were all enclosed nowadays in a definite limitation, he said; there were only about two great ideas, two great streams of activity remaining, with various forms of reaction therefrom. The reactions were all varied in various people, but they followed a few great laws, and intrinsically there was no difference. They acted and reacted involuntarily according to a few great laws, and once the laws, the great principles, were known, people were no longer mystically interesting. They were all essentially alike, the differences were only variations on a theme. None of them transcended the given terms.

Ursula did not agree – people were still an adventure to her – but – perhaps not as much as she tried to persuade herself. Perhaps there was something mechanical, now, in her interest. Perhaps also her interest was destructive, her analysing was a real tearing to pieces. There was an under-space in her where she did not care for people and their idiosyncracies, even to destroy them. She seemed to touch for a moment this undersilence in herself, she became still, and she turned for a moment purely to Birkin.

'Won't it be lovely to go home in the dark?' she said. 'We might have tea rather late – shall we? – and have high tea? Wouldn't that be rather nice?'

'I promised to be at Shortlands for dinner,' he said.

'But - it doesn't matter - you can go tomorrow - '

'Hermione is there,' he said, in rather an uneasy voice. 'She is going away in two days. I suppose I ought to say good-bye to her. I shall never see her again.'

Ursula drew away, closed in a violent silence. He knitted his brows, and his eyes began to sparkle again in anger.

'You don't mind, do you?' he asked irritably.

'No, I don't care. Why should I? Why should I mind?' Her tone was jeering and offensive.

'That's what I ask myself,' he said; 'why *should* you mind! But you seem to.' His brows were tense with violent irritation.

'I assure you I don't, I don't mind in the least. Go where you belong – it's what I want you to do.'

'Ah you fool!' he cried, 'with your "go where you belong." It's finished between Hermione and me. She means much more to you, if it comes to that, than she does to me. For you can only revolt in pure reaction from her – and to be her opposite is to be her counterpart.'

'Ah, opposite!' cried Ursula. 'I know your dodges. I am not taken in by your word-twisting. You belong to Hermione and her dead show. Well, if you do, you do. I don't blame you. But then you've nothing to do with me.

In his inflamed, overwrought exasperation, he stopped the car, and they sat there, in the middle of the country lane, to have it out. It was a crisis of war between them, so they did not see the ridiculousness of their situation.

'If you weren't a fool, if only you weren't a fool,' he cried in bitter despair, 'you'd see that one could be decent, even when one has been wrong. I *was* wrong to go on all those years with Hermione – it was a deathly process. But after all, one can have a little human decency. But no, you would tear my soul out with your jealousy at the very mention of Hermione's name.'

'I jealous! I – jealous! You *are* mistaken if you think that. I'm not jealous in the least of Hermione, she is nothing to me, not *that*!' And Ursula snapped her fingers. 'No, it's you who are a liar. It's you who must return, like a dog to his vomit. It is what Hermione *stands for* that I *hate*. I *hate* it. It is lies, it is false, it is death. But you want it, you can't help it, you can't help yourself. You belong to that old, deathly way of living – then go back to it. But don't come to me, for I've nothing to do with it.'

And in the stress of her violent emotion, she got down from the car and went to the hedgerow, picking unconsciously some flesh-pink spindleberries, some of which were burst, showing their orange seeds.

'Ah, you are a fool,' he cried, bitterly, with some contempt.

'Yes, I am. I am a fool. And thank God for it. I'm too big a fool to swallow your cleverness. God be praised. You go to your women - go to them - they are your sort - you've always had a string of them trailing after you - and you always will. Go to your spiritual brides but don't come to me as well, because I'm not having any, thank you. You're not satisfied, are you? Your spiritual brides can't give you what you want, they aren't common and fleshy enough for you, aren't they? So you come to me, and keep them in the background! You will marry me for daily use. But you'll keep yourself well provided with spiritual brides in the background. I know your dirty little game.' Suddenly a flame ran over her, and she stamped her foot madly on the road, and he winced, afraid that she would strike him. 'And I, I'm not spiritual enough, I'm not as spiritual as that Hermione - !' Her brows knitted, her eyes blazed like a tiger's. 'Then go to her, that's all I say, go to her, go. Ha, she spiritual - spiritual, she! A dirty materialist as she is. She spiritual? What does she care for, what is her spirituality? What is it?'

Her fury seemed to blaze out and burn his face. He shrank a little. 'I tell you it's *dirt*, *dirt*, and nothing *but* dirt. And it's dirt you want, you crave for it. Spiritual! Is *that* spiritual, her bullying, her conceit, her sordid materialism? She's a fishwife, a fishwife, she is such a materialist. And all so sordid. What does she work out to, in the end, with all her social passion, as you call it. Social passion – what social passion has she? – show it me! – where is it? She wants petty, immediate *power*, she wants the illusion that she is a great woman, that is all. In her soul she's a devilish unbeliever, common as dirt. That's what she is at the bottom. And all the rest is pretence – but you love it. You love the sham spirituality, it's your food. And why? Because of the dirt underneath. Do you think I don't know the foulness of your sex life – and her's? – I do. And it's that foulness you want, you liar. Then have it, have it. You're such a liar.'

She turned away, spasmodically tearing the twigs of spindleberry from the hedge, and fastening them, with vibrating fingers, in the bosom of her coat.

He stood watching in silence. A wonderful tenderness burned in him, at the sight of her quivering, so sensitive fingers: and at the same time he was full of rage and callousness.

'This is a degrading exhibition,' he said coolly.

'Yes, degrading indeed,' she said. 'But more to me than to you.'

'Since you choose to degrade yourself,' he said. Again the flash came over her face, the yellow lights concentrated in her eyes.

'You!' she cried. 'You! You truth-lover! You purity-monger! It *stinks*, your truth and your purity. It stinks of the offal you feed on, you scavenger dog, you eater of corpses. You are foul, *foul* and you must know it. Your purity, your candour, your goodness – yes, thank you, we've had some. What you are is a foul, deathly thing, obscene, that's what you are, obscene and perverse. You, and love! You may well say, you don't want love. No, you want *yourself*, and dirt, and death – that's what you want. You are so *perverse*, so death-eating. And then – '

'There's a bicycle coming,' he said, writhing under her loud denunciation.

She glanced down the road.

'I don't care,' she cried.

Nevertheless she was silent. The cyclist, having heard the voices raised in altercation, glanced curiously at the man, and the woman, and at the standing motor-car as he passed.

'- Afternoon,' he said, cheerfully.

'Good-afternoon,' replied Birkin coldly.

They were silent as the man passed into the distance.

WOMEN IN LOVE

A clearer look had come over Birkin's face. He knew she was in the main right. He knew he was perverse, so spiritual on the one hand, and in some strange way, degraded, on the other. But was she herself any better? Was anybody any better?

'It may all be true, lies and stink and all,' he said. 'But Hermione's spiritual intimacy is no rottener than your emotional-jealous intimacy. One can preserve the decencies, even to one's enemies: for one's own sake. Hermione is my enemy – to her last breath! That's why I must bow her off the field.'

'You! You and your enemies and your bows! A pretty picture you make of yourself. But it takes nobody in but yourself. I *jealous*! I! What I say,' her voice sprang into flame, 'I say because it is *true*, do you see, because you are *you*, a foul and false liar, a whited sepulchre. That's why I say it. And *you* hear it.'

'And be grateful,' he added, with a satirical grimace.

'Yes,' she cried, 'and if you have a spark of decency in you, be grateful.'

'Not having a spark of decency, however - ' he retorted.

'No,' she cried, 'you haven't a *spark*. And so you can go your way, and I'll go mine. It's no good, not the slightest. So you can leave me now, I don't want to go any further with you – leave me – '

'You don't even know where you are,' he said.

'Oh, don't bother, I assure you I shall be all right. I've got ten shillings in my purse, and that will take me back from anywhere you have brought me to.' She hesitated. The rings were still on her fingers, two on her little finger, one on her ring finger. Still she hesitated.

'Very good,' he said. 'The only hopeless thing is a fool.'

'You are quite right,' she said.

Still she hesitated. Then an ugly, malevolent look came over her face, she pulled the rings from her fingers, and tossed them at him. One touched his face, the others hit his coat, and they scattered into the mud.

'And take your rings,' she said, 'and go and buy yourself a female elsewhere – there are plenty to be had, who will be quite glad to share your spiritual mess, – or to have your physical mess, and leave your spiritual mess to Hermione.'

With which she walked away, desultorily, up the road. He stood motionless, watching her sullen, rather ugly walk. She was sullenly picking and pulling at the twigs of the hedge as she passed. She grew smaller, she seemed to pass out of his sight. A darkness came over his mind. Only a small, mechanical speck of consciousness hovered near him.

He felt tired and weak. Yet also he was relieved. He gave up his old position. He went and sat on the bank. No doubt Ursula was right. It was true, really, what she said. He knew that his spirituality was concomitant of a process of depravity, a sort of pleasure in selfdestruction. There really was a certain stimulant in self-destruction, for him - especially when it was translated spiritually. But then he knew it - he knew it, and had done. And was not Ursula's way of emotional intimacy, emotional and physical, was it not just as dangerous as Hermione's abstract spiritual intimacy? Fusion, fusion, this horrible fusion of two beings, which every woman and most men insisted on, was it not nauseous and horrible anyhow, whether it was a fusion of the spirit or of the emotional body? Hermione saw herself as the perfect Idea, to which all men must come: And Ursula was the perfect Womb, the bath of birth, to which all men must come! And both were horrible. Why could they not remain individuals, limited by their own limits? Why this dreadful all-comprehensiveness, this hateful tyranny? Why not leave the other being free, why try to absorb, or melt, or merge? One might abandon oneself utterly to the moments, but not to any other being.

He could not bear to see the rings lying in the pale mud of the road. He picked them up, and wiped them unconsciously on his hands. They were the little tokens of the reality of beauty, the reality of happiness in warm creation. But he had made his hands all dirty and gritty.

There was a darkness over his mind. The terrible knot of consciousness that had persisted there like an obsession was broken, gone, his life was dissolved in darkness over his limbs and his body. But there was a point of anxiety in his heart now. He wanted her to come back. He breathed lightly and regularly like an infant, that breathes innocently, beyond the touch of responsibility.

She was coming back. He saw her drifting desultorily under the high hedge, advancing towards him slowly. He did not move, he did not look again. He was as if asleep, at peace, slumbering and utterly relaxed.

She came up and stood before him, hanging her head.

'See what a flower I found you,' she said, wistfully holding a piece of purple-red bell-heather under his face. He saw the clump of coloured bells, and the tree-like, tiny branch: also her hands, with their overfine, over-sensitive skin.

'Pretty!' he said, looking up at her with a smile, taking the flower. Everything had become simple again, quite simple, the complexity gone into nowhere. But he badly wanted to cry: except that he was weary and bored by emotion.

Then a hot passion of tenderness for her filled his heart. He stood up and looked into her face. It was new and oh, so delicate in its luminous wonder and fear. He put his arms round her, and she hid her face on his shoulder.

It was peace, just simple peace, as he stood folding her quietly there on the open lane. It was peace at last. The old, detestable world of tension had passed away at last, his soul was strong and at ease.

She looked up at him. The wonderful yellow light in her eyes now was soft and yielded, they were at peace with each other. He kissed her, softly, many, many times. A laugh came into her eyes.

'Did I abuse you?' she asked.

He smiled too, and took her hand, that was so soft and given.

'Never mind,' she said, 'it is all for the good.' He kissed her again, softly, many times.

'Isn't it?' she said.

'Certainly,' he replied. 'Wait! I shall have my own back.'

She laughed suddenly, with a wild catch in her voice, and flung her arms around him.

'You are mine, my love, aren't you?' she cried straining him close.

'Yes,' he said, softly.

His voice was so soft and final, she went very still, as if under a fate which had taken her. Yes, she acquiesced – but it was accomplished without her acquiescence. He was kissing her quietly, repeatedly, with a soft, still happiness that almost made her heart stop beating.

'My love!' she cried, lifting her face and looking with frightened, gentle wonder of bliss. Was it all real? But his eyes were beautiful and soft and immune from stress or excitement, beautiful and smiling lightly to her, smiling with her. She hid her face on his shoulder, hiding before him, because he could see her so completely. She knew he loved her, and she was afraid, she was in a strange element, a new heaven round about her. She wished he were passionate, because in passion she was at home. But this was so still and frail, as space is more frightening than force.

Again, quickly, she lifted her head.

'Do you love me?' she said, quickly, impulsively.

'Yes,' he replied, not heeding her motion, only her stillness.

She knew it was true. She broke away.

'So you ought,' she said, turning round to look at the road. 'Did you find the rings?'

'Yes.'

'Where are they?'

'In my pocket.'

She put her hand into his pocket and took them out.

She was restless.

'Shall we go?' she said.

'Yes,' he answered. And they mounted to the car once more, and left behind them this memorable battle-field.

They drifted through the wild, late afternoon, in a beautiful motion that was smiling and transcendent. His mind was sweetly at ease, the life flowed through him as from some new fountain, he was as if born out of the cramp of a womb.

'Are you happy?' she asked him, in her strange, delighted way.

'Yes,' he said.

'So am I,' she cried in sudden ecstacy, putting her arm round him and clutching him violently against her, as he steered the motor-car.

'Don't drive much more,' she said. 'I don't want you to be always doing something.'

'No,' he said. 'We'll finish this little trip, and then we'll be free.'

'We will, my love, we will,' she cried in delight, kissing him as he turned to her.

He drove on in a strange new wakefulness, the tension of his consciousness broken. He seemed to be conscious all over, all his body awake with a simple, glimmering awareness, as if he had just come awake, like a thing that is born, like a bird when it comes out of an egg, into a new universe.

They dropped down a long hill in the dusk, and suddenly Ursula recognised on her right hand, below in the hollow, the form of Southwell Minster.

'Are we here!' she cried with pleasure.

The rigid, sombre, ugly cathedral was settling under the gloom of the coming night, as they entered the narrow town, the golden lights showed like slabs of revelation, in the shop-windows.

'Father came here with mother,' she said, 'when they first knew each other. He loves it – he loves the Minster. Do you?'

'Yes. It looks like quartz crystals sticking up out of the dark hollow. We'll have our high tea at the Saracen's Head.'

As they descended, they heard the Minster bells playing a hymn, when the hour had struck six.

Glory to thee my God this night For all the blessings of the light –⁸⁹

So, to Ursula's ear, the tune fell out, drop by drop, from the unseen sky

WOMEN IN LOVE

on to the dusky town. It was like dim, bygone centuries sounding. It was all so far off. She stood in the old yard of the inn, smelling of straw and stables and petrol. Above, she could see the first stars. What was it all? This was no actual world, it was the dream-world of one's childhood – a great circumscribed reminiscence. The world had become unreal. She herself was a strange, transcendent reality.

They sat together in a little parlour by the fire.

'Is it true?' she said, wondering.

'What?'

'Everything – is everything true?'

'The best is true,' he said, grimacing at her.

'Is it?' she replied, laughing, but unassured.

She looked at him. He seemed still so separate. New eyes were opened in her soul. She saw a strange creature from another world, in him. It was as if she were enchanted, and everything were metamorphosed. She recalled again the old magic of the Book of Genesis, where the sons of God saw the daughters of men, that they were fair. And he was one of these, one of these strange creatures from the beyond, looking down at her, and seeing she was fair.⁹⁰

He stood on the hearth-rug looking at her, at her face that was upturned exactly like a flower, a fresh, luminous flower, glinting faintly golden with the dew of the first light. And he was smiling faintly as if there were no speech in the world, save the silent delight of flowers in each other. Smilingly they delighted in each other's presence, pure presence, not to be thought of, even known. But his eyes had a faintly ironical contraction.

And she was drawn to him strangely, as in a spell. Kneeling on the hearth-rug before him, she put her arms round his loins, and put her face against his thigh. Riches! Riches! She was overwhelmed with a sense of a heavenful of riches.

'We love each other,' she said in delight.

'More than that,' he answered, looking down at her with his glimmering, easy face.

Unconsciously, with her sensitive fingertips, she was tracing the back of his thighs, following some mysterious life-flow there. She had discovered something, something more than wonderful, more wonderful than life itself. It was the strange mystery of his life-motion, there, at the back of the thighs, down the flanks. It was a strange reality of his being, the very stuff of being, there in the straight downflow of the thighs. It was here she discovered him one of the sons of God such as were in the beginning of the world, not a man, something other, something more.

This was release at last. She had had lovers, she had known passion. But this was neither love nor passion. It was the daughters of men coming back to the sons of God, the strange inhuman sons of God who are in the beginning.

Her face was now one dazzle of released, golden light, as she looked up at him, and laid her hands full on his thighs, behind, as he stood before her. He looked down at her with a rich bright brow like a diadem above his eyes. She was beautiful as a new marvellous flower opened at his knees, a paradisal flower she was, beyond womanhood, such a flower of luminousness. Yet something was tight and unfree in him. He did not like this crouching, this radiance – not altogether.

It was all achieved, for her. She had found one of the sons of God from the Beginning, and he had found one of the first most luminous daughters of men.

She traced with her hands the line of his loins and thighs, at the back, and a living fire ran through her, from him, darkly. It was a dark flood of electric passion she released from him, drew into herself. She had established a rich new circuit, a new current of passional electric energy, between the two of them, released from the darkest poles of the body and established in perfect circuit. It was a dark fire of electricity that rushed from him to her, and flooded them both with rich peace, satisfaction.

'My love,' she cried, lifting her face to him, her eyes, her mouth open in transport.

'My love,' he answered, bending and kissing her, always kissing her.

She closed her hands over the full, rounded body of his loins, as he stooped over her, she seemed to touch the quick of the mystery of darkness that was bodily him. She seemed to faint beneath, and he seemed to faint, stooping over her. It was a perfect passing away for both of them, and at the same time the most intolerable accession into being, the marvellous fullness of immediate gratification, overwhelming, out-flooding from the source of the deepest life-force, the darkest, deepest, strangest life-source of the human body, at the back and base of the loins.

After a lapse of stillness, after the rivers of strange dark fluid richness had passed over her, flooding, carrying away her mind and flooding down her spine and down her knees, past her feet, a strange flood, sweeping away everything and leaving her an essential new being, she was left quite free, she was free in complete ease, her complete self. So she rose, stilly and blithe, smiling at him. He stood before her, glimmering, so awfully real, that her heart almost stopped beating. He stood there in his strange, whole body, that had its marvellous

WOMEN IN LOVE

fountains, like the bodies of the sons of God who were in the beginning. There were strange fountains of his body, more mysterious and potent than any she had imagined or known, more satisfying, ah, finally, mystically-physically satisfying. She had thought there was no source deeper than the phallic source. And now, behold, from the smitten rock of the man's body, from the strange marvellous flanks and thighs, deeper, further in mystery than the phallic source, came the floods of ineffable darkness and ineffable riches.

They were glad, and they could forget perfectly. They laughed, and went to the meal provided. There was a venison pasty, of all things, a large broad-faced cut ham, eggs and cresses and red beet-root, and medlars and apple-tart, and tea.

'What good things!' she cried with pleasure. 'How noble it looks! - shall I pour out the tea? - '

She was usually nervous and uncertain at performing these public duties, such as giving tea. But today she forgot, she was at her ease, entirely forgetting to have misgivings. The tea-pot poured beautifully from a proud slender spout. Her eyes were warm with smiles as she gave him his tea. She had learned at last to be still and perfect.

'Everything is ours,' she said to him.

'Everything,' he answered.

She gave a queer little crowing sound of triumph.

'I'm so glad!' she cried, with unspeakable relief.

'So am I,' he said. 'But I'm thinking we'd better get out of our responsibilities as quick as we can.'

'What responsibilities?' she asked, wondering.

'We must drop our jobs, like a shot.'

A new understanding dawned into her face.

'Of course,' she said, 'there's that.'

'We must get out,' he said. 'There's nothing for it but to get out, quick.'

She looked at him doubtfully across the table.

'But where?' she said.

'I don't know,' he said. 'We'll just wander about for a bit.'

Again she looked at him quizzically.

'I should be perfectly happy at the Mill,' she said.

'It's very near the old thing,' he said. 'Let us wander a bit.'

His voice could be so soft and happy-go-lucky, it went through her veins like an exhilaration. Nevertheless she dreamed of a valley, and wild gardens, and peace. She had a desire too for splendour – an aristocratic extravagant splendour. Wandering seemed to her like restlessness, dissatisfaction.

'Where will you wander to?' she asked.

'I don't know. I feel as if I would just meet you and we'd set off - just towards the distance.'

'But where can one go?' she asked anxiously. 'After all, there is only the world, and none of it is very distant.'

'Still,' he said, 'I should like to go with you – nowhere. It would be rather wandering just to nowhere. That's the place to get to – nowhere. One wants to wander away from the world's somewheres, into our own nowhere.'

Still she meditated.

'You see, my love,' she said, 'I'm so afraid that while we are only people, we've got to take the world that's given – because there isn't any other.'

Yes there is,' he said. 'There's somewhere where we can be free – somewhere where one needn't wear much clothes – none even – where one meets a few people who have gone through enough, and can take things for granted – where you be yourself, without bothering. There is somewhere – there are one or two people – '

'But where -?' she sighed.

'Somewhere – anywhere. Let's wander off. That's the thing to do – let's wander off.'

'Yes - ' she said, thrilled at the thought of travel. But to her it was only travel.

'To be free,' he said. 'To be free, in a free place, with a few other people!'

'Yes,' she said wistfully. Those 'few other people' depressed her.

'It isn't really a locality, though,' he said. 'It's a perfected relation between you and me, and others – the perfect relation – so that we are free together.'

'It is, my love, isn't it,' she said. 'It's you and me. It's you and me, isn't it?' She stretched out her arms to him. He went across and stooped to kiss her face. Her arms closed round him again, her hands spread upon his shoulders, moving slowly there, moving slowly on his back, down his back slowly, with a strange recurrent, rhythmic motion, yet moving slowly down, pressing mysteriously over his loins, over his flanks. The sense of the awfulness of riches that could never be impaired flooded her mind like a swoon, a death in most marvellous possession, mystic-sure. She possessed him so utterly and intolerably, that she herself lapsed out. And yet she was only sitting still in the chair, with her hands pressed upon him, and lost.

Again he softly kissed her.

'We shall never go apart again,' he murmured quietly. And she did not speak, but only pressed her hands firmer down upon the source of darkness in him.

They decided, when they woke again from the pure swoon, to write their resignations from the world of work there and then. She wanted this.

He rang the bell, and ordered note-paper without a printed address. The waiter cleared the table.

'Now then,' he said, 'yours first. Put your home address, and the date – then "Director of Education, Town Hall – Sir – " Now then! – I don't know how one really stands – I suppose one could get out of it in less than month – Anyhow "Sir – I beg to resign my post as class-mistress in the Willey Green Grammar School. I should be very grateful if you would liberate me as soon as possible, without waiting for the expiration of the month's notice." That'll do. Have you got it? Let me look. "Ursula Brangwen." Good! Now I'll write mine. I ought to give them three months, but I can plead health. I can arrange it all right."

He sat and wrote out his formal resignation.

'Now,' he said, when the envelopes were sealed and addressed, 'shall we post them here, both together? I know Jackie will say, "Here's a coincidence!" when he receives them in all their identity. Shall we let him say it, or not?'

'I don't care,' she said.

'No -?' he said, pondering.

'It doesn't matter, does it?' she said.

'Yes,' he replied. 'Their imaginations shall not work on us. I'll post yours here, mine after. I cannot be implicated in their imaginings.'

He looked at her with his strange, non-human singleness.

'Yes, you are right,' she said.

She lifted her face to him, all shining and open. It was as if he might enter straight into the source of her radiance. His face became a little distracted.

'Shall we go?' he said.

'As you like,' she replied.

They were soon out of the little town, and running through the uneven lanes of the country. Ursula nestled near him, into his constant warmth, and watched the pale-lit revelation racing ahead, the visible night. Sometimes it was a wide old road, with grass-spaces on either side, flying magic and elfin in the greenish illumination, sometimes it was trees looming overhead, sometimes it was bramble bushes, sometimes the walls of a crew-yard and the butt of a barn.

'Are you going to Shortlands to dinner?' Ursula asked him suddenly. He started.

'Good God!' he said. 'Shortlands! Never again. Not that. Besides we should be too late.'

'Where are we going then - to the Mill?'

'If you like. Pity to go anywhere on this good dark night. Pity to come out of it, really. Pity we can't stop in the good darkness. It is better than anything ever would be – this good immediate darkness.'

She sat wondering. The car lurched and swayed. She knew there was no leaving him, the darkness held them both and contained them, it was not to be surpassed Besides she had a full mystic knowledge of his suave loins of darkness, dark-clad and suave, and in this knowledge there was some of the inevitability and the beauty of fate, fate which one asks for, which one accepts in full.

He sat still like an Egyptian Pharoah, driving the car. He felt as if he were seated in immemorial potency, like the great carven statues of real Egypt, as real and as fulfilled with subtle strength, as these are, with a vague inscrutable smile on the lips. He knew what it was to have the strange and magical current of force in his back and loins, and down his legs, force so perfect that it stayed him immobile, and left his face subtly, mindlessly smiling. He knew what it was to be awake and potent in that other basic mind, the deepest physical mind. And from this source he had a pure and magic control, magical, mystical, a force in darkness, like electricity.

It was very difficult to speak, it was so perfect to sit in this pure living silence, subtle, full of unthinkable knowledge and unthinkable force, upheld immemorially in timeless force, like the immobile, supremely potent Egyptians, seated forever in their living, subtle silence.

'We need not go home,' he said. 'This car has seats that let down and make a bed, and we can lift the hood.'

She was glad and frightened. She cowered near to him.

'But what about them at home?' she said.

'Send a telegram.'

Nothing more was said. They ran on in silence. But with a sort of second consciousness he steered the car towards a destination. For he had the free intelligence to direct his own ends. His arms and his breast and his head were rounded and living like those of the Greek, he had not the unawakened straight arms of the Egyptian, nor the sealed, slumbering head. A lambent intelligence played secondarily above his pure Egyptian concentration in darkness.

They came to a village that lined along the road. The car crept slowly along, until he saw the post-office. Then he pulled up.

'I will send a telegram to your father,' he said. 'I will merely say "spending the night in town," shall I?'

WOMEN IN LOVE

'Yes,' she answered. She did not want to be disturbed into taking thought.

She watched him move into the post-office. It was also a shop, she saw. Strange, he was. Even as he went into the lighted, public place he remained dark and magic, the living silence seemed the body of reality in him, subtle, potent, indiscoverable. There he was! In a strange uplift of elation she saw him, the being never to be revealed, awful in its potency, mystic and real. This dark, subtle reality of him, never to be translated, liberated her into perfection, her own perfected being. She too was dark and fulfilled in silence.

He came out, throwing some packages into the car.

'There is some bread, and cheese, and raisins, and apples, and hard chocolate,' he said, in his voice that was as if laughing, because of the unblemished stillness and force which was the reality in him. She would have to touch him. To speak, to see, was nothing. It was a travesty to look and to comprehend the man there. Darkness and silence must fall perfectly on her, then she could know mystically, in unrevealed touch. She must lightly, mindlessly connect with him, have the knowledge which is death of knowledge, the reality of surety in not-knowing.

Soon they had run on again into the darkness. She did not ask where they were going, she did not care. She sat in a fullness and a pure potency that was like apathy, mindless and immobile. She was next to him, and hung in a pure rest, as a star is hung, balanced unthinkably. Still there remained a dark lambency of anticipation. She would touch him. With perfect fine finger-tips of reality she would touch the reality in him, the suave, pure, untranslatable reality of his loins of darkness. To touch, mindlessly in darkness to come in pure touching upon the living reality of him, his suave perfect loins and thighs of darkness, this was her sustaining anticipation.

And he too waited in the magical steadfastness of suspense, for her to take this knowledge of him as he had taken it of her. He knew her darkly, with the fullness of dark knowledge. Now she would know him, and he too would be liberated. He would be night-free, like an Egyptian, steadfast in perfectly suspended equilibrium, pure mystic nodality of physical being. They would give each other this starequilibrium which alone is freedom.

She saw that they were running among trees – great old trees with dying bracken undergrowth. The palish, gnarled trunks showed ghostly, and like old priests in the hovering distance, the fern rose magical and mysterious. It was a night all darkness, with low cloud. The motor-car advanced slowly. 'Where are we?' she whispered.

'In Sherwood Forest.'

It was evident he knew the place. He drove softly, watching. Then they came to a green road between the trees. They turned cautiously round, and were advancing between the oaks of the forest, down a green lane. The green lane widened into a little circle of grass, where there was a small trickle of water at the bottom of a sloping bank. The car stopped.

'We will stay here,' he said, 'and put out the lights.'

He extinguished the lamps at once, and it was pure night, with shadows of trees like realities of other, nightly being. He threw a rug on to the bracken, and they sat in stillness and mindless silence. There were faint sounds from the wood, but no disturbance, no possible disturbance, the world was under a strange ban, a new mystery had supervened. They threw off their clothes, and he gathered her to him, and found her, found the pure lambent reality of her forever invisible flesh. Quenched, inhuman, his fingers upon her unrevealed nudity were the fingers of silence upon silence, the body of mysterious night upon the body of mysterious night, the night masculine and feminine, never to be seen with the eye, or known with the mind, only known as a palpable revelation of living otherness.

She had her desire of him, she touched, she received the maximum of unspeakable communication in touch, dark, subtle, positively silent, a magnificent gift and give again, a perfect acceptance and yielding, a mystery, the reality of that which can never be known, vital, sensual reality that can never be transmuted into mind content, but remains outside, living body of darkness and silence and subtlety, the mystic body of reality. She had her desire fulfilled. He had his desire fulfilled. For she was to him what he was to her, the immemorial magnificence of mystic, palpable, real otherness.

They slept the chilly night through under the hood of the car, a night of unbroken sleep. It was already high day when he awoke. They looked at each other and laughed, then looked away, filled with darkness and secrecy. Then they kissed and remembered the magnificence of the night. It was so magnificent, such an inheritance of a universe of dark reality, that they were afraid to seem to remember. They hid away the remembrance and the knowledge.

CHAPTER XXIV

Death and Love

THOMAS CRICH died slowly, terribly slowly. It seemed impossible to everybody that the thread of life could be drawn out so thin, and yet not break. The sick man lay unutterably weak and spent, kept alive by morphia and by drinks, which he sipped slowly. He was only half conscious – a thin strand of consciousness linking the darkness of death with the light of day. Yet his will was unbroken, he was integral, complete. Only he must have perfect stillness about him.

Any presence but that of the nurses was a strain and an effort to him now. Every morning Gerald went into the room, hoping to find his father passed away at last. Yet always he saw the same transparent face, the same dread dark hair on the waxen forehead, and the awful, inchoate dark eyes, which seemed to be decomposing into formless darkness, having only a tiny grain of vision within them.

And always, as the dark, inchoate eyes turned to him, there passed through Gerald's bowels a burning stroke of revolt, that seemed to resound through his whole being, threatening to break his mind with its clangour, and making him mad.

Every morning, the son stood there, erect and taut with life, gleaming in his blondness. The gleaming blondness of his strange, imminent being put the father into a fever of fretful irritation. He could not bear to meet the uncanny, downward look of Gerald's blue eyes. But it was only for a moment. Each on the brink of departure, the father and son looked at each other, then parted.

For a long time Gerald preserved a perfect sang froid, he remained quite collected. But at last, fear undermined him. He was afraid of some horrible collapse in himself. He had to stay and see this thing through. Some perverse will made him watch his father drawn over the borders of life. And yet, now, every day, the great red-hot stroke of horrified fear through the bowels of the son struck a further inflammation. Gerald went about all day with a tendency to cringe, as if there were the point of a sword of Damocles⁹¹ pricking the nape of his neck.

There was no escape – he was bound up with his father, he had to see him through. And the father's will never relaxed or yielded to death. It would have to snap when death at last snapped it, – if it did not persist after a physical death. In the same way, the will of the son never yielded. He stood firm and immune, he was outside this death and this dying. It was a trial by ordeal. Could he stand and see his father slowly dissolve and disappear in death, without once yielding his will, without once relenting before the omnipotence of death. Like a Red Indian undergoing torture, Gerald would experience the whole process of slow death without wincing or flinching. He even triumphed in it. He somehow *wanted* this death, even forced it. It was as if he himself were dealing the death, even when he most recoiled in horror. Still, he would deal it, he would triumph through death.

But in the stress of this ordeal, Gerald too lost his hold on the outer, daily life. That which was much to him, came to mean nothing. Work, pleasure – it was all left behind. He went on more or less mechanically with his business, but this activity was all extraneous. The real activity was this ghastly wrestling for death in his own soul. And his own will should triumph. Come what might, he would not bow down or submit or acknowledge a master. He had no master in death.

But as the fight went on, and all that he had been and was continued to be destroyed, so that life was a hollow shell all round him, roaring and clattering like the sound of the sea, a noise in which he participated externally, and inside this hollow shell was all the darkness and fearful space of death, he knew he would have to find reinforcements, otherwise he would collapse inwards upon the great dark void which circled at the centre of his soul. His will held his outer life, his outer mind, his outer being unbroken and unchanged. But the pressure was too great. He would have to find something to make good the equilibrium. Something must come with him into the hollow void of death in his soul, fill it up, and so equalise the pressure within to the pressure without. For day by day he felt more and more like a bubble filled with darkness, round which whirled the iridescence of his consciousness, and upon which the pressure of the outer world, the outer life, roared vastly.

In this extremity his instinct led him to Gudrun. He threw away everything now – he only wanted the relation established with her. He would follow her to the studio, to be near her, to talk to her. He would stand about the room, aimlessly picking up the implements, the lumps of clay, the little figures she had cast – they were whimsical and grotesque – looking at them without perceiving them. And she felt him following her, dogging her heels like a doom. She held away from him, and yet she knew he drew always a little nearer, a little nearer.

'I say,' he said to her one evening, in an odd, unthinking, uncertain way, 'won't you stay to dinner tonight? I wish you would.'

She started slightly. He spoke to her like a man making a request of another man.

'They'll be expecting me at home,' she said.

'Oh, they won't mind, will they?' he said. 'I should be awfully glad if you'd stay.'

Her long silence gave consent at last.

'I'll tell Thomas, shall I?' he said.

'I must go almost immediately after dinner,' she said.

It was a dark, cold evening. There was no fire in the drawing-room, they sat in the library. He was mostly silent, absent, and Winifred talked little. But when Gerald did rouse himself, he smiled and was pleasant and ordinary with her. Then there came over him again the long blanks, of which he was not aware.

She was very much attracted by him. He looked so preoccupied, and his strange, blank silences, which she could not read, moved her and made her wonder over him, made her feel reverential towards him.

But he was very kind. He gave her the best things at the table, he had a bottle of slightly sweet, delicious golden wine brought out for dinner, knowing she would prefer it to the burgundy. She felt herself esteemed, needed almost.

As they took coffee in the library, there was a soft, very soft knocking at the door. He started, and called 'Come in.' The timbre of his voice, like something vibrating at high pitch, unnerved Gudrun. A nurse in white entered, half hovering in the doorway like a shadow. She was very good-looking, but strangely enough, shy and self-mistrusting.

'The doctor would like to speak to you, Mr Crich,' she said, in her low, discreet voice.

'The doctor!' he said, starting up. 'Where is he?'

'He is in the dining-room.'

'Tell him I'm coming.'

He drank up his coffee, and followed the nurse, who had dissolved like a shadow.

'Which nurse was that?' asked Gudrun.

'Miss Inglis - I like her best,' replied Winifred.

After a while Gerald came back, looking absorbed by his own thoughts, and having some of that tension and abstraction which is seen in a slightly drunken man. He did not say what the doctor had wanted him for, but stood before the fire, with his hands behind his back, and his face open and as if rapt. Not that he was really thinking – he was only arrested in pure suspense inside himself, and thoughts wafted through his mind without order.

'I must go now and see Mama,' said Winifred, 'and see Dadda before he goes to sleep.'

She bade them both good-night.

Gudrun also rose to take her leave.

'You needn't go yet, need you?' said Gerald, glancing quickly at the clock.' It is early yet. I'll walk down with you when you go. Sit down, don't hurry away.'

Gudrun sat down, as if, absent as he was, his will had power over her. She felt almost mesmerised. He was strange to her, something unknown. What was he thinking, what was he feeling, as he stood there so rapt, saying nothing? He kept her – she could feel that. He would not let her go. She watched him in humble submissiveness.

'Had the doctor anything new to tell you?' she asked, softly, at length, with that gentle, timid sympathy which touched a keen fibre in his heart. He lifted his eyebrows with a negligent, indifferent expression.

'No – nothing new,' he replied, as if the question were quite casual, trivial. 'He says the pulse is very weak indeed, very intermittent – but that doesn't necessarily mean much, you know.'

He looked down at her. Her eyes were dark and soft and unfolded, with a stricken look that roused him.

'No,' she murmured at length. 'I don't understand anything about these things.'

Just as well not,' he said. 'I say, won't you have a cigarette? – do!' He quickly fetched the box, and held her a light. Then he stood before her on the hearth again.

'No,' he said, 'we've never had much illness in the house, either – not till father.' He seemed to meditate a while. Then looking down at her, with strangely communicative blue eyes, that filled her with dread, he continued: 'It's something you don't reckon with, you know, till it is there. And then you realise that it was there all the time – it was always there – you understand what I mean? – the possibility of this incurable illness, this slow death.'

He moved his feet uneasily on the marble hearth, and put his cigarette to his mouth, looking up at the ceiling.

'I know,' murmured Gudrun: 'it is dreadful.'

He smoked without knowing. Then he took the cigarette from his lips, bared his teeth, and putting the tip of his tongue between his teeth spat off a grain of tobacco, turning slightly aside, like a man who is alone, or who is lost in thought.

'I don't know what the effect actually *is*, on one,' he said, and again he looked down at her. Her eyes were dark and stricken with knowledge, looking into his. He saw her submerged, and he turned aside his face. 'But I absolutely am not the same. There's nothing left, if you understand what I mean. You seem to be clutching at the void – and at the same time you are void yourself. And so you don't know what to do.'

'No,' she murmured. A heavy thrill ran down her nerves, heavy, almost pleasure, almost pain. 'What can be done?' she added.

He turned, and flipped the ash from his cigarette on to the great marble hearth-stones, that lay bare in the room, without fender or bar.

'I don't know, I'm sure,' he replied. 'But I do think you've got to find some way of resolving the situation – not because you want to, but because you've *got* to, otherwise you're done. The whole of everything, and yourself included, is just on the point of caving in, and you are just holding it up with your hands. Well, it's a situation that obviously can't continue. You can't stand holding the roof up with your hands, for ever. You know that sooner or later you'll *bave* to let go. Do you understand what I mean? And so something's got to be done, or there's a universal collapse – as far as you yourself are concerned.'

He shifted slightly on the hearth, crunching a cinder under his heel. He looked down at it. Gudrun was aware of the beautiful old marble panels of the fireplace, swelling softly carved, round him and above him. She felt as if she were caught at last by fate, imprisoned in some horrible and fatal trap.

'But what *can* be done?' she murmured humbly. 'You must use me if I can be of any help at all – but how can I? I don't see how I *can* help you.'

He looked down at her critically.

'I don't want you to *belp*,' he said, slightly irritated, 'because there's nothing to be *done*. I only want sympathy, do you see: I want somebody I can talk to sympathetically. That eases the strain. And there *is* nobody to talk to sympathetically. That's the curious thing. There *is* nobody. There's Rupert Birkin. But then he *isn't* sympathetic, he wants to *dictate*. And that is no use whatsoever.'

She was caught in a strange snare. She looked down at her hands.

Then there was the sound of the door softly opening. Gerald started. He was chagrined. It was his starting that really startled Gudrun. Then he went forward, with quick, graceful, intentional courtesy.

'Oh, mother!' he said. 'How nice of you to come down. How are you?'

The elderly woman, loosely and bulkily wrapped in a purple gown, came forward silently, slightly hulked, as usual. Her son was at her side. He pushed her up a chair, saying 'You know Miss Brangwen, don't you?'

The mother glanced at Gudrun indifferently.

'Yes,' she said. Then she turned her wonderful, forget-me-not blue eyes up to her son, as she slowly sat down in the chair he had brought her.

'I came to ask you about your father,' she said, in her rapid, scarcelyaudible voice. 'I didn't know you had company.'

284

'No? Didn't Winifred tell you? Miss Brangwen stayed to dinner, to make us a little more lively – '

Mrs Crich turned slowly round to Gudrun, and looked at her, but with unseeing eyes.

'I'm afraid it would be no treat to her.' Then she turned again to her son. 'Winifred tells me the doctor had something to say about your father. What is it?'

'Only that the pulse is very weak – misses altogether a good many times – so that he might not last the night out,' Gerald replied.

Mrs Crich sat perfectly impassive, as if she had not heard. Her bulk seemed hunched in the chair, her fair hair hung slack over her ears. But her skin was clear and fine, her hands, as she sat with them forgotten and folded, were quite beautiful, full of potential energy. A great mass of energy seemed decaying up in that silent, hulking form.

She looked up at her son, as he stood, keen and soldierly, near to her. Her eyes were most wonderfully blue, bluer than forget-me-nots. She seemed to have a certain confidence in Gerald, and to feel a certain motherly mistrust of him.

'How are *you?*' she muttered, in her strangely quiet voice, as if nobody should hear but him. 'You're not getting into a state, are you? You're not letting it make you hysterical?'

The curious challenge in the last words startled Gudrun.

'I don't think so, mother,' he answered, rather coldly cheery. 'Somebody's got to see it through, you know.'

'Have they? Have they?' answered his mother rapidly. 'Why should *you* take it on yourself? What have you got to do, seeing it through. It will see itself through. You are not needed.'

'No, I don't suppose I can do any good,' he answered. 'It's just how it affects us, you see.'

'You like to be affected – don't you? It's quite nuts for you? You would have to be important. You have no need to stop at home. Why don't you go away!'

These sentences, evidently the ripened grain of many dark hours, took Gerald by surprise.

'I don't think it's any good going away now, mother, at the last minute,' he said, coldly.

'You take care,' replied his mother. 'You mind *yourself* – that's your business. You take too much on yourself. You mind *yourself*, or you'll find yourself in Queer Street, that's what will happen to you. You're hysterical, always were.'

'I'm all right, mother,' he said. 'There's no need to worry about me, I assure you.'

'Let the dead bury their dead 92 – don't go and bury yourself along with them – that's what I tell you. I know you well enough.'

He did not answer this, not knowing what to say. The mother sat bunched up in silence, her beautiful white hands, that had no rings whatsoever, clasping the pommels of her arm-chair.

'You can't do it,' she said, almost bitterly. 'You haven't the nerve. You're as weak as a cat, really – always were. Is this young woman staying here?'

'No,' said Gerald. 'She is going home tonight.'

'Then she'd better have the dog-cart. Does she go far?'

'Only to Beldover.'

'Ah!' The elderly woman never looked at Gudrun, yet she seemed to take knowledge of her presence.

'You are inclined to take too much on yourself, Gerald,' said the mother, pulling herself to her feet, with a little difficulty.

'Will you go, mother?' he asked, politely.

'Yes, I'll go up again,' she replied. Turning to Gudrun, she bade her 'Good-night.' Then she went slowly to the door, as if she were unaccustomed to walking. At the door she lifted her face to him, implicitly. He kissed her.

'Don't come any further with me,' she said, in her barely audible voice. 'I don't want you any further.'

He bade her good-night, watched her across to the stairs and mount slowly. Then he closed the door and came back to Gudrun. Gudrun rose also, to go.

'A queer being, my mother,' he said.

'Yes,' replied Gudrun.

'She has her own thoughts.'

'Yes,' said Gudrun.

Then they were silent.

'You want to go?' he asked. 'Half a minute, I'll just have a horse put in -'

'No,' said Gudrun. 'I want to walk.'

He had promised to walk with her down the long, lonely mile of drive, and she wanted this.

'You might just as well drive,' he said.

'I'd much rather walk,' she asserted, with emphasis.

'You would! Then I will come along with you. You know where your things are? I'll put boots on.'

He put on a cap, and an overcoat over his evening dress. They went out into the night.

'Let us light a cigarette,' he said, stopping in a sheltered angle of the

porch. 'You have one too.'

So, with the scent of tobacco on the night air, they set off down the dark drive that ran between close-cut hedges through sloping meadows.

He wanted to put his arm round her. If he could put his arm round her, and draw her against him as they walked, he would equilibriate himself. For now he felt like a pair of scales, the half of which tips down and down into an indefinite void. He must recover some sort of balance. And here was the hope and the perfect recovery.

Blind to her, thinking only of himself, he slipped his arm softly round her waist, and drew her to him. Her heart fainted, feeling herself taken. But then, his arm was so strong, she quailed under its powerful close grasp. She died a little death, and was drawn against him as they walked down the stormy darkness. He seemed to balance her perfectly in opposition to himself, in their dual motion of walking. So, suddenly, he was liberated and perfect, strong, heroic.

He put his hand to his mouth and threw his cigarette away, a gleaming point, into the unseen hedge. Then he was quite free to balance her.

'That's better,' he said, with exultancy.

The exultation in his voice was like a sweetish, poisonous drug to her. Did she then mean so much to him! She sipped the poison.

'Are you happier?' she asked, wistfully.

'Much better,' he said, in the same exultant voice, 'and I was rather far gone.'

She nestled against him. He felt her all soft and warm, she was the rich, lovely substance of his being. The warmth and motion of her walk suffused through him wonderfully.

'I'm so glad if I help you,' she said.

'Yes,' he answered. 'There's nobody else could do it, if you wouldn't.'

'That is true,' she said to herself, with a thrill of strange, fatal elation. As they walked, he seemed to lift her nearer and nearer to himself, till she moved upon the firm vehicle of his body.

He was so strong, so sustaining, and he could not be opposed. She drifted along in a wonderful interfusion of physical motion, down the dark, blowy hillside. Far across shone the little yellow lights of Beldover, many of them, spread in a thick patch on another dark hill. But he and she were walking in perfect, isolated darkness, outside the world.

'But how much do you care for me!' came her voice, almost querulous. 'You see, I don't know, I don't understand!'

'How much!' His voice rang with a painful elation. 'I don't know either – but everything.' He was startled by his own declaration. It was

true. So he stripped himself of every safeguard, in making this admission to her. He cared everything for her – she was everything.

'But I can't believe it,' said her low voice, amazed, trembling. She was trembling with doubt and exultance. This was the thing she wanted to hear, only this. Yet now she heard it, heard the strange clapping vibration of truth in his voice as he said it, she could not believe. She could not believe – she did not believe. Yet she believed, triumphantly, with fatal exultance.

'Why not?' he said. 'Why don't you believe it? It's true. It is true, as we stand at this moment – ' he stood still with her in the wind; 'I care for nothing on earth, or in heaven, outside this spot where we are. And it isn't my own presence I care about, it is all yours. I'd sell my soul a hundred times – but I couldn't bear not to have you here. I couldn't bear to be alone. My brain would burst. It is true.' He drew her closer to him, with definite movement.

'No,' she murmured, afraid. Yet this was what she wanted. Why did she so lose courage?

They resumed their strange walk. They were such strangers – and yet they were so frightfully, unthinkably near. It was like a madness. Yet it was what she wanted, it was what she wanted. They had descended the hill, and now they were coming to the square arch where the road passed under the colliery railway. The arch, Gudrun knew, had walls of squared stone, mossy on one side with water that trickled down, dry on the other side. She had stood under it to hear the train rumble thundering over the logs overhead. And she knew that under this dark and lonely bridge the young colliers stood in the darkness with their sweethearts, in rainy weather. And so she wanted to stand under the bridge with *ber* sweetheart, and be kissed under the bridge in the invisible darkness. Her steps dragged as she drew near.

So, under the bridge, they came to a standstill, and he lifted her upon his breast. His body vibrated taut and powerful as he closed upon her and crushed her, breathless and dazed and destroyed, crushed her upon his breast. Ah, it was terrible, and perfect. Under this bridge, the colliers pressed their lovers to their breast. And now, under the bridge, the master of them all pressed her to himself! And how much more powerful and terrible was his embrace than theirs, how much more concentrated and supreme his love was, than theirs in the same sort! She felt she would swoon, die, under the vibrating, inhuman tension of his arms and his body – she would pass away. Then the unthinkable high vibration slackened and became more undulating. He slackened and drew her with him to stand with his back to the wall.

She was almost unconscious. So the colliers' lovers would stand with

their backs to the walls, holding their sweethearts and kissing them as she was being kissed. Ah, but would their kisses be fine and powerful as the kisses of the firm-mouthed master? Even the keen, short-cut moustache – the colliers would not have that.

And the colliers' sweethearts would, like herself, hang their heads back limp over their shoulder, and look out from the dark archway, at the close patch of yellow lights on the unseen hill in the distance, or at the vague form of trees, and at the buildings of the colliery wood-yard, in the other direction.

His arms were fast around her, he seemed to be gathering her into himself, her warmth, her softness, her adorable weight, drinking in the suffusion of her physical being, avidly. He lifted her, and seemed to pour her into himself, like wine into a cup.

'This is worth everything,' he said, in a strange, penetrating voice.

So she relaxed, and seemed to melt, to flow into him, as if she were some infinitely warm and precious suffusion filling into his veins, like an intoxicant. Her arms were round his neck, he kissed her and held her perfectly suspended, she was all slack and flowing into him, and he was the firm, strong cup that receives the wine of her life. So she lay cast upon him, stranded, lifted up against him, melting and melting under his kisses, melting into his limbs and bones, as if he were soft iron becoming surcharged with her electric life.

Till she seemed to swoon, gradually her mind went, and she passed away, everything in her was melted down and fluid, and she lay still, become contained by him, sleeping in him as lightning sleeps in a pure, soft stone. So she was passed away and gone in him, and he was perfected.

When she opened her eyes again, and saw the patch of lights in the distance, it seemed to her strange that the world still existed, that she was standing under the bridge resting her head on Gerald's breast. Gerald – who was he? He was the exquisite adventure, the desirable unknown to her.

She looked up, and in the darkness saw his face above her, his shapely, male face. There seemed a faint, white light emitted from him, a white aura, as if he were visitor from the unseen. She reached up, like Eve reaching to the apples on the tree of knowledge, and she kissed him, though her passion was a transcendent fear of the thing he was, touching his face with her infinitely delicate, encroaching wondering fingers. Her fingers went over the mould of his face, over his features. How perfect and foreign he was – ah how dangerous! Her soul thrilled with complete knowledge. This was the glistening, forbidden apple, this face of a man. She kissed him, putting her fingers over his face, his

eyes, his nostrils, over his brows and his ears, to his neck, to know him, to gather him in by touch. He was so firm, and shapely, with such satisfying, inconceivable shapeliness, strange, yet unutterably clear. He was such an unutterable enemy, yet glistening with uncanny white fire. She wanted to touch him and touch him and touch him, till she had him all in her hands, till she had strained him into her knowledge. Ah, if she could have the precious *knowledge* of him, she would be filled, and nothing could deprive her of this. For he was so unsure, so risky in the common world of day.

'You are so beautiful,' she murmured in her throat.

He wondered, and was suspended. But she felt him quiver, and she came down involuntarily nearer upon him. He could not help himself. Her fingers had him under their power. The fathomless, fathomless desire they could evoke in him was deeper than death, where he had no choice.

But she knew now, and it was enough. For the time, her soul was destroyed with the exquisite shock of his invisible fluid lightning. She knew. And this knowledge was a death from which she must recover. How much more of him was there to know? Ah much, much, many days harvesting for her large, yet perfectly subtle and intelligent hands upon the field of his living, radio-active body. Ah, her hands were eager, greedy for knowledge. But for the present it was enough, enough, as much as her soul could bear. Too much, and she would shatter herself, she would fill the fine vial of her soul too quickly, and it would break. Enough now – enough for the time being. There were all the after days when her hands, like birds, could feed upon the fields of his mystical plastic form – till then enough.

And even he was glad to be checked, rebuked, held back. For to desire is better than to possess, the finality of the end was dreaded as deeply as it was desired.

They walked on towards the town, towards where the lamps threaded singly, at long intervals down the dark high-road of the valley. They came at length to the gate of the drive.

'Don't come any further,' she said.

'You'd rather I didn't?' he asked, relieved. He did not want to go up the public streets with her, his soul all naked and alight as it was.

'Much rather - good-night.' She held out her hand. He grasped it, then touched the perilous, potent fingers with his lips.

'Good-night,' he said. 'Tomorrow.'

And they parted. He went home full of the strength and the power of living desire.

But the next day, she did not come, she sent a note that she was kept

indoors by a cold. Here was a torment! But he possessed his soul in some sort of patience, writing a brief answer, telling her how sorry he was not to see her.

The day after this, he stayed at home – it seemed so futile to go down to the office. His father could not live the week out. And he wanted to be at home, suspended.

Gerald sat on a chair by the window in his father's room. The landscape outside was black and winter-sodden. His father lay grey and ashen on the bed, a nurse moved silently in her white dress, neat and elegant, even beautiful. There was a scent of eau-de-cologne in the room. The nurse went out of the room, Gerald was alone with death, facing the winter-black landscape.

'Is there much more water in Denley?' came the faint voice, determined and querulous, from the bed. The dying man was asking about a leakage from Willey Water into one of the pits.

'Some more - we shall have to run off the lake,' said Gerald.

'Will you?' The faint voice filtered to extinction. There was dead stillness. The grey-faced, sick man lay with eyes closed, more dead than death. Gerald looked away. He felt his heart was seared, it would perish if this went on much longer.

Suddenly he heard a strange noise. Turning round, he saw his father's eyes wide open, strained and rolling in a frenzy of inhuman struggling. Gerald started to his feet, and stood transfixed in horror.

'Wha-a-ah-h-h-' came a horrible choking rattle from his father's throat, the fearful, frenzied eye, rolling awfully in its wild fruitless search for help, passed blindly over Gerald, then up came the dark blood and mess pumping over the face of the agonised being. The tense body relaxed, the head fell aside, down the pillow.

Gerald stood transfixed, his soul echoing in horror. He would move, but he could not. He could not move his limbs. His brain seemed to re-echo, like a pulse.

The nurse in white softly entered. She glanced at Gerald, then at the bed.

'Ah!' came her soft whimpering cry, and she hurried forward to the dead man. 'Ah-h!' came the slight sound of her agitated distress, as she stood bending over the bedside. Then she recovered, turned, and came for towel and sponge. She was wiping the dead face carefully, and murmuring, almost whimpering, very softly: 'Poor Mr Crich! – Poor Mr Crich! Poor Mr Crich!'

'Is he dead?' clanged Gerald's sharp voice.

'Oh yes, he's gone,' replied the soft, moaning voice of the nurse, as she looked up at Gerald's face. She was young and beautiful and quivering. A strange sort of grin went over Gerald's face, over the horror. And he walked out of the room.

He was going to tell his mother. On the landing he met his brother Basil.

'He's gone, Basil,' he said, scarcely able to subdue his voice, not to let an unconscious, frightening exultation sound through.

'What?' cried Basil, going pale.

Gerald nodded. Then he went on to his mother's room.

She was sitting in her purple gown, sewing, very slowly sewing, putting in a stitch then another stitch. She looked up at Gerald with her blue undaunted eyes.

'Father's gone,' he said.

'He's dead? Who says so?'

'Oh, you know, mother, if you see him.'

She put her sewing down, and slowly rose.

'Are you going to see him?' he asked.

'Yes,' she said

By the bedside the children already stood in a weeping group.

'Oh, mother!' cried the daughters, almost in hysterics, weeping loudly.

But the mother went forward. The dead man lay in repose, as if gently asleep, so gently, so peacefully, like a young man sleeping in purity. He was still warm. She stood looking at him in gloomy, heavy silence, for some time.

'Ay,' she said bitterly, at length, speaking as if to the unseen witnesses of the air. 'You're dead.' She stood for some minutes in silence, looking down. 'Beautiful,' she asserted, 'beautiful as if life had never touched you – never touched you. God send I look different. I hope I shall look my years, when I am dead. Beautiful, beautiful,' she crooned over him. 'You can see him in his teens, with his first beard on his face. A beautiful soul, beautiful – 'Then there was a tearing in her voice as she cried: 'None of you look like this, when you are dead! Don't let it happen again.' It was a strange, wild command from out of the unknown. Her children moved unconsciously together, in a nearer group, at the dreadful command in her voice. The colour was flushed bright in her cheek, she looked awful and wonderful. 'Blame me, blame me if you like, that he lies there like a lad in his teens, with his first beard on his face. Blame me if you like. But you none of you know.' She was silent in intense silence.

Then there came, in a low, tense voice: 'If I thought that the children I bore would lie looking like that in death, I'd strangle them when they were infants, yes -'

292

'No, mother,' came the strange, clarion voice of Gerald from the background, 'we are different, we don't blame you.'

She turned and looked full in his eyes. Then she lifted her hands in a strange half-gesture of mad despair.

'Pray!' she said strongly. 'Pray for yourselves to God, for there's no help for you from your parents.'

'Oh mother!' cried her daughters wildly.

But she had turned and gone, and they all went quickly away from each other.

When Gudrun heard that Mr Crich was dead, she felt rebuked. She had stayed away lest Gerald should think her too easy of winning. And now, he was in the midst of trouble, whilst she was cold.

The following day she went up as usual to Winifred, who was glad to see her, glad to get away into the studio. The girl had wept, and then, too frightened, had turned aside to avoid any more tragic eventuality. She and Gudrun resumed work as usual, in the isolation of the studio, and this seemed an immeasurable happiness, a pure world of freedom, after the aimlessness and misery of the house. Gudrun stayed on till evening. She and Winifred had dinner brought up to the studio, where they ate in freedom, away from all the people in the house.

After dinner Gerald came up. The great high studio was full of shadow and a fragrance of coffee. Gudrun and Winifred had a little table near the fire at the far end, with a white lamp whose light did not travel far. They were a tiny world to themselves, the two girls surrounded by lovely shadows, the beams and rafters shadowy overhead, the benches and implements shadowy down the studio.

'You are cosy enough here,' said Gerald, going up to them.

There was a low brick fireplace, full of fire, an old blue Turkish rug, the little oak table with the lamp and the white-and-blue cloth and the dessert, and Gudrun making coffee in an odd brass coffee-maker, and Winifred scalding a little milk in a tiny saucepan.

'Have you had coffee?' said Gudrun.

'I have, but I'll have some more with you,' he replied.

'Then you must have it in a glass - there are only two cups,' said Winifred.

'It is the same to me,' he said, taking a chair and coming into the charmed circle of the girls. How happy they were, how cosy and glamorous it was with them, in a world of lofty shadows! The outside world, in which he had been transacting funeral business all the day was completely wiped out. In an instant he snuffed glamour and magic.

They had all their things very dainty, two odd and lovely little cups, scarlet and solid gilt, and a little black jug with scarlet discs, and the

curious coffee-machine, whose spirit-flame flowed steadily, almost invisibly. There was the effect of rather sinister richness, in which Gerald at once escaped himself.

They all sat down, and Gudrun carefully poured out the coffee.

'Will you have milk?' she asked calmly, yet nervously poising the little black jug with its big red dots. She was always so completely controlled, yet so bitterly nervous.

'No, I won't,' he replied.

So, with a curious humility, she placed him the little cup of coffee, and herself took the awkward tumbler. She seemed to want to serve him.

'Why don't you give me the glass – it is so clumsy for you,' he said. He would much rather have had it, and seen her daintily served. But she was silent, pleased with the disparity, with her self-abasement.

'You are quite en ménage,'93 he said.

'Yes. We aren't really at home to visitors,' said Winifred.

'You're not? Then I'm an intruder?'

For once he felt his conventional dress was out of place, he was an outsider.

Gudrun was very quiet. She did not feel drawn to talk to him. At this stage, silence was best – or mere light words. It was best to leave serious things aside. So they talked gaily and lightly, till they heard the man below lead out the horse, and call it to 'back-back!' into the dog-cart that was to take Gudrun home. So she put on her things, and shook hands with Gerald, without once meeting his eyes. And she was gone.

The funeral was detestable. Afterwards, at the tea-table, the daughters kept saying – 'He was a good father to us – the best father in the world' – or else – 'We shan't easily find another man as good as father was.'

Gerald acquiesced in all this. It was the right conventional attitude, and, as far as the world went, he believed in the conventions. He took it as a matter of course. But Winifred hated everything, and hid in the studio, and cried her heart out, and wished Gudrun would come.

Luckily everybody was going away. The Criches never stayed long at home. By dinner-time, Gerald was left quite alone. Even Winifred was carried off to London, for a few days with her sister Laura.

But when Gerald was really left alone, he could not bear it. One day passed by, and another. And all the time he was like a man hung in chains over the edge of an abyss. Struggle as he might, he could not turn himself to the solid earth, he could not get footing. He was suspended on the edge of a void, writhing. Whatever he thought of, was the abyss – whether it were friends or strangers, or work or play, it all showed him only the same bottomless void, in which his heart swung perishing. There was no escape, there was nothing to grasp hold

294

of. He must writhe on the edge of the chasm, suspended in chains of invisible physical life.

At first he was quiet, he kept still, expecting the extremity to pass away, expecting to find himself released into the world of the living, after this extremity of penance. But it did not pass, and a crisis gained upon him.

As the evening of the third day came on, his heart rang with fear. He could not bear another night. Another night was coming on, for another night he was to be suspended in chain of physical life, over the bottomless pit of nothingness. And he could not bear it. He could not bear it. He was frightened deeply, and coldly, frightened in his soul. He did not believe in his own strength any more. He could not fall into this infinite void, and rise again. If he fell, he would be gone for ever. He must withdraw, he must seek reinforcements. He did not believe in his own single self, any further than this.

After dinner, faced with the ultimate experience of his own nothingness, he turned aside. He pulled on his boots, put on his coat, and set out to walk in the night.

It was dark and misty. He went through the wood, stumbling and feeling his way to the Mill. Birkin was away. Good – he was half glad. He turned up the hill, and stumbled blindly over the wild slopes, having lost the path in the complete darkness. It was boring. Where was he going? No matter. He stumbled on till he came to a path again. Then he went on through another wood. His mind became dark, he went on automatically. Without thought or sensation, he stumbled unevenly on, out into the open again, fumbling for stiles, losing the path, and going along the hedges of the fields till he came to the outlet.

And at last he came to the high road. It had distracted him to struggle blindly through the maze of darkness. But now, he must take a direction. And he did not even know where he was. But he must take a direction now. Nothing would be resolved by merely walking, walking away. He had to take a direction.

He stood still on the road, that was high in the utterly dark night, and he did not know where he was. It was a strange sensation, his heart beating, and ringed round with the utterly unknown darkness. So he stood for some time.

Then he heard footsteps, and saw a small, swinging light. He immediately went towards this. It was a miner.

'Can you tell me,' he said, 'where this road goes?'

'Road? Ay, it goes ter Whatmore.'

'Whatmore! Oh thank you, that's right. I thought I was wrong. Good-night.'

'Good-night,' replied the broad voice of the miner.

Gerald guessed where he was. At least, when he came to Whatmore, he would know. He was glad to be on a high road. He walked forward as in a sleep of decision.

That was Whatmore Village – ? Yes, the King's Head – and there the hall gates. He descended the steep hill almost running. Winding through the hollow, he passed the Grammar School, and came to Willey Green Church. The churchyard! He halted.

Then in another moment he had clambered up the wall and was going among the graves. Even in this darkness he could see the heaped pallor of old white flowers at his feet. This then was the grave. He stooped down. The flowers were cold and clammy. There was a raw scent of chrysanthemums and tube-roses, deadened. He felt the clay beneath, and shrank, it was so horribly cold and sticky. He stood away in revulsion.

Here was one centre then, here in the complete darkness beside the unseen, raw grave. But there was nothing for him here. No, he had nothing to stay here for. He felt as if some of the clay were sticking cold and unclean, on his heart. No, enough of this.

Where then? – home? Never! It was no use going there. That was less than no use. It could not be done. There was somewhere else to go. Where?

A dangerous resolve formed in his heart, like a fixed idea. There was Gudrun – she would be safe in her home. But he could get at her – he would get at her. He would not go back tonight till he had come to her, if it cost him his life. He staked his all on this throw.

He set off walking straight across the fields towards Beldover. It was so dark, nobody could ever see him. His feet were wet and cold, heavy with clay. But he went on persistently, like a wind, straight forward, as if to his fate. There were great gaps in his consciousness. He was conscious that he was at Winthorpe hamlet, but quite unconscious how he had got there. And then, as in a dream, he was in the long street of Beldover, with its street-lamps.

There was a noise of voices, and of a door shutting loudly, and being barred, and of men talking in the night. The 'Lord Nelson' had just closed, and the drinkers were going home. He had better ask one of these where she lived – for he did not know the side streets at all.

'Can you tell me where Somerset Drive is?' he asked of one of the uneven men.

'Where what?' replied the tipsy miner's voice.

'Somerset Drive.'

'Somerset Drive! – I've heard o' such a place, but I couldn't for my life say where it is. Who might you be wanting?'

'Mr Brangwen - William Brangwen.'

'William Brangwen -? -?'

'Who teaches at the Grammar School, at Willey Green – his daughter teaches there too.'

'O-o-o-oh, Brangwen! Now I've got you. Of course, William Brangwen! Yes, yes, he's got two lasses as teachers, aside hisself. Ay, that's him – that's him! Why certainly I know where he lives, back your life I do! Yi – what place do they ca' it?'

'Somerset Drive,' repeated Gerald patiently. He knew his own colliers fairly well.

'Somerset Drive, for certain!' said the collier, swinging his arm as if catching something up. 'Somerset Drive – yi! I couldn't for my life lay hold o' the lercality o' the place. Yis, I know the place, to be sure I do –'

He turned unsteadily on his feet, and pointed up the dark, nigh-deserted road.

'You go up theer – an' you ta'e th' first – yi, th' first turnin' on your left – o' that side – past Withamses tuffy shop – '

'I know,' said Gerald.

'Ay! You go down a bit, past wheer th' water-man lives – and then Somerset Drive, as they ca' it, branches off on 't right hand side – an' there's nowt but three houses in it, no more than three, I believe, – an' I'm a'most certain as theirs is th' last – th' last o' th' three – you see – '

'Thank you very much,' said Gerald. 'Good-night.'

And he started off, leaving the tipsy man there standing rooted.

Gerald went past the dark shops and houses, most of them sleeping now, and twisted round to the little blind road that ended on a field of darkness. He slowed down, as he neared his goal, not knowing how he should proceed. What if the house were closed in darkness?

But it was not. He saw a big lighted window, and heard voices, then a gate banged. His quick ears caught the sound of Birkin's voice, his keen eyes made out Birkin, with Ursula standing in a pale dress on the step of the garden path. Then Ursula stepped down, and came along the road, holding Birkin's arm.

Gerald went across into the darkness and they dawdled past him, talking happily, Birkin's voice low, Ursula's high and distinct. Gerald went quickly to the house.

The blinds were drawn before the big, lighted window of the diningroom. Looking up the path at the side he could see the door left open, shedding a soft, coloured light from the hall lamp. He went quickly and silently up the path, and looked up into the hall. There were pictures on the walls, and the antlers of a stag – and the stairs going up on one side – and just near the foot of the stairs the half opened door of the dining-room. With heart drawn fine, Gerald stepped into the hall, whose floor was of coloured tiles, went quickly and looked into the large, pleasant room. In a chair by the fire, the father sat asleep, his head tilted back against the side of the big oak chimney piece, his ruddy face seen foreshortened, the nostrils open, the mouth fallen a little. It would take the merest sound to wake him.

Gerald stood a second suspended. He glanced down the passage behind him. It was all dark. Again he was suspended. Then he went swiftly upstairs. His senses were so finely, almost supernaturally keen, that he seemed to cast his own will over the half-unconscious house.

He came to the first landing. There he stood, scarcely breathing. Again, corresponding to the door below, there was a door again. That would be the mother's room. He could hear her moving about in the candlelight. She would be expecting her husband to come up. He looked along the dark landing.

Then, silently, on infinitely careful feet, he went along the passage, feeling the wall with the extreme tips of his fingers. There was a door. He stood and listened. He could hear two people's breathing. It was not that. He went stealthily forward. There was another door, slightly open. The room was in darkness. Empty. Then there was the bathroom, he could smell the soap and the heat. Then at the end another bedroom – one soft breathing. This was she.

With an almost occult carefulness he turned the door handle, and opened the door an inch. It creaked slightly. Then he opened it another inch – then another. His heart did not beat, he seemed to create a silence about himself, an obliviousness.

He was in the room. Still the sleeper breathed softly. It was very dark. He felt his way forward inch by inch, with his feet and hands. He touched the bed, he could hear the sleeper. He drew nearer, bending close as if his eyes would disclose whatever there was. And then, very near to his face, to his fear, he saw the round, dark head of a boy.

He recovered, turned round, saw the door ajar, a faint light revealed. And he retreated swiftly, drew the door to without fastening it, and passed rapidly down the passage. At the head of the stairs he hesitated. There was still time to flee.

But it was unthinkable. He would maintain his will. He turned past the door of the parental bedroom like a shadow, and was climbing the second flight of stairs. They creaked under his weight – it was exasperating. Ah what disaster, if the mother's door opened just beneath him, and she saw him! It would have to be, if it were so. He held the control still.

He was not quite up these stairs when he heard a quick running of

feet below, the outer door was closed and locked, he heard Ursula's voice, then the father's sleepy exclamation. He pressed on swiftly to the upper landing.

Again a door was ajar, a room was empty. Feeling his way forward, with the tips of his fingers, travelling rapidly, like a blind man, anxious lest Ursula should come upstairs, he found another door. There, with his preternaturally fine senses alert, he listened. He heard someone moving in bed. This would be she.

Softly now, like one who has only one sense, the tactile sense, he turned the latch. It clicked. He held still. The bed-clothes rustled. His heart did not beat. Then again he drew the latch back, and very gently pushed the door. It made a sticking noise as it gave.

'Ursula?' said Gudrun's voice, frightened. He quickly opened the door and pushed it behind him.

'Is it you, Ursula?' came Gudrun's frightened voice. He heard her sitting up in bed. In another moment she would scream.

'No, it's me,' he said, feeling his way towards her. 'It is I, Gerald.'

She sat motionless in her bed in sheer astonishment. She was too astonished, too much taken by surprise, even to be afraid.

'Gerald!' she echoed, in blank amazement. He had found his way to the bed, and his outstretched hand touched her warm breast blindly. She shrank away.

'Let me make a light,' she said, springing out.

He stood perfectly motionless. He heard her touch the match-box, he heard her fingers in their movement. Then he saw her in the light of a match, which she held to the candle. The light rose in the room, then sank to a small dimness, as the flame sank down on the candle, before it mounted again.

She looked at him, as he stood near the other side of the bed. His cap was pulled low over his brow, his black overcoat was buttoned close up to his chin. His face was strange and luminous. He was inevitable as a supernatural being. When she had seen him, she knew. She knew there was something fatal in the situation, and she must accept it. Yet she must challenge him.

'How did you come up?' she asked.

'I walked up the stairs - the door was open.'

She looked at him.

'I haven't closed this door, either,' he said. She walked swiftly across the room, and closed her door, softly, and locked it. Then she came back.

She was wonderful, with startled eyes and flushed cheeks, and her plait of hair rather short and thick down her back, and her long, fine

white night-dress falling to her feet.

She saw that his boots were all clayey, even his trousers were plastered with clay. And she wondered if he had made footprints all the way up. He was a very strange figure, standing in her bedroom, near the tossed bed.

'Why have you come?' she asked, almost querulous.

'I wanted to,' he replied.

And this she could see from his face. It was fate.

'You are so muddy,' she said, in distaste, but gently.

He looked down at his feet.

'I was walking in the dark,' he replied. But he felt vividly elated. There was a pause. He stood on one side of the tumbled bed, she on the other. He did not even take his cap from his brows.

'And what do you want of me,' she challenged.

He looked aside, and did not answer. Save for the extreme beauty and mystic attractiveness of this distinct, strange face, she would have sent him away. But his face was too wonderful and undiscovered to her. It fascinated her with the fascination of pure beauty, cast a spell on her, like nostalgia, an ache.

'What do you want of me?' she repeated in an estranged voice.

He pulled off his cap, in a movement of dream-liberation, and went across to her. But he could not touch her, because she stood barefoot in her night-dress, and he was muddy and damp. Her eyes, wide and large and wondering, watched him, and asked him the ultimate question.

'I came - because I must,' he said. 'Why do you ask?'

She looked at him in doubt and wonder.

'I must ask,' she said.

He shook his head slightly.

'There is no answer,' he replied, with strange vacancy.

There was about him a curious, and almost godlike air of simplicity and naive directness. He reminded her of an apparition, the young Hermes.⁹⁴

'But why did you come to me?' she persisted.

'Because - it has to be so. If there weren't you in the world, then I shouldn't be in the world, either.'

She stood looking at him, with large, wide, wondering, stricken eyes. His eyes were looking steadily into hers all the time, and he seemed fixed in an odd supernatural steadfastness. She sighed. She was lost now. She had no choice.

'Won't you take off your boots,' she said. 'They must be wet.'

He dropped his cap on a chair, unbuttoned his overcoat, lifting up his chin to unfasten the throat buttons. His short, keen hair was ruffled.

300

He was so beautifully blond, like wheat. He pulled off his overcoat.

Quickly he pulled off his jacket, pulled loose his black tie, and was unfastening his studs, which were headed each with a pearl. She listened, watching, hoping no one would hear the starched linen crackle. It seemed to snap like pistol shots.

He had come for vindication. She let him hold her in his arms, clasp her close against him. He found in her an infinite relief. Into her he poured all his pent-up darkness and corrosive death, and he was whole again. It was wonderful, marvellous, it was a miracle. This was the everrecurrent miracle of his life, at the knowledge of which he was lost in an ecstasy of relief and wonder. And she, subject, received him as a vessel filled with his bitter potion of death. She had no power at this crisis to resist. The terrible frictional violence of death filled her, and she received it in an ecstasy of subjection, in throes of acute, violent sensation.

As he drew nearer to her, he plunged deeper into her enveloping soft warmth, a wonderful creative heat that penetrated his veins and gave him life again. He felt himself dissolving and sinking to rest in the bath of her living strength. It seemed as if her heart in her breast were a second unconquerable sun, into the glow and creative strength of which he plunged further and further. All his veins, that were murdered and lacerated, healed softly as life came pulsing in, stealing invisibly in to him as if it were the all-powerful effluence of the sun. His blood, which seemed to have been drawn back into death, came ebbing on the return, surely, beautifully, powerfully.

He felt his limbs growing fuller and flexible with life, his body gained an unknown strength. He was a man again, strong and rounded. And he was a child, so soothed and restored and full of gratitude.

And she, she was the great bath of life, he worshipped her. Mother and substance of all life she was. And he, child and man, received of her and was made whole. His pure body was almost killed. But the miraculous, soft effluence of her breast suffused over him, over his seared, damaged brain, like a healing lymph, like a soft, soothing flow of life itself, perfect as if he were bathed in the womb again.

His brain was hurt, seared, the tissue was as if destroyed. He had not known how hurt he was, how his tissue, the very tissue of his brain was damaged by the corrosive flood of death. Now, as the healing lymph of her effluence flowed through him, he knew how destroyed he was, like a plant whose tissue is burst from inwards by a frost.

He buried his small, hard head between her breasts, and pressed her breasts against him with his hands. And she with quivering hands pressed his head against her, as he lay suffused out, and she lay fully

conscious. The lovely creative warmth flooded through him like a sleep of fecundity within the womb. Ah, if only she would grant him the flow of this living effluence, he would be restored, he would be complete again. He was afraid she would deny him before it was finished. Like a child at the breast, he cleaved intensely to her, and she could not put him away. And his seared, ruined membrane relaxed, softened, that which was seared and stiff and blasted yielded again, became soft and flexible, palpitating with new life. He was infinitely grateful, as to God, or as an infant is at its mother's breast. He was glad and grateful like a delirium, as he felt his own wholeness come over him again, as he felt the full, unutterable sleep coming over him, the sleep of complete exhaustion and restoration.

But Gudrun lay wide awake, destroyed into perfect consciousness. She lay motionless, with wide eyes staring motionless into the darkness, whilst he was sunk away in sleep, his arms round her.

She seemed to be hearing waves break on a hidden shore, long, slow, gloomy waves, breaking with the rhythm of fate, so monotonously that it seemed eternal. This endless breaking of slow, sullen waves of fate held her life a possession, whilst she lay with dark, wide eyes looking into the darkness. She could see so far, as far as eternity – yet she saw nothing. She was suspended in perfect consciousness – and of what was she conscious?

This mood of extremity, when she lay staring into eternity, utterly suspended, and conscious of everything, to the last limits, passed and left her uneasy. She had lain so long motionless. She moved, she became self-conscious. She wanted to look at him, to see him.

But she dared not make a light, because she knew he would wake, and she did not want to break his perfect sleep, that she knew he had got of her.

She disengaged herself, softly, and rose up a little to look at him. There was a faint light, it seemed to her, in the room. She could just distinguish his features, as he slept the perfect sleep. In this darkness, she seemed to see him so distinctly. But he was far off, in another world. Ah, she could shriek with torment, he was so far off, and perfected, in another world. She seemed to look at him as at a pebble far away under clear dark water. And here was she, left with all the anguish of consciousness, whilst he was sunk deep into the other element of mindless, remote, living shadow-gleam. He was beautiful, far-off, and perfected. They would never be together. Ah, this awful, inhuman distance which would always be interposed between her and the other being!

There was nothing to do but to lie still and endure. She felt an

overwhelming tenderness for him, and a dark, under-stirring of jealous hatred, that he should lie so perfect and immune, in an other-world, whilst she was tormented with violent wakefulness, cast out in the outer darkness.

She lay in intense and vivid consciousness, an exhausting superconsciousness. The church clock struck the hours, it seemed to her, in quick succession. She heard them distinctly in the tension of her vivid consciousness. And he slept as if time were one moment, unchanging and unmoving.

She was exhausted, wearied. Yet she must continue in this state of violent active superconsciousness. She was conscious of everything – her childhood, her girlhood, all the forgotten incidents, all the unrealised influences and all the happenings she had not understood, pertaining to herself, to her family, to her friends, her lovers, her acquaintances, everybody. It was as if she drew a glittering rope of knowledge out of the sea of darkness, drew and drew and drew it out of the fathomless depths of the past, and still it did not come to an end, there was no end to it, she must haul and haul at the rope of glittering consciousness, pull it out phosphorescent from the endless depths of the unconsciousness, till she was weary, aching, exhausted, and fit to break, and yet she had not done.

Ah, if only she might wake him! She turned uneasily. When could she rouse him and send him away? When could she disturb him? And she relapsed into her activity of automatic consciousness, that would never end.

But the time was drawing near when she could wake him. It was like a release. The clock had struck four, outside in the night. Thank God the night had passed almost away. At five he must go, and she would be released. Then she could relax and fill her own place. Now she was driven up against his perfect sleeping motion like a knife white-hot on a grindstone. There was something monstrous about him, about his juxtaposition against her.

The last hour was the longest. And yet, at last it passed. Her heart leapt with relief – yes, there was the slow, strong stroke of the church clock – at last, after this night of eternity. She waited to catch each slow, fatal reverberation. 'Three – four – five!' There, it was finished. A weight rolled off her.

She raised herself, leaned over him tenderly, and kissed him. She was sad to wake him. After a few moments, she kissed him again. But he did not stir. The darling, he was so deep in sleep! What a shame to take him out of it. She let him lie a little longer. But he must go – he must really go.

With full over-tenderness she took his face between her hands, and

kissed his eyes. The eyes opened, he remained motionless, looking at her. Her heart stood still. To hide her face from his dreadful opened eyes, in the darkness, she bent down and kissed him, whispering:

'You must go, my love.'

But she was sick with terror, sick.

He put his arms round her. Her heart sank.

'But you must go, my love. It's late.'

'What time is it?' he said.

Strange, his man's voice. She quivered. It was an intolerable oppression to her.

'Past five o'clock,' she said.

But he only closed his arms round her again. Her heart cried within her in torture. She disengaged herself firmly.

'You really must go,' she said.

'Not for a minute,' he said.

She lay still, nestling against him, but unyielding.

'Not for a minute,' he repeated, clasping her closer.

'Yes,' she said, unyielding, 'I'm afraid if you stay any longer.'

There was a certain coldness in her voice that made him release her, and she broke away, rose and lit the candle. That then was the end.

He got up. He was warm and full of life and desire. Yet he felt a little bit ashamed, humiliated, putting on his clothes before her, in the candle-light. For he felt revealed, exposed to her, at a time when she was in some way against him. It was all very difficult to understand. He dressed himself quickly, without collar or tie. Still he felt full and complete, perfected. She thought it humiliating to see a man dressing: the ridiculous shirt, the ridiculous trousers and braces. But again an idea saved her.

'It is like a workman getting up to go to work,' thought Gudrun. 'And I am like a workman's wife.' But an ache like nausea was upon her: a nausea of him.

He pushed his collar and tie into his overcoat pocket. Then he sat down and pulled on his boots. They were sodden, as were his socks and trouser-bottoms. But he himself was quick and warm.

'Perhaps you ought to have put your boots on downstairs,' she said.

At once, without answering, he pulled them off again, and stood holding them in his hand. She had thrust her feet into slippers, and flung a loose robe round her. She was ready. She looked at him as he stood waiting, his black coat buttoned to the chin, his cap pulled down, his boots in his hand. And the passionate almost hateful fascination revived in her for a moment. It was not exhausted. His face was so warm-looking, wide-eyed and full of newness, so perfect. She felt old,

304

old. She went to him heavily, to be kissed. He kissed her quickly. She wished his warm, expressionless beauty did not so fatally put a spell on her, compel her and subjugate her. It was a burden upon her, that she resented, but could not escape. Yet when she looked at his straight man's brows, and at his rather small, well-shaped nose, and at his blue, indifferent eyes, she knew her passion for him was not yet satisfied, perhaps never could be satisfied. Only now she was weary, with an ache like nausea. She wanted him gone.

They went downstairs quickly. It seemed they made a prodigious noise. He followed her as, wrapped in her vivid green wrap, she preceded him with the light. She suffered badly with fear, lest her people should be roused. He hardly cared. He did not care now who knew. And she hated this in him. One *must* be cautious. One must preserve oneself.

She led the way to the kitchen. It was neat and tidy, as the woman had left it. He looked up at the clock – twenty minutes past five. Then he sat down on a chair to put on his boots. She waited, watching his every movement. She wanted it to be over, it was a great nervous strain on her.

He stood up – she unbolted the back door, and looked out. A cold, raw night, not yet dawn, with a piece of a moon in the vague sky. She was glad she need not go out.

'Good-bye then,' he murmured.

'I'll come to the gate,' she said.

And again she hurried on in front, to warn him of the steps. And at the gate, once more she stood on the step whilst he stood below her.

'Good-bye,' she whispered.

He kissed her dutifully, and turned away.

She suffered torments hearing his firm tread going so distinctly down the road. Ah, the insensitiveness of that firm tread!

She closed the gate, and crept quickly and noiselessly back to bed. When she was in her room, and the door closed, and all safe, she breathed freely, and a great weight fell off her. She nestled down in bed, in the groove his body had made, in the warmth he had left. And excited, worn-out, yet still satisfied, she fell soon into a deep, heavy sleep.

Gerald walked quickly through the raw darkness of the coming dawn. He met nobody. His mind was beautifully still and thoughtless, like a still pool, and his body full and warm and rich. He went quickly along towards Shortlands, in a grateful self-sufficiency.

CHAPTER XXV

Marriage or Not

THE BRANGWEN family was going to move from Beldover. It was necessary now for the father to be in town.

Birkin had taken out a marriage licence, yet Ursula deferred from day to day. She would not fix any definite time – she still wavered. Her month's notice to leave the Grammar School was in its third week. Christmas was not far off.

Gerald waited for the Ursula-Birkin marriage. It was something crucial to him.

'Shall we make it a double-barrelled affair?' he said to Birkin one day. 'Who for the second shot?' asked Birkin.

'Gudrun and me,' said Gerald, the venturesome twinkle in his eyes. Birkin looked at him steadily, as if somewhat taken aback.

'Serious - or joking?' he asked.

'Oh, serious. Shall I? Shall Gudrun and I rush in along with you?'

'Do by all means,' said Birkin. 'I didn't know you'd got that length.'

'What length?' said Gerald, looking at the other man, and laughing. 'Oh yes, we've gone all the lengths.'

'There remains to put it on a broad social basis, and to achieve a high moral purpose,' said Birkin.

'Something like that: the length and breadth and height of it,' replied Gerald, smiling.

'Oh well,' said Birkin,' it's a very admirable step to take, I should say.' Gerald looked at him closely.

'Why aren't you enthusiastic?' he asked. 'I thought you were such dead nuts on marriage.'

Birkin lifted his shoulders.

'One might as well be dead nuts on noses. There are all sorts of noses, snub and otherwise - '

Gerald laughed.

'And all sorts of marriage, also snub and otherwise?' he said.

'That's it.'

'And you think if I marry, it will be snub?' asked Gerald quizzically, his head a little on one side.

Birkin laughed quickly.

'How do I know what it will be!' he said. 'Don't lambaste me with my own parallels -'

Gerald pondered a while.

'But I should like to know your opinion, exactly,' he said.

'On your marriage? – or marrying? Why should you want my opinion? I've got no opinions. I'm not interested in legal marriage, one way or another. It's a mere question of convenience.'

Still Gerald watched him closely.

'More than that, I think,' he said seriously. 'However you may be bored by the ethics of marriage, yet really to marry, in one's own personal case, is something critical, final – '

'You mean there is something final in going to the registrar with a woman?'

'If you're coming back with her, I do,' said Gerald. 'It is in some way irrevocable.'

'Yes, I agree,' said Birkin.

'No matter how one regards legal marriage, yet to enter into the married state, in one's own personal instance, is final -'

'I believe it is,' said Birkin, 'somewhere.'

'The question remains then, should one do it,' said Gerald.

Birkin watched him narrowly, with amused eyes.

'You are like Lord Bacon,⁹⁵ Gerald,' he said. 'You argue it like a lawyer – or like Hamlet's to-be-or-not-to-be. If I were you I would *not* marry: but ask Gudrun, not me. You're not marrying me, are you?'

Gerald did not heed the latter part of this speech.

'Yes,' he said, 'one must consider it coldly. It is something critical. One comes to the point where one must take a step in one direction or another. And marriage is one direction -'

'And what is the other?' asked Birkin quickly.

Gerald looked up at him with hot, strangely-conscious eyes, that the other man could not understand.

'I can't say,' he replied. 'If I knew *that* - ' He moved uneasily on his feet, and did not finish.

'You mean if you knew the alternative?' asked Birkin. 'And since you don't know it, marriage is a *pis aller*.'⁹⁶

Gerald looked up at Birkin with the same hot, constrained eyes.

'One does have the feeling that marriage is a pis aller,' he admitted.

'Then don't do it,' said Birkin. 'I tell you,' he went on, 'the same as I've said before, marriage in the old sense seems to me repulsive. *Egoïsme à deux*⁹⁷ is nothing to it. It's a sort of tacit hunting in couples: the world all in couples, each couple in its own little house, watching its own little interests, and stewing in its own little privacy – it's the most repulsive thing on earth.'

'I quite agree,' said Gerald. 'There's something inferior about it. But as I say, what's the alternative.'

'One should avoid this *home* instinct. It's not an instinct, it's a habit of cowardliness. One should never have a *home*.'

'I agree really,' said Gerald. 'But there's no alternative.'

'We've got to find one. I do believe in a permanent union between a man and a woman. Chopping about is merely an exhaustive process. But a permanent relation between a man and a woman isn't the last word – it certainly isn't.'

'Quite,' said Gerald.

'In fact,' said Birkin, 'because the relation between man and woman is made the supreme and exclusive relationship, that's where all the tightness and meanness and insufficiency comes in.'

'Yes, I believe you,' said Gerald.

'You've got to take down the love-and-marriage ideal from its pedestal. We want something broader. I believe in the *additional* perfect relationship between man and man – additional to marriage.'

'I can never see how they can be the same,' said Gerald.

'Not the same - but equally important, equally creative, equally sacred, if you like.'

'I know,' said Gerald, 'you believe something like that. Only I can't *feel* it, you see.' He put his hand on Birkin's arm, with a sort of deprecating affection. And he smiled as if triumphantly.

He was ready to be doomed. Marriage was like a doom to him. He was willing to condemn himself in marriage, to become like a convict condemned to the mines of the underworld, living no life in the sun, but having a dreadful subterranean activity. He was willing to accept this. And marriage was the seal of his condemnation. He was willing to be sealed thus in the underworld, like a soul damned but living forever in damnation. But he would not make any pure relationship with any other soul. He could not. Marriage was not the committing of himself into a relationship with Gudrun. It was a committing of himself in acceptance of the established world, he would accept the established order, in which he did not livingly believe, and then he would retreat to the underworld for his life. This he would do.

The other way was to accept Rupert's offer of alliance, to enter into the bond of pure trust and love with the other man, and then subsequently with the woman. If he pledged himself with the man he would later be able to pledge himself with the woman: not merely in legal marriage, but in absolute, mystic marriage.

Yet he could not accept the offer. There was a numbress upon him, a numbress either of unborn, absent volition, or of atrophy. Perhaps it was the absence of volition. For he was strangely elated at Rupert's offer. Yet he was still more glad to reject it, not to be committed.

CHAPTER XXVI

A Chair

THERE WAS a jumble market every Monday afternoon in the old market-place in town. Ursula and Birkin strayed down there one afternoon. They had been talking of furniture, and they wanted to see if there was any fragment they would like to buy, amid the heaps of rubbish collected on the cobble-stones.

The old market-square was not very large, a mere bare patch of granite setts, usually with a few fruit-stalls under a wall. It was in a poor quarter of the town. Meagre houses stood down one side, there was a hosiery factory, a great blank with myriad oblong windows, at the end, a street of little shops with flagstone pavement down the other side, and, for a crowning monument, the public baths, of new red brick, with a clock-tower. The people who moved about seemed stumpy and sordid, the air seemed to smell rather dirty, there was a sense of many mean streets ramifying off into warrens of meanness. Now and again a great chocolate-and-yellow tramcar ground round a difficult bend under the hosiery factory.

Ursula was superficially thrilled when she found herself out among the common people, in the jumbled place piled with old bedding, heaps of old iron, shabby crockery in pale lots, muffled lots of unthinkable clothing. She and Birkin went unwillingly down the narrow aisle between the rusty wares. He was looking at the goods, she at the people.

She excitedly watched a young woman, who was going to have a baby, and who was turning over a mattress and making a young man, down-at-heel and dejected, feel it also. So secretive and active and anxious the young woman seemed, so reluctant, slinking, the young man. He was going to marry her because she was having a child.

When they had felt the mattress, the young woman asked the old man seated on a stool among his wares, how much it was. He told her, and she turned to the young man. The latter was ashamed, and selfconscious. He turned his face away, though he left his body standing there, and muttered aside. And again the woman anxiously and actively fingered the mattress and added up in her mind and bargained with the old, unclean man. All the while, the young man stood by, shamefaced and down-at-heel, submitting.

'Look,' said Birkin, 'there is a pretty chair.'

'Charming!' cried Ursula. 'Oh, charming.'

It was an arm-chair of simple wood, probably birch, but of such fine delicacy of grace, standing there on the sordid stones, it almost brought tears to the eyes. It was square in shape, of the purest, slender lines, and four short lines of wood in the back, that reminded Ursula of harpstrings.

'It was once,' said Birkin, 'gilded – and it had a cane seat. Somebody has nailed this wooden seat in. Look, here is a trifle of the red that underlay the gilt. The rest is all black, except where the wood is worn pure and glossy. It is the fine unity of the lines that is so attractive. Look, how they run and meet and counteract. But of course the wooden seat is wrong – it destroys the perfect lightness and unity in tension the cane gave. I like it though – '

'Ah yes,' said Ursula, 'so do I.'

'How much is it?' Birkin asked the man.

'Ten shillings.'

'And you will send it -?'

It was bought.

'So beautiful, so pure!' Birkin said. 'It almost breaks my heart.' They walked along between the heaps of rubbish. 'My beloved country – it had something to express even when it made that chair.'

'And hasn't it now?' asked Ursula. She was always angry when he took this tone.

'No, it hasn't. When I see that clear, beautiful chair, and I think of England, even Jane Austen's England – it had living thoughts to unfold even then, and pure happiness in unfolding them. And now, we can only fish among the rubbish heaps for the remnants of their old expression. There is no production in us now, only sordid and foul mechanicalness.'

'It isn't true,' cried Ursula. 'Why must you always praise the past, at the expense of the present? *Really*, I don't think so much of Jane Austen's England. It was materialistic enough, if you like – '

'It could afford to be materialistic,' said Birkin, 'because it had the power to be something other – which we haven't. We are materialistic because we haven't the power to be anything else – try as we may, we can't bring off anything but materialism: mechanism, the very soul of materialism.'

Ursula was subdued into angry silence. She did not heed what he said. She was rebelling against something else.

'And I hate your past. I'm sick of it,' she cried. 'I believe I even hate that old chair, though it is beautiful. It isn't my sort of beauty. I wish it had been smashed up when its day was over, not left to preach the beloved past to us. I'm sick of the beloved past.'

'Not so sick as I am of the accursed present,' he said.

'Yes, just the same. I hate the present – but I don't want the past to take its place – I don't want that old chair.'

He was rather angry for a moment. Then he looked at the sky shining beyond the tower of the public baths, and he seemed to get over it all. He laughed.

'All right,' he said, 'then let us not have it. I'm sick of it all, too. At any rate one can't go on living on the old bones of beauty.'

'One can't,' she cried. 'I don't want old things.'

'The truth is, we don't want things at all,' he replied. 'The thought of a house and furniture of my own is hateful to me.'

This startled her for a moment. Then she replied:

'So it is to me. But one must live somewhere.'

'Not somewhere – anywhere,' he said. 'One should just live anywhere – not have a definite place. I don't want a definite place. As soon as you get a room, and it is *complete*, you want to run from it. Now my rooms at the Mill are quite complete, I want them at the bottom of the sea. It is a horrible tyranny of a fixed milieu, where each piece of furniture is a commandment-stone.'

She clung to his arm as they walked away from the market.

'But what are we going to do?' she said. 'We must live somehow. And I do want some beauty in my surroundings. I want a sort of natural grandeur even, splendour.'

'You'll never get it in houses and furniture – or even clothes. Houses and furniture and clothes, they are all terms of an old base world, a detestable society of man. And if you have a Tudor house and old, beautiful furniture, it is only the past perpetuated on top of you, horrible. And if you have a perfect modern house done for you by Poiret,⁹⁸ it is something else perpetuated on top of you. It is all horrible. It is all possessions, possessions, bullying you and turning you into a generalisation. You have to be like Rodin, Michelangelo,⁹⁹ and leave a piece of raw rock unfinished to your figure. You must leave your surroundings sketchy, unfinished, so that you are never contained, never confined, never dominated from the outside.'

She stood in the street contemplating.

'And we are never to have a complete place of our own – never a home?' she said.

'Pray God, in this world, no,' he answered.

'But there's only this world,' she objected.

He spread out his hands with a gesture of indifference.

'Meanwhile, then, we'll avoid having things of our own,' he said.

'But you've just bought a chair,' she said.

'I can tell the man I don't want it,' he replied.

She pondered again. Then a queer little movement twitched her face. 'No,' she said, 'we don't want it. I'm sick of old things.'

'New ones as well,' he said.

They retraced their steps.

There – in front of some furniture, stood the young couple, the woman who was going to have a baby, and the narrow-faced youth. She was fair, rather short, stout. He was of medium height, attractively built. His dark hair fell sideways over his brow, from under his cap, he stood strangely aloof, like one of the damned.

'Let us give it to *them*,' whispered Ursula. 'Look they are getting a home together.'

'I won't aid and abet them in it,' he said petulantly, instantly sympathising with the aloof, furtive youth, against the active, procreant female.

'Oh yes,' cried Ursula. 'It's right for them - there's nothing else for them.'

'Very well,' said Birkin, 'you offer it to them. I'll watch.'

Ursula went rather nervously to the young couple, who were discussing an iron washstand – or rather, the man was glancing furtively and wonderingly, like a prisoner, at the abominable article, whilst the woman was arguing.

'We bought a chair,' said Ursula, 'and we don't want it. Would you have it? We should be glad if you would.'

The young couple looked round at her, not believing that she could be addressing them.

'Would you care for it?' repeated Ursula. 'It's really *very* pretty – but – but – ' she smiled rather dazzlingly.

The young couple only stared at her, and looked significantly at each other, to know what to do. And the man curiously obliterated himself, as if he could make himself invisible, as a rat can.

'We wanted to *give* it to you,' explained Ursula, now overcome with confusion and dread of them. She was attracted by the young man. He was a still, mindless creature, hardly a man at all, a creature that the towns have produced, strangely pure-bred and fine in one sense, furtive, quick, subtle. His lashes were dark and long and fine over his eyes, that had no mind in them, only a dreadful kind of subject, inward consciousness, glazed and dark. His dark brows and all his lines, were finely drawn. He would be a dreadful, but wonderful lover to a woman, so marvellously contributed. His legs would be marvellously subtle and alive, under the shapeless trousers, he had some of the fineness and stillness and silkiness of a dark-eyed, silent rat.

Ursula had apprehended him with a fine *frisson* of attraction. The full-built woman was staring offensively. Again Ursula forgot him.

'Won't you have the chair?' she said.

The man looked at her with a sideways look of appreciation, yet faroff, almost insolent. The woman drew herself up. There was a certain costermonger richness about her. She did not know what Ursula was after, she was on her guard, hostile. Birkin approached, smiling wickedly at seeing Ursula so nonplussed and frightened.

'What's the matter?' he said, smiling. His eyelids had dropped slightly, there was about him the same suggestive, mocking secrecy that was in the bearing of the two city creatures. The man jerked his head a little on one side, indicating Ursula, and said, with curious amiable, jeering warmth:

'What she warnt? - eh?' An odd smile writhed his lips.

Birkin looked at him from under his slack, ironical eyelids.

'To give you a chair - that - with the label on it,' he said, pointing.

The man looked at the object indicated. There was a curious hostility in male, outlawed understanding between the two men.

'What's she warnt to give it us for, guvnor,' he replied, in a tone of free intimacy that insulted Ursula.

'Thought you'd like it – it's a pretty chair. We bought it and don't want it. No need for you to have it, don't be frightened,' said Birkin, with a wry smile.

The man glanced up at him, half inimical, half recognising.

'Why don't you want it for yourselves, if you've just bought it?' asked the woman coolly. ' 'Taint good enough for you, now you've had a look at it. Frightened it's got something in it, eh?'

She was looking at Ursula, admiringly, but with some resentment.

'I'd never thought of that,' said Birkin. 'But no, the wood's too thin everywhere.'

'You see,' said Ursula, her face luminous and pleased. 'We are just going to get married, and we thought we'd buy things. Then we decided, just now, that we wouldn't have furniture, we'd go abroad.'

The full-built, slightly blowsy city girl looked at the fine face of the other woman, with appreciation. They appreciated each other. The youth stood aside, his face expressionless and timeless, the thin line of the black moustache drawn strangely suggestive over his rather wide, closed mouth. He was impassive, abstract, like some dark suggestive presence, a gutter-presence.

'It's all right to be some folks,' said the city girl, turning to her own young man. He did not look at her, but he smiled with the lower part of his face, putting his head aside in an odd gesture of assent. His eyes were unchanging, glazed with darkness.

'Cawsts something to change your mind,' he said, in an incredibly low accent.

'Only ten shillings this time,' said Birkin.

The man looked up at him with a grimace of a smile, furtive, unsure.

'Cheap at 'arf a quid, guvnor,' he said. 'Not like getting divawced.'

'We're not married yet,' said Birkin.

'No, no more aren't we,' said the young woman loudly. 'But we shall be, a Saturday.'

Again she looked at the young man with a determined, protective look, at once overbearing and very gentle. He grinned sicklily, turning away his head. She had got his manhood, but Lord, what did he care! He had a strange furtive pride and slinking singleness.

'Good luck to you,' said Birkin.

'Same to you,' said the young woman. Then, rather tentatively: 'When's yours coming off, then?'

Birkin looked round at Ursula.

'It's for the lady to say,' he replied. 'We go to the registrar the moment she's ready.'

Ursula laughed, covered with confusion and bewilderment.

'No 'urry,' said the young man, grinning suggestive.

'Oh, don't break your neck to get there,' said the young woman. ' 'Slike when you're dead – you're a long time married.'

The young man turned aside as if this hit him.

'The longer the better, let us hope,' said Birkin.

'That's it, guvnor,' said the young man admiringly. 'Enjoy it while it larsts – niver whip a dead donkey.'

'Only when he's shamming dead,' said the young woman, looking at her young man with caressive tenderness of authority.

'Aw, there's a difference,' he said satirically.

'What about the chair?' said Birkin.

'Yes, all right,' said the woman.

They trailed off to the dealer, the handsome but abject young fellow hanging a little aside.

'That's it,' said Birkin. 'Will you take it with you, or have the address altered.'

'Oh, Fred can carry it. Make him do what he can for the dear old 'ome.'

'Mike use of 'im,' said Fred, grimly humorous, as he took the chair from the dealer. His movements were graceful, yet curiously abject, slinking.

314

' 'Ere's mother's cosy chair,' he said. 'Warnts a cushion.' And he stood it down on the market stones.

'Don't you think it's pretty?' laughed Ursula.

'Oh, I do,' said the young woman.

''Ave a sit in it, you'll wish you'd kept it,' said the young man.

Ursula promptly sat down in the middle of the market-place.

'Awfully comfortable,' she said. 'But rather hard. You try it.' She invited the young man to a seat. But he turned uncouthly, awkwardly aside, glancing up at her with quick bright eyes, oddly suggestive, like a quick, live rat.

'Don't spoil him,' said the young woman. 'He's not used to armchairs, 'e isn't.'

The young man turned away, and said, with averted grin:

'Only warnts legs on 'is.'

The four parted. The young woman thanked them.

'Thank you for the chair - it'll last till it gives way.'

'Keep it for an ornyment,' said the young man.

'Good afternoon - good afternoon,' said Ursula and Birkin.

'Goo'-luck to you,' said the young man, glancing and avoiding Birkin's eyes, as he turned aside his head.

The two couples went asunder, Ursula clinging to Birkin's arm. When they had gone some distance, she glanced back and saw the young man going beside the full, easy young woman. His trousers sank over his heels, he moved with a sort of slinking evasion, more crushed with odd self-consciousness now he had the slim old arm-chair to carry, his arm over the back, the four fine, square tapering legs swaying perilously near the granite setts of the pavement. And yet he was somewhere indomitable and separate, like a quick, vital rat. He had a queer, subterranean beauty, repulsive too.

'How strange they are!' said Ursula.

'Children of men,' he said. 'They remind me of Jesus: "The meek shall inherit the earth." '100

'But they aren't the meek,' said Ursula.

'Yes, I don't know why, but they are,' he replied.

They waited for the tramcar. Ursula sat on top and looked out on the town. The dusk was just dimming the hollows of crowded houses.

'And are they going to inherit the earth?' she said.

'Yes - they.'

'Then what are we going to do?' she asked. 'We're not like them – are we? We're not the meek?'

'No. We've got to live in the chinks they leave us.'

'How horrible!' cried Ursula. 'I don't want to live in chinks.'

'Don't worry,' he said. 'They are the children of men, they like market-places and street-corners best. That leaves plenty of chinks.'

'All the world,' she said.

'Ah no - but some room.'

The trancar mounted slowly up the hill, where the ugly winter-grey masses of houses looked like a vision of hell that is cold and angular. They sat and looked. Away in the distance was an angry redness of sunset. It was all cold, somehow small, crowded, and like the end of the world.

'I don't mind it even then,' said Ursula, looking at the repulsiveness of it all. 'It doesn't concern me.'

'No more it does,' he replied, holding her hand. 'One needn't see. One goes one's way. In my world it is sunny and spacious – '

'It is, my love, isn't it?' she cried, hugging near to him on the top of the tramcar, so that the other passengers stared at them.

'And we will wander about on the face of the earth,' he said, 'and we'll look at the world beyond just this bit.'

There was a long silence. Her face was radiant like gold, as she sat thinking.

'I don't want to inherit the earth,' she said. 'I don't want to inherit anything.'

He closed his hand over hers.

'Neither do I. I want to be disinherited.'

She clasped his fingers closely.

'We won't care about anything,' she said.

He sat still, and laughed.

'And we'll be married, and have done with them,' she added.

Again he laughed.

'It's one way of getting rid of everything,' she said, 'to get married.' 'And one way of accepting the whole world,' he added.

'A whole other world, yes,' she said happily.

'Perhaps there's Gerald - and Gudrun - 'he said.

'If there is there is, you see,' she said. 'It's no good our worrying. We can't really alter them, can we?'

'No,' he said. 'One has no right to try – not with the best intentions in the world.'

'Do you try to force them?' she asked.

'Perhaps,' he said. 'Why should I want him to be free, if it isn't his business?'

She paused for a time.

'We can't *make* him happy, anyhow,' she said. 'He'd have to be it of himself.'

'I know,' he said. 'But we want other people with us, don't we?' 'Why should we?' she asked.

'I don't know,' he said uneasily. 'One has a hankering after a sort of further fellowship.'

'But why?' she insisted. 'Why should you hanker after other people? Why should you need them?'

This hit him right on the quick. His brows knitted.

'Does it end with just our two selves?' he asked, tense.

'Yes – what more do you want? If anybody likes to come along, let them. But why must you run after them?'

His face was tense and unsatisfied.

'You see,' he said, 'I always imagine our being really happy with some few other people -a little freedom with people.'

She pondered for a moment.

'Yes, one does want that. But it must *bappen*. You can't do anything for it with your will. You always seem to think you can *force* the flowers to come out. People must love us because they love us – you can't *make* them.'

'I know,' he said. 'But must one take no steps at all? Must one just go as if one were alone in the world – the only creature in the world?'

'You've got me,' she said. 'Why should you *need* others? Why must you force people to agree with you? Why can't you be single by yourself, as you are always saying? You try to bully Gerald – as you tried to bully Hermione. You must learn to be alone. And it's so horrid of you. You've got me. And yet you want to force other people to love you as well. You do try to bully them to love you. And even then, you don't want their love.'

His face was full of real perplexity.

'Don't I?' he said. 'It's the problem I can't solve. I know I want a perfect and complete relationship with you: and we've nearly got it – we really have. But beyond that. Do I want a real, ultimate relationship with Gerald? Do I want a final, almost extra-human relationship with him – a relationship in the ultimate of me and him – or don't I?'

She looked at him for a long time, with strange bright eyes, but she did not answer.

CHAPTER XXVII

Flitting

THAT EVENING Ursula returned home very bright-eyed and wondrous – which irritated her people. Her father came home at suppertime, tired after the evening class, and the long journey home. Gudrun was reading, the mother sat in silence.

Suddenly Ursula said to the company at large, in a bright voice, 'Rupert and I are going to be married tomorrow.'

Her father turned round, stiffly.

'You what?' he said.

'Tomorrow!' echoed Gudrun.

'Indeed!' said the mother.

But Ursula only smiled wonderfully, and did not reply.

'Married tomorrow!' cried her father harshly. 'What are you talking about.'

'Yes,' said Ursula. 'Why not?' Those two words, from her, always drove him mad. 'Everything is all right – we shall go to the registrar's office – '

There was a second's hush in the room, after Ursula's blithe vagueness.

'Really, Ursula!' said Gudrun.

'Might we ask why there has been all this secrecy?' demanded the mother, rather superbly.

'But there hasn't,' said Ursula. 'You knew.'

'Who knew?' now cried the father. 'Who knew? What do you mean by your "you knew"?'

He was in one of his stupid rages, she instantly closed against him.

'Of course you knew,' she said coolly. 'You knew we were going to get married.'

There was a dangerous pause.

'We knew you were going to get married, did we? Knew! Why, does anybody know anything about you, you shifty bitch!'

'Father!' cried Gudrun, flushing deep in violent remonstrance. Then, in a cold, but gentle voice, as if to remind her sister to be tractable: 'But isn't it a *fearfully* sudden decision, Ursula?' she asked.

'No, not really,' replied Ursula, with the same maddening cheerfulness. 'He's been *wanting* me to agree for weeks – he's had the licence ready. Only I - I wasn't ready in myself. Now I am ready – is there

anything to be disagreeable about?'

'Certainly not,' said Gudrun, but in a tone of cold reproof. 'You are perfectly free to do as you like.'

"Ready in yourself" – *yourself*, that's all that matters, isn't it! "I wasn't ready in myself," 'he mimicked her phrase offensively. 'You and *yourself*, you're of some importance, aren't you?'

She drew herself up and set back her throat, her eyes shining yellow and dangerous.

'I am to myself,' she said, wounded and mortified. 'I know I am not to anybody else. You only wanted to *bully* me – you never cared for my happiness.'

He was leaning forward watching her, his face intense like a spark.

'Ursula, what are you saying? Keep your tongue still,' cried her mother.

Ursula swung round, and the lights in her eyes flashed.

'No, I won't,' she cried. 'I won't hold my tongue and be bullied. What does it matter which day I get married – what does it *matter*! It doesn't affect anybody but myself.'

Her father was tense and gathered together like a cat about to spring. 'Doesn't it?' he cried, coming nearer to her. She shrank away.

'No, how can it?' she replied, shrinking but stubborn.

'It doesn't matter to *me* then, what you do – what becomes of you?' he cried, in a strange voice like a cry.

The mother and Gudrun stood back as if hypnotised.

'No,' stammered Ursula. Her father was very near to her. 'You only want to -'

She knew it was dangerous, and she stopped. He was gathered together, every muscle ready.

'What?' he challenged.

'Bully me,' she muttered, and even as her lips were moving, his hand had caught her smack at the side of the face and she was sent up against the door.

'Father!' cried Gudrun in a high voice, 'it is impossible!'

He stood unmoving. Ursula recovered, her hand was on the door handle. She slowly drew herself up. He seemed doubtful now.

'It's true,' she declared, with brilliant tears in her eyes, her head lifted up in defiance. 'What has your love meant, what did it ever mean? – bullying, and denial – it did – '

He was advancing again with strange, tense movements, and clenched fist, and the face of a murderer. But swift as lightning she had flashed out of the door, and they heard her running upstairs.

He stood for a moment looking at the door. Then, like a defeated

WOMEN IN LOVE

animal, he turned and went back to his seat by the fire.

Gudrun was very white. Out of the intense silence, the mother's voice was heard saying, cold and angry:

'Well, you shouldn't take so much notice of her.'

Again the silence fell, each followed a separate set of emotions and thoughts.

Suddenly the door opened again: Ursula, dressed in hat and furs, with a small valise in her hand:

'Good-bye!' she said, in her maddening, bright, almost mocking tone. 'I'm going.'

And in the next instant the door was closed, they heard the outer door, then her quick steps down the garden path, then the gate banged, and her light footfall was gone. There was a silence like death in the house.

Ursula went straight to the station, hastening heedlessly on winged feet. There was no train, she must walk on to the junction. As she went through the darkness, she began to cry, and she wept bitterly, with a dumb, heart-broken, child's anguish, all the way on the road, and in the train. Time passed unheeded and unknown, she did not know where she was, nor what was taking place. Only she wept from fathomless depths of hopeless, hopeless grief, the terrible grief of a child, that knows no extenuation.

Yet her voice had the same defensive brightness as she spoke to Birkin's landlady at the door.

'Good evening! Is Mr Birkin in? Can I see him?'

'Yes, he's in. He's in his study.'

Ursula slipped past the woman. His door opened. He had heard her voice.

'Hello!' he exclaimed in surprise, seeing her standing there with the valise in her hand, and marks of tears on her face. She was one who wept without showing many traces, like a child.

'Do I look a sight?' she said, shrinking.

'No - why? Come in,' he took the bag from her hand and they went into the study.

There – immediately, her lips began to tremble like those of a child that remembers again, and the tears came rushing up.

'What's the matter?' he asked, taking her in his arms. She sobbed violently on his shoulder, whilst he held her still, waiting.

'What's the matter?' he said again, when she was quieter. But she only pressed her face further into his shoulder, in pain, like a child that cannot tell.

'What is it, then?' he asked.

Suddenly she broke away, wiped her eyes, regained her composure, and went and sat in a chair.

'Father hit me,' she announced, sitting bunched up, rather like a ruffled bird, her eyes very bright.

'What for?' he said.

She looked away, and would not answer. There was a pitiful redness about her sensitive nostrils, and her quivering lips.

'Why?' he repeated, in his strange, soft, penetrating voice.

She looked round at him, rather defiantly.

'Because I said I was going to be married tomorrow, and he bullied me.'

Her mouth dropped again, she remembered the scene once more, the tears came up.

'Because I said he didn't care - and he doesn't, it's only his domineeringness that's hurt - 'she said, her mouth pulled awry by her weeping, all the time she spoke, so that he almost smiled, it seemed so childish. Yet it was not childish, it was a mortal conflict, a deep wound.

'It isn't quite true,' he said. 'And even so, you shouldn't say it.'

'It is true – it is true,' she wept, 'and I won't be bullied by his pretending it's love – when it isn't – he doesn't care, how can he – no, he can't – '

He sat in silence. She moved him beyond himself.

'Then you shouldn't rouse him, if he can't,' replied Birkin quietly.

'And I *have* loved him, I have,' she wept. 'I've loved him always, and he's always done this to me, he has -'

'It's been a love of opposition, then,' he said. 'Never mind – it will be all right. It's nothing desperate.'

'Yes,' she wept, 'it is, it is.'

'Why?'

'I shall never see him again -'

'Not immediately. Don't cry, you had to break with him, it had to be - don't cry.'

He went over to her and kissed her fine, fragile hair, touching her wet cheeks gently.

'Don't cry,' he repeated, 'don't cry any more.'

He held her head close against him, very close and quiet.

At last she was still. Then she looked up, her eyes wide and frightened.

'Don't you want me?' she asked.

'Want you?' His darkened, steady eyes puzzled her and did not give her play.

'Do you wish I hadn't come?' she asked, anxious now again for fear

she might be out of place.

'No,' he said. 'I wish there hadn't been the violence – so much ugliness – but perhaps it was inevitable.'

She watched him in silence. He seemed deadened.

'But where shall I stay?' she asked, feeling humiliated.

He thought for a moment.

'Here, with me,' he said. 'We're married as much today as we shall be tomorrow.'

'But - '

'I'll tell Mrs Varley,' he said. 'Never mind now.'

He sat looking at her. She could feel his darkened steady eyes looking at her all the time. It made her a little bit frightened. She pushed her hair off her forehead nervously.

'Do I look ugly?' she said.

And she blew her nose again.

A small smile came round his eyes.

'No,' he said, 'fortunately.'

And he went across to her, and gathered her like a belonging in his arms. She was so tenderly beautiful, he could not bear to see her, he could only bear to hide her against himself. Now; washed all clean by her tears, she was new and frail like a flower just unfolded, a flower so new, so tender, so made perfect by inner light, that he could not bear to look at her, he must hide her against himself, cover his eyes against her. She had the perfect candour of creation, something translucent and simple, like a radiant, shining flower that moment unfolded in primal blessedness. She was so new, so wonder-clear, so undimmed. And he was so old, so steeped in heavy memories. Her soul was new, undefined and glimmering with the unseen. And his soul was dark and gloomy, it had only one grain of living hope, like a grain of mustard seed.¹⁰¹ But this one living grain in him matched the perfect youth in her.

'I love you,' he whispered as he kissed her, and trembled with pure hope, like a man who is born again to a wonderful, lively hope far exceeding the bounds of death.

She could not know how much it meant to him, how much he meant by the few words. Almost childish, she wanted proof, and statement, even over-statement, for everything seemed still uncertain, unfixed to her.

But the passion of gratitude with which he received her into his soul, the extreme, unthinkable gladness of knowing himself living and fit to unite with her, he, who was so nearly dead, who was so near to being gone with the rest of his race down the slope of mechanical death,

could never be understood by her. He worshipped her as age worships youth, he gloried in her, because, in his one grain of faith, he was young as she, he was her proper mate. This marriage with her was his resurrection and his life.¹⁰²

All this she could not know. She wanted to be made much of, to be adored. There were infinite distances of silence between them. How could he tell her of the immanence of her beauty, that was not form, or weight, or colour, but something like a strange, golden light! How could he know himself what her beauty lay in, for him. He said 'Your nose is beautiful, your chin is adorable.' But it sounded like lies, and she was disappointed, hurt. Even when he said, whispering with truth, 'I love you, I love you,' it was not the real truth. It was something beyond love, such a gladness of having surpassed oneself, of having transcended the old existence. How could he say "I" when he was something new and unknown, not himself at all? This I, this old formula of the age, was a dead letter.

In the new, superfine bliss, a peace superseding knowledge, there was no I and you, there was only the third, unrealised wonder, the wonder of existing not as oneself, but in a consummation of my being and of her being in a new one, a new, paradisal unit regained from the duality. Nor can I say 'I love you,' when I have ceased to be, and you have ceased to be: we are both caught up and transcended into a new oneness where everything is silent, because there is nothing to answer, all is perfect and at one. Speech travels between the separate parts. But in the perfect One there is perfect silence of bliss.

They were married by law on the next day, and she did as he bade her, she wrote to her father and mother. Her mother replied, not her father.

She did not go back to school. She stayed with Birkin in his rooms, or at the Mill, moving with him as he moved. But she did not see anybody, save Gudrun and Gerald. She was all strange and wondering as yet, but relieved as by dawn.

Gerald sat talking to her one afternoon in the warm study down at the Mill. Rupert had not yet come home.

'You are happy?' Gerald asked her, with a smile.

'Very happy!' she cried, shrinking a little in her brightness.

'Yes, one can see it.'

'Can one?' cried Ursula in surprise.

He looked up at her with a communicative smile.

'Oh yes, plainly.'

She was pleased. She meditated a moment.

'And can you see that Rupert is happy as well?'

He lowered his eyelids, and looked aside.

'Oh yes,' he said.

'Really!'

'Oh yes.'

He was very quiet, as if it were something not to be talked about by him. He seemed sad.

She was very sensitive to suggestion. She asked the question he wanted her to ask.

'Why don't you be happy as well?' she said. 'You could be just the same.'

He paused a moment.

'With Gudrun?' he asked.

'Yes!' she cried, her eyes glowing. But there was a strange tension, an emphasis, as if they were asserting their wishes, against the truth.

'You think Gudrun would have me, and we should be happy?' he said.

'Yes, I'm sure!' she cried.

Her eyes were round with delight. Yet underneath she was constrained, she knew her own insistence.

'Oh, I'm so glad,' she added.

He smiled.

'What makes you glad?' he said.

'For *her* sake,' she replied. 'I'm sure you'd – you're the right man for her.'

'You are?' he said. 'And do you think she would agree with you?'

'Oh yes!' she exclaimed hastily. Then, upon reconsideration, very uneasy: 'Though Gudrun isn't so very simple, is she? One doesn't know her in five minutes, does one? She's not like me in that.' She laughed at him with her strange, open, dazzled face.

'You think she's not much like you?' Gerald asked.

She knitted her brows.

'Oh, in many ways she is. But I never know what she will do when anything new comes.'

'You don't?' said Gerald. He was silent for some moments. Then he moved tentatively. 'I was going to ask her, in any case, to go away with me at Christmas,' he said, in a very small, cautious voice.

'Go away with you? For a time, you mean?'

'As long as she likes,' he said, with a deprecating movement.

They were both silent for some minutes.

'Of course,' said Ursula at last, 'she *might* just be willing to rush into marriage. You can see.'

'Yes,' smiled Gerald. 'I can see. But in case she won't - do you think

she would go abroad with me for a few days - or for a fortnight?'

'Oh yes,' said Ursula. 'I'd ask her.'

'Do you think we might all go together?'

'All of us?' Again Ursula's face lighted up. 'It would be rather fun, don't you think?'

'Great fun,' he said.

'And then you could see,' said Ursula.

'What?'

'How things went. I think it is best to take the honeymoon before the wedding – don't you?'

She was pleased with this mot.¹⁰³ He laughed.

'In certain cases,' he said. 'I'd rather it were so in my own case.'

'Would you!' exclaimed Ursula. Then doubtingly, 'Yes, perhaps you're right. One should please oneself.'

Birkin came in a little later, and Ursula told him what had been said.

'Gudrun!' exclaimed Birkin. 'She's a born mistress, just as Gerald is a born lover – *amant en titre*.¹⁰⁴ If as somebody says all women are either wives or mistresses, then Gudrun is a mistress.'

'And all men either lovers or husbands,' cried Ursula. 'But why not both?'

'The one excludes the other,' he laughed.

'Then I want a lover,' cried Ursula.

'No you don't,' he said.

'But I do,' she wailed.

He kissed her, and laughed.

It was two days after this that Ursula was to go to fetch her things from the house in Beldover. The removal had taken place, the family had gone. Gudrun had rooms in Willey Green.

Ursula had not seen her parents since her marriage. She wept over the rupture, yet what was the good of making it up! Good or not good, she could not go to them. So her things had been left behind and she and Gudrun were to walk over for them, in the afternoon.

It was a wintry afternoon, with red in the sky, when they arrived at the house. The windows were dark and blank, already the place was frightening. A stark, void entrance-hall struck a chill to the hearts of the girls.

'I don't believe I dare have come in alone,' said Ursula. 'It frightens me.'.

'Ursula!' cried Gudrun. 'Isn't it amazing! Can you believe you lived in this place and never felt it? How I lived here a day without dying of terror, I cannot conceive!'

They looked in the big dining-room. It was a good-sized room, but now a cell would have been lovelier. The large bay windows were naked, the floor was stripped, and a border of dark polish went round the tract of pale boarding.

In the faded wallpaper were dark patches where furniture had stood, where pictures had hung. The sense of walls, dry, thin, flimsy-seeming walls, and a flimsy flooring, pale with its artificial black edges, was neutralising to the mind. Everything was null to the senses, there was enclosure without substance, for the walls were dry and papery. Where were they standing, on earth, or suspended in some cardboard box? In the hearth was burnt paper, and scraps of half-burnt paper.

'Imagine that we passed our days here!' said Ursula.

'I know,' cried Gudrun. 'It is too appalling. What must we be like, if we are the contents of *tbis*?'

'Vile!' said Ursula. 'It really is.'

And she recognised half-burnt covers of 'Vogue' – half-burnt representations of women in gowns – lying under the grate.

They went to the drawing-room. Another piece of shut-in air; without weight or substance, only a sense of intolerable papery imprisonment in nothingness. The kitchen did look more substantial, because of the red-tiled floor and the stove, but it was cold and horrid.

The two girls tramped hollowly up the bare stairs. Every sound reechoed under their hearts. They tramped down the bare corridor. Against the wall of Ursula's bedroom were her things – a trunk, a work-basket, some books, loose coats, a hat-box, standing desolate in the universal emptiness of the dusk.

'A cheerful sight, aren't they?' said Ursula, looking down at her forsaken possessions.

'Very cheerful,' said Gudrun.

The two girls set to, carrying everything down to the front door. Again and again they made the hollow, re-echoing transit. The whole place seemed to resound about them with a noise of hollow, empty futility. In the distance the empty, invisible rooms sent forth a vibration almost of obscenity. They almost fled with the last articles, into the out-of-door.

But it was cold. They were waiting for Birkin, who was coming with the car. They went indoors again, and upstairs to their parents' front bedroom, whose windows looked down on the road, and across the country at the black-barred sunset, black and red barred, without light.

They sat down in the window-seat, to wait. Both girls were looking over the room. It was void, with a meaninglessness that was almost dreadful.

'Really,' said Ursula, 'this room *couldn't* be sacred, could it?' Gudrun looked over it with slow eyes.

'Impossible,' she replied.

'When I think of their lives – father's and mother's, their love, and their marriage, and all of us children, and our bringing-up – would you have such a life, Prune?'

'I wouldn't, Ursula.'

'It all seems so *nothing* – their two lives – there's no meaning in it. Really, if they had *not* met, and *not* married, and not lived together – it wouldn't have mattered, would it?'

'Of course - you can't tell,' said Gudrun.

'No. But if I thought my life was going to be like it - Prune,' she caught Gudrun's arm, 'I should run.'

Gudrun was silent for a few moments.

'As a matter of fact, one cannot contemplate the ordinary life – one cannot contemplate it,' replied Gudrun. 'With you, Ursula, it is quite different. You will be out of it all, with Birkin. He's a special case. But with the ordinary man, who has his life fixed in one place, marriage is just impossible. There may be, and there *are*, thousands of women who want it, and could conceive of nothing else. But the very thought of it sends me *mad*. One must be free, above all, one must be free. One may forfeit everything else, but one must be free – one must not become 7, Pinchbeck Street – or Somerset Drive – or Shortlands. No man will be sufficient to make that good – no man! To marry, one must have a free lance, or nothing, a comrade-in-arms, a Glücksritter. A man with a position in the social world – well, it is just impossible, impossible!'

'What a lovely word – a Glücksritter!' said Ursula. 'So much nicer than a soldier of fortune.'

'Yes, isn't it?' said Gudrun. 'I'd tilt the world with a Glücksritter. But a home, an establishment! Ursula, what would it mean? - think!'

'I know,' said Ursula. 'We've had one home – that's enough for me.' 'Quite enough,' said Gudrun.

'The little grey home in the west,' quoted Ursula ironically.

'Doesn't it sound grey, too,' said Gudrun grimly.

They were interrupted by the sound of the car. There was Birkin. Ursula was surprised that she felt so lit up, that she became suddenly so free from the problems of grey homes in the west.

They heard his heels click on the hall pavement below.

'Hello!' he called, his voice echoing alive through the house. Ursula smiled to herself. *He* was frightened of the place too.

'Hello! Here we are,' she called downstairs. And they heard him quickly running up.

'This is a ghostly situation,' he said.

'These houses don't have ghosts - they've never had any personality,

and only a place with personality can have a ghost,' said Gudrun.

'I suppose so. Are you both weeping over the past?'

'We are,' said Gudrun, grimly.

Ursula laughed.

'Not weeping that it's gone, but weeping that it ever *was*,' she said. 'Oh,' he replied, relieved.

He sat down for a moment. There was something in his presence, Ursula thought, lambent and alive. It made even the impertinent structure of this null house disappear.

'Gudrun says she could not bear to be married and put into a house,' said Ursula meaningful – they knew this referred to Gerald.

He was silent for some moments.

'Well,' he said, 'if you know beforehand you couldn't stand it, you're safe.'

'Quite!' said Gudrun.

'Why *does* every woman think her aim in life is to have a hubby and a little grey home in the west? Why is this the goal of life? Why should it be?' said Ursula.

'Il faut avoir le respect de ses bêtises,' said Birkin.

'But you needn't have the respect for the *bêtise* before you've committed it,' laughed Ursula.

'Ah then, des bêtises du papa?'

'Et de la maman,' added Gudrun satirically.

'Et des voisins,'105 said Ursula.

They all laughed, and rose. It was getting dark. They carried the things to the car. Gudrun locked the door of the empty house. Birkin had lighted the lamps of the automobile. It all seemed very happy, as if they were setting out.

'Do you mind stopping at Coulsons. I have to leave the key there,' said Gudrun.

'Right,' said Birkin, and they moved off.

They stopped in the main street. The shops were just lighted, the last miners were passing home along the causeways, half-visible shadows in their grey pit-dirt, moving through the blue air. But their feet rang harshly in manifold sound, along the pavement.

How pleased Gudrun was to come out of the shop, and enter the car, and be borne swiftly away into the downhill of palpable dusk, with Ursula and Birkin! What an adventure life seemed at this moment! How deeply, how suddenly she envied Ursula! Life for her was so quick, and an open door – so reckless as if not only this world, but the world that was gone and the world to come were nothing to her. Ah, if she could be *just like that*, it would be perfect.

For always, except in her moments of excitement, she felt a want within herself. She was unsure. She had felt that now, at last, in Gerald's strong and violent love, she was living fully and finally. But when she compared herself with Ursula, already her soul was jealous, unsatisfied. She was not satisfied – she was never to be satisfied.

What was she short of now? It was marriage – it was the wonderful stability of marriage. She did want it, let her say what she might. She had been lying. The old idea of marriage was right even now – marriage and the home. Yet her mouth gave a little grimace at the words. She thought of Gerald and Shortlands – marriage and the home! Ah well, let it rest! He meant a great deal to her – but – ! Perhaps it was not in her to marry. She was one of life's outcasts, one of the drifting lives that have no root. No, no it could not be so. She suddenly conjured up a rosy room, with herself in a beautiful gown, and a handsome man in evening dress who held her in his arms in the firelight, and kissed her. This picture she entitled 'Home.' It would have done for the Royal Academy.

'Come with us to tea -do,' said Ursula, as they ran nearer to the cottage of Willey Green.

'Thanks awfully – but I *must* go in – ' said Gudrun. She wanted very much to go on with Ursula and Birkin.

That seemed like life indeed to her. Yet a certain perversity would not let her.

'Do come - yes, it would be so nice,' pleaded Ursula.

'I'm awfully sorry - I should love to - but I can't - really - '

She descended from the car in trembling haste:

'Can't you really!' came Ursula's regretful voice.

'No, really I can't,' responded Gudrun's pathetic, chagrined words out of the dusk.

'All right, are you?' called Birkin.

'Quite!' said Gudrun. 'Good-night!'

'Good-night,' they called.

'Come whenever you like, we shall be glad,' called Birkin.

'Thank you very much,' called Gudrun, in the strange, twanging voice of lonely chagrin that was very puzzling to him. She turned away to her cottage gate, and they drove on. But immediately she stood to watch them, as the car ran vague into the distance. And as she went up the path to her strange house, her heart was full of incomprehensible bitterness.

In her parlour was a long-case clock, and inserted into its dial was a ruddy, round, slant-eyed, joyous-painted face, that wagged over with the most ridiculous ogle when the clock ticked, and back again with the

WOMEN IN LOVE

same absurd glad-eye at the next tick. All the time the absurd smooth, brown-ruddy face gave her an obtrusive 'glad-eye.' She stood for minutes, watching it, till a sort of maddened disgust overcame her, and she laughed at herself hollowly. And still it rocked, and gave her the glad-eye from one side, then from the other, from one side, then from the other. Ah, how unhappy she was! In the midst of her most active happiness, ah, how unhappy she was! She glanced at the table. Gooseberry jam, and the same home-made cake with too much soda in it! Still, gooseberry jam was good, and one so rarely got it.

All the evening she wanted to go to the Mill. But she coldly refused to allow herself. She went the next afternoon instead. She was happy to find Ursula alone. It was a lovely, intimate secluded atmosphere. They talked endlessly and delightedly. 'Aren't you *fearfully* happy here?' said Gudrun to her sister glancing at her own bright eyes in the mirror. She always envied, almost with resentment, the strange positive fullness that subsisted in the atmosphere around Ursula and Birkin.

'How really beautifully this room is done,' she said aloud. 'This hard plaited matting – what a lovely colour it is, the colour of cool light!'

And it seemed to her perfect.

'Ursula,' she said at length, in a voice of question and detachment, 'did you know that Gerald Crich had suggested our going away all together at Christmas?'

'Yes, he's spoken to Rupert.'

A deep flush dyed Gudrun's cheek. She was silent a moment, as if taken aback, and not knowing what to say.

'But don't you think,' she said at last, 'it is amazingly cool!'

Ursula laughed.

'I like him for it,' she said.

Gudrun was silent. It was evident that, whilst she was almost mortified by Gerald's taking the liberty of making such a suggestion to Birkin, yet the idea itself attracted her strongly.

'There's a rather lovely simplicity about Gerald, I think,' said Ursula, 'so defiant, somehow! Oh, I think he's *very* lovable.'

Gudrun did not reply for some moments. She had still to get over the feeling of insult at the liberty taken with her freedom.

'What did Rupert say - do you know?' she asked.

'He said it would be most awfully jolly,' said Ursula.

Again Gudrun looked down, and was silent.

'Don't you think it would?' said Ursula, tentatively. She was never quite sure how many defences Gudrun was having round herself.

Gudrun raised her face with difficulty and held it averted.

'I think it might be awfully jolly, as you say,' she replied. 'But don't you

think it was an unpardonable liberty to take – to talk of such things to Rupert – who after all – you see what I mean, Ursula – they might have been two men arranging an outing with some little *type* they'd picked up. Oh, I think it's unforgivable, quite!' She used the French word '*type*.'

Her eyes flashed, her soft face was flushed and sullen. Ursula looked on, rather frightened, frightened most of all because she thought Gudrun seemed rather common, really like a little *type*. But she had not the courage quite to think this – not right out.

'Oh no,' she cried, stammering. 'Oh no – not at all like that – oh no! No, I think it's rather beautiful, the friendship between Rupert and Gerald. They just are simple – they say anything to each other, like brothers.'

Gudrun flushed deeper. She could not *bear* it that Gerald gave her away - even to Birkin.

'But do you think even brothers have any right to exchange confidences of that sort?' she asked, with deep anger.

'Oh yes,' said Ursula. 'There's never anything said that isn't perfectly straightforward. No, the thing that's amazed me most in Gerald – how perfectly simple and direct he can be! And you know, it takes rather a big man. Most of them *must* be indirect, they are such cowards.'

But Gudrun was still silent with anger. She wanted the absolute secrecy kept, with regard to her movements.

'Won't you go?' said Ursula. 'Do, we might all be so happy! There is something I *love* about Gerald – he's *much* more lovable than I thought him. He's free, Gudrun, he really is.'

Gudrun's mouth was still closed, sullen and ugly. She opened it at length.

'Do you know where he proposes to go?' she asked.

'Yes – to the Tyrol, where he used to go when he was in Germany – a lovely place where students go, small and rough and lovely, for winter sport!'

Through Gudrun's mind went the angry thought - 'they know everything.'

'Yes,' she said aloud, 'about forty kilometres from Innsbruck, isn't it?'

'I don't know exactly where - but it would be lovely, don't you think, high in the perfect snow -?'

'Very lovely!' said Gudrun, sarcastically.

Ursula was put out.

'Of course,' she said, 'I think Gerald spoke to Rupert so that it shouldn't seem like an outing with a type - '

'I know, of course,' said Gudrun, 'that he quite commonly does take up with that sort.'

WOMEN IN LOVE

'Does he!' said Ursula. 'Why how do you know?'

'I know of a model in Chelsea,' said Gudrun coldly. Now Ursula was silent. 'Well,' she said at last, with a doubtful laugh, 'I hope he has a good time with her.' At which Gudrun looked more glum.

CHAPTER XXVIII

Gudrun in the Pompadour

CHRISTMAS DREW NEAR, all four prepared for flight. Birkin and Ursula were busy packing their few personal things, making them ready to be sent off, to whatever country and whatever place they might choose at last. Gudrun was very much excited. She loved to be on the wing.

She and Gerald, being ready first, set off via London and Paris to Innsbruck, where they would meet Ursula and Birkin. In London they stayed one night. They went to the music-hall, and afterwards to the Pompadour Café.

Gudrun hated the Café, yet she always went back to it, as did most of the artists of her acquaintance. She loathed its atmosphere of petty vice and petty jealousy and petty art. Yet she always called in again, when she was in town. It was as if she *bad* to return to this small, slow, central whirlpool of disintegration and dissolution: just give it a look.

She sat with Gerald drinking some sweetish liqueur, and staring with black, sullen looks at the various groups of people at the tables. She would greet nobody, but young men nodded to her frequently, with a kind of sneering familiarity. She cut them all. And it gave her pleasure to sit there, cheeks flushed, eyes black and sullen, seeing them all objectively, as put away from her, like creatures in some menagerie of apish degraded souls. God, what a foul crew they were! Her blood beat black and thick in her veins with rage and loathing. Yet she must sit and watch, watch. One or two people came to speak to her. From every side of the Café, eyes turned half furtively, half jeeringly at her, men looking over their shoulders, women under their hats.

The old crowd was there, Carlyon in his corner with his pupils and his girl, Halliday and Libidnikov and the Pussum – they were all there. Gudrun watched Gerald. She watched his eyes linger a moment on Halliday, on Halliday's party. These last were on the look-out – they nodded to him, he nodded again. They giggled and whispered among themselves. Gerald watched them with the steady twinkle in his eyes. They were urging the Pussum to something. She at last rose. She was wearing a curious dress of dark silk splashed and spattered with different colours, a curious motley effect. She was thinner, her eyes were perhaps hotter, more disintegrated. Otherwise she was just the same. Gerald watched her with the same steady twinkle in his eyes as she came across. She held out her thin brown hand to him.

'How are you?' she said.

He shook hands with her, but remained seated, and let her stand near him, against the table. She nodded blackly to Gudrun, whom she did not know to speak to, but well enough by sight and reputation.

'I am very well,' said Gerald. 'And you?'

'Oh I'm all wight. What about Wupert?'

'Rupert? He's very well, too.'

'Yes, I don't mean that. What about him being married?'

'Oh - yes, he is married.'

The Pussum's eyes had a hot flash.

'Oh, he's weally bwought it off then, has he? When was he married?' 'A week or two ago.'

'Weally! He's never written.'

'No.'

'No. Don't you think it's too bad?'

This last was in a tone of challenge. The Pussum let it be known by her tone, that she was aware of Gudrun's listening.

'I suppose he didn't feel like it,' replied Gerald.

'But why didn't he?' pursued the Pussum.

This was received in silence. There was an ugly, mocking persistence in the small, beautiful figure of the short-haired girl, as she stood near Gerald.

'Are you staying in town long?' she asked.

'Tonight only.'

'Oh, only tonight. Are you coming over to speak to Julius?'

'Not tonight.'

'Oh very well. I'll tell him then.' Then came her touch of diablerie. 'You're looking awf'lly fit.'

'Yes - I feel it.' Gerald was quite calm and easy, a spark of satiric amusement in his eye.

'Are you having a good time?'

This was a direct blow for Gudrun, spoken in a level, toneless voice of callous ease.

'Yes,' he replied, quite colourlessly.

'I'm awf'lly sorry you aren't coming round to the flat. You aren't very faithful to your fwiends.'

'Not very,' he said.

She nodded them both 'Good-night', and went back slowly to her own set. Gudrun watched her curious walk, stiff and jerking at the loins. They heard her level, toneless voice distinctly.

'He won't come over; - he is otherwise engaged,' it said. There was more laughter and lowered voices and mockery at the table.

'Is she a friend of yours?' said Gudrun, looking calmly at Gerald.

'I've stayed at Halliday's flat with Birkin,' he said, meeting her slow, calm eyes. And she knew that the Pussum was one of his mistresses – and he knew she knew.

She looked round, and called for the waiter. She wanted an iced cocktail, of all things. This amused Gerald – he wondered what was up.

The Halliday party was tipsy, and malicious. They were talking out loudly about Birkin, ridiculing him on every point, particularly on his marriage.

'Oh, *don't* make me think of Birkin,' Halliday was squealing. 'He makes me perfectly sick. He is as bad as Jesus. "Lord, *what* must I do to be saved!" '

He giggled to himself tipsily.

'Do you remember,' came the quick voice of the Russian, 'the letters he used to send. "Desire is holy – "'

'Oh yes!' cried Halliday. 'Oh, how perfectly splendid. Why, I've got one in my pocket. I'm sure I have.'

He took out various papers from his pocket book.

'I'm sure I've - bic! Ob dear! - got one.'

Gerald and Gudrun were watching absorbedly.

'Oh yes, how perfectly – *hic!* – splendid! Don't make me laugh, Pussum, it gives me the hiccup. Hic! – 'They all giggled.

'What did he say in that one?' the Pussum asked, leaning forward, her dark, soft hair falling and swinging against her face. There was something curiously indecent, obscene, about her small, longish, dark skull, particularly when the ears showed.

'Wait – oh do wait! *No-o*, I won't give it to you, I'll read it aloud. I'll read you the choice bits, – hic! Oh dear! Do you think if I drink water it would take off this hiccup? *Hic!* Oh, I feel perfectly helpless.'

'Isn't that the letter about uniting the dark and the light – and the Flux of Corruption?' asked Maxim, in his precise, quick voice.

'I believe so,' said the Pussum.

'Oh is it? I'd forgotten – *bic*! – it was that one,' Halliday said, opening the letter. '*Hic*! Oh yes. How perfectly splendid! This is one of the best. "There is a phase in every race – " ' he read in the sing-song, slow, distinct voice of a clergyman reading the Scriptures, ' "when the desire for destruction overcomes every other desire. In the individual, this

desire is ultimately a desire for destruction in the self" - bic! -' he paused and looked up.

'I hope he's going ahead with the destruction of himself,' said the quick voice of the Russian. Halliday giggled, and lolled his head back, vaguely.

'There's not much to destroy in him,' said the Pussum. 'He's so thin already, there's only a fag-end to start on.'

'Oh, isn't it beautiful! I love reading it! I believe it has cured my hiccup!' squealed Halliday. 'Do let me go on. "It is a desire for the reduction process in oneself, a reducing back to the origin, a return along the Flux of Corruption, to the original rudimentary conditions of being -!" Oh, but I *do* think it is wonderful. It almost supersedes the Bible -'

'Yes - Flux of Corruption,' said the Russian, 'I remember that phrase.'

'Oh, he was always talking about Corruption,' said the Pussum. 'He must be corrupt himself, to have it so much on his mind.'

'Exactly!' said the Russian.

'Do let me go on! Oh, this is a perfectly wonderful piece! But do listen to this. "And in the great retrogression, the reducing back of the created body of life, we get knowledge, and beyond knowledge, the phosphorescent ecstasy of acute sensation." Oh, I do think these phrases are too absurdly wonderful. Oh but don't you think they *are* – they're nearly as good as Jesus. "And if, Julius, you want this ecstasy of reduction with the Pussum, you must go on till it is fulfilled. But surely there is in you also, somewhere, the living desire for positive creation, relationships in ultimate faith, when all this process of active corruption, with all its flowers of mud, is transcended, and more or less finished – "I do wonder what the flowers of mud are. Pussum, you are a flower of mud.'

'Thank you - and what are you?'

'Oh, I'm another, surely, according to this letter! We're all flowers of mud – *Fleurs – hic! du mal!* It's perfectly wonderful, Birkin harrowing Hell – harrowing the Pompadour – *Hic!*'

'Go on - go on,' said Maxim. 'What comes next? It's really very interesting.'

'I think it's awful cheek to write like that,' said the Pussum.

'Yes – yes, so do I,' said the Russian. 'He is a megalomaniac, of course, it is a form of religious mania. He thinks he is the Saviour of man – go on reading.'

'Surely,' Halliday intoned, ' "surely goodness and mercy hath followed me all the days of my life – " ' he broke off and giggled. Then

he began again, intoning like a clergyman. '"Surely there will come an end in us to this desire – for the constant going apart, – this passion for putting asunder – everything – ourselves, reducing ourselves part from part – reacting in intimacy only for destruction, – using sex as a great reducing agent, reducing the two great elements of male and female from their highly complex unity – reducing the old ideas, going back to the savages for our sensations, – always seeking to *lose* ourselves in some ultimate black sensation, mindless and infinite – burning only with destructive fires, raging on with the hope of being burnt out utterly – "'

'I want to go,' said Gudrun to Gerald, as she signalled the waiter. Her eyes were flashing, her cheeks were flushed. The strange effect of Birkin's letter read aloud in a perfect clerical sing-song, clear and resonant, phrase by phrase, made the blood mount into her head as if she were mad.

She rose, whilst Gerald was paying the bill, and walked over to Halliday's table. They all glanced up at her.

'Excuse me,' she said. 'Is that a genuine letter you are reading?'

'Oh yes,' said Halliday. 'Quite genuine.'

'May I see?'

Smiling foolishly he handed it to her, as if hypnotised.

'Thank you,' she said.

And she turned and walked out of the Café with the letter, all down the brilliant room, between the tables, in her measured fashion. It was some moments before anybody realised what was happening.

From Halliday's table came half articulate cries, then somebody booed, then all the far end of the place began booing after Gudrun's retreating form. She was fashionably dressed in blackish-green and silver, her hat was brilliant green, like the sheen on an insect, but the brim was soft dark green, a falling edge with fine silver, her coat was dark green, lustrous, with a high collar of grey fur, and great fur cuffs, the edge of her dress showed silver and black velvet, her stockings and shoes were silver grey. She moved with slow, fashionable indifference to the door. The porter opened obsequiously for her, and, at her nod, hurried to the edge of the pavement and whistled for a taxi. The two lights of a vehicle almost immediately curved round towards her, like two eyes.

Gerald had followed in wonder, amid all the booing, not having caught her misdeed. He heard the Pussum's voice saying:

'Go and get it back from her. I never heard of such a thing! Go and get it back from her. Tell Gerald Crich – there he goes – go and make him give it up.'

Gudrun stood at the door of the taxi, which the man held open for her.

'To the hotel?' she asked, as Gerald came out, hurriedly.

'Where you like,' he answered.

'Right!' she said. Then to the driver, 'Wagstaff's – Barton Street.' The driver bowed his head, and put down the flag.

Gudrun entered the taxi, with the deliberate cold movement of a woman who is well-dressed and contemptuous in her soul. Yet she was frozen with overwrought feelings. Gerald followed her.

'You've forgotten the man,' she said coolly, with a slight nod of her hat. Gerald gave the porter a shilling. The man saluted. They were in motion.

'What was all the row about?' asked Gerald, in wondering excitement.

'I walked away with Birkin's letter,' she said, and he saw the crushed paper in her hand.

His eyes glittered with satisfaction.

'Ah!' he said. 'Splendid! A set of jackasses!'

'I could have *killed* them!' she cried in passion. '*Dogs!* – they are dogs! Why is Rupert such a *fool* as to write such letters to them? Why does he give himself away to such canaille?¹⁰⁶ It's a thing that *cannot be borne*.'

Gerald wondered over her strange passion.

And she could not rest any longer in London. They must go by the morning train from Charing Cross. As they drew over the bridge, in the train, having glimpses of the river between the great iron girders, she cried:

'I feel I could *never* see this foul town again – I couldn't *bear* to come back to it.'

CHAPTER XXIX

Continental

URSULA WENT on in an unreal suspense, the last weeks before going away. She was not herself, – she was not anything. She was something that is going to be – soon – soon – very soon. But as yet, she was only imminent.

She went to see her parents. It was a rather stiff, sad meeting, more like a verification of separateness than a reunion. But they were all vague and indefinite with one another, stiffened in the fate that moved them apart.

She did not really come to until she was on the ship crossing from

Dover to Ostend. Dimly she had come down to London with Birkin, London had been a vagueness, so had the train-journey to Dover. It was all like a sleep.

And now, at last, as she stood in the stern of the ship, in a pitch-dark, rather blowy night, feeling the motion of the sea, and watching the small, rather desolate little lights that twinkled on the shores of England, as on the shores of nowhere, watched them sinking smaller and smaller on the profound and living darkness, she felt her soul stirring to awake from its anaesthetic sleep.

'Let us go forward, shall we?' said Birkin. He wanted to be at the tip of their projection. So they left off looking at the faint sparks that glimmered out of nowhere, in the far distance, called England, and turned their faces to the unfathomed night in front.

They went right to the bows of the softly plunging vessel. In the complete obscurity, Birkin found a comparatively sheltered nook, where a great rope was coiled up. It was quite near the very point of the ship, near the black, unpierced space ahead. There they sat down, folded together, folded round with the same rug, creeping in nearer and ever nearer to one another, till it seemed they had crept right into each other, and become one substance. It was very cold, and the darkness was palpable.

One of the ship's crew came along the deck, dark as the darkness, not really visible. They then made out the faintest pallor of his face. He felt their presence, and stopped, unsure – then bent forward. When his face was near them, he saw the faint pallor of their faces. Then he withdrew like a phantom. And they watched him without making any sound.

They seemed to fall away into the profound darkness. There was no sky, no earth, only one unbroken darkness, into which, with a soft, sleeping motion, they seemed to fall like one closed seed of life falling through dark, fathomless space.

They had forgotten where they were, forgotten all that was and all that had been, conscious only in their heart, and there conscious only of this pure trajectory through the surpassing darkness. The ship's prow cleaved on, with a faint noise of cleavage, into the complete night, without knowing, without seeing, only surging on.

In Ursula the sense of the unrealised world ahead triumphed over everything. In the midst of this profound darkness, there seemed to glow on her heart the effulgence of a paradise unknown and unrealised. Her heart was full of the most wonderful light, golden like honey of darkness, sweet like the warmth of day, a light which was not shed on the world, only on the unknown paradise towards which she was going, a sweetness of habitation, a delight of living quite unknown, but hers

infallibly. In her transport she lifted her face suddenly to him, and he touched it with his lips. So cold, so fresh, so sea-clear her face was, it was like kissing a flower that grows near the surf.

But he did not know the ecstasy of bliss in fore-knowledge that she knew. To him, the wonder of this transit was overwhelming. He was falling through a gulf of infinite darkness, like a meteorite plunging across the chasm between the worlds. The world was torn in two, and he was plunging like an unlit star through the ineffable rift. What was beyond was not yet for him. He was overcome by the trajectory.

In a trance he lay enfolding Ursula round about. His face was against her fine, fragile hair, he breathed its fragrance with the sea and the profound night. And his soul was at peace; yielded, as he fell into the unknown. This was the first time that an utter and absolute peace had entered his heart, now, in this final transit out of life.

When there came some stir on the deck, they roused. They stood up. How stiff and cramped they were, in the night-time! And yet the paradisal glow on her heart, and the unutterable peace of darkness in his, this was the all-in-all.

They stood up and looked ahead. Low lights were seen down the darkness. This was the world again. It was not the bliss of her heart, nor the peace of his. It was the superficial unreal world of fact. Yet not quite the old world. For the peace and the bliss in their hearts was enduring.

Strange, and desolate above all things, like disembarking from the Styx into the desolated underworld, was this landing at night. There was the raw, half-lighted, covered-in vastness of the dark place, boarded and hollow underfoot, with only desolation everywhere. Ursula had caught sight of the big, pallid, mystic letters 'OSTEND,' standing in the darkness. Everybody was hurrying with a blind, insect-like intentness through the dark grey air, porters were calling in un-English English, then trotting with heavy bags, their colourless blouses looking ghostly as they disappeared; Ursula stood at a long, low, zinc-covered barrier, along with hundreds of other spectral people, and all the way down the vast, raw darkness was this low stretch of open bags and spectral people, whilst, on the other side of the barrier, pallid officials in peaked caps and moustaches were turning the underclothing in the bags, then scrawling a chalk-mark.

It was done. Birkin snapped the hand bags, off they went, the porter coming behind. They were through a great doorway, and in the open night again - ah, a railway platform! Voices were still calling in inhuman agitation through the dark-grey air, spectres were running along the darkness between the train.

'Köln – Berlin – ' Ursula made out on the boards hung on the high train on one side.

'Here we are,' said Birkin. And on her side she saw: 'Elsass - Lothringen - Luxembourg, Metz - Basle.'

'That was it, Basle!'

The porter came up.

'A Bâle – deuxième classe? – Voilà!' And he clambered into the high train. They followed. The compartments were already some of them taken. But many were dim and empty. The luggage was stowed, the porter was tipped.

'Nous avons encore - ?' said Birkin, looking at his watch and at the porter.

'Encore une demi-heure.'¹⁰⁷ With which, in his blue blouse, he disappeared. He was ugly and insolent.

'Come,' said Birkin. 'It is cold. Let us eat.'

There was a coffee-wagon on the platform. They drank hot, watery coffee, and ate the long rolls, split, with ham between, which were such a wide bite that it almost dislocated Ursula's jaw; and they walked beside the high trains. It was all so strange, so extremely desolate, like the underworld, grey, grey, dirt grey, desolate, forlorn, nowhere – grey, dreary nowhere.

At last they were moving through the night. In the darkness Ursula made out the flat fields, the wet flat dreary darkness of the Continent. They pulled up surprisingly soon – Bruges! Then on through the level darkness, with glimpses of sleeping farms and thin poplar trees and deserted high-roads. She sat dismayed, hand in hand with Birkin. He pale, immobile like a *revenant* himself, looked sometimes out of the window, sometimes closed his eyes. Then his eyes opened again, dark as the darkness outside.

A flash of a few lights on the darkness – Ghent station! A few more spectres moving outside on the platform – then the bell – then motion again through the level darkness. Ursula saw a man with a lantern come out of a farm by the railway, and cross to the dark farm-buildings. She thought of the Marsh, the old, intimate farm-life at Cossethay. My God, how far was she projected from her childhood, how far was she still to go! In one life-time one travelled through æons. The great chasm of memory from her childhood in the intimate country surroundings of Cossethay and the Marsh Farm – she remembered the servant Tilly, who used to give her bread and butter sprinkled with brown sugar, in the old living-room where the grandfather clock had two pink roses in a basket painted above the figures on the face – and now when she was travelling into the unknown with Birkin, an utter

stranger – was so great, that it seemed she had no identity, that the child she had been, playing in Cossethay churchyard, was a little creature of history, not really herself.¹⁰⁸

They were at Brussels – half an hour for breakfast. They got down. On the great station clock it said six o'clock. They had coffee and rolls and honey in the vast desert refreshment room, so dreary, always so dreary, dirty, so spacious, such desolation of space. But she washed her face and hands in hot water, and combed her hair – that was a blessing.

Soon they were in the train again and moving on. The greyness of dawn began. There were several people in the compartment, large florid Belgian business-men with long brown beards, talking incessantly in an ugly French she was too tired to follow.

It seemed the train ran by degrees out of the darkness into a faint light, then beat after beat into the day. Ah, how weary it was! Faintly, the trees showed, like shadows. Then a house, white, had a curious distinctness. How was it? Then she saw a village – there were always houses passing.

This was an old world she was still journeying through, winter-heavy and dreary. There was plough-land and pasture, and copses of bare trees, copses of bushes, and homesteads naked and work-bare. No new earth had come to pass.

She looked at Birkin's face. It was white and still and eternal, too eternal. She linked her fingers imploringly in his, under the cover of her rug. His fingers responded, his eyes looked back at her. How dark, like a night, his eyes were, like another world beyond! Oh, if he were the world as well, if only the world were he! If only he could call a world into being, that should be their own world!

The Belgians left, the train ran on, through Luxembourg, through Alsace-Lorraine, through Metz. But she was blind, she could see no more. Her soul did not look out.

They came at last to Basle, to the hotel. It was all a drifting trance, from which she never came to. They went out in the morning, before the train departed. She saw the street, the river, she stood on the bridge. But it all meant nothing. She remembered some shops – one full of pictures, one with orange velvet and ermine. But what did these signify? – nothing.

She was not at ease till they were in the train again. Then she was relieved. So long as they were moving onwards, she was satisfied. They came to Zürich, then, before vcry long, ran under the mountains, that were deep in snow. At last she was drawing near. This was the other world now.

Innsbruck was wonderful, deep in snow, and evening. They drove in

an open sledge over the snow: the train had been so hot and stifling. And the hotel, with the golden light glowing under the porch, seemed like a home.

They laughed with pleasure when they were in the hall. The place seemed full and busy.

'Do you know if Mr and Mrs Crich – English – from Paris, have arrived?' Birkin asked in German.

The porter reflected a moment, and was just going to answer, when Ursula caught sight of Gudrun sauntering down the stairs, wearing her dark glossy coat, with grey fur.

'Gudrun! Gudrun!' she called, waving up the well of the staircase. 'Shu-hu!'

Gudrun looked over the rail, and immediately lost her sauntering, diffident air. Her eyes flashed.

'Really – Ursula!' she cried. And she began to move downstairs as Ursula ran up. They met at a turn and kissed with laughter and exclamations inarticulate and stirring.

'But!' cried Gudrun, mortified. 'We thought it was *tomorrow* you were coming! I wanted to come to the station.'

'No, we've come today!' cried Ursula. 'Isn't it lovely here!'

'Adorable!' said Gudrun. 'Gerald's just gone out to get something. Ursula, aren't you *fearfully* tired?'

'No, not so very. But I look a filthy sight, don't I!'

'No, you don't. You look almost perfectly fresh. I like that fur cap *immensely!*' She glanced over Ursula, who wore a big soft coat with a collar of deep, soft, blond fur, and a soft blond cap of fur.

'And you!' cried Ursula. 'What do you think you look like!'

Gudrun assumed an unconcerned, expressionless face.

'Do you like it?' she said.

'It's very fine!' cried Ursula, perhaps with a touch of satire.

'Go up – or come down,' said Birkin. For there the sisters stood, Gudrun with her hand on Ursula's arm, on the turn of the stairs half way to the first landing, blocking the way and affording full entertainment to the whole of the hall below, from the door porter to the plump Jew in black clothes.

The two young women slowly mounted, followed by Birkin and the waiter.

'First floor?' asked Gudrun, looking back over her shoulder.

'Second Madam – the lift!' the waiter replied. And he darted to the elevator to forestall the two women. But they ignored him, as, chattering without heed, they set to mount the second flight. Rather chagrined, the waiter followed.

It was curious, the delight of the sisters in each other, at this meeting. It was as if they met in exile, and united their solitary forces against all the world. Birkin looked on with some mistrust and wonder.

When they had bathed and changed, Gerald came in. He looked shining like the sun on frost.

'Go with Gerald and smoke,' said Ursula to Birkin. 'Gudrun and I want to talk.'

Then the sisters sat in Gudrun's bedroom, and talked clothes, and experiences. Gudrun told Ursula the experience of the Birkin letter in the café. Ursula was shocked and frightened.

'Where is the letter?' she asked.

'I kept it,' said Gudrun.

'You'll give it me, won't you?' she said.

But Gudrun was silent for some moments, before she replied:

'Do you really want it, Ursula?'

'I want to read it,' said Ursula.

'Certainly,' said Gudrun.

Even now, she could not admit, to Ursula, that she wanted to keep it, as a memento, or a symbol. But Ursula knew, and was not pleased. So the subject was switched off.

'What did you do in Paris?' asked Ursula.

'Oh,' said Gudrun laconically – 'the usual things. We had a *fine* party one night in Fanny Bath's studio.'

'Did you? And you and Gerald were there! Who else? Tell me about it.'

Well,' said Gudrun. 'There's nothing particular to tell. You know Fanny is *frightfully* in love with that painter, Billy Macfarlane. He was there – so Fanny spared nothing, she spent *very* freely. It was really remarkable! Of course, everybody got fearfully drunk – but in an interesting way, not like that filthy London crowd. The fact is these were all people that matter, which makes all the difference. There was a Roumanian, a fine chap. He got completely drunk, and climbed to the top of a high studio ladder, and gave the most marvellous address – really, Ursula, it was wonderful! He began in French – La vie, c'est une affaire d'âmes impériales¹⁰⁹ – in a most beautiful voice – he was a finelooking chap – but he had got into Roumanian before he had finished, and not a soul understood. But Donald Gilchrist was worked to a frenzy. He dashed his glass to the ground, and declared, by God, he was glad he had been born, by God, it was a miracle to be alive. And do you know, Ursula, so it was – 'Gudrun laughed rather hollowly.

'But how was Gerald among them all?' asked Ursula.

'Gerald! Oh, my word, he came out like a dandelion in the sun! He's

a whole saturnalia¹¹⁰ in himself, once he is roused. I shouldn't like to say whose waist his arm did not go round. Really, Ursula, he seems to reap the women like a harvest. There wasn't one that would have resisted him. It was too amazing! Can you understand it?'

Ursula reflected, and a dancing light came into her eyes.

'Yes,' she said. 'I can. He is such a whole-hogger.'

'Whole-hogger! I should think so!' exclaimed Gudrun. 'But it is true, Ursula, every woman in the room was ready to surrender to him. Chanticleer¹¹¹ isn't in it – even Fanny Bath, who is *genuinely* in love with Billy Macfarlane! I never was more amazed in my life! And you know, afterwards – I felt I was a whole *roomful* of women. I was no more myself to him, than I was Queen Victoria. I was a whole roomful of women at once. It was most astounding! But my eye, I'd caught a Sultan that time – '

Gudrun's eyes were flashing, her cheek was hot, she looked strange, exotic, satiric. Ursula was fascinated at once – and yet uneasy.

They had to get ready for dinner. Gudrun came down in a daring gown of vivid green silk and tissue of gold, with green velvet bodice and a strange black-and-white band round her hair. She was really brilliantly beautiful and everybody noticed her. Gerald was in that fullblooded, gleaming state when he was most handsome. Birkin watched them with quick, laughing, half-sinister eyes, Ursula quite lost her head. There seemed a spell, almost a blinding spell, cast round their table, as if they were lighted up more strongly than the rest of the dining-room.

'Don't you love to be in this place?' cried Gudrun. 'Isn't the snow wonderful! Do you notice how it exalts everything? It is simply marvellous. One really does feel *übermenschlich*¹¹² – more than human.'

'One does,' cried Ursula. 'But isn't that partly the being out of England?'

'Oh, of course,' cried Gudrun. 'One could never feel like this in England, for the simple reason that the damper is *never* lifted off one, there. It is quite impossible really to let go, in England, of that I am assured.'

And she turned again to the food she was eating. She was fluttering with vivid intensity.

'It's quite true,' said Gerald, 'it never is quite the same in England. But perhaps we don't want it to be – perhaps it's like bringing the light a little too near the powder-magazine, to let go altogether, in England. One is afraid what might happen, if *everybody else* let go.'

'My God!' cried Gudrun. 'But wouldn't it be wonderful, if all England did suddenly go off like a display of fireworks.'

WOMEN IN LOVE

'It couldn't,' said Ursula. 'They are all too damp, the powder is damp in them.'

'I'm not so sure of that,' said Gerald.

'Nor I,' said Birkin. 'When the English really begin to go off, en masse, it'll be time to shut your ears and run.'

'They never will,' said Ursula.

'We'll see,' he replied.

'Isn't it marvellous,' said Gudrun, 'how thankful one can be, to be out of one's country. I cannot believe myself, I am so transported, the moment I set foot on a foreign shore. I say to myself "Here steps a new creature into life." '

'Don't be too hard on poor old England,' said Gerald. 'Though we curse it, we love it really.'

To Ursula, there seemed a fund of cynicism in these words.

'We may,' said Birkin. 'But it's a damnably uncomfortable love: like a love for an aged parent who suffers horribly from a complication of diseases, for which there is no hope.'

Gudrun looked at him with dilated dark eyes.

'You think there is no hope?' she asked, in her pertinent fashion.

But Birkin backed away. He would not answer such a question.

'Any hope of England's becoming real? God knows. It's a great actual unreality now, an aggregation into unreality. It might be real, if there were no Englishmen.'

'You think the English will have to disappear?' persisted Gudrun. It was strange, her pointed interest in his answer. It might have been her own fate she was inquiring after. Her dark, dilated eyes rested on Birkin, as if she could conjure the truth of the future out of him, as out of some instrument of divination.

He was pale. Then, reluctantly, he answered:

'Well – what else is in front of them, but disappearance? They've got to disappear from their own special brand of Englishness, anyhow.'

Gudrun watched him as if in a hypnotic state, her eyes wide and fixed on him.

'But in what way do you mean, disappear? - ' she persisted.

'Yes, do you mean a change of heart?' put in Gerald.

'I don't mean anything, why should I?' said Birkin. 'I'm an Englishman, and I've paid the price of it. I can't talk about England – I can only speak for myself.'

'Yes,' said Gudrun slowly, 'you love England immensely, *immensely*, Rupert.'

'And leave her,' he replied.

'No, not for good. You'll come back,' said Gerald, nodding sagely.

'They say the lice crawl off a dying body,' said Birkin, with a glare of bitterness. 'So I leave England.'

'Ah, but you'll come back,' said Gudrun, with a sardonic smile.

'Tant pis pour moi,'113 he replied.

'Isn't he angry with his mother country!' laughed Gerald, amused.

'Ah, a patriot!' said Gudrun, with something like a sneer.

Birkin refused to answer any more.

Gudrun watched him still for a few seconds. Then she turned away. It was finished, her spell of divination in him. She felt already purely cynical. She looked at Gerald. He was wonderful like a piece of radium to her. She felt she could consume herself and know *all*, by means of this fatal, living metal. She smiled to herself at her fancy. And what would she do with herself, when she had destroyed herself? For if spirit, if integral being is destructible, Matter is indestructible.

He was looking bright and abstracted, puzzled, for the moment. She stretched out her beautiful arm, with its fluff of green tulle, and touched his chin with her subtle, artist's fingers.

'What are they then?' she asked, with a strange, knowing smile.

'What?' he replied, his eyes suddenly dilating with wonder.

'Your thoughts.'

Gerald looked like a man coming awake.

'I think I had none,' he said.

'Really!' she said, with grave laughter in her voice.

And to Birkin it was as if she killed Gerald, with that touch.

'Ah but,' cried Gudrun, 'let us drink to Britannia – let us drink to Britannia.'

It seemed there was wild despair in her voice. Gerald laughed, and filled the glasses.

'I think Rupert means,' he said, 'that *nationally* all Englishmen must die, so that they can exist individually and – '

'Super-nationally - ' put in Gudrun, with a slight ironic grimace, raising her glass.

The next day, they descended at the tiny railway station of Hohenhausen, at the end of the tiny valley railway. It was snow everywhere, a white, perfect cradle of snow, new and frozen, sweeping up an either side, black crags, and white sweeps of silver towards the blue pale heavens.

As they stepped out on the naked platform, with only snow around and above, Gudrun shrank as if it chilled her heart.

'My God, Jerry,' she said, turning to Gerald with sudden intimacy, 'you've done it now.'

'What?'

She made a faint gesture, indicating the world on either hand. 'Look at it!'

She seemed afraid to go on. He laughed.

They were in the heart of the mountains. From high above, on either side, swept down the white fold of snow, so that one seemed small and tiny in a valley of pure concrete heaven, all strangely radiant and changeless and silent.

'It makes one feel so small and alone,' said Ursula, turning to Birkin and laying her hand on his arm.

'You're not sorry you've come, are you?' said Gerald to Gudrun.

She looked doubtful. They went out of the station between banks of snow.

'Ah,' said Gerald, sniffing the air in elation, 'this is perfect. There's our sledge. We'll walk a bit – we'll run up the road.'

Gudrun, always doubtful, dropped her heavy coat on the sledge, as he did his, and they set off. Suddenly she threw up her head and set off scudding along the road of snow, pulling her cap down over her ears. Her blue, bright dress fluttered in the wind, her thick scarlet stockings were brilliant above the whiteness. Gerald watched her: she seemed to be rushing towards her fate, and leaving him behind. He let her get some distance, then, loosening his limbs, he went after her.

Everywhere was deep and silent snow. Great snow-eaves weighed down the broad-roofed Tyrolese houses, that were sunk to the window-sashes in snow. Peasant-women, full-skirted, wearing each a cross-over shawl, and thick snow-boots, turned in the way to look at the soft, determined girl running with such heavy fleetness from the man, who was overtaking her, but not gaining any power over her.

They passed the inn with its painted shutters and balcony, a few cottages, half buried in the snow; then the snow-buried silent sawmill by the roofed bridge, which crossed the hidden stream, over which they ran into the very depth of the untouched sheets of snow. It was a silence and a sheer whiteness exhilarating to madness. But the perfect silence was most terrifying, isolating the soul, surrounding the heart with frozen air.

'It's a marvellous place, for all that,' said Gudrun, looking into his eyes with a strange, meaning look. His soul leapt.

'Good,' he said.

A fierce electric energy seemed to flow over all his limbs, his muscles were surcharged, his hands felt hard with strength. They walked along rapidly up the snow-road, that was marked by withered branches of trees stuck in at intervals. He and she were separate, like opposite poles of one fierce energy. But they felt powerful enough to leap over the confines of life into the forbidden places, and back again.

Birkin and Ursula were running along also, over the snow. He had disposed of the luggage, and they had a little start of the sledges. Ursula was excited and happy, but she kept turning suddenly to catch hold of Birkin's arm, to make sure of him.

'This is something I never expected,' she said. 'It is a different world, here.'

They went on into a snow meadow. There they were overtaken by the sledge, that came tinkling through the silence. It was another mile before they came upon Gudrun and Gerald on the steep up-climb, beside the pink, half-buried shrine.

Then they passed into a gulley, where were walls of black rock and a river filled with snow, and a still blue sky above. Through a covered bridge they went, drumming roughly over the boards, crossing the snow-bed once more, then slowly up and up, the horses walking swiftly, the driver cracking his long whip as he walked beside, and calling his strange wild *bue-bue!*, the walls of rock passing slowly by, till they emerged again between slopes and masses of snow. Up and up, gradually they went, through the cold shadow-radiance of the afternoon, silenced by the imminence of the mountains, the luminous, dazing sides of snow that rose above them and fell away beneath.

They came forth at last in a little high table-land of snow, where stood the last peaks of snow like the heart petals of an open rose. In the midst of the last deserted valleys of heaven stood a lonely building with brown wooden walls and white heavy roof, deep and deserted in the waste of snow, like a dream. It stood like a rock that had rolled down from the last steep slopes, a rock that had taken the form of a house, and was now half-buried. It was unbelievable that one could live there uncrushed by all this terrible waste of whiteness and silence and clear, upper, ringing cold.

Yet the sledges ran up in fine style, people came to the door laughing and excited, the floor of the hostel rang hollow, the passage was wet with snow, it was a real, warm interior.

The new-comers tramped up the bare wooden stairs, following the serving woman. Gudrun and Gerald took the first bedroom. In a moment they found themselves alone in a bare, smallish, close-shut room that was all of golden-coloured wood, floor, walls, ceiling, door, all of the same warm gold panelling of oiled pine. There was a window opposite the door, but low down, because the roof sloped. Under the slope of the ceiling were the table with wash-hand bowl and jug, and across, another table with mirror. On either side the door were two beds piled high with an enormous blue-checked overbolster, enormous.

This was all – no cupboard, none of the amenities of life. Here they were shut up together in this cell of golden-coloured wood, with two blue checked beds. They looked at each other and laughed, frightened by this naked nearness of isolation.

A man knocked and came in with the luggage. He was a sturdy fellow with flattish cheek-bones, rather pale, and with coarse fair moustache. Gudrun watched him put down the bags, in silence, then tramp heavily out.

'It isn't too rough, is it?' Gerald asked.

The bedroom was not very warm, and she shivered slightly.

'It is wonderful,' she equivocated. 'Look at the colour of this panelling – it's wonderful, like being inside a nut.'

He was standing watching her, feeling his short-cut moustache, leaning back slightly and watching her with his keen, undaunted eyes, dominated by the constant passion, that was like a doom upon him.

She went and crouched down in front of the window, curious.

'Oh, but this - !' she cried involuntarily, almost in pain.

In front was a valley shut in under the sky, the last huge slopes of snow and black rock, and at the end, like the navel of the earth, a white-folded wall, and two peaks glimmering in the late light. Straight in front ran the cradle of silent snow, between the great slopes that were fringed with a little roughness of pine-trees, like hair, round the base. But the cradle of snow ran on to the eternal closing-in, where the walls of snow and rock rose impenetrable, and the mountain peaks above were in heaven immediate. This was the centre, the knot, the navel of the world, where the earth belonged to the skies, pure, unapproachable, impassable.

It filled Gudrun with a strange rapture. She crouched in front of the window, clenching her face in her hands, in a sort of trance. At last she had arrived, she had reached her place. Here at last she folded her venture and settled down like a crystal in the navel of snow, and was gone.

Gerald bent above her and was looking out over her shoulder. Already he felt he was alone. She was gone. She was completely gone, and there was icy vapour round his heart. He saw the blind valley, the great cul-de-sac of snow and mountain peaks, under the heaven. And there was no way out. The terrible silence and cold and the glamorous whiteness of the dusk wrapped him round, and she remained crouching before the window, as at a shrine, a shadow.

'Do you like it?' he asked, in a voice that sounded detached and foreign. At least she might acknowledge he was with her. But she only averted her soft, mute face a little from his gaze. And he knew that there were tears in her eyes, her own tears, tears of her strange religion, that put him to nought.

Quite suddenly, he put his hand under her chin and lifted up her face to him. Her dark blue eyes, in their wetness of tears, dilated as if she was startled in her very soul. They looked at him through their tears in terror and a little horror. His light blue eyes were keen, small-pupilled and unnatural in their vision. Her lips parted, as she breathed with difficulty.

The passion came up in him, stroke after stroke, like the ringing of a bronze bell, so strong and unflawed and indomitable. His knees tightened to bronze as he hung above her soft face, whose lips parted and whose eyes dilated in a strange violation. In the grasp of his hand her chin was unutterably soft and silken. He felt strong as winter, his hands were living metal, invincible and not to be turned aside. His heart rang like a bell clanging inside him.

He took her up in his arms. She was soft and inert, motionless. All the while her eyes, in which the tears had not yet dried, were dilated as if in a kind of swoon of fascination and helplessness. He was superhumanly strong, and unflawed, as if invested with supernatural force.

He lifted her close and folded her against him. Her softness, her inert, relaxed weight lay against his own surcharged, bronze-like limbs in a heaviness of desirability that would destroy him, if he were not fulfilled. She moved convulsively, recoiling away from him. His heart went up like a flame of ice, he closed over her like steel. He would destroy her rather than be denied.

But the overweening power of his body was too much for her. She relaxed again, and lay loose and soft, panting in a little delirium. And to him, she was so sweet, she was such bliss of release, that he would have suffered a whole eternity of torture rather than forego one second of this pang of unsurpassable bliss.

'My God,' he said to her, his face drawn and strange, transfigured, 'what next?'

She lay perfectly still, with a still, child-like face and dark eyes, looking at him. She was lost, fallen right away.

'I shall always love you,' he said, looking at her.

But she did not hear. She lay, looking at him as at something she could never understand, never: as a child looks at a grown-up person, without hope of understanding, only submitting.

He kissed her, kissed her eyes shut, so that she could not look any more. He wanted something now, some recognition, some sign, some admission. But she only lay silent and child-like and remote, like a child that is overcome and cannot understand, only feels lost. He kissed her again, giving up.

'Shall we go down and have coffee and Kuchen?' he asked.

The twilight was falling slate-blue at the window. She closed her eyes, closed away the monotonous level of dead wonder, and opened them again to the every-day world.

'Yes,' she said briefly, regaining her will with a click. She went again to the window. Blue evening had fallen over the cradle of snow and over the great pallid slopes. But in the heaven the peaks of snow were rosy, glistening like transcendent, radiant spikes of blossom in the heavenly upper-world, so lovely and beyond.

Gudrun saw all their loveliness, she *knew* how immortally beautiful they were, great pistils of rose-coloured, snow-fed fire in the blue twilight of the heaven. She could *see* it, she knew it, but she was not of it. She was divorced, debarred, a soul shut out.

With a last look of remorse, she turned away, and was doing her hair. He had unstrapped the luggage, and was waiting, watching her. She knew he was watching her. It made her a little hasty and feverish in her precipitation.

They went downstairs, both with a strange other-world look on their faces, and with a glow in their eyes. They saw Birkin and Ursula sitting at the long table in a corner, waiting for them.

'How good and simple they look together,' Gudrun thought, jealously. She envied them some spontaneity, a childish sufficiency to which she herself could never approach. They seemed such children to her.

'Such good Kranzkuchen!' cried Ursula greedily. 'So good!'

'Right,' said Gudrun. 'Can we have Kaffee mit Kranzkuchen?' she added to the waiter.

And she seated herself on the bench beside Gerald. Birkin, looking at them, felt a pain of tenderness for them.

'I think the place is really wonderful, Gerald,' he said; 'prachtvoll and wunderbar and wunderschön and unbeschreiblich and all the other German adjectives.'¹¹⁴

Gerald broke into a slight smile.

'I like it,' he said.

The tables, of white scrubbed wood, were placed round three sides of the room, as in a Gasthaus. Birkin and Ursula sat with their backs to the wall, which was of oiled wood, and Gerald and Gudrun sat in the corner next them, near to the stove. It was a fairly large place, with a tiny bar, just like a country inn, but quite simple and bare, and all of oiled wood, ceilings and walls and floor, the only furniture being the tables and benches going round three sides, the great green stove, and the bar and the doors on the fourth side. The windows were double, and quite uncurtained. It was early evening. The coffee came - hot and good - and a whole ring of cake.

'A whole Kuchen!' cried Ursula. 'They give you more than us! I want some of yours.'

There were other people in the place, ten altogether, so Birkin had found out: two artists, three students, a man and wife, and a Professor and two daughters – all Germans. The four English people, being newcomers, sat in their coign of vantage to watch. The Germans peeped in at the door, called a word to the waiter, and went away again. It was not meal-time, so they did not come into this dining-room, but betook themselves, when their boots were changed, to the Reunionsaal.

The English visitors could hear the occasional twanging of a zither, the strumming of a piano, snatches of laughter and shouting and singing, a faint vibration of voices. The whole building being of wood, it seemed to carry every sound, like a drum, but instead of increasing each particular noise, it decreased it, so that the sound of the zither seemed tiny, as if a diminutive zither were playing somewhere, and it seemed the piano must be a small one, like a little spinet.

The host came when the coffee was finished. He was a Tyrolese, broad, rather flat-cheeked, with a pale, pock-marked skin and flourishing moustaches.

'Would you like to go to the Reunionsaal to be introduced to the other ladies and gentlemen?' he asked, bending forward and smiling, showing his large, strong teeth. His blue eyes went quickly from one to the other – he was not quite sure of his ground with these English people. He was unhappy too because he spoke no English and he was not sure whether to try his French.

'Shall we go to the Reunionsaal, and be introduced to the other people?' repeated Gerald, laughing.

There was a moment's hesitation.

'I suppose we'd better - better break the ice,' said Birkin.

The women rose, rather flushed. And the Wirt's black, beetle-like, broad-shouldered figure went on ignominiously in front, towards the noise. He opened the door and ushered the four strangers into the play-room.

Instantly a silence fell, a slight embarrassment came over the company. The newcomers had a sense of many blond faces looking their way. Then, the host was bowing to a short, energetic-looking man with large moustaches, and saying in a low voice:

'Herr Professor, darf ich vorstellen - '

The Herr Professor was prompt and energetic. He bowed low to the English people, smiling, and began to be a comrade at once.

'Nehmen die Herrschaften teil an unserer Unterhaltung?'115 he said,

with a vigorous suavity, his voice curling up in the question.

The four English people smiled, lounging with an attentive uneasiness in the middle of the room. Gerald, who was spokesman, said that they would willingly take part in the entertainment. Gudrun and Ursula, laughing, excited, felt the eyes of all the men upon them, and they lifted their heads and looked nowhere, and felt royal.

The Professor announced the names of those present, *sans cérémonie*.¹¹⁶ There was a bowing to the wrong people and to the right people. Everybody was there, except the man and wife. The two tall, clear-skinned, athletic daughters of the professor, with their plain-cut, dark blue blouses and loden skirts, their rather long, strong necks, their clear blue eyes and carefully banded hair, and their blushes, bowed and stood back; the three students bowed very low, in the humble hope of making an impression of extreme good-breeding; then there was a thin, dark-skinned man with full eyes, an odd creature, like a child, and like a troll, quick, detached; he bowed slightly; his companion, a large fair young man, stylishly dressed, blushed to the eyes and bowed very low.

It was over.

'Herr Loerke was giving us a recitation in the Cologne dialect,' said the Professor.

'He must forgive us for interrupting him,' said Gerald, 'we should like very much to hear it.'

There was instantly a bowing and an offering of seats. Gudrun and Ursula, Gerald and Birkin sat in the deep sofas against the wall. The room was of naked oiled panelling, like the rest of the house. It had a piano, sofas and chairs, and a couple of tables with books and magazines. In its complete absence of decoration, save for the big, blue stove, it was cosy and pleasant.

Herr Loerke was the little man with the boyish figure, and the round, full, sensitive-looking head, and the quick, full eyes, like a mouse's. He glanced swiftly from one to the other of the strangers, and held himself aloof.

'Please go on with the recitation,' said the Professor, suavely, with his slight authority. Loerke, who was sitting hunched on the piano stool, blinked and did not answer.

'It would be a great pleasure,' said Ursula, who had been getting the sentence ready, in German, for some minutes.

Then, suddenly, the small, unresponding man swung aside, towards his previous audience and broke forth, exactly as he had broken off; in a controlled, mocking voice, giving an imitation of a quarrel between an old Cologne woman and a railway guard.

His body was slight and unformed, like a boy's, but his voice was

mature, sardonic, its movement had the flexibility of essential energy, and of a mocking penetrating understanding. Gudrun could not understand a word of his monologue, but she was spell-bound, watching him. He must be an artist, nobody else could have such fine adjustment and singleness. The Germans were doubled up with laughter, hearing his strange droll words, his droll phrases of dialect. And in the midst of their paroxysms, they glanced with deference at the four English strangers, the elect. Gudrun and Ursula were forced to laugh. The room rang with shouts of laughter. The blue eyes of the Professor's daughters were swimming over with laughter-tears, their clear cheeks were flushed crimson with mirth, their father broke out in the most astonishing peals of hilarity, the students bowed their heads on their knees in excess of joy. Ursula looked round amazed, the laughter was bubbling out of her involuntarily. She looked at Gudrun. Gudrun looked at her, and the two sisters burst out laughing, carried away. Loerke glanced at them swiftly, with his full eves. Birkin was sniggering involuntarily. Gerald Crich sat erect, with a glistening look of amusement on his face. And the laughter crashed out again, in wild paroxysms, the Professor's daughters were reduced to shaking helplessness, the veins of the Professor's neck were swollen, his face was purple, he was strangled in ultimate, silent spasms of laughter. The students were shouting half-articulated words that tailed off in helpless explosions. Then suddenly the rapid patter of the artist ceased, there were little whoops of subsiding mirth, Ursula and Gudrun were wiping their eves, and the Professor was crving loudly.

'Das war ausgezeichnet, das war famos - '

'Wirklich famos,' echoed his exhausted daughters, faintly.

'And we couldn't understand it,' cried Ursula.

'Oh leider, leider!' cried the Professor.

'You couldn't understand it?' cried the Students, let loose at last in speech with the newcomers. 'Ja, das ist wirklich schade, das ist schade, gnädige Frau. Wissen Sie – '¹¹⁷

The mixture was made, the newcomers were stirred into the party, like new ingredients, the whole room was alive. Gerald was in his element, he talked freely and excitedly, his face glistened with a strange amusement. Perhaps even Birkin, in the end, would break forth. He was shy and withheld, though full of attention.

Ursula was prevailed upon to sing 'Annie Lowrie,'¹¹⁸ as the Professor called it. There was a hush of *extreme* deference. She had never been so flattered in her life. Gudrun accompanied her on the piano, playing from memory.

Ursula had a beautiful ringing voice, but usually no confidence, she

spoiled everything. This evening she felt conceited and untrammelled. Birkin was well in the background, she shone almost in reaction, the Germans made her feel fine and infallible, she was liberated into overweening self-confidence. She felt like a bird flying in the air, as her voice soared out, enjoying herself extremely in the balance and flight of the song, like the motion of a bird's wings that is up in the wind, sliding and playing on the air, she played with sentimentality, supported by rapturous attention. She was very happy, singing that song by herself, full of a conceit of emotion and power, working upon all those people, and upon herself, exerting herself with gratification, giving immeasurable gratification to the Germans.

At the end, the Germans were all touched with admiring, delicious melancholy, they praised her in soft, reverent voices, they could not say too much.

'Wie schön, wie rührend! Ach, die Schottischen Lieder, sie haben so viel Stimmung! Aber die gnädige Frau hat eine *wunderbare* Stimme; die gnädige Frau ist wirklich eine Künstlerin, aber wirklich!'¹¹⁹

She was dilated and brilliant, like a flower in the morning sun. She felt Birkin looking at her, as if he were jealous of her, and her breasts thrilled, her veins were all golden. She was as happy as the sun that has just opened above clouds. And everybody seemed so admiring and radiant, it was perfect.

After dinner she wanted to go out for a minute, to look at the world. The company tried to dissuade her – it was so terribly cold. But just to look, she said.

They all four wrapped up warmly, and found themselves in a vague, unsubstantial outdoors of dim snow and ghosts of an upper-world, that made strange shadows before the stars. It was indeed cold, bruisingly, frighteningly, unnaturally cold. Ursula could not believe the air in her nostrils. It seemed conscious, malevolent, purposive in its intense murderous coldness.

Yet it was wonderful, an intoxication, a silence of dim, unrealised snow, of the invisible intervening between her and the visible, between her and the flashing stars. She could see Orion sloping up. How wonderful he was, wonderful enough to make one cry aloud.

And all around was this cradle of snow, and there was firm snow underfoot, that struck with heavy cold through her boot-soles. It was night, and silence. She imagined she could hear the stars. She imagined distinctly she could hear the celestial, musical motion of the stars, quite near at hand. She seemed like a bird flying amongst their harmonious motion.

And she clung close to Birkin. Suddenly she realised she did not

know what he was thinking. She did not know where he was ranging. 'My love!' she said, stopping to look at him.

His face was pale, his eyes dark, there was a faint spark of starlight on them. And he saw her face soft and upturned to him, very near. He kissed her softly.

'What then?' he asked.

'Do you love me?' she asked.

'Too much,' he answered quietly.

She clung a little closer.

'Not too much,' she pleaded.

'Far too much,' he said, almost sadly.

'And does it make you sad, that I am everything to you?' she asked, wistful. He held her close to him, kissing her, and saying, scarcely audible:

'No, but I feel like a beggar – I feel poor.'

She was silent, looking at the stars now. Then she kissed him.

'Don't be a beggar,' she pleaded, wistfully. 'It isn't ignominious that you love me.'

'It is ignominious to feel poor, isn't it?' he replied.

'Why? Why should it be?' she asked. He only stood still, in the terribly cold air that moved invisibly over the mountain tops, folding her round with his arms.

'I couldn't bear this cold, eternal place without you,' he said. 'I couldn't bear it, it would kill the quick of my life.'

She kissed him again, suddenly.

'Do you hate it?' she asked, puzzled, wondering.

'If I couldn't come near to you, if you weren't here, I should hate it. I couldn't bear it,' he answered.

'But the people are nice,' she said.

'I mean the stillness, the cold, the frozen eternality,' he said.

She wondered. Then her spirit came home to him, nestling unconscious in him.

'Yes, it is good we are warm and together,' she said.

And they turned home again. They saw the golden lights of the hotel glowing out in the night of snow-silence, small in the hollow, like a cluster of yellow berries. It seemed like a bunch of sun-sparks, tiny and orange in the midst of the snow-darkness. Behind, was a high shadow of a peak, blotting out the stars, like a ghost.

They drew near to their home. They saw a man come from the dark building, with a lighted lantern which swung golden, and made that his dark feet walked in a halo of snow. He was a small, dark figure in the darkened snow. He unlatched the door of an outhouse. A smell of

cows, hot, animal, almost like beef, came out on the heavily cold air. There was a glimpse of two cattle in their dark stalls, then the door was shut again, and not a chink of light showed. It had reminded Ursula again of home, of the Marsh, of her childhood, and of the journey to Brussels, and, strangely, of Anton Skrebensky.¹²⁰

Oh, God, could one bear it, this past which was gone down the abyss? Could she bear, that it ever had been! She looked round this silent, upper world of snow and stars and powerful cold. There was another world, like views on a magic lantern; The Marsh, Cossethay, Ilkeston, lit up with a common, unreal light. There was a shadowy unreal Ursula, a whole shadow-play of an unreal life. It was as unreal, and circumscribed, as a magic-lantern show. She wished the slides could all be broken. She wished it could be gone for ever, like a lantern-slide which was broken. She wanted to have no past. She wanted to have come down from the slopes of heaven to this place, with Birkin, not to have toiled out of the murk of her childhood and her upbringing, slowly, all soiled. She felt that memory was a dirty trick played upon her. What was this decree, that she should 'remember'! Why not a bath of pure oblivion, a new birth, without any recollections or blemish of a past life. She was with Birkin, she had just come into life, here in the high snow, against the stars. What had she to do with parents and antecedents? She knew herself new and unbegotten, she had no father, no mother, no anterior connections, she was herself, pure and silvery, she belonged only to the oneness with Birkin, a oneness that struck deeper notes, sounding into the heart of the universe, the heart of reality, where she had never existed before.

Even Gudrun was a separate unit, separate, separate, having nothing to do with this self, this Ursula, in her new world of reality. That old shadow-world, the actuality of the past – ah, let it go! She rose free on the wings of her new condition.

Gudrun and Gerald had not come in. They had walked up the valley straight in front of the house, not like Ursula and Birkin, on to the little hill at the right. Gudrun was driven by a strange desire. She wanted to plunge on and on, till she came to the end of the valley of snow. Then she wanted to climb the wall of white finality, climb over, into the peaks that sprang up like sharp petals in the heart of the frozen, mysterious navel of the world. She felt that there, over the strange blind, terrible wall of rocky snow, there in the navel of the mystic world, among the final cluster of peaks, there, in the infolded navel of it all, was her consummation. If she could but come there, alone, and pass into the infolded navel of eternal snow and of uprising, immortal peaks of snow and rock, she would be a oneness with all, she would be herself the

WOMEN IN LOVE

eternal, infinite silence, the sleeping, timeless, frozen centre of the All.

They went back to the house, to the Reunionsaal. She was curious to see what was going on. The men there made her alert, roused her curiosity. It was a new taste of life for her, they were so prostrate before her, yet so full of life.

The party was boisterous; they were dancing all together, dancing the Schuhplatteln, the Tyrolese dance of the clapping hands and tossing the partner in the air at the crisis. The Germans were all proficient – they were from Munich chiefly. Gerald also was quite passable. There were three zithers twanging away in a corner. It was a scene of great animation and confusion. The Professor was initiating Ursula into the dance, stamping, clapping, and swinging her high, with amazing force and zest. When the crisis came even Birkin was behaving manfully with one of the Professor's fresh, strong daughters, who was exceedingly happy. Everybody was dancing, there was the most boisterous turmoil.

Gudrun looked on with delight. The solid wooden floor resounded to the knocking heels of the men, the air quivered with the clapping hands and the zither music, there was a golden dust about the hanging lamps.

Suddenly the dance finished, Loerke and the students rushed out to bring in drinks. There was an excited clamour of voices, a clinking of mug-lids, a great crying of 'Prosit – Prosit!'¹²¹ Loerke was everywhere at once, like a gnome, suggesting drinks for the women, making an obscure, slightly risky joke with the men, confusing and mystifying the waiter.

He wanted very much to dance with Gudrun. From the first moment he had seen her, he wanted to make a connection with her. Instinctively she felt this, and she waited for him to come up. But a kind of sulkiness kept him away from her, so she thought he disliked her.

'Will you schuhplatteln, gnädige Frau?' said the large, fair youth, Loerke's companion. He was too soft, too humble for Gudrun's taste. But she wanted to dance, and the fair youth, who was called Leitner, was handsome enough in his uneasy, slightly abject fashion, a humility that covered a certain fear. She accepted him as a partner.

The zithers sounded out again, the dance began. Gerald led them, laughing, with one of the Professor's daughters. Ursula danced with one of the students, Birkin with the other daughter of the Professor, the Professor with Frau Kramer, and the rest of the men danced together, with quite as much zest as if they had had women partners.

Because Gudrun had danced with the well-built, soft youth, his companion, Loerke, was more pettish and exasperated than ever, and

would not even notice her existence in the room. This piqued her, but she made up to herself by dancing with the Professor, who was strong as a mature, well-seasoned bull, and as full of coarse energy. She could not bear him, critically, and yet she enjoyed being rushed through the dance, and tossed up into the air, on his coarse, powerful impetus. The Professor enjoyed it too, he eyed her with strange, large blue eyes, full of galvanic fire. She hated him for the seasoned, semi-paternal animalism with which he regarded her, but she admired his weight of strength.

The room was charged with excitement and strong, animal emotion. Loerke was kept away from Gudrun, to whom he wanted to speak, as by a hedge of thorns, and he felt a sardonic ruthless hatred for this young love-companion, Leitner, who was his penniless dependent. He mocked the youth, with an acid ridicule, that made Leitner red in the face and impotent with resentment.

Gerald, who had now got the dance perfectly, was dancing again with the younger of the Professor's daughters, who was almost dying of virgin excitement, because she thought Gerald so handsome, so superb. He had her in his power, as if she were a palpitating bird, a fluttering, flushing, bewildered creature. And it made him smile, as she shrank convulsively between his hands, violently, when he must throw her into the air. At the end, she was so overcome with prostrate love for him, that she could scarcely speak sensibly at all.

Birkin was dancing with Ursula. There were odd little fires playing in his eyes, he seemed to have turned into something wicked and flickering, mocking, suggestive, quite impossible. Ursula was frightened of him, and fascinated. Clear, before her eyes, as in a vision, she could see the sardonic, licentious mockery of his eyes, he moved towards her with subtle, animal, indifferent approach. The strangeness of his hands, which came quick and cunning, inevitably to the vital place beneath her breasts, and, lifting with mocking, suggestive impulse, carried her through the air as if without strength, through blackmagic, made her swoon with fear. For a moment she revolted, it was horrible. She would break the spell. But before the resolution had formed she had submitted again, yielded to her fear. He knew all the time what he was doing, she could see it in his smiling, concentrated eyes. It was his responsibility, she would leave it to him.

When they were alone in the darkness, she felt the strange, licentiousness of him hovering upon her. She was troubled and repelled. Why should he turn like this?

'What is it?' she asked in dread.

But his face only glistened on her, unknown, horrible. And yet she

was fascinated. Her impulse was to repel him violently, break from this spell of mocking brutishness. But she was too fascinated, she wanted to submit, she wanted to know. What would he do to her?

He was so attractive, and so repulsive at once. The sardonic suggestivity that flickered over his face and looked from his narrowed eyes, made her want to hide, to hide herself away from him and watch him from somewhere unseen.

'Why are you like this?' she demanded again, rousing against him with sudden force and animosity.

The flickering fires in his eyes concentrated as he looked into her eyes. Then the lids drooped with a faint motion of satiric contempt. Then they rose again to the same remorseless suggestivity. And she gave way, he might do as he would. His licentiousness was repulsively attractive. But he was self-responsible, she would see what it was.

They might do as they liked – this she realised as she went to sleep. How could anything that gave one satisfaction be excluded? What was degrading? Who cared? Degrading things were real, with a different reality. And he was so unabashed and unrestrained. Wasn't it rather horrible, a man who could be so soulful and spiritual, now to be so – she balked at her own thoughts and memories: then she added – so bestial? So bestial, they two! – so degraded! She winced. But after all, why not? She exulted as well. Why not be bestial, and go the whole round of experience? She exulted in it. She was bestial. How good it was to be really shameful! There would be no shameful thing she had not experienced. Yet she was unabashed, she was herself. Why not? She was free, when she knew everything, and no dark shameful things were denied her.

Gudrun, who had been watching Gerald in the Reunionsaal, suddenly thought:

'He should have all the women he can – it is his nature. It is absurd to call him monogamous – he is naturally promiscuous. That is his nature.'

The thought came to her involuntarily. It shocked her somewhat. It was as if she had seen some new *Mene! Mene!*¹²² upon the wall. Yet it was merely true. A voice seemed to have spoken it to her so clearly, that for the moment she believed in inspiration.

'It is really true,' she said to herself again.

She knew quite well she had believed it all along. She knew it implicitly. But she must keep it dark – almost from herself. She must keep it completely secret. It was knowledge for her alone, and scarcely even to be admitted to herself.

The deep resolve formed in her, to combat him. One of them must

triumph over the other. Which should it be? Her soul steeled itself with strength. Almost she laughed within herself, at her confidence. It woke a certain keen, half contemptuous pity, tenderness for him: she was so ruthless.

Everybody retired early. The Professor and Loerke went into a small lounge to drink. They both watched Gudrun go along the landing by the railing upstairs.

'Ein schönes Frauenzimmer,' said the Professor.

'Ja!'123 asserted Loerke, shortly.

Gerald walked with his queer, long wolf-steps across the bedroom to the window, stooped and looked out, then rose again, and turned to Gudrun, his eyes sharp with an abstract smile. He seemed very tall to her, she saw the glisten of his whitish eyebrows, that met between his brows.

'How do you like it?' he said.

He seemed to be laughing inside himself, quite unconsciously. She looked at him. He was a phenomenon to her, not a human being: a sort of creature, greedy.

'I like it very much,' she replied.

'Who do you like best downstairs?' he asked, standing tall and glistening above her, with his glistening stiff hair erect.

'Who do I like best?' she repeated, wanting to answer his question, and finding it difficult to collect herself. 'Why I don't know, I don't know enough about them yet, to be able to say. Who do you like best?'

'Oh, I don't care - I don't like or dislike any of them. It doesn't matter about me. I wanted to know about you.'

'But why?' she asked, going rather pale. The abstract, unconscious smile in his eyes was intensified.

'I wanted to know,' he said.

She turned aside, breaking the spell. In some strange way, she felt he was getting power over her.

'Well, I can't tell you already,' she said.

She went to the mirror to take out the hairpins from her hair. She stood before the mirror every night for some minutes, brushing her fine dark hair. It was part of the inevitable ritual of her life.

He followed her, and stood behind her. She was busy with bent head, taking out the pins and shaking her warm hair loose. When she looked up, she saw him in the glass standing behind her, watching unconsciously, not consciously seeing her, and yet watching, with finepupilled eyes that *seemed* to smile, and which were not really smiling.

She started. It took all her courage for her to continue brushing her hair, as usual, for her to pretend she was at her ease. She was far, far from being at her ease with him. She beat her brains wildly for something to say to him.

'What are your plans for tomorrow?' she asked nonchalantly, whilst her heart was beating so furiously, her eyes were so bright with strange nervousness, she felt he could not but observe. But she knew also that he was completely blind, blind as a wolf looking at her. It was a strange battle between her ordinary consciousness and his uncanny, black-art consciousness.

'I don't know,' he replied, 'what would you like to do?'

He spoke emptily, his mind was sunk away.

'Oh,' she said, with easy protestation, 'I'm ready for anything – anything will be fine for me, I'm sure.'

And to herself she was saying: 'God, why am I so nervous – why are you so nervous, you fool. If he sees it I'm done for forever – you *know* you're done for forever, if he sees the absurd state you're in.'

And she smiled to herself as if it were all child's play. Meanwhile her heart was plunging, she was almost fainting. She could see him, in the mirror, as he stood there behind her, tall and over-arching - blond and terribly frightening. She glanced at his reflection with furtive eyes, willing to give anything to save him from knowing she could see him. He did not know she could see his reflection. He was looking unconsciously, glisteningly down at her head, from which the hair fell loose, as she brushed it with wild, nervous hand. She held her head aside and brushed and brushed her hair madly. For her life, she could not turn round and face him. For her life, she could not. And the knowledge made her almost sink to the ground in a faint, helpless, spent. She was aware of his frightening, impending figure standing close behind her, she was aware of his hard, strong, unvielding chest, close upon her back. And she felt she could not bear it any more, in a few minutes she would fall down at his feet, grovelling at his feet, and letting him destroy her.

The thought pricked up all her sharp intelligence and presence of mind. She dared not turn round to him – and there he stood motionless, unbroken. Summoning all her strength, she said, in a full, resonant, nonchalant voice, that was forced out with all her remaining self-control:

'Oh, would you mind looking in that bag behind there and giving me my – '

Here her power fell inert. 'My what – my what – ?'she screamed in silence to herself.

But he had started round, surprised and startled that she should ask him to look in her bag, which she always kept so *very* private to herself.

She turned now, her face white, her dark eyes blazing with uncanny, overwrought excitement. She saw him stooping to the bag, undoing the loosely buckled strap, unattentive.

'Your what?' he asked.

'Oh, a little enamel box – yellow – with a design of a cormorant plucking her breast – '

She went towards him, stooping her beautiful, bare arm, and deftly turned some of her things, disclosing the box, which was exquisitely painted.

'That is it, see,' she said, taking it from under his eyes.

And he was baffled now. He was left to fasten up the bag, whilst she swiftly did up her hair for the night, and sat down to unfasten her shoes. She would not turn her back to him any more.

He was baffled, frustrated, but unconscious. She had the whip hand over him now. She knew he had not realised her terrible panic. Her heart was beating heavily still. Fool, fool that she was, to get into such a state! How she thanked God for Gerald's obtuse blindness. Thank God he could see nothing.

She sat slowly unlacing her shoes, and he too commenced to undress. Thank God that crisis was over. She felt almost fond of him now, almost in love with him.

'Ah, Gerald,' she laughed, caressively, teasingly, 'Ah, what a fine game you played with the Professor's daughter – didn't you now?'

'What game?' he asked, looking round.

'Isn't she in love with you – oh *dear*, isn't she in love with you!' said Gudrun, in her gayest, most attractive mood.

'I shouldn't think so,' he said.

'Shouldn't think so!' she teased. 'Why the poor girl is lying at this moment overwhelmed, dying with love for you. She thinks you're *wonderful* – oh marvellous, beyond what man has ever been. *Really*, isn't it funny?'

'Why funny, what is funny?' he asked.

'Why to see you working it on her,' she said, with a half reproach that confused the male conceit in him. 'Really Gerald, the poor girl -!'

'I did nothing to her,' he said.

'Oh, it was too shameful, the way you simply swept her off her feet.'

'That was Schuhplatteln,' he replied, with a bright grin.

'Ha - ha - ha!' laughed Gudrun.

Her mockery quivered through his muscles with curious re-echoes. When he slept he seemed to crouch down in the bed, lapped up in his own strength, that yet was hollow.

And Gudrun slept strongly, a victorious sleep. Suddenly, she was

WOMEN IN LOVE

almost fiercely awake. The small timber room glowed with the dawn, that came upwards from the low window. She could see down the valley when she lifted her head: the snow with a pinkish, half-revealed magic, the fringe of pine-trees at the bottom of the slope. And one tiny figure moved over the vaguely-illuminated space.

She glanced at his watch; it was seven o'clock. He was still completely asleep. And she was so hard awake, it was almost frightening – a hard, metallic wakefulness. She lay looking at him.

He slept in the subjection of his own health and defeat. She was overcome by a sincere regard for him. Till now, she was afraid before him. She lay and thought about him, what he was, what he represented in the world. A fine, independent will, he had. She thought of the revolution he had worked in the mines, in so short a time. She knew that, if he were confronted with any problem, any hard actual difficulty, he would overcome it. If he laid hold of any idea, he would carry it through. He had the faculty of making order out of confusion. Only let him grip hold of a situation, and he would bring to pass an inevitable conclusion.

For a few moments she was borne away on the wild wings of ambition. Gerald, with his force of will and his power for comprehending the actual world, should be set to solve the problems of the day, the problem of industrialism in the modern world. She knew he would, in the course of time, effect the changes he desired, he could re-organise the industrial system. She knew he could do it. As an instrument, in these things, he was marvellous, she had never seen any man with his potentiality. He was unaware of it, but she knew.

He only needed to be hitched on, he needed that his hand should be set to the task, because he was so unconscious. And this she could do. She would marry him, he would go into Parliament in the Conservative interest, he would clear up the great muddle of labour and industry. He was so superbly fearless, masterful, he knew that every problem could be worked out, in life as in geometry. And he would care neither about himself nor about anything but the pure working out of the problem. He was very pure, really.

Her heart beat fast, she flew away on wings of elation, imagining a future. He would be a Napoleon of peace, or a Bismarck – and she the woman behind him. She had read Bismarck's letters, and had been deeply moved by them. And Gerald would be freer, more dauntless than Bismarck.

But even as she lay in fictitious transport, bathed in the strange, false sunshine of hope in life, something seemed to snap in her, and a terrible cynicism began to gain upon her, blowing in like a wind.

Everything turned to irony with her: the last flavour of everything was ironical. When she felt her pang of undeniable reality, this was when she knew the hard irony of hopes and ideas.

She lay and looked at him, as he slept. He was sheerly beautiful, he was a perfect instrument. To her mind, he was a pure, inhuman, almost superhuman instrument. His instrumentality appealed so strongly to her, she wished she were God, to use him as a tool.

And at the same instant, came the ironical question: 'What for?' She thought of the colliers' wives, with their linoleum and their lace curtains and their little girls in high-laced boots. She thought of the wives and daughters of the pit-managers, their tennis-parties, and their terrible struggles to be superior each to the other, in the social scale. There was Shortlands with its meaningless distinction, the meaningless crowd of the Criches. There was London, the House of Commons, the extant social world. My God!

Young as she was, Gudrun had touched the whole pulse of social England. She had no ideas of rising in the world. She knew, with the perfect cynicism of cruel youth, that to rise in the world meant to have one outside show instead of another, the advance was like having a spurious half-crown instead of a spurious penny. The whole coinage of valuation was spurious. Yet of course, her cynicism knew well enough that, in a world where spurious coin was current, a bad sovereign was better than a bad farthing. But rich and poor, she despised both alike.

Already she mocked at herself for her dreams. They could be fulfilled easily enough. But she recognised too well, in her spirit, the mockery of her own impulses. What did she care, that Gerald had created a richlypaying industry out of an old worn-out concern? What did she care? The worn-out concern and the rapid, splendidly organised industry, they were bad money. Yet of course, she cared a great deal, outwardly – and outwardly was all that mattered, for inwardly was a bad joke.

Everything was intrinsically a piece of irony to her. She leaned over Gerald and said in her heart, with compassion:

'Oh, my dear, my dear, the game isn't worth even you. You are a fine thing really – why should you be used on such a poor show!'

Her heart was breaking with pity and grief for him. And at the same moment, a grimace came over her mouth, of mocking irony at her own unspoken tirade. Ah, what a farce it was! She thought of Parnell and Katherine O'Shea.¹²⁴ Parnell! After all, who can take the nationalisation of Ireland seriously? Who can take political Ireland really seriously, whatever it does? And who can take political England seriously? Who can? Who can care a straw, really, how the old patched-up Constitution is tinkered at any more? Who cares a button for our national ideas, any

WOMEN IN LOVE

more than for our national bowler hat? Aha, it is all old hat, it is all old bowler hat!

That's all it is, Gerald, my young hero. At any rate we'll spare ourselves the nausea of stirring the old broth any more. You be beautiful, my Gerald, and reckless. There *are* perfect moments. Wake up, Gerald, wake up, convince me of the perfect moments. Oh, convince me, I need it.

He opened his eyes, and looked at her. She greeted him with a mocking, enigmatic smile in which was a poignant gaiety. Over his face went the reflection of the smile, he smiled, too, purely unconsciously.

That filled her with extraordinary delight, to see the smile cross his face, reflected from her face. She remembered that was how a baby smiled. It filled her with extraordinary radiant delight.

'You've done it,' she said.

'What?' he asked, dazed.

'Convinced me.'

And she bent down, kissing him passionately, passionately, so that he was bewildered. He did not ask her of what he had convinced her, though he meant to. He was glad she was kissing him. She seemed to be feeling for his very heart to touch the quick of him. And he wanted her to touch the quick of his being, he wanted that most of all.

Outside, somebody was singing, in a manly, reckless handsome voice:

'Mach mir auf, mach mir auf, du Stolze, Mach mir ein Feuer von Holze. Vom Regen bin ich nass Vom Regen bin ich nass – '¹²⁵

Gudrun knew that that song would sound through her eternity, sung in a manly, reckless, mocking voice. It marked one of her supreme moments, the supreme pangs of her nervous gratification. There it was, fixed in eternity for her.

The day came fine and bluish. There was a light wind blowing among the mountain tops, keen as a rapier where it touched, carrying with it a fine dust of snow-powder. Gerald went out with the fine, blind face of a man who is in his state of fulfilment. Gudrun and he were in perfect static unity this morning, but unseeing and unwitting. They went out with a toboggan, leaving Ursula and Birkin to follow.

Gudrun was all scarlet and royal blue – a scarlet jersey and cap, and a royal blue skirt and stockings. She went gaily over the white snow, with Gerald beside her, in white and grey, pulling the little toboggan. They

grew small in the distance of snow, climbing the steep slope.

For Gudrun herself, she seemed to pass altogether into the whiteness of the snow, she became a pure, thoughtless crystal. When she reached the top of the slope, in the wind, she looked round, and saw peak beyond peak of rock and snow, bluish, transcendent in heaven. And it seemed to her like a garden, with the peaks for pure flowers, and her heart gathering them. She had no separate consciousness for Gerald.

She held on to him as they went sheering down over the keen slope. She felt as if her senses were being whetted on some fine grindstone, that was keen as flame. The snow sprinted on either side, like sparks from a blade that is being sharpened, the whiteness round about ran swifter, swifter, in pure flame the white slope flew against her, and she fused like one molten, dancing globule, rushed through a white intensity. Then there was a great swerve at the bottom, when they swung as it were in a fall to earth, in the diminishing motion.

They came to rest. But when she rose to her feet, she could not stand. She gave a strange cry, turned and clung to him, sinking her face on his breast, fainting in him. Utter oblivion came over her, as she lay for a few moments abandoned against him.

'What is it?' he was saying. 'Was it too much for you?'

But she heard nothing.

When she came to, she stood up and looked round, astonished. Her face was white, her eyes brilliant and large.

'What is it?' he repeated. 'Did it upset you?'

She looked at him with her brilliant eyes that seemed to have undergone some transfiguration, and she laughed, with a terrible merriment.

'No,' she cried, with triumphant joy. 'It was the complete moment of my life.'

And she looked at him with her dazzling, overweening laughter, like one possessed. A fine blade seemed to enter his heart, but he did not care, or take any notice.

But they climbed up the slope again, and they flew down through the white flame again, splendidly, splendidly. Gudrun was laughing and flashing, powdered with snow-crystals, Gerald worked perfectly. He felt he could guide the toboggan to a hair-breadth, almost he could make it pierce into the air and right into the very heart of the sky. It seemed to him the flying sledge was but his strength spread out, he had but to move his arms, the motion was his own. They explored the great slopes, to find another slide. He felt there must be something better than they had known. And he found what he desired, a perfect long, fierce sweep, sheering past the foot of a rock and into the trees at the base. It was dangerous, he knew. But then he knew also he would direct the sledge between his fingers.

The first days passed in an ecstasy of physical motion, sleighing, skiing, skating, moving in an intensity of speed and white light that surpassed life itself, and carried the souls of the human beings beyond into an inhuman abstraction of velocity and weight and eternal, frozen snow.

Gerald's eyes became hard and strange, and as he went by on his skis he was more like some powerful, fateful sigh than a man, his muscles elastic in a perfect, soaring trajectory, his body projected in pure flight, mindless, soulless, whirling along one perfect line of force.

Luckily there came a day of snow, when they must all stay indoors: otherwise Birkin said, they would all lose their faculties, and begin to utter themselves in cries and shrieks, like some strange, unknown species of snow-creatures.

It happened in the afternoon that Ursula sat in the Reunionsaal talking to Loerke. The latter had seemed unhappy lately. He was lively and full of mischievous humour, as usual.

But Ursula had thought he was sulky about something. His partner, too, the big, fair, good-looking youth, was ill at ease, going about as if he belonged to nowhere, and was kept in some sort of subjection, against which he was rebelling.

Loerke had hardly talked to Gudrun. His associate, on the other hand, had paid her constantly a soft, over-deferential attention. Gudrun wanted to talk to Loerke. He was a sculptor, and she wanted to hear his view of his art. And his figure attracted her. There was the look of a little wastrel about him, that intrigued her, and an old man's look, that interested her, and then, beside this, an uncanny singleness, a quality of being by himself, not in contact with anybody else, that marked out an artist to her. He was a chatterer, a magpie, a maker of mischievous word-jokes, that were sometimes very clever, but which often were not. And she could see in his brown, gnome's eyes, the black look of inorganic misery, which lay behind all his small buffoonery.

His figure interested her – the figure of a boy, almost a street arab. He made no attempt to conceal it. He always wore a simple loden suit, with knee breeches. His legs were thin, and he made no attempt to disguise the fact: which was of itself remarkable, in a German. And he never ingratiated himself anywhere, not in the slightest, but kept to himself, for all his apparent playfulness.

Leitner, his companion, was a great sportsman, very handsome with his big limbs and his blue eyes. Loerke would go toboganning or skating, in little snatches, but he was indifferent. And his fine, thin nostrils, the nostrils of a pure-bred street arab, would quiver with

contempt at Leitner's splothering gymnastic displays. It was evident that the two men who had travelled and lived together, sharing the same bedroom, had now reached the stage of loathing. Leitner hated Loerke with an injured, writhing, impotent hatred, and Loerke treated Leitner with a fine-quivering contempt and sarcasm. Soon the two would have to go apart.

Already they were rarely together. Leitner ran attaching himself to somebody or other, always deferring, Loerke was a good deal alone. Out of doors he wore a Westphalian cap, a close brown-velvet head with big brown velvet flaps down over his ears, so that he looked like a lop-eared rabbit, or a troll. His face was brown-red, with a dry, bright skin, that seemed to crinkle with his mobile expressions. His eyes were arresting – brown, full, like a rabbit's, or like a troll's, or like the eyes of a lost being, having a strange, dumb, depraved look of knowledge, and a quick spark of uncanny fire. Whenever Gudrun had tried to talk to him he had shied away unresponsive, looking at her with his watchful dark eyes, but entering into no relation with her. He had made her feel that her slow French and her slower German, were hateful to him. As for his own inadequate English, he was much too awkward to try it at all. But he understood a good deal of what was said, nevertheless. And Gudrun, piqued, left him alone.

This afternoon, however, she came into the lounge as he was talking to Ursula. His fine, black hair somehow reminded her of a bat, thin as it was on his full, sensitive-looking head, and worn away at the temples. He sat hunched up, as if his spirit were bat-like. And Gudrun could see he was making some slow confidence to Ursula, unwilling, a slow, grudging, scanty self-revelation. She went and sat by her sister.

He looked at her, then looked away again, as if he took no notice of her. But as a matter of fact, she interested him deeply.

'Isn't it interesting, Prune,' said Ursula, turning to her sister, 'Herr Loerke is doing a great frieze for a factory in Cologne, for the outside, the street.'

She looked at him, at his thin, brown, nervous hands, that were prehensile, and somehow like talons, like 'griffes,'¹²⁶ inhuman.

'What in?' she asked.

'Aus was?' repeated Ursula.

'Granit,' he replied.

It had become immediately a laconic series of question and answer between fellow craftsmen.

'What is the relief?' asked Gudrun.

'Alto relievo.'127

'And at what height?'

It was very interesting to Gudrun to think of his making the great granite frieze for a great granite factory in Cologne. She got from him some notion of the design. It was a representation of a fair, with peasants and artisans in an orgy of enjoyment, drunk and absurd in their modern dress, whirling ridiculously in roundabouts, gaping at shows, kissing and staggering and rolling in knots, swinging in swingboats, and firing down shooting galleries, a frenzy of chaotic motion.

There was a swift discussion of technicalities. Gudrun was very much impressed.

'But how wonderful, to have such a factory!' cried Ursula. 'Is the whole building fine?'

'Oh yes,' he replied. 'The frieze is part of the whole architecture. Yes, it is a colossal thing.'

Then he seemed to stiffen, shrugged his shoulders, and went on:

'Sculpture and architecture must go together. The day for irrelevant statues, as for wall pictures, is over. As a matter of fact sculpture is always part of an architectural conception. And since churches are all museum stuff, since industry is our business, now, then let us make our places of industry our art – our factory-area our Parthenon, *ecco*?

Ursula pondered.

'I suppose,' she said, 'there is no *need* for our great works to be so hideous.'

Instantly he broke into motion.

"There you are!' he cried, 'there you are! There is not only no need for our places of work to be ugly, but their ugliness ruins the work, in the end. Men will not go on submitting to such intolerable ugliness. In the end it will hurt too much, and they will wither because of it. And this will wither the work as well. They will think the work itself is ugly: the machines, the very act of labour. Whereas the machinery and the acts of labour are extremely, maddeningly beautiful. But this will be the end of our civilisation, when people will not work because work has become so intolerable to their senses, it nauseates them too much, they would rather starve. Then we shall see the hammer used only for smashing, then we shall see it. Yet here we are – we have the opportunity to make beautiful factories, beautiful machine-houses – we have the opportunity –'

Gudrun could only partly understand. She could have cried with vexation.

'What does he say?' she asked Ursula. And Ursula translated, stammering and brief. Loerke watched Gudrun's face, to see her judgment.

'And do you think then,' said Gudrun, 'that art should serve industry?'

'Art should *interpret* industry, as art once interpreted religion,' he said.

'But does your fair interpret industry?' she asked him.

'Certainly. What is man doing, when he is at a fair like this? He is fulfilling the counterpart of labour – the machine works him, instead of he the machine. He enjoys the mechanical motion, in his own body.'

'But is there nothing but work - mechanical work?' said Gudrun.

'Nothing but work!' he repeated, leaning forward, his eyes two darknesses, with needle-points of light. 'No, it is nothing but this, serving a machine, or enjoying the motion of a machine – motion, that is all. You have never worked for hunger, or you would know what god governs us.'

Gudrun quivered and flushed. For some reason she was almost in tears.

'No, I have not worked for hunger,' she replied, 'but I have worked!' 'Travaillé – lavorato?' he asked. 'E che lavoro – che lavoro? Quel travail est-ce que vous avez fait?'¹²⁸

He broke into a mixture of Italian and French, instinctively using a foreign language when he spoke to her.

'You have never worked as the world works,' he said to her, with sarcasm.

'Yes,' she said. 'I have. And I do - I work now for my daily bread.'

He paused, looked at her steadily, then dropped the subject entirely. She seemed to him to be trifling.

'But have you ever worked as the world works?' Ursula asked him.

He looked at her untrustful.

'Yes,' he replied, with a surly bark. 'I have known what it was to lie in bed for three days, because I had nothing to eat.'

Gudrun was looking at him with large, grave eyes, that seemed to draw the confession from him as the marrow from his bones. All his nature held him back from confessing. And yet her large, grave eyes upon him seemed to open some valve in his veins, and involuntarily he was telling.

'My father was a man who did not like work, and we had no mother. We lived in Austria, Polish Austria. How did we live? Ha! – somehow! Mostly in a room with three other families – one set in each corner – and the W.C. in the middle of the room – a pan with a plank on it – ha! I had two brothers and a sister – and there might be a woman with my father. He was a free being, in his way – would fight with any man in the town – a garrison town – and was a little man too. But he wouldn't work for anybody – set his heart against it, and wouldn't.'

'And how did you live then?' asked Ursula.

He looked at her - then, suddenly, at Gudrun.

'Do you understand?' he asked.

'Enough,' she replied.

Their eyes met for a moment. Then he looked away. He would say no more.

'And how did you become a sculptor?' asked Ursula.

'How did I become a sculptor – 'he paused. 'Dunque – 'he resumed, in a changed manner, and beginning to speak French – 'I became old enough – I used to steal from the market-place. Later I went to work – imprinted the stamp on clay bottles, before they were baked. It was an earthenware-bottle factory. There I began making models. One day, I had had enough. I lay in the sun and did not go to work. Then I walked to Munich – then I walked to Italy – begging, begging everything.'

'The Italians were very good to me – they were good and honourable to me. From Bozen to Rome, almost every night I had a meal and a bed, perhaps of straw, with some peasant. I love the Italian people, with all my heart.

'Dunque, adesso – maintenant¹²⁹ – I earn a thousand pounds in a year, or I earn two thousand – '

He looked down at the ground, his voice tailing off into silence.

Gudrun looked at his fine, thin, shiny skin, reddish-brown from the sun, drawn tight over his full temples; and at his thin hair – and at the thick, coarse, brush-like moustache, cut short about his mobile, rather shapeless mouth.

'How old are you?' she asked.

He looked up at her with his full, elfin eyes startled.

'Wie alt?' he repeated. And he hesitated. It was evidently one of his reticencies.

'How old are you?' he replied, without answering.

'I am twenty-six,' she answered.

'Twenty-six,' he repeated, looking into her eyes. He paused. Then he said:

'Und Ibr Herr Gemahl, wie alt is er?'

'Who?' asked Gudrun.

'Your husband,' said Ursula, with a certain irony.

'I haven't got a husband,' said Gudrun in English. In German she answered,

'He is thirty-one.'

But Loerke was watching closely, with his uncanny, full, suspicious eyes. Something in Gudrun seemed to accord with him. He was really like one of the 'little people' who have no soul, who has found his mate in a human being. But he suffered in his discovery. She too was fascinated by him, fascinated, as if some strange creature, a rabbit or a bat, or a brown seal, had begun to talk to her. But also, she knew what he was unconscious of, his tremendous power of understanding, of apprehending her living motion. He did not know his own power. He did not know how, with his full, submerged, watchful eyes, he could look into her and see her, what she was, see her secrets. He would only want her to be herself – he knew her verily, with a subconscious, sinister knowledge, devoid of illusions and hopes.

To Gudrun, there was in Loerke the rock-bottom of all life. Everybody else had their illusion, must have their illusion, their before and after. But he, with a perfect stoicism, did without any before and after, dispensed with all illusion. He did not deceive himself in the last issue. In the last issue he cared about nothing, he was troubled about nothing, he made not the slightest attempt to be at one with anything. He existed a pure, unconnected will, stoical and momentaneous. There was only his work.

It was curious too, how his poverty, the degradation of his earlier life, attracted her. There was something insipid and tasteless to her, in the idea of a gentleman, a man who had gone the usual course through school and university. A certain violent sympathy, however, came up in her for this mud-child. He seemed to be the very stuff of the underworld of life. There was no going beyond him.

Ursula too was attracted by Loerke. In both sisters he commanded a certain homage. But there were moments when to Ursula he seemed indescribably inferior, false, a vulgarism.

Both Birkin and Gerald disliked him, Gerald ignoring him with some contempt, Birkin exasperated.

'What do the women find so impressive in that little brat?' Gerald asked.

'God alone knows,' replied Birkin, 'unless it's some sort of appeal he makes to them, which flatters them and has such a power over them.'

Gerald looked up in surprise.

'Does he make an appeal to them?' he asked.

'Oh yes,' replied Birkin. 'He is the perfectly subjected being, existing almost like a criminal. And the women rush towards that, like a current of air towards a vacuum.'

'Funny they should rush to that,' said Gerald.

'Makes one mad, too,' said Birkin. 'But he has the fascination of pity and repulsion for them, a little obscene monster of the darkness that he is.'

Gerald stood still, suspended in thought.

'What do women want, at the bottom?' he asked.

Birkin shrugged his shoulders.

'God knows,' he said. 'Some satisfaction in basic repulsion, it seems to me. They seem to creep down some ghastly tunnel of darkness, and will never be satisfied till they've come to the end.'

Gerald looked out into the mist of fine snow that was blowing by. Everywhere was blind today, horribly blind.

'And what is the end?' he asked.

Birkin shook his head.

'I've not got there yet, so I don't know. Ask Loerke, he's pretty near. He is a good many stages further than either you or I can go.'

'Yes, but stages further in what?' cried Gerald, irritated.

Birkin sighed, and gathered his brows into a knot of anger.

'Stages further in social hatred,' he said. 'He lives like a rat, in the river of corruption, just where it falls over into the bottomless pit. He's further on than we are. He hates the ideal more acutely. He *bates* the ideal utterly, yet it still dominates him. I expect he is a Jew – or part Jewish.'

'Probably,' said Gerald.

'He is a gnawing little negation, gnawing at the roots of life.'

'But why does anybody care about him?' cried Gerald.

'Because they hate the ideal also, in their souls. They want to explore the sewers, and he's the wizard rat that swims ahead.'

Still Gerald stood and stared at the blind haze of snow outside.

'I don't understand your terms, really,' he said, in a flat, doomed voice. 'But it sounds a rum sort of desire.'

'I suppose we want the same,' said Birkin. 'Only we want to take a quick jump downwards, in a sort of ecstasy – and he ebbs with the stream, the sewer stream.'

Meanwhile Gudrun and Ursula waited for the next opportunity to talk to Loerke. It was no use beginning when the men were there. Then they could get into no touch with the isolated little sculptor. He had to be alone with them. And he preferred Ursula to be there, as a sort of transmitter to Gudrun.

'Do you do nothing but architectural sculpture?' Gudrun asked him one evening.

'Not now,' he replied. 'I have done all sorts – except portraits – I never did portraits. But other things –'

'What kind of things?' asked Gudrun.

He paused a moment, then rose, and went out of the room. He returned almost immediately with a little roll of paper, which he handed to her. She unrolled it. It was a photogravure reproduction of a statuette, signed F. Loerke.

'That is quite an early thing - not mechanical,' he said, 'more popular.'

The statuette was of a naked girl, small, finely made, sitting on a great naked horse. The girl was young and tender, a mere bud. She was sitting sideways on the horse, her face in her hands, as if in shame and grief, in a little abandon. Her hair, which was short and must be flaxen, fell forward, divided, half covering her hands.

Her limbs were young and tender. Her legs, scarcely formed yet, the legs of a maiden just passing towards cruel womanhood, dangled childishly over the side of the powerful horse, pathetically, the small feet folded one over the other, as if to hide. But there was no hiding. There she was exposed naked on the naked flank of the horse.

The horse stood stock still, stretched in a kind of start. It was a massive, magnificent stallion, rigid with pent-up power. Its neck was arched and terrible, like a sickle, its flanks were pressed back, rigid with power.

Gudrun went pale, and a darkness came over her eyes, like shame, she looked up with a certain supplication, almost slave-like. He glanced at her, and jerked his head a little.

'How big is it?' she asked, in a toneless voice, persisting in appearing casual and unaffected.

'How big?' he replied, glancing again at her. 'Without pedestal – so high – ' he measured with his hand – 'with pedestal, so – '

He looked at her steadily. There was a little brusque, turgid contempt for her in his swift gesture, and she seemed to cringe a little.

'And what is it done in?' she asked, throwing back her head and looking at him with affected coldness.

He still gazed at her steadily, and his dominance was not shaken.

'Bronze - green bronze.'

'Green bronze!' repeated Gudrun, coldly accepting his challenge. She was thinking of the slender, immature, tender limbs of the girl, smooth and cold in green bronze.

'Yes, beautiful,' she murmured, looking up at him with a certain dark homage.

He closed his eyes and looked aside, triumphant.

'Why,' said Ursula, 'did you make the horse so stiff? It is as stiff as a block.'

'Stiff?' he repeated, in arms at once.

'Yes. *Look* how stock and stupid and brutal it is. Horses are sensitive, quite delicate and sensitive, really.'

He raised his shoulders, spread his hands in a shrug of slow indifference, as much as to inform her she was an amateur and an impertinent nobody.

WOMEN IN LOVE

'Wissen Sie,'¹³⁰ he said, with an insulting patience and condescension in his voice, 'that horse is a certain *form*, part of a whole form. It is part of a work of art, a piece of form. It is not a picture of a friendly horse to which you give a lump of sugar, do you see – it is part of a work of art, it has no relation to anything outside that work of art.'

Ursula, angry at being treated quite so insultingly *de baut en bas*,¹³¹ from the height of esoteric art to the depth of general exoteric amateurism, replied, hotly, flushing and lifting her face.

'But it is a picture of a horse, nevertheless.'

He lifted his shoulders in another shrug.

'As you like - it is not a picture of a cow, certainly.'

Here Gudrun broke in, flushed and brilliant, anxious to avoid any more of this, any more of Ursula's foolish persistence in giving herself away.

'What do you mean by "it is a picture of a horse?" 'she cried at her sister. 'What do you mean by a horse? You mean an idea you have in *your* head, and which you want to see represented. There is another idea altogether, quite another idea. Call it a horse if you like, or say it is not a horse. I have just as much right to say that *your* horse isn't a horse, that it is a falsity of your own make-up.'

Ursula wavered, baffled. Then her words came.

'But why does he have this idea of a horse?' she said. 'I know it is his idea. I know it is a picture of himself, really - '

Loerke snorted with rage.

'A picture of myself!' he repeated, in derision. 'Wissen sie, gnädige Frau, that is a Kunstwerk, a work of art. It is a work of art, it is a picture of nothing, of absolutely nothing. It has nothing to do with anything but itself, it has no relation with the everyday world of this and other, there is no connection between them, absolutely none, they are two different and distinct planes of existence, and to translate one into the other is worse than foolish, it is a darkening of all counsel, a making confusion everywhere. Do you see, you *must not* confuse the relative work of action, with the absolute world of art. That you *must not do*.'

'That is quite true,' cried Gudrun, let loose in a sort of rhapsody. 'The two things are quite and permanently apart, they have *nothing* to do with one another. *I* and my art, they have nothing to do with each other. My art stands in another world, I am in this world.'

Her face was flushed and transfigured. Loerke who was sitting with his head ducked, like some creature at bay, looked up at her, swiftly, almost furtively, and murmured,

'Ja - so ist es, so ist es.'¹³²

Ursula was silent after this outburst. She was furious. She wanted to

poke a hole into them both.

'It isn't a word of it true, of all this harangue you have made me,' she replied flatly. 'The horse is a picture of your own stock, stupid brutality, and the girl was a girl you loved and tortured and then ignored.'

He looked up at her with a small smile of contempt in his eyes. He would not trouble to answer this last charge.

Gudrun too was silent in exasperated contempt. Ursula *was* such an insufferable outsider, rushing in where angels would fear to tread. But then – fools must be suffered, if not gladly.

But Ursula was persistent too.

'As for your world of art and your world of reality,' she replied, 'you have to separate the two, because you can't bear to know what you are. You can't bear to realise what a stock, stiff, hide-bound brutality you *are* really, so you say "it's the world of art." The world of art is only the truth about the real world, that's all – but you are too far gone to see it.'

She was white and trembling, intent. Gudrun and Loerke sat in stiff dislike of her. Gerald too, who had come up in the beginning of the speech, stood looking at her in complete disapproval and opposition. He felt she was undignified, she put a sort of vulgarity over the esotericism which gave man his last distinction. He joined his forces with the other two. They all three wanted her to go away. But she sat on in silence, her soul weeping, throbbing violently, her fingers twisting her handkerchief.

The others maintained a dead silence, letting the display of Ursula's obtrusiveness pass by. Then Gudrun asked, in a voice that was quite cool and casual, as if resuming a casual conversation:

'Was the girl a model?'

'Nein, sie war kein Modell. Sie war eine kleine Malschülerin.'133

'An art-student!' replied Gudrun.

And how the situation revealed itself to her! She saw the girl artstudent, unformed and of pernicious recklessness, too young, her straight flaxen hair cut short, hanging just into her neck, curving inwards slightly, because it was rather thick; and Loerke, the wellknown master-sculptor, and the girl, probably well-brought-up, and of good family, thinking herself so great to be his mistress. Oh how well she knew the common callousness of it all. Dresden, Paris, or London, what did it matter? She knew it.

'Where is she now?' Ursula asked.

Loerke raised his shoulders, to convey his complete ignorance and indifference.

'That is already six years ago,' he said; 'she will be twenty-three years old, no more good.'

Gerald had picked up the picture and was looking at it. It attracted him also. He saw on the pedestal, that the piece was called 'Lady Godiva.'

'But this isn't Lady Godiva,' he said, smiling good-humouredly. 'She was the middle-aged wife of some Earl or other, who covered herself with her long hair.'

'A la Maud Allan,'134 said Gudrun with a mocking grimace.

'Why Maud Allan?' he replied. 'Isn't it so? I always thought the legend was that.'

'Yes, Gerald dear, I'm quite sure you've got the legend perfectly.'

She was laughing at him, with a little, mock-caressive contempt.

'To be sure, I'd rather see the woman than the hair,' he laughed in return.

'Wouldn't you just!' mocked Gudrun.

Ursula rose and went away, leaving the three together.

Gudrun took the picture again from Gerald, and sat looking at it closely.

'Of course,' she said, turning to tease Loerke now, 'you *understood* your little Malschülerin.'

He raised his eyebrows and his shoulders in a complacent shrug.

'The little girl?' asked Gerald, pointing to the figure.

Gudrun was sitting with the picture in her lap. She looked up at Gerald, full into his eyes, so that he seemed to be blinded.

'Didn't he understand her!' she said to Gerald, in a slightly mocking, humorous playfulness. 'You've only to look at the feet - aren't they darling, so pretty and tender - oh, they're really wonderful, they are really -'

She lifted her eyes slowly, with a hot, flaming look into Loerke's eyes. His soul was filled with her burning recognition, he seemed to grow more uppish and lordly.

Gerald looked at the small, sculptured feet. They were turned together, half covering each other in pathetic shyness and fear. He looked at them a long time, fascinated. Then, in some pain, he put the picture away from him. He felt full of barrenness.

'What was her name?' Gudrun asked Loerke.

'Annette von Weck,' Loerke replied reminiscent. 'Ja, sie war hübsch.¹³⁵ She was pretty – but she was tiresome. She was a nuisance, – not for a minute would she keep still – not until I'd slapped her hard and made her cry – then she'd sit for five minutes.'

He was thinking over the work, his work, the all important to him.

'Did you really slap her?' asked Gudrun, coolly.

He glanced back at her, reading her challenge.

'Yes, I did,' he said, nonchalant, 'harder than I have ever beat anything in my life. I had to, I had to. It was the only way I got the work done.'

Gudrun watched him with large, dark-filled eyes, for some moments. She seemed to be considering his very soul. Then she looked down, in silence.

'Why did you have such a young Godiva then?' asked Gerald. 'She is so small, besides, on the horse – not big enough for it – such a child.'

A queer spasm went over Loerke's face.

'Yes,' he said. 'I don't like them any bigger, any older. Then they are beautiful, at sixteen, seventeen, eighteen – after that, they are no use to me.'

There was a moment's pause.

'Why not?' asked Gerald.

Loerke shrugged his shoulders.

'I don't find them interesting – or beautiful – they are no good to me, for my work.'

'Do you mean to say a woman isn't beautiful after she is twenty?' asked Gerald.

'For me, no. Before twenty, she is small and fresh and tender and slight. After that – let her be what she likes, she has nothing for me. The Venus of Milo¹³⁶ is a bourgeoise – so are they all.'

'And you don't care for women at all after twenty?' asked Gerald.

'They are no good to me, they are of no use in my art,' Loerke repeated impatiently. 'I don't find them beautiful.'

'You are an epicure,'¹³⁷ said Gerald, with a slight sarcastic laugh.

'And what about men?' asked Gudrun suddenly.

'Yes, they are good at all ages,' replied Loerke. 'A man should be big and powerful – whether he is old or young is of no account, so he has the size, something of massiveness and – and stupid form.'

Ursula went out alone into the world of pure, new snow. But the dazzling whiteness seemed to beat upon her till it hurt her, she felt the cold was slowly strangling her soul. Her head felt dazed and numb.

Suddenly she wanted to go away. It occurred to her, like a miracle, that she might go away into another world. She had felt so doomed up here in the eternal snow, as if there were no beyond.

Now suddenly, as by a miracle she remembered that away beyond, below her, lay the dark fruitful earth, that towards the south there were stretches of land dark with orange trees and cypress, grey with olives, that ilex trees lifted wonderful plumy tufts in shadow against a blue sky. Miracle of miracles! – this utterly silent, frozen world of the mountain-tops was not universal! One might leave it and have done with it. One might go away.

She wanted to realise the miracle at once. She wanted at this instant to have done with the snow-world, the terrible, static ice-built mountain tops. She wanted to see the dark earth, to smell its earthy fecundity, to see the patient wintry vegetation, to feel the sunshine touch a response in the buds.

She went back gladly to the house, full of hope. Birkin was reading, lying in bed.

'Rupert,' she said, bursting in on him. 'I want to go away.'

He looked up at her slowly.

'Do you?' he replied mildly.

She sat by him und put her arms round his neck. It surprised her that he was so little surprised.

'Don't you?' she asked troubled.

'I hadn't thought about it,' he said. 'But I'm sure I do.'

She sat up, suddenly erect.

'I hate it,' she said. 'I hate the snow, and the unnaturalness of it, the unnatural light it throws on everybody, the ghastly glamour, the unnatural feelings it makes everybody have.'

He lay still and laughed, meditating.

'Well,' he said, 'we can go away – we can go tomorrow. We'll go tomorrow to Verona, and find Romeo and Juliet, and sit in the amphitheatre – shall we?'

Suddenly she hid her face against his shoulder with perplexity and shyness. He lay so untrammelled.

'Yes,' she said softly, filled with relief. She felt her soul had new wings, now he was so uncaring. 'I shall love to be Romeo and Juliet,' she said. 'My love!'

'Though a fearfully cold wind blows in Verona,' he said, 'from out of the Alps. We shall have the smell of the snow in our noses.'

She sat up and looked at him.

'Are you glad to go?' she asked, troubled.

His eyes were inscrutable and laughing. She hid her face against his neck, clinging close to him, pleading:

'Don't laugh at me – don't laugh at me.'

'Why how's that?' he laughed, putting his arms round her.

'Because I don't want to be laughed at,' she whispered.

He laughed more, as he kissed her delicate, finely perfumed hair.

'Do you love me?' she whispered, in wild seriousness.

'Yes,' he answered, laughing.

Suddenly she lifted her mouth to be kissed. Her lips were taut and

quivering and strenuous, his were soft, deep and delicate. He waited a few moments in the kiss. Then a shade of sadness went over his soul.

'Your mouth is so hard,' he said, in faint reproach.

'And yours is so soft and nice,' she said gladly.

'But why do you always grip your lips?' he asked, regretful.

'Nover mind,' she said swiftly. 'It is my way.'

She knew he loved her; she was sure of him. Yet she could not let go a certain hold over herself, she could not bear him to question her. She gave herself up in delight to being loved by him. She knew that, in spite of his joy when she abandoned herself, he was a little bit saddened too. She could give herself up to his activity. But she could not be herself, she *dared* not come forth quite nakedly to his nakedness, abandoning all adjustment, lapsing in pure faith with him. She abandoned herself to *bim*, or she took hold of him and gathered her joy of him. And she enjoyed him fully. But they were never *quite* together, at the same moment, one was always a little left out. Nevertheless she was glad in hope, glorious and free, full of life and liberty. And he was still and soft and patient, for the time.

They made their preparations to leave the next day. First they went to Gudrun's room, where she and Gerald were just dressed ready for the evening indoors.

'Prune,' said Ursula, 'I think we shall go away tomorrow. I can't stand the snow any more. It hurts my skin and my soul.'

'Does it really hurt your soul, Ursula?' asked Gudrun, in some surprise. 'I can believe quite it hurts your skin – it is *terrible*. But I thought it was *admirable* for the soul.'

'No, not for mine. It just injures it,' said Ursula.

'Really!' cried Gudrun.

There was a silence in the room. And Ursula and Birkin could feel that Gudrun and Gerald were relieved by their going.

'You will go south?' said Gerald, a little ring of uneasiness in his voice.

'Yes,' said Birkin, turning away. There was a queer, indefinable hostility between the two men, lately. Birkin was on the whole dim and indifferent, drifting along in a dim, easy flow, unnoticing and patient, since he came abroad, whilst Gerald on the other hand, was intense and gripped into white light, agonistes. The two men revoked one another.

Gerald and Gudrun were very kind to the two who were departing, solicitous for their welfare as if they were two children. Gudrun came to Ursula's bedroom with three pairs of the coloured stockings for which she was notorious, and she threw them on the bed. But these were thick silk stockings, vermilion, cornflower blue, and grey, bought

WOMEN IN LOVE

in Paris. The grey ones were knitted, seamless and heavy. Ursula was in raptures. She knew Gudrun must be feeling *very* loving, to give away such treasures.

'I can't take them from you, Prune,' she cried. 'I can't possibly deprive you of them - the jewels.'

'Aren't they jewels!' cried Gudrun, eyeing her gifts with an envious eye. 'Aren't they real lambs!'

Yes, you must keep them,' said Ursula.

'I don't *want* them, I've got three more pairs. I *want* you to keep them – I want you to have them. They're yours, there – '

And with trembling, excited hands she put the coveted stockings under Ursula's pillow.

'One gets the greatest joy of all out of really lovely stockings,' said Ursula.

'One does,' replied Gudrun; 'the greatest joy of all.'

And she sat down in the chair. It was evident she had come for a last talk. Ursula, not knowing what she wanted, waited in silence.

'Do you *feel*, Ursula,' Gudrun began, rather sceptically, that you are going-away-for-ever, never-to-return, sort of thing?'

'Oh, we shall come back,' said Ursula. 'It isn't a question of trainjourneys.'

'Yes, I know. But spiritually, so to speak, you are going away from us all?'

Ursula quivered.

'I don't know a bit what is going to happen,' she said. 'I only know we are going somewhere.'

Gudrun waited.

'And you are glad?' she asked.

Ursula meditated for a moment.

'I believe I am very glad,' she replied.

But Gudrun read the unconscious brightness on her sister's face, rather than the uncertain tones of her speech.

'But don't you think you'll *want* the old connection with the world – father and the rest of us, and all that it means, England and the world of thought – don't you think you'll *need* that, really to make a world?'

Ursula was silent, trying to imagine.

'I think,' she said at length, involuntarily, 'that Rupert is right – one wants a new space to be in, and one falls away from the old.'

Gudrun watched her sister with impassive face and steady eyes.

'One wants a new space to be in, I quite agree,' she said. 'But *I* think that a new world is a development from this world, and that to isolate oneself with one other person, isn't to find a new world at all, but only

to secure oneself in one's illusions.'

Ursula looked out of the window. In her soul she began to wrestle, and she was frightened. She was always frightened of words, because she knew that mere word-force could always make her believe what she did not believe.

'Perhaps,' she said, full of mistrust, of herself and everybody. 'But,' she added, 'I do think that one can't have anything new whilst one cares for the old – do you know what I mean? – even fighting the old is belonging to it. I know, one is tempted to stop with the world, just to fight it. But then it isn't worth it.'

Gudrun considered herself.

'Yes,' she said. 'In a way, one is of the world if one lives in it. But isn't it really an illusion to think you can get out of it? After all, a cottage in the Abruzzi, or wherever it may be, isn't a new world. No, the only thing to do with the world, is to see it through.'

Ursula looked away. She was so frightened of argument.

'But there *can* be something else, can't there?' she said. 'One can see it through in one's soul, long enough before it sees itself through in actuality. And then, when one has seen one's soul, one is something else.'

'Can one see it through in one's soul?' asked Gudrun. 'If you mean that you can see to the end of what will happen, I don't agree. I really can't agree. And anyhow, you can't suddenly fly off on to a new planet, because you think you can see to the end of this.'

Ursula suddenly straightened herself.

'Yes,' she said. 'Yes – one knows. One has no more connections here. One has a sort of other self, that belongs to a new planet, not to this. You've got to hop off.'

Gudrun reflected for a few moments. Then a smile of ridicule, almost of contempt, came over her face.

'And what will happen when you find yourself in space?' she cried in derision. 'After all, the great ideas of the world are the same there. You above everybody can't get away from the fact that love, for instance, is the supreme thing, in space as well as on earth.'

'No,' said Ursula, 'it isn't. Love is too human and little. I believe in something inhuman, of which love is only a little part. I believe what we must fulfil comes out of the unknown to us, and it is something infinitely more than love. It isn't so merely *human*.'

Gudrun looked at Ursula with steady, balancing eyes. She admired and despised her sister so much, both! Then, suddenly she averted her face, saying coldly, uglily:

'Well, I've got no further than love, yet.'

WOMEN IN LOVE

Over Ursula's mind flashed the thought: 'Because you never *have* loved, you can't get beyond it.'

Gudrun rose, came over to Ursula and put her arm round her neck.

'Go and find your new world, dear,' she said, her voice clanging with false benignity. 'After all, the happiest voyage is the quest of Rupert's Blessed Isles.'¹³⁸

Her arm rested round Ursula's neck, her fingers on Ursula's cheek for a few moments. Ursula was supremely uncomfortable meanwhile. There was an insult in Gudrun's protective patronage that was really too hurting. Feeling her sister's resistance, Gudrun drew awkwardly away, turned over the pillow, and disclosed the stockings again.

'Ha – ha!' she laughed, rather hollowly. 'How we do talk indeed – new worlds and old - !'

And they passed to the familiar worldly subjects.

Gerald and Birkin had walked on ahead, waiting for the sledge to overtake them, conveying the departing guests.

'How much longer will you stay here?' asked Birkin, glancing up at Gerald's very red, almost blank face.

'Oh, I can't say,' Gerald replied. 'Till we get tired of it.'

'You're not afraid of the snow melting first?' asked Birkin.

Gerald laughed.

'Does it melt?' he said.

'Things are all right with you then?' said Birkin.

Gerald screwed up his eyes a little.

'All right?' he said. 'I never know what those common words mean. All right and all wrong, don't they become synonymous, somewhere?'

'Yes, I suppose. How about going back?' asked Birkin.

'Oh, I don't know. We may never get back. I don't look before and after,' said Gerald.

'Nor pine for what is not,' said Birkin.

Gerald looked into the distance, with the small-pupilled, abstract eyes of a hawk.

'No. There's something final about this. And Gudrun seems like the end, to me. I don't know – but she seems so soft, her skin like silk, her arms heavy and soft. And it withers my consciousness, somehow, it burns the pith of my mind.' He went on a few paces, staring ahead, his eyes fixed, looking like a mask used in ghastly religions of the barbarians. 'It blasts your soul's eye,' he said, 'and leaves you sightless. Yet you *want* to be sightless, you *want* to be blasted, you don't want it any different.'

He was speaking as if in a trance, verbal and blank. Then suddenly he braced himself up with a kind of rhapsody, and looked at Birkin with

vindictive, cowed eyes, saying:

'Do you know what it is to suffer when you are with a woman? She's so beautiful, so perfect, you find her *so good*, it tears you like a silk, and every stroke and bit cuts hot – ha, that perfection, when you blast yourself! And then – ' he stopped on the snow and suddenly opened his clenched hands – 'it's nothing – your brain might have gone charred as rags – and – ' he looked round into the air with a queer histrionic movement 'it's blasting – you understand what I mean – it is a great experience, something final – and then – you're shrivelled as if struck by electricity.' He walked on in silence. It seemed like bragging, but like a man in extremity bragging truthfully.

'Of course,' he resumed, 'I wouldn't *not* have had it! It's a complete experience. And she's a wonderful woman. But – how I hate her somewhere! It's curious – '

Birkin looked at him, at his strange, scarcely conscious face. Gerald seemed blank before his own words.

'But you've had enough now?' said Birkin. 'You have had your experience. Why work on an old wound?'

'Oh,' said Gerald, 'I don't know. It's not finished -'

And the two walked on.

'I've loved you, as well as Gudrun, don't forget,' said Birkin bitterly. Gerald looked at him strangely, abstractedly.

'Have you?' he said, with icy scepticism. 'Or do you think you have?' He was hardly responsible for what he said.

The sledge came. Gudrun dismounted and they all made their farewell. They wanted to go apart, all of them. Birkin took his place, and the sledge drove away leaving Gudrun and Gerald standing on the snow, waving. Something froze Birkin's heart, seeing them standing there in the isolation of the snow, growing smaller and more isolated.

CHAPTER XXX

Snowed Up

WHEN URSULA and Birkin were gone, Gudrun felt herself free in her contest with Gerald. As they grew more used to each other, he seemed to press upon her more and more. At first she could manage him, so that her own will was always left free. But very soon, he began to ignore her female tactics, he dropped his respect for her whims and her privacies, he began to exert his own will blindly, without submitting to hers.

WOMEN IN LOVE

Already a vital conflict had set in, which frightened them both. But he was alone, whilst already she had begun to cast round for external resource.

When Ursula had gone, Gudrun felt her own existence had become stark and elemental. She went and crouched alone in her bedroom, looking out of the window at the big, flashing stars. In front was the faint shadow of the mountain-knot. That was the pivot. She felt strange and inevitable, as if she were centred upon the pivot of all existence, there was no further reality.

Presently Gerald opened the door. She knew he would not be long before he came. She was rarely alone, he pressed upon her like a frost, deadening her.

'Are you alone in the dark?' he said. And she could tell by his tone he resented it, he resented this isolation she had drawn round herself. Yet, feeling static and inevitable, she was kind towards him.

'Would you like to light the candle?' she asked.

He did not answer, but came and stood behind her, in the darkness.

'Look,' she said, 'at that lovely star up there. Do you know its name?' He crouched beside her, to look through the low window.

'No,' he said. 'It is very fine.'

'*Isn't* it beautiful! Do you notice how it darts different coloured fires – it flashes really superbly – '

They remained in silence. With a mute, heavy gesture she put her hand on his knee, and took his hand.

'Are you regretting Ursula?' he asked.

'No, not at all,' she said. Then, in a slow mood, she asked:

'How much do you love me?'

He stiffened himself further against her.

'How much do you think I do?' he asked.

'I don't know,' she replied.

'But what is your opinion?' he asked.

There was a pause. At length, in the darkness, came her voice, hard and indifferent:

'Very little indeed,' she said coldly, almost flippant.

His heart went icy at the sound of her voice.

'Why don't I love you?' he asked, as if admitting the truth of her accusation, yet hating her for it.

'I don't know why you don't – I've been good to you. You were in a *fearful* state when you came to me.'

Her heart was beating to suffocate her, yet she was strong and unrelenting.

'When was I in a fearful state?' he asked.

'When you first came to me. I had to take pity on you. But it was never love.'

It was that statement 'It was never love,' which sounded in his ears with madness.

'Why must you repeat it so often, that there is no love?' he said in a voice strangled with rage.

'Well you don't think you love, do you?' she asked.

He was silent with cold passion of anger.

'You don't think you *can* love me, do you?' she repeated almost with a sneer.

'No,' he said.

'You know you never have loved me, don't you?'

'I don't know what you mean by the word 'love,' he replied.

'Yes, you do. You know all right that you have never loved me. Have you, do you think?'

'No,' he said, prompted by some barren spirit of truthfulness and obstinacy.

'And you never will love me,' she said finally, 'will you?'

There was a diabolic coldness in her, too much to bear.

'No,' he said.

'Then,' she replied, 'what have you against me!'

He was silent in cold, frightened rage and despair. If only I could kill her,' his heart was whispering repeatedly. If only I could kill her -I should be free.'

It seemed to him that death was the only severing of this Gordian knot.

'Why do you torture me?' he said.

She flung her arms round his neck.

'Ah, I don't want to torture you,' she said pityingly, as if she were comforting a child. The impertinence made his veins go cold, he was insensible. She held her arms round his neck, in a triumph of pity. And her pity for him was as cold as stone, its deepest motive was hate of him, and fear of his power over her, which she must always counterfoil.

'Say you love me,' she pleaded. 'Say you will love me for ever – won't you – won't you?'

But it was her voice only that coaxed him. Her senses were entirely apart from him, cold and destructive of him. It was her overbearing *will* that insisted.

'Won't you say you'll love me always?' she coaxed. 'Say it, even if it isn't true – say it Gerald, do.'

'I will love you always,' he repeated, in real agony, forcing the words out.

She gave him a quick kiss.

'Fancy your actually having said it,' she said with a touch of raillery.

He stood as if he had been beaten.

'Try to love me a little more, and to want me a little less,' she said, in a half contemptuous, half coaxing tone.

The darkness seemed to be swaying in waves across his mind, great waves of darkness plunging across his mind. It seemed to him he was degraded at the very quick, made of no account.

'You mean you don't want me?' he said.

'You are so insistent, and there is so little grace in you, so little fineness. You are so crude. You break me – you only waste me – it is horrible to me.'

'Horrible to you?' he repeated.

'Yes. Don't you think I might have a room to myself, now Ursula has gone? You can say you want a dressing room.'

'You do as you like - you can leave altogether if you like,' he managed to articulate.

'Yes, I know that,' she replied. 'So can you. You can leave me whenever you like - without notice even.'

The great tides of darkness were swinging across his mind, he could hardly stand upright. A terrible weariness overcame him, he felt he must lie on the floor. Dropping off his clothes, he got into bed, and lay like a man suddenly overcome by drunkenness, the darkness lifting and plunging as if he were lying upon a black, giddy sea. He lay still in this strange, horrific reeling for some time, purely unconscious.

At length she slipped from her own bed and came over to him. He remained rigid, his back to her. He was all but unconscious.

She put her arms round his terrifying, insentient body, and laid her cheek against his hard shoulder.

'Gerald,' she whispered. 'Gerald.'

There was no change in him. She caught him against her. She pressed her breasts against his shoulders, she kissed his shoulder, through the sleeping jacket. Her mind wondered, over his rigid, unliving body. She was bewildered, and insistent, only her will was set for him to speak to her.

'Gerald, my dear!' she whispered, bending over him, kissing his ear.

Her warm breath playing, flying rhythmically over his ear, seemed to relax the tension. She could feel his body gradually relaxing a little, losing its terrifying, unnatural rigidity. Her hands clutched his limbs, his muscles, going over him spasmodically.

The hot blood began to flow again through his veins, his limbs relaxed.

'Turn round to me,' she whispered, forlorn with insistence and triumph.

So at last he was given again, warm and flexible. He turned and gathered her in his arms. And feeling her soft against him, so perfectly and wondrously soft and recipient, his arms tightened on her. She was as if crushed, powerless in him. His brain seemed hard and invincible now like a jewel, there was no resisting him.

His passion was awful to her, tense and ghastly, and impersonal, like a destruction, ultimate. She felt it would kill her. She was being killed.

'My God, my God,' she cried, in anguish, in his embrace, feeling her life being killed within her. And when he was kissing her, soothing her, her breath came slowly, as if she were really spent, dying.

'Shall I die, shall I die?' she repeated to herself.

And in the night, and in him, there was no answer to the question.

And yet, next day, the fragment of her which was not destroyed remained intact and hostile, she did not go away, she remained to finish the holiday, admitting nothing. He scarcely ever left her alone, but followed her like a shadow, he was like a doom upon her, a continual 'thou shalt,' 'thou shalt not.' Sometimes it was he who seemed strongest, whilst she was almost gone, creeping near the earth like a spent wind; sometimes it was the reverse. But always it was this eternal see-saw, one destroyed that the other might exist, one ratified because the other was nulled.

'In the end,' she said to herself, 'I shall go away from him.'

'I can be free of her,' he said to himself in his paroxysms of suffering.

And he set himself to be free. He even prepared to go away, to leave her in the lurch. But for the first time there was a flaw in his will.

'Where shall I go?' he asked himself.

'Can't you be self-sufficient?' he replied to himself, putting himself upon his pride.

'Self-sufficient!' he repeated.

It seemed to him that Gudrun was sufficient unto herself, closed round and completed, like a thing in a case. In the calm, static reason of his soul, he recognised this, and admitted it was her right, to be closed round upon herself, self-complete, without desire. He realised it, he admitted it, it only needed one last effort on his own part, to win for himself the same completeness. He knew that it only needed one convulsion of his will for him to be able to turn upon himself also, to close upon himself as a stone fixes upon itself, and is impervious, selfcompleted, a thing isolated.

This knowledge threw him into a terrible chaos. Because, however much he might mentally *will* to be immune and self-complete, the

WOMEN IN LOVE

desire for this state was lacking, and he could not create it. He could see that, to exist at all, he must be perfectly free of Gudrun, leave her if she wanted to be left, demand nothing of her, have no claim upon her.

But then, to have no claim upon her, he must stand by himself, in sheer nothingness. And his brain turned to nought at the idea. It was a state of nothingness. On the other hand, he might give in, and fawn to her. Or, finally, he might kill her. Or he might become just indifferent, purposeless, dissipated, momentaneous. But his nature was too serious, not gay enough or subtle enough for mocking licentiousness.

A strange rent had been torn in him; like a victim that is torn open and given to the heavens, so he had been torn apart and given to Gudrun. How should he close again? This wound, this strange, infinitely-sensitive opening of his soul, where he was exposed, like an open flower, to all the universe, and in which he was given to his complement, the other, the unknown, this wound, this disclosure, this unfolding of his own covering, leaving him incomplete, limited, unfinished, like an open flower under the sky, this was his cruellest joy. Why then should he forego it? Why should he close up and become impervious, immune, like a partial thing in a sheath, when he had broken forth, like a seed that has germinated, to issue forth in being, embracing the unrealised heavens.

He would keep the unfinished bliss of his own yearning even through the torture she inflicted upon him. A strange obstinacy possessed him. He would not go away from her whatever she said or did. A strange, deathly yearning carried him along with her. She was the determinating influence of his very being, though she treated him with contempt, repeated rebuffs, and denials, still he would never be gone, since in being near her, even, he felt the quickening, the going forth in him, the release, the knowledge of his own limitation and the magic of the promise, as well as the mystery of his own destruction and annihilation.

She tortured the open heart of him even as he turned to her. And she was tortured herself. It may have been her will was stronger. She felt, with horror, as if he tore at the bud of her heart, tore it open, like an irreverent persistent being. Like a boy who pulls off a fly's wings, or tears open a bud to see what is in the flower, he tore at her privacy, at her very life, he would destroy her as an immature bud, torn open, is destroyed.

She might open towards him, a long while hence, in her dreams, when she was a pure spirit. But now she was not to be violated and ruined. She closed against him fiercely.

They climbed together, at evening, up the high slope, to see the

sunset. In the finely breathing, keen wind they stood and watched the yellow sun sink in crimson and disappear. Then in the east the peaks and ridges glowed with living rose, incandescent like immortal flowers against a brown-purple sky, a miracle, whilst down below the world was a bluish shadow, and above, like an annunciation, hovered a rosy transport in mid-air.

To her it was so beautiful, it was a delirium, she wanted to gather the glowing, eternal peaks to her breast, and die. He saw them, saw they were beautiful. But there arose no clamour in his breast, only a bitterness that was visionary in itself. He wished the peaks were grey and unbeautiful, so that she should not get her support from them. Why did she betray the two of them so terribly, in embracing the glow of the evening? Why did she leave him standing there, with the ice-wind blowing through his heart, like death, to gratify herself among the rosy snow-tips?

'What does the twilight matter?' he said. 'Why do you grovel before it? Is it so important to you?'

She winced in violation and in fury.

'Go away,' she cried, 'and leave me to it. It is beautiful, beautiful,' she sang in strange, rhapsodic tones. 'It is the most beautiful thing I have ever seen in my life. Don't try to come between it and me. Take yourself away, you are out of place -'

He stood back a little, and left her standing there, statue-like, transported into the mystic glowing east. Already the rose was fading, large white stars were flashing out. He waited. He would forego everything but the yearning.

'That was the most perfect thing I have ever seen,' she said in cold, brutal tones, when at last she turned round to him. 'It amazes me that you should want to destroy it. If you can't see it yourself, why try to debar me?' But in reality, he had destroyed it for her, she was straining after a dead effect.

'One day,' he said, softly, looking up at her, 'I shall destroy you, as you stand looking at the sunset; because you are such a liar.'

There was a soft, voluptuous promise to himself in the words. She was chilled but arrogant.

'Ha!' she said. 'I am not afraid of your threats!' She denied herself to him, she kept her room rigidly private to herself. But he waited on, in a curious patience, belonging to his yearning for her.

'In the end,' he said to himself with real voluptuous promise, 'when it reaches that point, I shall do away with her.' And he trembled delicately in every limb, in anticipation, as he trembled in his most violent accesses of passionate approach to her, trembling with too much desire. She had a curious sort of allegiance with Loerke, all the while, now, something insidious and traitorous. Gerald knew of it. But in the unnatural state of patience, and the unwillingness to harden himself against her, in which he found himself, he took no notice, although her soft kindliness to the other man, whom he hated as a noxious insect, made him shiver again with an access of the strange shuddering that came over him repeatedly.

He left her alone only when he went skiing, a sport he loved, and which she did not practise. Then he seemed to sweep out of life, to be a projectile into the beyond. And often, when he went away, she talked to the little German sculptor. They had an invariable topic, in their art.

They were almost of the same ideas. He hated Mestrovic, 139 was not satisfied with the Futurists, he liked the West African wooden figures, the Aztec art, Mexican and Central American. He saw the grotesque, and a curious sort of mechanical motion intoxicated him, a confusion in nature. They had a curious game with each other, Gudrun and Loerke, of infinite suggestivity, strange and leering, as if they had some esoteric understanding of life, that they alone were initiated into the fearful central secrets, that the world dared not know. Their whole correspondence was in a strange, barely comprehensible suggestivity, they kindled themselves at the subtle lust of the Egyptians or the Mexicans. The whole game was one of subtle inter-suggestivity, and they wanted to keep it on the plane of suggestion. From their verbal and physical nuances they got the highest satisfaction in the nerves, from a queer interchange of half-suggested ideas, looks, expressions and gestures, which were quite intolerable, though incomprehensible, to Gerald. He had no terms in which to think of their commerce, his terms were much too gross.

The suggestion of primitive art was their refuge, and the inner mysteries of sensation their object of worship. Art and Life were to them the Reality and the Unreality.

'Of course,' said Gudrun, 'life doesn't *really* matter – it is one's art which is central. What one does in one's life has *peu de rapport*,¹⁴⁰ it doesn't signify much.'

'Yes, that is so, exactly,' replied the sculptor. 'What one does in one's art, that is the breath of one's being. What one does in one's life, that is a bagatelle for the outsiders to fuss about.'

It was curious what a sense of elation and freedom Gudrun found in this communication. She felt established for ever. Of course Gerald was *bagatelle*.¹⁴¹ Love was one of the temporal things in her life, except in so far as she was an artist. She thought of Cleopatra – Cleopatra must have been an artist; she reaped the essential from a man, she harvested the ultimate sensation, and threw away the husk; and Mary Stuart, and the great Rachel, panting with her lovers after the theatre, these were the exoteric exponents of love. After all, what was the lover but fuel for the transport of this subtle knowledge, for a female art, the art of pure, perfect knowledge in sensuous understanding.

One evening Gerald was arguing with Loerke about Italy and Tripoli. The Englishman was in a strange, inflammable state, the German was excited. It was a contest of words, but it meant a conflict of spirit between the two men. And all the while Gudrun could see in Gerald an arrogant English contempt for a foreigner. Although Gerald was quivering, his eyes flashing, his face flushed, in his argument there was a brusqueness, a savage contempt in his manner, that made Gudrun's blood flare up, and made Loerke keen and mortified. For Gerald came down like a sledge-hammer with his assertions, anything the little German said was merely contemptible rubbish.

At last Loerke turned to Gudrun, raising his hands in helpless irony, a shrug of ironical dismissal, something appealing and child-like.

'Sehen sie, gnädige Frau - ' he began.

'Bitte sagen Sie nicht immer, gnädige Frau,' cried Gudrun, her eyes flashing, her cheeks burning. She looked like a vivid Medusa.¹⁴² Her voice was loud and clamorous, the other people in the room were startled.

'Please don't call me Mrs Crich,' she cried aloud.

The name, in Loerke's mouth particularly, had been an intolerable humiliation and constraint upon her, these many days.

The two men looked at her in amazement. Gerald went white at the cheek-bones.

'What shall I say, then?' asked Loerke, with soft, mocking insinuation. 'Sagen Sie nur nicht das,' she muttered, her cheeks flushed crimson. 'Not that, at least.'

She saw, by the dawning look on Locrke's face, that he had understood. She was *not* Mrs Crich! So-o-, that explained a great deal.

'Soll ich Fräulein sagen?'143 he asked, malevolently.

'I am not married,' she said, with some hauteur.

Her heart was fluttering now, beating like a bewildered bird. She knew she had dealt a cruel wound, and she could not bear it.

Gerald sat erect, perfectly still, his face pale and calm, like the face of a statue. He was unaware of her, or of Loerke or anybody. He sat perfectly still, in an unalterable calm. Loerke, meanwhile, was crouching and glancing up from under his ducked head.

Gudrun was tortured for something to say, to relieve the suspense. She twisted her face in a smile, and glanced knowingly, almost sneering, at Gerald.

'Truth is best,' she said to him, with a grimace.

But now again she was under his domination; now, because she had dealt him this blow; because she had destroyed him, and she did not know how he had taken it. She watched him. He was interesting to her. She had lost her interest in Loerke.

Gerald rose at length, and went over in a leisurely still movement, to the Professor. The two began a conversation on Goethe.¹⁴⁴

She was rather piqued by the simplicity of Gerald's demeanour this evening. He did not seem angry or disgusted, only he looked curiously innocent and pure, really beautiful. Sometimes it came upon him, this look of clear distance, and it always fascinated her.

She waited, troubled, throughout the evening. She thought he would avoid her, or give some sign. But he spoke to her simply and unemotionally, as he would to anyone else in the room. A certain peace, an abstraction possessed his soul.

She went to his room, hotly, violently in love with him. He was so beautiful and inaccessible. He kissed her, he was a lover to her. And she had extreme pleasure of him. But he did not come to, he remained remote and candid, unconscious. She wanted to speak to him. But this innocent, beautiful state of unconsciousness that had come upon him prevented her. She felt tormented and dark.

In the morning, however, he looked at her with a little aversion, some horror and some hatred darkening into his eyes. She withdrew on to her old ground. But still he would not gather himself together, against her.

Loerke was waiting for her now. The little artist, isolated in his own complete envelope, felt that here at last was a woman from whom he could get something. He was uneasy all the while, waiting to talk with her, subtly contriving to be near her. Her presence filled him with keenness and excitement, he gravitated cunningly towards her, as if she had some unseen force of attraction.

He was not in the least doubtful of himself, as regards Gerald. Gerald was one of the outsiders. Loerke only hated him for being rich and proud and of fine appearance. All these things, however, riches, pride of social standing, handsome physique, were externals. When it came to the relation with a woman such as Gudrun, he, Loerke, had an approach and a power that Gerald never dreamed of.

How should Gerald hope to satisfy a woman of Gudrun's calibre? Did he think that pride or masterful will or physical strength would help him? Loerke knew a secret beyond these things. The greatest power is the one that is subtle and adjusts itself, not one which blindly attacks. And he, Loerke, had understanding where Gerald was a calf.

He, Loerke, could penetrate into depths far out of Gerald's knowledge. Gerald was left behind like a postulant in the ante-room of this temple of mysteries, this woman. But he Loerke, could he not penetrate into the inner darkness, find the spirit of the woman in its inner recess, and wrestle with it there, the central serpent that is coiled at the core of life.

What was it, after all, that a woman wanted? Was it mere social effect, fulfilment of ambition in the social world, in the community of mankind? Was it even a union in love and goodness? Did she want 'goodness'? Who but a fool would accept this of Gudrun? This was but the street view of her wants. Cross the threshold, and you found her completely, completely cynical about the social world and its advantages. Once inside the house of her soul and there was a pungent atmosphere of corrosion, an inflamed darkness of sensation, and a vivid, subtle, critical consciousness, that saw the world distorted, horrific.

What then, what next? Was it sheer blind force of passion that would satisfy her now? Not this, but the subtle thrills of extreme sensation in reduction. It was an unbroken will reacting against her unbroken will in a myriad subtle thrills of reduction, the last subtle activities of analysis and breaking down, carried out in the darkness of her, whilst the outside form, the individual, was utterly unchanged, even sentimental in its poses.

But between two particular people, any two people on earth, the range of pure sensational experience is limited. The climax of sensual reaction, once reached in any direction, is reached finally, there is no going on. There is only repetition possible, or the going apart of the two protagonists, or the subjugating of the one will to the other, or death.

Gerald had penetrated all the outer places of Gudrun's soul. He was to her the most crucial instance of the existing world, the *ne plus ultra* of the world of man as it existed for her. In him she knew the world, and had done with it. Knowing him finally she was the Alexander seeking new worlds. But there *were* no new worlds, there were no more *men*, there were only creatures, little, ultimate *creatures* like Loerke. The world was finished now, for her. There was only the inner, individual darkness, sensation within the ego, the obscene religious mystery of ultimate reduction, the mystic frictional activities of diabolic reducing down, disintegrating the vital organic body of life.

All this Gudrun knew in her subconsciousness, not in her mind. She knew her next step – she knew what she should move on to, when she left Gerald. She was afraid of Gerald, that he might kill her. But she did not intend to be killed. A fine thread still united her to him. It should not be *her* death which broke it. She had further to go, a further, slow exquisite experience to reap, unthinkable subtleties of sensation to know, before she was finished.

Of the last series of subtleties, Gerald was not capable. He could not touch the quick of her. But where his ruder blows could not penetrate, the fine, insinuating blade of Loerke's insect-like comprehension could. At least, it was time for her now to pass over to the other, the creature, the final craftsman. She knew that Loerke, in his innermost soul, was detached from everything, for him there was neither heaven nor earth nor hell. He admitted no allegiance, he gave no adherence anywhere. He was single and, by abstraction from the rest, absolute in himself.

Whereas in Gerald's soul there still lingered some attachment to the rest, to the whole. And this was his limitation. He was limited, *borné*, subject to his necessity, in the last issue, for goodness, for righteousness, for oneness with the ultimate purpose. That the ultimate purpose might be the perfect and subtle experience of the process of death, the will being kept unimpaired, that was not allowed in him. And this was his limitation.

There was a hovering triumph in Loerke, since Gudrun had denied her marriage with Gerald. The artist seemed to hover like a creature on the wing, waiting to settle. He did not approach Gudrun violently, he was never ill-timed. But carried on by a sure instinct in the complete darkness of his soul, he corresponded mystically with her, imperceptibly, but palpably.

For two days, he talked to her, continued the discussions of art, of life, in which they both found such pleasure. They praised the by-gone things, they took a sentimental, childish delight in the achieved perfections of the past. Particularly they liked the late eighteenth century, the period of Goethe and of Shelley, and Mozart.

They played with the past, and with the great figures of the past, a sort of little game of chess, or marionettes, all to please themselves. They had all the great men for their marionettes, and they two were the God of the show, working it all. As for the future, that they never mentioned except one laughed out some mocking dream of the destruction of the world by a ridiculous catastrophe of man's invention: a man invented such a perfect explosive that it blew the earth in two, and the two halves set off in different directions through space, to the dismay of the inhabitants: or else the people of the world divided into two halves, and each half decided *it* was perfect and right, the other half was wrong and must be destroyed; so another end of the world. Or else, Loerke's dream of fear, the world went cold, and snow fell everywhere, and only white creatures, polar-bears, white foxes, and men like awful white snow-birds, persisted in ice cruelty.

Apart from these stories, they never talked of the future. They delighted most either in mocking imaginations of destruction, or in sentimental, fine marionette-shows of the past. It was a sentimental delight to reconstruct the world of Goethe at Weimar, or of Schiller and poverty and faithful love, or to see again Jean Jacques in his quakings, or Voltaire at Ferney, or Frederick the Great reading his own poetry.

They talked together for hours, of literature and sculpture and painting, amusing themselves with Flaxman and Blake and Fuseli, with tenderness, and with Feuerbach and Böcklin.¹⁴⁵ It would take them a life-time, they felt to live again, *in petto*, the lives of the great artists. But they preferred to stay in the eighteenth and the nineteenth centuries.

They talked in a mixture of languages. The ground-work was French, in either case. But he ended most of his sentences in a stumble of English and a conclusion of German, she skilfully wove herself to her end in whatever phrase came to her. She took a peculiar delight in this conversation. It was full of odd, fantastic expression, of double meanings, of evasions, of suggestive vagueness. It was a real physical pleasure to her to make this thread of conversation out of the differentcoloured strands of three languages.

And all the while they two were hovering, hesitating round the flame of some invisible declaration. He wanted it, but was held back by some inevitable reluctance. She wanted it also, but she wanted to put it off, to put it off indefinitely, she still had some pity for Gerald, some connection with him. And the most fatal of all, she had the reminiscent sentimental compassion for herself in connection with him. Because of what *bad* been, she felt herself held to him by immortal, invisible threads – because of what *bad* been, because of his coming to her that first night, into her own house, in his extremity, because –

Gerald was gradually overcome with a revulsion of loathing for Loerke. He did not take the man seriously, he despised him merely, except as he felt in Gudrun's veins the influence of the little creature. It was this that drove Gerald wild, the feeling in Gudrun's veins of Loerke's presence, Loerke's being, flowing dominant through her.

'What makes you so smitten with that little vermin?' he asked, really puzzled. For he, man-like, could not see anything attractive or important *at all* in Loerke. Gerald expected to find some handsomeness or nobleness, to account for a woman's subjection. But he saw none here, only an insect-like repulsiveness.

Gudrun flushed deeply. It was these attacks she would never forgive.

'What do you mean?' she replied. 'My God, what a mercy I am not married to you!'

Her voice of flouting and contempt scotched him. He was brought up short. But he recovered himself.

'Tell me, only tell me,' he reiterated in a dangerous narrowed voice – 'tell me what it is that fascinates you in him.'

'I am not fascinated,' she said, with cold repelling innocence.

'Yes, you are. You are fascinated by that little dry snake, like a bird gaping ready to fall down its throat.'

She looked at him with black fury.

'I don't choose to be discussed by you,' she said.

'It doesn't matter whether you choose or not,' he replied, 'that doesn't alter the fact that you are ready to fall down and kiss the feet of that little insect. And I don't want to prevent you – do it, fall down and kiss his feet. But I want to know, what it is that fascinates you – what is it?'

She was silent, suffused with black rage.

'How *dare* you come brow-beating me,' she cried, 'how dare you, you little squire, you bully. What right have you over me, do you think?'

His face was white and gleaming, she knew by the light in his eyes that she was in his power – the wolf. And because she was in his power, she hated him with a power that she wondered did not kill him. In her will she killed him as he stood, effaced him.

'It is not a question of right,' said Gerald, sitting down on a chair. She watched the change in his body. She saw his clenched, mechanical body moving there like an obsession. Her hatred of him was tinged with fatal contempt.

'It's not a question of my right over you – though I *have* some right, remember. I want to know, I only want to know what it is that subjugates you to that little scum of a sculptor downstairs, what it is that brings you down like a humble maggot, in worship of him. I want to know what you creep after.'

She stood over against the window, listening. Then she turned round.

'Do you?' she said, in her most easy, most cutting voice. 'Do you want to know what it is in him? It's because he has some understanding of a woman, because he is not stupid. That's why it is.'

A queer, sinister, animal-like smile came over Gerald's face.

'But what understanding is it?' he said. 'The understanding of a flea, a hopping flea with a proboscis. Why should you crawl abject before the understanding of a flea?'

There passed through Gudrun's mind Blake's representation of the

soul of a flea.¹⁴⁶ She wanted to fit it to Loerke. Blake was a clown too. But it was necessary to answer Gerald.

'Don't you think the understanding of a flea is more interesting than the understanding of a fool?' she asked.

'A fool!' he repeated.

'A fool, a conceited fool - a Dummkopf,' she replied, adding the German word.

'Do you call me a fool?' he replied. 'Well, wouldn't I rather be the fool I am, than that flea downstairs?'

She looked at him. A certain blunt, blind stupidity in him palled on her soul, limiting her.

'You give yourself away by that last,' she said.

He sat and wondered.

'I shall go away soon,' he said.

She turned on him.

'Remember,' she said, 'I am completely independent of you - completely. You make your arrangements, I make mine.'

He pondered this.

'You mean we are strangers from this minute?' he asked.

She halted and flushed. He was putting her in a trap, forcing her hand. She turned round on him.

'Strangers,' she said, 'we can never be. But if you *want* to make any movement apart from me, then I wish you to know you are perfectly free to do so. Do not consider me in the slightest.'

Even so slight an implication that she needed him and was depending on him still was sufficient to rouse his passion. As he sat a change came over his body, the hot, molten stream mounted involuntarily through his veins. He groaned inwardly, under its bondage, but he loved it. He looked at her with clear eyes, waiting for her.

She knew at once, and was shaken with cold revulsion. *How* could he look at her with those clear, warm, waiting cycs, waiting for her, even now? What had been said between them, was it not enough to put them worlds asunder, to freeze them forever apart! And yet he was all transfused and roused, waiting for her.

It confused her. Turning her head aside, she said:

'I shall always tell you, whenever I am going to make any change - '

And with this she moved out of the room.

He sat suspended in a fine recoil of disappointment, that seemed gradually to be destroying his understanding. But the unconscious state of patience persisted in him. He remained motionless, without thought or knowledge, for a long time. Then he rose, and went downstairs, to play at chess with one of the students. His face was open and clear, with a certain innocent *laisser-aller*¹⁴⁷ that troubled Gudrun most, made her almost afraid of him, whilst she disliked him deeply for it.

It was after this that Loerke, who had never yet spoken to her personally, began to ask her of her state.

'You are not married at all, are you?' he asked.

She looked full at him.

'Not in the least,' she replied, in her measured way. Loerke laughed, wrinkling up his face oddly. There was a thin wisp of his hair straying on his forehead, she noticed that his skin was of a clear brown colour, his hands, his wrists. And his hands seemed closely prehensile. He seemed like topaz, so strangely brownish and pellucid.

'Good,' he said.

Still it needed some courage for him to go on.

'Was Mrs Birkin your sister?' he asked.

'Yes.'

'And was *she* married?'

'She was married.'

'Have you parents, then?'

'Yes,' said Gudrun, 'we have parents.'

And she told him, briefly, laconically, her position. He watched her closely, curiously all the while.

'So!' he exclaimed, with some surprise. 'And the Herr Crich, is he rich?'

'Yes, he is rich, a coal owner.'

'How long has your friendship with him lasted?'

'Some months.'

There was a pause.

'Yes, I am surprised,' he said at length. 'The English, I thought they were so - cold. And what do you think to do when you leave here?'

'What do I think to do?' she repeated.

'Yes. You cannot go back to the teaching. No – ' he shrugged his shoulders – 'that is impossible. Leave that to the *canaille* who can do nothing else. You, for your part – you know, you are a remarkable woman, eine seltsame Frau. Why deny it – why make any question of it? You are an extraordinary woman, why should you follow the ordinary course, the ordinary life?'

Gudrun sat looking at her hands, flushed. She was pleased that he said, so simply, that she was a remarkable woman. He would not say that to flatter her – he was far too self-opinionated and objective by nature. He said it as he would say a piece of sculpture was remarkable, because he knew it was so.

And it gratified her to hear it from him. Other people had such a

passion to make everything of one degree, of one pattern. In England it was chic to be perfectly ordinary. And it was a relief to her to be acknowledged extraordinary. Then she need not fret about the common standards.

'You see,' she said, 'I have no money whatsoever.'

'Ach, money!' he cried, lifting his shoulders. 'When one is grown up, money is lying about at one's service. It is only when one is young that it is rare. Take no thought for money – that always lies to hand.'

'Does it?' she said, laughing.

'Always. The Gerald will give you a sum, if you ask him for it -' She flushed deeply.

'I will ask anybody else,' she said, with some difficulty – 'but not him.' Loerke looked closely at her.

'Good,' he said. 'Then let it be somebody else. Only don't go back to that England, that school. No, that is stupid.'

Again there was a pause. He was afraid to ask her outright to go with him, he was not even quite sure he wanted her; and she was afraid to be asked. He begrudged his own isolation, was *very* chary of sharing his life, even for a day.

'The only other place I know is Paris,' she said, 'and I can't stand that.'

She looked with her wide, steady eyes full at Loerke. He lowered his head and averted his face.

'Paris, no!' he said. 'Between the *réligion d'amour*,¹⁴⁸ and the latest 'ism, and the new turning to Jesus, one had better ride on a carrousel all day. But come to Dresden. I have a studio there – I can give you work, – oh, that would be easy enough. I haven't seen any of your things, but I believe in you. Come to Dresden – that is a fine town to be in, and as good a life as you can expect of a town. You have everything there, without the foolishness of Paris or the beer of Munich.'

He sat and looked at her, coldly. What she liked about him was that he spoke to her simple and flat, as to himself. He was a fellow craftsman, a fellow being to her, first.

'No – Paris,' he resumed, 'it makes me sick. Pah – l'amour. I detest it. L'amour, l'amore, die Liebe – I detest it in every language. Women and love, there is no greater tedium,' he cried.

She was slightly offended. And yet, this was her own basic feeling. Men, and love – there was no greater tedium.

'I think the same,' she said.

'A bore,' he repeated. 'What does it matter whether I wear this hat or another. So love. I needn't wear a hat at all, only for convenience. Neither need I love except for convenience. I tell you what, gnädige Frau – ' and he leaned towards her – then he made a quick, odd gesture, as of striking something aside – 'gnädige Fraulein, never mind – I tell you what, I would give everything, everything, all your love, for a little companionship in intelligence – ' his eyes flickered darkly, evilly at her. 'You understand?' he asked, with a faint smile. 'It wouldn't matter if she were a hundred years old, a thousand – it would be all the same to me, so that she can *understand*.' He shut his eyes with a little snap.

Again Gudrun was rather offended. Did he not think her goodlooking, then? Suddenly she laughed.

'I shall have to wait about eighty years to suit you, at that!' she said. 'I am ugly enough, aren't I?'

He looked at her with an artist's sudden, critical, estimating eye.

'You are beautiful,' he said, 'and I am glad of it. But it isn't that – it isn't that,' he cried, with emphasis that flattered her. 'It is that you have a certain wit, it is the kind of understanding. For me, I am little, chétif, insignificant. Good! Do not ask me to be strong and handsome, then. But it is the me -' he put his fingers to his mouth, oddly – 'it is the methat is looking for a mistress, and my me is waiting for the *thee* of the mistress, for the match to my particular intelligence. You understand?'

'Yes,' she said, 'I understand.'

'As for the other, this amour – 'he made a gesture, dashing his hand aside, as if to dash away something troublesome – 'it is unimportant, unimportant. Does it matter, whether I drink white wine this evening, or whether I drink nothing? *It does not matter*, it does not matter. So this love, this amour, this *baiser*. Yes or no, soit ou soit pas, today, tomorrow, or never, it is all the same, it does not matter – no more than the white wine.'

He ended with an odd dropping of the head in a desperate negation. Gudrun watched him steadily. She had gone pale.

Suddenly she stretched over and seized his hand in her own.

'That is true,' she said, in rather a high, vehement voice, 'that is true for me too. It is the understanding that matters.'

He looked up at her almost frightened, furtive. Then he nodded, a little sullenly. She let go his hand: he had made not the lightest response. And they sat in silence.

'Do you know,' he said, suddenly looking at her with dark, self-important, prophetic eyes, 'your fate and mine, they will run together, till -' and he broke off in a little grimace.

'Till when?' she asked, blanched, her lips going white. She was terribly susceptible to these evil prognostications, but he only shook his head.

'I don't know,' he said, 'I don't know.'

Gerald did not come in from his skiing until nightfall, he missed the coffee and cake that she took at four o'clock. The snow was in perfect condition, he had travelled a long way, by himself, among the snow ridges, on his skis, he had climbed high, so high that he could see over the top of the pass, five miles distant, could see the Marienhütte, the hostel on the crest of the pass, half buried in snow, and over into the deep valley beyond, to the dusk of the pine trees. One could go that way home; but he shuddered with nausea at the thought of home; – one could travel on skis down there, and come to the old imperial road,¹⁴⁹ below the pass. But why come to any road? He revolted at the thought of finding himself in the world again. He must stay up there in the snow forever. He had been happy by himself, high up there alone, travelling swiftly on skis, taking far flights, and skimming past the dark rocks veined with brilliant snow.

But he felt something icy gathering at his heart. This strange mood of patience and innocence which had persisted in him for some days, was passing away, he would be left again a prey to the horrible passions and tortures.

So he came down reluctantly, snow-burned, snow-estranged, to the house in the hollow, between the knuckles of the mountain tops. He saw its lights shining yellow, and he held back, wishing he need not go in, to confront those people, to hear the turmoil of voices and to feel the confusion of other presences. He was isolated as if there were a vacuum round his heart, or a sheath of pure ice.

The moment he saw Gudrun something jolted in his soul. She was looking rather lofty and superb, smiling slowly and graciously to the Germans. A sudden desire leapt in his heart, to kill her. He thought, what a perfect voluptuous fulfilment it would be, to kill her. His mind was absent all the evening, estranged by the snow and his passion. But he kept the idea constant within him, what a perfect voluptuous consummation it would be to strangle her, to strangle every spark of life out of her, till she lay completely inert, soft, relaxed for ever, a soft heap lying dead between his hands, utterly dead. Then he would have had her finally and for ever; there would be such a perfect voluptuous finality.

Gudrun was unaware of what he was feeling, he seemed so quiet and amiable, as usual. His amiability even made her feel brutal towards him.

She went into his room when he was partially undressed. She did not notice the curious, glad gleam of pure hatred, with which he looked at her. She stood near the door, with her hand behind her.

'I have been thinking, Gerald,' she said, with an insulting nonchalance, 'that I shall not go back to England.' 'Oh,' he said, 'where will you go then?'

But she ignored his question. She had her own logical statement to make, and it must be made as she had thought it.

'I can't see the use of going back,' she continued. 'It is over between me and you – '

She paused for him to speak. But he said nothing. He was only talking to himself, saying ' Over, is it? I believe it is over. But it isn't finished. Remember, it isn't finished. We must put some sort of a finish on it. There must be a conclusion, there must be finality.'

So he talked to himself, but aloud he said nothing whatever.

'What has been, has been,' she continued. 'There is nothing that I regret. I hope you regret nothing -'

She waited for him to speak.

'Oh, I regret nothing,' he said, accommodatingly.

'Good then,' she answered, 'good then. Then neither of us cherishes any regrets, which is as it should be.'

'Quite as it should be,' he said aimlessly.

She paused to gather up her thread again.

'Our attempt has been a failure,' she said. 'But we can try again, elsewhere.'

A little flicker of rage ran through his blood. It was as if she were rousing him, goading him. Why must she do it?

'Attempt at what?' he asked.

'At being lovers, I suppose,' she said, a little baffled, yet so trivial she made it all seem.

'Our attempt at being lovers has been a failure?' he repeated aloud.

To himself he was saying, 'I ought to kill her here. There is only this left, for me to kill her.' A heavy, overcharged desire to bring about her death possessed him. She was unaware.

'Hasn't it?' she asked. 'Do you think it has been a success?'

Again the insult of the flippant question ran through his blood like a current of fire.

'It had some of the elements of success, our relationship,' he replied. 'It – might have come off.'

But he paused before concluding the last phrase. Even as he began the sentence, he did not believe in what he was going to say. He knew it never could have been a success.

'No,' she replied. 'You cannot love.'

'And you?' he asked.

Her wide, dark-filled eyes were fixed on him, like two moons of darkness.

'I couldn't love you,' she said, with stark cold truth.

A blinding flash went over his brain, his body jolted. His heart had burst into flame. His consciousness was gone into his wrists, into his hands. He was one blind, incontinent desire, to kill her. His wrists were bursting, there would be no satisfaction till his hands had closed on her.

But even before his body swerved forward on her, a sudden, cunning comprehension was expressed on her face, and in a flash she was out of the door. She ran in one flash to her room and locked herself in. She was afraid, but confident. She knew her life trembled on the edge of an abyss. But she was curiously sure of her footing. She knew her cunning could outwit him.

She trembled, as she stood in her room, with excitement and awful exhilaration. She knew she could outwit him. She could depend on her presence of mind, and on her wits. But it was a fight to the death, she knew it now. One slip, and she was lost. She had a strange, tense, exhilarated sickness in her body, as one who is in peril of falling from a great height, but who does not look down, does not admit the fear.

'I will go away the day after tomorrow,' she said.

She only did not want Gerald to think that she was afraid of him, that she was running away because she was afraid of him. She was not afraid of him, fundamentally. She knew it was her safeguard to avoid his physical violence. But even physically she was not afraid of him. She wanted to prove it to him. When she had proved it, that, whatever he was, she was not afraid of him; when she had proved *that*, she could leave him forever. But meanwhile the fight between them, terrible as she knew it to be, was inconclusive. And she wanted to be confident in herself. However many terrors she might have, she would be unafraid, uncowed by him. He could never cow her, nor dominate her, nor have any right over her; this she would maintain until she had proved it. Once it was proved, she was free of him forever.

But she had not proved it yet, neither to him nor to herself. And this was what still bound her to him. She was bound to him, she could not live beyond him. She sat up in bed, closely wrapped up, for many hours, thinking endlessly to herself. It was as if she would never have done weaving the great provision of her thoughts.

'It isn't as if he really loved me,' she said to herself. 'He doesn't. Every woman he comes across he wants to make her in love with him. He doesn't even know that he is doing it. But there he is, before every woman he unfurls his male attractiveness, displays his great desirability, he tries to make every woman think how wonderful it would be to have him for a lover. His very ignoring of the women is part of the game. He is never *unconscious* of them. He should have been a cockerel, so he could strut before fifty females, all his subjects. But really, his Don Juan

WOMEN IN LOVE

does *not* interest me. I could play Dona Juanita a million times better than he plays Juan. He bores me, you know. His maleness bores me. Nothing is so boring, so inherently stupid and stupidly conceited. Really, the fathomless conceit of these men, it is ridiculous – the little strutters.

'They are all alike. Look at Birkin. Built out of the limitation of conceit they are, and nothing else. Really, nothing but their ridiculous limitation and intrinsic insignificance could make them so conceited.

'As for Loerke, there is a thousand times more in him than in a Gerald. Gerald is so limited, there is a dead end to him. He would grind on at the old mills forever. And really, there is no corn between the millstones any more. They grind on and on, when there is nothing to grind – saying the same things, believing the same things, acting the same things. Oh, my God, it would wear out the patience of a stone.

'I don't worship Loerke, but at any rate, he is a free individual. He is not stiff with conceit of his own maleness. He is not grinding dutifully at the old mills. Oh God, when I think of Gerald, and his work – those offices at Beldover, and the mines – it makes my heart sick. What *have* I to do with it – and him thinking he can be a lover to a woman! One might as well ask it of a self-satisfied lamp-post. These men, with their eternal jobs – and their eternal mills of God that keep on grinding at nothing! It is too boring, just boring. However did I come to take him seriously at all!

'At least in Dresden, one will have one's back to it all. And there will be amusing things to do. It will be amusing to go to these eurythmic displays, and the German opera, the German theatre. It will be amusing to take part in German Bohemian life. And Loerke is an artist, he is a free individual. One will escape from so much, that is the chief thing, escape so much hideous boring repetition of vulgar actions, vulgar phrases, vulgar postures. I don't delude myself that I shall find an elixir of life in Dresden. I know I shan't. But I shall get away from people who have their own homes and their own children and their own acquaintances and their own this and their own that. I shall be among people who don't own things and who haven't got a home and a domestic servant in the background, who haven't got a standing and a status and a degree and a circle of friends of the same. Oh God, the wheels within wheels of people, it makes one's head tick like a clock, with a very madness of dead mechanical monotony and meaninglessness. How I hate life, how I hate it. How I hate the Geralds, that they can offer one nothing else.

'Shortlands! - Heavens! Think of living there, one week, then the next, and *then the third* -

'No, I won't think of it - it is too much.'

And she broke off, really terrified, really unable to bear any more.

The thought of the mechanical succession of day following day, day following day, *ad infinitum*, was one of the things that made her heart palpitate with a real approach of madness. The terrible bondage of this tick-tack of time, this twitching of the hands of the clock, this eternal repetition of hours and days – oh God, it was too awful to contemplate. And there was no escape from it, no escape.

She almost wished Gerald were with her to save her from the terror of her own thoughts. Oh, how she suffered, lying there alone, confronted by the terrible clock, with its eternal tick-tack. All life, all life resolved itself into this: tick-tack, tick-tack, tick-tack; then the striking of the hour; then the tick-tack, tick-tack, and the twitching of the clock-fingers.

Gerald could not save her from it. He, his body, his motion, his life – it was the same ticking, the same twitching across the dial, a horrible mechanical twitching forward over the face of the hours. What were his kisses, his embraces. She could hear their tick-tack, tick-tack.

Ha - ha - she laughed to herself, so frightened that she was trying to laugh it off - ha - ha, how maddening it was, to be sure, to be sure!

Then, with a fleeting self-conscious motion, she wondered if she would be very much surprised, on rising in the morning, to realise that her hair had turned white. She had *felt* it turning white so often, under the intolerable burden of her thoughts, und her sensations. Yet there it remained, brown as ever, and there she was herself, looking a picture of health.

Perhaps she was healthy. Perhaps it was only her unabateable health that left her so exposed to the truth. If she were sickly she would have her illusions, imaginations. As it was, there was no escape. She must always see and know and never escape. She could never escape. There she was, placed before the clock-face of life. And if she turned round as in a railway station, to look at the bookstall, still she could see, with her very spine, she could see the clock, always the great white clock-face. In vain she fluttered the leaves of books, or made statuettes in clay. She knew she was not *really* reading. She was not *really* working. She was watching the fingers twitch across the eternal, mechanical, monotonous clock-face of time. She never really lived, she only watched. Indeed, she was like a little, twelve-hour clock, vis-à-vis with the enormous clock of eternity – there she was, like Dignity and Impudence,¹⁵⁰ or Impudence and Dignity.

The picture pleased her. Didn't her face really look like a clock dial – rather roundish and often pale, and impassive. She would have got up

to look, in the mirror, but the thought of the sight of her own face, that was like a twelve-hour clock-dial, filled her with such deep terror, that she hastened to think of something else.

Oh, why wasn't somebody kind to her? Why wasn't there somebody who would take her in their arms, and hold her to their breast, and give her rest, pure, deep, healing rest. Oh, why wasn't there somebody to take her in their arms and fold her safe and perfect, for sleep. She wanted so much this perfect enfolded sleep. She lay always so unsheathed in sleep. She would lie always unsheathed in sleep, unrelieved, unsaved. Oh, how could she bear it, this endless unrelief, this eternal unrelief.

Gerald! Could he fold her in his arms and sheathe her in sleep? Ha! He needed putting to sleep himself – poor Gerald. That was all he needed. What did he do, he made the burden for her greater, the burden of her sleep was the more intolerable, when he was there. He was an added weariness upon her unripening nights, her unfruitful slumbers. Perhaps he got some repose from her. Perhaps he did. Perhaps this was what he was always dogging her for, like a child that is famished, crying for the breast. Perhaps this was the secret of his passion, his forever unquenched desire for her – that he needed her to put him to sleep, to give him repose.

What then! Was she his mother? Had she asked for a child, whom she must nurse through the nights, for her lover. She despised him, she despised him, she hardened her heart. An infant crying in the night, this Don Juan.

Ooh, but how she hated the infant crying in the night. She would murder it gladly. She would stifle it and bury it, as Hetty Sorrell did. No doubt Hetty Sorrell's infant cried in the night – no doubt Arthur Donnithorne's infant would. Ha – the Arthur Donnithornes,¹⁵¹ the Geralds of this world. So manly by day, yet all the while, such a crying of infants in the night. Let them turn into mechanisms, let them. Let them become instruments, pure machines, pure wills, that work like clock-work, in perpetual repetition. Let them be this, let them be taken up entirely in their work, let them be perfect parts of a great machine, having a slumber of constant repetition. Let Gerald manage his firm. There he would be satisfied, as satisfied as a wheelbarrow that goes backwards and forwards along a plank all day – she had seen it.

The wheel-barrow – the one humble wheel – the unit of the firm. Then the cart, with two wheels; then the truck, with four; then the donkey-engine, with eight, then the winding-engine, with sixteen, and so on, till it came to the miner, with a thousand wheels, and then the electrician, with three thousand, and the underground manager, with twenty thousand, and the general manager with a hundred thousand

little wheels working away to complete his make-up, and then Gerald, with a million wheels and cogs and axles.

Poor Gerald, such a lot of little wheels to his make-up! He was more intricate than a chronometer-watch. But oh heavens, what weariness! What weariness, God above! A chronometer-watch – a beetle – her soul fainted with utter ennui, from the thought. So many wheels to count and consider and calculate! Enough, enough – there was an end to man's capacity for complications, even. Or perhaps there was no end.

Meanwhile Gerald sat in his room, reading. When Gudrun was gone, he was left stupefied with arrested desire. He sat on the side of the bed for an hour, stupefied, little strands of consciousness appearing and reappearing. But he did not move, for a long time he remained inert, his head dropped on his breast.

Then he looked up and realised that he was going to bed. He was cold. Soon he was lying down in the dark.

But what he could not bear was the darkness. The solid darkness confronting him drove him mad. So he rose, and made a light. He remained seated for a while, staring in front. He did not think of Gudrun, he did not think of anything.

Then suddenly he went downstairs for a book. He had all his life been in terror of the nights that should come, when he could not sleep. He knew that this would be too much for him, to have to face nights of sleeplessness and of horrified watching the hours.

So he sat for hours in bed, like a statue, reading. His mind, hard and acute, read on rapidly, his body understood nothing. In a state of rigid unconsciousness, he read on through the night, till morning, when, weary and disgusted in spirit, disgusted most of all with himself, he slept for two hours.

Then he got up, hard and full of energy. Gudrun scarcely spoke to him, except at coffee when she said:

'I shall be leaving tomorrow.'

'We will go together as far as Innsbruck, for appearance's sake?' he asked.

'Perhaps,' she said.

She said 'Perhaps' between the sips of her coffee. And the sound of her taking her breath in the word, was nauseous to him. He rose quickly to be away from her.

He went and made arrangements for the departure on the morrow. Then, taking some food, he set out for the day on the skis. Perhaps, he said to the Wirt, he would go up to the Marienhütte, perhaps to the village below.

To Gudrun this day was full of a promise like spring. She felt an

WOMEN IN LOVE

approaching release, a new fountain of life rising up in her. It gave her pleasure to dawdle through her packing, it gave her pleasure to dip into books, to try on her different garments, to look at herself in the glass. She felt a new lease of life was come upon her, and she was happy like a child, very attractive and beautiful to everybody, with her soft, luxuriant figure, and her happiness. Yet underneath was death itself.

In the afternoon she had to go out with Loerke. Her tomorrow was perfectly vague before her. This was what gave her pleasure. She might be going to England with Gerald, she might be going to Dresden with Loerke, she might be going to Munich, to a girl-friend she had there. Anything might come to pass on the morrow. And today was the white, snowy iridescent threshold of all possibility. All possibility – that was the charm to her, the lovely, iridescent, indefinite charm, – pure illusion. All possibility – because death was inevitable, and *nothing* was possible but death.

She did not want things to materialise, to take any definite shape. She wanted, suddenly, at one moment of the journey tomorrow, to be wafted into an utterly new course, by some utterly unforeseen event, or motion. So that, although she wanted to go out with Loerke for the last time into the snow, she did not want to be serious or businesslike.

And Loerke was not a serious figure. In his brown velvet cap, that made his head as round as a chestnut, with the brown-velvet flaps loose and wild over his ears, and a wisp of elf-like, thin black hair blowing above his full, elf-like dark eyes, the shiny, transparent brown skin crinkling up into odd grimaces on his small-featured face, he looked an odd little boy-man, a bat. But in his figure, in the greeny loden suit, he looked *chétif*¹⁵² and puny, still strangely different from the rest.

He had taken a little toboggan, for the two of them, and they trudged between the blinding slopes of snow, that burned their now hardening faces, laughing in an endless sequence of quips and jests and polyglot fancies. The fancies were the reality to both of them, they were both so happy, tossing about the little coloured balls of verbal humour and whimsicality. Their natures seemed to sparkle in full interplay, they were enjoying a pure game. And they wanted to keep it on the level of a game, their relationship: *such* a fine game.

Loerke did not take the toboganning very seriously. He put no fire and intensity into it, as Gerald did. Which pleased Gudrun. She was weary, oh so weary of Gerald's gripped intensity of physical motion. Loerke let the sledge go wildly, and gaily, like a flying leaf, and when, at a bend, he pitched both her and him out into the snow, he only waited for them both to pick themselves up unhurt off the keen white ground, to be laughing and pert as a pixie. She knew he would be

making ironical, playful remarks as he wandered in hell – if he were in the humour. And that pleased her immensely. It seemed like a rising above the dreariness of actuality, the monotony of contingencies.

They played till the sun went down, in pure amusement, careless and timeless. Then, as the little sledge twirled riskily to rest at the bottom of the slope,

'Wait!' he said suddenly, and he produced from somewhere a large thermos flask, a packet of Keks, and a bottle of Schnapps.

'Oh Loerke,' she cried. 'What an inspiration! What a *comble de joie indeed!* What is the Schnapps?'

He looked at it, and laughed.

'Heidelbeer!' he said.

'No! From the bilberries under the snow. Doesn't it look as if it were distilled from snow. Can you – ' she sniffed, and sniffed at the bottle – 'can you smell bilberries? Isn't it wonderful? It is exactly as if one could smell them through the snow.'

She stamped her foot lightly on the ground. He kneeled down and whistled, and put his ear to the snow. As he did so his black eyes twinkled up.

'Ha! Ha!' she laughed, warmed by the whimsical way in which he mocked at her verbal extravagances. He was always teasing her, mocking her ways. But as he in his mockery was even more absurd than she in her extravagances, what could one do but laugh and feel liberated.

She could feel their voices, hers and his, ringing silvery like bells in the frozen, motionless air of the first twilight. How perfect it was, how *very* perfect it was, this silvery isolation and interplay.

She sipped the hot coffee, whose fragrance flew around them like bees murmuring around flowers, in the snowy air, she drank tiny sips of the Heidelbeerwasser, she ate the cold, sweet, creamy wafers. How good everything was! How perfect everything tasted and smelled and sounded, here in this utter stillness of snow and falling twilight.

'You are going away tomorrow?' his voice came at last. 'Yes.'

There was a pause, when the evening seemed to rise in its silent, ringing pallor infinitely high, to the infinite which was near at hand. *'Wohin?'*

That was the question - wohin? Whither? Wohin? What a lovely word! She never wanted it answered. Let it chime for ever.

'I don't know,' she said, smiling at him.

He caught the smile from her.

'One never does,' he said.

'One never does,' she repeated.

WOMEN IN LOVE

There was a silence, wherein he ate biscuits rapidly, as a rabbit eats leaves.

'But,' he laughed, 'where will you take a ticket to?'

'Oh heaven!' she cried. 'One must take a ticket.'

Here was a blow. She saw herself at the wicket, at the railway station. Then a relieving thought came to her. She breathed freely.

'But one needn't go,' she cried.

'Certainly not,' he said.

'I mean one needn't go where one's ticket says.'

That struck him. One might take a ticket, so as not to travel to the destination it indicated. One might break off, and avoid the destination. A point located. That was an idea!

'Then take a ticket to London,' he said. 'One should never go there.' 'Right,' she answered.

He poured a little coffee into a tin can.

'You won't tell me where you will go?' he asked.

'Really and truly,' she said, 'I don't know. It depends which way the wind blows.'

He looked at her quizzically, then he pursed up his lips, like Zephyrus,¹⁵³ blowing across the snow.

'It goes towards Germany,' he said.

'I believe so,' she laughed.

Suddenly, they were aware of a vague white figure near them. It was Gerald. Gudrun's heart leapt in sudden terror, profound terror. She rose to her feet.

'They told me where you were,' came Gerald's voice, like a judgment in the whitish air of twilight.

'Maria! You come like a ghost,' exclaimed Loerke.

Gerald did not answer. His presence was unnatural and ghostly to them.

Loerke shook the flask – then he held it inverted over the snow. Only a few brown drops trickled out.

'All gone!' he said.

To Gerald, the smallish, odd figure of the German was distinct and objective, as if seen through field glasses. And he disliked the small figure exceedingly, he wanted it removed.

Then Loerke rattled the box which held the biscuits.

'Biscuits there are still,' he said.

And reaching from his seated posture in the sledge, he handed them to Gudrun. She fumbled, and took one. He would have held them to Gerald, but Gerald so definitely did not want to be offered a biscuit, that Loerke, rather vaguely, put the box aside. Then he took up the

small bottle, and held it to the light.

'Also there is some Schnapps,' he said to himself.

Then suddenly, he elevated the bottle gallantly in the air, a strange, grotesque figure leaning towards Gudrun, and said:

'Gnädiges Fraulein,' he said, 'wohl -'

There was a crack, the bottle was flying, Loerke had started back, the three stood quivering in violent emotion.

Loerke turned to Gerald, a devilish leer on his bright-skinned face.

'Well done!' he said, in a satirical demoniac frenzy. 'C'est le sport, sans doute.'

The next instant he was sitting ludicrously in the snow, Gerald's fist having rung against the side of his head. But Loerke pulled himself together, rose, quivering, looking full at Gerald, his body weak and furtive, but his eyes demoniacal with satire.

'Vive le héros, vive - '

But he flinched, as, in a black flash Gerald's fist came upon him, banged into the other side of his head, and sent him aside like a broken straw.

But Gudrun moved forward. She raised her clenched hand high, and brought it down, with a great downward stroke on to the face and on to the breast of Gerald.

A great astonishment burst upon him, as if the air had broken. Wide, wide his soul opened, in wonder, feeling the pain. Then it laughed, turning, with strong hands outstretched, at last to take the apple of his desire. At last he could finish his desire.

He took the throat of Gudrun between his hands, that were hard and indomitably powerful. And her throat was beautifully, so beautifully soft, save that, within, he could feel the slippery chords of her life. And this he crushed, this he could crush. What bliss! Oh what bliss, at last, what satisfaction, at last! The pure zest of satisfaction filled his soul. He was watching the unconsciousness come unto her swollen face, watching the eyes roll back. How ugly she was! What a fulfilment, what a satisfaction! How good this was, oh how good it was, what a God-given gratification, at last! He was unconscious of her fighting and struggling. The struggling was her reciprocal lustful passion in this embrace, the more violent it became, the greater the frenzy of delight, till the zenith was reached, the crisis, the struggle was overborne, her movement became softer, appeased.

Loerke roused himself on the snow, too dazed and hurt to get up. Only his eyes were conscious.

'Monsieur!' he said, in his thin, roused voice: 'Quand vous aurez fini – ' 154

A revulsion of contempt and disgust came over Gerald's soul. The disgust went to the very bottom of him, a nausea. Ah, what was he doing, to what depths was he letting himself go! As if he cared about her enough to kill her, to have her life on his hands!

A weakness ran over his body, a terrible relaxing, a thaw, a decay of strength. Without knowing, he had let go his grip, and Gudrun had fallen to her knees. Must he see, must he know?

A fearful weakness possessed him, his joints were turned to water. He drifted, as on a wind, veered, and went drifting away.

'I didn't want it, really,' was the last confession of disgust in his soul, as he drifted up the slope, weak, finished, only sheering off unconsciously from any further contact. 'I've had enough – I want to go to sleep. I've had enough.' He was sunk under a sense of nausea.

He was weak, but he did not want to rest, he wanted to go on and on, to the end. Never again to stay, till he came to the end, that was all the desire that remained to him. So he drifted on and on, unconscious and weak, not thinking of anything, so long as he could keep in action.

The twilight spread a weird, unearthly light overhead, bluish-rose in colour, the cold blue night sank on the snow. In the valley below, behind, in the great bed of snow, were two small figures: Gudrun dropped on her knees, like one executed, and Loerke sitting propped up near her. That was all.

Gerald stumbled on up the slope of snow, in the bluish darkness, always climbing, always unconsciously climbing, weary though he was. On his left was a steep slope with black rocks and fallen masses of rock and veins of snow slashing in and about the blackness of rock, veins of snow slashing vaguely in and about the blackness of rock. Yet there was no sound, all this made no noise.

To add to his difficulty, a small bright moon shone brilliantly just ahead, on the right, a painful brilliant thing that was always there, unremitting, from which there was no escape. He wanted so to come to the end – he had had enough. Yet he did not sleep.

He surged painfully up, sometimes having to cross a slope of black rock, that was blown bare of snow. Here he was afraid of falling, very much afraid of falling. And high up here, on the crest, moved a wind that almost overpowered him with a sleep-heavy iciness. Only it was not here, the end, and he must still go on. His indefinite nausea would not let him stay.

Having gained one ridge, he saw the vague shadow of something higher in front. Always higher, always higher. He knew he was following the track towards the summit of the slopes, where was the marienhütte, and the descent on the other side. But he was not really conscious. He only wanted to go on, to go on whilst he could, to move, to keep going, that was all, to keep going, until it was finished. He had lost all his sense of place. And yet in the remaining instinct of life, his feet sought the track where the skis had gone.

He slithered down a sheer snow slope. That frightened him. He had no alpenstock, nothing. But having come safely to rest, he began to walk on, in the illuminated darkness. It was as cold as sleep. He was between two ridges, in a hollow. So he swerved. Should he climb the other ridge, or wander along the hollow? How frail the thread of his being was stretched! He would perhaps climb the ridge. The snow was firm and simple. He went along. There was something standing out of the snow. He approached, with dimmest curiosity.

It was a half-buried Crucifix, a little Christ under a little sloping hood, at the top of a pole. He sheered away. Somebody was going to murder him. He had a great dread of being murdered. But it was a dread which stood outside him, like his own ghost.

Yet why be afraid? It was bound to happen. To be murdered! He looked round in terror at the snow, the rocking, pale, shadowy slopes of the upper world. He was bound to be murdered, he could see it. This was the moment when the death was uplifted, and there was no escape.

Lord Jesus, was it then bound to be - Lord Jesus! He could feel the blow descending, he knew he was murdered. Vaguely wandering forward, his hands lifted as if to feel what would happen, he was waiting for the moment when he would stop, when it would cease. It was not over yet.

He had come to the hollow basin of snow, surrounded by sheer slopes and precipices, out of which rose a track that brought one to the top of the mountain. But he wandered unconsciously, till he slipped and fell down, and as he fell something broke in his soul, and immediately he went to sleep.

CHAPTER XXXI

Exeunt

WHEN THEY brought the body home, the next morning, Gudrun was shut up in her room. From her window she saw men coming along with a burden, over the snow. She sat still and let the minutes go by.

There came a tap at her door. She opened. There stood a woman, saying softly, oh, far too reverently:

"They have found him, madam!"

'Il est mort?'155

'Yes - hours ago.'

Gudrun did not know what to say. What should she say? What should she feel? What should she do? What did they expect of her? She was coldly at a loss.

'Thank you,' she said, and she shut the door of her room. The woman went away mortified. Not a word, not a tear – ha! Gudrun was cold, a cold woman.

Gudrun sat on in her room, her face pale and impassive. What was she to do? She could not weep and make a scene. She could not alter herself. She sat motionless, hiding from people. Her one motive was to avoid actual contact with events. She only wrote out a long telegram to Ursula and Birkin.

In the afternoon, however, she rose suddenly to look for Loerke. She glanced with apprehension at the door of the room that had been Gerald's. Not for worlds would she enter there.

She found Loerke sitting alone in the lounge. She went straight up to him.

'It isn't true, is it?' she said.

He looked up at her. A small smile of misery twisted his face. He shrugged his shoulders.

'True?' he echoed.

'We haven't killed him?' she asked.

He disliked her coming to him in such a manner. He raised his shoulders wearily.

'It has happened,' he said.

She looked at him. He sat crushed and frustrated for the time being, quite as emotionless and barren as herself. My God! this was a barren tragedy, barren, barren.

She returned to her room to wait for Ursula and Birkin. She wanted to get away, only to get away. She could not think or feel until she had got away, till she was loosed from this position.

The day passed, the next day came. She heard the sledge, saw Ursula and Birkin alight, and she shrank from these also.

Ursula came straight up to her.

'Gudrun!' she cried, the tears running down her cheeks. And she took her sister in her arms. Gudrun hid her face on Ursula's shoulder, but still she could not escape the cold devil of irony that froze her soul.

'Ha, ha!' she thought, 'this is the right behaviour.'

But she could not weep, and the sight of her cold, pale, impassive face soon stopped the fountain of Ursula's tears. In a few moments, the sisters had nothing to say to each other.

'Was it very vile to be dragged back here again?' Gudrun asked at length.

Ursula looked up in some bewilderment.

'I never thought of it,' she said.

'I felt a beast, fetching you,' said Gudrun. 'But I simply couldn't see people. That is too much for me.'

'Yes,' said Ursula, chilled.

Birkin tapped and entered. His face was white and expressionless. She knew he knew. He gave her his hand, saying:

'The end of this trip, at any rate.'

Gudrun glanced at him, afraid.

There was silence between the three of them, nothing to be said. At length Ursula asked in a small voice:

'Have you seen him?'

He looked back at Ursula with a hard, cold look, and did not trouble to answer.

'Have you seen him?' she repeated.

'I have,' he said, coldly.

Then he looked at Gudrun.

'Have you done anything?' he said.

'Nothing,' she replied, 'nothing.'

She shrank in cold disgust from making any statement.

'Loerke says that Gerald came to you, when you were sitting on the sledge at the bottom of the Rudelbahn, that you had words, and Gerald walked away. What were the words about? I had better know, so that I can satisfy the authorities, if necessary.'

Gudrun looked up at him, white, childlike, mute with trouble.

'There weren't even any words,' she said. 'He knocked Loerke down and stunned him, he half strangled me, then he went away.'

To herself she was saying:

'A pretty little sample of the eternal triangle!' And she turned ironically away, because she knew that the fight had been between Gerald and herself and that the presence of the third party was a mere contingency – an inevitable contingency perhaps, but a contingency none the less. But let them have it as an example of the eternal triangle, the trinity of hate. It would be simpler for them.

Birkin went away, his manner cold and abstracted. But she knew he would do things for her, nevertheless, he would see her through. She smiled slightly to herself, with contempt. Let him do the work, since he was so extremely *good* at looking after other people.

Birkin went again to Gerald. He had loved him. And yet he felt chiefly disgust at the inert body lying there. It was so inert, so coldly dead, a carcase, Birkin's bowels seemed to turn to ice. He had to stand and look at the frozen dead body that had been Gerald. It was the frozen carcase of a dead male. Birkin remembered a rabbit which he had once found frozen like a board on the snow. It had been rigid like a dried board when he picked it up. And now this was Gerald, stiff as a board, curled up as if for sleep, yet with the horrible hardness somehow evident. It filled him with horror. The room must be made warm, the body must be thawed. The limbs would break like glass or like wood if they had to be straightened.

He reached and touched the dead face. And the sharp, heavy bruise of ice bruised his living bowels. He wondered if he himself were freezing too, freezing from the inside. In the short blond moustache the life-breath was frozen into a block of ice, beneath the silent nostrils. And this was Gerald!

Again he touched the sharp, almost glittering fair hair of the frozen body. It was icy-cold, hair icy-cold, almost venomous. Birkin's heart began to freeze. He had loved Gerald. Now he looked at the shapely, strange-coloured face, with the small, fine, pinched nose and the manly cheeks, saw it frozen like an ice-pebble – yet he had loved it. What was one to think or feel? His brain was beginning to freeze, his blood was turning to ice-water. So cold, so cold, a heavy, bruising cold pressing on his arms from outside, and a heavier cold congealing within him, in his heart and in his bowels.

He went over the snow slopes, to see where the death had been. At last he came to the great shallow among the precipices and slopes, near the summit of the pass. It was a grey day, the third day of greyness and stillness. All was white, icy, pallid, save for the scoring of black rocks that jutted like roots sometimes, and sometimes were in naked faces. In the distance a slope sheered down from a peak, with many black rock-slides.

It was like a shallow pot lying among the stone and snow of the upper world. In this pot Gerald had gone to sleep. At the far end, the guides had driven iron stakes deep into the snow-wall, so that, by means of the great rope attached, they could haul themselves up the massive snow-front, out on to the jagged summit of the pass, naked to heaven, where the Marienhütte hid among the naked rocks. Round about, spiked, slashed snow-peaks pricked the heaven.

Gerald might have found this rope. He might have hauled himself up to the crest. He might have heard the dogs in the Marienhütte, and found shelter. He might have gone on, down the steep, steep fall of the south-side, down into the dark valley with its pines, on to the great Imperial road leading south to Italy.

He might! And what then? The Imperial road! The south? Italy? What then? Was it a way out? It was only a way in again. Birkin stood

high in the painful air, looking at the peaks, and the way south. Was it any good going south, to Italy? Down the old, old Imperial road?

He turned away. Either the heart would break, or cease to care. Best cease to care. Whatever the mystery which has brought forth man and the universe, it is a non-human mystery, it has its own great ends, man is not the criterion. Best leave it all to the vast, creative, non-human mystery. Best strive with oneself only, not with the universe.

'God cannot do without man.' It was a saying of some great French religious teacher. But surely this is false. God can do without man. God could do without the ichthyosauri and the mastodon. These monsters failed creatively to develop, so God, the creative mystery, dispensed with them. In the same way the mystery could dispense with man, should he too fail creatively to change and develop. The eternal creative mystery could dispose of man, and replace him with a finer created being. Just as the horse has taken the place of the mastodon.

It was very consoling to Birkin, to think this. If humanity ran into a *cul de sac* and expended itself, the timeless creative mystery would bring forth some other being, finer, more wonderful, some new, more lovely race, to carry on the embodiment of creation. The game was never up. The mystery of creation was fathomless, infallible, inexhaustible, forever. Races came and went, species passed away, but ever new species arose, more lovely, or equally lovely, always surpassing wonder. The fountain-head was incorruptible and unsearchable. It had no limits. It could bring forth miracles, create utter new races and new species, in its own hour, new forms of consciousness, new forms of body, new units of being. To be man was as nothing compared to the possibilities of the creative mystery. To have one's pulse beating direct from the mystery, this was perfection, unutterable satisfaction. Human or inhuman mattered nothing. The perfect pulse throbbed with indescribable being, miraculous unborn species.

Birkin went home again to Gerald. He went into the room, and sat down on the bed. Dead, dead and cold!

Imperial Caesar dead, and turned to clay Would stop a hole to keep the wind away.¹⁵⁶

There was no response from that which had been Gerald. Strange, congealed, icy substance - no more. No more!

Terribly weary, Birkin went away, about the day's business. He did it all quietly, without bother. To rant, to rave, to be tragic, to make situations – it was all too late. Best be quiet, and bear one's soul in patience and in fullness. But when he went in again, at evening, to look at Gerald between the candles, because of his heart's hunger, suddenly his heart contracted, his own candle all but fell from his hand, as, with a strange whimpering cry, the tears broke out. He sat down in a chair, shaken by a sudden access. Ursula who had followed him, recoiled aghast from him, as he sat with sunken head and body convulsively shaken, making a strange, horrible sound of tears.

'I didn't want it to be like this – I didn't want it to be like this,' he cried to himself. Ursula could but think of the Kaiser's: 'Ich habe as nicht gewollt.'¹⁵⁷ She looked almost with horror on Birkin.

Suddenly he was silent. But he sat with his head dropped, to hide his face. Then furtively he wiped his face with his fingers. Then suddenly he lifted his head, and looked straight at Ursula, with dark, almost vengeful eyes.

'He should have loved me,' he said. 'I offered him.'

She, afraid, white, with mute lips answered:

'What difference would it have made!'

'It would!' he said. 'It would.'

He forgot her, and turned to look at Gerald. With head oddly lifted, like a man who draws his head back from an insult, half haughtily, he watched the cold, mute, material face. It had a bluish cast. It sent a shaft like ice through the heart of the living man. Cold, mute, material! Birkin remembered how once Gerald had clutched his hand, with a warm, momentaneous grip of final love. For one second – then let go again, let go for ever. If he had kept true to that clasp, death would not have mattered. Those who die, and dying still can love, still believe, do not die. They live still in the beloved. Gerald might still have been living in the spirit with Birkin, even after death. He might have lived with his friend, a further life.

But now he was dead, like clay, like bluish, corruptible ice. Birkin looked at the pale fingers, the inert mass. He remembered a dead stallion he had seen: a dead mass of maleness, repugnant. He remembered also the beautiful face of one whom he had loved, and who had died still having the faith to yield to the mystery. That dead face was beautiful, no one could call it cold, mute, material. No one could remember it without gaining faith in the mystery, without the soul's warming with new, deep life-trust.

And Gerald! The denier! He left the heart cold, frozen, hardly able to beat. Gerald's father had looked wistful, to break the heart: but not this last terrible look of cold, mute Matter. Birkin watched and watched.

Ursula stood aside watching the living man stare at the frozen face of the dead man. Both faces were unmoved and unmoving. The candle-flames flickered in the frozen air, in the intense silence.

'Haven't you seen enough?' she said.

He got up.

'It's a bitter thing to me,' he said.

'What - that he's dead?' she said.

His eyes just met hers. He did not answer.

'You've got me,' she said.

He smiled and kissed her.

'If I die,' he said, 'you'll know I haven't left you.'

'And me?' she cried.

'And you won't have left me,' he said. 'We shan't have any need to despair, in death.'

She took hold of his hand.

'But need you despair over Gerald?' she said.

'Yes,' he answered.

They went away. Gerald was taken to England, to be buried. Birkin and Ursula accompanied the body, along with one of Gerald's brothers. It was the Crich brothers and sisters who insisted on the burial in England. Birkin wanted to leave the dead man in the Alps, near the snow. But the family was strident, loudly insistent.

Gudrun went to Dresden. She wrote no particulars of herself. Ursula stayed at the Mill with Birkin for a week or two. They were both very quiet.

'Did you need Gerald?' she asked one evening.

'Yes,' he said.

'Aren't I enough for you?' she asked.

'No,' he said. 'You are enough for me, as far as a woman is concerned. You are all women to me. But I wanted a man friend, as eternal as you and I are eternal.'

'Why aren't I enough?' she said. 'You are enough for me. I don't want anybody else but you. Why isn't it the same with you?'

'Having you, I can live all my life without anybody else, any other sheer intimacy. But to make it complete, really happy, I wanted eternal union with a man too: another kind of love,' he said.

'I don't believe it,' she said. 'It's an obstinacy, a theory, a perversity.' 'Well – ' he said.

'You can't have two kinds of love. Why should you!'

It seems as if I can't,' he said. 'Yet I wanted it.'

'You can't have it, because it's false, impossible,' she said.

'I don't believe that,' he answered.

4 sadress

NOTES

These notes are informative rather than interpretative, and focus on classical, biblical, cultural and historical references, and on foreign vocabulary. Extensive annotations of the text, including connections with Lawrence's life and work, are to be found in the Cambridge University Press edition of *Women in Love*, edited by David Farmer, Lindeth Vasey and John Worthen (Cambridge 1987), in the 'Works of D. H. Lawrence' series.

- 1 (p. 4) sisters of Artemis rather than of Hebe Artemis: daughter of Zeus and Leto, a virgin associated with safety, also childbirth; Hebe: daughter of Zeus and Hera, goddess of youthful power and cup-bearer to the gods
- 2 (p. 5) *reculer pour mieux sauter* to retreat, the better to jump again (French)
- 3 (p. 11) Rossetti Dante Gabriel Rossetti (1828–82), Pre-Raphaelite poet and painter
- 4 (p. 11) Kulturtrager vehicle for culture (German)
- 5 (p. 19) Cain eldest son of Adam and Eve, who killed his brother Abel (Genesis 4)
- 6 (p. 32) The eternal apple fruit of the Tree of Knowledge, with which Eve tempted Adam (Genesis 2 and 3)
- 7 (p. 33) Lady of Shalott poem (1832) by Alfred, Lord Tennyson (1809–92)
- 8 (p. 33) *like a stricken pythoness of the Greek oracle* the priestess of Apollo, possessing the gift of the oracle (Greek mythology)
- 9 (p. 34) Woman wailing for her demon lover from the poem 'Kubla Khan' (1798), line 16, by Samuel Taylor Coleridge (1772–1834)
- 10 (p. 41) *pour moi, elle n'existe pas* as far as I'm concerned, she doesn't exist (French)

11 (p. 41) à terre down to earth (French)

- 12 (p. 41) *like Corneille* Pierre Corneille (1606–84), French verse dramatist, renowned for the heroic tone of his classical tragedies
- 13 (p. 42) Je m'en fiche I don't give a damn (French)
- 14 (p. 44) Gaby Deslys (1884–1920), actress and music-hall artiste, appeared in London 1906–15
- 15 (p. 44) *Brocken spectre* apparition on a mountain of the magnified image of the observer projected on to cloud or mist; figures in Romantic discourse in, for example, the writing of Wordsworth, De Quincey and James Hogg
- 16 (p. 48) destroyed like Sodom Sodom and Gomorrah, cities destroyed by God for their wickedness and immorality (Genesis 19:24-5)
- 17 (p. 48) *Bohemia* relating to a community of artists, stemming from the belief that gypsies originated from Bohemia
- 18 (p. 49) Miles and miles from the poem 'Love Among the Ruins' (1855), II, 1-4, by Robert Browning (1812-89)
- 19 (p. 52) the last war the Boer War, 1899-1908
- 20 (p. 59) to cat to vomit
- 21 (p. 61) *wood-carvings from West Africa* fetishes or objects worshipped for their housing of spirits; indicating the early twentiethcentury Modernist fascination with so-called 'primitive' art; see also Chapter VII
- 22 (p. 62) *Futurist manner* pre-war movement of modern art founded in Italy by Filippo Tomasso Marinetti (1876–1944), celebrating machinery, speed and war, later associated with fascism in Italy
- 23 (p. 64) *Pietà* image of the Virgin Mary holding the body of the dead Christ
- 24 (p. 66-7) comme il faut stylish yet correct (French)
- 25 (p. 68) Georgian English architecture and decorative art 1714– 1830, principally Classical in style; hence 'Corinthian', popular Greek architectural style of the Ionic order
- 26 (p. 68) *Liberal member of Parliament* The Liberal party gained a landslide victory in the General Election of 1906 and maintained office, though in Tory coalition after 1916, until 1922.
- 27 (p. 71) who remembers Disraeli Probably Alvan in The Tragic Comedians (1892), a novel by George Meredith (1828–1909). The character's robustness recalls Benjamin Disraeli (1804–81), Tory Prime Minister 1868 and 1874–80.

NOTES

- 28 (p. 72) a peak in Dariayn from the poem 'On First Looking into Chapman's Homer' (1817), last line, by John Keats (1795–1821)
- 29 (p. 72) Fathers and Sons novel (1862) by Ivan Turgenev (1818-83)
- 30 (p. 76) revenant ghost (French)
- 31 (p. 76) *Cassandra* daughter of Priam and Hecuba, given the spirit of prophecy by Apollo, but not believed
- 32 (p. 76) Anche tu, Palestra, ballerai si, per piacere You too, Palestra, will you dance? Yes, please (Italian)
- 33 (p. 77) Vergini Delle Rochette 'Virgins of the little rocks' (Italian), possibly relating to Le Vergini delle roche (1895), play by the Italian dramatist Gabriele D'Annunzio (1863–1938)
- 34 (p. 77) Naomi and Ruth and Orpah Ruth and Orpah are the widowed Naomi's widowed daughters-in-law in the Old Testament
- 35 (p. 77) *Pavlova and Nijinsky* principal dancers in the Russian ballet of Serge Diaghilev (1872–1929)
- 36 (p. 78) Cosa vuol'dire, Palestra? What do you mean, Palestra? (Italian)
- 37 (p. 81) *Render* . . . that are Caesarina's a play on Matthew 22:21 ('Render therefore unto Caesar . . .)
- 38 (p. 81) scelerisque purus of unblemished life and spotless reputation (Horace, Odes, I, xxii, 1)
- 39 (p. 83) salvator femininus female saviour (Latin)
- 40 (p. 86) *Dionysos* Greek god of fertility and wine, inspiring music and poetry; revived in the philosophy of Friedrich Nietzsche (1844–1900), e.g. *The Birth of Tragedy* (1872)
- 41 (p. 92) *Alexander Selkirk* Alexander Selcraig (1676–1721), Scottish sailor, prototype for Daniel Defoe's Robinson Crusoe
- 42 (p. 98) *Daphne* daughter of the river god Peneus, beloved of Apollo, but dedicated to virginity, therefore turned into a laurel tree in order to avoid his attention
- 43 (p. 105) *Paul et Virginie* romance (1787) by Bernardin de St Pierre (1737–1814)
- 44 (p. 105) Watteau Jean Antoine Watteau (1684-1721), French artist
- 45 (p. 107) *apples of Sodom* fruits which are externally beautiful but internally rotten
- 46 (p. 109) Salvator Mundi saviour of the world; for an ominous Modernist interpretation, see 'The Second Coming' (1921), poem by W. B. Yeats (1865–1939)

WOMEN IN LOVE

- 47 (p. 111) Ark of the Covenant sacred box of the Hebrews, containing the tablets of the Ten Commandments, a pot of manna and Aaron's Rod
- 48 (p. 114) Fabre Jean-Henri Casimir Fabre (1823–1915), French naturalist
- 49 (p. 128) Wille zur Macht Friedrich Nietzsche, Der Wille zur Macht (1887), translated as The Will to Power (1906)
- 50 (p. 133) des biboux incroyables? Look, look at those people! Aren't they incredible owls? (French)
- 51 (p. 137) Un peu trop de monde A little too many people (French)
- 52 (p. 137) Cradle of the Deep religious song, nineteenth century
- 53 (p. 141) Annchen von Tharau traditional German folk song
- 54 (p. 141) *Dalcroze* Emile Jacques-Dalcroze (1865–1950), founder of influential 'eurythmics', a system of musical training through self-expressive bodily movement
- 55 (p. 143) Way . . . in Tennessee 'Way down dar in Tennessee', popular song by Alfred Scott-Gatty (1847-1918)
- 56 (p. 145) *Cordelia* youngest daughter of Shakespeare's King Lear, who loves her father most, but will not declare her love to order
- 57 (p. 147) *Apbrodite* the Greek Venus, who sprang from the foam of the sea
- 58 (p. 148) *fleurs du mal* referring to *Les fleurs du mal* (1857), key poetic work of the French writer Charles-Pierre Baudelaire (1821–1867), an important Symboliste precursor of Modernism
- 59 (p. 148) *Herakleitos* early Greek philosopher, an influential figure in Nietzsche's philosophy and for Lawrence
- 60 (p. 164) Sappho Greek poet of Lesbos, c.600BC, who threw herself into the sea having been rejected by the beautiful youth Phaon
- 61 (p. 172) *she was detestable* Magna Mater and Mater Dolorosa each refer to the Great Mother, the ancient female principle of the suffering, sacrificial mother.
- 62 (p. 175) Amazon race of female warriors from Scythia, in Greek mythology
- 63 (p. 176) *Timor mortis conturbat me* The fear of death disturbs me (Latin); from the Roman Catholic office for the dead
- 64 (p. 178) Blutbruderschaft blood-brotherhood (German)
- 65 (p. 195) Ye ... nor eat bread close to Leviticus 23:14 ('Ye shall eat neither bread, nor parched corn ...')

- 66 (p. 198) *Deus ex machina* the god from the machine (Latin); literally, the stage apparatus by which the gods were suspended above stage in Greek and Roman theatre
- 67 (p. 199) *sati* virtuous wife (Sanscrit); referring to the ancient Hindu custom by which the widow throws herself upon the husband's funeral pyre
- 68 (p. 200) *butty system* system of colliery work organisation in which an individual led a gang working on a section of coal seam and was responsible for the distribution of pay
- 69 (p. 205) Bluecoat boys boys of the Christ's Hospital schools
- 70 (p. 205) *Bismarck* Otto von Bismarck (1815–98), Prussian Prime Minister and German Chancellor
- 71 (p. 206) Bon jour, Mademoiselle . . . Non, Monsieur In this extended conversation, combining French and German, Gudrun and the governess tease Winifred about her rabbit. The governess complains that she has not yet been allowed to see or speak to him, and points out that Bismarck, despite being a 'marvel', was only a chancellor, not a king.
- 72 (p. 213) *Syria Dea* Cybele is the great mother in Roman mythology, and the Syria Dea is the Babylonian goddess of love and war. Both represent the female principle.
- 73 (p. 220) *ball-rolling scarab* the sacred dung-beetle, worshipped in Ancient Egypt as a type of the sun god
- 74 (p. 229) Lloyd George David Lloyd George (1863–1945), Liberal Prime Minister 1916–22
- 75 (p. 230) *nauseous Meredith poem* referring to 'A Preaching from a Spanish Ballad', lines 33-6, by George Meredith
- 76 (p. 240) *faience* fine crockery; Dresden was the source of a hard, glazed porcelain, the Copenhagen style specialised in animal figures
- 77 (p. 241) mauvaise honte bashfulness (French)
- 78 (p. 247) the great serpent of Laocoön Greek sculpture, mid-second century BC or later, depicting the Trojan priest Laocoön and his two sons being crushed to death by snakes, as punishment for warning the Trojans against the wooden horse of the Greeks
- 79 (p. 249) *while Rome burns* Emperor Nero (37–68) is reported to have danced during the burning of Rome, said to have been caused by Nero himself, though he blamed the Christians
- 80 (p. 249) Roman licence referring to the descent of Rome into licentiousness and degradation after the second century AD

- 81 (p. 252) a Mohammedan referring to the Muslim paradise of sensuality
- 82 (p. 253) et puis? and then? (French)
- 83 (p. 254) *Mammon* the god of this world, signifying the evils of greed ('Ye cannot serve God and mammon': Matthew 6:24, Luke 16:13)
- 84 (p. 256) odalisk a female slave in a harem
- 85 (p. 257) si jeunesse savait if youth but knew (French)
- 86 (p. 259) fat a foppish or conceited person (French)
- 87 (p. 259) Il Sandro . . . sono tutti Sandro [Alexander, Hermione's brother] writes that he has been greeted with the greatest enthusiasm, all the young people, both girls and boys, are passionate, passionate for Italy, and they absolutely want to learn everything (Italian)
- 88 (p. 261) Vieni . . . così selvatico ! In speaking Italian to the cat, Hermione teasingly emphasises her recent intimacy with Birkin; 'he remembers me', she says, and claims that 'they are teaching you to do bad things'.
- 89 (p. 271) Glory . . . blessings of the light from a hymn by Bishop Thomas Ken (1637–1711)
- 90 (p. 272) seeing she was fair This reference, and the reference below to 'the sons of God', is to Genesis 6:2-4.
- 91 (p. 280) *sword of Damocles* Damocles, a sycophant of Dionysius, tyrant of Syracuse, was made to sit at a banquet with a sword suspended by a hair over his head.
- 92 (p. 286) Let the dead bury their dead Matthew 8:22
- 93 (p. 294) en ménage like a couple at home (French)
- 94 (p. 300) the young Hermes Greek messenger and herald of the gods
- 95 (p. 307) Lord Bacon Francis Bacon (1561–1626), lawyer, Renaissance scientist, founder of inductive philosophy
- 96 (p. 307) pis aller makeshift, last resort (French)
- 97 (p. 307) Egoisme à deux Egoism for two, possibly attributable to Madame de Staël (1766–1817)
- 98 (p. 311) Poiret Paul Poiret (1879–1943), decorative and furniture designer
- 99 (p. 311) Rodin, Michaelangelo Auguste Rodin (1840–1917), Michaelangelo Buonarroti (1475–1564)
- 100 (p. 315) The meek shall inherit the earth Matthew 5:5

WOMEN IN LOVE

- 101 (p. 322) grain of mustard seed Matthew 13:31-2 and 17:20
- 102 (p. 323) bis resurrection and bis life John 11:25
- 103 (p. 325) mot as in 'bon mot', witticism (French)
- 104 (p. 325) amant en titre recognised lover (French)
- 105 (p. 328) Il faut . . . Et des voisins 'One must respect one's own follies . . . ', 'those of Daddy?', 'And of Mummy', 'And of the neighbours' (French)
- 106 (p. 337) canaille riff-raff (French)
- 107 (p. 340) A Bâle . . . une demi-heure In this exchange, the porter shows Birkin and Ursula to their second-class seats, and informs them that there is half an hour before departure.
- 108 (p. 341) not really herself Ursula's early life is explored in great detail in The Rainbow (1915).
- 109 (p. 343) *La vie . . . d'âmes impériales* Life is an affair of imperial souls. (French)
- 110 (p. 344) *saturnalia* ancient Roman festival of Saturn, involving licentiousness and debauchery
- 111 (p. 344) Chanticleer the virile cock in Chaucer's Nun's Priest's Tale
- 112 (p. 334) übermenschlich superman (German), inevitably associated with the philosophy of Friedrich Nietzsche, e.g., Also sprach Zarathustra (1883–91)
- 113 (p. 346) Tant pis pour moi So much the worse for me (French)
- 114 (p. 351) German adjectives splendid...wonderful...very beautiful...indescribable (German)
- 115 (p. 352) Herr Professor . . . unserer Unterbaltung? The host introduces the new guests to Loerke, and Loerke invites them to join the entertainment.
- 116 (p. 353) sans cérémonie without ceremony (French)
- 117 (p. 354) Das war... Wissen Sie Loerke's monologue is deemed to be 'remarkable' and 'great', and regret is expressed that the English couldn't understand it.
- 118 (p. 354) Annie Lowrie 'Annie Laurie', nineteenth-century musical setting of a poem by the Scottish writer William Douglas (1672-1748)
- 119 (p. 355) *Wie schön*... *aber wirklich!* How beautiful, how moving! Ah, Scottish songs, they have such feeling! But the gracious lady has a *wonderful* voice; the gracious lady really is an artist, really! (German)

- 120 (p. 357) Anton Skrebensky For the story of Ursula's affair with Skrebensky, see The Rainbow (1915).
- 121 (p. 358) Prosit! Your health! (German)
- 122 (p. 360) *Mene! Mene!* King Belshazzar of Babylon saw a hand writing these words on a wall during a feast, foretelling his doom (Daniel 5:25).
- 123 (p. 361) Ein schönes ... Ja! A beautiful lady! ... Yes! (German)
- 124 (p. 365) *Katherine O'Shea* Charles Stewart Parnell (1846–91), Irish politician and leader of the Nationalist movement, was forced to resign from Parliament after an adulterous relationship with 'Kitty' O'Shea, whom he later married.
- 125 (p. 366) *Mach mir*... *bin ich nass* Let me in, let me in, you proud woman, / Make me a fire of wood, / I am wet from the rain, / I am wet from the rain (German); version of a common European folksong, 'The Miller's Wife'
- 126 (p. 369) griffes claws, sometimes in architectural ornamentation
- 127 (p. 369) Alto relievo High relief (Italian)
- 128 (p. 371) *Travaillé*... *vous avez fait?* Worked worked?... And what work what work? What work have you done? (Italian and French)
- 129 (p. 372) *Dunque*... *maintenant* 'Dunque' is perhaps a version of 'donc', so/therefore (French); 'adesso' and 'maintenant' are both 'now' (Italian and French).
- 130 (p. 376) Wissen Sie You know (German)
- 131 (p. 376) de haut en has as if from high to low, condescendingly (French)
- 132 (p. 376) 7a... so ist es Yes so it is, so it is (German)
- 133 (p. 377) *Nein . . . Mal schülerin* No, she wasn't a model. She was a little art-student. (German)
- 134 (p. 378) *Maud Allan* Canadian dancer and teacher (1883–1956), famous for her 'Dance of Salome'
- 135 (p. 378) Ja, sie war bübsch Yes, she was pretty (German)
- 136 (p. 379) Venus of Milo marble statue of Aphrodite, Greek, c. 100 BC, now a treasure of the Louvre in Paris
- 137 (p. 379) epicure a hedonist of refined and fastidious taste
- 138 (p. 384) Blessed Isles the Hesperides, containing a garden of golden apples protected by the daughters of Hesperus

- 139 (p. 392) Mestrovic Ivan Mestrovic (1883–1962), Yugoslavian sculptor
- 140 (p. 392) *peu de rapport* little relationship (French possibly a poor choice of translation)
- 141 (p. 392) bagatelle a trifle (French)
- 142 (p. 393) *Medusa* the chief of the Gorgons (with claws, and snakes for hair), whose face was so terrible that it turned onlookers to stone
- 143 (p. 393) Sehen sie . . . Fraulein sagen? In this highly-charged exchange, Gudrun insists that Loerke does not call her either 'gracious lady' or Mrs Crich. 'Shall I say Miss?' he finally enquires.
- 144 (p. 394) Goethe Johann Wolfgang von Goethe (1749–1832), German poet, novelist, scientist, polymath, a key figure in the development of German Romanticism
- 145 (p. 397) *Feuerbach and Böcklin* From 'Goethe at Weimar', the implication is that Loerke and Gudrun focus their attention on great figures of Romantic, mainly eighteenth-century literature and art.
- 146 (p. 399) *soul of a flea* painting (post-1819) by William Blake (1757-1827)
- 147 (p. 400) laisser-aller free and easy manner (French)
- 148 (p. 401) réligion d'amour religion of love (French)
- 149 (p. 403) the old imperial road over the Brenner pass, from Munich across the Tyrol to Verona in Italy; see Lawrence's 'The Crucifix Across the Mountains', in *Twilight in Italy* (1916)
- 150 (p. 407) *Dignity and Impudence* painting of two dogs in a kennel by Edwin Henry Landseer (1802–73)
- 151 (p. 408) the Arthur Donnithornes reference to the novel Adam Bede (1859) by George Eliot (1819–1880), in which Donnithorne abandons Hetty Sorrell, who is then responsible for the death of their illegitimate child
- 152 (p. 410) chétif stunted, sickly (French)
- 153 (p. 412) Zepbyrus in Greek mythology, god of the west wind
- 154 (p. 413) Monsieur . . . vous aurez fini Sir! When you've quite finished – (French). Earlier, Loerke has responded to the attack with 'I suppose you think that's fun' and 'Long live the hero.'
- 155 (p. 415) Il est mort? Is he dead?

WOMEN IN LOVE

- 156 (p. 419) Imperial Caesar . . . the wind away Shakespeare's Hamlet, 5, 1, lines 207–8
- 157 (p. 420) Icb . . . nicht gewollt I didn't want it (German), supposedly a comment by the Kaiser on the war, as translated in The Times, 2 August 1915